VISUAL QUICKSTART C P9-BZX-631

Photoshop CC

2014 release

FOR WINDOWS AND MACINTOSH

ELAINE WEINMANN PETER LOUREKAS

Peachpit Press

For Alicia

Visual QuickStart Guide Photoshop CC (2014 release)

Elaine Weinmann and Peter Lourekas

Peachpit Press www.peachpit.com

To report errors, please send a note to errata@peachpit.com Peachpit Press is a division of Pearson Education

Copyright © 2015 by Elaine Weinmann and Peter Lourekas

Cover Design: RHDG/Riezebos Holzbaur Design Group, Peachpit Press

Logo Design: MINE™ www.minesf.com Interior Design: Elaine Weinmann

Production: Elaine Weinmann and Peter Lourekas

Illustrations: Elaine Weinmann and Peter Lourekas, except as noted

Notice of Rights

All rights reserved. No part of this book may be reproduced or transmitted in any form by any means, electronic, mechanical, photocopying, recording, or otherwise, without the prior written permission of the publisher. For information on getting permission for reprints and excerpts, contact permissions@peachpit.com.

Notice of Liability

The information in this book is distributed on an "As Is" basis without warranty. While every precaution has been taken in the preparation of the book, neither the authors nor Peachpit shall have any liability to any person or entity with respect to any loss or damage caused or alleged to be caused directly or indirectly by the instructions contained in this book or by the computer software and hardware products described in it.

Trademarks

Visual QuickStart Guide is a registered trademark of Peachpit Press, a division of Pearson Education.

Adobe and Photoshop are registered trademarks of Adobe Systems Incorporated in the United States and/or other countries. All other trademarks are the property of their respective owners.

Many of the designations used by manufacturers and sellers to distinguish their products are claimed as trademarks. Where those designations appear in this book, and Peachpit was aware of a trademark claim, the designations appear as requested by the owner of the trademark. All other product names and services identified throughout this book are used in editorial fashion only and for the benefit of such companies with no intention of infringement of the trademark. No such use, or the use of any trade name, is intended to convey endorsement or other affiliation with this book.

ISBN-13: 978-0-13398046-2

ISBN-10: 0-13398046-4

987654321

Printed and bound in the United States of America

Acknowledgments

Nancy Aldrich-Ruenzel, publisher of Peachpit Press, has steered the company (for nearly two decades!) through a changing and unpredictable publishing landscape with steady, yet flexible, hands.

Susan Rimerman, editor at Peachpit Press, helped us find the resources we needed to get this big project done.

Victor Gavenda, editor at Peachpit Press, keeps us apprised of developments in the software and publishing industries, and gives us valuable advice.

David Van Ness, production editor, spearheaded the final prepress production of this book before sending the files off to RR Donnelley.

Nancy Davis, editor-in-chief; Sara Todd, marketing manager; Alison Serafini, contracts manager; and many other terrific, hard-working people at Peachpit contributed their respective talents.

Elaine Soares, photo research manager, and Lee Scher, photo research coordinator, of the Image Resource Center at Pearson Education (the parent company of Peachpit Press), procured the stock photos from Shutterstock.com that we requested.

Adobe Systems, Inc. produces innovative software that is a pleasure to use and write about. For permitting us to access prerelease versions of Photoshop CC for this 2014 edition, and for helping

us untangle its mysteries and complexities by way of the online forum, we thank the entire Photoshop prerelease team, especially Zorana Gee, senior product manager; Stephen Nielson, senior product manager; Vishal Rana, project lead, prerelease programs; and Pallab Jyotee Hazarika, prerelease program associate. Also thanks to Tom Hogarty, group product manager for Digital Imaging, and Steve Guilhamet, quality engineer.

In addition to writing and testing the instructional material in this book, we designed, illustrated, and composed (packaged) it in Adobe InDesign. Our team of helpers for this edition included the following people:

Rob Knight, ace photographer and Photoshop expert, keystroked some of the tasks in this book.

Patricia Pane, proofreader, combed through our final pages for errors.

Steve Rath produced a comprehensive index, tailored to our needs.

Recently, we moved our household and offices from the coast of New England to the mountains of Asheville, North Carolina. We are grateful to our friends and family who have encouraged and supported us in this journey.

- Elaine Weinmann and Peter Lourekas

In this table of contents and throughout this book, sections that cover new or improved features of Photoshop CC (2014 release) are identified by red stars.

Contents

1: Color Management	4: Camera Raw
Launching Photoshop 1	Why use Camera Raw?
Photoshop color 2	Opening photos into Camera Raw
Introduction to color management 5	The Camera Raw tools
Calibrating your display 6	Cropping and straightening photos \bigstar
Choosing a color space for Photoshop 7	Choosing default workflow options ★
Synchronizing color settings among Adobe	Using the Camera Raw tabs ★61
applications 9	Using the Basic tab 🛣
Customizing the color policies for Photoshop 10	Using the Tone Curve tab68
Installing and saving custom color settings 11	Using the Detail tab ★
Acquiring printer profiles11	Using the HSL/Grayscale tab
Changing a document's color profile	Using the Adjustment Brush tool ★
2: Creating Files	Using the Split Toning tab79
Calculating the correct file resolution	Using the Lens Corrections tab
Creating a new, blank document ★	Using the Effects tab84
Creating document presets16	Using the Graduated Filter tool ★
Editing 16-bit files in Photoshop *	Using the Radial Filter tool 🛣
Saving your document18	Using the Spot Removal tool ★90
Using the Status bar 🖈	Saving and applying Camera Raw settings ★ 92
Ending a work session22	Synchronizing Camera Raw settings94
3: Bridge	Converting, opening, and saving Camera Raw files 🖈
Launching Adobe Bridge	5: Workspaces
Downloading photos from a camera24	Using the Application frame97
Features of the Bridge window	
Choosing a workspace for Bridge28	Tiling multiple documents
Previewing images in Bridge	Changing the zoom level
Opening files from Bridge into Photoshop *	Rotating the canvas view
Customizing the Bridge window	Changing the screen mode
Saving custom workspaces	Choosing a workspace
Resetting the Bridge workspaces	Configuring the panels
Assigning keywords to files	Saving custom workspaces
Rating and labeling thumbnails	Resetting workspaces
Rearranging and sorting thumbnails	Using the Options bar
Filtering thumbnails	6: Panels & Presets
Using thumbnail stacks	The Photoshop panel icons
Managing files using Bridge	The Photoshop panels that are used in
Searching for files	this book ★113
Creating and using collections	Choosing basic brush settings
Exporting the Bridge cache	Managing presets via the pickers and panels130

Exporting and importing presets	Refining selection edges
8: Layer Essentials Creating layers ★	11: Using Color Choosing colors in Photoshop
9: Selections & MasksCreating layer-based selections.167Using the Rectangular and Elliptical Marquee tools.168Using two of the lasso tools.169Deselecting and reselecting selections.170Deleting or filling a selection.170Moving a selection border.171Using the Quick Selection tool.172Using the Magic Wand tool.174Inverting a selection175Using the Color Range command ★176Hiding and showing the selection border.178Creating a frame-shaped selection.179Selecting in-focus areas of a photo ★180Saving and loading selections.182	12: Adjustments Creating adjustment layers

Tinting an image via a Gradient Map adjustment 248	Using the Content-Aware Move tool ★
Applying the Merge to HDR Pro command250	Removing an image element with the
Screening back a layer using Levels254	Patch tool 🖈
13: Combining Images	16: Refocusing
Using the Clipboard255	Applying a filter in the Blur Gallery ★ 325
Drag-copying a selection on a layer 259	Applying the Smart Sharpen filter
Drag-copying a selection or layer between files	Applying the Unsharp Mask filter
with the Move tool	Applying the Shake Reduction filter 🖈
Drag-copying layers between files via the	Using the Sharpen tool
Layers panel	17: Fun with Layers
Creating a layered document from file thumbnails 264	Using clipping masks
Creating embedded Smart Objects 🖈	Blending layers
Replacing an embedded or linked	Applying transformations
Smart Object 🖈271	Applying Content-Aware scaling
Creating linked Smart Objects ★	Using the Liquify filter \bigstar
Working with linked Smart Objects ★273	Applying the Warp command
Combining multiple "exposures"	18: Filters
Fading the edge of a layer via a gradient in a	Applying filters
layer mask279	Creating and editing Smart Filters
Aligning and distributing layers 281	Hiding, copying, and deleting Smart Filters361
Using the Clone Stamp tool and the Clone	Working with the Smart Filters mask
Source panel	More filter techniques
Using the Photomerge command	19: Type
Using Smart Guides, ruler guides, and the grid 🕇 286	Creating editable type
14: Painting	Selecting type
Using the Brush tool289	Recoloring type
Customizing a brush	Changing the font family and font style \bigstar 373
Managing brush presets *	Using Adobe Typekit ★
Using the Mixer Brush tool	Converting type
Using the Eraser tool	Changing the font size
Using the History Brush tool	Applying kerning and tracking
15: Retouching	Adjusting the leading
Using the Replace Color command304	Shifting type from the baseline
Using the Color Replacement tool	Inserting special characters
Whitening teeth or eyes	Applying paragraph settings
Using the Red Eye tool	Formatting type with paragraph and character styles
Using the Healing Brush tool	Transforming the bounding box for
Using the Spot Healing Brush tool	paragraph type
Healing areas with the Patch tool	Screening back type
Retouching by cloning	Rasterizing a type layer
Applying a Content-Aware fill * 321	Putting type in a spot color channel

20: Layer Styles	Playing or reviewing a video451
Layer effect essentials	Splitting a clip
Applying a bevel or emboss effect	Adding transitions to video clips452
Applying a shadow effect	Adding still images to a video453
Applying the Stroke effect	Adding title clips to a video453
Applying the Gradient and Pattern Overlay	Applying adjustment layers and filters to a video 454
effects ★396	Keyframing
Copying, moving, and removing layer effects 398	Adding audio clips
Changing the layer fill percentage399	Rendering clips into a movie
Applying layer styles	24: Preferences
Creating layer styles	Opening the Preferences dialogs
Applying multiple layer effects402	General Preferences *
21: Vector Drawing	Interface Preferences ★
Creating shapes layers with a shape tool 406	Sync Settings Preferences ★
Changing the attributes of a shape layer 🛨 407	File Handling Preferences
Selecting shape layer paths 🖈	Performance Preferences
Isolating a shape layer ★	Cursors Preferences
Working with multiple shapes	Transparency & Gamut Preferences
Creating vector masks	Units & Rulers Preferences
Working with vector masks	Guides, Grid & Slices Preferences
Drawing with the Freeform Pen tool418	Plug-ins Preferences *
Saving, displaying, selecting, and repositioning	Type Preferences
paths *418	Experimental Features Preferences *
Drawing with the Pen tool	Preferences for Adobe Bridge
More ways to create paths and shapes 423	
Reshaping vector objects *	25: Print & Export
Working with paths425	Proofing document colors onscreen
22. Actions	Outputting a file to an inkjet printer
22: Actions Recording an action	Preparing a file for commercial printing
Playing an action	Getting Photoshop files into Adobe InDesign
Editing an action	and Illustrator
Deleting commands and actions	Saving a file in the PDF format
Saving and loading action sets	Saving a file in the TIFF format
Saving and loading action sets436	Saving multiple files in the JPEG, PSD, or TIFF format
23: Presentation	Generating image assets from Photoshop layers 🛨 489
Creating a vignette	Using the Package command ★
Adding an artistic border	
Creating a PDF presentation of images	Appendix: Creative Cloud ★ 499
Creating and using layer comps ★ 446	Index499
Creating a PDF presentation of layer comps448	HIMEA47:
Importing video clips into Photoshop 449	
Adding video tracks to a timpling (50)	

Changing the length, order, or speed of a clip 451

REGISTER THIS BOOK, THEN DOWNLOAD PHOTOS FOR FREE!

Purchasing this book entitles you to more than just a couple of pounds of paper. If you register the book with Peachpit Press, you will also be entitled to download copies of many of the images that are used throughout the book, which you can use to practice with as you follow our step-by-step tutorials.

To access the bonus images, log in to your Peachpit account or create one at Peachpit.com/join (it's free). On your Account page (under the Registered Products tab), click Register Your Products Here or Register Another Product, enter the ISBN number for this book: 0133980464, then click Submit. Finally, below the title of this book, click the Access Bonus Content link.

Note: The downloadable images that we have made available are low resolution (not suitable for printing), and they are copyrighted by their owners, who have watermarked them to discourage unauthorized reproduction. They are for your personal use only — not for distribution or publication.

A NOTE REGARDING THE CONTENT OF THIS BOOK

Before going to press with this book, we tested (and retested) our text to ensure that it accurately describes the options and features we viewed in the prerelease version of Photoshop. Due to the nature of Creative Cloud subscriptions, however, some features may change or be updated at a later date.

KEEPING YOUR COPY OF PHOTOSHOP UP-TO-DATE

As a subscriber to Creative Cloud, you will be able to access updates to Photoshop (and any other Adobe Creative Cloud programs you have installed) as soon as they are released by Adobe. To access updates, and to manage assets (files and fonts) stored in the Cloud, click the Creative Cloud icon in the Taskbar (in Windows) or on the menu bar (in the Mac OS) to open the application. Click the Apps panel, then click Update for Photoshop (or any other program). It's that simple. Note: In the Mac OS, when updates are available, the Creative Cloud icon will turn blue and a number will display by its side to signify how many of your installed programs have updates.

Welcome to Photoshop! We know you want to dive into the editing features of Camera Raw or Photoshop right away, but achieving successful results will depend on your establishing proper color management settings first.

In this chapter, you will launch Photoshop and familiarize yourself with the Photoshop color basics. Key color management tasks that you will learn about include calibrating your display, choosing and saving color settings in Photoshop, and downloading and installing the correct printer profiles. (In Chapter 25, color management will come into play once more, when you prepare your final files for output.)

Launching Photoshop

To launch Photoshop in Windows:

Do one of the following:

In a 64-bit version of Windows 7, click the Start button, choose All Programs, then click Adobe Photoshop CC 2014.

In Windows 8, display the Start screen, then click the tile for Adobe Photoshop CC 2014 (64-bit) or Adobe Photoshop CC 2014.

Double-click a Photoshop file icon (the file will open and Photoshop will launch).

To enable Photoshop to be launched from the Desktop, right-click the application icon and choose Pin This Program to Taskbar.

To launch Photoshop in the Mac OS:

Do one of the following:

Click the Adobe Photoshop CC 2014 icon in the Dock. (If that icon isn't in your dock, open the Adobe Photoshop CC 2014 folder in the Applications folder, then drag the Adobe Photoshop CC 2014 application icon into the Dock.)

Open the Adobe Photoshop CC 2014 folder in the Applications folder, then double-click the Adobe Photoshop CC 2014 application icon.

Double-click a Photoshop file icon (the file will open and Photoshop will launch).

FINDING THE NEW STUFF IN THIS BOOK

This symbol \star identifies Photoshop features that are new or improved.

IN THIS CHAPTER

Launching Photoshop 1
Photoshop color
Introduction to color management 5
Calibrating your display 6
Choosing a color space for Photoshop7
Synchronizing color settings among Adobe applications 9
Customizing the color policies for Photoshop
Installing and saving custom color settings
Acquiring printer profiles 11
Changing a document's color profile 12

WANT TO SEE AN IMAGE ONSCREEN?

If you want to make the screen more "live" as you read through this chapter, open one of the photos that we have made available for our readers to download (see page viii).

Photoshop color

The building blocks of a Photoshop image

Onscreen, your Photoshop image is a bitmap a geometric arrangement, or mapping, of dots on a rectangular grid. Each dot (pixel) represents a different color or shade. If you drag with a painting tool, such as the Brush tool, across an area of an image, pixels below the pointer are recolored. If you display your document at a high zoom level, you will be able to see the individual pixels (and also edit them individually). A Bitmap programs like Photoshop are best suited for editing photographic or painterly images that contain subtle gradations of color, called "continuous tones." The images you work with in Photoshop can originate from a digital camera, from a photo print that was input via a scanner, from a file that was saved in another application, or even from scratch using Photoshop features, such as painting tools and filters.

To enable color images to be viewed onscreen, your computer display projects red, green, and blue (RGB) light. Combined in their purest form, these additive primaries produce white light. If you were to send your Photoshop file to a commercial print shop for four-color process printing, it would be rendered using cyan (C), magenta (M), yellow (Y), and black (K) inks. Because your display uses the RGB model, it can only simulate the CMYK inks used in commercial printing.

A In this extreme close-up of a photo in Photoshop, you can see the individual pixels that make up the image.

The successful translation of a digital image to a printed one is more complex than you might expect. For one, the same document may look surprisingly dissimilar on different displays, due to such variables as the temperature of the display, the lighting in the room, and even the paint color on the office wall. Second, many colors that you see in the natural world or that can be displayed onscreen can't be printed (have no ink equivalents), and conversely, some colors that can be printed cannot be displayed the same way onscreen. And third, the same image will produce different results depending on the output device and paper type. The color management techniques that we outline in this chapter are designed to help smooth out the color discrepancies that can arise when an image is transferred from digital input to display onscreen, then finally to print.

Photoshop channels

Every Photoshop image contains one, three, or four channels, each of which stores the intensity of a particular color component (e.g., red, green, or blue) as one of 256 levels of gray. Because the 256 gray levels are represented by 8 bits (short for "binary digits") of computer data, the bit depth of such an image is said to be 8 bits per channel. Files that have a higher bit depth of 16 or 32 bits per channel contain more color information than those containing 8 bits per channel (to learn about 16-bit images, see page 17).

Open an RGB Color image and display the Channels panel (Window > Channels) (A, next page). Click Red, Green, or Blue on the panel to display only that channel in your document, then click the topmost channel name on the panel to restore the composite display. Although you can make adjustments to individual channels, normally you will edit all the channels simultaneously while viewing the composite image.

In addition to the core channels (e.g., RGB or CMYK), you can add two other kinds of channels to a Photoshop document. You can save a selection as a mask in a grayscale (alpha) channel, and you can add channels for individual spot colors (colors that are output by a commercial print shop using premixed inks).

Photoshop document color modes

In Photoshop, a document can be converted to, displayed in, and edited in any of the following color modes: Bitmap, Grayscale, Duotone, Indexed Color, RGB Color, CMYK Color, Lab Color, or Multichannel. The availability of some Photoshop commands and options varies depending on the color mode of the current document, so one reason to make a color mode conversion is to take advantage of specific editing or output options.

To convert a document to a different mode, make a selection from the Image > Mode submenu. If a mode is dimmed on the menu and you want to make it available, you need to convert the file to a different mode as a transitional step. For example, to convert a file to Duotone mode, you need to put it into Grayscale mode first. The mode that Photoshop users most commonly work in is RGB Color.

Some mode conversions can cause noticeable color shifts. For example, if you convert a file from RGB Color mode (the mode used by computer displays) to CMYK Color mode (which contains fewer colors than RGB but is necessary for commercial printing), printable colors in the image will be substituted for any RGB colors that are outside the printable range, or gamut. The fewer times you convert a file, the better, as the color data is altered with each conversion. Some conversions cause layers to be flattened, such as a conversion to Indexed Color, Multichannel, or Bitmap mode. Other conversions (such as from RGB to CMYK) give you the option to preserve layers via a Don't Flatten button in an alert dialog that pops up.

Digital cameras and medium- to low-end scanners produce images in RGB color mode. We recommend keeping your files in that mode for faster editing, and to preserve your access to all the Photoshop filters. In fact, most desktop color inkjet printers, especially those that use six or more ink colors, are designed to accept RGB files.

To "soft-proof" your RGB document onscreen (make it look as if it was converted to CMYK Color mode without performing an actual mode change), see pages 474-475.

Continued on the following page

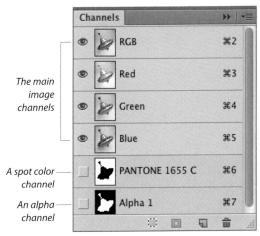

A The number of main image channels is determined by the document color mode (alpha and spot color channels are optional additions).

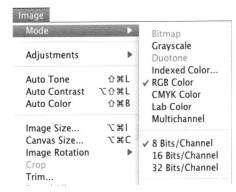

B Use the Mode submenu to change the color mode of your document.

CHANNELS AND THE DOCUMENT COLOR MODE

The number of channels in a document has a major impact on its file size. For instance, if you convert a document from Grayscale mode (one channel) to RGB mode (three channels), it will become three times larger.

DOCUMENT

DEFAULT NUMBER

OF CHANNELS	COLOR MODE
1	Bitmap, Grayscale, Duotone, Indexed Color
3	RGB, Lab, Multichannel
4	CMYK, Multichannel

The following is a brief summary of the document color modes that are available in Photoshop:

In Bitmap mode, pixels are either 100% black or 100% white, and no layers, filters, or adjustment commands are available. To convert a file to this mode, you must convert it to Grayscale mode first.

In Grayscale mode, pixels are black, white, or up to 254 shades of gray (a total of 256). If you convert a file from a color mode to Grayscale mode and then save and close it, its luminosity (light and dark) values are preserved, but its color information is deleted permanently. (In Chapter 12, we show you how to change the colors in a layer to grayscale without actually changing the document color mode.)

To produce a duotone, a grayscale image is printed using two or more extra plates, which add tonal richness and depth. Producing a duotone requires special preparatory steps in Photoshop, and in the case of commercial printing, expertise on the part of the print shop.

A file in Indexed Color mode contains just one channel, no layers, and a maximum of 256 colors or shades in an 8-bit color table. Options for the color table are set in a dialog (Image > Mode > Color Table).

RGB Color is the most versatile and widely used of all the Photoshop modes. A It's the mode in which digital cameras save your photos; the only mode in which all the Photoshop tool options and filters are accessible; and the mode of choice for export to the Web, mobile devices, video, multimedia programs, and most inkjet printers.

In Photoshop, although you can display and edit a document in CMYK Color mode, B a better approach is to perform all your image edits in RGB Color mode first, then convert a copy of your file to CMYK Color mode only when required for commercial printing or for export to a page-layout application. Images that are saved by high-end scanners in CMYK Color mode are exceptions; you should keep those files in CMYK to preserve their original color data.

Lab Color, a three-channel mode, was developed for the purpose of achieving consistency among various devices, such as between printers and displays. Lab Color files are device independent, meaning their color definitions stay the same regardless of how each output device defines color. The channels represent lightness (the image details), the colors green to red, and the colors blue to yellow. The lightness and color values can be edited independently

of one another. Although Photoshop uses Lab Color to produce conversions between RGB and CMYK Color modes internally, Photoshop users like us rarely, if ever, need to convert files to this mode.

Multichannel images contain multiple 256-level grayscale channels. If you convert an image from RGB Color to Multichannel mode, its Red, Green, and Blue channels are converted to Cyan, Magenta, and Yellow (as a result, the image may become lighter and its contrast is reduced). Some Photoshop pros assemble individual channels from several images into a single composite image by using this mode.

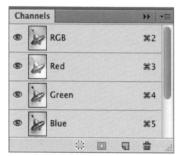

A The mode of this document is RGB Color, so it contains three channels.

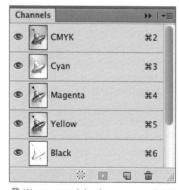

B We converted the document to CMYK Color mode, which upped the number of channels to four.

THE COLOR MODELS IN PHOTOSHOP

In Photoshop, you can choose colors using the Grayscale, RGB, HSB, CMYK, or Lab Color model. or choose predefined colors from a color matching system, such as PANTONE. See Chapter 11.

Introduction to color management

Problems with color inconsistency can arise due to the fact that hardware devices and software packages read or output color differently. If you were to compare an image onscreen in an assortment of imaging programs and Web browsers, the colors might look completely different in each case, and worse still, might look different from the picture you originally shot with your digital camera. Print the image, and you'd probably find the results were different yet again. In some cases, these differences might be slight and unobjectionable, but in other cases such color shifts could wreak havoc with your design or even turn a project into a disaster!

A color management system can prevent most color discrepancies from arising by acting as a color interpreter. The system knows how each particular device and program interprets color, and if necessary, adjusts the colors accordingly. The result is that the colors in your files will display and output more consistently as you shuttle them among various programs and devices. Applications in the Adobe Creative Cloud adhere to standard ICC (International Color Consortium) profiles, which tell your color management system how each specific device defines color.

Each particular device can capture and reproduce only a limited gamut of colors. In the jargon of color management, this gamut is known as the color space. The mathematical description of the color space of each device, in turn, is known as a color profile. Furthermore, each input device, such as a camera, attaches its own profile to the files it produces. Photoshop uses that profile in order to display and edit the colors in your document; or if a document doesn't contain a profile, Photoshop will use the current working space (a color space that you choose for the program) instead. Color management is important for both print and online output, and

when outputting the same document in different media.

On the following pages, we give instructions for choosing color management options, and we strongly recommend that you follow them before editing your images in Photoshop. The steps are centered on using Adobe RGB as the color space for your image-editing work in order to maintain color consistency throughout your workflow. We'll show you how to set the color space of your digital camera to Adobe RGB, give guidelines on calibrating a display, specify Adobe RGB as the color space for Photoshop, acquire the proper profiles for your inkjet printer and paper type, and assign the Adobe RGB profile to files that you have opened in Photoshop.

You'll need to focus on color management later in the production cycle if and when you prepare your file for printing. In Chapter 25, we'll show you how to create a soft-proof setting for your particular inkjet printer and paper using the profiles you have acquired, and then use that setting to soft-proof your document onscreen. The same profile will also be used to output files on a color inkjet printer. Finally, we'll show you how to obtain and install the proper profiles for outputting either to the Web or to a commercial press.

Continued on the following page

SETTING ADOBE RGB AS THE COLOR SPACE FOR YOUR CAMERA

Before shooting photos (and before choosing color settings in Photoshop), you should establish Adobe RGB as the color space your camera will use to process your photos. You can do this via the onscreen menu on most high-end, advanced amateur cameras and digital SLRs. This is especially important if you shoot photos in JPEG format. If you shoot raw files, setting the color space in your camera makes for the most efficient workflow, but if you forget to do it, you can assign Adobe RGB as the color space to your photos later in Camera Raw (see page 58).

Calibrating your display

Why calibrate a display?

In an LCD (liquid crystal, or flat panel) display, a grid of fixed-sized liquid crystals filters color from a light source in the back. Although the color profile that is provided with a typical LCD display (and that is installed in your system automatically) describes the display characteristics accurately, over time — a period of weeks or months — the colors you view onscreen will gradually become less accurate and the device will need adjustment.

Although you can adjust the brightness setting on an LCD monitor, it's best to leave that setting alone and give your display a periodic tune-up using an external calibration device instead. This device. or calibrator, will produce a profile containing the proper settings (white point, black point, and gamma) for your particular display. The Adobe color management system, in turn, will interpret the colors in your Photoshop document and display them more accurately, based on that profile.

Calibrators range widely in cost, from a \$100 to \$300 colorimeter to a much more expensive (but more precise) high-end professional gadget, such as a spectrophotometer. Even with a basic colorimeter and its simple step-by-step wizard, you will be able to calibrate your display more precisely than by using subjective "eyeball" judgments. Among moderately priced calibrators, some currently popular and reliable models include Spyder4PRO and Spyder4ELITE by Datacolor and i1 Display Pro by X-Rite.

Note: Don't be tempted to calibrate your display using the utility that's built into your computer system — it's not going to yield accurate results. If you want to achieve good output from Photoshop, you owe it to yourself to invest in a hardware calibrator. Even the least expensive external device is superior to the internal controls.

The basic calibration settings

An external calibrator will evaluate and then adjust three basic characteristics of your display: It will set the white (brightest) point to a consistent working standard; it will set the black (darkest) point to the maximum value; and it will establish a gamma (neutral gray) by equalizing the values of R, G, and B.

- The white point data sets the brightest white for the display to the industry-standard color temperature. Photographers favor using D65/6500K as the temperature setting for the white point; it is the standard white point setting in LCD displays.
- The black point is the darkest black a display can project. In other words, all the other shades that a monitor displays are lighter than this black. With the black point set correctly, you will be better able to view the shadow details in your photos.
- The gamma controls the display of midtones (the tones between the black and white points), for improved contrast. A gamma setting of 1.0 reproduces the linear brightness scale that is found in nature. However, a setting of 1.0 would make your photos look washed out because human vision responds to brightness in a nonlinear fashion. Instead, photography experts recommend using a gamma setting of 2.2 for both Windows and Macintosh displays. This higher setting redistributes more of the midtones into the dark range. which our eyes are more sensitive to, and enables your photos to look closer to the way you expect them to.

CALIBRATE, AND STAY CALIBRATED

- ➤ Computer displays become uncalibrated gradually, and you may not notice the change until the colors are way off. To maintain the color consistency of your display, stick to a regular monthly calibration schedule. Our calibration software reminds us to recalibrate via a monthly onscreen alert. If yours offers this option, you should take advantage of it.
- Also, be sure to recalibrate your display if you adjust its brightness and contrast settings (intentionally or not), change the temperature or amount of lighting in your office — or repaint the walls in your office!

Choosing a color space for Photoshop

Next, you will establish the color space for Photoshop (the gamut of colors that Photoshop works with and displays). This is an essential step in color management. If you produce images primarily for print output and you want to get up and running quickly, you can choose a preset, as in these steps.

To choose a color settings preset for Photoshop:

- 1. Choose Edit > Color Settings (Ctrl-Shift-K/ Cmd-Shift-K). The Color Settings dialog opens.
- 2. Choose Settings: North America Prepress 2 A (readers residing outside North America, choose an equivalent for your geographic location). This preset changes the RGB working space to Adobe RGB (1998), and sets all the color management policies to the safe choice of Preserve Embedded Profiles, enabling each file you open in Photoshop to keep its own profile.
- Click OK.

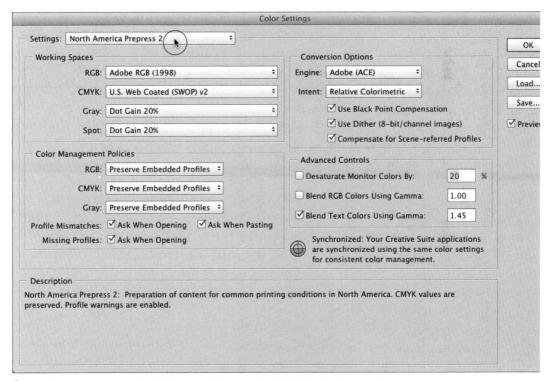

A From the Settings menu in the Color Settings dialog, we chose North America Prepress 2.

Here you can delve further into the Color Settings dialog. Be sure to choose options that are suitable for your output requirements.

To choose color settings options for Photoshop:

- 1. Choose Edit > Color Settings (Ctrl-Shift-K/ Cmd-Shift-K). The Color Settings dialog opens.
- 2. From the **Settings** menu, choose one of the following presets, depending on your output needs:

Monitor Color sets the RGB working space to your display profile. This preset is a good choice for video output, but not for print output.

North America General Purpose 2 meets general requirements for screen and print output in North America, but we don't recommend it for print output because it uses the sRGB IEC61966-2.1 color space (see step 3, at right). All profile warnings are shut off.

North America Newspaper manages color for output on newsprint paper stock.

North America Prepress 2 manages color to conform to common press conditions in North America using the Adobe RGB (1998) color space. We recommend this preset for print documents. When CMYK documents are opened into Photoshop, their values are preserved.

North America Web/Internet is designed for online output. All RGB images are converted to the sRGB IEC61966-2.1 color space.

3. The **Working Spaces** settings govern how colors are treated in documents that lack an embedded profile. You can either leave these menu settings as they are or choose one of these recommended RGB color spaces, depending on your output needs:

Adobe RGB (1998) contains a wide range of colors and is useful when converting RGB images to CMYK. This option is recommended for print output but not for Web output.

ProPhoto RGB contains a very wide range of colors and is useful for output to high-end inkjet and dye-sublimation printers.

sRGB IEC61966-2.1 is a good choice for Web output, as it reflects the settings of the average computer display. Although this setting isn't a good choice for print output (because it contains fewer colors in the printable CMYK gamut than Adobe RGB), many online Web printing sites accept or require files to be in this color space.

- 4. Click OK.
- We recommend that you avoid the Working Spaces settings of Apple RGB and ColorMatch RGB, which were designed for displays that are no longer standard. Also avoid the Monitor RGB [current display profile] and ColorSync RGB profiles, both of which rely on the viewer's display and system settings — variables that can undermine color consistency.

Synchronizing color settings among Adobe applications

If the color settings differ among the Adobe programs that you have installed on your system (such as between Photoshop and Illustrator or InDesign), the word "Unsynchronized" will display in the Color Settings dialog in those programs. If you have a Creative Cloud subscription or have installed multiple Adobe programs (including Adobe Bridge), you can use the Color Settings dialog in Bridge to quickly synchronize the color settings for all of your colormanaged Adobe programs.

Note: Before using Bridge to synchronize the color settings among your Adobe programs, you should establish the correct settings in Photoshop (see the preceding page).

To synchronize the color settings among your Adobe Creative Cloud applications:

- 1. If you're in Photoshop, choose File > Browse in Bridge (Ctrl-Alt-O/Cmd-Option-O).
- 2. In Bridge, choose Edit > Color Settings (Ctrl-Shift-K/Cmd-Shift-K). The Color Settings dialog opens.A
- 3. Click the same settings preset that you chose in the Color Settings dialog in Photoshop (e.g., North America Prepress 2), then click Apply. Bridge will change (synchronize) the color settings of the other Adobe applications to conform to those in the preset you have selected.
- The preset choices in the Color Settings dialog in Bridge match the presets on the Settings menu in the Color Settings dialog in Photoshop (see the preceding page). In the Color Settings dialog in Bridge, keep Show Expanded List of Color Settings Files unchecked to limit the display to just the five basic presets.

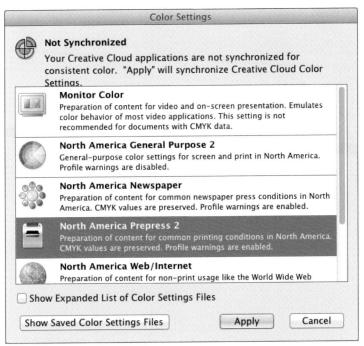

A Use the Color Settings dialog to synchronize the color settings of all your colormanaged Adobe applications.

Customizing the color policies for Photoshop

Photoshop supports document-specific color, meaning that the profile that is embedded in a document controls how colors in that file are previewed onscreen, edited, and converted upon output. The current color management policies govern whether Photoshop honors or overrides a document's settings if the color profile in the file, when opened or imported, doesn't conform to the current color settings in Photoshop. If you chose the North America Prepress 2 setting in the Color Settings dialog (see page 8), the Ask When Opening policy (the safest option, in our opinion) is already chosen for you, and you can skip these steps.

To customize the color management policies for Photoshop:

- 1. Choose Edit > Color Settings (Ctrl-Shift-K/Cmd-Shift-K). The Color Settings dialog opens. A
- 2. From each of the Color Management Policies menus, choose an option for files that you open or import into Photoshop:

Off to prevent Photoshop from color-managing the files.

Preserve Embedded Profiles if you expect to work with both color-managed and

non-color-managed files, and you want each document to keep its own profile.

Convert to Working RGB, Convert to Working Gray, or Convert to Working CMYK to have all files that you open or import into Photoshop adopt the program's current color working space.

3. Optional: For Profile Mismatches, check Ask When Opening to have Photoshop display an alert when the color profile in a file you're opening doesn't match the current working space. Via the alert, you will be able to either convert the document colors to the current working space or keep the embedded profile in the document.

Check Ask When Pasting to have Photoshop display an alert if it encounters a color profile mismatch when you paste or drag and drop imagery into a document. Via the alert, you will be able to accept or override the current color management policy.

- 4. Optional: For Missing Profiles, check Ask When Opening to have Photoshop display an alert when opening a file that lacks a profile, giving you the opportunity to assign one.
- 5. Click OK.

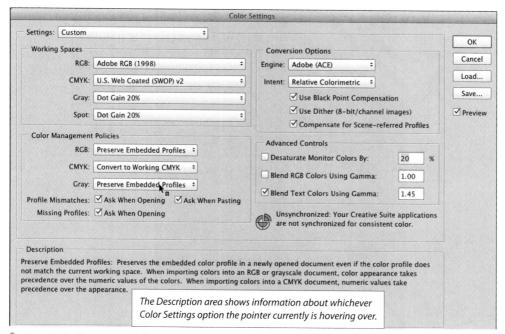

Installing and saving custom color settings

For desktop color printing, we recommended choosing North America Prepress 2 as the color setting for Photoshop (see page 8). For commercial printing, you can let the pros supply the proper color settings: Ask your print shop for a .csf (custom settings) file, which should contain all the correct Working Spaces and Color Management Policies settings for the particular press they will be using for your project. Once you receive the .csf file, all you need to do is install it in the proper location, as described below, and when needed, choose it from the Settings menu in the Color Settings dialog.

To install a .csf file in your system:

In Windows, place the .csf file in a folder of your choice. Choose Edit > Color Settings, click Load, locate and click the .csf file, then click Open.

In the Mac OS, put the file in Users/[user name]/Library/Application Support/Adobe/ Color/Settings.

The .csf is now available as a choice on the Settings menu in the Color Settings dialog.

To access the hidden Library folder in the Mac OS X or later, in the Finder, hold down Option and choose Library from the Go menu.

If your print shop gives you a list of recommended settings for the Color Settings dialog instead of a .csf file, you can create your own .csf file that contains the recommended settings, as in these steps.

To save custom color settings as a .csf file:

- 1. Choose Edit > Color Settings (Ctrl-Shift-K/Cmd-Shift-K). The Color Settings dialog opens.
- 2. Choose and check the settings that your print shop has recommended.
- 3. Click Save. In the dialog, enter a file name (we suggest including the printer type in the name). Keep the .csf extension (make sure Hide Extension is unchecked), and keep the default location. Click Save.
- 4. Click OK to exit the Color Settings dialog.

Acquiring printer profiles

Here we summarize how to acquire the proper printer profile(s) so you can incorporate color management into your specific printing scenario. Most printer manufacturers have a website from which you can download either an ICC profile for a specific printer/paper combination or a printer driver that contains a collection of specific ICC printer/paper profiles. Be sure to choose a profile that conforms to the particular printer/paper combination you are planning to use.

Note: If you're using Windows 8 or later or Mac OS X 10.8 or later and a Canon inkjet printer, the latest Canon drivers (which include profiles) are already installed in your system and you don't need to follow these steps. If you're running an older operating system, download the needed driver from usa.canon.com.

To download the printer profile for your inkiet printer:

1. Do either of the following:

Download the correct profile from the website for your printer. For example, for an Epson Stylus Photo Inkiet device, visit epson.com, locate your printer model, then locate either the driver or the ICC profile for your paper type.

Download an ICC profile for a specific printer/ paper combo from the website of a paper manufacturer, such as ilford.com or museofineart.com.

2. After visiting the website, install the profile you have downloaded by following the instructions that accompany it.

On pages 474-475, we'll show you how to use the profile you have downloaded to soft-proof vour document onscreen.

Changing a document's color profile

When the profile that is embedded in a document doesn't conform to the current working space for Photoshop (which in our case is Adobe RGB), or the document lacks a profile altogether, you can use the Assign Profile command to assign the correct one. You may notice visible color shifts if the color data of the file is reinterpreted to conform to the new profile, but rest assured, the color data in the actual image is preserved. Do keep Preview checked, though, so you can see what you're getting into.

To change or remove a file's color profile:

- 1. With a file open in Photoshop, choose Edit > Assign Profile. If the file contains layers, an alert may appear, warning you that the appearance of the layers may change; click OK.
- 2. The Assign Profile dialog opens. A Check Preview. then click one of the following:
 - To remove the color profile, click Don't Color Manage This Document.

To assign the current working space, as established in the Color Settings dialog, click Working [the document color mode and the name of your chosen working space]. If you followed our steps on page 8, the menu should already be set to the option of Adobe RGB (1998).

To assign a different profile, click Profile, then choose a profile that differs from your current working space.

3. Click OK. Using the File > Save As dialog, save your file in the Photoshop (.psd) format (see page 20). In that dialog, be sure to check ICC Profile (in Windows) or Embed Color Profile (in the Mac OS) to embed the assigned profile into the file.

The Convert to Profile command lets you preview the conversion of a document to a different output profile and intent, then it converts the color data to the chosen profile. Use this command to convert a file to sRGB, if that color space is required (e.g., for online Web printing). Note: This command performs a mode conversion and changes the actual color data in your file, so you should apply it to a copy of your file, not to the original (see page 20).

To convert a file's color profile:

- 1. Choose Edit > Convert to Profile. In the Convert to Profile dialog, check Preview.B
- 2. Under Destination Space, from the **Profile** menu. choose the profile to which you want to convert the file (it doesn't necessarily have to be the current working space).
- 3. Under Conversion Options, choose an Intent (for the intents, see the sidebar on page 475).
- 4. Leave the default Engine as Adobe (ACE), keep the Use Black Point Compensation and Use Dither options checked and, if it's available, check Flatten Image to Preserve Appearance to allow Photoshop to merge all layers and adjustment layers into the Background.
- 5. Click OK.

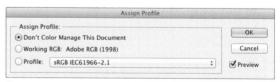

A Use the Assign Profile dialog to either remove a color profile from a file or assign a different one.

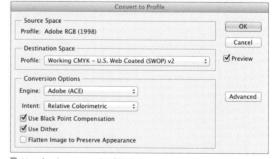

B Use the Convert to Profile dialog to convert your document to a different color profile. Here we switched our file from the Adobe RGB profile to the Working CMYK-U.S. Web Coated (SWOP) v2 profile (for commercial printing).

In Photoshop, you can edit a single photo to your heart's content, create a complex montage of imagery that you gather from multiple files, or paint an image entirely from

scratch. Photoshop generously accepts and reads files in a wide assortment of file formats, so your imagery can be gathered from a variety of sources, such as from a digital camera, scanner, or drawing application.

In this chapter, you will learn how to create a new, blank document, create document presets for your favorite settings, understand the characteristics of 16-bits-per-channel files, save and generate new versions of a file, use the Status bar, and close up shop.

Just to give you an idea of where you're headed, in the next chapter, you will learn how to download photos from a camera and use Bridge to open and manage files, and, in Chapter 4, you will learn how to correct photos in Camera Raw, and open them into Photoshop.

Calculating the correct file resolution

Resolution and dimensions for Web output

Choosing the correct resolution for Web output is a no-brainer: Set the resolution for your file to 72 ppi.

Choosing the correct dimensions for Web output requires a little more forethought, because you need to calculate how your Photoshop document is going to be used in the Web page layout. The easiest way to create a document with the proper dimensions and resolution for Web output is by choosing a preset, as described in step 3 on page 15.

To determine a maximum custom size for a Photoshop image that is going to be displayed on a Web page, you need to estimate how large the average user's browser window is likely to be, then calculate how much of that window the image is going to fill. On a desktop computer, viewers commonly have their browser window open to a width of approximately 1000 pixels. Subtract the space that is occupied by the menu bar, scroll bars, and other controls in the browser interface, and you're left with an area around 950 pixels wide by 600 pixels high; you can use those dimensions as a guideline. In the more likely event that your Photoshop file is going to be used as a small element within a Web page layout, you can choose smaller dimensions.

2

IN THIS CHAPTER

Calculating the correct file	
resolution	3
Creating a new, blank document 19	5
Creating document presets 10	5
Editing 16-bit files in Photoshop 1	7
Saving your document	3
Using the Status bar 2	1
Ending a work session	2

Resolution for print output

Most digital cameras provide a choice: You can let the camera capture and save all the pixels as raw files (recommended) or you can let the camera process, compress, and save the data into small, medium, or large JPEG files. We prefer raw files, for reasons that we explain in Chapter 4. When using a scanner to acquire images for Photoshop, you can set the input resolution in the scanner software to control how many pixels the device captures.

Your image files should contain the minimum resolution needed to obtain quality output from your target output device, at the desired output size. Highresolution photos contain more pixels, and therefore finer details, than low-resolution photos, but they also have a larger file size, take longer to render onscreen, require more processing time to edit, and are slower to print. Low-resolution images, however, look coarse and jagged and lack detail, most noticeably when printed. Your goal is to set an appropriate resolution — one that is neither too high nor too low.A-C

There are three ways to set the resolution value for a digital file:

- ➤ If you use Camera Raw to process a raw or JPEG photo, as we recommend, you can specify an image resolution in its Workflow Options dialog (see page 58).
- When scanning a photo, you should set the image resolution using the scanning software for that device.
- After opening a file into Photoshop, you can change the image resolution via the Image Size dialog (see pages 136-139).

The print resolution for digital images is measured in pixels per inch, or ppi for short. For output to a desktop inkjet printer, an appropriate file resolution is between 240 and 300 ppi. For commercial printing, the first step is to ask your print shop what resolution you should set your document to for their press. If you are told only the halftone screen frequency (lines per inch, or lpi) setting, you can use that number to quickly calculate the correct resolution for your files. For a grayscale image, set the resolution to approximately one-and-a-half times the lpi setting of the output device (usually a resolution of around 200 ppi); for a color image, set the resolution to approximately twice the lpi (usually a resolution of around 250-350 ppi).

A 72 ppi

B 150 ppi

C 300 ppi

Creating a new, blank document

Although in most cases you are going to open existing photos into Photoshop, you still need to know how to create a new, blank document, as we show you in these steps. To create image content, you can drag and drop or copy and paste imagery into the document from other files, draw or paint imagery by hand using brushes, create shapes with vector tools, or enter type.

To create a new, blank document:

- 1. Do either of the following: Choose File > New (Ctrl-N/Cmd-N). Right-click the tab of an existing open document and choose New Document.
- 2. The New dialog opens. A Type a name in the Name field.
- 3. Do either of the following:

From the **Preset** menu, depending on your output medium, choose Default Photoshop Size, U.S. Paper, International Paper, Photo, Web, Mobile & Devices, or Film & Video. Next, from the Size menu, choose a specific size for the preset.

Choose a unit of measure from the menu next to the Width field: the same unit will be chosen automatically for the Height (or to change the unit for just one dimension, hold down Shift while choosing it). Enter custom Width and Height values (or use the scrubby sliders).

- 4. Enter the Resolution required for your target output device. For Web output, enter 72; for print output, see the preceding page.
- 5. Choose a document Color Mode (we recommend RGB Color), then from the adjacent menu, choose 8 bit or 16 bit as the color depth (see page 17).
- 6. Note the current Image Size on the right side of the dialog. If you need to reduce that size, you can choose smaller dimensions, a lower resolution, or a lower bit depth.
- 7. From the Background Contents menu, choose White (the option we recommend if you're a new Photoshop user), or choose Transparent if you want the bottommost tier of the document to be a transparent layer (see Chapter 8). If you are familiar with Photoshop's color controls, you can click the color square and choose a custom color *
- 8. Under Advanced, choose a Color Profile. The list of available profiles will vary depending on the document Color Mode. If you chose RGB Color in step 5, we recommend choosing Adobe RGB (1998) here. (Note: You can also assign or change the profile at a later time via the Edit > Assign Profile dialog. To learn more about color profiles. see pages 10-12.)

Continued on the following page

			New		
	Name:	Sleeping cat			ОК
Preset:	Custom		•		Cancel
	Size:			÷	Save Preset
	Width:	8	Inches	÷	Delete Preset.
	Height:	6	Inches	‡	
	Resolution:	300	Pixels/Inch	÷	
	Color Mode:	RGB Color	‡ 16 bit	‡]	
Backgro	ound Contents:	White		Image Size:	
Advan	ced				24.7M
	Color Profile:	Working RGB:	Adobe RGB (1998)	¢	
Pixe	Aspect Ratio:	Square Pixels		‡	

A In the New dialog, enter a file Name; either choose a Preset size or enter custom Width, Height, and Resolution values; also choose RGB Color mode, a Background Contents option, and a Color Profile.

For Web or print output, leave the Pixel Aspect Ratio on the default setting of Square Pixels. For video output, choose an applicable option (see Photoshop Help).

- 9. Click OK. A new, blank document window appears onscreen. To save the file, see page 18.
- To force the New dialog settings to display the specs of an existing open document, from the bottom of the Preset menu, choose the name of the document that has the desired dimensions.
- If the Clipboard contains image data (say, from artwork that you copied from Adobe Photoshop or Illustrator), the New dialog will automatically display the dimensions of that content. Those dimensions will also display if you choose Clipboard from the Preset menu in the New dialog. If you want to prevent the Clipboard dimensions from displaying (and have the dialog show the last-used file dimensions instead), hold down Alt/Option as you choose File > New.

SETTING DEFAULT RESOLUTION VALUES

In Edit/Photoshop > Preferences > Units & Rulers, under New Document Preset Resolutions, you can enter Print Resolution and Screen Resolution values. Thereafter, one or the other of those values will appear in the Resolution field in the File > New dialog when you choose a preset from the Preset menu. The Print Resolution value is used for the Paper and Photo presets (the default value is 300 ppi); the Screen Resolution value is used for the Web and Film & Video presets (the default value is 72 ppi).

Creating document presets

If you tend to choose the same custom document size, color mode, and other settings over and over in the New dialog, here's a way to streamline your workflow and save yourself some startup time. Create a preset for each "group" of settings. Then, as you create a new document, choose one of your presets from the menu in the New dialog.

To create a document preset:

- 1. Choose File > New or press Ctrl-N/Cmd-N. The New dialog opens.
- 2. Choose settings, including the width, height, resolution, color mode, bit depth, background contents, color profile, and pixel aspect ratio. Ignore any setting that you don't want to include in the preset; you'll exclude it from the preset in step 4.
- 3. Click Save Preset. The New Document Preset dialog opens.A
- 4. Enter a Preset Name. Under Include in Saved Settings, uncheck any New dialog settings that you don't want to save in the preset. Click OK. Your new preset is now listed on the Preset menu in the New dialog.
- To delete a user-created preset, choose it from the Preset menu, click Delete Preset, then click Yes (this cannot be undone).

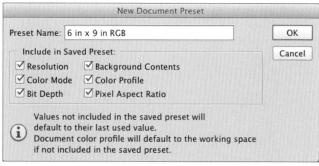

A Use the New Document Preset dialog to name your new preset and to control which of the current settings in the New dialog it will contain.

Editing 16-bit files in Photoshop

The 16-bit advantage

To get high-quality output from Photoshop, a wide range of tonal values must be captured by the input device (e.g., your camera or a scanner). The wider the dynamic range of your chosen input device, the finer the subtleties of color and shade in the resulting images.

Most advanced amateur and professional digital SLR cameras capture 12 bits or more of accurate data per channel. Like cameras, scanners range widely in quality: Low-end models capture approximately 10 bits of accurate data per channel, whereas highend models capture up to 16 bits of accurate data per channel. If your camera can capture 12 to 16 bits per channel, or you work with high-resolution scans, your images will be higher quality, because they will contain an abundance of pixels in all levels of the tonal spectrum. Details (or a lack thereof) will be more noticeable in the shadow areas, because those are the hardest areas for a device to capture well.

The editing and resampling commands in Photoshop (and in particular, tonal adjustment commands, such as Levels and Curves), remove pixel data from a photo and alter the distribution of pixels across the tonal spectrum. Signs of pixel loss from these destructive edits are more visible, for example, in a high-end print of an 8-bit image than in one of a 16-bit image. A-B Because 16-bit images contain more pixels in all parts of the tonal spectrum at the outset, more tonal values are preserved, even after editing (it's like extra "padding").

Histogram Colors Channel: \$ Source: Entire Image

A Levels adjustment that we applied to this 8-bit image caused some image data to be discarded, as shown by the spikes and gaps in the histogram.

Working with 16-bit files

Photoshop can open files that contain 8, 16, or 32 bits per channel. All the Photoshop commands, modes, and tools are available for 8-bit files, whereas most but not all commands, modes, and tools are available for 16-bit files. 16-bit files are higher quality, so we recommend downgrading them only when necessary. When editing a 16-bit file, you can access all the filters in the top part of the Filter menu (e.g., Camera Raw, Lens Correction), but not the Filter Gallery. On the submenus, you can access all filters except Blur > Smart Blur; Render > Lighting Effects; and Stylize > Extrude, Tiles, and Wind. * 32-bit files can be edited using only a limited number of Photoshop commands, so they are not a practical choice.

If system or storage limitations prevent you from working with 16-bit images in Photoshop, try this two-stage approach: Perform your initial tonal corrections on the 16-bits-per-channel image, then via the Image > Mode menu, convert the file to 8 Bits/Channel mode for further editing.

If your output service provider requests that you submit an 8-bit file instead of a 16-bit one, and your computer setup allows you to work with 16-bit files, do all your editing on the higher-quality file, then save a copy of it in the lower bit depth for output.

16-bit files can be saved in many formats, such as Photoshop (.psd), Large Document (.psb), Photoshop PDF (.pdf), PNG (.png), TIFF (.tif), and JPEG 2000 (.jpf).

Finally, 16-bit files can be printed as 16-bit from Photoshop, provided the target output device supports 16-bit printing.

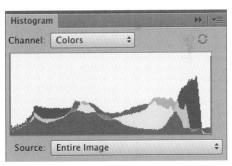

₿ Here we applied the same Levels adjustment to a 16-bit version of the same image. Due to the higher bit depth, the smooth tonal transitions were preserved.

Saving your document

Although Photoshop lets you create, open, edit, and save files in over a dozen different formats, you'll probably encounter or use just a few of them, such as Photoshop (the native Photoshop file format, or PSD for short), Photoshop PDF, JPEG, and TIFF. If you're not sure what format to use, stick with the Photoshop format (we use it for most of our work).

To save an unsaved document:

- 1. If your document contains any content, you can choose File > Save (Ctrl-S/Cmd-S); if it's completely blank, choose File > Save As (Ctrl-Shift-S/ Cmd-Shift-S). The Save As dialog opens.
- 2. Type a name in the File Name field (Windows) or the Save As field (Mac OS).
- 3. Choose a location for the file.
 - In Windows, if you need to navigate to a different folder or drive, use the Navigation pane on the left side of the dialog.
 - In the Mac OS, click a drive or folder in the Sidebar panel on the left side of the window, then click a subfolder in one of the columns, if necessary. To locate a recently used folder, use the menu below the Save As field.
- 4. From the Save as Type/Format menu, choose a file format (A-B, next page). The Photoshop (PSD), Large Document Format (PSB), Photoshop PDF, and TIFF formats support layers, a feature that you will be using extensively in Photoshop (learn about flattening layers on page 166).
- 5. If you're not yet familiar with the features listed in the **Save** area, leave the settings as they are. For the As a Copy option, see step 5 on page 20.
- 6. If the file contains an embedded color profile and the format you have chosen supports profiles, in the Color area, you can check ICC Profile [profile name] (in Windows) or Embed Color Profile [profile name] (in the Mac OS) to save the profile with the file. (To learn about embedded profiles, see pages 7-8, 10, and 12.)
- 7. Click Save.

- In the Mac OS, to have Photoshop append a three-character extension (e.g., .tif, .psd) to the file name automatically when a file is saved for the first time, in Edit/Photoshop > Preferences > File Handling, choose Append File Extension: Always. Extensions are required when exporting Macintosh files to the Windows platform and when posting files to a Web server.
- To learn about the Maximize PSD and PSB File Compatibility option in the File Handling panel of the Preferences dialog, see page 462.

Once a file has been saved for the first time, each subsequent use of the Save command overwrites (saves over) the previous version.

To save a previously saved document:

Choose File > Save (Ctrl-S/Cmd-S).

- An asterisk on a document tab or title bar. indicates that the document contains unsaved changes.
- To learn about the automatic save recovery feature in Photoshop, see page 462.

The simple Revert command restores your document to the last-saved version.

Note: We know you can't learn everything at once, but keep in mind for the near future that the History panel, which is covered in Chapter 10, serves as a full-service multiple undo feature. In fact, each use of the Revert command is listed as a separate state on the History panel, so you can undo any revert by clicking an earlier history state.

To revert a document to the last saved version:

Choose File > Revert.

- To undo the last edit, choose Edit > Undo [name] of edit] (Ctrl-Z/Cmd-Z). Not all edits can be undone by this command.
- For more undo and redo commands, see the sidebar on page 111.

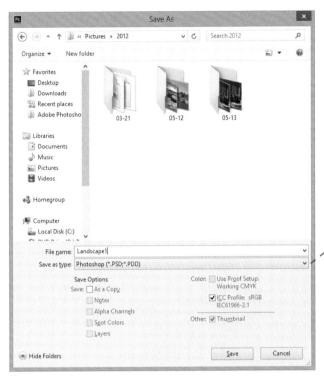

A This is the Save As dialog in Windows.

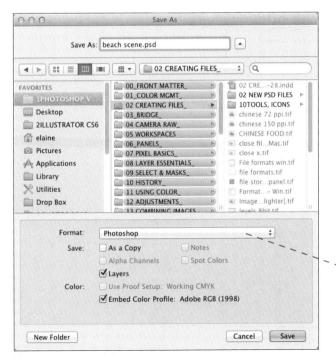

Photoshop (* PSD * PDD) Large Document Format (*.PSB) BMP (*.BMP;*.RLE;*.DIB) CompuServe GIF (*.GIF) Dicom (*.DCM;*.DC3;*.DIC) Photoshop EPS (*.EPS) Photoshop DCS 1.0 (*.EPS) Photoshop DCS 2.0 (*.EPS) IFF Format (*.IFF;*.TDI) JPEG (".JPG;".JPEG;".JPE) JPEG 2000 (".JPF;".JPX;".JP2;".J2C;".J2K;".JPC) JPEG Stereo (*.JPS) Multi-Picture Format (*.MPO) PCX (*.PCX) Photoshop PDF (*.PDF;*.PDP) Photoshop Raw (*.RAW) Pixar (*.PXR) PNG (*.PNG:*.PNS) Portable Bit Map (*.PBM;*.PGM;*.PPM;*.PNM;*.PFM;*.PAM) Scitex CT (*.SCT) Targa (* TGA:* VDA:* JCB:* VST) TIFF (*.TIF; *.TIFF)

FORMATS THAT PRESERVE PHOTOSHOP FEATURES

Choose the Photoshop (PSD), Large Document (PSB), TIFF, or Photoshop PDF format to preserve the following Photoshop features in a document: multiple layers; layer transparency; adjustment, editable type, Smart Object, and shape layers; layer effects; alpha channels; and grids and guides. ICC color management profiles are also preserved by the above-mentioned formats, and by the JPEG format.

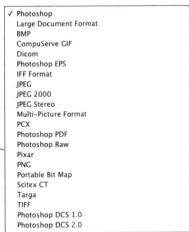

This is the Save As dialog in the Mac OS.

Using the Save As command, you can save a copy of a file under a new name (say, to create a design or tonal adjustment variation), save it with different options chosen (e.g., with or without alpha channels or layers), or save a flattened copy of it in a different format for export to another application (a necessity when exporting to most non-Adobe applications, which can't import Photoshop PSD files or read Photoshop layers).

To save a new version of a file:

- 1. Choose File > Save As (Ctrl-Shift-S/Cmd-Shift-S). The Save As dialog opens.
- 2. Change the name in the File Name/Save As field (if you're planning to change only the file format, this step is unnecessary).
- 3. Choose a location for the new version of the file from the Navigation pane in Windows or by using the Sidebar panel and columns in the Mac OS
- 4. Optional: From the Save as Type/Format menu. choose a different file format. Only formats that are available for a file's current color mode and bit depth are listed. Note: If you try to save a 16-bit file in the JPEG (.jpg) format, Photoshop will produce a flattened, 8-bit copy of the file automatically.
 - Beware! If you choose a format that doesn't support layers, the Layers option is dimmed automatically, a yellow alert icon displays, and layers in the new version will be flattened.
- 5. Check any available options in the Save area that you deem necessary. For example, you could check As a Copy to have the copy of the file remain closed and the original file stay open onscreen, or uncheck this option to have the original file close and the copy stay open. In Edit/Photoshop > Preferences > File Handling, under File Saving Options, we choose the set
 - ting of Image Previews: Always Save to have Photoshop include file previews automatically. If you choose Ask When Saving as the preference, this preview option will display in the Save As dialog instead; see page 462. For the Append File Extension option (Mac OS only), we also choose the setting of Always.
- 6. In the Color area, check ICC Profile/Embed Color Profile: [profile name], if available, to include the

- current profile, for good color management (see pages 7-8, 10, and 12).
- 7. Click Save. Depending on the file format you have chosen, another dialog may appear. For the PDF format, see page 486; for the TIFF format, see page 487; for other formats, see Photoshop Help.
- If you fail (or forget) to change the file name or format in the Save As dialog, but you do proceed to click Save, an alert will appear. A Click Yes/ Replace to replace the original file, or click No/ Cancel to return to the Save As dialog, where you should change the file name or format.
- To have the location in the Save As dialog always default to the location of the current file, go to Edit/Photoshop > Preferences > File Handling. and check Save As to Original Folder.
- For Web output, learn how to create GIF, JPEG, PNG, and SVG image assets from Photoshop layers on pages 489-494.

A If you try to save a file via the Save As command without changing the file name or format, you will get this friendly warning.

PHOTOSHOP GIGANTIC

In Photoshop, you can create and save a file as large as 300,000 x 300,000 pixels — over 2 gigabytes (GB) — and each Photoshop file can contain up to 56 user-created channels. The Large Document (PSB) format (nicknamed "Photoshop Big") is designed specifically for saving such huge files.

What can you do with PSB files? If you have enough disk space to store and work with them and have access to a wide-format printer that can output extra-large images (up to 32,000 x 32,000 pixels), awesome. If not, you will need to drastically lower the resolution of a copy of your PSB file in order to output it to an ordinary printer.

Using the Status bar

Using the Status bar and menu at the bottom of the document window, you can read data pertaining to the current document or find out how Photoshop is currently using available memory. Note: To view more detailed data about a file, use the Metadata panel in Bridge; see page 26.

To use the Status bar:

Open a document, then from the menu adjacent to the Status bar at the bottom of the Application frame, choose the type of data you want Photoshop to display on the bar:

Document Sizes to list the approximate file storage size of a flattened version of the file if it were to be saved in the PSD format (the value on the left) and the storage size of the file including all its current layers and any alpha channels (the value on the right). Note: For the most accurate file size value, view the file listing in Explorer/Finder.

Document Profile to list the color profile that is embedded in the current file and the number of bits per channel. A If the document doesn't have an embedded profile, it will be listed as untagged.

Document Dimensions to list the image dimensions (width and height) and resolution. Measurement Scale to list the current pixel scale ratio for the document, as set via the Measurement Log panel.

Scratch Sizes to list the amount of RAM that Photoshop is using to process all the currently open files (the value on the left) and the amount of RAM that is currently available to Photoshop (the value on the right). When Photoshop is utilizing virtual memory on the scratch disk, the first value is greater than the second one.

Efficiency to list the percentage of program operations that are being done in RAM as opposed to on the scratch disk (see page 464). When the scratch disk is being used, this value is below 100.

Timing to list the duration of the last operation.

Current Tool to list the name of the current tool.

32-Bit Exposure to display a slider that you can drag to adjust the preview of an HDR image that has 32 bits per channel.

Save Progress to have a dynamic percentage value display as a file is being saved (e.g., "Saving 88%").

Smart Objects to list the number of Missing and Changed (modified) linked Smart Objects in the document.

GETTING DOCUMENT INFO FAST

Regardless of which info category is selected on the Status bar menu, at any time you can click and hold on the Status bar to learn the dimensions, number of channels, color mode, bit depth, and resolution of the current document.

Status bar

A From the menu for the Status bar, choose the type of data you want Photoshop to display on the bar.

Adobe Drive Document Sizes ✓ Document Profile **Document Dimensions** Measurement Scale Scratch Sizes Efficiency Timing Current Tool 32-bit Exposure Save Progress

Smart Objects

Ending a work session

To close a document:

- Do one of the following:
 Click the X in a document tab.A
 Choose File > Close (Ctrl-W/Cmd-W).
 Click the Close (X) button in the upper-right corner of a floating document window in Windows,B
 or click the Close button in upper-left corner of a floating document window in the Mac OS.C
- 2. If you try to close a file that was modified since it was last saved (as indicated by an asterisk in the document tab), an alert dialog will appear. D Click No (N)/Don't Save (D) to close the file without saving it, or click Yes (Y)/Save (S) to save the file before closing it (or click Cancel or press Esc to dismiss the Close command).
- To quickly close all (multiple) open documents, press Ctrl-Alt-W/Cmd-Option-W. If an alert dialog appears, you can check Apply to All, if desired, to have just one response apply to all the open documents, then click No/Don't Save or Yes/Save.
- In Photoshop, to close a file and launch or go to Bridge, choose File > Close and Go to Bridge or press Ctrl-Shift-W/Cmd-Shift-W.

To exit/quit Photoshop and close all open files:

- In Windows, choose File > Exit (Ctrl-Q) or click the Close button for the application frame.
 In the Mac OS, choose Photoshop > Quit Photoshop (Cmd-Q).
- 2. If any open files contain unsaved changes, an alert dialog will appear for each one. Click No (N)/ Don't Save (D) to close the file without saving it, or click Yes (Y)/Save (S) to save it before exiting/ quitting Photoshop (or click Cancel or press Esc to dismiss the Exit/Quit command).

A To close a document that is docked as a tab, click the X on the tab in the Mac OS or in Windows.

B To close a floating document window in Windows, click the Close button.

 ℂ To close a floating document window in the Mac OS, click the Close (red) button.

D If you try to close a file that contains unsaved changes, this alert prompt will appear. A similar prompt will appear if you exit/quit Photoshop and any of your open files contain unsaved changes.

The Adobe Bridge application is aptly named because it serves as a link to the programs

in Adobe Creative Cloud. You will initially find that Bridge is useful for viewing both thumbnails and large previews of your images before you open them into Camera Raw or Photoshop. Dig a little deeper, and you will find it offers a wealth of other useful features as well. In Chapter 1, you used Bridge to synchronize the color settings for your Creative Cloud programs. Here we show you first how to use Bridge to download photos from a digital camera. Then you will learn how to preview, examine, label, rate, sort, and filter image thumbnails in the Bridge window; customize the Bridge workspace; organize thumbnails into collections and collapsible stacks; search for, move, copy, and assign keywords to files; and open files into Photoshop. Finally, you will find instructions for exporting the Bridge cache.

Note: Adobe Bridge must be downloaded and installed separately from Photoshop.

Launching Adobe Bridge

When you launch Adobe Bridge, the Bridge window opens.

To launch Adobe Bridge:

Do one of the following:

In Windows 7, click the Start button, choose All Programs, then click **Adobe Bridge CC**.

In Windows 8, display the Start screen, then click the tile for **Adobe Bridge CC**.

In the Mac OS, click the **Adobe Bridge CC** icon but the Dock. Or in the Applications > Adobe Bridge CC folder, double-click the **Adobe Bridge CC** application icon.

In Photoshop, press Ctrl-Alt-O/Cmd-Option-O.

If you want to have Bridge launch automatically at startup, but without the Bridge window opening, go to Edit/Adobe Bridge CC > Preferences (Ctrl-K/ Cmd-K), display the Advanced panel, and check Start Bridge at Login. This is called "stealth mode."

IN THIS CHAPTER

Launching Adobe Bridge	23
Downloading photos from a camera	24
Features of the Bridge window	26
Choosing a workspace for Bridge	28
Previewing images in Bridge	29
Opening files from Bridge into Photoshop	33
Customizing the Bridge window	36
Saving custom workspaces	38
Resetting the Bridge workspaces	38
Assigning keywords to files	38
Rating and labeling thumbnails	40
Rearranging and sorting thumbnails	41
Filtering thumbnails	41
Using thumbnail stacks	42
Managing files using Bridge	43
Searching for files	45
Creating and using collections	46
Exporting the Bridge cache	48

Downloading photos from a camera

When you use a digital camera, your photos are stored on a removable memory card — most likely a CompactFlash (CF) or Secure Digital (SD) card. Rather than having to tether your camera directly to a computer, you can remove the memory card and insert it into a card reader device, then download your photos from the card reader to your computer via a USB or other cable, depending on which connection your camera supports.

When you start downloading images from a camera, the default application or dialog for acquiring images in your system may launch automatically. Instead of using that application, we recommend using the Photo Downloader application that is included with Bridge, the instructions for which we provide here.

To download photos from a card reader via Photo Downloader:

- 1. Take the card out of your camera and insert it into the appropriate slot in the card reader.
- 2. Plug the card reader into your computer. If the default system application for acquiring photos launches, exit/quit it.
- 3. Launch Bridge, then click the Get Photos from Camera button A at the top of the Bridge window. The Photo Downloader dialog opens. A If an alert dialog appears and you want to make Photo Downloader the default capture application, click Yes (as we do); if not, click No.
- 4. From the Get Photos From menu in the Source area, select your card reader.
- 5. In the **Import Settings** area, do the following: To change the save location, click Browse/ Choose, then navigate to the desired folder. Click OK/Open to assign that folder and return to the Photo Downloader dialog.

To create a new subfolder within the currently selected folder, choose a naming convention from the Create Subfolder(s) menu, or choose Custom Name and enter a folder name (or choose None for no new subfolder).

To assign recognizable names and shorter sequential numbers to your digital images instead of the long default number, choose a Custom Name option from the Rename Files menu, then enter a name and a starting number. A sample of your entry displays below the field.

Keep Preserve Current Filename in XMP unchecked.

Check Open Adobe Bridge to have the photos display in Bridge when the downloading process is complete.

Also keep Convert to DNG and Delete Original Files unchecked.

To send copies of your photos to a designated folder on an external hard drive (as a backup), check Save Copies To, click Browse/Choose, choose a location, then click OK/Open. This will be your first backup copy.

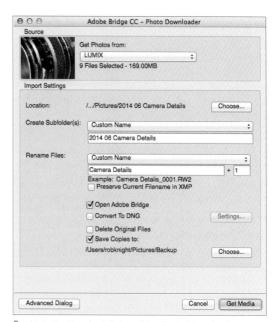

A This is the Standard dialog of the Photo Downloader.

- 6. If you want to download select photos (instead of the whole batch) from your memory card, click Advanced Dialog to expand the dialog. Below the thumbnail window, click UnCheck All, then check the box below each photo you want to download. Or hold down Ctrl/Cmd and click multiple photo thumbnails, then check the box for one of them; a check mark will appear below each of the selected photos.
 - Optional: In the Apply Metadata area, enter Creator and Copyright info to be added to the metadata of all the downloaded photos. (This metadata will display in Bridge.)

- To switch back to the smaller Standard dialog at any time, click Standard Dialog.
- 7. Click Get Media to begin the downloading process. When it's completed, the Photo Downloader dialog is dismissed automatically. Since you checked the Open Adobe Bridge option, your photos will display in a new window in Bridge. Don't worry about previewing or opening them just yet. We'll step you through that process later.
- 8. Unmount your card reader.
- 9. We recommend that you copy your photos to a removable hard drive.

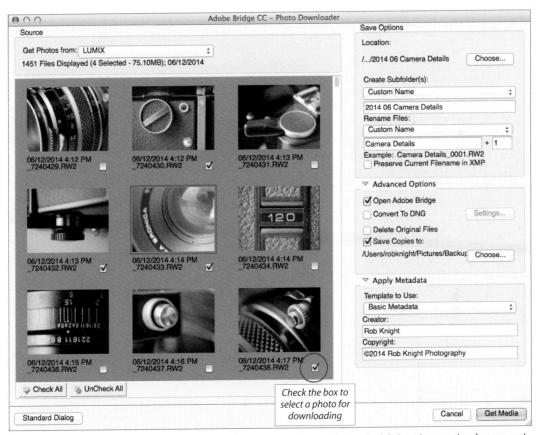

A The Advanced dialog of the Photo Downloader contains the same options as the Standard dialog, plus metadata features and an area for selecting specific photos to be downloaded.

Features of the Bridge window

We'll identify the main components of the Bridge window first, starting from the top (A, next page). The two rows of buttons and menus running across the top of the window are referred to jointly as the toolbar. The second row of the toolbar is also called the Path bar. If the Path bar is hidden, choose Window > Path Bar.

The large sections of the Bridge window are called panes. Each pane contains one or more panels, each of which is accessed via its own tab: Favorites, Folders, Filter, Collections, Content, Preview, Metadata, and Keywords. In the default workspace, Essentials, the panels in the two side panes let you manage files, preview image thumbnails, filter the display of thumbnails, and display file data; the Content panel in the middle displays file and folder thumbnails. At the bottom of the Bridge window are controls for changing the thumbnail size and layout. (To customize the Bridge window, see pages 28 and 36-37.)

Next, we'll briefly describe the Bridge panels that you will learn about in this chapter.

The Favorites panel displays a list of folders that you've designated as favorites, for quick and easy access. See page 29.

The Folders panel contains a scrolling window with a hierarchical listing of all the top-level and nested folders on your hard drive(s). See page 29.

The Filter panel lists criteria pertaining to the images in the currently selected folder, such as how many have a specific label, star rating, file type, creation date, or modification date. By clicking various criteria in the Filter panel on or off, you can control which images in the current folder display in the Content panel. To expand or collapse a category, click its arrowhead. See page 41.

The Collections panel displays the names and icons of collections, which are thumbnail groups that you create to organize your images. See pages 46-47.

The Content panel displays thumbnails for images within the currently selected folder (and optionally, thumbnails for nested folders). In the lower-right corner of the Bridge window, you can click a View Content As button to control whether, and in what

format, metadata pertaining to the current files displays for each thumbnail in the Content panel (see page 37). For any view type, you can change the thumbnail size (see page 36). The Content panel is used and illustrated in many tasks throughout this chapter.

The Preview panel displays a large preview of the image (or folder) thumbnail that is currently selected in the Content panel. Or if the thumbnail for a video or PDF file is selected, controls for playing the video or for viewing the pages display in this panel. Two or more selected image thumbnails can be previewed in this panel, for comparison, and it has a loupe mechanism that you can use to inspect small details. See pages 29-31.

The Metadata panel has two main sections, both of which display data pertaining to the currently selected thumbnail. The placard at the top contains a quick summary (see the sidebar on page 29), and the main part of the panel lists more detailed data, in collapsible categories. In the File Properties category, for example, you can view the current file name, file size, etc. Via the IPTC Core category, you can attach a copyright notice and other data to a file (see page 39). When the thumbnail for a digital photo is selected, the Camera Data (Exif) category lists the camera settings with which the photo was captured. If the photo was edited in Camera Raw, the panel will also show a Camera Raw category in which the Basic tab settings that are applied to the current photo are listed (to add more Camera Raw data to this category, go to Edit/Adobe Bridge CC > Preferences, Metadata pane, and check the desired boxes under Camera Raw).

Use the Keywords panel to assign one or more descriptive subkeywords to your images, such as an event, subject, client, or location, so they can be located quickly using other Bridge features (see pages 38-39). You can run a search to find image thumbnails based on keyword criteria, or narrow the display of thumbnails in the Content panel to subcategories of images by checking specific keywords in the Filter panel.

Note: The Inspector panel isn't covered in this book.

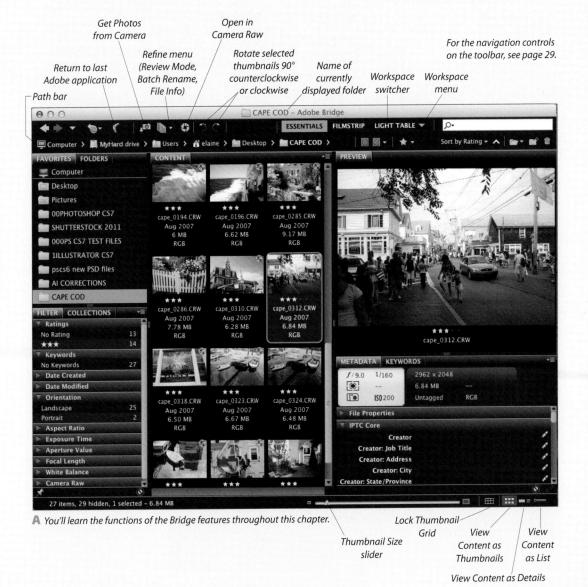

Choosing a workspace for Bridge

To reconfigure the Bridge window quickly, choose one of the predefined workspaces. (To create and save custom workspaces, see pages 36-38.)

To choose a workspace for Bridge:

Do one of the following:

On the upper toolbar, click Essentials, Filmstrip, Light Table, Metadata (List View for the thumbnails), Keywords, Preview, Folders, or a saved custom workspace. A (If there's room on the toolbar and you want to display more workspace names, pull the gripper bar to the left.)

From the Workspace menu on the toolbar, choose a workspace. B-C

Press the shortcut for one of the first six workspaces on the switcher (as listed on the Workspace menu): Ctrl-F1/Cmd-F1 through Ctrl-F6/Cmd-F6.

The shortcuts are assigned automatically to the first six workspaces on the switcher, according to their current order from left to right. (Not working? These shortcuts may already be used by your operating system, in which case they won't work in Bridge.)

- To change the order of workspaces on the switcher, drag a name to the left or right.
- To learn how to resize the thumbnails in the Content panel, see page 36.
- To create a second Bridge window, choose File > New Window (Ctrl-N/Cmd-N). You can display a different workspace and folder in each window.

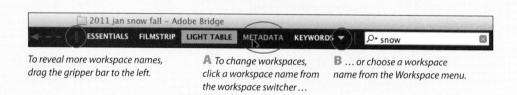

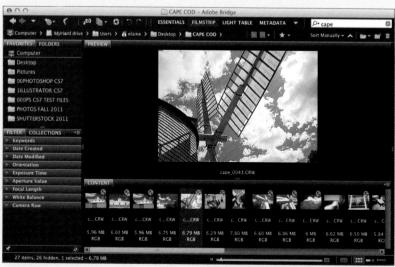

The Filmstrip workspace features a large preview of the currently selected thumbnail(s).

Previewing images in Bridge

To add a folder to the Favorites panel:

Do either of the following:

Drag a folder icon from the Content panel or the Explorer/Finder into the Favorites panel (the pointer will be a + symbol).

Right-click a folder in the Folders or Content panel and choose **Add to Favorites**.

- ➤ Via check boxes in the Favorite Items area of Edit/ Adobe Bridge CC > Preferences > General, you can control which system folders are listed in the Favorites panel.
- ➤ To remove a folder from the list of Favorites, right-click it and choose Remove from Favorites.

To display and select images in Bridge:

1. Do any of the following:

In the **Folders** panel, navigate to a folder. To expand or collapse a folder, click its arrowhead.

Display the contents of a folder by clicking its icon in the **Folders** panel or by double-clicking its thumbnail in the **Content** panel. Note: For folder thumbnails to display in the Content panel, Show Folders must be checked on the View menu.

Click the **Go Back** button on the toolbar A to step back through the last folders viewed, or the **Go Forward** button to reverse your steps.

Click a folder name in the Favorites panel.

From the **Go to Parent or Favorites** menu **a** on the toolbar, choose a parent or Favorites folder.

Click a folder name on the **Path** bar (if the bar is hidden, choose Window > Path Bar).

From one of the menus on the Path bar, choose a folder. If another submenu displays, click yet *Path*

another folder; repeat until you reach the desired folder.

- ➤ To display thumbnails for images in all nested subfolders within the current folder, choose Show Items from Subfolders from the folder menu. To restore the normal view, click the Cancel button on the Path bar.
- 2. In the Content panel, do one of the following:

Click an image thumbnail. A colored border appears around it, and data about the file is listed in the Metadata panel. An enlarged preview of the image also displays in the **Preview** panel, if that panel is showing.

To select multiple, nonconsecutive thumbnails, Ctrl-click/Cmd-click them.

To select a series of consecutive thumbnails, click the first thumbnail in the series, then Shift-click the last one.

- ➤ A number in the upper-left corner of an image thumbnail signifies that it's part of a stack (group) of thumbnails. To display or hide the contents of a stack, click the stack number (see pages 42–43).
- To cycle through thumbnails in the currently displayed folder, press an arrow key on the keyboard.
- To quickly locate and select a particular thumbnail, start typing the file name without clicking anywhere first.

A These are the navigation controls in Bridge.

bar

THE METADATA PLACARD

To show the Metadata placard, check Show Metadata Placard on the Metadata panel menu. The left side of the placard lists settings that were used to shoot the currently selected photo (the icons and data vary depending on the camera settings and model). The right side of the placard lists the pixel dimensions, size, resolution, color profile, and color mode of the current file.

You can control whether thumbnails and the preview render quickly at low resolution, or more slowly and color-managed at high resolution.

To choose a quality option for the Bridge thumbnails and previews:

From the Options for Thumbnail Quality and Preview Generation menu on the Bridge toolbar, choose a preference for the preview quality of image thumbnails:

Prefer Embedded (Faster) displays low-resolution thumbnails and is useful for displaying a high volume of images quickly.

High Quality on Demand displays highresolution, color-managed thumbnails and previews (generated from the source files) for selected thumbnails and low-resolution previews for unselected thumbnails. This is a good compromise between the two other options.

Always High Quality, the default setting, displays high-resolution thumbnails and previews, whether the thumbnails are selected or not. Rendering is the slowest with this option.

- To quickly access lower-quality, faster previewing, click the Browse Quickly by Preferring Embedded Images button on the Path bar; this enables the Prefer Embedded (Faster) option. Click the button again to return to the current setting on the Options for Thumbnail Quality and Preview Generation menu.
- The Generate 100% Previews option on the Options for Thumbnail Quality and Preview Generation menu saves actual-size JPEG versions of thumbnails, which in turn enables Bridge to generate higher-quality previews when the loupe is used or when images are displayed at 100% size in Full Screen Preview or Slideshow view. This option uses a lot of disk space and can make browsing slower, so we recommend keeping it unchecked.

To compare two or more image previews:

- 1. In Bridge, display the Filmstrip or Preview workspace.
- 2. In the Content panel, Ctrl-click/Cmd-click up to nine thumbnails (the maximum number that can be previewed at a time) (A, next page). Large versions of the thumbnails will display in the Preview
- 3. Optional: Ctrl-click/Cmd-click an unselected thumbnail in the Content panel to add it to the Preview panel, or do the same for a selected thumbnail to remove it from the Preview panel.

To display a full-screen preview of an image thumbnail:

- 1. Press the Spacebar to display a full-screen preview of the currently selected thumbnail and hide the Bridge window temporarily.
- 2. To zoom in or out, press + or or use the scroll wheel on your mouse (you can drag the magnified preview). If desired, press the left or right arrow key to cycle through other thumbnails in the same
- 3. To redisplay the Bridge window, press the Spacebar or Esc.

- 1. To make the loupe appear, click an image in the Preview panel; B or if Bridge is in Review mode, click the frontmost image (see the next page).
 Note: If the loupe doesn't appear, it's because the Ctrl-Click/Cmd-Click Opens the Loupe When Previewing or Reviewing option is checked in Edit/Adobe Bridge CC > Preferences > General. To make the loupe appear (or disappear), Ctrl-click/Cmd-click the preview.
- 2. Click the area to be examined. To zoom in on the loupe display (up to 800%), press +, or to zoom out, press -.
- **3.** To examine a different area, click that area or drag the loupe to it.
- **4.** Optional: If you're previewing two images using two loupes, you can Ctrl-drag/Cmd-drag either loupe to move them both simultaneously.
- 5. To remove the loupe, click inside it.

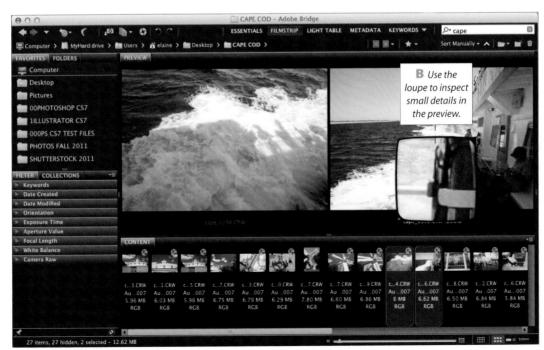

A We Ctrl/Cmd-clicked two image thumbnails to display them in the Preview panel, then clicked one preview to display the loupe.

When you put selected thumbnails into Review mode, they display as large previews on a black background (the Bridge window is hidden), and you can cycle through them as if they're on a carousel. You can also rate thumbnails in this mode.

To preview images in Review mode:

- **1.** Do one of the following: Open a folder of images. Hold down Alt/Option and click a thumbnail stack (see page 42). Select five or more image thumbnails (Ctrl/Cmd
- 2. Press Ctrl-B/Cmd-B, or from the Refine menu at the top of the Bridge window, choose Review Mode. The Bridge window is hidden temporarily, and the images display on a black background.
- **3.** To rotate the carousel, do any of the following: Drag any image preview to the left or right. Click one of the smaller previews to bring it to the forefront.
 - Press the left or right arrow key.

or Shift-click them).

- Click (and keep clicking) the Go Forward are or Go Backward dbutton in the lower-left corner.
- 4. To examine the frontmost (enlarged) image with a loupe, click it. Drag the loupe to move it. Click the loupe again to remove it.
- 5. To rate or label the frontmost thumbnail, rightclick it and choose a star rating or a label from the context menu A or press Ctrl/Cmd plus a numeral between 1 and 9. (To view a list of shortcuts, press H.)
- **6.** To take the frontmost image out of the carousel, click the down-pointing arrow in the lowerleft corner, or drag the image to the bottom of your screen. (This won't delete the actual file.)
 - You can use this method to pare down a selection of images before grouping them as a stack (see pages 42-43) or putting them in a collection (see pages 46-47).
- 7. To exit Review mode, press Esc or click the Min the lower-right corner.
- **8.** Click any image thumbnail to deselect the rest.

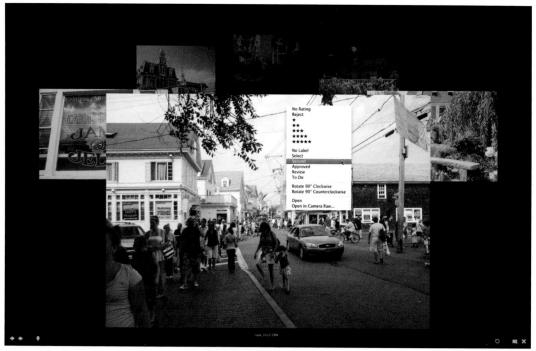

🖪 We held down Ctrl/Cmd and clicked six image thumbnails, pressed Ctrl-B/Cmd-B to view them in Review mode, then rightclicked the frontmost thumbnail and are choosing a label from the context menu.

Opening files from Bridge into Photoshop

You can open as many files into Photoshop as the currently available RAM and scratch disk space on your computer will allow.

Note: To open a raw, JPEG, or TIFF digital photo into Camera Raw (so you can apply corrections to it before opening it into Photoshop), see page 53.

To open files from Bridge into Photoshop:

- 1. In the Content panel, display the thumbnail for the image(s) to be opened.
- 2. Do either of the following: Double-click an image thumbnail. Click an image thumbnail or select multiple thumbnails, then double-click one of them or press Ctrl-O/Cmd-O.
- 3. Photoshop will launch, if it isn't already running, and the image(s) will appear onscreen. If any alert dialogs appear, see the next page.
- If a photo has been opened and edited in Camera Raw, it will have this icon 🚭 in the top-right corner of its thumbnail. If you want to open such a file (or a raw photo) directly into Photoshop — without opening it into Camera Raw first — double-click the thumbnail with Shift held down.
- To locate an "actual" file in Explorer/Finder, rightclick its thumbnail in Bridge and choose Reveal in Explorer/Reveal in Finder from the context menu. The folder that the file resides in will open in a window in Explorer/Finder and the file icon will be selected.
- By default, the Bridge window stays open after you use it to open a file. To minimize the Bridge window as you open a file, hold down Alt/Option while double-clicking the file thumbnail.
- To open an image from Review mode in Bridge into Photoshop, right-click it and choose Open from the context menu.

To reopen a recently opened file:

To reopen a file that was recently opened and then closed, choose the file name in one of these locations:

In Bridge, choose from the Open Recent File menu on the right side of the Path bar. In Bridge or Photoshop, choose from the File > Open Recent submenu.

In Bridge, from the Reveal Recent File or Go to Recent Folder menu. choose Adobe Photoshop > Recent Adobe Photoshop Files. Thumbnails for the recently opened files will display in the Content panel. Double-click a thumbnail to open that file. To redisplay the last displayed folder when you return to Bridge, click the Go Back arrow.

GETTING TO PHOTOSHOP QUICKLY

If Photoshop was the last Adobe application you were using, you can return to it quickly from Bridge by clicking the Return to Adobe Photoshop (boomerang) button on the toolbar. Photoshop will launch, if it isn't already running.

ALAS. THE POOR OPEN COMMAND

With Bridge serving as the best vehicle for opening files, the Open command is relegated to this sidebar. To use the Open command in Photoshop, choose File > Open (Ctrl-O/Cmd-O). In Windows, from the file type menu, choose All Formats; in the Mac OS, choose Enable: All Readable Documents. Locate and click the desired file name, then click Open.

When you open a Photoshop file that is using missing fonts (the fonts are either unavailable or not installed in your system), a Creative Cloud dialog opens. For each missing font, you can let Typekit substitute a matching font from its collection, choose a default font, or open the document into Photoshop without resolving the issue. (To learn more about Adobe Typekit, see page 374.)

Note: To verify that Typekit is turned on for the following task, see the sidebar on this page.

To respond to an alert regarding missing fonts: *

- 1. If you open a Photoshop file in which one or more missing fonts are being used, the Missing Fonts dialog will appear. A
- 2. From the menu next to the name of each missing font, choose one of these options:
 - If Typekit finds a matching font from its collection, you can leave that font as the choice on the menu. Note the Typekit icon.
 - If Typekit cannot locate a matching font, you can choose the default substitution font.
 - If you want to leave a missing font as unresolved, choose Don't Resolve from the menu.
 - If other fonts that are being used in the file are available, you can choose from that list on the lower part of the menu.

- (If you want to dismiss the dialog immediately and open the file into Photoshop, click Cancel.)
- 3. Click Resolve Fonts to close the Missing Fonts dialog and open the document into Photoshop. All matching Typekit fonts that were chosen on the menus in that dialog will be synced to your computer. Note: If you chose Don't Resolve from the menu(s) for all the missing fonts, click Don't Resolve instead (same button, different name).
- 4. If you chose Don't Resolve from any menu (or you clicked Cancel) in the Missing Fonts dialog, when the file opens into Photoshop, a Font Missing on System alert icon 🕮 will display on the Layers panel for every layer that is using missing fonts. If you try to edit one of those layers, another alert dialog will appear, indicating that font substitution will occur. You can either click OK to allow the missing font(s) to be replaced by the default font, or click Cancel, make the required fonts available, then close/reopen the document.
- In Photoshop, if you would like to reopen the Missing Fonts dialog to resolve missing fonts, choose Type > Resolve All Missing Fonts. Or if you want to replace all missing fonts with the default substitution font, choose Type > Replace All Missing Fonts.

TURNING ON TYPEKIT

Typekit will search for and sync fonts between the Creative Cloud and Photoshop only if the feature is turned on. You can verify this in either of two ways:

- Open the Creative Cloud Desktop app, then click Fonts. If Typekit is off, a Turn Typekit On button displays; click the button.
- Open the Creative Cloud Desktop app, @ click the gear icon, then click Preferences. In the dialog, click Fonts, then under Settings, for Typekit On/Off, make sure the On button is clicked. Close the dialog.

A The Missing Fonts dialog will appear if any fonts used in the document that you're opening are missing. If Typekit finds a matching font, you can leave that choice on the menu. Your other menu options are to choose Don't Resolve; choose the default substitution font; or choose from a list of available fonts, if any, that are being used in the document.

To respond to an alert regarding a missing color profile:

If the color profile of the document you're opening doesn't match the current working space for Photoshop, the Embedded Profile Mismatch alert dialog will appear. A Click Use the Embedded Profile (Instead of the Working Space) if you must keep the current profile. Or for consistency with the color management workflow that we have recommended, click Convert Document's Colors to the Working Space to convert the profile to the current working space. Click OK. See pages 7, 8, 10, and 12.

If the Missing Profile alert dialog appears, B click Assign Working RGB: Adobe RGB (1998) to assign the profile that you chose as the working space for Photoshop. Click OK. See pages 7 and 12.

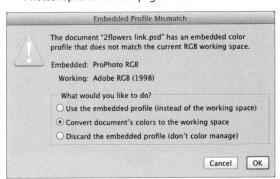

To respond to an alert regarding missing linked Smart Objects: ★

- 1. If the Photoshop document that you're opening contains Smart Objects that are linked to external files, and if those files were renamed or moved, Photoshop may not be able to locate and update the link(s) to them automatically. In this case, an alert dialog will appear. Click the Choose button for a missing link. In the Locate Missing File dialog, locate the file, then click Place. A check mark should appear before the file name, and before the names of any other missing linked files that were found in the same folder.
- 2. Repeat the preceding step for any other missing links, then click OK.
- To learn about linked Smart Objects, see pages 272-275.

A If this Embedded Profile Mismatch alert dialog appears, indicate whether you want to continue to use the embedded profile or convert the file to the current working space.

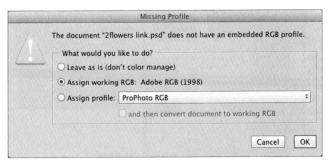

B If this Missing Profile alert dialog appears, click Assign Working RGB: Adobe RGB (1998) to convert the file to the default working space for Photoshop.

C This alert dialog will appear if Photoshop can't locate the external files for one or more linked Smart Objects in your document. For each missing link, click Choose, locate the file, then click Place.

Customizing the Bridge window

To display or hide individual panels:

On the Window menu, check the panels you want to show and uncheck the ones you want to hide.

To quickly hide (and then show) the side panes. press Tab or double-click the dark vertical bar between a side pane and the middle pane.

To configure the Bridge panes and panels manually:

Do any of the following:

To make a panel or panel group taller or shorter, drag its horizontal gripper bar upward or downward.A

To make a whole pane wider or narrower, drag its vertical gripper bar horizontally; B the adjacent pane resizes accordingly.

To minimize a panel or panel group to just a tab (or to restore its former size), double-click its tab.

To move a panel into a different group, drag the panel tab and release the mouse when the blue drop zone border appears around the desired group.

To display a panel as a separate group, drag its tab upward or downward between two panels and release the mouse when the horizontal blue drop zone line appears.

To resize the image thumbnails:

At the bottom of the Bridge window, drag the Thumbnail Size slider. C You could also click the Smaller Thumbnail Size or Larger Thumbnail Size button, located to the left and right of the slider.

To display only full thumbnails, with grid lines between them, click the Lock Thumbnail Grid button **at the bottom of the Bridge window.** With this option on, no shuffling of thumbnails will occur if you resize the Content panel.

A We're dragging the horizontal bar upward to shorten the Favorites/Folders panel group and lengthen the Filter/ Collections panel group.

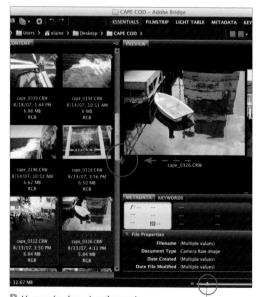

B Here we're dragging the vertical bar (for the right pane) to the left to widen the Preview. Metadata, and Keywords panels.

C To resize your image thumbnails, use this slider.

To control how metadata is displayed in the Content panel:

- In the lower-right corner of the Bridge window, click one of these View Content buttons: A
 View Content as Thumbnails (minimal file data),
 View Content as Details (more file data), B or View
 Content as List (small icons with columns of data).
- 2. To control which categories of metadata display below or next to the image thumbnails when the View Content as Thumbnails option is chosen, go to Edit/Adobe Bridge CC > Preferences > Thumbnails, then select from any or all of the Details: Show menus. For example, to display exposure settings, you would choose Exposure.
- ➤ With the View Content as List option chosen, you can change the column order by dragging any column header to the left or right. You can also right-click any column header to access options for changing the column data, inserting and closing columns, and changing the column width.
- When the View Content as Thumbnails option is chosen for Bridge, you can toggle the display of metadata on and off by pressing Ctrl-T/Cmd-T. When viewing thumbnails in the Light Table workspace, we prefer to keep the metadata hidden.

A These buttons control the display of metadata in the Content panel.

METADATA IN THE TOOL TIPS

If Show Tooltips is checked in Edit/Adobe Bridge CC > Preferences > Thumbnails and you rest the pointer on an image thumbnail, the Tool Tip will list the metadata for that image. (Turn this feature off if you find it annoying.)

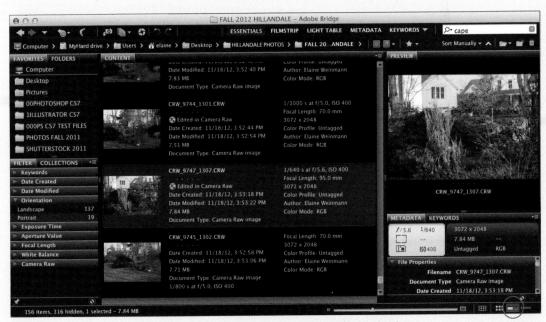

B With the View Content as Details button clicked, metadata displays next to the file thumbnails.

Saving custom workspaces

If you save your customized workspaces, you'll be able to access them again quickly at any time and will avoid having to reconfigure the Bridge window at the beginning of each work session.

To save a custom workspace for Bridge:

1. Do all of the following:

Choose a size and location for the overall Bridge

Arrange the panel sizes and groups as desired. Set the thumbnail size for the Content panel. Choose a sorting order for thumbnails from the Sort menu at the top of the Bridge window (see page 41).

Click a View Content button (see the previous page).

- 2. From the Workspace menu on the workspace switcher, choose New Workspace.
- 3. In the New Workspace dialog, A enter a Name for the workspace. If desired, check Save Window Location as Part of Workspace and/or Save Sort Order as Part of Workspace, then click Save. Note: Your new workspace will be listed first on the switcher and will be assigned the first shortcut (Ctrl-F1/Cmd-F1). To change the order of workspaces on the switcher, drag any workspace name horizontally to a different slot. When you do this, the shortcuts will be reassigned based
- To delete a user-saved workspace, from the Workspace menu, choose Delete Workspace. From the menu in the dialog, choose the workspace to be deleted, then click Delete.

on the new order.

To choose colors for the Bridge interface (including the background shade behind the panels and image previews, and the highlight border around selected thumbnails), see page 470.

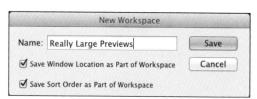

A Use the New Workspace dialog to name your custom workspace and choose options for it.

Resetting the Bridge workspaces

If you make a manual change to a saved workspace. the change will stick with the workspace even if you switch to a different one (or exit/quit and relaunch Bridge). For instance, if you were to change the thumbnail size for the Filmstrip workspace, switch to the Essentials workspace, then switch back to Filmstrip, you would see your chosen thumbnail size again. On the occasion that you want a fresh start, however, there are commands for restoring the default settings to any individual predefined (standard Adobe) or user-saved workspace, or to all the predefined workspaces at once.

To reset the Bridge workspace:

Do either of the following:

To restore the default settings to one workspace, right-click the workspace name on the switcher and choose Reset.

To restore the default settings to all the Adobe predefined workspaces, choose Reset Standard Workspaces from the Workspace menu.

Assigning keywords to files

Keywords (words that are assigned to files) are used by operating system search utilities to locate files and by file management programs to organize them. In Bridge, you can create parent keyword categories (for events, places, themes, clients, etc.), and nested subkeywords within those categories, and then assign them to your files. You can locate files by entering keywords as search criteria in the Find dialog, build a Smart Collection based on a search for keywords (see page 46), and display files by checking Keywords criteria in the Filter panel (see page 41).

To create keywords and subkeywords in the Keywords panel:

- 1. Display the Keywords panel. To create a new parent keyword category, click the New Keyword button, type a keyword, then press Enter/Return.
- 2. To create a nested subkeyword, click a parent keyword, click the New Sub Keyword button, type a word, then press Enter/Return (A, next page). Each time you want to add a subkeyword, click the parent keyword first. You can also create nested sub-subkeywords.
- You can move (drag) any subkeyword from one parent keyword category into another.

To assign keywords to files via the **Keywords panel:**

- 1. Select one or more image thumbnails in the Content panel. If keywords are already assigned to any of those files, they will be listed at the top of the Keywords panel (you can assign more).
- 2. Check the box for one or more subkeywords. To remove a keyword from a file, uncheck the box.
- Read about the Keywords preferences on page 472.
- If you select the thumbnail for a file to which keywords were assigned outside of Bridge (e.g., in Photoshop via File > File Info), those keywords will display temporarily in the Keywords panel, under Other Keywords. To convert a temporary subkeyword to a permanent one, right-click it and choose Make Persistent from the context menu.

To assign keywords to files via the Metadata panel:

- 1. Select one or more image thumbnails in the Content panel.
- 2. Display the Metadata panel, and expand the IPTC Core category.
- 3. Click the **Keywords** listing, then enter keywords, separated by semicolons or commas. Be on the alert for typing errors!
- 4. Click the Apply button in the lower-right corner of the panel.
- > You can also use the IPTC Core category in the Metadata panel to assign other data to a file, such as a copyright notice. Use the same method as in the steps above (you can press Tab to proceed from one field to the next).

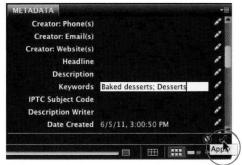

We're assigning keywords to a file via the Metadata panel.

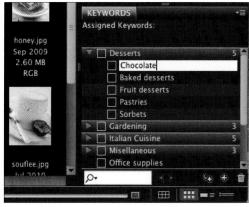

A We created a new parent keyword "Desserts," then added some subkeywords to it via the New Sub Keyword button.

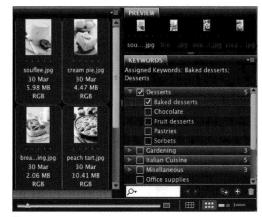

We clicked four image thumbnails, then assigned the subkeyword "Baked desserts" to them by checking the box.

USING THE KEYWORDS PANEL Rename Right-click the word, choose a parent Rename from the context menu, keyword or then type a name (this won't alter subkeyword data that is already embedded). Delete Click the word, then click the Delete Keyword button. If that keyword a parent keyword or is assigned to any files, it will now subkeyword be listed in italics. (To reinstate an italicized keyword, choose Make Persistent from the context menu.) Find a Type the word in the field at the keyword or bottom of the panel. Choose a subkeyword search parameter from the menu. P.

Rating and labeling thumbnails

If you assign each thumbnail a star rating and/or a color label, you'll be able to use those criteria to sort thumbnails in the Content panel, filter them via the Filter panel, and locate them via the Find command. In addition, you can apply a Reject rating to any image thumbnails that you want to hide from the Content panel but aren't ready to delete from your hard drive.

To rate and label thumbnails:

- 1. Select either View Content as Thumbnails or View Content as Details as the view option for thumbnails (see page 37). Select one or more image thumbnails in the Content panel.
- 2. When you do any of the following, either a specific number of stars, a "Reject" label, or a colored label appears below the image thumbnail:

From the Label menu, choose a Rating and/or a Label.A

Click a thumbnail, then click any one of the five dots below it; stars will appear. B To remove one star, click the star to its left. To remove all the stars

A We gave this thumbnail an Approved (green) rating.

B We clicked the third dot on this thumbnail to give it a three-star rating...

C...but then we changed our minds, so we clicked to the left of the stars to remove them.

D We gave this poor fellow a Reject rating (Alt-Del/Option-Delete).

from a thumbnail, click to the left of the first one. (If you don't see the dots or stars, enlarge the thumbnails via the Thumbnail Size slider)

Press one of the keyboard shortcuts that are listed on the Label menu, such as Ctrl/Cmd plus a number (e.g., Ctrl-2/Cmd-2 for two stars, or Ctrl-8/ Cmd-8 for Approved).

Right-click a thumbnail in the Content panel, then choose a category from the Label submenu on the context menu.

Right-click in the Preview panel and choose a star rating and/or label from the context menu.

To label the losers with a red "Reject" label, choose Label > Reject or press Alt-Del/Option-Delete. Via the Show Reject Files option on the View menu, you can show or hide all rejected thumbnails.

You can assign custom names to the labels in Edit/Adobe Bridge CC > Preferences > Labels.

To remove ratings or labels from thumbnails:

- 1. Select one or more image thumbnails.
- 2. To remove stars, choose No Rating from the Label menu or press Ctrl-0/Cmd-0 (zero). To remove a label, choose No Label from the Label menu or press the shortcut for the currently assigned label. (If the selected thumbnails have different labels, you'll need to press the shortcut twice.)

RATING THUMBNAILS IN REVIEW MODE

To rate or label images in Review mode, right-click the large, frontmost image and choose from the context menu or use one of the assigned shortcuts (as listed on the Label menu.)

Rearranging and sorting thumbnails

To rearrange thumbnails manually:

Drag a thumbnail to a new location; or Ctrl-click/ Cmd-click multiple thumbnails, then drag one of the selected thumbnails. The listing on the Sort menu on the Path bar changes to "Sort Manually."

The current criterion on the Sort menu controls the order in which thumbnails display in the Content panel. After applying ratings to our thumbnails, we choose By Rating from the Sort menu to display them by rating, in ascending order. The sorting order also affects the batch and automate commands in Bridge, because those commands process files based on the current sequence of thumbnails.

To choose a sorting order for thumbnails:

From the **Sort** menu on the Path bar, choose a sorting criterion (such as By Rating). A All thumbnails that are currently displaying in the Content panel will be re-sorted. Sorting doesn't change the order of thumbnails within stacks. Note: If you display a different folder, the current sorting order will apply.

- To restore the last sequence of thumbnails that was created by dragging them manually, choose Manually from the Sort menu.
- To reverse the current order, click the Ascending Order or Descending Order arrowhead.

Filtering thumbnails

The categories and listings on the Filter panel (e.g., Ratings, Keywords, Date Created) change dynamically depending on the data contained in the currently displayed folder of thumbnails, and also on the categories checked on the panel menu. When you check the boxes for specific criteria in the panel, only the thumbnails that meet those criteria will display in the Content panel. Note: Filtering doesn't affect the thumbnails in stacks.

To filter the display of thumbnails:

Do either of the following:

On the **Filter** panel, click the arrowhead to expand any category, such as Labels, Ratings, or Keywords, then check one or more criteria. For example, to display only files that have an Approved label and a rating of three stars, check Approved under Labels and check the three-star listing under Ratings. To remove a criterion, click the listing again.

From the **Filter Items by Rating** menu on the Bridge toolbar, C check the desired criteria.

- To prevent the current filters (those with check marks) from clearing when you display other folders, activate the Keep Filter When Browsing button on the panel; when activated, the button displays in color.
- ➤ To remove all check marks from the Filter panel, click the Clear Filter button at the bottom of the panel or press Ctrl-Alt-A/Cmd-Option-A.

A From the Sort menu on the Path bar, we're choosing a sorting order for our thumbnails.

B Because we checked the threestar rating in the Filter panel (Ratings category), only thumbnails that have three stars will display in the Content panel.

C Via the Filter Items by Rating menu, you can filter thumbnails based on their ratings.

Using thumbnail stacks

One way to reduce the number of thumbnails that display at a given time is to group them into expandable stacks. You can organize your stacks based on categories, such as landscapes, portraits, or shots taken with a particular camera setting. Unlike collections (see pages 46-47), stacks can't be labeled.

To group thumbnails into a stack:

- 1. Shift-click or Ctrl-click/Cmd-click to select two or more file thumbnails. A The thumbnail that is listed first in your selection will become the "stack thumbnail" (is going to display on top of the stack).
- 2. Press Ctrl-G/Cmd-G or right-click one of the selected thumbnails and choose Stack > Group as Stack. B A stack looks like a couple of playing cards in a pile, with the stack thumbnail on top. The number in the upper-left corner (the "stack number") indicates how many thumbnails are in the stack.

To select the thumbnails in a stack:

To both select and display all the thumbnails in a stack, click the stack number (click it again to collapse the stack). The stack will remain selected. To select all the thumbnails in a stack while keeping the stack collapsed, click the stack border (the bottom "card") or Alt-click/Option-click the stack thumbnail (the top image in the stack). Note that although the stack is collapsed, because it is selected, the thumbnails it contains will display in the Preview panel, if that panel is showing.

Provided your thumbnails aren't too small, a slider will display on a bar next to the stack number of a closed stack. You can drag the slider to quickly preview the thumbnails.

To rearrange thumbnails within a stack:

To move a thumbnail to a different position in an expanded stack, click it to deselect the other selected thumbnails, then drag it to a new spot (as indicated by the vertical drop zone line).

To move an entire stack to a different position:

- 1. Collapse the stack, then Alt-click/Option-click the stack thumbnail. The borders of both "cards" in the stack should now be highlighted.
- 2. Drag the stack thumbnail (not the border).

We selected several thumbnails for grouping into a stack.

This is after we chose the Group as Stack command.

If you drag the top thumbnail of an unselected stack, you'll move just that thumbnail, not the whole stack.

To add a thumbnail to a stack:

Drag a thumbnail over a stack thumbnail, or if the stack is expanded, to the desired position.

To remove a thumbnail from a stack:

- 1. Click the stack number to expand the stack.
- 2. Click the thumbnail to be removed, then drag it out of the stack.

To ungroup a stack:

- 1. If the stack is collapsed, click the stack thumbnail; if the stack is expanded, click the stack number.
- 2. Press Control-Shift-G/Cmd-Shift-G (Stacks > Ungroup from Stack) or right-click a stack thumbnail and choose Stack > Ungroup from Stack. The stack number and border disappear.

Managing files using Bridge

To create a new folder:

- 1. Via the Folders panel or the Path bar, navigate to the folder to which you want to add a folder.
- 2. Click the New Folder button at the right end of the Bridge toolbar (Ctrl-Shift-N/Cmd-Shift-N). Type a name to replace the highlighted one, then press Enter/Return.

You can move files to a different folder on your hard disk either by dragging them manually or by using a command.

To move or copy files between folders: Method 1 (by dragging)

- 1. Select one or more thumbnails (Content panel).
- 2. In the Folders panel, navigate to (but don't click) the folder or subfolder into which you want to move the selected files.
- 3. To move the selected files, drag them over the folder name in the Folders panel (then release), or to copy them, do the same except hold down Ctrl/Option while dragging (a + symbol displays in the pointer). Note: If you want to move (not copy) files to another hard disk, hold down Shift/ Cmd while dragging.
- You can also move or copy files to a folder in the Favorites panel.

Method 2 (via the context menu)

- 1. Select one or more thumbnails in the Content panel.
- 2. Right-click one of the selected thumbnails, then from the Move To or Copy To submenu on the context menu, do either of the following: Select a folder name under Recent Folders or Favorites
 - Select Choose Folder, Locate a folder in the Open dialog, then click Open.
- To copy files via the Clipboard, select one or more thumbnails, press Ctrl-C/Cmd-C to copy them, click the desired folder, then press Ctrl-V/ Cmd-V to paste.

To delete a file or folder:

- 1. Click an image or folder thumbnail or Ctrl-click/ Cmd-click multiple thumbnails, or Shift-click a series of them.
- 2. Do either of the following:
 - Press Ctrl-Backspace/Cmd-Delete, then if an alert dialog appears, click OK.
 - Press Del/Delete on your extended keyboard, then if an alert dialog appears, click Delete.
- Oops! Change your mind? To retrieve a deleted file or folder, choose Edit > Undo immediately. Or to dig it out of the trash, double-click the Recycle Bin/Trash icon for your operating system, then drag the item into the Content panel in Bridge.

To rename a file or folder:

- 1. Click a thumbnail, then click the file or folder name. The name becomes highlighted. A
- 2. Type a new name B (for an image file, don't try to delete the extension), then either press Enter/ Return or click outside the name field.

A To rename a file, click the existing name...

 \mathbb{B} ...then type a new name.

When you download digital photos from your camera to your computer, they keep the sequential numerical labels (e.g., "CRW_3816") that your camera assigned to them. Via the Batch Rename command in Bridge, you can assign more recognizable names to your photos, to make them easier to identify.

To batch-rename files:

- Display the contents of the folder that contains the files to be renamed, then select the thumbnails for the files to be renamed.
- 2. Do either of the following:

Choose Tools > **Batch Rename** (Ctrl-Shift-R/Cmd-Shift-R).

From the Refine menu at the top of the Bridge toolbar, choose **Batch Rename**. The Batch Rename dialog opens. A

- 3. From the Preset menu, choose Default.
- **4.** Under Destination Folder, click one of the following:

Rename in Same Folder to have Bridge rename the files and leave them in their current location.

Move to Other Folder to have Bridge rename the files and move them to a new location.

Copy to Other Folder to leave the original files unchanged but rename the copies and move them to a new location (this is a quick way

to duplicate a batch of photos). We recommend using this option, especially if you didn't elect to copy your photos when you downloaded them. For the Move or Copy option, also click **Browse**, choose or create a new folder, then click Open.

5. In the New Filenames area, specify data to be included in the names: Text (enter the desired name); Date Time (choose an option from both menus in the row); and Sequence Number to include an incremental number in the names (enter a starting number and choose a digit option).

To add another row of criteria fields, click the ⊕ button, or to remove a row of fields, click the ⊕ button.

Click **Preview** to view a listing of the new file names, then click OK to exit that dialog.

- 6. Under Options, leave Preserve Current Filename in XMP Metadata unchecked (unless you need to preserve the old names), but for Compatibility, check any other operating system(s) in which you want your renamed files to be readable.
- Optional: To save the current New Filenames and Options settings as a preset for future use, click Save, enter a name, then click OK. Your custom preset will appear on the Preset menu.
- **8.** To apply your naming choices to the selected thumbnails, click Rename.

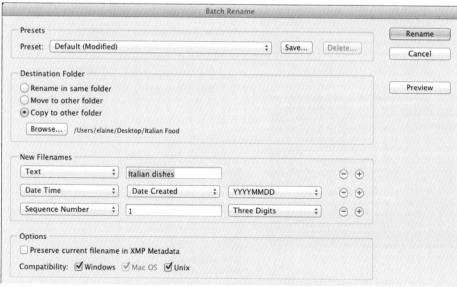

A Via the Batch Rename dialog, you can quickly rename an entire folder full of photos.

Searching for files

To find files via Bridge:

- 1. In Bridge, choose Edit > Find (Ctrl-F/Cmd-F). The Find dialog opens.A
- 2. From the Look In menu in the Source area, choose the folder to be searched (by default, the current folder is listed). To select a folder that isn't listed on the menu, choose Browse, locate the desired folder, then click Open.
- 3. From the menus in the Criteria area, choose search criteria (e.g., Filename, Date Created, Keywords, Label, Rating, or a category of camera settings), choose a parameter from the adjoining menu, and enter data in the field. To add another criterion to the search, click the 🕆 button, or to remove a row of fields, click .
- 4. From the Match menu, choose "If any criteria are met" to find files based on one or more of the criteria you have specified, or choose "If all criteria are met" to narrow the selection to just the files that meet all your criteria.

- 5. Check Include All Subfolders to include, in the search, any of the subfolders that are inside the folder you chose in step 2.
- 6. Optional: Check Include Non-Indexed Files to search through files that Bridge hasn't yet indexed (any folder Bridge has yet to display). As indicated, this could slow down the search.
- 7. Click Find. The results of the search will be placed in a temporary folder called Search Results: [name of source folder] and will display in the Content panel. B The folder will be listed on the Path bar and on the Reveal Recent File or Go to Recent Folder menu on the Bridge toolbar.
- 8. To create a collection from the results of the search, follow the steps on the next page.
- To discard the current search results and start a new search, click New Search, or to cancel the results, click the Cancel button.

		Fine	d		
Source Look in: Italian	Food				•
Criteria					
Keywords	‡]	contains	\$	pizza	Θ
Keywords	‡]	contains	*	salad	⊝ ⊕
Filename	.	contains	\$	tomato	⊕ ⊕
Results Match: If any cr Include All Sut	ofolders	e met Files (may be slow	‡		
				Find	Cancel

A We entered three criteria in the Find dialog (then we clicked Find).

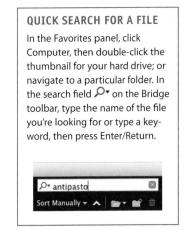

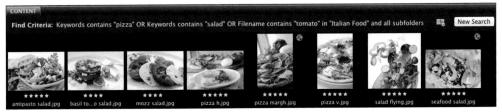

B The results from our search appeared in the Content panel. The parameters used for the search and the folder that was searched are listed next to "Find Criteria."

Creating and using collections

Using the collection features in Bridge, you can catalog your file thumbnails without having to relocate the actual files. There are two kinds of collections: a Smart Collection that you create from the results of a Find search, and a standard collection, which you create by dragging thumbnails manually.

To create a Smart Collection:

- 1. Click the tab for the Collections panel. (If it's hidden, choose Window > Collections Panel.)
- 2. Perform a search via the Edit > Find command (see the preceding page). When the search is completed, click the Save as Smart Collection button at the top of the Content panel.
- 3. A new Smart Collection icon appears in the Collections panel. Type a name in the highlighted field, then press Enter/Return.B
- To add a collection to the Favorites panel, rightclick the icon and choose Add to Favorites.
- To delete a collection, click it, click the Delete Collection button, then click Yes if an alert dialog appears (this won't delete the actual files).

To display the contents of a collection:

In the Collections panel, click the icon or name of a Smart Collection.

If you run a new search for an existing Smart Collection using different criteria, the contents of the collection will update automatically (this is what makes it "smart").

To edit a Smart Collection:

- 1. In the Collections panel, click the icon for an existing Smart Collection.
- 2. At the top of the Content panel or in the lowerleft corner of the Collections panel, click the Edit Smart Collection button.
- 3. The Edit Smart Collection dialog opens. It looks just like the Find dialog, which is shown on the preceding page. To add another criterion, click the next 🕀 button, choose and enter data, and choose "If any criteria are met" from the Match menu. You can also change the source folder and/or change or eliminate the original criteria.
- 4. Click Save. The results of the new search will display in the Content panel.

Note: If you move a thumbnail from a Smart Collection (or move the actual file) into a folder that wasn't used in the search, it will be removed from the collection, but not from your hard disk. If you delete a thumbnail from a Smart Collection, on the other hand — watch out! — the actual file will be deleted from your hard disk!

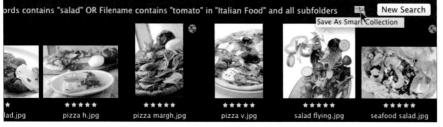

A To create a Smart Collection, use the Find command, then click the Save as Smart Collection button in the Content panel.

B A new Smart Collection icon appears in the Collections panel. Type a name for it in the field.

C To edit a Smart Collection, click its icon in the Collections panel, then click the Edit Smart Collection button.

You can also create a standard, "nonsmart" collection without running a search first.

To create a standard collection:

1. Do either of the following:

On the Content panel, select the image thumbnails to be put into a collection. In the Collections panel, click the New Collection button, then click Yes in the alert dialog. While viewing some thumbnails in Review mode (Ctrl-B/Cmd-B), drag any files you don't want to include in the collection out of the carousel, then click the New Collection button.

2. Type a name in the highlighted field in the Collection panel. A The number of thumbnails the collection contains is listed next to the name.

To add thumbnails to a standard collection:

- 1. Display the Collections panel.
- 2. Drag one or more thumbnails from the Content panel over a standard collection icon. 🍱 B
- You can copy and paste, or drag, thumbnails from a Smart Collection into a standard one, or from one standard collection into another. You can't drag thumbnails into a Smart Collection.

To remove thumbnails from a standard collection:

- 1. On the Collections panel, click the icon for a standard collection to display its contents.
- 2. Select the thumbnails to be removed, then click Remove from Collection at the top of the Content panel.

If you rename a file in Explorer/Finder or move a file from its original location on disk, it may be listed as missing from any standard collections it is a part of, and Bridge will try to relink it to those collections. If Bridge is unsuccessful, do as follows.

To relink a missing file to a standard collection:

- 1. On the Collections panel, click the collection to which you need to relink one or more files.
- 2. At the top of the Content panel, click Fix. D
- 3. In the Find Missing Files dialog, click Browse, click the missing file (the name is listed at the top of the dialog), click Open, then click OK.

A To create a standard collection, click the New Collection button, then type a name.

B Drag thumbnails to a standard collection listing.

To remove one or more selected thumbnails from the currently displayed collection, click Remove from Collection.

D To relink a file that's missing from a collection, click Fix.

Exporting the Bridge cache

When the contents of a particular folder are displayed in the Content panel in Bridge for the first time, Bridge creates its own hidden cache files that pertain to those files, and places them in the same folder. Bridge uses the cache to display program features, such as ratings, labels, and high-quality thumbnails. You will notice that the thumbnails in a given folder redisplay more quickly once the cache has been created. Note: These hidden cache files can be read and used only by Bridge.

By setting the following preference, as we recommend, you can ensure that Bridge will include its own cache data with any files that you copy to a removable disc or to a shared folder on a network

To set a preference to have Bridge export the cache automatically:

- 1. In Bridge, choose Edit/Adobe Bridge CC > Preferences (Ctrl-K/Cmd-K), then click Cache.
- 2. Under Options, check Automatically Export Cache to Folders When Possible, then click OK.

If for some reason the cache preference is turned off and you need to export the cache for files in a specific folder, you may do so via the steps below. The hidden cache files will be placed in the current folder and will also be included if you move or copy the image files.

To export the Bridge cache for the current folder:

- 1. Display the contents of a folder in Bridge.
- 2. Choose Tools > Cache > Build and Export Cache.
- 3. In the Build Cache dialog, keep the Build 100% Previews option off but check Export Cache to Folders, then click OK.

To display the cache file icons in the current folder:

- 1. Display a folder in the Content panel.
- Choose View > Show Hidden Files.

If Bridge is having trouble displaying a particular folder of thumbnails, you can usually solve the problem by purging the cache for those thumbnails. This prompts Bridge to rebuild the cache.

To purge cache files from the current folder:

Do either of the following:

To purge all the cache files from the current folder, choose Tools > Cache > Purge Cache for Folder "[current folder name]." Multiple new (hidden) cache files will be generated.

To purge the cache files for specific thumbnails, select them, then right-click one of them and choose Purge Cache for Selection.

Using the powerful and wide-ranging controls in the Adobe Camera Raw plug-in, you can apply corrections to your photos before opening them into Photoshop. In this comprehensive chapter, you'll learn about the Camera Raw tools and tabs; choose workflow options for Camera Raw; apply cropping and straightening; and correct photos for defects, such as poor contrast, underor overexposure, color casts, blurriness, geometric distortion, and noise. You will also learn how to enhance your photos with special effects, such as a vignette, grain texture, or tint; retouch blemishes; access Camera Raw controls from Photoshop; save and synchronize Camera Raw settings among related photos; then finally, open your corrected photos into Photoshop.

Note: The Camera Raw plug-in, which we refer to simply as "Camera Raw," is included with Photoshop. Some users also refer to the plug-in as "ACR," short for Adobe Camera Raw.

Why use Camera Raw?

Amateur-level digital cameras store images in the JPEG or TIFF format, whereas advanced amateur and pro models offer the option to save images as raw data files, which offers substantial advantages. Cameras apply internal processing to photos that are captured as JPEG or TIFF, such as sharpening, automatic color adjustments, and a white balance setting. With raw files, you get only the original raw information that the lens captured onto the camera's digital sensor, leaving you with full control over subsequent image processing and correction.

These are some basic facts about Camera Raw:

- Camera Raw can process raw, TIFF, and JPEG photos from most digital camera models.
- Camera Raw offers powerful controls for correcting problems in your photos, such as over- and underexposure and color casts, and for applying enhancements, such as a vignette or a grain texture.
- ➤ Camera Raw saves edits to TIFF and JPEG files in the file itself, whereas edits to raw files are saved as instructions (in a separate "sidecar" file or in the Camera Raw database). When you open a photo from Camera Raw into Photoshop, the instructions are applied to a copy of the file, and the original raw file is preserved.
- To any image layer in Photoshop, you can apply some Camera Raw features via the Filter > Camera Raw Filter command.

IN THIS CHAPTER

why use camera kaw:	49
Opening photos into Camera Raw	52
The Camera Raw tools	55
Cropping and straightening photos	56
Choosing default workflow options	58
Using the Camera Raw tabs	61
Using the Basic tab	63
Using the Tone Curve tab	68
Using the Detail tab	70
Using the HSL/Grayscale tab	72
Using the Adjustment Brush tool	74
Using the Split Toning tab	79
Using the Lens Corrections tab	80
Using the Effects tab	84
Using the Graduated Filter tool	86
Using the Radial Filter tool	88
Using the Spot Removal tool	90
Saving and applying Camera Raw	02
settings	
Synchronizing Camera Raw settings	94
Converting, opening, and saving Camera Raw files	95
Camera Naw Intes	,,

More reasons to use Camera Raw

In case you're not fully sold on the benefits of correcting your digital photos in Camera Raw before opening them into Photoshop, consider these points:

Ability to preview raw files: The only way to preview a raw photo is in Camera Raw (or other software that converts raw files). Note: The photo that you view on the LCD screen of your digital camera is merely a JPEG preview of the raw capture, not the "actual" raw capture.

Great correction features: Camera Raw offers many unique adjustment controls that you simply won't find in Photoshop.

Less destructive edits: When applying corrections to a photo, the goal is to preserve as much of the image quality as possible. Adjustments that you make to a photo in Camera Raw (and that are applied automatically when the photo is opened in Photoshop) cause less data loss than similar adjustment commands in Photoshop.

Preserves 16 bits per channel: To preserve more of the original pixel data in a raw photo, Camera Raw keeps the bit depth as 16 bits per channel. This helps offset the data loss from subsequent image edits in Photoshop, and results in a better-quality photo.

Tonal redistribution: The sensor in a digital camera captures and records the existing range of tonal values in a scene as is, in a linear fashion, without skewing the data toward a particular tonal range. A That sounds fine on paper, but the reality is that the human eye is more sensitive to lower light levels

the incoming data. A light value of 50% is located at the

midpoint of the tonal range.

than to higher light levels. In other words, we're more likely to notice if shadow areas lack detail and less likely to notice extra details in highlight areas. The result is that digital photos typically contain more data than necessary for the highlight values in a scene and insufficient data for the lower midtone and shadow values. In a Camera Raw conversion. data is shifted more into the midtone and shadow ranges of your photo. This not only helps compensate for the peculiarities of human vision, but also helps prepare your photos for subsequent image edits in Photoshop. If you apply tonal adjustments in Photoshop to a photo that contains insufficient shadow data, the result is posterization and a noticeable loss of detail; if you apply the same edits to a good-quality photo that has been converted in Camera Raw, the destructive edits will be far less noticeable.

Superior noise reduction and sharpening: Not to knock Photoshop, but the noise reduction and sharpening features in Camera Raw cause less data loss than similar features in Photoshop.

Learning the Camera Raw features will give you a head start: The tonal and color controls in Camera Raw are similar to many of the adjustment controls in Photoshop (e.g., Levels, Curves, and Hue/ Saturation) that are discussed in later chapters. As you proceed through the lessons in this book, you will apply and build on the skills you have mastered in this chapter.

light value past the midpoint. As a result, the lower tonal

values — the range the human eye tends to be more

sensitive to — contain more data.

CAPTURING TONAL VALUES: YOUR CAMERA VERSUS THE HUMAN EYE 50% light value 50% light value A The digital sensor in a camera captures tonal values B Camera Raw redistributes some of the captured tonal in a linear fashion, from light to dark, without altering values to the shadows and midtones, shifting the 50%

Raw, JPEG, or TIFF?

Unfortunately, Camera Raw can't correct deficiencies in digital JPEG and TIFF photos as fully as it can in raw photos, for several reasons. First, cameras reduce digital JPEG and TIFF photos to a bit depth of 8 bits per channel, and in so doing discard some of the captured pixels. Cameras save raw photos at a bit depth of 16 bits per channel, and preserve all the captured pixels.

Second, cameras apply color and tonal corrections to JPEGs and TIFFs (called "in-camera" processing). Camera Raw must reinterpret this processed data, with less successful results than when it has access to the raw, unprocessed data.

All of the above notwithstanding, if your camera doesn't shoot raw photos or you acquire JPEG or TIFF photos from other sources, you can still use practically all of the outstanding correction and adjustment features in Camera Raw to process them.

Note: In this chapter, we focus only on processing raw and JPEG files in Camera Raw - not TIFF files. The JPEG format is mentioned only when a particular feature treats a JPEG differently than a raw file.

Factoid: Each digital camera manufacturer creates its own version of a raw file and attaches a different extension to the names of its raw files. such as .nef for Nikon and .crw or .cr2 for Canon.

KEEPING CAMERA RAW UP TO DATE

Of the many proprietary raw "formats" in the universe, some are unique to each manufacturer (such as Nikon or Canon) and some are unique to each camera model. To ensure that Camera Raw is using the latest interpreter for your camera, visit www.adobe.com periodically, and download and install any Camera Raw updates that are posted for your camera model.

JPEG ...

JPEG advantages

- ➤ JPEG files have a smaller storage size than raw files, so your digital camera can store more of them.
- In sports, nature, and other fast-action photography, speed is a necessity. Photo sequences can be captured more rapidly as JPEG files (due to their smaller storage size) than raw files.
- ➤ Most software programs can read JPEG files, but only a few programs can read raw files.

JPEG drawbacks

- ➤ The JPEG format discards some captured pixels due to its lower bit depth of 8 bits per channel.
- ➤ The JPEG compression methods destroy some image data and can produce defects, such as artifacts, banding, and loss of detail.
- The pixel data in JPEG photos is processed internally by the camera. Although Camera Raw can be used to improve your JPEG photos, it won't have access to the original pixel data (nor will you).

... COMPARED TO RAW

Raw advantages

- ➤ The raw compression methods are nondestructive.
- Raw files have a higher bit depth of 16 bits per channel.
- ➤ Raw files contain the original, unprocessed pixel data and full range of tonal levels that were captured by the camera. Camera Raw is given all that image data to work with, and the result is a higherquality image — even after adjustments.
- ➤ Because the white point setting isn't applied to your raw photo (it's merely stored in the metadata of the file), you can adjust that setting at any time in Camera Raw.
- ➤ Camera Raw does a better job of redistributing tonal values in raw files than in JPEG files, making raw files better candidates for Photoshop edits.

Raw drawbacks

- ➤ Raw files have larger storage sizes than JPEG files.
- Digital cameras create and store raw files more slowly than JPEG files, a potential drawback in fast-action photography (although as camera technology improves, this may become less of an issue).

The bottom line

Despite the faster speed and smaller storage sizes of JPEG files, raw files have more advantages.

Opening photos into Camera Raw

For a smooth workflow, we recommend setting the proper preferences so your raw photos (and JPEG or TIFF photos, if any) will open directly into Camera Raw.

To set a preference so your raw photos open directly into Camera Raw:

- 1. In Photoshop, go to Edit/Photoshop > Preferences (Ctrl-K/Cmd-K) > File Handling.
- 2. Under File Compatibility, check Prefer Adobe Camera Raw for Supported Raw Files, then click OK. When you double-click a raw file, it will open into Camera Raw (as opposed to other software that can be used to convert raw files).

To set a preference so your JPEG or TIFF photos open directly into Camera Raw:

- 1. In Bridge, choose Edit/Adobe Bridge CC > Camera Raw Preferences.
- 2. At the bottom of the dialog, from the JPEG menu, choose Automatically Open JPEGs with Settings.
- 3. If you shoot digital TIFF photos, from the TIFF menu, choose Automatically Open TIFFs with Settings; or if you shoot only raw or JPEG photos (not TIFF photos), choose Disable TIFF Support.
- 4. Click OK.

When you want to open a JPEG or TIFF photo into Camera Raw that has not yet been edited (doesn't have Camera Raw settings), click the thumbnail in Bridge, then click the Open in Camera Raw button for press Ctrl-R/Cmd-R.

To open a JPEG or TIFF photo that has been edited previously in Camera Raw (that is "with Settings"), double-click its thumbnail or press Ctrl-R/Cmd-R.

- If you enable both "Automatically Open" options (steps 2-3, above), but there is an occasion when you want to open a JPEG or TIFF photo directly into Photoshop instead of Camera Raw, click the thumbnail, then press Ctrl-O/Cmd-O. This shortcut will work only if the file hasn't yet been edited in Camera Raw.
- ► If the Open in Camera Raw button is available when you click a thumbnail in Bridge, it's a sign that the file can be opened into Camera Raw.

You can set a preference to have either Bridge or Photoshop host the Camera Raw plug-in when you open a raw or JPEG photo. In the case of Photoshop, the program will launch, if it's not already running. Also, when Bridge is the host for Camera Raw, the default (highlighted) button for exiting that dialog is labeled Done, whereas when Photoshop is the host for Camera Raw, the default exit button is Open Image or Open Object, depending on a setting in the Workflow Options dialog (see step 9 on page 58).

To choose a host for Camera Raw:

- 1. In Bridge, choose Edit/Adobe Bridge CC > Preferences (Ctrl-K/Cmd-K), then show the General pane.
- 2. Check Double-Click Edits Camera Raw Settings in Bridge if you want Camera Raw to be hosted by Bridge when you double-click a thumbnail in Bridge (a raw photo or a JPEG that was previously edited in Camera Raw), or uncheck this option to have the file open into Camera Raw hosted by Photoshop, Click OK.

RECOGNIZING THE BADGE

In Bridge, the thumbnail for a file that has been opened and edited previously in Camera Raw will display this badge a in the upper-right corner, and the thumbnail and preview will reflect the current settings. Another clue: If the currently selected file has been edited in Camera Raw, you will see a Camera Raw category in the Metadata panel.

After setting the necessary preferences, and before learning the particulars of Camera Raw, you should familiarize yourself with this basic workflow.

To open a raw or JPEG digital photo into Camera Raw:

- 1. Launch Bridge, display the thumbnail for a raw or JPEG photo, then do either of the followina: For a raw photo, double-click the thumbnail. For a raw or JPEG photo, click the thumbnail, then press Ctrl-R/Cmd-R or click the Open in Camera Raw button on the Bridge toolbar (or rightclick the photo and choose Open in Camera Raw).
- 2. The Camera Raw dialog opens. An alert symbol nay display in the upper-right corner of the preview while Camera Raw reads in the image data, and will disappear when it's done. Information about your photo (taken from the metadata that was embedded into it by the

- camera) is listed in several locations; the camera model in the title bar at the top of the dialog; the file name below the preview; and the camera settings used to take the photo (aperture, shutter speed, ISO, and focal length) below the histogram.
- The adjustment features are located in 10 tabs: Basic, Tone Curve, Detail, HSL/Grayscale, Split Toning, Lens Corrections, Effects, Camera Calibration, Presets, and Snapshots. Switch among the tabs to correct your photo (we cover most of the tabs in depth in this chapter).
- 3. When you're done correcting the photo, you can either click Open Image to open the photo into Photoshop or click Done to close Camera Raw without opening the photo. In either case, the Camera Raw settings will stick to the photo, and the original data will be preserved. (Note: If you want to open the photo into Photoshop as a Smart Object, see the Note on page 95.)

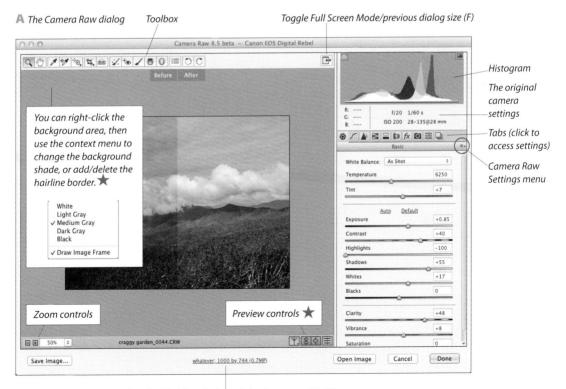

Link to the Workflow Options dialog (see pages 58-60)

A file that you open from Camera Raw into Photoshop as a Smart Object can be reedited using the full array of features in Camera Raw at any time. A standard image layer in a Photoshop document can also be edited using most — but not all — of the Camera Raw features by way of the Camera Raw Filter, as described in the task below. If you convert the image layer to a Smart Object first (an optional step), you will be able to edit the filter settings at any time. Note: To learn about layers, which are used in this task, see Chapter 8. To learn more about Smart Objects, see pages 264-275. See also the first Note on page 95.

Among the Camera Raw features that aren't available via the Camera Raw Filter are the Crop and Straighten tools, the rotate buttons, the Workflow Options dialog, the Snapshots tab, and some options on the Camera Raw Settings menu. Don't be dissuaded by this list of "nos," however — the filter gives you access to the essential Camera Raw features.

To open and edit a Photoshop image layer in Camera Raw:

- 1. In an RGB document in Photoshop, display the Layers panel. Click the image layer (or the Background) that you want to edit in Camera Raw, then press Ctrl-J/Cmd-J to duplicate it. Keep the duplicate layer selected.
- 2. Optional (but recommended): To keep your Camera Raw settings editable, choose Filter > Convert for Smart Filters, or right-click the duplicate image layer and choose Convert to Smart Object. B If an alert dialog appears, click OK.
- 3. With the image layer or Smart Object selected. choose Filter > Camera Raw Filter (Ctrl-Shift-A/ Cmd-Shift-A).
- 4. The image layer opens in Camera Raw. Apply the needed corrections.
- 5. Click OK (a progress bar may display while the filter is processing).
- 6. If you applied the filter to a Smart Object, on the Layers panel, you will see a Camera Raw Filter listing below a Smart Filters listing. C To edit the Camera Raw settings at any time, double-click the Camera Raw Filter listing. To learn more about Smart Filters, see pages 360-364.
- To create a document via the Merge to HDR Pro command, and adjust the new document via the Camera Raw Filter, see pages 250–253.

CAMERA RAW FILTER OR PHOTOSHOP?

Although we sing the praises of Camera Raw in the first two pages of this chapter and strongly recommend using it as a first step before opening a photo into Photoshop, Photoshop is no slouch when it comes to adjustment options. In fact, Photoshop has some commands and features that you won't find in Camera Raw, such as adjustment layers. You can easily hide, show, clip, or restack any adjustment layer: edit its layer mask; and change its opacity or blending mode (see Chapter 12). Fortunately, you don't have to decide between Camera Raw and Photoshop — you can use both!

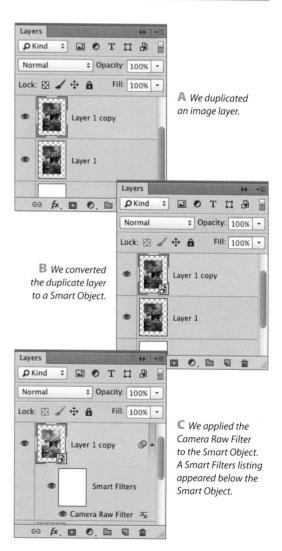

The Camera Raw tools A

In the upper-left corner of the dialog, click the Zoom tool, then click the image preview to zoom in or Alt-click/Option-click it to zoom out.

Use the **Hand** tool to move a magnified preview image in the window (if another tool is selected, hold down the Spacebar for a temporary Hand tool).

For the White Balance tool, see the sidebar on page 62.

Choose the Color Sampler tool, then click in the image preview to place up to nine samplers. A breakdown of the RGB components below each sampler in the photo displays in a readout below the tool box; the readouts will update as you make color and tonal adjustments. To reposition a sampler, drag it with the Color Sampler tool. To remove a sampler, hold down Alt/Option and click it. To remove all samplers, click Clear Samplers.

For the **Targeted Adjustment** tool [†] **(or TAT for** short), see pages 68-69 and 73.

For the **Crop** tool, 4, see page 56.

For the **Straighten** tool, is see page 57.

For the **Spot Removal** tool, see pages 90–91.

The **Red Eye Removal** tool * works like the Red Eye tool in Photoshop (see page 309).

For the **Adjustment Brush** tool, see pages 74–78.

For the **Graduated Filter** tool, see pages 86–87.

For the Radial Filter tool, see pages 88–89.

Note: If tool settings are displaying on the right side of the Camera Raw dialog (if, say, you were using the Adjustment Brush tool) and you want to redisplay the row of tab icons, click one of the first seven tools.

The tools in Camera Raw are "memory-loaded," meaning that you can toggle them. Press a tool shortcut to select a different tool, then press the same key again to return to the original tool.

Other buttons at the top of the dialog:

- ➤ The Open Preferences Dialog button : (or press Ctrl-K/Cmd-K) opens the Camera Raw Preferences dialog.
- ➤ The Rotate 90° Counterclockwise button and the Rotate 90° Clockwise button or rotate the image. The results preview in the dialog.

MORE WAYS TO ZOOM IN THE PREVIEW

- ► Hold down Alt/Option-Spacebar and click to zoom out, or hold down Ctrl/Cmd-Spacebar and click to zoom in.
- ➤ Press Ctrl –/Cmd (hyphen) to zoom out or Ctrl-+/Cmd-+ to zoom in.
- ➤ Use the zoom buttons (- or +) or the Zoom Level menu, located below the image preview.
- Double-click the Zoom tool to set the zoom level to 100%.
- ➤ Double-click the Hand tool to fit the image in the preview window.

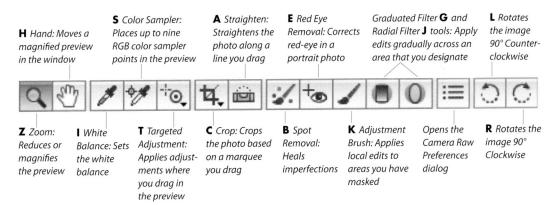

Cropping and straightening photos

With the Crop and Straighten tools, you can control which portion of a photo opens into Photoshop. You can readjust the crop box at any time without losing any image data, and the outlying areas will remain available even after you click Save, Done, or Open.

To crop a photo:

- 1. Open a photo into Camera Raw A (see step 1 on page 53).
- 2. Choose the Crop tool 4. (C).
- 3. Drag in the preview to make a crop box appear.
- 4. Optional: To move the crop box, drag inside it. To resize the box, drag a handle.
- 5. To preview the results of the Crop tool, press Enter/Return or click any tool except the Crop or Straighten tool.
- To redisplay the current crop box after exiting crop mode, click the Crop tool. If you want to remove the box and redisplay the whole image, press Esc.

A This is the original photo, in Camera Raw.

B With the Crop tool, we drew a crop box in the preview window. Here, we are resizing the box.

We pressed Enter/Return to preview the results.

To straighten a crooked photo automatically:★

- 1. Open a photo into Camera Raw, then doubleclick the Straighten tool (A); or choose the Straighten tool, then double-click anywhere in the image.
- 2. Press Enter/Return.
- To turn the Crop tool into a temporary Straighten tool, hold down Ctrl/Cmd.

To straighten a crooked photo manually:

- 1. Open a photo into Camera Raw, then choose the Straighten tool (A).
- 2. Drag along an edge in the photo that you want to align to the horizontal or vertical axis. A crop box will display, aligned to the angle you drew.B
- 3. To preview the straighten results, press Enter/ Return.
- > To change the straighten results after exiting crop mode, choose the Straighten tool (A), then drag again.
- If you want to remove the crop box, choose the Crop tool (C), then press Esc.

B A crop box displays.

A With the Straighten tool, we are dragging along an edge that we want to align to the vertical axis.

We pressed Enter/Return to preview the results.

Choosing default workflow options

Via the Workflow Options dialog, you can resize or sharpen a photo, or change its color space or bit depth, before opening it into Photoshop — the original raw or JPEG file isn't altered. Note that the choices that you make in this dialog become the new default settings, so they apply not only to the current photo, but also to subsequent photos that you open into Camera Raw. The dialog contains new Color Space and Preset options (see this page and the next), as well as Image Sizing options (see page 60).

To choose settings in the Workflow Options dialog: *

- 1. Open a photo into Camera Raw, then below the large image preview, click the underlined link. The Workflow Options dialog opens (A, next page).
- 2. If you want to apply a user-saved preset, choose it from the **Preset** menu (B, next page). ** Next, either click OK to exit the dialog, or choose custom options, as in the remaining steps.
- 3. From the Space menu, choose a color profile to be used for converting the raw file to RGB: Adobe RGB (1998), ColorMatch RGB, ProPhoto RGB, or sRGB IEC61966-2.1 (or "sRGB," for short). The menu also lists preset RGB and CMYK output profiles for printers and displays, as well as any other profiles that you have installed in your system. *\in Chapter 1, you assigned Adobe RGB (1998) as the default color space for color management, so for optimal color consistency, we recommend also choosing that option here.
- 4. The Intent options control how colors will change in a photo when it is converted to the chosen profile. If you chose any profile from the Space menu except one of the first five, from the Intent menu, choose Perceptual or Relative. If your photos tend to contain many colors that are outside the gamut of the chosen color space, Perceptual is the best choice because it attempts to preserve the appearance of colors as it shifts them into gamut. If your photos contain few colors that are out of gamut, Relative is the best choice, as it preserves more of the original colors. Your photo will display as a soft proof (a simulation of print output from your target device).
- 5. To control the amount of color and tonal information in your photos, from the **Depth** menu, choose 8 Bits/Channel or 16 Bits/Channel. If you choose

- 16 Bits/Channel, more of the original capture information will be preserved in your photos as you edit them in Photoshop, but they will also have a larger file size and will require a large hard disk and a fast system with a lot of RAM for processing (see page 17).
- 6. If you chose a printer profile, check Simulate Paper & Ink to preview the photo using the range of black values that can be produced by that printer, on a simulation of white printing paper.
- 7. In a standard workflow, you can keep Resize to Fit unchecked. If, on the other hand, you need to resize the current photo and other photos that you open into Camera Raw, keep the dialog open after step 12, and follow the task on page 60.
- 8. Camera Raw applies a Resolution of 300 ppi to all photos as they are opened into Photoshop. If needed, you can choose a different value here.
- 9. Optional: Use options under Output Sharpening to apply predefined sharpening. Check Sharpen For, then from the Sharpen For menu, choose an output medium of Screen, Glossy Paper, or Matte Paper; and from the Amount menu, choose the desired level of sharpening (Standard is a good all-purpose choice).
 - The sharpening values that Camera Raw applies via this dialog aren't listed anywhere. If you want to control specific values when sharpening, uncheck Sharpen For and use the sliders in the Detail tab (see pages 70–71).
- 10. The Open in Photoshop as Smart Objects option converts the Open Image button in the main Camera Raw dialog to an Open Object button, which opens your photo into Photoshop as a Smart Object.
 - If you leave this workflow option unchecked, you can convert the Open Image button to Open Object in the main Camera Raw dialog (for any photo) by holding down Shift. Learn about Smart Objects on pages 264-275.
- 11. Optional: To save your current, custom Workflow Options settings as a preset that can be applied to any photo, from the Preset menu, choose New Workflow Preset.★ Enter a descriptive name for the preset, then click OK.

- 12. Optional: If you chose a preset and then changed any of the settings in the dialog, the word "(edited)" is now listed in the preset name. If you want to permanently update the current preset with your new custom settings, from the Preset menu, choose Update [preset name].*
- 13. Click OK. Your chosen workflow settings will be applied to the current photo and to all photos that you subsequently open into Camera Raw.
- To rename a user-saved Workflow Options preset, from the Preset menu in the dialog, choose the preset to be renamed, choose Rename [preset name], type the desired name, then click OK.*

,						
Space:	Adobe R	GB (1998)	*)	Dept	th:
Intent:				*	_ s	imu
	W:	2400	H : 1800	pixels	÷	
Res	olution:	300	pixels/inch		•	

A Via the Workflow Options dialog, you can choose Preset, Color Space, Image Sizing, and Output Sharpening settings for the current and future photos.

USING THE GAMUT WARNING BUTTON IN THE CAMERA RAW HISTOGRAM *

If you choose a printer profile from the Space menu in the Workflow Options dialog, instead of two clipping warning buttons on the histogram in the main Camera Raw dialog, you will see just one Gamut Warning button 🗐 (O). When this button is activated, areas of the photo that are outside the gamut of the chosen output device will display as red in the preview. If you need to bring those errant colors back into gamut, you can use either the Vibrance slider in the Basic tab or the Saturation sliders in the HSL/Gravscale tab.

QUICK AND EASY WAY TO APPLY A WORKFLOW OPTIONS PRESET ★

To apply a Workflow Options preset to a photo, instead of opening the Workflow Options dialog, right-click the link below the preview in the main Camera Raw dialog and choose a preset name from the context menu.

B From the Preset menu in the Workflow Options dialog, you can choose a user-saved workflow preset.

If you need to resize multiple photos according to a specific criterion, such as the dimension of a long or short side of one of the photos, use the Resize to Fit feature in the Workflow Options dialog. If you don't require the original high-megapixel count of your photos for image editing or output, shrinking them is an acceptable option. Enlarging photos, on the other hand, should be done only when necessary, as it diminishes their quality (preferably, don't enlarge your photos by more than 25% or 30%).

Note: To resize or change the resolution of an individual photo for a particular output medium, instead of using the options dialog in Camera Raw, we recommend using the Image Size dialog in Photoshop after you exit Camera Raw (see pages 136-139). The latter offers many image resizing options, including choices for resampling, with a document preview.

To resize images via the Workflow Options dialog: *

- 1. Open one or more photos into Camera Raw, then click the Workflow Options link. Under Image Sizing, check Resize to Fit.
- 2. Optional: Check Don't Enlarge if you want to prevent your photos from being enlarged.
- 3. Under Image Sizing, from the Resize to Fit menu, A do one of the following (Camera Raw will resize all your photos proportionately, whether or not you enter proportionate values): Choose Width & Height, then enter the desired maximum W and H values within which the current and future photos will be resized. For resizing to occur, both of these values must be either larger or smaller than the original dimensions of

the current photo.

Choose Dimensions, B then enter the desired maximum values in the two fields within which Camera Raw will resize your photos. Camera Raw will fit the longer dimension of each photo to the larger of the two values (regardless of the orientation of the photo). You could use this option to resize a series of horizontal or vertical photos to the same long dimension.

If the Width & Height or Dimensions option produces unexpected resizing results in your photos, try entering the same value in both fields, thereby providing a larger resizing area, or use the Long Side or Short Side option instead (see the next option).

Choose Long Side or Short Side, then enter the desired value for that dimension.

Choose Megapixels, then enter the desired total pixel count value. All photos will be resized to that value.

Choose Percentage, then enter a percentage by which you want your photos to be resized (preferably, less than 130%, and not more).

- When you use the Resize to Fit option, the new dimensions and megapixel (MP) count are listed in the right side of the Image Sizing area. If you want to learn the original dimensions of the current photo, uncheck Resize to Fit; the original dimensions will display in the dimmed W and H fields; now recheck the box.
- 4. Click OK. Note: Because the current settings in the Workflow Options dialog are applied to all photos that you open into Camera Raw, after using the dialog to resize the desired photos, exit Camera Raw. Upon reopening Camera Raw, be sure to open the Workflow Options dialog and uncheck Resize to Fit.

		Workflow	Options
Preset: 2800x25	00 AdobeRGB 8-bit		
Color Space —			
Space: Adob	e RGB (1998)	•	Depth:
Intent:		*	☐ Simula
☐ Image Sizing — ☑ Resize to Fi	Dimensions		166

From the Resize to Fit menu in the Workflow Options dialog, choose a criterion for resizing your photos.

☑ Resize to Fit:	Dimens	☐ Don'		
	2800	x 2500 pixe	els ‡	1867 by
Resolution:	300	pixels/inch		

B If you choose Dimensions as the Resize to Fit option, you must then enter pixel values in the two fields below the menu.

Using the Camera Raw tabs

The Camera Raw tabs

To access a panel of related settings in Camera Raw, click one of the tab icons (shown above). We perform most of our work in the first four tabs, and recommend that you do the same. Use the other tabs for specialty corrections or enhancements, as needed.

Basic: Adjust the white balance and exposure (see pages 63-67).

Tone Curve: Fine-tune a specific tonal range, such as the upper or lower midtones (see pages 68-69).

Detail: Apply capture sharpening and reduce unwanted noise (see pages 70-71).

HSL/Grayscale: Adjust the hue, saturation, and luminance of individual colors (see pages 72-73).

Split Toning: Apply one color tint to the highlight areas of a photo and a second tint to the shadow areas (see page 79).

Lens Corrections: Correct a photo for the effects of lens distortion, such as geometric distortion (e.g., a building that is tilted backward or isn't level), underor overexposure at the edges (an unwanted vignette), chromatic aberration, and color fringes.

Effects: As a special effect, apply a grain texture or a light or dark vignette (see pages 84-85).

Camera Calibration: The Process menu in this tab lets you update a file to the latest Camera Raw processing (see the sidebar on the next page). If the profile that Camera Raw provides for your camera model doesn't produce satisfactory color results, use the sliders in this tab to tweak the settings manually.

Presets: Create a custom preset of the current Camera Raw settings for future application to any other photos (see page 92).

Snapshots: For flexibility in editing, save interim versions of a photo as you make corrections. When necessary, you can restore the photo to any snapshot version (see the sidebar on page 92).

USING THE SCRUBBIES

To change a value quickly in a Camera Raw tab, instead of dragging a slider, drag to the left or right across the slider name (this is called a scrubby slider).

If you find a need to undo or reset your slider settings as you work in Camera Raw, you can use any of the methods below. (To learn about related options on the Camera Raw Settings menu, see the next page.)

To restore default settings to sliders in the Camera Raw tabs:

Do any of the following:

Double-click a slider to reset it to its default value (usually 0).

Shift-double-click a slider in the Basic tab to reset it to the Auto value.

Click Default in the Basic or HSL/Grayscale tab to reset all the sliders in just that tab to 0.

Hold down Alt/Option and click Reset at the bottom of the dialog (Cancel becomes Reset) to restore the settings, in all tabs, that were in effect when you opened the dialog.

USING THE PREVIEW BUTTONS *

From the Before/After Views menu L below the preview, choose a preview option. For instance, Before/ After Left/Right displays the original photo on the left (or displays the photo with the settings that were copied to the button, see below), and the photo with the current Camera Raw settings on the right. Before/After Top/Bottom Split displays the two versions in top and bottom halves of one image. Or if you prefer to cycle through the menu settings, click (and keep clicking) the Before/After Views button (Q). To customize the views, choose Preview Preferences from the menu.

- ➤ To swap the positions of the previews, click the Swap Before/After Settings button (P).
- ➤ To save the current Camera Raw settings as the Before state of the image, click the Copy Current Settings to Before button (Alt-P/Option-P). Thereafter, when you choose a Before/After view, those settings will display in the top or left part of the preview.

When you open a photo into Camera Raw, by default, it's adjusted according to the built-in profile for your camera model, and all the sliders in the Basic tab are set to 0. At any time, you can assign a different collection of settings to your file, or restore the original settings.

To restore settings via the Camera Raw Settings menu:

From the Camera Raw Settings menu, choose one of these options: A

Image Settings to restore the settings that were attached to the file during the initial photo shoot or, if the photo was previously edited in Camera Raw, from the last Camera Raw session. When a photo is opened for the first time into Camera Raw, these settings will match the Camera Raw Defaults settings.

Camera Raw Defaults to remove all custom settings and reapply the default settings for your camera model, your specific camera, or the ISO setting that was used to take the photo.

Previous Conversion to apply the settings from the prior image that was adjusted in Camera Raw.

Custom Settings to reapply the custom settings that you have chosen since opening the photo into Camera Raw.

If a user-saved preset is applied to the current photo, that preset will also be listed as an option on this menu (see page 92).

TOGGLING THE ACR DEFAULT SETTINGS *

To quickly toggle between the current (custom) settings and the Adobe Camera Raw Default settings for your photo, click the rightmost button below the preview (Ctrl-Alt-P/Cmd-Option-P). If the photo is displayed in a divided preview, the default settings will display in just the "After" section.

A Use options on the Camera Raw Settings menu to restore default settings to your photo or to reapply the prior settings.

UPDATING LEGACY PHOTOS AND THE **CAMERA RAW SLIDERS**

When you bring an unprocessed photo into Camera Raw 8.x, the dialog uses its most up-to-date profiles for noise reduction, de-mosaicing, sharpening, color calibration, and other processing. If you want to update a raw photo that was already processed in Camera Raw 6 or earlier using the new profiles, and also update the sliders in the Basic and other tabs to the newest versions (as described in this chapter), before applying any custom adjustments, click the Update to Current Process (2012) 💷 icon at the bottom right of the preview window. The Process menu in the Camera Calibration tab Changes to the setting of 2012 (Current). Note: If you want to preserve access to the older rendering of the photo, take a snapshot of it before you update it (see the sidebar on page 92).

SETTING THE WHITE BALANCE

The color temperature of the lighting in which a photo is shot, whether natural or artificial, influences the relative amounts of red, green, and blue that are recorded by the camera. A digital camera attempts to balance the three colors to produce an accurate white, which in turn makes other colors in the photo more accurate; this is called the "white balance."

There are a few ways to adjust the white balance of a photo in Camera Raw. Note: Before adjusting the white balance, make sure your display is properly calibrated.

- ➤ Our recommended method is to drag the Temperature and Tint sliders in the Basic tab, choosing settings based on how the photo looks to your eye (see the next page).
- For photos that are shot in controlled lighting, such as in a studio, another method is to use the White Balance tool (I). Drag (don't click) to define a rectangle on a medium to light gray area of the photo — if you can find one. Camera Raw will set the White Balance based on pixel values in the sampled area. Note that although the White Balance tool is improved, sampling a larger area of "nearly gray" pixels than before, * the resulting color temperature and tint correction may still not be adequate, and may need further adjustment.
- ➤ Here's an iffy, but quick, method: Shift-doubleclick the Temperature slider, and Shift-double-click the Tint slider. Camera Raw will apply auto settings for those controls.

Using the Basic tab

As its name implies, the Basic tab contains the most essential correction features of Camera Raw — and it displays first, by default, when you open the dialog. We have divided the use of this tab into several tasks, beginning with setting the White Balance, on this page, then proceeding through exposure, contrast, and saturation adjustments, on pages 64-67.

To apply white balance adjustments via the Basic tab:

- 1. With a photo open in Camera Raw, click the Basic tab. A If the whole photo isn't visible in the preview, double-click the Hand tool $\ ^{\ }$ in the toolbox.
- 2. Do either of the following:

From the White Balance menu, choose a preset that best describes the lighting conditions in which the photo was taken, such as Daylight or Shade. (Choose As Shot, if needed, to restore the original camera settings. Note that only As Shot and Custom are available for JPEG and TIFF files.)

Lower the Temperature value to add blue and make the image look cooler, B or raise it to add yellow and make the image look warmer. To finetune the temperature correction, move the **Tint** slider slightly to the left to add a bit of green or to the right to add magenta. (The White Balance menu setting changes to Custom, to indicate that you have chosen manual settings.)

A When a photo is opened for the first time into Camera Raw, the White Balance menu in the Basic tab is set to As Shot. This photo has a high Temperature value and looks too warm (yellowish).

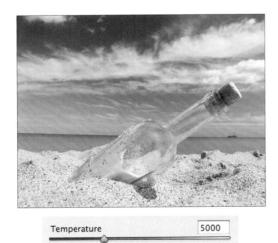

B We lowered the Temperature value too much. Now the photo looks too cool (has a bluish cast).

Temperature

C A Temperature value of 5500 strikes a good balance between warm and cool.

On the histogram in the Camera Raw dialog, the red, green, and blue areas represent the three color channels in a photo, and the white areas represent the areas where those three colors overlap. Clipping, the shifting of tonal values to absolute black or white in a photo, occurs if the tonal range of a scene is wider than the range that can be captured by the camera. You can tell that pixels are clipped in a photo if the vertical bars are primarily clustered in taller peaks at one or both ends of the histogram (shadow pixels on the left, highlight pixels on the right). You can also drag in the histogram to apply tonal adjustments.

As you make slider adjustments in Camera Raw, your goal is to bring the pixels into the range of your chosen RGB color space and minimize clipping. When tonal values are redistributed, the histogram updates accordingly. Note: Remember, we recommended that you choose Adobe RGB as the color space both for your camera (see page 5) and for photos that you open into Camera Raw (see page 58).

To turn on the histogram clipping warnings for the preview:

In the top-left corner of the histogram, click the Shadow Clipping Warning button (U); A clipped shadows display in the preview as blue. In the topright corner, click the Highlight Clipping Warning button (O); clipped highlights display in the preview as red. (When a button is activated, it has a white border.)

In the two tasks that follow this one, we show you how to use a number of sliders in the Basic tab. Once you learn the function of the sliders, remember that you can also make adjustments by dragging in the histogram, as described here.

To make tonal edits via the histogram: *

- 1. In Camera Raw, display the Basic tab, then roll over the histogram. As you move the pointer, one of five vertical gray drag zones will appear. The drag zone, as well as the data in the info area below the histogram, corresponds to one of these five sliders: Blacks, Shadows, Exposure, Highlights, or Whites.
- 2. Drag horizontally in a drag zone to adjust that tonal range; the corresponding slider will shift accordingly.B

Use the middle batch of sliders in the Basic tab to apply tonal corrections to your photo, preferably in the order listed in the dialog (there's a logic to their sequence). At first, all the sliders are set to 0 and the underlined word "Default" is dimmed.

To apply exposure and contrast adjustments via the Basic tab:

- 1. Turn on the Clipping Warning buttons.
- 2. Use the Exposure slider to lighten or darken the entire photo, as needed.
- 3. Use the Contrast slider to increase or reduce the color intensity and tonal contrast (A-B, next page).

Instructions continue on page 66

A When we rolled over an area of the histogram, a drag zone appeared, and the corresponding Basic slider name and setting appeared in the info area.

B When we positioned our pointer within the drag zone for the Shadows range in the histogram, then dragged horizontally, the corresponding Shadows slider in the Basic tab shifted accordingly.

A This original photo was underexposed (too dark), causing the colors to look dull. The blue warning color in the preview indicates the shadow areas in the photo that are clipped.

B Our first goal is to lighten the overall photo and recover details in the midtones and shadows without washing out the highlights. In the Basic tab, we increased the Exposure value,* then increased the Contrast value to intensify the highlights, shadows, and color saturation. We're not concerned that the photo is still too dark, as it can be lightened with further adjustments.

Exposure	+0.60
Contrast	+25
Highlights	0
Shadows	0
Whites	0
Blacks	0
Clarity	0
Vibrance	0
Saturation	0

^{*}We chose an Exposure value of +0.60 for the raw version of this photo. If you are working with the JPEG version that we have supplied for downloading, use an Exposure value of +0.80 instead.

slider to the left.

- 4. If you increased the contrast, the highlights and shadows probably now need to be adjusted: To restore details in the highlights, move the Highlights slider to the left until only a smidgen remains of the red highlight warning color. To restore details in the shadows, move the Shadows slider to the right until only a smidgen remains of the blue shadow warning color. A Or
- 5. Now that details have been restored to the midtones and highlights, you're ready to adjust the whites and blacks.

if you need to darken the shadows, move this

Increase the Whites value to brighten the white areas in the photo. This slider also has the effect of lightening the upper midtones and brightening the colors.

Use the Blacks slider to lighten or darken the black areas (A, next page). This slider may also affect the color brightness.

- If the colors are now washed out as a result of your increasing the Whites or Blacks value, you could try increasing the Contrast value.
- To further adjust the tonal values in the midtones, see pages 68-69.
- To have Camera Raw set the Whites or Blacks value automatically, hold down Shift while double-clicking one of those sliders.

REMOVE CLIPPING IN THRESHOLD PREVIEW

To remove shadow clipping a different way, Alt-drag/ Option-drag the Shadows or Blacks slider. A Threshold preview displays (as shown below). Release the mouse when small amounts of color or black display in the white preview.

You can also Alt-drag/Option-drag the Exposure, Highlights, or Whites slider to display a Threshold preview for that adjustment. Release the mouse when only a smidgen of white displays in the black preview.

	Auto Def	ault
Exposure		+0.60
Contrast		+25
Highlights		-100
Shadows		+50
Whites		0
Blacks		0

A We reduced the Highlights value to recover details in the sky and increased the Shadows value to recover details in the shadows and lower midtones. The colors and detail in the midtones, and the overall balance of lights and darks. are improved. However, reducing the Highlights value caused the white areas to look dull.

Exposure	+0.60
Contrast	+25
Highlights	-100
Shadows	+50
Whites	+33
Blacks	+53

A We increased the Whites value to lighten the upper midtones and brighten the whites, and increased the Blacks value to recover more details in the shadows. Overall, the brightness, as well as the colors, are much improved.

To apply edge contrast and color saturation adjustments using the Basic tab:

- 1. To add depth by intensifying the edge contrast in the midtones, increase the Clarity value; or for a deliberate soft-focus effect (such as in a portrait or landscape), reduce the Clarity value.
- 2. Change the Vibrance value to adjust the color saturation.B
- 3. Turn off both clipping warnings by pressing U, then O.

We recommend using the Vibrance slider instead of the Saturation slider to adjust color saturation because the former is less likely to cause oversaturation (and it protects skin tones), whereas the latter is more likely to cause oversaturation and highlight clipping. To view the effect of this, drag the Saturation slider to the far right.

B Finally, we increased the Clarity value slightly to sharpen the details and increased the Vibrance value slightly to boost the color saturation (note the change on the car body). Our cumulative adjustments to this photo improved the contrast, clarified the details, and produced richer color. Vroom, vroom!

+22 +22

Using the Tone Curve tab

After using the Basic tab, a next logical step is to make a more refined adjustment of the upper and lower midtones, which we recommend doing individually via the Parametric sliders in the Tone Curve tab.

Note: We avoid manipulating the curve in the nested Point tab, because a misshapen curve can cause a photo to look posterized. The sliders in the Parametric tab don't cause this problem.

To apply tonal adjustments using the Parametric sliders in the Tone Curve tab:

- 1. With a photo open in Camera Raw, A click the Tone Curve tab, then the nested Parametric tab. Behind the curve you'll see a static display of the current histogram.
- 2. Do either of the following:

If you have already adjusted the Highlights and Shadows sliders in the Basic tab, leave the Highlights or Shadows sliders in this tab alone and just tweak the upper and lower midtones using the Lights and Darks sliders. If you didn't adjust the Highlights and Shadows sliders in the Basic tab, you can use the sliders here to lighten or darken any individual tonal range: Highlights, Lights (upper midtones), Darks (lower midtones), or Shadows. As you move a slider, the

corresponding portion of the curve will be raised above or lowered below the diagonal line (A-B, next page).

Click the Targeted Adjustment tool (T). Drag within a tonal range of the photo that needs adjustment (C, next page). As you do this, the slider and curve that correspond to the tonal range under the pointer will move accordingly.

- To boost the contrast in a photo, try moving the Lights slider to the right and the Darks slider to the left.
- 3. To control the range of tonal values that are affected by the slider adjustments you made in the preceding step, move any of the region controls (located below the graph). The left region control affects the Shadows slider, the right region control affects the Highlights slider, and the middle region control affects both the Lights and Darks sliders (D-E, next page). Move a control to the left to raise the curve and lighten adjacent tonal ranges, or move a control to the right to lower the curve and darken adjacent tonal ranges.
- To use one shortcut to get to the nested Parametric tab in the Tone Curve tab and select the Targeted Adjustment tool, press Ctrl-Alt-Shift-T/Cmd-Option-Shift-T.

A In this photo, the midtones are too dark — few details are visible in those areas.

A To lighten the lower midtones, we increased the Darks value. This adjustment raised the middle of the curve.

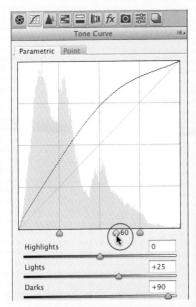

D Finally, we moved the middle region control slightly to the right, which had the effect of increasing the contrast and lightening the sky.

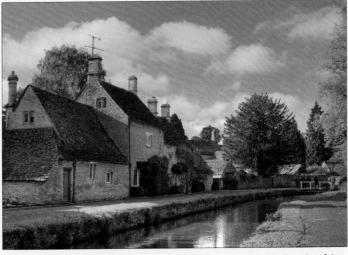

B More details are now visible in the lightened midtones, such as on the sides of the buildings and on the side and surface of the canal. However, the sky looks a bit dull.

C To lighten the upper midtones (and thereby brighten the clouds, sky, and trees), we dragged upward over a light midtone area with the Targeted Adjustment tool; o, the Lights value increased automatically.

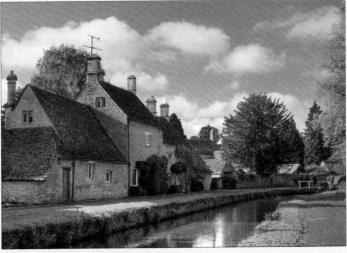

Now the tonal values in the image look just right.

Using the Detail tab

Via the Sharpening sliders in the Detail tab, you can adjust the sharpness of your photo (a process called "capture" sharpening), and via the Noise Reduction sliders, you can reduce any unwanted color noise.

To sharpen a photo using the Detail tab:

- 1. Click the **Detail** tab **A** and choose a zoom level of 100%. In the preview, drag to reveal an area of the photo that has some detail (hold down the Spacebar for a temporary Hand tool). Note: If the words "Sharpening (Preview Only)"
 - display at the top of the Detail tab, click the Open Preferences Dialog button in the toolbox. In the Camera Raw Preferences dialog, choose Apply Sharpening To: All Images, then click OK.
- 2. Under Sharpening, adjust the Amount value for the degree of edge definition. For subject matter that needs a lot of sharpening, such as hard-edged objects or buildings, try a value of 100; if less sharpening is needed, try a value of 50-60. (For a raw photo, the default Amount value is 25; for a JPEG photo, the default value is 0.)
 - To better evaluate the Amount value via a grayscale preview, Alt-drag/Option-drag the
- 3. Use the Radius slider to control how many pixels surrounding each sharpened edge are modified. We keep this value between 1 and 1.3.
- 4. Alt-drag/Option-drag the Detail slider slightly to the right to emphasize edge details and textures.
- 5. Alt-drag/Option-drag the Masking slider to around 50 to protect low-contrast areas with a black mask, and thereby sharpen only high-contrast areas.

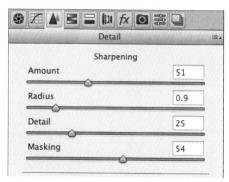

A These are the Sharpening controls in the Detail tab.

All digital cameras produce some luminance (grayscale) noise and color artifacts (randomly colored pixels). Although budget cameras tend to produce the most noise, it can also be produced by a high-end camera if it's used with a high ISO (light sensitivity) setting in a poorly lit scene. It's a good practice to remove as much noise from your photos as possible in Camera Raw, because it can become accentuated by image editing in Photoshop.

As you follow these steps, you'll discover that after you shift one slider, another slider will need adjusting.

To reduce luminance and color noise using the Detail tab:

- 1. With a photo open in Camera Raw (A, next page), click the **Detail** tab **M** and choose a zoom level of 200-300% for the preview.
- 2. To reduce grayscale noise (graininess), increase the Luminance value (B, next page). Try a value between 20 and 70.
- 3. Increasing the Luminance can cause high-contrast edges in a photo to lose definition. To resharpen edges, raise the Luminance Detail value — but not so much that you reintroduce noise (C, next page).
 - To move a different area of the photo into view, hold down the Spacebar and drag.
- 4. Raise the Luminance Contrast value to restore some edge contrast. The effect of this slider is most noticeable in photos that contain a lot of noise.
- 5. Color artifacts and random speckling tend to be most noticeable in solid-color areas of a photo (e.g., flat surfaces), especially in shadow areas. To reduce these defects in a raw photo, increase the Color value to around 40-50, depending on the subject matter (for a JPEG photo, which has a default Color value of 0, use a lower Color value).
- 6. Raising the Color value may lower the intensity of colors in areas of the photo that were poorly lit. To restore some saturation and intensity to those areas, increase the Color Detail value from the default value of 50 to around 75, or just until the color saturation looks good (D, next page).
- 7. To help reduce color mottling and artifacts in dark. low-contrast (low-frequency) areas of the photo, use the Color Smoothness slider.
- 8. Lower the zoom level for the preview to judge the overall effect of the Detail settings.

A This is a close-up of a photo of a shop window (viewed at a zoom level of 300%), with the Noise Reduction: Luminance and Color sliders in the Detail tab set to 0 (no noise reduction applied). Grayscale noise is evident in the signage, and color artifacts are evident on the poorly lit interior surfaces behind the letters.

Noise Reduction 69 Luminance Luminance Detail 0 **Luminance Contrast** 0 **△** 0 Color

B To remove noise from the letters, we increased the Luminance value to 69, but this also diminished the edge definition.

ANOTHER WAY TO REDUCE NOISE

To reduce noise in select areas via the Adjustment Brush tool and a mask, see pages 74-78.

C To resharpen the edges of the letters, we increased the Luminance Detail value to 65.

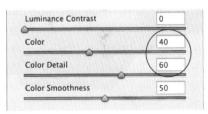

D To remove color artifacts from the dark areas, we increased the Color value to 40; this also had the effect of desaturating the colors. To revive the colors and produce the final version of the image (shown at left), we increased the Color Detail value to 60.

Using the HSL/Grayscale tab

Using the powerful sliders in the HSL/Grayscale tab, you can adjust the hue, saturation, and luminance of each color component of a photo individually.

To adjust individual colors via the HSL sliders:

- 1. Click the HSL/Grayscale tab, and doubleclick the Hand tool 🖑 to fit the image in the preview.A
- 2. Click the nested Hue tab. Move any slider to shift that color into adjacent hues, as shown in the bar. For example, you could shift the Greens

- slider toward yellow to make a landscape look warmer, or toward agua to make it look cooler.
- 3. Click the Saturation tab. Move any slider to the left to desaturate that color (add gray to it) or to the right to make it more vivid (pure). B-C Avoid oversaturating the photo, to keep it looking realistic and so it stays printable.
 - To make a bluish sky more vivid, increase the saturation of the Blues and Aguas. To make a sunset look warmer, increase the saturation of the Oranges or Yellows.

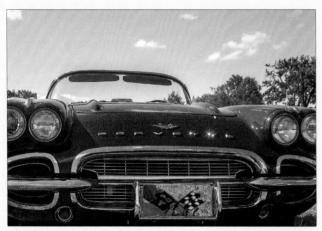

A In the original photo, the sky lacks contrast and the reds on the car body are slightly undersaturated.

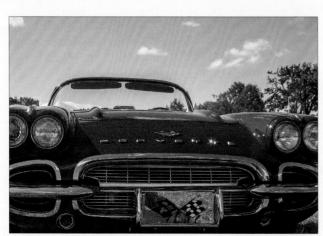

The Saturation adjustments intensified the reds in the car (particularly in the upper midtones) and intensified the blues in the sky.

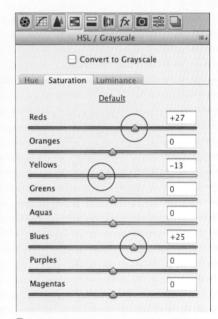

B In the nested Saturation tab of the HSL/ Gravscale tab, we reduced the saturation of the Yellows and increased the saturation of the Reds and Blues.

- 4. Click the Luminance tab. A-B Move a slider to the left to darken that color (add black) or to the right to lighten it (add white). Avoid lightening any of the colors too much, to prevent the highlights from being clipped.
- For a more accurate rendering of your adjusted pixels, choose a zoom level of 66% or 100% for the Camera Raw preview.

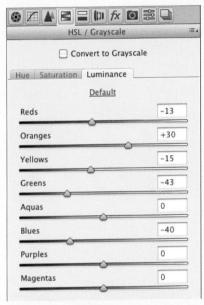

A In the nested Luminance tab, we lightened the Oranges and darkened the Reds, Yellows, Greens, and Blues. (Tip: Reducing the Blues value can make a photo look as if it was shot with a polarizing filter on the camera.)

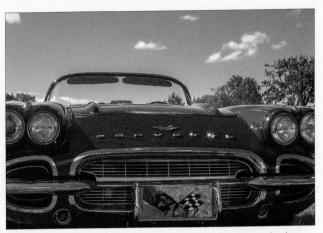

B Decreasing the luminance of the Blues darkened the colors in the sky, while decreasing the luminance of the Reds and increasing the luminance of the Oranges produced a brighter, richer red on the car body. Now the colors are equally intense in the upper and lower areas of the photo.

USING THE TARGETED ADJUSTMENT TOOL

To apply local color adjustments to a photo, hold down Ctrl-Alt-Shift/Cmd-Option-Shift and press H, S, or L. The nested Hue, Saturation, or Luminance tab in the HSL/Grayscale tab displays and the Targeted Adjustment tool 🔩 becomes selected. Drag upward or to the right over a color area to increase the slider values specifically for that area, or downward or to the left to decrease those values. The sliders that correspond to the color under the pointer will shift automatically.

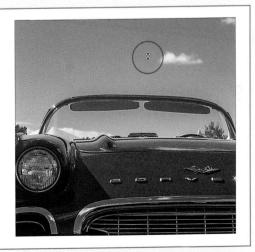

Using the Adjustment Brush tool

Unlike corrections that are made in the Camera Raw tabs, which apply to the overall photo, corrections made with the Adjustment Brush tool are "local" (affect specific areas of the photo). You apply a mask in the preview to define which areas are going to be affected by the adjustment, then you apply the correction via the sliders. Use this tool after you have finished your broad, overall corrections, to fix a few specific areas or to accentuate some details. A Awesome feature!

To apply local edits with the Adjustment Brush tool:

- 1. After making adjustments in the Basic and Tone Curve tabs, click the Adjustment Brush tool 🖋 (K). The sliders for the tool display (some are like the sliders in the Basic tab).
- 2. Click the + or button for any slider to "zero out" all the sliders except the one you click.
- 3. For the brush settings (the last four sliders), try a Feather value of 50-95 (to allow the edits to fade into surrounding areas), a Flow value of 60 (for the amount of adjustment produced by each stroke), and a Density value of 60 (for the level of transparency in the stroke).
- 4. Check Mask (Y) (scroll down in the settings area if you don't see this option), adjust the brush size by pressing [or], then draw strokes over areas of the photo that need the same adjustment. A tint covers the areas where you apply strokes, and a pin appears where you started dragging.B
 - The brush size is represented by the solid circle in the pointer; the feather value is represented by the black-and-white dashed circle.
- 5. Uncheck Mask, then use the sliders to apply adjustments to the masked areas (A, next page).
 - To show or hide all the pins, press V or check or uncheck Overlay.
 - To display the mask for an existing pin temporarily, with your mouse or stylus, roll over the pin.

We studied this photo and decided what improvements to make: Smooth the skin, sharpen the eyelashes, darken the eyebrows, and minimize the under-eye circles.

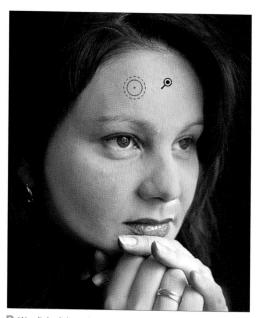

B We clicked the Adjustment Brush tool, zeroed out the sliders, checked Mask, then drew strokes on the broad areas of the face in the preview, being careful to avoid the key facial features.

A We hid the mask, then chose a higher Tint value to add magenta to the skin tones, higher Exposure and Shadows values to lighten the skin tones, and lower Clarity and Sharpness values to smooth the skin texture. The results are shown at right.

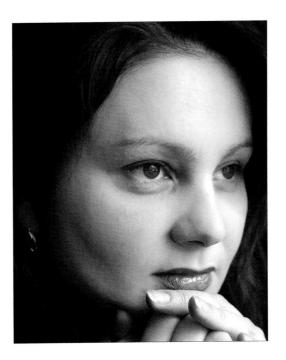

B To sharpen the eyelashes, we clicked New, showed the mask, then covered the lashes using a small brush.

- 6. To apply different adjustment settings to another area of the photo, click New, then repeat steps 2-5 B-C (and A-E, next page).
 - If you want to duplicate a pin and its mask, hold down Ctrl-Alt/Cmd-Option and drag the pin (you don't have to click it first). Or click a pin, right-click it and choose Duplicate from the context menu, then drag the new pin.*
- 7. To redisplay the main Camera Raw tabs, press H (Hand tool).

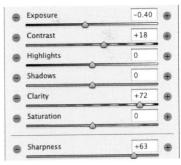

We hid the mask, then chose higher Contrast, Clarity, and Sharpness values to accentuate the masked areas, and a lower Exposure value to darken them.

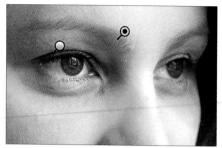

A To darken the eyebrows, we clicked New, checked Mask, then masked those areas.

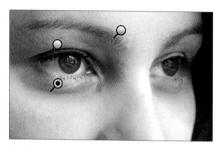

To minimize the dark circles under the eyes, we clicked New, checked Mask, then applied a mask to those areas.

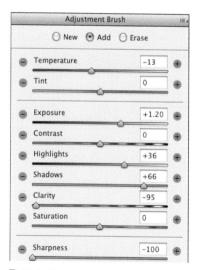

D We hid the mask again, then reduced the Temperature value to cool the redness of the skin tones; increased the Exposure, Highlights, and Shadows values to lighten the skin; and reduced the Clarity and Sharpness values to soften the skin texture.

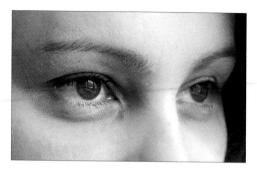

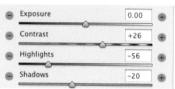

B We hid the mask, then chose a higher Contrast value to define the hairs more crisply against the skin, and lower Highlights and Shadows values for a darkening effect.

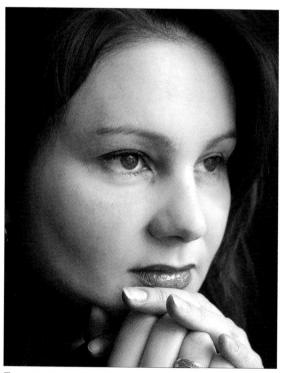

E This final image shows the cumulative results of all the local corrections that we applied via the Adjustment Brush tool.

To edit an Adjustment Brush tool correction:

- 1. Choose the Adjustment Brush tool / (K).
- 2. Check Mask (Y) and Overlay (V).
- 3. Click a pin. A black dot appears in the center of the pin.
- 4. Do any of the following:

To add areas to the mask, drag with the brush in the image preview.A-B

To move the mask to a different area of the photo, drag its pin.

To adjust the correction for the current pin, uncheck Mask (Y), then move the sliders.

USING THE AUTO MASK OPTION WITH THE ADJUSTMENT BRUSH TOOL

To mask an area according to color, zoom into that area. Check Auto Mask (M), position the Adjustment Brush tool over the color, scale the brush tip to cover just the width of the area, and start drawing a stroke. The mask will cover only the areas that match the first color area the brush touches.

 If you want to change the mask overlay color, click the Mask Overlay Color swatch, then choose a color in the Color Picker.

A After using the Adjustment Brush tool in this photo, we clicked an existing pin, and checked Mask to display the mask associated with that pin (we changed our mask color to yellow).

B We dragged with the Adjustment Brush tool to add an area to the mask for the currently selected pin (note the brush cursor on the right side of the photo).

To remove Adjustment Brush tool edits:

- 1. Choose the Adjustment Brush tool (K).
- 2. Check Mask (Y) and Overlay (V).
- 3. Do either of the following:

To remove adjustments locally, click a pin, click the Erase button (or hold down Alt/Option), then apply strokes where you want to erase the mask. A To remove a pin and its adjustments, click the pin, then press Backspace/Delete; or right-click a selected pin, then choose Delete from the context menu; B or hold down Alt/Option and click a selected or unselected pin (note the scissors pointer).

To remove all Adjustment Brush tool edits from the current photo and reset the tool mode to New, click the Clear All button.

A We clicked an existing Adjustment Brush pin, and checked Mask to display the mask associated with that pin. Next, we clicked the Erase button, then dragged with the brush to remove an area from the selected mask.

B To remove a selected Adjustment Brush pin, we rightclicked it and chose Delete from the context menu.

Using the Split Toning tab

Using the Split Toning controls, you can apply one color tint, or tone, to the highlight areas of a photo and a different tint to the shadow areas. For the best results with this technique (and to mimic its traditional origins), convert the colors in your photo to grayscale first. We've gotten good results on photos of metallic objects, such as the antique car shown here.

To apply a color tint to a grayscale version of a photo:

- 1. Click the HSL/Grayscale tab, then check Convert to Grayscale.
- 2. Click the Basic tab, and adjust the exposure and contrast.
- 3. Click the Split Toning tab.
- 4. Move both of the Saturation sliders approximately halfway across the bar to make it easier to judge the colors you will apply in the next step (don't worry that the photo looks awful).
- 5. Move the Highlights Hue slider to tint the highlights B and the Shadows Hue slider to tint the shadows.
- 6. Readjust the Saturation value for each hue.
- 7. Reduce the Balance setting to apply more of the Shadows tint to the entire photo, or increase it to apply more of the Highlights tint to the entire photo.C-D

A This is the original, full-color photo.

B After converting the colors in the photo to grayscale, we used the Split Toning tab to tint the highlights with a brownish yellow hue.

C Next, we tinted the shadows with blue, then moved the Balance slider to the right to favor the highlight color more.

D This is the final result of our Split Toning adjustments. Applying separate tints to the highlights and shadows accentuated the lines and araceful curves of this sleek antique.

Using the Lens Corrections tab

Via the Lens Corrections tab in Camera Raw, you can correct a photo for various adverse effects of lens distortion. You can straighten out an architectural feature, such as a building or fence, that looks as if it's leaning toward or away from the viewer, or that is tilted horizontally (isn't level); and you can correct for under- or overexposure at the edges of a photo (vignetting). The corrections can be applied using a preset profile (this page) or manually (pages 81-83).

To correct geometric distortion and vignetting via Profile settings:

- 1. Click the Lens Corrections tab. Double-click the Hand tool to fit the image in the preview.
- 2. To access predefined lens profiles, click the Profile tab, then check Enable Lens Profile Corrections.
- **3.** From the **Setup** menu, A do the following: Choose Auto to have Camera Raw read the EXIF metadata in the photo and attempt to select the proper lens make, model, and predefined profile. If an error message indicates that the Auto option was unable to locate a profile, choose your lens manufacturer from the Make menu. B Camera Raw will locate a matching lens model and list it on the Model menu, and will locate a predefined profile and list it on the Profile menu. If the Model menu

- lists more than one model, choose the one with which the photo was shot.
- 4. Under Correction Amount, do the following: Set the **Distortion** value to control the amount of correction.
 - Set the Vignetting value to correct for under- or overexposure at the edges of the photo.
- 5. Optional: If Camera Raw managed to locate your lens profile (step 3), you can save that profile and any custom Correction Amount settings as your new default profile by choosing Save New Lens Profile Defaults from the Setup menu. In future Camera Raw editing sessions, if you choose Default from the Setup menu, and the current photo was taken with this lens, the saved profile and settings will be applied. (To restore the Adobe predefined settings for your chosen lens, from the Setup menu, choose Reset Lens Profile Defaults.)
- **6.** Optional: If you want to further correct any lens distortion manually, see the next task.
- When applying lens corrections to a Smart Object in Photoshop, we use the Lens Corrections tab in Camera Raw (accessed via Filter > Camera Raw Filter) because it has more extensive manual controls than the Lens Correction filter in Photoshop.

A Check Enable Lens Profile Corrections. then choose Auto from the Setup menu...

B ... or choose your lens maker from the Make menu. Regardless of the Setup option, if necessary, adjust the Distortion value.

To correct geometric distortion or vignetting via the Manual tab:

- 1. Click the Lens Corrections tab, and double-click the Hand tool to fit the image in the preview.
- 2. Click the Manual tab.B
- 3. In the Upright area, click a button to apply a preset correction:

Auto A to apply level correction and fix horizontal and vertical convergence, balanced with as little distortion as possible.

Level to apply only level correction (not fix horizontal or vertical convergence).

Vertical III to apply level correction and fix vertical convergence (but not horizontal convergence).

Full for a stronger correction of horizontal and vertical convergence, in addition to level correction (A, next page).

4. If further manual correction is needed, do any of the following:

To spread the image out (fix pincushion distortion), lower the Distortion value; or to pinch the image inward (fix barrel distortion), increase the Distortion value.

To display a grid over the image so you can check the alignment, check Show

Continued on the following page

A The original photo (above) shows signs of lens distortion: The house looks as if it's tilting away from the camera, and it's not level.

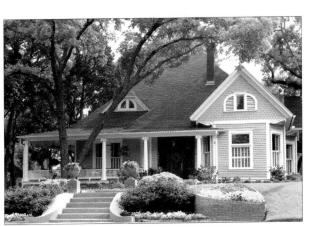

B We clicked the Manual tab (under Lens Corrections) to access these menu options and sliders.

C Under Upright, we clicked the Auto button for a balanced correction. This partially corrected the vertical lines and vertical tilt, but the left side of the house still looks as if it's farther away from the viewer than the right side.

Grid or press V. Adjust the grid size via the slider.B

To widen the top of the image, (correct keystoning) reduce the Vertical value; to widen the bottom of the image, increase the Vertical value. Readjust the Distortion value, if needed.

To widen the left edge of the image, reduce the Horizontal value; to widen the right edge of the image, increase the Horizontal value.

To rotate the image, change the Rotate value. To enlarge or shrink the photo, change the Scale value. Note: You could crop the photo instead.

To stretch the image horizontally or vertically, change the Aspect value. This option is useful for correcting strong perspective distortion in photos taken with a wide-angle lens (A-B, next page).

- If you moved the Distortion slider, you can click Reanalyze (below the buttons) to force a recalculation of the Upright correction based on the Distortion value. If you want to turn off (but preserve) all your Upright corrections, click the Off button. If you click a different Upright button, as an alert will inform you, all the Transform sliders (except Distortion) will be reset to 0.
- 5. To correct or apply Lens Vignetting (lighten or darken the outer areas of the photo), set the Amount value for the strength of the correction, then set the Midpoint value to expand the vignette inward or outward. Readjust the Amount value, if needed.

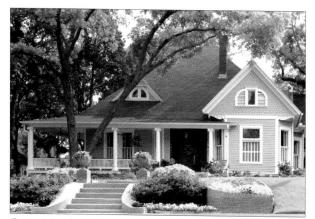

 $oldsymbol{\mathbb{A}}$ We clicked the Full button instead, which successfully made the house level and upright. To lighten the outer areas of the photo, we increased the Amount value (under Lens Vignetting).

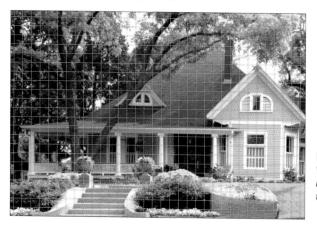

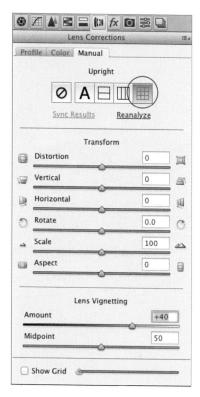

B We made some minor Vertical and Rotate adjustments, with Show Grid checked to help us gauge the effect.

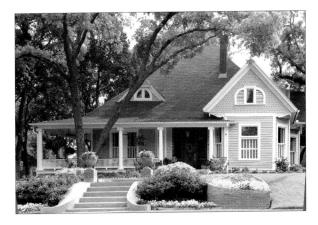

A We tried increasing the Aspect value, but this setting exaggerated and distorted the verticals of the house too much.

f B Instead, we set the Aspect value to –5, which exaggerated the horizontal proportion only slightly. The final settings we chose for the image are shown at right.

SYNCING LENS CORRECTIONS TO MULTIPLE PHOTOS

To apply Lens Corrections edits to multiple photos that you open into Camera Raw:

➤ If the photos don't require exactly the same corrections, click one photo, choose settings in the Manual tab of Lens Corrections, then on the left side of the dialog, click Select All, then click Synchronize. In the dialog, choose Lens Corrections from the menu, check only Transform and Lens Vignetting, then click OK. Camera Raw will analyze and correct each photo separately (see also page 94).

➤ If the photos do require exactly the same correction (e.g., bracketed shots of the same subject), click one photo, then click an Upright button in Lens Corrections. Click Select All on the left side of the dialog, then click Sync Results in Lens Corrections. The first photo will be analyzed according to the chosen Upright mode, then the same correction will be applied to all the other photos.

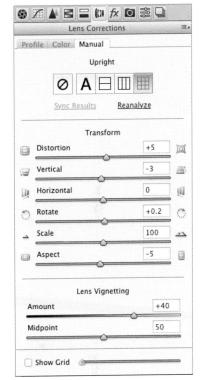

Using the Effects tab

In traditional photography, the faster the film speed, the larger and more apparent the grain. As an intentional effect, you can simulate this grainy texture via the Grain controls in Camera Raw. Choose a photo that won't suffer aesthetically when its details lose definition.

To add a grain texture to a photo:

- 1. Click the Effects tab, and double-click the Hand tool to fit the image in the preview.
- 2. To create a noticeable grain, under Grain, choose an Amount value of around 50.
- 3. To emulate the fine grain of slow film or the coarse grain of fast film, do as follows:

Set the Size value for the size of the grain particles. When this value is greater than 25, a small degree of blurring is also applied, to help blend the grain with the imagery.

Reduce the Roughness value below the default value of 50 for a more uniform grain, or increase it for an uneven, coarse grain. Zoom in to examine the grain, then readjust the Amount value, if needed.

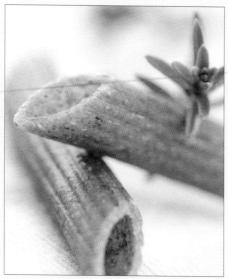

A This photo is a good candidate for the Grain effect because we won't mind if the details are softened and it contains muted colors

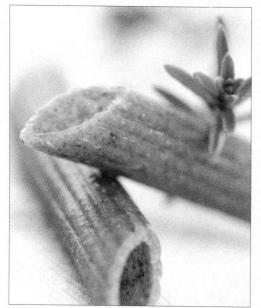

B The first settings we chose were Grain Amount 50 and Size 80 (we left the Roughness control at the default value of 50). The food textures are beginning to blend with the soft background.

We increased the Amount to 75, the Size to 60, and the Roughness to 65. The coarser grain unifies the highlights and background with the food textures even more. Please pass the Parmesan...

Using the Post Crop Vignetting controls, you can apply a light or dark vignette to a photo (lighten or darken the outer areas). If you crop the photo subsequently in Camera Raw, the vignette will reconform to the new dimensions.

To apply a vignette to a photo:

- 1. Click the Effects tab, fx and double-click the Hand tool to fit the image in the preview.
- 2. Under Post Crop Vignetting, do all of the following: B-D

Choose Style: Highlight Priority.

Choose a negative Amount value for a dark vignette or a positive value for a light vignette.

Adjust the Midpoint value to expand the vignette inward or outward.

Adjust the Roundness value to make the vignette shape more oval or more like a rounded rectangle.

Adjust the Feather setting to control the softness of the transition to the nonvignetted areas.

Adjust the Highlights setting to control the brightness of the highlights within the vignette area.

A This is the original image.

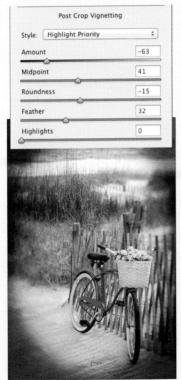

B In the Effects tab, under Post Crop Vignetting, we chose the values above.

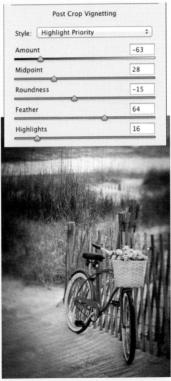

We lowered the Midpoint value and raised the Feather and Highlights values.

D When we cropped the image, the vignette readjusted automatically.

Using the Graduated Filter tool

When shooting landscapes, you may have run into this common predicament: You set the proper exposure for the foreground, and the sky winds up being overexposed. To solve this problem on site, you can reduce the light on the upper part of the lens with a graduated neutral-density filter. To darken a sky in a photo that is shot without such a filter (Plan B!), you can use the Graduated Filter tool in Camera Raw.

With this tool, you create an overlay to define the area to be edited, then you apply the adjustment via any of a dozen sliders. The slider options are the same as for the Adjustment Brush tool.

To adjust an area of a photo using the **Graduated Filter tool:**

- 1. After adjusting your photo via the Basic and Tone Curve tabs, A choose the Graduated Filter tool (G). The sliders for the tool display in the right panel.
- 2. Click the + or button for any slider to "zero out" all the sliders except the one you click.
- 3. To define where the filter edits will be applied, Shift-drag over an area in the photo, beginning from the location where you want the adjustment to be strongest. The filter will be applied fully at the green dashed border of the overlay, gradually diminishing to nil at the red dashed border. Note: If you want to draw the overlay on a diagonal, don't hold down Shift while dragging.
- 4. Do either or both of the following: Use the Temperature and/or Tint slider to make the filtered area warmer or cooler.

A Despite our applying Basic and Tone Curve adjustments, the sky in this photo looks overexposed (washed out).

- Use other sliders to adjust such characteristics as the exposure, sharpness, or noise in the filtered area (A-C, next page).
- 5. To redisplay the main tabs, press H (for the Hand tool).
- At any time, you can lengthen or shorten the filter overlay by dragging or Shift-dragging the green or red dot. To reposition the whole overlay, drag the line that connects the two dots.
- To apply a separate overlay to another area of the photo, click New, then repeat steps 2-4. If you want to clone an overlay, hold down Ctrl-Alt/ Cmd-Option and drag the dashed line that connects the two pins; or right-click a selected overlay and choose Duplicate from the context menu, then move the duplicate overlay.
- To hide the filter overlay, uncheck Overlay or press V.
- To remove a filter overlay, right-click a selected pin then choose Delete from the context menu; or hold down Alt/Option and click the overlay (note the scissors pointer); ** or click the overlay. then press Backspace/Delete.

EDITING A GRADUATED OR RADIAL FILTER MASK WITH A BRUSH *

- ➤ Create or select a filter overlay. Click the Brush button at the top of the panel (Shift-K) to display brush options, then click the Brush + (add to) or Brush - (erase from) button. Press [or] to size the brush, then apply strokes in the preview. (You can also toggle the plus and minus buttons for the brush by holding down Alt/Option.) If you want to choose different sizes for the plus and minus functions of the brush, check Separate Eraser Size on the panel menu.
- In the panel, you can set the Feather value to control how much the brush edits fade into surrounding areas, and the Flow value to control the amount of adjustment. Check Auto Mask (M) to mask only the areas that match the first color area the brush touches (see also the sidebar on page 77).
- ➤ To remove all manual brush strokes from the currently selected overlay, click Clear.

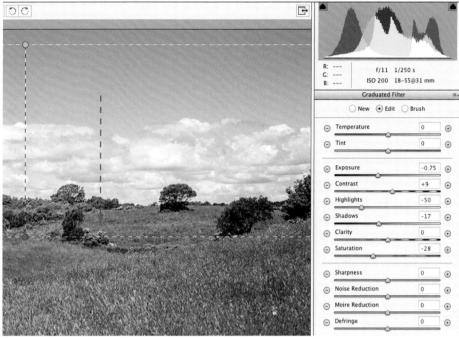

A After zeroing out the sliders for the Graduated Filter tool, we Shift-dragged downward in the photo (as shown by the arrow above), then chose slider settings to darken the exposure within the overlay area.

B To add more blue to the upper area of sky, we lowered the Temperature value.

lacksquare In the final image, the adjustment is strongest in the sky, fading to nil in the upper part of the ground.

Using the Radial Filter tool

With the Radial Filter tool, you define an elliptical area with an overlay, then apply adjustments via sliders to the area either inside or outside the overlay.

To darken an area of a photo via the Radial Filter tool:

- 1. After adjusting your photo via the Basic and Tone Curve tabs, A click the Radial Filter tool (J). The sliders for the tool display.
- 2. Click the + or button for any slider to "zero out" all the sliders except the one you click. At the bottom of the panel, click Effect: Outside or Inside to control where the filter effect will occur relative to the overlay you will draw in the next step.
- 3. Drag over an area in the photo to produce an overlay. B If you want to reposition the overlay as you create it, drag with the Spacebar held down.
- 4. Use any of the sliders to adjust the filtered area (A-C, next page). If the Effect setting is Outside, the adjustment will be at full strength outside the overlay, then diminish gradually to no adjustment at the dashed border. If the Effect setting is Inside, the adjustment will be at full strength at the center of the overlay and diminish gradually to no adjustment at the dashed border.

A Although the exposure in this photo is well balanced, we want to spotlight the spa products more.

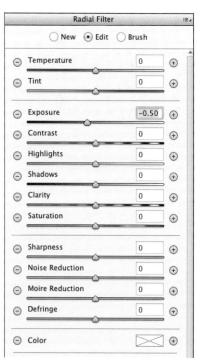

B We zeroed out the sliders for the Radial Filter tool, then dragged in the preview to create an overlay.

- 5. To control how gradual the adjustment is at the edge of the overlay, use the Feather slider.
- 6. To hide the overlay(s) to gauge the adjustment, uncheck **Overlay** or press V. Redisplay the overlay for the next step.
- 7. To edit the overlay, do any of the following (all optional):

To reposition the overlay, drag inside it. To reshape the overlay, drag one of its handles. To resize the overlay, Shift-drag a handle.

To swap the adjustment from Outside to Inside the overlay, or vice versa, click the unselected Effect button or press X.

8. Optional: To add another overlay, click New, then follow steps 2-7. To clone an overlay, hold down

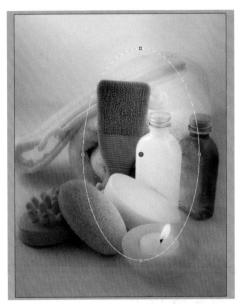

A We used the first four sliders to darken the filtered area and the Clarity and Sharpness sliders to soften the image details.

To make the lighting in the darkened areas cooler, we reduced the Temperature value (added blue).

Ctrl-Alt/Cmd-Option and drag its center pin; or right-click the pin and choose Duplicate from the context menu, then drag the new pin. *Note: Adjustments are cumulative where overlays overlap; to edit adjustment settings, click a pin first.

- 9. To redisplay the main tabs, press H (Hand tool).
- To delete an overlay, select its center pin, then right-click the pin and choose Delete from the context menu: or hold down Alt/Option and click the pin (scissors pointer); *\price or click the pin, then press Backspace/Delete.
- To expand an overlay to the edges of a photo, double-click inside it; or to do this when creating a new overlay, double-click in the preview.

EDIT THE MASK WITH A BRUSH

To edit a Radial Filter mask with a brush, follow the steps in the sidebar on page 86.

C The tonal, temperature, and sharpness adjustments helped to accentuate the candle, soap, and white bottle.

Using the Spot Removal tool

Use the Spot Removal tool to remove imperfections from a photo, such as spots caused by dust on the camera lens, blemishes in a portrait, or insects on flowers. You can let Camera Raw locate a source area. for the repair automatically, or you can choose a source area.

The Spot Removal tool does an improved job of locating a source area automatically, especially when used to heal nonsmooth textures (Adobe mentions bark, rocks, and foliage as examples of textures in which healing results are improved). Also, if you use this tool on a photo that you cropped in Camera Raw, the tool will look for source areas within the crop boundary first.*

To remove blemishes or spots:

- 1. Choose the **Spot Removal** tool **(B)**.
- 2. Zoom in on an area to be repaired.
- 3. Press [or] to size the brush cursor, then do one of the following:

Ctrl-Alt-drag/Cmd-Option-drag outward from the center of a blemish to create and scale a target circle A; or click a blemish; or if you want to control which area Camera Raw uses as the source, Ctrl-drag/Cmd-drag from the target area to the desired source area. When you release the mouse, a red dashed circle surrounds the target region and a green dashed circle surrounds the source area. B Drag across a blemish to create a target region.

When you release the mouse, a border with a red pin surrounds the target region and a border with a green pin surrounds a source region. C-E

A With the Spot Removal tool, we held down Ctrl-Alt/Cmd-Option and dragged to create a target circle around a blemish.

B The tool created a linked source circle in a similar area and repaired the blemish.

To remove an imperfection from a leaf, we're dragging to create a target region.

D The tool created a source region and two pins.

E The line is eliminated from the leaf.

- To display a black-and-white version of the photo to help you pinpoint dust spots or other irregularities, check Visualize Spots (Y). Adjust the black-to-white threshold via the slider. Press Y to return to the normal display.
- 4. Optional: To soften the transition between the current target area and surrounding areas, adjust the Feather value. A-C Or to adjust the Feather value interactively (within the current size of the brush cursor), with Shift and right-click held down, drag horizontally in the preview. The new Feather value will display within the selected target area. The Feather value is sticky, meaning the current value will persist for future editing sessions until you change it.*
- 5. From the Type menu, choose Heal to blend source pixels into the texture and luminosity values of the target pixels (often the best choice), or Clone to copy the source pixels exactly without any healing. Optional: To cycle through alternative source locations that Camera Raw detects, press (and keeping pressing) /.
- 6. To hide all regions and circles at any time in order to judge the Spot Removal results, uncheck Overlay (V). Recheck it for the remaining steps.
- 7. Select a target or source region by clicking its pin, or select a circle by clicking inside it, then do any of the following optional steps:

To reposition a region or circle, drag inside it. To control the opacity of the repair, change the Opacity value in the panel.

To resize a pair of target and source circles (not irregular-shaped regions), drag the dashed border. To add to an existing region (or to convert a circle to a region), position the pointer just outside it, then hold down Shift and click or drag.

8. Optional: Create more regions or circles to correct other blemishes.

To remove a pair of circles or regions, hold down Alt/Option and click in the target or source area; or to delete multiple circles and/or regions, Alt/ Option drag a marquee across them; or to remove all Spot Removal circles and regions, click Clear All.

- 9. To redisplay the main tabs, press H (Hand tool).
- To redisplay the current Spot Removal overlays at any time, choose the tool again (press B).

A The shed in this photo is a distracting element.

B Using the Spot Removal tool, we dragged outward from the center of the shed. With the Feather value for the tool set to 100%, the healing is fading around the rim of the circle, and sections of the original background aren't replaced.

 $lue{}$ We changed the Feather slider for the tool to 10%. Now the shed is more fully replaced with tree pixels, with minimal fading along the rim of the target region.

Saving and applying Camera Raw settings

After carefully choosing custom settings for a photo in Camera Raw, you'll be glad to know that you can save those settings as a preset and then apply the preset to other photos that need the same or similar corrections.

To save Camera Raw settings as a preset:

Method 1 (Camera Raw Settings menu)

- 1. With your corrected photo open in Camera Raw, choose Save Settings from the Camera Raw Settings menu.
- 2. The Save Settings dialog opens. A
- 3. Choose Subset: All Settings, then check the categories of settings you want saved in the preset. If you want to filter which boxes are checked for a subset, choose a tab name from the Subset menu, then check/uncheck boxes. For any menu choice, you can also click Check All or Check None; or to select one box exclusively, hold down Alt/Option and click it.
- 4. Click Save. A different Save Settings dialog opens (yes, it's confusing that the two dialogs have the same name). Enter a name (preferably one that describes the function of the preset), keep the location as the Settings folder, then click Save.
- 5. The saved settings preset is now available in the Presets tab 🚟 for any open photo.

Method 2 (Presets tab)

- 1. With your corrected photo open in Camera Raw, click the Presets tab. ## then click the New Preset button.
- 2. In the New Preset dialog, enter a name for the preset. Follow step 3, above.
- 3. Click OK. Your new preset is now available in the Presets tab for any open photo.
- To delete a user-saved preset, click the preset name, then click the Delete button.

You can apply a user-defined preset (saved collection of settings) to a single photo via Camera Raw (see below), to multiple photos via Bridge (see the following page), or to multiple thumbnails via the Synchronize option in Camera Raw (see page 94).

To apply a Camera Raw preset to a photo:

With a photo open in Camera Raw, click the Presets tab, ## then click a preset name.

You can also apply a preset via the Apply Preset submenu on the Camera Raw Settings menu.

A In the Save Settings dialog, check which categories of custom Camera Raw settings are to be saved in a preset.

TAKING SNAPSHOTS OF YOUR CR SETTINGS

A snapshot is a record of the current Camera Raw settings that you have chosen for a photo. By saving snapshots of your photo periodically while editing it, you preserve the option to restore the photo to those earlier settings. Unlike snapshots on the History panel in Photoshop, snapshots save with the Camera Raw file. Click the Snapshots tab, then click the New Snapshot button. In the New Snapshot dialog, enter a name, then click OK. To restore the photo to a snapshot at any time, click a snapshot name in the Snapshots tab. (For other ways to restore Camera Raw settings, see pages 61–62.)

To update an existing snapshot with the current settings, right-click the snapshot listing and choose Update with Current Settings from the context menu. The settings presets that you save in the Presets tab of the Camera Raw dialog can also be applied to multiple photos via the Develop Settings submenu in Bridge. In fact, as a strategy, you could save separate presets for settings in individual Camera Raw tabs and then assign them to multiple photos in succession (e.g., a preset for the Basic tab first, then a preset for the Tone Curve tab, and so on). If you haven't saved the needed settings as presets, a quick alternative method is to copy and paste all the current settings from one photo into one or more other photos.

To apply Camera Raw settings to multiple photos via Bridge:

Method 1 (apply a preset)

- 1. In Bridge, Ctrl-click/Cmd-click multiple photo thumbnails (or Shift, then Shift-click a consecutive series of thumbnails).
- 2. To apply settings, from the Edit > Develop Settings submenu, choose a preset; or right-click a selected thumbnail and choose a preset from the Develop Settings submenu on the context menu. A Choose additional presets, if needed.

Method 2 (copy and paste settings from a photo)

- 1. Click the thumbnail for a photo that has the desired settings, then choose Edit > Develop Settings > Copy Camera Raw Settings (Ctrl-Alt-C/ Cmd-Option-C), or right-click the selected thumbnail and choose Develop Settings > Copy Settings from the context menu.
- 2. Click another thumbnail (or Ctrl-click/Cmd-click multiple thumbnails), then choose Edit > Develop Settings > Paste Camera Raw Settings (Ctrl-Alt-V/ Cmd-Option-V), or right-click the selected thumbnail and choose Develop Settings > Paste Settings from the context menu.
- 3. The Paste Camera Raw Settings dialog opens. Uncheck any settings you don't want to paste; or choose a tab name from the Subset menu, then remove or add any check marks; or to select one box exclusively, hold down Alt/Option and click it. * Click OK.
- To remove all Camera Raw settings from a selected photo thumbnail in Bridge, choose Edit > Develop Settings > Clear Settings or right-click the thumbnail and choose Develop Settings > Clear Settings from the context menu.

A Using commands on the Develop Settings submenu in Bridge, you can apply one or more saved settings presets to multiple selected thumbnails, or copy and paste the current settings from one thumbnail to other thumbnails.

Synchronizing Camera Raw settings

When you open multiple photos into Camera Raw, they are represented by thumbnails in a panel on the left side of the dialog. After adjusting one photo, you can click Synchronize to apply those settings to one or more of the other photos. Because it's unlikely that every single adjustment needed for one photo will be perfectly suited to all the others (even photos taken during the same shoot), a more practical approach is to adjust subsets of the grouping. For instance, you could apply a settings preset or some Basic tab adjustments to one photo (say, to correct the white balance and exposure), apply those settings to most or all of the other photos, then select incrementally smaller numbers of photos and apply more targeted or specialty adjustments.

To synchronize the Camera Raw settings among multiple photos:

- 1. In Bridge, select two or more photo thumbnails, preferably ones that were shot under the same lighting conditions and that require the same kind of correction (for the most accurate and consistent corrections, select all raw files or all JPEG files). Double-click one of the selected thumbnails.
- 2. In the filmstrip panel on the left side of the Camera Raw dialog, click one of the thumbnails. A
- 3. Make the needed adjustments to the selected image (including cropping, if you want to crop all the images in exactly the same way). You can apply adjustments via the tabs or tools or by clicking a preset in the Presets tab.
- 4. Click Select All at the top of the filmstrip panel or Ctrl-click/Cmd-click the thumbnails to which you want to apply corrections, then click Synchronize.
- 5. The Synchronize dialog opens (it looks like the Save Settings dialog, which is shown on page 92). Check only the settings you want to apply to all the selected thumbnails; or choose a category from the Synchronize menu, then remove or add any check marks. Click OK.
- To cycle through the photos in the filmstrip panel, click the left or right arrowhead below the preview (in the lower right). If more than one thumbnail is selected, Camera Raw will cycle among only the selected photos.

A We opened four photos into Camera Raw. The thumbnails for the images display in the filmstrip panel on the left side of the dialog.

WHERE CR SETTINGS ARE SAVED

Depending on the current setting on the Save Image Settings In menu in the Camera Raw Preferences dialog (Ctrl-K/Cmd-K), settings for raw photos (not JPEGs) are saved either in the internal Camera Raw Database on your system or as hidden Sidecar .xmp Files in the same folder as the raw files. Don't confuse these files with the user-settings files that you create via the Save Settings command.

Converting, opening, and saving Camera Raw files

Still with us? At long last, you get to open your Camera Raw file into Photoshop.

To open a photo from Camera Raw into Photoshop:

- 1. After applying adjustments to your photo in Camera Raw, click Open Image; or if you opened and corrected multiple files, select them on the left side of the dialog, then click Open Images.
- 2. The photo appears as the Background in a new Photoshop document (or documents). Save the file(s) in the Photoshop (PSD) format. Note: If Open in Photoshop as Smart Objects is checked in the Workflow Options dialog (see step 10 on page 58), the Open Image button is labeled Open Object and a photo opens as a Smart Object in a new Photoshop document. To learn about Smart Objects, see pages 264-275 (to edit the Camera Raw settings of a Smart Object, see page 268). If the workflow option is off, you can convert the Open Image button to Open Object by hold-
- To close the Camera Raw dialog without opening your file, but save your settings to the file as instructions, click Done. The settings will redisplay if you reopen the file in Camera Raw.

ARCHIVING PHOTOS AS DNG FILES

ing down Shift.

Photographs capture unrepeatable moments, and archiving them is both a priority and a concern for photographers. Ideally, there would be one standard file format for digital photos that photographers could depend on with confidence, knowing their photos will be stable and accessible for the foreseeable future. At the present time, each camera maker uses a unique, proprietary format for their raw files. Should a maker discontinue its format, raw photos from their cameras might become unreadable by Photoshop or other image-editing applications.

Luckily, DNG (short for Digital Negative), a format developed by Adobe, preserves all the raw, unprocessed pixel information that is recorded by the camera. The coding for the DNG format is nonproprietary (open standard), meaning that it is accessible to all interested companies. DNG may be the long-term solution that photographers will eventually come to rely on — provided it is adopted as the standard by a majority of camera and software manufacturers.

If desired, you can open a copy of a Camera Raw file with its current (custom) settings into Photoshop without changing the settings in the original raw or JPEG file.

To open a copy of a Camera Raw file:

In the Camera Raw dialog, hold down Alt/Option and click Open Copy (Open Image or Open Object becomes Open Copy).

Settings in the Workflow Options dialog are assigned automatically to all photos that you open into Camera Raw (see pages 58-60). If you want to convert and save a copy of an individual photo in the Digital Negative (DNG), JPEG, TIFF, or Photoshop (PSD) format using custom file naming, format, color space, sizing, or sharpening settings instead, use the Save Options dialog, as described below. New Color Space, Image Sizing, and Preset features, found in the Workflow Options dialog, are also available in the Save Options dialog.*

When you save a copy of a photo in the Digital Negative format via Save Options, the Camera Raw settings it inherits from the original file remain accessible and editable in Camera Raw. See also the sidebar on this page.

When you save a photo in the JPEG, TIFF, or PSD format via Save Options, the Camera Raw settings are applied to the copy of the photo permanently. Although you can open and edit the resulting JPEG or TIFF file in Camera Raw, you will see that the sliders are reset to their default values. PSD files can't be opened into Camera Raw.

Note: Settings that you choose in the Save Options dialog are independent of — and have no effect on the settings in the Workflow Options dialog.

To save a copy of a Camera Raw file in the DNG, JPEG, TIFF, or PSD format:

- 1. Open and adjust a photo in Camera Raw, then in the lower-left corner of the dialog, click Save
- 2. The Save Options dialog opens (A, next page). For the **Destination**, choose Save in Same Location or Save in New Location. For the latter, choose a location in the Select Destination Folder dialog, then click Select.

Continued on the following page

- 3. Under File Naming, choose a naming or numbering convention from the menu or enter a file name. If desired, you can also choose an additional naming or numbering convention from the adjacent menu.
- 4. Choose a Format of Digital Negative, JPEG, TIFF, or Photoshop, then choose related options. For instance, if you cropped the photo in Camera Raw and then choose the Photoshop format here, you will need to decide whether to check Preserve Cropped Pixels.
- 5. For a photo in the JPEG, TIFF, or Photoshop format, choose an option from the Metadata menu to control what metadata will be saved with the file. And via the Remove Location Info check box, control whether you want location information for the file to be preserved.
- 6. For a photo in the JPEG, TIFF, or Photoshop format, you can choose options under Color Space, * Image Sizing, * and Output Sharpening. For Color Space, see step 3 on page 58; for Image Sizing, see page 60; and for Output Sharpening, see step 9 on page 58.
- 7. Optional: To save the current dialog settings as a preset for future use on any photo, from the Preset menu, * choose New Save Options Preset. In the dialog, enter a name, then click OK.
- 8. Click Save. A copy of the file appears in the designated location. The original file, with its current settings, remains open in Camera Raw.
- User-created presets are available on the Preset menu. Once you choose a preset, the menu also provides Delete [preset name] and Rename [preset name] commands.
- When you assign a color space and an intent to a photo via the Workflow Options dialog, those settings display as a soft proof in the main Camera Raw dialog, whereas when you choose color space and an intent options in the Save Options dialog, no soft proof displays.

A In the Save Options dialog, choose Destination, File Naming, Format, Color Space, Image Sizing, and Output Sharpening settings.

Now that you know how to create and open documents, you're ready to customize the Photoshop workspace for your needs. In this chapter, you'll learn how to use the main features of the Photoshop interface, such as the Application frame and document tabs. You'll change the zoom level and screen mode, rotate the canvas view, configure the panels, choose a workspace, save custom workspaces, and use the Options bar. Note: The individual panels (including the Tools panel) are described and illustrated in the next chapter.

ENABLE OPENGL FOR THIS CHAPTER

To use the OpenGL features in Photoshop, such as Animated and Scrubby Zoom (see page 101), flick panning (see page 102), and the Rotate View tool (see page 103), your system must contain a video driver or card that provides OpenGL acceleration, and in Photoshop, Use Graphics Processor must be enabled in Edit/Photoshop > Preferences > Performance. If the preference option isn't checked, check it, then close and reopen your document.

Using the Application frame

In Windows, all the Photoshop features are housed in an Application window. It contains a menu bar and Options bar along the top; panels (including the Tools panel); and any open documents, which by default are docked as tabs. A

Continued on the following page

Menu bar

Options bar

This is the onscreen environment for Photoshop in Windows.

IN THIS CHAPTER

Using the Application frame 97
Tiling multiple documents
Changing the zoom level
Rotating the canvas view
Changing the screen mode104
Choosing a workspace104
Configuring the panels
Saving custom workspaces108
Resetting workspaces
Using the Options bar

The Application frame in the Mac OS serves the same purpose as the Application window in Windows: It holds the Options bar (see page 110), panels, and open documents (which are docked as tabs). A Although the Application frame is an optional feature in the Mac OS, there are good reasons for using it. It keeps all the Photoshop features neatly organized and readily accessible (and hides Desktop clutter!). If the frame is hidden, choose Window > Application Frame. We use and refer to it throughout this book.

Note: For the sake of simplicity, we also refer to the Windows application window generically as the "Application frame."

- To resize the Application frame, drag an edge or a corner.
- To minimize the Application frame and any tabbed documents in the Mac OS, click the Minimize button in the upper-left corner; in Windows, click the Minimize button in the upper-right corner.

The document tab lists the file name, file format, current zoom level, current layer if the file contains layers, color mode, and bit depth. An asterisk indicates that the file contains unsaved changes. To close a document, click the X.

Use the Options bar to choose settings for the current tool.

Store open panels in one or more docks. To save space, you can collapse any dock to icons (see page 106).

A This is the Application frame in the Mac OS.

We recommend docking all open document windows as tabs (the default setting for Photoshop) rather than floating them as separate windows outside the frame (the only option in early versions of Photoshop). With documents docked as tabs, you will be able to keep the documents you're not working on out of view but readily accessible. To display a document that is docked as a tab, simply click the tab.

If documents aren't docking as tabs automatically, we recommend resetting the preference so that they do.

To set a preference to have documents open as tabs:

- 1. Choose Edit/Photoshop > Preferences, then click Interface on the left to display that pane.
- 2. Check Open Documents as Tabs, then click OK.

If you inadvertently (or out of curiosity) drag a document out of the tab area, and thereby turn a tabbed document into a floating one, follow these instructions to bring it home.

To dock floating document windows as tabs:

Do either of the following:

To dock one floating document window manually, drag its title bar to the tab area (just below the Options bar) of the Application frame, and release when the blue drop zone border appears. A-B

To dock all floating documents as tabs via a command, choose Window > Arrange > Consolidate All to Tabs; or if at least one document is docked as a tab, right-click a tab and choose Consolidate All to Here from the context menu.

- To cycle among all currently open documents, press Ctrl-Tab/Control-Tab or Ctrl-~ (tilde)/Cmd-~.
- One of the drawbacks to floating document windows when using the Application frame is that if you click in the frame, your floating documents will be hidden behind it. If you insist on floating your documents, consider at least docking them together by dragging the title bar of one window just below the title bar of another.

A To dock a floating document window as a tab manually, drag its title bar to the tab area of the Application frame and release the mouse when the blue drop zone border appears.

B Our document is now docked within the Application frame.

Tiling multiple documents

If you need to view or edit multiple documents simultaneously, you can arrange them in a preset layout, such as two documents side by side or in a vertical format, or four or six documents in a grid.

To tile multiple documents:

- From the Window > Arrange submenu, choose a tiling command, such as 2-Up Vertical or 4-Up.A The availability of commands will vary depending on how many documents are open.
 - ➤ To resize a window, drag either the bar between two windows or the lower-right corner. To reduce the number of visible windows by one, drag the tab of a document to the tab of another document, and release when the blue drop zone border appears.
- When you're ready to view just one document at a time, do either of the following:
 Choose Window > Arrange > Consolidate All to Tabs.

- Right-click a tab and choose **Consolidate All to Here** from the context menu.
- If any open documents are floating when you choose a tiling command, they will be docked as tabs automatically.

ONE IMAGE, TWO WINDOWS

To display the current document in a duplicate (tabbed) window, we recommend closing any other open documents first, then choose Window > Arrange > New Window for [document name]. To show both windows, choose a Tile All or 2-Up option from the Window > Arrange submenu. In this setup, you could choose an option on the View > Proof Colors submenu for one of the documents and not the other, or display the documents at different zoom levels.

 $oldsymbol{\mathbb{A}}$ To arrange these tabbed documents in quadrants, we chose 4-Up on the Window > Arrange submenu.

Changing the zoom level

You can easily switch between displaying the entire live canvas area of an image in the document window and magnifying just part of the image to concentrate on a small detail. The current zoom level percentage is listed in three locations: on the document tab, in the lower-left corner of the document window, and on the Navigator panel (if showing).

Note: For smoother and more continuous zooming, in Edit/Photoshop > Preferences > General, check Animated Zoom. Also, to use both the Animated Zoom and Scrubby Zoom features, Use Graphics Processor must be checked in Preferences > Performance. For more Zoom preferences, see page 458.

To change the zoom level with the Zoom

- 1. Choose the **Zoom** tool, or to spring-load the Zoom tool (select it temporarily) if another tool is selected, hold down Z.
- 2. Do one of the following:

Check Scrubby Zoom on the Options bar, then in the image, drag to the right to zoom in A or to the left to zoom out.

Click and hold (don't drag) in the image to zoom in, or hold down Alt/Option and click and hold to zoom out. This is the Animated Zoom feature, also known as bird's-eye zooming.

Click in the image to zoom in, or hold down Alt/ Option and click to zoom out.

Right-click in the image and choose a zoom option from the context menu, or click one of these buttons on the Options bar: 100%; Fit

Screen to display the entire image at the largest size that can fit in the window; or Fill Screen to have the image completely fill the window (only part of the image may be visible).

The View > 100% and View > 200% commands are new; View > Actual Pixels is gone.

A VIEW FOR USERS OF RETINA DISPLAYS

For more accurate rendering on a retina display, Photoshop draws interface elements at twice their normal size (this is because a retina display has double the pixel density of a nonretina display). To view "actual pixels" in your image on a retina display, choose View > 200% (double the zoom level of 100%).

SHORTCUTS FOR ZOOMING IN AND OUT

	Windows	Mac OS
Zoom in via the keyboard	Ctrl-+ (plus)	Cmd-+ (plus)
Zoom out via the keyboard	Ctrl(minus)	Cmd (minus)
Zoom in manually	Ctrl-Spacebar click or drag	Cmd-Spacebar click or drag
Zoom out manually	Alt-Spacebar click or drag	Option- Spacebar click or drag
Fit on Screen	Ctrl-0 (zero)	Cmd-0 (zero)
100% view	Ctrl-1	Cmd-1

Note: The zoom shortcuts also can be used when some Photoshop dialogs are open.

A With the Zoom tool, and with Scrubby Zoom checked on the Options bar, we're dragging to the right to zoom in.

The Navigator panel has two functions. You can use it to change the zoom level of an image or to reposition the image in the document window (to bring an area you want to edit or examine into view).

To change the zoom level or reposition the image in the window via the Navigator panel:

- 1. Display the Navigator panel.
- 2. To change the zoom level, in the Navigator panel, do any of the following:

Ctrl-drag/Cmd-drag across part of the image thumbnail to target that area for magnification. Double-click the existing value in the zoom field, type the desired percentage, then press Enter/

type the desired percentage, then press Enter/ Return. Or to zoom to a value and rehighlight the field, enter the desired value, then press Shift-Enter/Shift-Return.

Drag the Zoom slider.

Click the Zoom Out or Zoom In button.

- **3.** If the image is magnified to the degree that areas are hidden outside the document window, you can reposition it by dragging the view box on the panel.
- You can also change the zoom level by entering a percentage in the Zoom Level field in the lower-left corner of the document window.

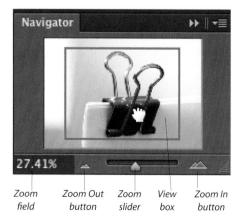

A You can use the Navigator panel to change the zoom level of your document and, if the image is magnified, to move it in the document window.

A magnified image can also be moved in the document window by using the Hand tool.

To reposition a magnified image with the Hand tool:

Do one of the following:

Choose the **Hand** tool (H) or hold down the Spacebar for a temporary Hand tool, then drag in the document window.

Choose the Hand tool (H) or hold down the Spacebar for a temporary Hand tool, do a quick little drag in the document, then release. The image will float across the screen (this is called "flick panning"); click again to stop the motion. Note: For this to work, Use Graphics Processor must be checked in Edit/Photoshop > Preferences > Performance before you open your document and Enable Flick Panning must be checked in Preferences > General.

To access the Hand tool temporarily if you have another tool selected, hold down the **H** key, press the mouse to display a wireframe view box, drag the view box over the area of the image you want to show, then release the mouse.

- If a document is in a tabbed window in the Application frame and is magnified, you can overscroll it — that is, drag it far off to the side (farther than you can drag an image in a floating window).
- You can also move a magnified image in the document window by dragging the scroll bar at the right and/or bottom edge of the window.

MATCHING THE ZOOM LEVEL, LOCATION, OR ROTATION AMONG MULTIPLE DOCUMENTS

If you have multiple documents open in Photoshop, from the Window > Arrange submenu, you can choose Match Zoom to match the zoom level of all open images to that of the currently active image, Match Location to match the relative positions of all open and magnified images within the document window to that of the current one, Match Rotation to match the canvas angle of all open images to that of the current one (the angle is produced by the Rotate View tool; see the next page), or Match All to do all of the above.

If you have multiple documents open (say, in a 2-Up or 3-Up layout), you can save time by scrolling or zooming all of them simultaneously.

To scroll or zoom in multiple document windows:

- 1. Open two or more documents, then on the Window > Arrange submenu, choose a Tile command or a 2-Up, 3-Up, 4-Up, 5-Up, or 6-Up command.
- 2. When using the Hand tool (H), check Scroll All Windows on the Options bar; or when using the **Zoom** tool, a check Zoom All Windows on the Options bar. Alternatively, when using either tool, you can leave the above-mentioned options unchecked and enable them temporarily by holding down Shift.

A With the Rotate View tool, we're dragging to tilt the canvas to the desired angle.

Rotating the canvas view

Unlike the Image > Image Rotation commands, which rotate an image permanently, the Rotate View tool tilts the canvas temporarily so you can draw, paint, or perform other edits at a more comfortable angle.

Note: To use the Rotate View tool, Use Graphics Processor must be checked in Edit/Photoshop > Preferences > Performance. If the preference is off, check it, then reopen the document.

To rotate the canvas view:

- 1. Change the zoom level, if necessary, so the entire image is showing in the document window.
- 2. Choose the Rotate View tool (R) or hold down R to spring-load the tool, then drag in the image (a compass displays temporarily).
- When the Rotate View tool is selected, you can also change the rotation angle on the Option bar (use the scrubby slider, or enter a value, or move the dial.

To reset the canvas view to the default angle:

- 1. Choose the **Rotate View** tool (R) or hold down R to spring-load the tool.
- 2. On the Options bar, click Reset View.

Changing the screen mode

The three screen modes control which Photoshop interface features display onscreen.

To change the screen mode:

Press F to cycle through the screen modes, or choose a mode from the Screen Mode menu 🖳 at the bottom of the Tools panel: A

Standard Screen Mode (the default mode) to display the full Photoshop interface, including the Application frame, Photoshop menu bar, Options bar, current document, document tabs, and panels — with the Desktop (and any other open application windows) visible outside it.

Full Screen Mode with Menu Bar to display the current document on a full-screen background with all of the above-mentioned interface features showing, but with the Application frame, document tabs, Desktop, and other windows hidden.B

Full Screen Mode to display only the current document on a full-screen background with all the Photoshop interface features hidden and the panels visible only upon rollover (see "To make hidden panel docks reappear" on the next page).

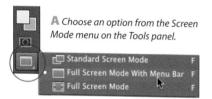

Choosing a workspace

To change your panel setup quickly, choose one of the predefined workspaces, which are designed for different kinds of tasks, or choose a user-defined workspace (see pages 108–109).

To choose a workspace:

From the Workspace menu on the right side of the Options bar C or from the Window > Workspace submenu, choose a predefined workspace, such as Essentials (Default), What's New, Painting, Photography, or Typography, or a userdefined workspace.

CUSTOMIZING THE BACKGROUND

- To quickly change the background shade around the canvas area for the current screen mode, rightclick the background, then on the context menu, choose default, Black, or a shade of gray. Although you could choose Select Custom Color (then choose a custom color via the Color Picker), we recommend sticking with neutral gray or black because it provides the best setting for judging color and tonal adjustments.
- ► In the Interface panel of the Edit/Photoshop > Preferences dialog, for the canvas area in each of the three screen modes, you can choose a background color or shade and a border style of Line, Drop Shadow, or None (see page 460).

f B When performing color correction work, we use the screen mode option of Full Screen Mode with Menu Bar.

We're choosing a workspace from the Workspace menu on the Options bar.

Configuring the panels

If you have chosen Standard Screen Mode or Full Screen Mode with Menu Bar and you want to fully maximize your screen space, you can hide all your open panels (see the shortcuts below) and make them reappear only when needed (see the next task). If you put your document into Full Screen mode, in which panels are hidden by default, you can also use these shortcuts to show the panels and keep them visible.

To hide (or show) the panels:

Do either of the following:

Press Tab to hide (or show) all the currently open panels, including the Tools panel.

Press Shift-Tab to hide (or show) all the currently open panels except the Tools panel.

To open an individual panel when the panels are hidden, choose the panel name from the Window menu.

To make hidden panel docks reappear:

- 1. Hide the panels as described above, or choose Full Screen Mode from the Screen Mode menu 🖳 on the Tools panel.
- 2. If your document is in Standard Screen mode, let the pointer hover over the dark gray vertical bar at the left or right edge of the Application frame. If your document is in either one of the Full Screen modes, let the pointer hover at the edge of your monitor; the dark gray vertical bar appears, then the docks appear. A

The panel docks will redisplay temporarily (freestanding panels will remain hidden). B Move the pointer away from the panels, and they'll disappear again.

Note: If this mechanism doesn't appear to be working, right-click any panel tab or icon and check Auto-Show Hidden Panels on the context menu. That should do the trick.

If you prefer to keep your panels visible onscreen, but you want to minimize how much space they occupy, shrink them to icons (see the last paragraph on the next page).

A If the panels are hidden, let the pointer pause just inside the right edge of the monitor or Application frame...

 $f B \ldots$ to make the panel docks appear temporarily. (Move the pointer away from the panels, and away they go.)

Most of the edits that you make in Photoshop will require the use of at least one of the panels — and more likely several. Fortunately, the panels are easy to hide, collapse, and expand so they don't intrude on your document space when you're not using them.

In the predefined workspaces, panels are arranged in docks on the right side of your screen, except for the Tools panel, which is on the left side. Each dock can hold one or more panels or panel groups, and you can customize how they're configured. (To save your custom workspaces, see pages 108-109.)

To reconfigure the panel groups and docks:

Show or hide a panel: Show a panel by choosing its name from the Window menu. The panel will display either in its default group and dock or in its last open location. To bring a panel to the front within its group, click its tab (panel name).

Expand a panel that's collapsed to an icon: Click the icon or panel name. If Auto-Collapse Iconic Panels is checked in Edit/Photoshop > Preferences > Interface and you open a panel from an icon, it collapses to an icon when you click outside it. With this preference off, the panel stays expanded; to collapse it back to an icon, click the Collapse to Icons button M on the panel bar (the horizontal gray bar to the right of the panel tab) or click the panel icon in the dock.

To quickly access the Auto-Collapse Iconic Panels option via a context menu, right-click any panel tab, bar, or icon.

Maximize or minimize an expanded panel or group vertically (to toggle the full panel to just a panel tab, or vice versa): Double-click the panel tab or bar.

Use a panel menu: Click the **see** icon to access the menu for the panel that is currently in front in its group.

Close a panel or group: To close a panel, right-click the panel tab and choose Close from the context menu. To close a whole panel group, choose Close Tab Group from the same context menu. To close a floating panel, you can click the close button in the upper-left corner.

Collapse a whole dock to icons, or to icons with names: Click the Collapse to Icons button Mat the top of the dock; or double-click the topmost bar; A-B or right-click a panel tab, bar, or icon and choose Collapse to Icons from the context menu. To expand icons to icons with names, or to reduce icons with names to just icons, drag the vertical edge of the dock horizontally.

A In this workspace, panels in the left dock are collapsed to icons, whereas the panels in the right dock are expanded. The Histogram panel is minimized vertically. We are doubleclicking the bar for the rightmost dock ...

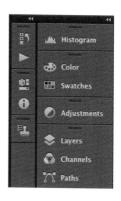

C Here we're dragging the edge of the rightmost dock to shrink that dock to just icons.

Widen or narrow a dock (and panels): Position the pointer over the vertical edge of the dock (+++ cursor), then drag horizontally.

Move a panel into a different group: Drag the panel tab over the panel bar of the desired group, and release when the blue drop zone border appears.

Move a panel to a different slot in the same group: Drag the panel tab (name) to the left or right.

Move a panel group upward or downward in a dock: Drag the panel bar, then release it when the horizontal blue drop zone bar appears in the desired location.

Create a new dock: Drag a panel tab or bar sideways to the vertical edge of the dock, and release the mouse when the blue vertical drop zone bar appears.

Reconfigure a dock that's collapsed to icons: Use methods like those you would use for an expanded group. Drag the double dotted line to the edge of a dock to create a new dock, or drag it vertically between groups to restack the group (release when the horizontal drop zone line appears), or drag it into another group to move it to that group (release when the blue drop zone border appears).

Float a docked panel or group: Drag the panel tab, icon, or bar out of the dock. To stack floating panels or groups together, drag the bar of one to the bottom of another (release when the horizontal blue drop zone line appears). To resize a floating panel, drag an edge or the resize box; not all panels are resizable.

To redock floating panels into the Application frame: If there is no existing dock, create one by dragging the topmost panel bar of a floating group or stack to the right edge of the Application frame, and release the mouse when the pointer is over the edge of the frame and a vertical blue drop zone line appears. If there is an existing dock, follow the instruction in "Create a new dock," above, or drag the panel bar of a floating panel, group, or stack into an existing dock (release when the horizontal blue drop zone line appears).

- To prevent a floating panel from docking as you move it, drag it with Ctrl/Cmd held down.
- When using a tool that uses brushes, you can show the Brush panel by clicking the Toggle Brush Panel button won the Options bar or on the Brush Presets panel. Similarly, when using a type tool, you can show the Character/Paragraph panel group by clicking this toggle button 🗐 on the Options bar.

A blue drop zone border appears as we drag a panel into a different group.

B A blue horizontal drop zone bar appears as we move our Layers/Channels panel group upward within the same dock.

C A blue vertical drop zone bar appears as we create a new dock for the History panel.

Saving custom workspaces

Now that you have learned how to personalize your workspace for Photoshop, the next step is to save some custom workspaces for various kinds of editing work you do in Photoshop. Your custom workspaces should reflect your normal work habits (and by this we don't mean working late and sleeping late!). For example, to set up a type-related workspace, you could open the Character, Paragraph, Paragraph Styles, and Character Styles panels, hide the panels you don't normally use when you work with type, and assign color labels to your favorite commands on the Type menu.

The current panel locations are included automatically when you save a custom workspace. Optionally, you can also include custom keyboard shortcuts and/ or menu sets (menu sets control the color label and visibility settings for menu commands).

To save a custom workspace:

1. Do any or all of the following:

Open and position all the desired panels in groups and docks.A

Collapse the panels you use occasionally to icons, and close the ones you rarely use. Or if you prefer to keep all your panels collapsed to icons or icons with names, set them up that way.

Resize any of the panels, as well as any of the pickers that open from the Options bar.

Choose Edit > Menus (Ctrl-Alt-Shift-M/Cmd-Option-Shift-M) and use the dialog to assign visibility settings and/or color labels to menu commands (for quick identification). Save your changes in a new menu set. (To learn about customizing the Photoshop keyboard shortcuts, see Photoshop

- 2. From the Workspace menu on the Options bar, choose New Workspace.
- 3. In the New Workspace dialog, enter a Name for the workspace (include your name, if desired). B
- 4. Under Capture, if you customized the Keyboard Shortcuts or the Menus, check those options.
- 5. Click Save. Your workspace will appear at the top of the Workspace menu on the Options bar (A, next page) and on the Window > Workspace submenu.
- To edit a saved workspace, display the workspace to be edited, make the desired changes to the

A This is the panel setup in one of our custom workspaces.

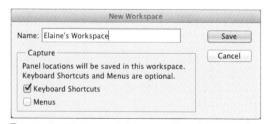

B In the New Workspace dialog, enter a Name for your workspace and check either or both of the Capture options.

Photoshop interface, choose the New Workspace command, retype the same name, click Save, then click Yes in the alert dialog.

- If you have dual displays, you can distribute freestanding panel groups or stacks between them and save that arrangement as a new workspace.
- All the panels that are open when you exit/quit Photoshop will display in the same location upon relaunch.

To delete a workspace:

- 1. From the Workspace menu on the Options bar, choose any workspace except the one you want to delete.
- 2. From the same menu, choose Delete Workspace.
- 3. In the Delete Workspace dialog, choose the name of the workspace to be deleted, B click Delete, then click Yes in the alert dialog.
- To restore all the default workspaces, see the last task on this page.

Resetting workspaces

Say you chose a workspace and then rearranged some panels manually. If you were to switch to another workspace and then back to your original one, your manual changes would redisplay (in other words, the manual changes are "sticky"). Perform the first task below to restore the original settings to an individual workspace, or the second task to restore the factory-default settings to all the predefined (non-user-defined) workspaces.

To reset the current workspace:

From the Workspace menu on the Options bar, choose Reset [workspace name].

To reset all non-user-defined workspaces:

- 1. To open the Interface pane of the Preferences dialog, right-click any panel tab, bar, or icon and choose Interface Options from the context menu.
- 2. Under Options, click Restore Default Workspaces. If an alert dialog appears, click OK, then click OK to exit the Preferences dialog.

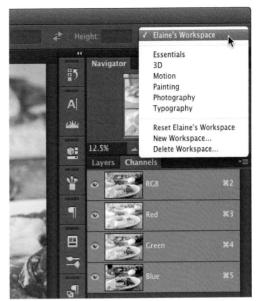

A Our new workspace (named "Elaine's Workspace") appeared on the Workspace menu on the Options bar.

B In the Delete Workspace dialog, choose the user-saved workspace you want to get rid of.

Using the Options bar

If the Options bar is hidden and you want to show it, choose Window > Options. You will use this bar primarily to choose settings for the current tool. For instance, for the Clone Stamp tool, you can choose a brush; a blending mode; opacity, flow, alignment, and sampling settings; and settings for a stylus, if you're using one. For a type tool, you can choose a font family, style, and size; anti-aliasing and alignment settings; and a color. The current Options bar settings remain in effect for each individual tool until you change them.

To open a picker, which displays one or more libraries of presets (e.g., brushes or gradients), click the picker icon or arrowhead. A To close a preset picker or other pop-up panel, either click outside it or click the arrowhead on the Options bar.

To cancel a value you have entered on the Options bar and exit the bar, press Esc (this also works for some pickers).

Features on the Options bar change depending on what tool is selected and the way it is being used in the document. For instance, if you begin to apply a transformation with the Move tool, Cancel Transform and Commit Transform buttons will appear on the Options bar. If you click either button to exit transformation mode, those buttons will disappear.

The Workspace menu (not shown below) is located on the right side of the Options bar; see pages 104 and 108–109.

Note that some tool settings can also — or only — be chosen in a panel or dialog. For instance, for the type tools, you will find additional options on the Character and Paragraph panels; for the Brush or Pencil tool, you will need to choose a Foreground color via the Color panel, Swatches panel, or Color Picker.

Click here to open the Tool Preset picker.

A Click an icon or arrowhead to open a preset picker (the Brush Preset picker is shown here).

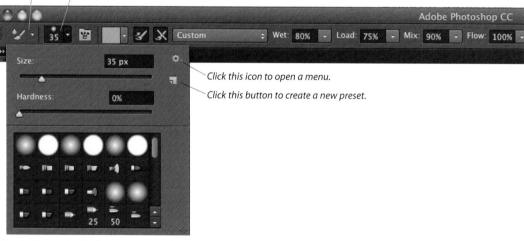

Here the Options bar is displaying settings for the Mixer Brush tool.

You will accomplish most of your editing work in Photoshop using the panels, which are the focus of this chapter, as well as via the Options bar and various editing tools. To open a panel, choose the panel name from the Window menu. To become a Photoshop speed demon, avoid using the menu bar except to choose commands that aren't available elsewhere in the interface.

In the preceding chapter, you learned how to arrange the panels onscreen (see pages 106–107). Here you will learn more about their specific functions. After a quick view of the panel icons and instructions for using the Tools panel, you will find illustrations and a brief summary (in alphabetical order) of all the panels that are used in this book. You can browse through our descriptions with or without viewing or fiddling with the panels onscreen. Later, as you become more acquainted with Photoshop, you can revisit this chapter and use it as a reference guide. (This chapter is just an introduction to the panels. In other chapters, you will find detailed instructions for using specific panels, and you will put them to lots of practical use.)

Also included in this chapter is a primer on choosing basic brush settings — steps that apply to many tools in Photoshop, not just the Brush tool. The final section of this chapter includes steps for managing and saving presets (predefined settings), which are stored and accessed via the many Photoshop panels and pickers. Some examples of presets are solid colors on the Swatches panel, styles on the Styles panel, and shapes on the Custom Shape picker.

LISTING THE LINDO SHORTCUTS

	Windows	Mac OS
Undo the last Photoshop edit (some edits can't be undone)	Ctrl-Z or Edit > Undo [name of edit]	Cmd-Z or Edit > Undo [name of edit]
Undo multiple editing steps in reverse order (Step Backward)	Ctrl-Alt-Z	Cmd-Option-Z
Step Forward through your editing steps (reinstate what you have undone)	Ctrl-Shift-Z	Cmd-Shift-Z

6

IN THIS CHAPTER

The Photoshop panel icons
The Photoshop panels that are used in this book113
Choosing basic brush settings 128
Managing presets via the pickers and panels130
Exporting and importing presets 132
Using the Preset Manager
Creating tool presets

The Photoshop panel icons

Each panel in Photoshop has a unique icon that displays when the panel is either fully or partially collapsed. Until you learn to identify collapsed panels by their icons, you may want to keep your panel docks only partially collapsed (so the names display) rather than fully collapsed to just icons. A You can also identify the panels via Tool Tips (see the sidebar at right).

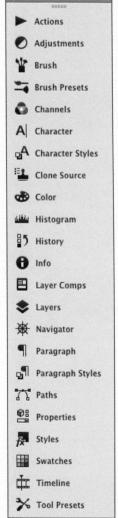

A Eventually, you will be able to quickly identify the panels by their icons.

USING CONTEXT MENUS

When you right-click in the document window depending on where you click and which tool is selected — a menu of context-sensitive commands pops up onscreen temporarily. Context menus are also available for some features of the Photoshop interface. such as the Layers panel. If a command is available on a context menu (or can be executed quickly via a keyboard shortcut), we let you know in our instructions to spare you from a trek to the main menu bar.

Note: If your mouse doesn't have a right-click button, hold down Control and click to open the context menu. If you're using a Trackpad on a Mac, you can tap with two fingers.

This is the context menu for a selection.

USING TOOL TIPS

If you need to identify a panel, button, icon, or menu in the Photoshop interface, you can find the information you need via the Tool Tip: Let the pointer hover over a feature without clicking the mouse button, and the item name pops up onscreen. Not happening? Go to Edit/Photoshop > Preferences > Interface, and check Show Tool Tips.

This Tool Tip is listing a tool name and shortcut.

This Tool Tip is identifying a panel.

The Photoshop panels that are used in this book*

Using the Tools panel

To display the Tools panel if it's hidden, choose Window > Tools (the panel is illustrated on the next three pages). To select a tool, do one of the following:

- If the desired tool is visible on the Tools panel, iust click it.
- To cycle through related tools in the same slot, hold down Alt/Option and click the visible one.
- To choose a hidden tool, click and hold on the visible tool, then click a tool on the menu.
- To select a tool quickly, press its designated letter shortcut (don't do this if your cursor is inserted in type). The shortcuts are shown on the next three pages, as well as in the Tool Tips. If the Use Shift Key for Tool Switch option is unchecked in Edit/Photoshop > Preferences > General, you can simply press the designated letter to cycle through related tools in the same slot (e.g., press L to cycle through the three lasso tools). If the Preferences option is checked, you have to press Shift plus the designated letter (e.g., Shift-L).
- To spring-load (access) a tool temporarily while another tool is selected, press and hold down its assigned letter key. See the sidebar on this page.

To see information pertaining to the current tool (called a tool hint), look at the bottom of the Info panel. If you don't see the tool hint, choose Panel Options from the Info panel menu (upper-right corner of the panel), then check Show Tool Hints (see page 122).

Before using a tool that you've selected, you need to choose settings for it on the Options bar. For example, for the Brush tool, you would choose a brush preset, as well as size, hardness, blending mode, and opacity settings. If the Options bar is hidden, show it by choosing Window > Options (see page 110).

The current Options bar settings for a specific tool remain in effect until you change them, reset that tool, or reset all tools. To restore the default settings to the current tool, right-click the thumbnail for the Tool Preset picker (located at the left end of the Options bar) and choose Reset Tool from the context menu. A To restore the default settings to all tools (including their default order on the fly-out menus in the Tools panel *, choose Reset All Tools from the same menu, then click OK in the alert dialog.

In Edit/Photoshop > Preferences > Cursors, you can control whether the pointer displays as a crosshair, as the icon of the current tool or, for some tools, as a circle either the size or half the size of the current brush diameter, with or without a crosshair inside it (see page 466).

For editing tools — such as the Brush, Pencil, Clone Stamp, Pattern Stamp, History Brush, Art History Brush, Blur, Sharpen, Smudge, Dodge, and Burn tools —you can choose from hundreds of brush tips, and you can also change many brush characteristics, such as size, hardness, and opacity (see pages 128-129).

A To access these two commands, riaht-click the Tool Preset picker thumbnail, which is located at the left end of the Options bar.

SPRING-LOADING A TOOL

- ➤ To quickly access a tool and its current Options bar settings temporarily without having to actually click the tool on the Tools panel, hold down its letter shortcut key. For example, say the Brush tool is selected but you want to reposition the contents of a layer, which requires using the Move tool. You would hold down the V key, drag in the document window, then release the V; the Brush tool will be reselected automatically. To access the Zoom tool temporarily, you would hold down the Z key.
- Spring-loading is slightly less efficient if you need to access a tool that shares a slot with other tools (as most tools do). In this case, the letter shortcut selects whichever tool happens to be visible on the Tools panel. To make this work, you need to plan ahead and select the tools that you want to switch back and forth between before using them.

^{*}The 3D tools, and the 3D, Measurement Log, and Notes panels aren't covered in this book, so they are not discussed in this chapter.

Tools panel

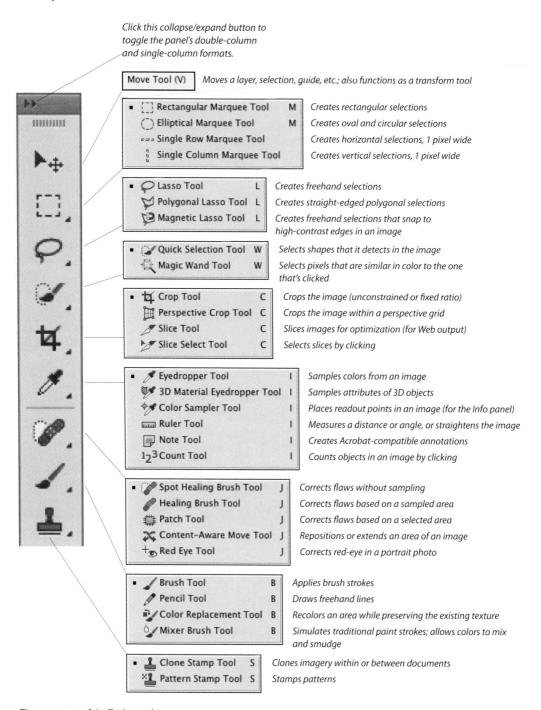

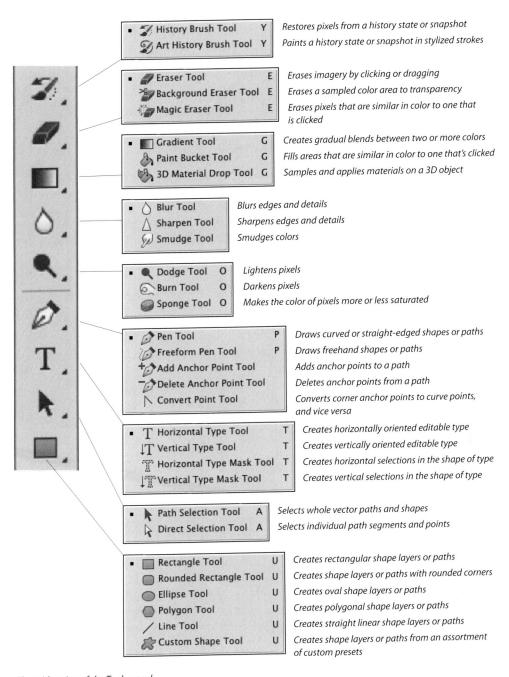

The midsection of the Tools panel

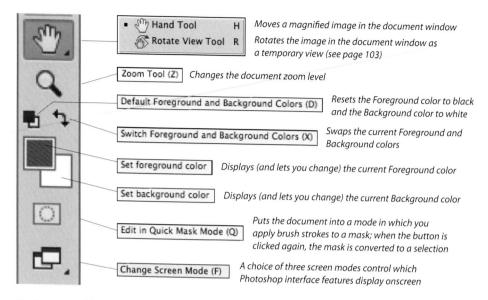

The lower part of the Tools panel

Actions panel

An action is a recorded sequence of commands that can be replayed on one image or on a batch of images. For instance, you could use an action to save a copy of a document (or multiple documents) in a different format or color mode, or to apply filters for a special effect, such as to add a texture or a frame. Using the Actions panel, you can record, store, edit, play, delete, save, and load actions. See Chapter 22.

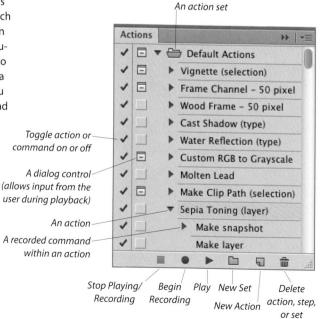

Adjustments panel

Each button on the Adjustments panel produces a different kind of adjustment layer, which you can use to apply flexible color and tonal edits and corrections to an image (the buttons are identified on page 222). Adjustment layers are listed on the Layers panel, but you choose and edit settings for them on the Properties panel. See Chapter 12.

9

Open

Preset

Manager

Live Tip

Brush

Preview

Brush stroke

preview

New

Brush

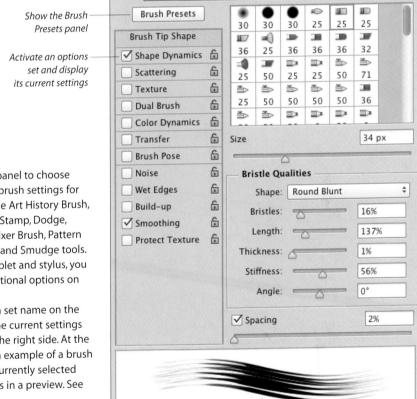

Brush

Brush panel ٌ

You will use the Brush panel to choose brush tips and custom brush settings for editing tools, such as the Art History Brush, Blur, Brush, Burn, Clone Stamp, Dodge, Eraser, History Brush, Mixer Brush, Pattern Stamp, Pencil, Sharpen, and Smudge tools. If you use a graphics tablet and stylus, you will have access to additional options on this panel.

If you click an option set name on the left side of the panel, the current settings for that set display on the right side. At the bottom of the panel, an example of a brush stroke made with the currently selected tip and settings displays in a preview. See Chapter 14.

Note: You can open this panel in several different ways: by choosing the panel name from the Window menu; by clicking the Toggle Brush Panel button 🐨 on the Brush Presets panel; or if a tool that uses brushes is selected, by clicking the Toggle Brush Panel button **a** on the Options bar.

Brush Presets panel

Use the Brush Presets panel to store, display, and choose from an assortment of predefined and user-created brush presets (tips and settings), for use with various editing tools. You can also use this panel to change the size of any brush preset temporarily, and to save any brush that you have customized as a new preset.

Via buttons at the bottom of the panel, you can show or hide the Live Tip Brush Preview, and also access the Preset Manager dialog. This panel can be opened from the Window menu or by clicking the Brush Presets button on the Brush panel. See page 295.

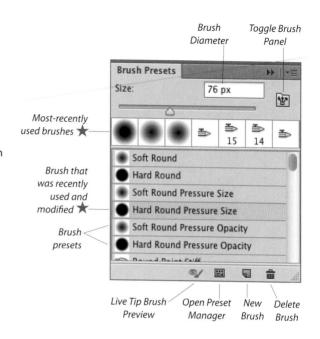

Channels panel

The Channels panel lists and displays thumbnails for all the color channels in the current document. To show a single channel in your document, click the channel name or press the keystroke that is listed on the panel. To redisplay the composite image (all the channels combined, such as RGB or CMYK), click the topmost channel on the panel or press Ctrl-2/Cmd-2. See pages 2–4.

You can also use this panel to save and load alpha channels, which are saved selections (see page 182). And you can use it to create and store spot color channels, which are printed from separate plates by a commercial shop using mixed ink colors (such as PANTONE PLUS colors).

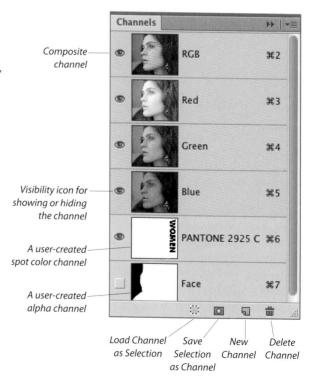

Character panel A

To choose attributes for a type tool, or to change the attributes of existing type, you can use the Character panel, which is shown here, or the Options bar (see page 370). Open this panel (or the Paragraph panel) from the Type or Window menu, or when a type tool is selected, by clicking the Toggle Character and Paragraph Panels button 🗐 on the Options bar. See Chapter 19.

Character Styles panel

With type styles, you can format and style your text more efficiently than by choosing individual type attributes, as well as ensure that your type has a consistent look throughout a document and among related documents. When you edit a style, all the type in which the style is being used updates automatically.

Use character styles to apply unique attributes (e.g., a boldface font style, larger size, or different color) in order to accentuate key characters or phrases. Using the Character Styles panel, you can create and edit character styles and apply them to your text. See pages 381-383. Note: We recommend styling paragraphs via the Paragraph Styles panel before applying character styles.

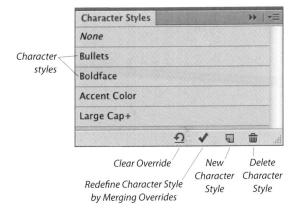

The Clone Source panel lets you keep track of up to five different source documents when cloning image pixels with the Clone Stamp tool. The sources are represented by a row of buttons at the top of the panel. You can also use this panel to hide, show, and control the opacity and mode of the clone overlay, and flip, scale, rotate, invert, or reposition the source pixels before or as you clone them. See pages 282–283.

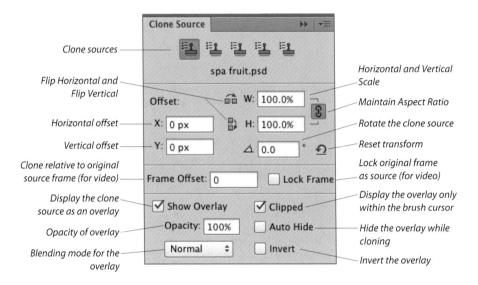

Color panel 🚳

There are several ways to choose colors in Photoshop, including via the Color panel. After selecting a color model from the panel menu, you can mix a color via the sliders or quick-select a color by clicking in the ramp at the bottom of the panel (other methods are described on page 206). Colors are applied to an image by various tools (e.g., the Brush or Pencil tool) and commands (e.g., Image > Canvas Size).

To open the Color Picker (or interchangeably, the Color Libraries dialog), in which you can also choose a color, click once on the Foreground Color or Background Color square on the Color panel if it's already selected (has an outer white border), or double-click the square if it's not selected. See also pages 203–206.

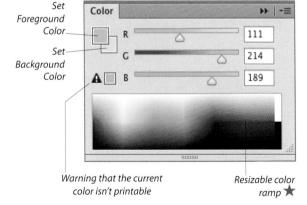

Histogram panel

On the Histogram panel, you can view a graph of the distribution of tonal (light and dark) values in the current image, and compare them with modified tonal values as you apply color and tonal adjustments.

Via the Channel menu, you can opt to have the panel display data for the composite channel (all the channels combined, as shown at right) or for just a single channel. Via the panel menu, you can also expand the panel to display a separate histogram for each channel. See pages 228-229.

> Source of the pixel data (all layers or just the currently selected layer)

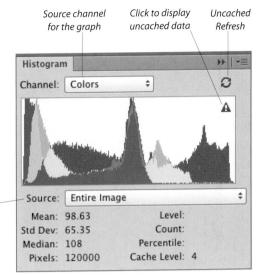

History panel

Each edit that you make to a document during the current work session (e.g., the use of a filter, tool, or command; the creation of a shape, type, or image layer; the application of a layer or layer comp) is listed as a separate state on the History panel, from the "Open" unedited state of the document at the top to the most recent state at the bottom. The most recent (last) edit keeps changing as you edit your document. If you click a prior state, the document is restored to that stage of editing. See Chapter 10.

The oldest history states are deleted from the panel as new edits are made — that is, when the maximum number of history states is reached (as specified in the History States field in Edit/ Photoshop > Preferences > Performance). All states are deleted when you close your document.

The New Snapshot command creates states that remain on the panel until you close your document, regardless of the current History States preference setting or the number of edits you apply.

You can use the History Brush tool to restore areas of an image by hand, after designating a state or snapshot as a source in the History panel (see pages 301-302).

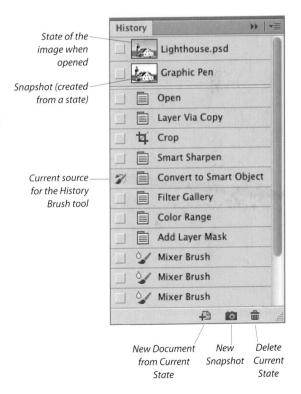

Info panel 0

The Info panel provides up-to-the-minute data about your document. For example, it displays a color breakdown of the pixel under the pointer at its current location. As you apply color corrections, the panel displays the post-edit percentages, too. If you need yet more color data, you can place up to four color samplers in your document, and the Info panel will display readouts for those locations. The panel also lists the current coordinates of the pointer on the x/y axes.

Additional data may display on the Info panel depending on which tool is being used, such as the angle (A) and distance (L) between points as you use the Ruler tool; the dimensions (W and H) of a rectangular or elliptical selection or of a crop box; or the width (W), height (H), angle (A), and horizontal skew (H) or vertical skew (V) values of a layer or selection as you apply a transform edit.

Press a mini arrowhead for a color readout on the panel to choose a color model (it can differ from the current document color mode). If you prefer to do this via a dialog, choose Panel Options from the panel menu, then select a Mode for the First Color Readout and the Second Color Readout (see the dialog below).

In the Info Panel Options dialog, you can also choose Ruler Units for Photoshop (including the rulers in the document window), check which categories of Status Information you want Photoshop to display in the lower part of the panel, and check Show Tool Hints to have the panel display helpful tips about the current tool. Alternatively, you can choose a unit of measurement for Photoshop via the menu in the X and Y area on the Info panel.

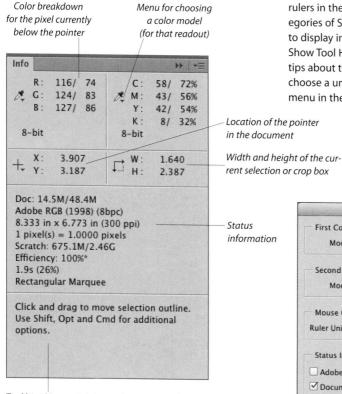

Use the Info Panel Options dialog to control which features display on the panel.

CHOOSING VALUES IN PHOTOSHOP

For a quick way to change numerical values on the Options bar, on some panels (such as the Layers and Character panels), and in some dialogs, use the scrubby slider: Drag slightly to the left or right across the option name or icon.

➤ To access a pop-up slider (e.g., to choose an Opacity percentage on the Layers panel), click the arrowhead. To close a slider, click anywhere outside it or press Enter/Return. Tip: If you click an arrowhead to open a slider, you can press Esc to close it and restore its last setting.

- > To change a value incrementally, click in a field in a dialog or panel (such as on the Character panel), then press the up or down arrow key on the keyboard.
- After typing a value in a field, you can press Tab to accept your edit (and highlight the value in the next field, if any) without exiting the dialog or panel.

Layer Comps panel

When you create a layer comp (short for "composition"), it includes, collectively, any of the following document characteristics: the current layer Visibility settings (which layers are showing and which are not), the Position of imagery on each layer, and the layer Appearance (layer styles, including the layer blending mode and opacity settings, and any layer effects). You can decide which document attributes will be included in a comp, as well as add explanatory comments for the viewer. Layer comps save with the document in which they're created.

Laver comps are useful if you're weighing the pros and cons of multiple versions of a document or if you need to present versions to a client for review. For example, say you've created a few designs for a book cover. You could create a layer comp of each one (e.g., the image with and without type, or with type in two different colors). When presenting your concepts, instead of having to open and close each separate file, you could simply display each version of the same file by clicking an individual Layer Comp icon. See pages 446-448.

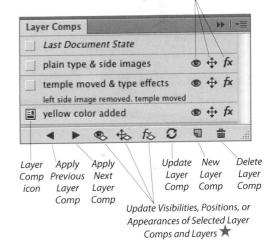

Layers panel 🕏

At minimum, every document in Photoshop contains either a solid-color Background or a transparent layer. Above that, you can add various kinds of layers:

- Image layers contain pixel imagery, such as a digital photo or paint strokes. See Chapter 8.
- Adjustment layers apply editable and removable adjustments to underlying layers. See Chapter 12.
- Fill layers apply an editable color, gradient, or pattern to underlying layers. See pages 211–213.
- ➤ A Smart Object can be created by converting an existing Photoshop layer, or by placing an Illustrator or PDF file, another Photoshop file, or a Camera Raw file into a Photoshop document. See pages 264–275.

- Editable type layers are created by the Horizontal Type or Vertical Type tool. See pages 370–371.
- ➤ Shape layers are produced by a shape tool, and contain vector shapes. See Chapter 21.

Using the Layers panel, you can create, hide, show, duplicate, restack, group, link, lock, merge, flatten, and delete layers. You can also use this panel to change the blending mode, opacity, or fill opacity of a layer; attach a mask to a layer; and apply layer effects. Via the Filter Type menu and buttons at the top of the panel, you can control which layers are listed.

You'll be using this panel in every work session!

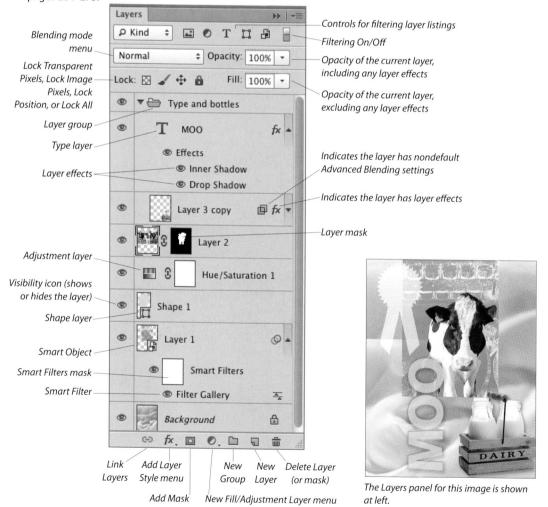

Navigator panel **

Using the Navigator panel, you can change the document zoom level, magnify a specific area of your document, or move a magnified document in the window. See page 102. (For other ways to zoom or move an image in the window, see pages 101-103.)

Paragraph panel

For paragraph type, you can use the Paragraph panel to apply paragraph-level settings, including alignment, indentation, spacing before, spacing after, and automatic hyphenation. Via the panel menu, you can access other type formatting commands (such as hanging punctuation and line-composer options), and open the Justification and Hyphenation dialogs. See page 380.

Paragraph Styles panel

Using paragraph styles, you can format and style whole paragraphs of text more efficiently than if you were to choose individual settings, and also ensure that your type styling is consistent. When you edit a style, all the type in which the style is being used updates automatically. Use the Paragraph Styles panel to create, edit, and apply paragraphlevel styles. See pages 381-383.

Paths panel 77

The Paths panel is used for storing and accessing paths — vector shapes that are drawn with the Pen tool, Freeform Pen tool, or a shape tool. Also use this panel to apply a fill or stroke to a path, create a path from a selection, load a path as a selection, or access the path of a shape layer. See pages 418-419, 423, and 425-426.

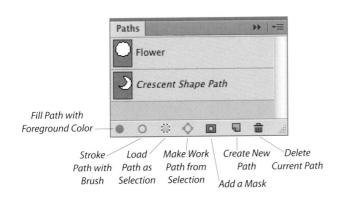

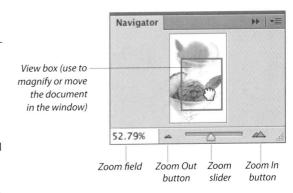

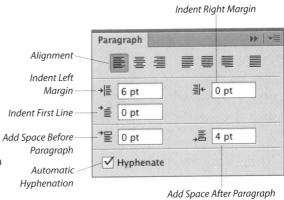

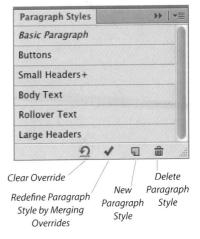

Properties panel 🕮

Adjustment layer options

Tonal and color corrections that you apply directly to a layer via any of the Image > Adjustments submenu commands are permanent, whereas corrections that you apply to underlying layers via an adjustment layer remain editable and reversible.

To create an adjustment layer, you can use either the Adjustments panel or the New Fill/Adjustment menu on the Layers panel. To choose and edit adjustment settings, you use the sliders and fields on the Properties panel (the options are different for each kind of adjustment layer). Via buttons on the Properties panel, you can clip (limit) the adjustment effect to just the underlying layer, view the previous state of the adjustment, restore the default settings, hide and show the current adjustment effect, or delete the current adjustment layer. See Chapter 12.

Mask options

In Photoshop, the black areas in a mask hide areas of a layer. A mask is created for every adjustment layer, fill layer, and Smart Filter automatically, but you can add a mask to other kinds of layers, such as to an image layer.

When you click a layer that contains a mask and then click the Select Filter Mask, Select Layer Mask, or Select Vector Mask button on the Properties panel, or click a mask thumbnail on the Layers panel, options for editing the mask appear on the Properties panel.

The nondestructive controls on the Properties panel include a Density slider for setting the overall opacity of a layer mask and a Feather slider for softening the edges of the mask. The Mask Edge button opens the Refine Mask dialog, which provides controls for refining a mask (the controls are the same as for the Refine Edge dialog; see pages 182–183). The Color Range button opens the Color Range dialog, which you can use to redefine the black and white areas in the mask. The Invert button swaps the black and white areas in the mask. Via other buttons on this panel, you can load a mask as a selection, apply a mask to a layer permanently, disable or enable the mask, or delete the mask.

For layer and vector masks, see pages 190–194; for vector masks, see also pages 414–417; for filter masks, see pages 362–364.

Other uses for the Properties panel

You can also use the Properties panel to access commands and info for a linked Smart Object (see pages 271–275), ★ or to change the properties of a shape layer (see pages 407–409 and 413).

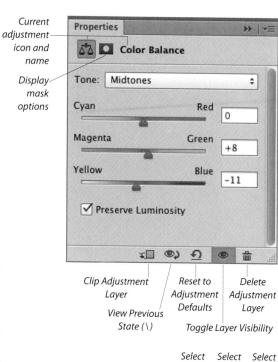

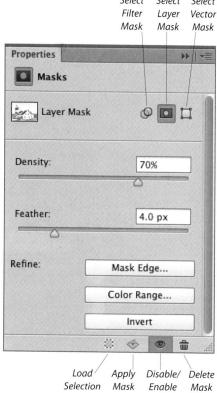

from Mask

Mask

Styles panel &

In Photoshop, a style is a collection of specific layer settings. A style may include the settings for layer effects (e.g., Drop Shadow, Outer Glow) and/or the settings for blending options (e.g., layer opacity and blending mode). In addition to using the Styles panel to apply a style to a layer, you can also use it to create custom styles, to be applied in any document. Via commands on the panel menu, you can save, load, and replace style libraries, which are collections of styles. See pages 400-401.

Swatches panel

The Swatches panel stores predefined and userdefined solid-color swatches, which are applied by various tools, filters, and commands. Via commands on the panel menu, you can save, load, and replace libraries of swatches. See page 207.

Timeline panel

Using the Timeline panel, you can compose a sequence of audio clips and video files (including files from a DSLR camera that captures digital video). Imported clips display as tracks on the Timeline. Using the panel, you can alter the duration of a clip, apply a filter or adjustment effect to all or part of a clip, apply transition effects, and finally, render a group of tracks into a choice of video file formats. See pages 449-456.

Tool Presets panel 🔀

A tool preset is a collection of settings for a particular tool that has been saved to, and can be accessed from, the Tool Presets panel. By using this panel (or the Tool Preset picker, which opens from the Options bar), you can create, save, load, sort, rename, reset, and delete presets for any Photoshop tool. See page 134.

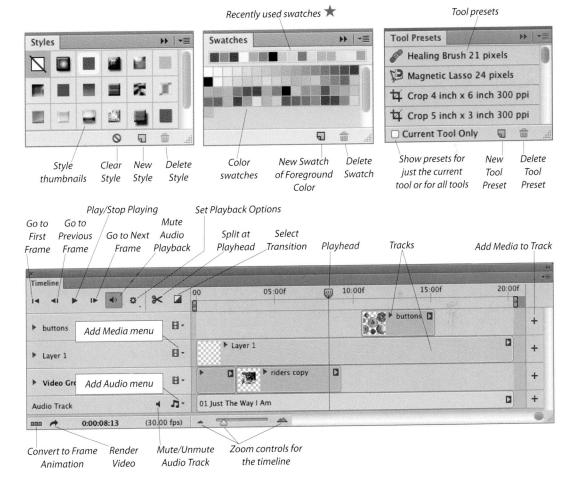

Choosing basic brush settings

Brush settings (e.g., size, hardness, and opacity), apply to many Photoshop tools, such as the Brush, Pencil, Mixer Brush, Clone Stamp, History Brush, Sharpen, Dodge, Burn, and Eraser. The image-editing tool we use most often is the Brush — but not necessarily in the way that you might expect. We use it to edit the pixels in a layer mask, and sometimes to apply paint.

When you're using a tool for any purpose besides painting, the only values that you typically need to set are the brush size, hardness, and opacity. The current brush settings for a tool remain in effect until you choose a different preset for that tool. (In Chapter 14, you will learn many other ways to customize a brush. To learn how to manage brush presets via the Brush Presets panel, see page 295.)

Below are the steps for choosing a Soft Round or Hard Round brush tip and basic settings — steps that you will be requested to do in many tasks in this book.

To choose basic brush settings:

- Choose an editing tool from the second grouping of tools on the Tools panel. Tools that use brush presets include the Brush, Pencil, Mixer Brush, Clone Stamp, Pattern Stamp, History Brush, Art History Brush, Eraser, Sharpen, and Smudge tools.
- 2. Right-click in the image to display the Brush Preset picker. You can also access the picker by clicking the Brush Preset arrowhead or thumbnail on the Options bar, which is located at the top of the Application frame (Window > Options). Note: You must use the bar to choose a preset for some tools, such as the Spot Healing Brush, Healing Brush, Color Replacement, and Background Eraser.
- 3. Do the following:

Click a brush tip that is labeled Soft Round or Hard Round (if those tips are available). (To load another library of brush tips onto the Brush Presets panel, see pages 131 and 133.)

Set the Size value.A

Optional: Change the Hardness (or Spacing) value. Optional: Change the Roundness value by dragging the small dot on the circle **B** and/or adjust the Angle value by dragging the arrowhead.

Press Enter/Return to exit the picker.

To choose other settings for a tool, such as an opacity value, use the Options bar. To choose a color for a tool (if applicable), see Chapter 11.

A We right-clicked in the image to display the Brush Preset picker, clicked a Soft Round preset in the scrolling window, and are setting the brush size via the scrubby slider.

B Here we're changing the brush roundness.

IDENTIFYING THE TYPES OF BRUSH PRESETS

Below are the basic icons (or examples of them) that you will see on the Brush Preset picker. They are also found on the Brush and Brush Presets panels.

You can also change the brush size, hardness, or opacity by dragging in the image.

Note: For the tasks below, to have the current brush values (e.g., Diameter, Hardness, Opacity) display in a label as you adjust a brush interactively, go to Edit/ Photoshop > Preferences > Interface, then from the Show Transformation Values menu, choose a location option for the readout.

To change the brush size interactively:

- 1. Choose a tool that uses brush presets (see step 1 on the preceding page).
- 2. Choose a brush tip.
- 3. Press [or] or hold down Alt-right-click/Control-Option and drag horizontally in the image.
- To choose preferences for cursors, such as whether the tool icon or a crosshair displays in the pointer and whether the brush diameter displays as a full or half-size black circle, see page 466.
- You can also change the Size value for a tool on the Brush panel Tor the Brush Presets panel.

To change the brush hardness or opacity interactively:

- 1. Go to Edit/Photoshop > Preferences > General, and check Vary Round Brush Hardness Based on **HUD Vertical Movement** to allow the shortcut to be used in step 3, below, change the hardness of a round brush tip, or uncheck this option to have the shortcut change the opacity of any tip.
 - In the Interface panel of the same dialog, make sure the Show Transformation Values menu is set to any option except Never.
 - And finally, to display the hardness or opacity value within the cursor as a tint (for round brush tips only), show the Performance panel of the Preferences dialog and make sure Use Graphics Processor is checked (if it's not, check it, then close and reopen your document after clicking OK). Click OK.
- 2. Choose the Brush, Pencil, Color Replacement, Clone Stamp, Pattern Stamp, History Brush, Art History Brush, Background Eraser, Blur, Sharpen, Smudge, Dodge, or Burn tool.
- 3. Hold down Alt-right-click/Control-Option and drag vertically in the image. Note: For the Eraser tool, you can change only the hardness value.

A With Alt-right-click/Control-Option held down, we're dragging horizontally in the image to change the brush size (to change the brush hardness or opacity, depending on the current preference setting, drag vertically instead).

BRUSH DIAMETER, OPACITY, AND HARDNESS

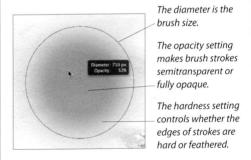

SHORTCUTS FOR CHANGING TOOL SETTINGS

One or both of the shortcuts listed below apply to image-editing tools, such as the Healing Brush, Brush, Pencil, Clone Stamp, History Brush, Sharpen, Dodge, and Burn tools.

Cycle through blending modes for the tool	Shift- + (plus) or Shift (minus)
Change the opacity, exposure, or strength percentage (or Shift- press a number to change the Flow level)*	Press a digit between 0 and 9 (e.g., 2 = 20%) or quickly type a percentage (e.g., "38"); 0 = 100%

*If the Airbrush button is activated on the Options bar, press a number to change the Flow percentage or Shift-press a number to change the opacity.

Managing presets via the pickers and panels

Photoshop presets are predefined items that you choose from a picker, such as brushes on the Brush Presets panel or picker and swatches on the Swatches panel. Other presets are found in less obvious locations, such as on the Contour pickers in some panels of the Layer Style dialog and on the Gradient picker in the Gradient Fill dialog. The preset categories include brushes, swatches, gradients, styles, patterns, contours, custom shapes, and tools. A collection of saved presets that can be loaded onto a picker is called a library.

New presets are created in various ways, such as when you define a pattern via the Define Pattern command, add a swatch to the Swatches panel, add a style to the Styles panel, create a gradient in the Gradient Editor dialog, or create a tool preset or brush (see the sidebar on this page).

Unsaved presets are stored in the Adobe Photoshop CC 2014 Prefs.psp file temporarily. They stay on the picker when you relaunch Photoshop, but will be discarded if you replace them with another library or restore the default library to the picker. Thankfully, you can save your custom presets as a library, either via an individual picker (see the steps on the next page) or via the Preset Manager dialog (see page 133). You can load a saved library of presets onto its related picker at any time, and you can share preset libraries with other Photoshop users.

Note: To sync your Photoshop preference settings and presets between computers via Adobe Creative Cloud, see pages 495–496.

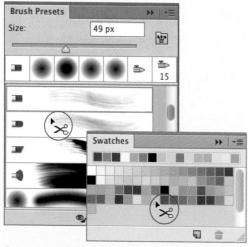

A Alt-click/Option-click a swatch to delete it.

When you use the Preset Manager to create a library, you can pick and choose which presets are included. When you create a library from a panel or a preset picker, all the presets currently on the picker are included — you can't choose only some of them. In the latter case, you should delete the presets that you want to exclude from the library first, as in the steps below.

Note: When you delete a preset from a picker or panel, no documents are altered and no existing presets are deleted from any libraries.

To delete presets from a panel or picker:

- 1. Display the picker or panel from which you want to delete presets, such as the Brush Presets panel or picker, the Custom Shape picker, or the Styles, Swatches, or Tool Presets panel.
- Do either of the following:
 Alt-click/Option-click a preset (scissors pointer).
 Right-click a preset and choose Delete [preset type]. If an alert dialog appears, click OK.

HOW ARE PRESETS CREATED?

All of the following methods will produce a preset:

- ➤ Customize a brush using the Brush panel, then click the New Brush button on the Brush or Brush Presets panel, or on the Brush Preset picker, which opens from the Options bar.
- ➤ Add the current Foreground color as a swatch by clicking the New Swatch of Foreground Color button on the Swatches panel.
- ➤ Create a tool preset by clicking the New Tool Preset button on the Tool Presets panel or the Tool Preset picker (see page 134).
- ➤ Create a gradient by clicking New in the Gradient Editor, which opens if you select the Gradient tool, then click the Gradient thumbnail on the Options bar, in the Gradient Fill dialog, or in the Layer Style dialog (for a Gradient Overlay effect).
- ➤ Create a style by clicking the New Style button
 on the Styles panel or by clicking New Style in the Layer Style dialog.
- ➤ Create a pattern via Edit > Define Pattern.
- ➤ Create a custom shape by drawing a path or shape, then choosing Edit > Define Custom Shape.

To save the presets currently on a picker as a library:

- 1. Make sure the preset picker or panel contains only the presets to be saved in a library (see the preceding page).
- 2. Do one of the following:

From the Brush Presets, Swatches, Styles, or Tool Presets panel menu, or from the Brush Preset, Tool Preset, or Custom Shape picker menu, 🗱 choose Save [preset type].A

For a gradient, in the Gradient Editor, click Save; or choose Save Gradients from the Gradient picker menu 🗱 in the Gradient Fill dialog (for a Gradient fill layer) or in the Gradient picker (Options bar, with the Gradient tool chosen).

For a pattern, choose Save Patterns from the Pattern picker menu 🌣 in the Layer Style dialog for the Pattern Overlay effect, in the Edit > Fill dialog (with Pattern chosen on the Use menu), or in the Pattern Fill dialog (for a Pattern Fill layer).

- 3. In the Save dialog, enter a name, keep the default extension and location, then click Save.
- 4. Relaunch Photoshop to make your new library appear on the panel and/or preset picker menu and on the menu in the Preset Manager.
- To overwrite an existing library, in step 3 above, locate and click the library name, click Save, then click Replace in the alert dialog.

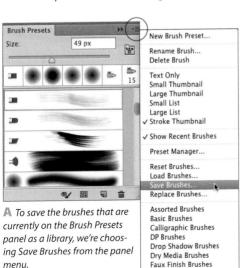

M Brushes Natural Brushes 2 Natural Brushes

To load a library of presets onto a panel or picker via an individual panel or picker, follow the steps below; to load presets via the Preset Manager, see page 133.

To load a library of presets:

1. Choose a preset library name in one of these locations:

The menu on the Brush Presets, Styles, Swatches, or Tool Presets panel.

The menu 🗱 in the Custom Shape picker on the Options bar (the Custom Shape tool must be selected first); see page 406.

The Gradient picker menu 🗱 in the Gradient Editor dialog (the Gradient tool must be selected first, then the Gradient thumbnail clicked on the Options bar); see pages 214-215.

The Gradient picker menu 🗱 in the Gradient Fill dialog for a Gradient fill layer; see pages 212-213.

The Custom Pattern picker menu 🌼 in the Edit > Fill dialog (choose Pattern from the Use menu); see page 217.

The Pattern picker menu 🗱 in the Pattern Fill dialog for a Pattern Fill layer.

The Styles, Contour, Gradient Overlay, or Pattern Overlay picker menu 🗱 in the Layer Style dialog (see pages 389–390, 396–397, and 400).

The menu 🌼 in the Tool Preset picker (see page 134) or Brush Preset picker (see page 129) on the Options bar.

- 2. In the alert dialog, click Append to add the chosen library of presets to the currents ones on the panel or picker, or click OK to replace the current presets with those in the library. Note: If the panel or picker contains unsaved presets, another alert dialog will appear, giving you the option to save the existing presets as a library. Click Don't Save or Save.
- If the library you want to load isn't in the default location (and therefore isn't listed on its related panel or picker menu), choose Load [preset name] from the menu, locate the library, then click Open.

You can restore the default library to any panel or picker.

To restore the default presets to a panel or picker:

- 1. From a panel or picker menu, choose **Reset** [preset name].
- When the alert dialog appears, click OK to replace the existing presets on the panel or picker with the default ones.

Note: If you made changes to the current presets, another alert dialog will appear. Click Don't Save; or click Save, then use the Save dialog to save the current presets as a library.

Exporting and importing presets

Using the Export/Import Presets dialog, it's easy to export and import preset libraries and share them among Photoshop users on your network.

To export preset libraries:

- 1. Choose Edit > Presets > Export/Import Presets.
- Click the Export Presets tab, then double-click each preset library you want to export A (or click a library, then click the right arrowhead >). Repeat

for any other libraries you want to export. (To remove a preset from the Presets to Export list, double-click it. To remove or add all the presets on the list, click Remove All or Add All.)

- 3. Click Export Presets.
- In the Choose a Folder dialog, choose a location, then click Open.

To import preset libraries:

- 1. Choose Edit > Presets > Export/Import Presets.
- Click the Import Presets tab, click Select Import Folder, locate and click the folder containing the desired preset library or libraries, then click Open.
- 3. Double-click each preset library you want to import. (To remove a preset from the Presets to Import list, double-click it. To remove or add all the presets on the list, click Remove All or Add All.)
- **4.** Click **Import Presets**. If an alert dialog appears, click Yes.
- To import all Photoshop CS6 presets into Photoshop CC (from both the user library and the Presets folder in the program folder), choose Edit > Presets > Migrate Presets, then click Yes in the alert dialog. You don't need to restart your system.

A In the Export/Import Presets dialog, we doubleclicked each selected library we wanted to export. (Our next step will be to click Export Presets.)

Using the Preset Manager

Using the all-inclusive Preset Manager dialog, you can save and load Photoshop presets of any variety.

To save presets as a library via the Preset Manager:

1. To open the Preset Manager, do one of the following:

Choose Edit > Presets > Preset Manager.

Choose Preset Manager from the menu of any picker or panel (e.g., the Custom Shape picker or the Swatches or Styles panel).

On the Brush or Brush Presets panel, click the Open Preset Manager button.

- 2. From the Preset Type menu, choose the category of presets for which you want to create a library, or press the shortcut that is listed on the menu.
- 3. From the menu in the dialog, 🗫 choose a view option for the scrolling window (such as Small Thumbnail or Small List). For Brushes, you can choose Stroke Thumbnail view to display a sample of the brush stroke alongside each thumbnail.
- 4. Shift-click or Ctrl-click/Cmd-click the presets to be saved in a library, then click Save Set. A
- 5. In the Save dialog, enter a name for the new library, keep the default extension and location, then click Save.
- 6. Click Done to exit the Preset Manager.
- 7. Relaunch Photoshop.
- To rename a preset when the Preset Manager is in a thumbnail view, double-click the thumbnail, then change the name in the dialog. If the Preset Manager is in a text-only or list view, double-click the preset name. You can also select multiple presets and then click Rename, in which case each naming dialog will open in succession.

You can reset any category of presets to the factory defaults, append (add) more presets to the current ones on the picker or panel, or replace the current presets with those in a library. Presets on the pickers and panels remain there when you relaunch Photoshop. Changes made in the Preset Manager appear in the corresponding picker, and vice versa.

To load presets via the Preset Manager:

- 1. Open the Preset Manager by following step 1 in the instructions at left.
- 2. From the Preset Type menu, choose a category of presets.
- 3. Any unsaved presets on the chosen picker will be deleted in the next step, unless you select the Append option in that step. To save the current presets as a library before proceeding, follow steps 4-5 at left.
- 4. From the menu in the dialog, . choose a library name; or to reload the default library, choose Reset [preset type]. In the alert dialog, click Append to add the new library to the current ones on the picker, or click OK to replace the current presets with the newly loaded ones. If the picker contains any unsaved presets (you didn't save them in a library), another alert will appear. Click Don't Save or Save.
- **5.** Optional: To delete presets from the picker (but not from the library), click a preset to be deleted or Shift-click or Ctrl-click/Cmd-click multiple presets, then click Delete. This can't be undone (but of course you can reload any library).
- 6. Click Done to exit the Preset Manager.

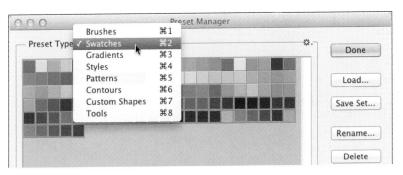

A In the Preset Manager dialog, choose a category from the Preset Type menu, select all the presets to be saved in a library, then click Save Set.

Creating tool presets

For any tool, you can choose a preset (such as a brush), Options bar settings, and a Foreground color (if applicable), then save that collection of settings as a tool preset. Thereafter, upon selecting that tool, you can simply choose your preset from the Tool Preset picker on the Options bar or from the Tool Presets panel; it contains all your saved settings. Although tool presets take some time to set up initially, it's time well spent.

To acquaint yourself with the Tool Presets panel. show it, then uncheck Current Tool Only. The tool presets for all tools display. Click a tool preset; the tool with which that preset is used becomes selected automatically. Check Current Tool Only; only presets for the current tool display. Via the panel or picker menu, you can load additional presets (see page 131).

To create a tool preset:

- 1. Select a tool and choose Options bar settings for it. For some tools, such as the brush and shape tools, the current Foreground color can be included in the preset; for the Gradient tool, you can include the currently selected gradient. If you opt to do this, choose that color or gradient now.
- 2. Do either of the following:

At the far left end of the Options bar, click the Tool Preset picker thumbnail or arrowhead. Show the Tool Presets panel. B

- 3. Click the New Tool Preset button on the picker or panel. The New Tool Preset dialog opens.
- 4. Optional: Rename the preset, if desired.
- 5. Optional: Check Include Color or Include Gradient (if that option is present).
- 6. Click OK. The new preset appears on the Tool Preset picker and the Tool Presets panel.
- 7. The presets that are on the Tool Presets panel (for all tools) will still be there when you relaunch Photoshop, but will disappear if you replace them with a library. To preserve your custom presets for future use, see the first task on page 131.
- To restore the default tool presets, follow the steps on page 132. Don't confuse the Reset All Tools command with the Reset Tool Presets command.
- To create a variation of an existing tool preset, click a preset, choose custom settings for it, then follow steps 3-6, above, making sure to rename it in step 4.

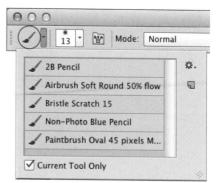

A To open the Tool Preset picker, click the thumbnail or arrowhead on the Options bar.

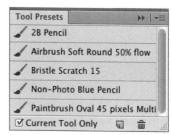

B Tool presets can also be created via the Tool Presets panel.

SOME SUGGESTIONS FOR TOOL PRESETS

Take note of which tools you use most often, and which settings you normally choose for them. Here are a few ideas for custom presets:

- Brush panel settings, Options bar settings, and a Foreground color for the Brush tool or Mixer Brush tool (for the latter tool, remember to choose a combination of Wet, Load, and Mix settings)
- Options bar settings for the Crop tool
- ➤ Character panel and Options bar settings for the Horizontal Type or Vertical Type tool, including a type color
- Oft-used Options bar settings for healing tools, such as the Healing Brush and Spot Healing Brush tools, or for the Clone Stamp or Sharpen tool
- Oft-used settings for the selection tools (e.g., Fixed Ratio values for the Rectangular Marquee tool)
- Options bar settings for the Gradient tool, with the "Black, White" gradient preset chosen

Before applying adjustment commands or other edits to an image in Photoshop, you need to make sure it has the proper resolution and dimensions. At any point, you can also crop or rotate it. In this chapter, you will learn how to change the resolution, dimensions, and canvas size of a file, and how to crop, straighten, flip, and rotate it.

Changing the document resolution and/or dimensions

In this chapter, you will encounter three related terms:

- ➤ The pixel count (pixel dimensions) of a file is arrived at by multiplying its pixel height and width values (as in 3000 x 2000 pixels equals 6 megapixels).
- ➤ The resolution (or "res," for short) of a file the fineness of detail is measured in pixels per inch, or ppi (as in 250 or 300 ppi).
- ➤ The process of changing a file's pixel count (adding or deleting pixels) is called "resampling." More specifically, the process of adding pixels is called "upscaling," and the process of deleting pixels is called "downsampling."

Some input devices (e.g., digital cameras that capture 10 megapixels of data or more, as well as high-end scanners) produce files with a higher pixel count than is necessary for most standard printing devices. If your Photoshop file falls into that category, you will be able to resize it via the Image Size dialog without having to resample it. Because its pixel count remains the same, its image quality is preserved.

If your file contains too low a pixel count for your target output device, you will need to resize it with resampling via the Image Size dialog. As you increase its resolution or dimensions, its pixel count and storage size will also increase. Although resampling is sometimes necessary, it reduces the image sharpness. For print output, this is a concern, but it can be compensated for somewhat by applying a sharpening filter afterward (see pages 334–338). Resampling is not a concern for Web output.

Using the Image Size dialog (and its large preview), we'll show you how to resize a file for print output without resampling, how to upscale a file for print output, and how to downsample a file for print or Web output.

IN THIS CHAPTER

Changing the document resolution
and/or dimensions
Changing the canvas size
Cropping an image
Cropping multiple images 144
Straightening a crooked image 147
Flipping or rotating an image 148

PIXELS

Pixels, short for "picture elements," are the building blocks that make up a digital image—the tiny individual dots that a digital camera uses to capture a scene or that a computer uses to display images onscreen. When working in Photoshop and for Web output, you'll need to be aware of the pixel dimensions, or pixel count, of an image. For print output, you'll need to be aware of its resolution.

When setting the proper resolution of an image for print output, you need to decide whether to permit resampling. For a digital photo that is shot with a digital SLR camera, the ideal scenario of no resampling is possible because it contains a sufficient number of pixels for high-quality output. However, such a photo will initially have a low resolution (usually 72 to 180 ppi) and very large width and height dimensions, so you will need to increase its resolution to the required value, as in these steps. Photos from a 16-megapixel camera can be output as high-quality prints up to 16 x 11, and photos from a 12-megapixel camera can be output as high-quality prints up to 14×9 .

To change the resolution of an image for print output (no resampling):

- 1. With your photo open in Photoshop, choose Image > Image Size (Ctrl-Alt-I/Cmd-Option-I). The Image Size dialog opens.
- 2. Optional: To enlarge the dialog and preview, drag any side or corner. You can Ctrl-click/Cmd-click in the preview to zoom in, or Alt-click/Option-click it to zoom out, or roll over the preview and click the - or + button. To bring a different area of a magnified image into view, either drag in the preview or click in the document.

- 3. From the menu next to the Width field, choose Inches (or a unit that is suitable for your output device); the same unit will be chosen automatically for the Height. Note: In this new dialog interface, there is only one set of Width and Height fields.
- 4. Uncheck Resample because the image contains a sufficient number of pixels for you to increase its resolution without resampling.A
- 5. Enter a Resolution of 300. The Width and Height values will change, but the document proportions and pixel count will stay the same (A, next page).
- 6. Click OK. No pixels were eliminated from the image, so you don't need to resharpen it.

PRESERVING IMAGE SIZE SETTINGS

- ➤ The current Resample and units menu settings (and dialog size) that you choose in the Image Size dialog stick for the application until you change them.
- ➤ The Fit To menu lists preset image sizes (width, height, and resolution) in three categories: display sizes, paper sizes, and photo print sizes. To add the current dialog values as a new preset, choose Save Preset from the Fit To menu, enter a name, then click Save; the preset appears on the menu.

A In the Image Size dialog, we unchecked Resample to make the Width, Height, and Resolution values interdependent (note the lines linking the Resolution to the Width and Height).

Men we increased the resolution value to 300, the Width and Height values changed automatically, but the Dimensions remained the same. We noted in the preview that the image quality was preserved.

If a file lacks a sufficient number of pixels to produce a medium-size, good-quality print, such as an 8 x 10 (e.g., the file has both small dimensions and a resolution of 200 ppi or below), you will need to upscale it so it has the necessary pixel count, as in the steps below. (For a smaller print, see the first task on page 139 instead.)

To upscale an image for print output:

- 1. Use File > Save As to copy your file.
- 2. Choose Image > Image Size (Ctrl-Alt-I/Cmd-Option-I). The Image Size dialog opens. Follow steps 2-3 on the preceding page.
- 3. Check Resample, and from the Dimensions menu, choose Pixels. To preserve the width-toheight ratio of the image (prevent distortion), click the Constrain Aspect Ratio button **1** to activate it.
- 4. In the Resolution field, enter 300.
- 5. In the Width or Height field, enter the dimension needed for the print.
- 6. From the Resample menu, choose the method you want Photoshop to use to reassign color values to added pixels based on the values of existing pixels:

Automatic to let Photoshop choose and apply the best method.

Preserve Details (Enlargement) to improve the sharpness and detail in the enlarged image. Also increase the Noise value until any artifacts that were produced by the detail enhancement are reduced (A-C, next page).

Bicubic Smoother (Enlargement).

- In the preview, zoom to 100%, and compare the results of choosing different Resample methods. Also use this zoom level to gauge the Noise setting (if you chose the Preserve Details option).
- 7. Click OK. Because the image was resampled, the next step is to resharpen it (see pages 334-338).
- To restore all the original settings that were in effect when you opened the Image Size dialog, either choose Original Size from the Fit To menu or hold down Alt/Option and click Reset (Cancel becomes Reset).

A As indicated by the original values shown in this Image Size dialog, this photo doesn't contain enough pixels, nor a high enough resolution, to produce a large, high-quality print.

USING AUTO RESOLUTION

To let Photoshop set the resolution of a document for commercial print output, from the Fit To menu in the Image Size dialog, choose Auto Resolution. The Auto Resolution dialog opens. Enter a Screen value as the lines per inch setting (such as 133 for a typical commercial press), then click a print Quality option. When you click OK to return to the Image Size dialog, you will see that Photoshop set the Resolution value.

SCALING STYLES

If your document contains layer styles and you want to permit them to be scaled as you change the Image Size, on the menu in that dialog, ** - make sure Scale Styles is checked (see Chapter 20).

B We checked Resample, increased the Width value (the Height changed automatically), increased the Resolution value. chose the Resample method of Preserve Details (Enlargement), and set the Noise value to 60. In the preview (set to 100% view), we noted that the edges and lines were softened, such as on the ruler and graph paper.

C To resharpen the edge details, we reset the Noise value to 0.

*

*

*

Say your photo was shot with a high-megapixel camera (and therefore has a high pixel count), but you want to print it at a smaller size, such as 5" x 8". If you downsample (a copy of) it first, its data will transfer more efficiently to your printer.

To downsample a photo for a smaller print size:

- 1. Use File > Save As to copy your file, then choose Image > Image Size (Ctrl-Alt-I/Cmd-Option-I). The Image Size dialog opens. A If you want to enlarge the dialog and preview, drag any side or corner.
- 2. Check Resample, and click the Constrain Aspect Ratio button **1** to activate it.
- 3. If the Resolution value isn't 300 ppi, enter that value now.
- 4. From the Resample menu, choose Automatic (this tells Photoshop to use the best method).
- 5. From the menu next to the Width field, choose Inches, then enter the Width or Height value needed for your print.
- 6. Click OK. Because the image was resampled, you should resharpen it (see pages 334-338).

To produce a GIF, JPEG, PNG, or SVG file from a Photoshop layer for output to the Web or a mobile device, we use the Generator plug-in; see pages 489-494. It's an easy process. If you need to specify a resolution, and width or height values, for a file while downsampling it (that is, lower its pixel count to enable it to download efficiently), before using Generator to create assets from it in one of the abovementioned formats, follow the steps below.

To downsample an image for Web output:

- 1. Follow step 1 in the preceding task.
- 2. Check Resample, and to preserve the width-toheight ratio of the image (prevent it from becoming distorted), click the Constrain Aspect Ratio button **a** to activate it.
- 3. From the Resample menu, choose Automatic (this enables Photoshop to use the best method).
- 4. Enter a Resolution of 72 ppi.
- 5. From the menu next to the Width field, choose Pixels, then enter the desired Width or Height value.D
- 6. Click OK.

A These are the original settings for our high-resolution photo (note the Image Size and Dimensions values).

B We checked Resample and activated the Constrain Aspect Ratio button, then changed the Width value to 8 inches. The Image Size and Dimensions shrank accordingly.

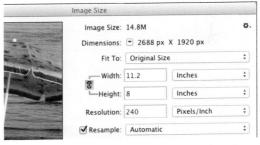

These are typical Image Size values of a digital photo that has not been resized or resampled.

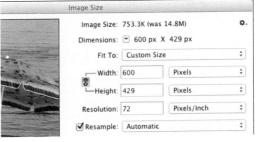

D We checked Resample, then set the Resolution to 72 and the Width to 600 pixels. The result was a much smaller image size.

Changing the canvas size

The canvas area is the live, editable part of a document. By using the Canvas Size command, you can add or delete pixels from one, two, three, or all four sides of the canvas. Adding pixels would be useful, say, if you want to make room for some type, as in the example shown here, or to accommodate imagery from other documents in a multilayer collage (see Chapter 13).

To change the canvas size of a document:

- Choose Image > Canvas Size (Ctrl-Alt-C/Cmd-Option-C). The Canvas Size dialog opens.
- 2. From the Width menu, choose a unit of measure.
- 3. Do either of the following:
 - Enter new **Width** and/or **Height** values. The dimensions work independently; changing one won't affect the other. **A-B**
 - Check **Relative**, then increase or reduce the **Width** and/or **Height** values to alter the ratio between those dimensions.
- **4.** Optional: The black dot in the center of the Anchor arrows represents the existing image area. Click

- a square to reposition the image relative to the canvas. The arrows point to where canvas area will be added or deleted.
- 5. If you're adding to the canvas, from the Canvas Extension Color menu, choose a color option for the new area. Or to choose a custom color, choose Other or click the color square next to the menu, then choose a color in the Color Picker (see pages 204–205) or by clicking in the document window. Note: If the image doesn't have a Background (take a peek at the Layers panel), this menu won't be available, and the added canvas area will be filled with transparency.
- **6.** Click OK. C If your settings made the canvas smaller, an alert dialog may appear. Click Proceed.
- To enlarge the canvas area manually with the Crop tool, see page 146. To enlarge the canvas to include all layer content, including any content that is hidden outside it, choose Image > Reveal All.

B To add canvas area to the top of this image, in the Canvas Size dialog, we increased the Height value, then clicked the bottom middle Anchor square to shift the black dot downward.

After adding pixels to the top of the canvas, we created an editable type layer.

Cropping an image

To crop an image manually:

- 1. Choose the Crop tool 4 (C or Shift-C).
- 2. Choose one of the following options, either from the Aspect Ratio (first) menu on the Options bar or from the context menu (right-click in the image):

To crop the image without constraints, on the Options bar, choose Ratio, then click Clear; or choose Clear Ratio from the context menu.

To preserve the original proportions of the document while cropping it, choose Original Ratio.

Choose a ratio preset, such as 5:7 (or enter custom width and height ratio values on the Options bar).

- 3. To preserve the cropped areas, uncheck Delete Cropped Pixels on the Options bar.
- 4. Define which part of the image you want to keep by dragging a handle or an edge of the crop box. A-B Areas outside the crop box will be covered with a tinted shield (see the next page).
 - To resize the crop box from the center, drag a handle with Alt/Option held down.
 - To preserve the current ratio (even if the ratio fields on the Options bar are blank), Shift-drag a corner handle.
- 5. Do any of the following optional steps:

To reposition the part of the image that is going to be preserved, drag inside the box.

To rotate the image in the crop box, position the cursor just outside the box, then drag in a circular direction. (To change the locus from which the image rotates, drag the reference point away from the center of the box before rotating.)

To hide, then show, the areas outside the crop box, press H.

To switch the orientation of the crop box, click the Swap Width and Height button 2 on the Options bar.

6. To accept the crop edits, double-click inside the crop box or press Enter/Return. You should resharpen the image, as you have just changed its pixel count. Note: Because you used the Crop tool with the Delete Cropped Pixels option off (step 3), the Background was converted to a layer; see the next chapter. You can drag the hidden cropped areas into view with the Move tool + (see page 257).

A We're dragging a handle on the crop box with the Ratio option chosen on the Aspect Ratio menu.

B Here we're dragging a handle on the crop box with the Original Ratio option chosen on the Aspect Ratio menu.

CLEAR, RESET, AND ORIGINAL RATIO

To clear the Width, Height (and Resolution) fields on the Options bar at any time and release the Crop tool from any ratio constraints, click the Clear button. The crop box won't change.

To restore the crop box to the edges of the canvas, reset the image rotation to the x/y axis (if it was rotated), and release the Crop tool from any ratio constraints, either click the Reset button 🗹 on the Options bar or right-click in the image and choose Reset Crop.

To restore the crop box to the original aspect ratio of the image at any time (and also clear the fields, if displaying), without restoring the box to the edges of the canvas, choose Original Ratio from the Aspect Ratio menu on the Options bar or from the context menu.

To choose preview and shield options for the Crop tool:

Choose the **Crop** tool 4 (C or Shift-C), click to open the **Crop Options** menu 5. on the Options bar, A then check any or all of these options;

Show Cropped Area (H) to display the image areas outside the crop box.

Auto Center Preview to allow the image to shift in the opposite direction as you drag a handle on the crop box.

Enable Crop Shield to display a tint over the cropped areas. From the Color menu, choose Match Canvas (the least obtrusive option); set the Opacity value for the tint; and check Auto Adjust Opacity to let the tint display in a reduced opacity while you drag to edit the crop box.

- To use the updated crop features of Photoshop, as described here, keep Use Classic Mode unchecked.
- If you crop an image nondestructively (with Delete Cropped Pixels unchecked), then reselect the Crop tool and click in the image (Show Cropped Area option checked), the cropped areas will redisplay.

The preset geometric guide lines that you can use with the Crop tool are based on timeless design principles.

To use guide lines with the Crop tool:

- 1. Choose the Crop tool (C or Shift-C).
- 2. From the Overlay menu B on the Options bar, do the following:

Choose an overlay icon/option. Your choice will display as the current menu icon.

Choose **Auto Show Overlay** to display the overlay only while the mouse button is pressed or **Always Show Overlay** to have the overlay stay visible after you click in the image with the Crop tool.

- 3. As you drag a handle of the crop box or reposition the image within it, let one or more key elements or shapes in your photo fall below a guide line (or areas within the guide lines) C-D (and A-D, next page). (When you're done using the overlay, you can hide it by choosing Auto Show Overlay or Never Show Overlay from the Overlay menu.)
- To cycle through the six guide options, choose the Crop tool, choose Always Show Overlay from the Overlay menu, click in the image, then keep pressing the letter O. To swap the orientation of the Triangle or Golden Spiral guide lines, press Shift-O.

A From the Crop Options menu, choose preview and shield options for the Crop tool.

B On the Overlay menu, click an icon and a display option.

GOLDEN RATIO

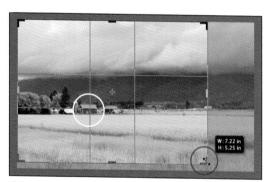

C Using the Golden Ratio option, we're positioning the horizontal guide lines at natural divisions in the landscape, and at an intersection over the red buildings. (The Rule of Thirds, a simplified form of the Golden Ratio, has equal divisions.)

This is the result.

TRIANGLE

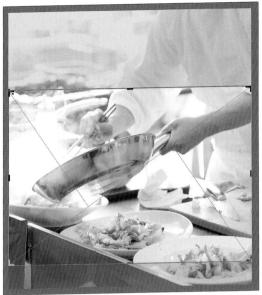

A Here we're using the Overlay option of Triangle (on the Options bar, the Aspect Ratio menu is set to Ratio). Note where key features of the photo are located within the overlay: the chef's hands and skillet in one triangle and the plates in another triangle.

B This is the result.

OVERRIDING THE SNAP

Normally, if you resize a crop box near the edge of the canvas area and the View > Snap To > Document Bounds option is on (has a check mark), the box will snap to the edge of the canvas area. If you want to position the crop box ever so slightly inside or outside the edge of the canvas, you will need to override the Snap to Document Bounds function temporarily: Start dragging one of the handles of the box, then hold down Ctrl/Control and continue to drag.

GOLDEN SPIRAL

C Using the Overlay option of Golden Spiral, we're positioning the center of the spiral over what we consider to be the key element of the photo.

D This is the result.

Cropping multiple images

Because the Crop tool keeps its current settings until you change them, you can easily apply the same aspect (width-to-height) ratio, size, or resolution values to multiple images, such as photos taken during the same shoot. In the first task below, we'll show you how to crop documents using the same aspect ratio. The dimensions of the images can vary.

To crop one or more images according to an aspect ratio:

- Open one or more images, then click in one of them. Choose the Crop tool (C or Shift-C).
- 2. Do one of the following:
 - Right-click in the image and choose **Use Front Image Aspect Ratio** from the context menu.
 - Choose a ratio preset (e.g., 5 : 7) from the **Aspect Ratio** menu on the Options bar, or enter width and height ratio values in the fields.
 - Resize the crop box, then right-click in the image and choose **Use Crop Box Aspect Ratio** from the context menu.
- 3. Values for the current document will be listed on the Options bar and will stick with the Crop tool until you change them. Size the crop box, if desired, then double-click inside the box or press Enter/Return to accept it.
- 4. Click the tab of another open document. Resize the crop box, then accept the crop edits; or to accept the crop without resizing it, press Enter/ Return twice. Repeat this entire step for any other open images.

Here you will crop multiple documents to specific resolution and dimensions values.

To crop multiple images to a specified size and resolution:

- Open two or more images, then click in one of them. Choose the Crop tool (C or Shift-C).
- 2. On the Options bar, do either of the following:
 From the Aspect Ratio menu, choose W x H x
 Resolution, then enter the desired width, height, and resolution values.
 - From the Aspect Ratio menu, choose a W x H x Resolution preset (e.g., 4 x 5 in 300 ppi).

- Optional: Resize the crop box (the specified dimensions and resolution will still apply to the crop box, regardless of its size).
- **4.** To accept the crop edits, either double-click inside the box or press Enter/Return.
- 5. Click the tab of another open document. Resize the crop box, then accept the crop; or to accept the crop without resizing it, press Enter/Return twice. Repeat this entire step for any other open documents.
- To correct perspective problems in a photo resulting from camera lens distortion, we recommend using the Lens Corrections tab in Camera Raw (see pages 80–83). Using those controls, you can preview the results, whereas with the Perspective Crop tool, you cannot.

You can also crop multiple images to the dimensions and resolution of an existing document (this task), or to a crop box and resolution (next task).

To crop multiple images to the size and resolution of a document:

- 1. Open two or more images, and click in the one that has the desired dimensions and resolution.
- 2. Choose the Crop tool 4 (C or Shift-C).
- 3. From the Aspect Ratio menu, choose Front Image; or right-click in the image and choose Use Front Image Size & Resolution from the context menu (A, next page). The document's width, height, and resolution display on the Options bar.
- 4. Click the tab of another open image (B, next page). Resize the crop box, if desired, then accept the crop edits; or to accept the crop without editing it, press Enter/Return twice. Repeat this entire step for any other documents.

To crop multiple images to a crop box in, and resolution of, a document:

- 1. Open two or more images, including one that has the desired resolution.
- 2. Choose the **Crop** tool **4** (C or Shift-C).
- 3. In the document that has the desired resolution, resize the crop box to the desired proportions, then right-click in the image and choose Use Crop Box Size & Resolution from the context menu.

- 4. To accept the crop edits, either double-click inside the box or press Enter/Return.
- 5. Click the tab of another open document. Resize the crop box, if desired, then accept the crop edits; or to accept the crop without editing it, press Enter/ Return twice. Repeat this entire step for any other documents.

To save the current settings of the Crop tool as a preset:

- 1. Choose the **Crop** tool 4 (C or Shift-C) and the desired values and settings, then from the Aspect Ratio menu, choose New Crop Preset.
- 2. In the New Crop Preset dialog, keep the name or change it, then click OK. Your new preset will appear on the menu.

APPLYING STICKY SETTINGS OUICKLY

The current Ratio and W x H x Resolution values for the Crop tool remain in effect until you change them, even after you exit/quit and relaunch Photoshop. To apply either set of those "sticky" values to a document, click the Crop tool, choose Ratio or W x H x Resolution from the Aspect Ratio menu on the Options bar, press Enter/Return to activate the crop box, then press Enter/Return once more to accept the crop edit.

USING A SELECTION TO DEFINE A CROP BOX

If you create a rectangular selection before choosing the Crop tool, the crop box will match the selection boundary. If you want to force the crop box to ignore the selection, press Esc.

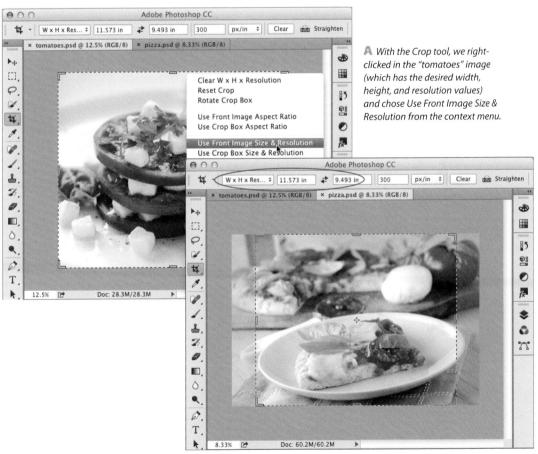

B We clicked another document tab. The width, height, and resolution of the front image are still displaying in the fields on the Options bar. If we were to accept the crop, this "pizza" image would adopt the values of the "tomatoes" image.

Another use of the Crop tool is to increase the canvas size, say, to add a blank area or to reveal imagery that is hidden outside the canvas. This is similar to the Canvas Size command, except here you use manual controls. All the layers in a document are affected.

To enlarge the canvas area with the Crop tool:

- To display more of the work canvas (gray area) around the image, enlarge the Application frame or lower the zoom level of your document.
- 2. Choose the Crop tool 4 (C or Shift-C).
- 3. On the Options bar, click Clear.
- 4. Drag a handle of the box outside the canvas area. A
- 5. On the Options bar, check whether you want Photoshop to Delete Cropped Pixels or preserve them. On all layers, regardless of this setting, any added areas that don't contain content will be filled with transparency. If the document has a Background and you check Delete Cropped Pixels, you should choose a Background color for the added canvas area now (see Chapter 11). With Delete Cropped Pixels off, the Background will convert to a layer and the added area will fill with transparency (for layers, see the next chapter).
- **6.** To accept the crop edits, either press Enter/Return or double-click inside the crop box.**B**

The Trim command trims away any excess transparent or solid-color areas from the perimeter of all the layers in a document, while preserving existing imagery, type, and shapes. Of course, the document remains rectangular.

To trim areas from around an image:

- If you want to trim transparent areas from a document that contains layers, on the Layers panel, hide the Background by clicking its visibility icon
- 2. Choose Image > Trim.
- 3. In the Trim dialog, click a Based On option:

Transparent Pixels trims transparent pixels from the edges of the image. If Photoshop doesn't detect any such areas in the image, this option won't be available.

Top Left Pixel Color removes any border areas that match the color of the left uppermost pixel in the image.

Bottom Right Pixel Color removes any border areas that match the color of the bottommost right pixel in the image.

- Check which edges of the image you want Photoshop to Trim Away: Top, Bottom, Left, and/ or Right.
- 5. Click OK.

A With the Crop tool, we're dragging the right midpoint handle outside the canvas, to add more canvas area to that side of the image.

B When we released the mouse, because Delete Cropped Pixels was checked for the tool, the added canvas area filled automatically with the current Background color (brown). We accepted the crop edit.

Straightening a crooked image

When you straighten a crooked image with the Crop tool, all the layers in the document are affected.

To straighten a crooked image with the Crop tool:

- 1. Choose the Crop tool 4 (C or Shift-C). The crop box displays.
- 2. Read step 5 of the first task on the preceding page, and either check Delete Cropped Pixels on the Options bar or not.
- 3. Do either of the following: On the Options bar, click Straighten or the Straighten icon. Hold down Ctrl/Cmd.
- 4. Drag along a shape in the image that you want Photoshop to align to the horizontal or vertical axis, then release.A
- 5. Optional: To tweak the rotation angle, drag outside the crop box. You can also edit the crop box via the usual controls.
- 6. Press Enter/Return, or double-click inside the box.
- To cancel the straighten and crop edits while the Crop tool is still selected, click the Reset button 🗹 on the Options bar.

When you straighten a crooked image with the Ruler tool, only the current layer is affected, and any pixels that lie outside the live canvas area on that layer are preserved.

To straighten a crooked layer with the Ruler tool:

- 1. Click the Background or a layer. If you select the Background, the Straighten Layer command will convert it to a layer.
- 2. Choose the Ruler tool (I or Shift-I).
- 3. Drag along a shape in the image that you want Photoshop to align to the horizontal or vertical axis. The angle will be listed as the A value on the Options bar.
- 4. Optional: To change the angle of the line, move either one of its endpoints.
- 5. On the Options bar, click Straighten Layer.
- 6. Optional: Reposition the layer with the Move tool.

A This image is slightly askew. We chose the Crop tool, clicked Straighten on the Options bar, then dragged downward along one of the columns.

B When we accepted the crop, the image was reoriented along the angle we defined.

Flipping or rotating an image

You can flip or rotate all the layers in an image, or just one layer at a time. (To learn about layers, see the next chapter.)

To flip all the layers in an image:

Choose Image > Image Rotation > Flip Canvas Horizontal A-B or Flip Canvas Vertical.

If you flipped a whole image that contains type, and the letters are now reading backwards, don't flip out! Just "unflip" the type layer using the Flip Horizontal command (see the next task). We've noticed photos in magazines and catalogs that were obviously flipped, because the lettering (e.g., in a stack of books) was unreadable.

- 1. Click a layer on the Layers panel.
- 2. Choose Edit > Transform > Flip Horizontal or Flip Vertical. Note: Any layers that are linked to the selected layer or layers will also flip.

To rotate all the layers in an image:

Do either of the following:

Choose Image > Image Rotation > 180°, 90° CW (clockwise), or 90° CCW (counterclockwise).

Choose Image > Image Rotation > Arbitrary. Enter an Angle value, click °CW (clockwise) or °CCW (counterclockwise), then click OK. Any exposed areas on the Background will be filled with the current Background color (see Chapter 11).

If you want any areas that are exposed by a rotation command to be filled with transparency instead of a solid color, click the lock icon in the Background listing to convert it to a layer before applying the command.

To rotate one layer:

- 1. On the Layers panel, click a layer.
- 2. Choose Edit > Transform > Rotate 180°, Rotate 90° CW, or Rotate 90° CCW.

A This is the original image.

B This is the same image after we chose the Flip Canvas Horizontal command.

In a standard Photoshop document, the image is listed as the Background on the Layers panel. By adding layers of various kinds on top of the Background, you can build complexity and flexibility into your documents. A For example, above the Background, you could add some editable text on one layer and perhaps a shape or some imagery surrounded by transparency on another layer. Layers can be added, deleted, or hidden when needed, and they can be edited individually.

Unlike the Background, which stays fully opaque and is stacked at the bottom of the Layers panel, a layer can contain partially or fully transparent areas and can be moved upward or downward in the stack. Within the transparent areas in a layer, you can see through to underlying layers. Photoshop uses a checkerboard pattern to represent transparent areas.

Because the Layers panel is so essential to image editing in Photoshop, we have devoted this whole chapter to helping you master its features. By the end of this chapter, you will know how to create, duplicate, select, restack, group, delete, hide, show, move, lock, filter, merge, and flatten layers, as well as change their opacity. Those techniques, along with the selection and masking techniques in the next chapter, will give you the necessary foundation for future tasks in this book.

A This document contains a type layer and five image layers, all of which are stacked above the Background.

LAUL LSSENTIALS

8

IN THIS CHAPTER

Creating layers
Selecting layers
Restacking layers
Creating layer groups
Deleting layers and groups156
Hiding and showing layers
Repositioning layer content
Changing the layer opacity 158
Using the lock options
Choosing Layers panel options 159
Filtering listings on the Layers panel
Merging layers
Flattening layers

PRACTICE ON AN IMAGE

You can download the file shown at left (see page viii). When you open it, click next to a layer name, then hide that layer by clicking the visibility icon. Click again to redisplay the icon and layer.

Creating layers

If you open a digital photo from Camera Raw into Photoshop using the Open Image button, the image will appear on the Background. If you create a document via the File > New dialog and choose the option of Background Contents: White or Background Color, your new document will have a Background; or if you choose Background Contents: Transparent instead, the document will contain a layer and no Background. Note: In this book, we identify the Background in a Photoshop document with an initial cap "B," to distinguish it from the general background (versus foreground) area of an image.

In these steps, you will learn how to create a new, blank image layer. To that layer, you can add pixels by applying brush strokes, cloning imagery, pasting into a selection, or performing other edits. You may add as many layers to a file as you like, but remember that a large image containing many image layers will utilize a fair amount of storage space and system memory.

Note: In other chapters, you will create adjustment, type, Smart Object, and shape layers.

To add a new, blank layer to a document:

- 1. Display the Layers panel.
- **2.** Click a layer or the Background. The new layer is going to appear above this selected one.
- 3. Click the New Layer button at the bottom of the panel. A The new layer will have the default blending mode of Normal and the default setting for both Opacity and Fill of 100%. B
- ➤ To choose options for a layer as you create it, Alt-click/Option-click the New Layer button or press Ctrl-Shift-N/Cmd-Shift-N. In the New Layer dialog, you can enter a layer Name and choose a nonprinting Color for the area on the Layers panel behind the visibility icon (see "To color-code a layer" on page 159).
- To rename a layer right on the panel, see the sidebar on page 152.

A We clicked the Background, then clicked the New Layer button.

B A new blank layer (Layer 1) appeared above the Background.

Another way to create a layer is by copying or cutting imagery from an existing layer or the Background and transferring it to a new layer. This can be done easily via a simple command.

To turn a selection of pixels into a layer:

- 1. On the Layers panel, click an image layer or the Background, then create a selection in the document (if you're new to Photoshop, see the steps on page 168).A
- 2. Do either of the following:

To put a copy of the selected pixels onto a new layer while leaving the original layer unchanged, right-click in the document and choose Layer via Copy, or press Ctrl-J/Cmd-J.B

To put the selected pixels on a new layer and remove them from the original layer, right-click in the document and choose Layer via Cut, or press Ctrl-Shift-J/Cmd-Shift-J. If you cut pixels from a layer, Photoshop will fill the exposed area on the original layer with transparency; if you cut pixels from the Background, the exposed area will be filled with the current Background color (see pages 203 and 255).

Follow these steps to duplicate a layer or layer group, or to turn a copy of the Background into a layer. (To learn about layer groups, see pages 154-155.)

To duplicate a layer or layer group:

On the Layers panel, do one of the following:

Click a layer or a layer group, or Ctrl-click/Cmdclick multiple layers, then press Ctrl-J/Cmd-J.

Drag a layer, a layer group, or the Background over the **New Layer** button. The duplicate will appear above the one you dragged.

To name the new layer as you create it, right-click a layer, a layer group, or the Background and choose Duplicate Layer or Duplicate Group. In the dialog, change the name in the "As" field (ignore the Destination field), then click OK.

- To control whether Photoshop adds the word "copy" to duplicate layer names automatically, choose Panel Options from the Layers panel menu, then check or uncheck Add "Copy" to Copied Layers and Groups.
- When you duplicate a layer, any masks and/or effects on that layer are also duplicated.

A We selected an area of the Background in this document.

B When we pressed Ctrl-J/Cmd-J, a copy of the selected pixels appeared on a new layer (Layer 1).

There are many things that can be done to a layer that can't be done to the Background. For example, you can't move the Background upward in the layer stack; change its blending mode, Opacity, or Fill setting; attach a mask to it; or embellish it with layer effects. You can, however, convert the Background to a layer, at which time it will adopt all the functions of a normal layer.

To convert the Background to a layer:

On the Layers panel, do either of the following:

To convert the Background to a layer without choosing options, click the **Lock** icon in the Background listing.*

Double-click the Background A to open the New Layer dialog, then do any of the following: Change the Name, choose a Color for the area behind the visibility icon, or change the blending Mode or Opacity setting. Click OK.C

You can also do the reverse of the preceding instructions, which is to convert any layer to the Background. This will come in handy, say, if you use the Crop tool with the Delete Cropped Pixels option off (which converts the Background to a layer), then decide you want to make the bottommost layer into the Background again.

To convert a layer to the Background:

- 1. Click the layer to be converted.
- 2. Choose Layer > New > Background from Layer. The new Background will appear as the bottom listing (its standard stacking position) on the panel.

A We doubleclicked the Background in this image.

B We typed a name for the layer in the New Layer dialog.

C The former Background is now a fullfledged layer.

RENAMING LAYERS AND LAYER GROUPS

- To rename a layer or layer group, double-click the layer or layer group name, type a new name, then press Enter/Return or click outside the field.
- ➤ After double-clicking a layer name, you can press Tab to highlight the name of the next listing below it, or press Shift-Tab to highlight the listing above it (don't include the Background in the cycle).

Tip: To identify a layer name that isn't fully displayed (e.g., if the panel shape is narrow), use the Tool Tip.

Selecting layers

There are good habits and bad habits. Here's a good one: Before applying a filter, brush stroke, or other image edit to your document, select the listing for the layer that you want Photoshop to alter. Easy to do, easy to forget! When a layer or layer group listing is selected, it has a blue highlight and the layer or group name appears in the document tab.

To select layers via the Layers panel:

Do one of the following:

To select a layer or layer group, click either the layer thumbnail or the blank area to the right of the layer or group name.A

To select multiple layers, click a layer, then Shiftclick the last in a series of consecutively listed layers, or Ctrl-click/Cmd-click individual layers (not their thumbnails). If you need to deselect an individual layer, Ctrl-click/Cmd-click it.

To select all the layers in your document (but not the Background), choose Select > All Layers or press Ctrl-Alt-A/Cmd-Option-A.

To select a layer or layer group with the Move tool:

- 1. Choose the **Move** tool or hold down V.
- 2. Do either of the following:

To select a layer that contains nontransparent pixels below the pointer, right-click in the document window and choose a layer or layer group name from the context menu. B (Adjustment layers may also be listed on the menu; see Chapter 12.)

On the Options bar, check Auto-Select and choose Group or Layer from the adjacent menu. Next, click a visible pixel area in the document. The Background can't be selected via this method.

When the Move tool is selected and Show Transform Controls is checked on the Options bar, a bounding box surrounds the nontransparent content of the currently selected layer. If you find the box to be distracting, uncheck the option. To transform a layer via its bounding box (e.g., scale or skew it), see pages 348-349.

A To select a layer, just click it.

B From the context menu, choose the name of the layer you want to select.

Restacking layers

When you restack a layer listing, the layer contents shift forward or backward in the document.

To restack layers:

Drag a layer or group name upward or downward on the Layers panel, and release the mouse when a double horizontal line appears in the desired stacking position. A-B

- To move the Background upward on the list, you must convert it to a layer first (see page 152). Layers can't be stacked below the Background.
- You can also restack a selected layer via commands on the Layer > Arrange submenu (or via the shortcuts that are listed on that submenu).

Creating layer groups

Putting layers in groups is more than just a convenient way to streamline and organize the listings on your Layers panel. You can also move, transform, duplicate, restack, hide, show, lock, or change the blending mode, Opacity, or Fill setting of all the layers in a group simultaneously. When you add a layer mask to a layer group, the mask applies to all the layers in the group (see page 190). You can also nest groups inside other groups.

To create a layer group:

Method 1 (from existing layers)

- Click a layer, then Shift-click or Ctrl-click/Cmdclick one or more additional layers. The layers can be nonconsecutive or hidden, and they can be different kinds.
- 2. Do either of the following:

Press Ctrl-G/Cmd-G.

Right-click one of the selected layers in the panel and choose **Group from Layers** from the context menu (or choose New Group from Layers from the panel menu). In the dialog, type a Name for the group, then click OK.

- 3. Optional: To add more layers to the group, follow step 2 on the next page.
- The default blending mode for a group is Pass Through; we recommend keeping that setting.

We used the New Group from Layers command to put those layers in a group.

Method 2 (create a group, then add layers)

1. On the Layers panel, do either of the following: To create a group without choosing settings for it, click the layer above which you want the group to appear, then click the New Group button. To name the group as you create it, Alt-click/ Option-click the New Group button or choose New

Group from the panel menu. In the dialog, enter a

Name, then click OK. 2. Do either of the following:

> Drag layers into the new group listing, releasing the mouse when the drop zone border appears around it.

Click the arrowhead to expand the group list, then drag layers into the group, releasing the mouse when the double lines appear in the desired stacking position.A

To expand or collapse a group, including any and all subgroup, effect, and Smart Filter listings within it, Alt-click/Option-click the arrowhead.

MOVING LAYERS OUT OF A GROUP

- To move a layer out of a group, expand the group listing, then drag a layer above or below the group.
- ➤ To move a layer from one group to another, expand the source group, then drag a layer over the target group (a border appears around it); or if the target listing is expanded, you can release the layer in the desired stacking position.

A We're moving a layer upward into an existing group.

USING CONTEXT MENUS ON THE LAYERS PANEL

Deleting layers and groups

To delete a layer:

- 1. If there is an active selection in your document, deselect (press Ctrl-D/Cmd-D).
- 2. Click the layer to be deleted, then press Backspace/
- Change your mind? Choose Edit > Undo immediately, or click the prior state on the History panel.
- ➤ To delete a selected layer another way, click the Delete Layer button, then click Yes in the alert dialog; or to bypass the alert, Alt-click/Option-click the Delete Layer button.

You can delete a layer group and its layers or merely disband the group while preserving the layers.

To delete or ungroup a layer group:

On the Layers panel, do one of the following:

To delete a group and its contents, click the group, then press Backspace/Delete.

Right-click a group and choose **Delete Group** from the context menu (or click a group, then click the Delete Layer button .). In the alert dialog, click **Group Only** or **Group and Contents**.

To ungroup a layer group without deleting its layers, click the group, then press Ctrl-Shift-G/Cmd-Shift-G. The group icon disappears from the panel and the layer listings are no longer indented.

Hiding and showing layers

You can hide any layer you're not currently working on, either because it's getting in the way of your editing or to eliminate it as a visual distraction. Hidden layers don't print. The instructions below apply both to layers and the Background.

To hide or show layers:

On the Layers panel, do one of the following:

To hide or show one layer or layer group, click in the visibility column. A-B

To hide or show multiple layers, drag upward or downward in the visibility column.

To hide all layers and layer groups except one, Alt-click/Option-click the visibility column for the layer or layer group that you want to keep visible. Repeat to redisplay all the layers (except for layers that were hidden before you used the command).

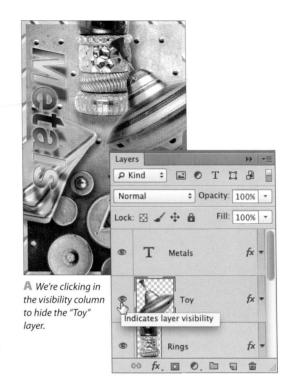

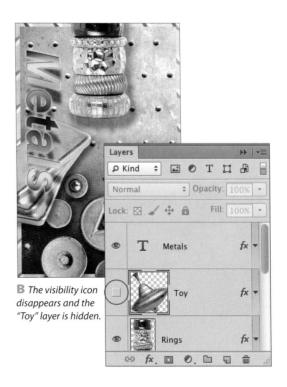

Repositioning layer content

You can reposition a selected layer or group of layers in your document.

To reposition layers manually:

Do either of the following:

On the Layers panel, click a layer or layer group, or Shift-click or Ctrl-click/Cmd-click multiple layers, hold down V to spring-load the Move tool, then drag in the document. A-B

Hold down V to spring-load the Move tool. On the Options bar, check Auto-Select, choose Group or Layer from the adjacent menu, then drag a nontransparent area in the document.

- If you move part of the layer or layers outside the canvas area, not to worry — those pixels will save with the document and can be moved back into view at any time. See "Working with pixels outside the canvas area" on page 257.
- To nudge a selected layer by one pixel at a time, choose the Move tool, then press an arrow key. Or press Shift-arrow to move a layer by 10 screen pixels at a time. (Don't press Alt-arrow/Optionarrow — unless you want to duplicate the layer.)
- For a more precise way to reposition layers, use the align buttons on the Options bar. See page 281.

ALIGNING LAYER CONTENT USING SMART GUIDES

As you drag a layer, you can align its edge with the edge or center of content of another layer by using Smart Guides. Verify that View > Show > Smart Guides has a check mark, then with the Move tool (V), start moving a layer or layer group. Temporary magnetic guide lines will appear onscreen when the edge of the layer imagery you're moving encounters the edge or center of nontransparent pixels, type, or a shape on another layer. To learn more about this feature, see page 286.

A We're dragging the "Toy" layer with the Move tool.

B Now the "Toy" layer is on the right side of the image.

Changing the layer opacity

The Opacity setting on the Layers panel controls whether a layer is semitransparent or opaque.

To change the opacity of a layer or layer group:

- 1. Select one or more layers or a layer group.
- 2. Change the Opacity percentage on the Layers panel (we like to use the scrubby slider). A-B
- To learn about the Fill slider, see page 399.
- In the Transparency Settings area of Edit/ Photoshop > Preferences > Transparency & Gamut, you can change the size or color of the gray and white checkerboard pattern that Photoshop uses to represent transparent pixels (or to hide the pattern, choose None from the Grid Size menu).
- To change the Opacity setting of the currently selected layer or layer group via the keyboard (standard or extended), choose a nonediting tool (such as the Move or Eyedropper tool or a selection tool), then press a digit between 0 and 9 (e.g., 2 = 20%) or quickly type a percentage (such as "38" for 38%). Press 0 to set the opacity to 100%or 00 to set it to 0%.

Using the lock options

The Lock Transparent Pixels button on the Layers panel prevents or allows the editing of transparent pixels by any command or tool. In these steps, you will use this feature with the Brush tool, just to learn how it works in practice.

To limit edits by locking transparent pixels:

- 1. Click an image layer (not an editable type layer) that contains some transparent pixels.
- 2. Choose the Brush tool (B or Shift-B). To change the brush diameter, press [or].
- 3. Show the Swatches panel, then click a color.
- 4. On the Layers panel, click the Lock Transparent Pixels button, ☐ then draw a few brush strokes in the document. COnly nontransparent pixels will be recolored.
- 5. Deactivate the Lock Transparent Pixels button by clicking it again or by pressing /.
- 6. Apply a few more brush strokes to the layer. Note that both transparent and opaque parts of the layer can be recolored.

A In this image, all the layers have an opacity of 100%.

We reduced the opacity of the tomatoes layer to 49%.

With the Lock Transparent Pixels option on, our brush strokes can recolor only nontransparent pixels.

With Lock Transparent Pixels off, our brush strokes can recolor transparent and opaque pixels.

To prevent layer characteristics from being edited, there are three other lock options on the Layers panel, in addition to the Lock Transparent Pixels button.

To lock one or more layers or a layer group:

- 1. Select one or more layers or a layer group.
- 2. Click any of the following:

The Lock Image Pixels button 🖌 prevents image layer pixels from being edited, such as by filters or brush strokes. Note: You can still move or restack the layer or change its layer style settings (blending mode, opacity, and effects).

The **Lock Position** button igoplus locks only the location of the layer. The layer content (e.g., pixels, type characters) can be edited as usual.

The Lock All button apprevents the layer from being moved and edited. A Unlike the other lock options, this button is also available for layer groups.

When any lock button is activated for a layer, a padlock icon displays next to the layer name.

Choosing Layers panel options To choose thumbnail options for the Layers panel:

Right-click any layer thumbnail and choose any of the following:

Small Thumbnails, Medium Thumbnails, or Large Thumbnails. Note: Turning off thumbnails by choosing No Thumbnails can help boost Photoshop's performance, but frankly, it's pretty darn hard to work productively without them.

Clip Thumbnails to Layer Bounds to preview, in the panel thumbnails, only the layer content, B or Clip Thumbnails to Document Bounds to preview the layer content relative to the full canvas size.

You can assign a color to the area behind the visibility icons to categorize your layers or make them easier to identify (or just to make the panel look pretty).

To color-code a layer:

Click a layer (or Ctrl-click/Cmd-click multiple layers), then right-click the visibility column (or the layer thumbnail or listing) and choose a color label from the context menu.C

A When the Lock All button option is activated for a layer, the padlock icon is black.

B For our Layers panel display options, we chose Large Thumbnails and Clip Thumbnails to Layer Bounds.

Filtering listings on the Layers panel

When you first start working in Photoshop, your Layers panel may look relatively spare, but before you know it, you will be adding image, adjustment, and type layers, Smart Objects, Smart Filters, and layer styles, and the number of listings will grow considerably. Finding the layers you need will require you to either scroll in the panel (a pain in the butt) or enlarge the panel to display all the listings (uses too much screen space). A Via the filtering features, you can reduce the listings that display on the panel at a given time to just the categories of layers you need to work on.

To filter the listings on the Layers panel:

At the top of the Layers panel, do one of the following:

Set the Filter Type menu to the default option of Kind, then click the Filter for Pixel Layers, Filter for Adjustment Layers (A-B, next page), Filter for Type Layers, Filter for Shape Layers, or Filter for Smart Objects button. Only listings in that chosen category will display. Optional: Click another of those buttons to display more listings.

From the Filter Type menu, choose Name, Effect, Mode, Attribute, Color, or Smart Object. Next, choose a criterion from the adjacent menu (C-F, next page); or for the Name option, start typing a word that appears in one or more layer names; or for the Smart Object option, click the Up-to-Date Linked Smart Objects, Out-of-Date Linked Smart Objects, For example, to display only layers that contain a layer mask, choose Attribute from the Filter Type menu and Layer Mask from the second menu. See also the sidebar on the next page.

For the **Selected** option on the Filter Type menu, see pages 162–163.

To deactivate layer filtering:

To deactivate layer filtering, in the upper-right corner of the Layers panel, click the Layer Filtering On/Off button. (If you click the button again, the last settings will be restored.)

Layer filtering settings remain in effect only while a file is open, and while the Layer Filtering On/Off button is activated on the Layers panel. When you close and then reopen your file, filtering is reset to none.

Filter Type menu

Layer Filtering On/Off button

A This is the Layers panel for the image shown above, with all the listings showing (unfiltered).

A We clicked the Filter for Pixel Layers button: Only image layers are displaying.

B We also clicked the Filter for Adjustment Layers button: Now both image and adjustment layers are displaying.

We chose Attribute from the Filter Type menu and Visible from the second menu: Only layers that have a visibility icon are displaying.

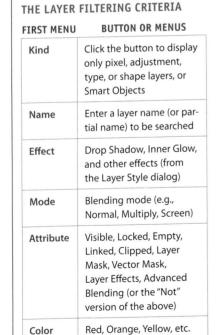

For Smart Objects, see the preceding page.

(the color that is assigned

to the visibility column)

ity column of most of the layers.

We chose Color from the Filter Type menu and Yellow from the second menu.

F We chose Effect from the Filter Type menu and Drop Shadow from the adjacent menu.

Unlike the filtering controls that are discussed on the prior two pages, the Isolate Layers feature lets you pick and choose which layers remain accessible (and they can be a mixture of different types). It's easier to select, then isolate, the layers you want to edit than it is to hide the layers you want to ignore. Like the other layer filtering controls, this feature is especially useful if you're working on a complex document that contains many layers.

Isolated layers can be edited as usual. For example, you can click any individual listing to edit just that layer; or select multiple layers of the same type and apply related edits (e.g., a fill or stroke color to multiple shape layers, or a font family to multiple type layers); or select multiple layers of the same or different types, and apply other edits, such as transformations.

While the Isolate Layers option is on, all the Layers panel features (except for a few buttons) are fully functional, such as the blending mode menu, the Opacity and Fill sliders, and the ability to restack, group, copy, and delete layers (among the ones that are isolated).

To isolate selected layers:

- On the Layers panel, hold down Ctrl/Cmd and click the layers you want to keep editable. The layers can be of any kind.
- 2. Do either of the following:

From the Filter Type menu at the top of the Layers panel, choose **Selected**.

If you're using the Move, Path Selection, or Direct Selection tool or a pen tool, right-click in the document and choose **Isolate Layers** from the context menu.

- **3.** As you edit the isolated layers, the nonisolated ones will remain visible in the document but will be uneditable (**A**-**B**, next page).
- **4.** Optional: To release an individual layer from isolation, click the listing for the layer to be released, then right-click it and choose Release from Isolation from the context menu.
- 5. Optional: To change which layers are isolated, on the Layers panel, click the Layer Filtering On/Off button (to deactivate layer filtering). All the document layers will redisplay on the Layers panel. Change the selection of layers (e.g., Ctrl/Cmd click a layer to add it to the selection, or click any selected layer to deselect it), then click the Layer Filtering On/Off button again to reactivate it.

A This image contains multiple layers.

B We selected three layers, then chose Selected from the Filter Type menu.

If you want to add an existing layer to the ones that are isolated (without having to use the Layers panel), choose the Move tool + (V). Right-click in the document, then from the context menu, choose the name of the additional layer you want to isolate.

- If you add a layer to your document while the Isolate Layers feature is on, the new layer will also be isolated. This includes fill and adjustment layers.
- Layer filtering settings, including isolation mode, remain in effect only while a document is open (and while the Layer Filtering On/Off button is activated on the Layers panel). When you close and then reopen your document, layer filtering is reset to the default setting of no filtering.
- To learn about isolating shape layers, see page 412.
- In Photoshop, nonisolated layers display at their full opacity, whereas in Isolation Mode in Adobe Illustrator, nonisolated objects are dimmed.

When you exit isolation mode, you can either make all the layers in the document accessible again, or revert to a prior layer filtering setting.

To exit isolation mode:

Do either of the following:

To exit isolation mode and also clear any other layer filtering, choose the Move, Path Selection, Direct Selection tool, or a pen tool, then rightclick in the document and uncheck Isolate Layers on the context menu. * This command works regardless of the current state of the Layer Filtering On/Off button. (You can also exit isolation mode by unchecking Isolate Layers on the Select menu.) To exit isolation mode by switching to a different filtering mode, make sure the Layer Filtering On/ Off button is activated, then from the Filter Type menu at the top of the Layers panel, choose any filtering option except Selected.

B Using the Free Transform command, we scaled down the three isolated layers simultaneously, while the nonisolated layers remained visible but uneditable.

A Only the listings for the layers that we isolated displayed on the panel.

Merging layers

The Merge Down command merges the current layer into the layer directly below it. The other merge commands — Merge Layers and Merge Visible — merge two or more selected layers into the bottommost of the selected layers. You can apply any of these commands periodically during the editing process to reduce the file size of your document or to declutter your Layers panel — just remember that you can't unmerge layers after you merge them except by using the History panel.

Note: Compare the merge commands with the Flatten Image command (see page 166), which is typically applied to a copy of a file as a final step before output.

To merge select layers:

1. Do one of the following:

The bottom one must be an image layer or the Background; it can't be fully locked (the Lock All button can't be activated) and it can't be a group. Ctrl-click/Cmd-click multiple layers. The layers can be solo, within a group, or a combination thereof. Click a group. (All the layers in the group will be merged — but just with one another.) Note: You can merge an adjustment layer into an image layer, but you can't merge adjustment layers into one another. If you merge a shape layer, an editable type layer, or a Smart Object, it will be rasterized into the underlying image layer.

Click the upper layer of two layers to be merged.

2. Do either of the following:

Right-click the selected layer or group, or one of the selected layers, and choose Merge Down, Merge Layers, or Merge Group from the context menu.

Press Ctrl-E/Cmd-E (this is the only method that works for a type layer).

Note: If only one layer is selected and you merge it downward into an underlying layer that contains a layer mask, an alert dialog will appear. Click Preserve to keep the mask editable, or click Apply to apply the mask effect but discard the mask.

- If you merge a group, the group icon will disappear from the panel.
- To merge an editable type layer into a shape layer, or vice versa, select both, then press Ctrl-E/Cmd-E.

A We clicked the "violin" layer.

B We chose the Merge Down command, which merged the "violin" layer into the "trumpet" layer.

SMART OBJECT IN LIEU OF MERGE OR FLATTEN

Instead of merging or flattening layers, consider grouping them into a Smart Object (see page 264). You'll achieve the same reduction of layers, plus you'll gain the ability to access and edit the original layers individually by double-clicking the Smart Object thumbnail (see page 268).

The Merge Visible command merges all the currently visible layers into the bottommost visible layer while preserving any hidden layers. By hiding the layers you don't want to merge before choosing this command, you can control which ones will be merged.

To merge all visible layers:

- 1. Make sure the layers that you want to merge are visible (have eye icons), and the layers that you don't want to merge are hidden.A
- 2. Right-click one of the visible layers (not a type layer) and choose Merge Visible (Ctrl-Shift-E/ Cmd-Shift-E).B

Note: This sort of goes without saying, but if you merge down an editable type layer, shape, or adjustment layer, the specific features of that kind of layer (such as the font and other character settings for a type layer, or the settings for an adjustment layer) will no longer be editable.

Both of the commands in this task will copy and merge ("stamp") two or more selected layers into a new layer in one step, while preserving the original, separate layers. This might come in handy, say, if you want to test some edits (such as filters or transformations) on multiple layers simultaneously; use one of these commands first, then apply your edits to the newly merged layer. The Note above also applies to these commands.

To copy and merge layers:

Do either of the following:

Ctrl-click/Cmd-click the layers (not the Background) to be copied or merged into a new layer, then press Ctrl-Alt-E/Cmd-Option-E.

To copy and merge all the currently visible layers into a new layer, including the Background (if visible), click any visible layer, then press Ctrl-Alt-Shift-E/Cmd-Option-Shift-E.

- If any layers and the Background are selected when you use the first shortcut listed above, content from the selected layers will be stamped into the Background, and no new layer will be created.
- For an alternative to the merge commands, see the sidebar on the preceding page.
- To create a document from one or more selected layers, from the Layers panel menu, choose Duplicate Layers. From the Document menu in the dialog, choose New, enter a document Name, then click OK. Save the new file.

A In this document, we hid the Background because we didn't want our layers to merge into it.

B The Merge Visible command merged all the layers except the Background, which was preserved and stayed hidden.

Flattening layers

When you flatten all the layers in a document, you reduce its file storage size and free up space on your hard disk (see the sidebar at right). Flattening layers may also be a necessary step when preparing a file for output or export. Although multiple layers are preserved by several formats (Photoshop PDF, Photoshop, Large Document, Dicom, and TIFF), if the application into which you're planning to import your file doesn't read or accept layers, you will have to produce a flattened copy of it, as in these steps. Any transparency in the bottommost layer will be converted to fully opaque white.

To save a flattened copy of a document:

- Choose File > Save As (Ctrl-Shift-S/Cmd-Shift-S).
 The Save As dialog opens.
- 2. Do all of the following:

Change the file name.

Choose a location.

Uncheck Layers (the As a Copy option becomes checked automatically; keep it that way).

Choose a file format from the Format menu.

Click Save.

Note: The layered version will remain open; the flattened version will be saved to disk.

If you're confident that your image is totally complete, finis, you can use the Flatten Image command instead of saving a flattened copy. This command merges all currently visible layers (including type, Smart Object, and adjustment layers) into the bottommost visible layer, rasterizes all type and shape layers, and applies the effect of all masks and layer styles to the document. Note: This command discards all hidden layers!

To flatten all the layers in a document:

- Make sure all the layers and layer groups you want to flatten are visible (have eye icons). A It doesn't matter which layer is selected.
- **2.** Right-click any layer name (not a type layer) and choose **Flatten Image**.
- 3. If the file contains any hidden layers, an alert dialog will appear; click OK. Any formerly transparent areas in the bottommost layer are now opaque white. B

LAYERS INCREASE THE FILE SIZE

From the Status bar menu at the bottom of the document window, choose Document Sizes, then note the value on the left (the file size without layers) versus the value on the right (the approximate file size with layers and alpha channels). The file for this status bar contains three image layers and a Background:

A In this document, the "Bottles" layer is hidden.

B The Flatten Image command flattened all the visible layers into the Background and discarded the hidden layer.

In this chapter, you will learn how to create and refine selections and layer masks. These techniques are put to practical use in many other chapters, and you will discover that they are essential to your work in Photoshop.

When you select an area of an image layer, only that area can be edited, and the rest of the layer is protected. If you apply a filter, for example, only pixels within the selection area on the currently active layer are affected. The function of a layer mask is to hide parts of a layer. Moreover, a selection can be converted to a layer mask, and a layer mask can be loaded as a selection.

Note: To deselect a selection, see page 170.

Creating layer-based selections

To select the entire canvas area of a layer:

On the Layers panel, click a layer or the Background, then choose Select > All or press Ctrl-A/Cmd-A. A border of "marching ants" surrounds the entire layer.

To select just the nontransparent areas of a layer:

On the Layers panel, Ctrl-click/Cmd-click a layer thumbnail. A-B

A To select only the nontransparent pixels on a layer, Ctrl-click/Cmd-click the layer thumbnail.

B Just the butterfly is selected.

ELECTIONS & MASUS

IN THIS CHAPTER

Creating layer-based selections 167
Using the Rectangular and Elliptical Marquee tools
Using two of the lasso tools 169
Deselecting and reselecting selections
Deleting or filling a selection 170
Moving a selection border
Moving selection contents
Using the Quick Selection tool 172
Using the Magic Wand tool174
Inverting a selection
Using the Color Range command176
Hiding and showing the selection border
Creating a frame-shaped selection179
Selecting in-focus areas of a photo 180
Saving and loading selections 182
Refining selection edges 182
Using Quick Masks
Creating layer masks190
Editing masks
Working with masks

Using the Rectangular and **Elliptical Marquee tools**

To create a rectangular or elliptical selection:

- 1. Click the layer you want to edit.
- 2. Choose the Rectangular Marquee or Elliptical Marquee tool (M or Shift-M).
- 3. Optional: For a smoother edge on an elliptical selection, check Anti-alias on the Options bar (see the sidebar on page 175) and set the Feather value to 0 px.
- 4. Drag diagonally. Hold down Shift while dragging to create a perfect square or circle; hold down Alt/ Option while dragging to draw the selection from the center. A syou draw a selection, width and height dimensions display in a readout next to the selection and on the Info panel. When you release the mouse, a selection border appears.
- 5. Optional: To add to the selection, Shift-drag; to subtract from it, Alt-drag/Option-drag.
- To move the selection while drawing it, keep the mouse button down, then drag with the Spacebar held down. To move the selection after releasing the mouse, drag inside it with any selection tool.
- To create the thinnest possible selection, choose the Single Row Marquee or Single Column Marquee tool, then click in the image.

To create a selection that has a fixed ratio or specific dimensions:

- 1. Click a layer.
- 2. Choose the Rectangular Marquee or Elliptical Marquee tool (M or Shift-M).
- 3. On the Options bar, set the Feather value to 0, then do either of the following:

From the Style menu, choose Fixed Ratio, enter a Width and Height for the ratio of the selection (e.g., 5 to 7), B then drag in the image diagonally to create a selection.

From the Style menu, choose Fixed Size, enter exact Width and Height values in any unit that can be used in Photoshop (see page 467), then click in the image.D

To swap the current Fixed Ratio or Fixed Size values, click the Swap Height and Width = button on the Options bar.

A With the Elliptical Marguee tool, we're holding down Alt/Option while dragging to draw a selection from the center.

B For the Rectangular Marquee tool, we chose Fixed Ratio and entered a width-to-height ratio of 5 to 7...

D We chose Fixed Size, entered exact Width and Height values, then clicked in the image to make the border appear (here, we're repositioning it).

Using two of the lasso tools

We use the Lasso tool to select an area loosely, say, to limit subtle color adjustments to a general area. We also use this tool to clean up selections made with other tools, such as the Magic Wand or Quick Selection tool.

To create a free-form selection:

- 1. Click the layer you want to edit.
- 2. Choose the Lasso tool (L or Shift-L).
- 3. Optional: For a smoother edge on a curved selection, check Anti-alias on the Options bar and set the Feather value to 0 px.
- 4. Drag around an area on the layer. A Your initial selection doesn't have to be perfect; you will have a chance to refine it in the next step. When you release the mouse, the open ends of the selection will join automatically.
- 5. To add to the same selection area, position the pointer inside it, then Shift-drag around the area to be added. B To subtract from the selection area, position the pointer outside it, then Alt-drag/ Option-drag around the area to be removed. C-D
- To feather an existing selection, see pages 192 and 259.
- To create a straight side with the Lasso tool, with the mouse button still down, hold down Alt/ Option and click to create corners. To resume creating free-form edges, press the mouse button, release Alt/Option, then drag.

To create a straight-sided selection:

- 1. Click the layer you want to edit.
- 2. Choose the Polygonal Lasso tool (L or Shift-L).
- 3. Click to create corners. To create a selection edge at a multiple of 45°, hold down Shift while clicking.
- 4. To join the open ends of the selection, do either of the following:
 - Click the starting point (a small circle appears in the pointer).
 - Ctrl-click/Cmd-click or double-click anywhere in the document. Photoshop will complete the selection with a straight side.
- To draw a free-form segment while creating a polygonal selection, Alt-drag/Option-drag. Release Alt/Option and click to create more straight sides.
- To delete the last corner while using the Polygonal Lasso tool, press Backspace/Delete.

A With the Lasso tool, we are selecting the left part of the ice cream.

B Using Shift, we are adding to the selection, to complete the shape.

C To eliminate the pistachio nut from the selection ...

D ... we are holding down Alt/Option and dragging around it with the Lasso tool.

E The Polygonal Lasso tool produces straight-edged selections.

CREATING A SELECTION WITH A VECTOR TOOL

To create a smooth, custom-shaped selection, draw a path with a shape tool or the Pen tool, then convert the path to a selection. See Chapter 21.

Deselecting and reselecting selections

If you don't like having to retrace your steps (we sure don't), deselect a selection only when you're sure you're done using it. Although selections register as states on the History panel, states disappear when the panel listings reach their maximum number or when you close your document. To preserve a selection for future access and use, save it in an alpha channel (see page 182) or convert it to a layer mask (see page 190).

To deselect a selection:

- Do one of the following:
- Press Ctrl-D/Cmd-D (Select > Deselect). Memorize this shortcut!
- Choose any selection tool, then right-click anywhere in the document and choose **Deselect**.
- Hold down M or L to spring-load a marquee or lasso tool, then click inside or outside the selection. A (If this doesn't work, click the New Selection button on the Options bar and try again.)

To reselect the last selection:

- Do one of the following:
- Press Ctrl-Shift-D/Cmd-Shift-D (Select > Reselect).
- With any selection tool except the Magic Wand, right-click in the document and choose **Reselect**.
- On the History panel, click the state that is labeled with the name of the tool or command that you used to create the selection.

A To deselect this selection, we're clicking inside it with a selection tool.

Deleting or filling a selection

When you delete a selection of image pixels from a layer, Photoshop fills that area automatically with transparent pixels. When you delete a selection of pixels from the Background, Photoshop fills the exposed area with a solid color.

To delete or fill a selection:

- 1. On the Layers panel, click a layer or the Background. For the Background, also choose a Foreground or Background color (see Chapter 11).
- 2. Do one of the following:
 - If a layer is active, press Backspace/Delete.B—C

 If the Background is active, press Alt-Backspace/
 Option-Delete to fill the selection with the

 Foreground color or Ctrl-Backspace/Cmd-Delete
 to fill the selection with the Background color.D
 - To delete the selection and put it on the Clipboard, choose Edit > Cut (Ctrl-X/Cmd-X). (To learn about the Clipboard, see pages 255–258.)
- To put a selection onto a new layer, see page 151.

B We selected the blue sky on an image layer, then pressed Backspace/Delete.

C Photoshop replaced the deleted area with transparent pixels.

D Here, with the Background selected, we pressed Ctrl-Backspace/Cmd-Delete, so the selection filled with the current Background color (in this case, the color red).

Moving a selection border

You can move a selection border to a different area of an image without moving its contents.

To move a selection border:

- Choose any selection tool except the Quick Selection tool or hold down M or L to spring-load a marquee or lasso tool, and activate the New Selection button on the Options bar.
- 2. Do either of the following:

Drag inside an existing selection. A To constrain the movement to a multiple of 45°, start dragging, then hold down Shift and continue to drag. The horizontal and vertical distance the selection border is being moved displays in a dynamic readout onscreen.

Press any arrow key to nudge the selection border by one pixel at a time, or press Shift-arrow to nudge the border by 10 pixels at a time.

- To transform a selection border (but not its contents), choose any selection tool except the Magic Wand. Right-click the image and choose Transform Selection. Use the handles on the transform box to scale, rotate, skew, distort, or apply perspective to the selection, as described on pages 348-349.
- To copy a selection border between documents, drag it to the tab of another open document with a selection tool, pause to let the second document display, then drag into the active window.

Moving selection contents

In these steps, you will move a selection with its contents.

To move the contents of a selection:

- 1. Create a selection.
- 2. Optional: For help in positioning the selection precisely at a specific location in the document, display the rulers (Ctrl-R/Cmd-R), drag a guide from the horizontal or vertical ruler, and turn on View > Snap To > Guides.
- 3. Do either of the following:

On the Layers panel, click the Background, then choose a Background color (see Chapter 11). The area that is exposed when you move the selection will be filled with this color.

Click a layer. The area you expose when you move the selection will be filled with transparent pixels.

- 4. Choose the Move tool or hold down V to spring-load the Move tool.
- 5. Drag from within the selection. B You can let the edge of the selection snap to a ruler guide, if you created one. The distance you move the selection displays in a dynamic readout onscreen.
- Deselect (Ctrl-D/Cmd-D).
- In Chapter 13 you will learn how to copy the contents of a selection and how to use other alignment aids, such as Smart Guides.
- With the Move tool chosen, you can press an arrow key to nudge a selection (and its contents) by one pixel at a time, or press Shift-arrow to nudge it by 10 pixels at a time.

A A selection border is moved with a selection tool.

B Selection contents are moved on a layer with the Move tool.

Using the Quick Selection tool

The Photoshop features we're going to discuss next the Quick Selection tool, Magic Wand tool, and Color Range command — create selections in a more automatic way than the marguee and lasso tools. With these tools, Photoshop does the work of detecting color boundaries for you.

If the area you want to select has fairly well-defined borders, try using the Quick Selection tool instead of a lasso tool. Rather than tediously tracing a precise contour, with this tool, you merely drag within a shape and pause to let it detect and select the shape's edge. You can push the resulting selection outward to include an adjacent color boundary or inward to make it smaller. This tool is awesome!

To use the Ouick Selection tool:

- 1. Click the layer you want to edit.
- 2. Choose the Quick Selection tool (W or Shift-W).
- 3. On the Options bar, do all of the following: Click the **New Selection** button to replace any existing selections with the one you're about to create (or press Ctrl-D/Cmd-D to deselect).
 - Check Sample All Layers to let the tool detect color boundaries on all layers, or uncheck this option to allow it to detect color boundaries on just the current layer.
 - Check Auto-Enhance for a smoother, more refined selection edge.
- 4. To choose a brush diameter, press] or [, then drag within the area to be selected. A The selection will expand to the first significant color or shade boundary that the tool detects. The selection will preview as you drag, and will become more precise when you release the mouse.
- 5. Do either of the following (optional):
 - To enlarge the selection, click or drag in an adjoining area; the selection will expand to include it.B-C
 - To shrink the selection, Alt-drag/Option-drag along the edge of the area to be subtracted (the modifier key is equivalent to clicking the Subtract From button on the Options bar) (A-B, next page).
- You can change the tool diameter between clicks.
- To block an adjacent area from being included as you enlarge an existing selection, hold down

A We selected the kumquat in the center of this layer by dragging inside it with the Quick Selection tool.

B After enlarging the brush diameter slightly, we clicked the kumquat on the right to add it to the selection.

Next, we dragged across the green leaf above the kumquats. The selection spread beyond the edge of the leaf to include some of the background area, which wasn't our intention.

Alt/Option and click or drag in that area, release Alt/ Option and the mouse, then drag to enlarge the selection area, while avoiding the blocked area. The area will remain blocked until you click it again with the Quick Selection tool. C-E

- To undo the last click or drag of the Quick Selection tool, press Ctrl-Z/Cmd-Z.
- To save a selection, see page 182.
- To clean up a Quick Selection, you can use another selection tool, such as the Lasso. To refine the selection, see pages 182-183.

A We Alt-dragged/Option-dragged below the leaf to subtract the background area from the selection...

f B \dots and did the same thing to subtract the area below the kumquats.

C We zoomed in, reduced the brush diameter, then Altclicked/Option-clicked areas around the stems to prevent them from becoming selected.

D We dragged along the stems to select them, then held down Alt/Option and clicked the background areas between the stems to remove them from the selection.

E Finally, we cleaned up the selection of the stems. (At this point, we could copy the selection to a new layer; it would be surrounded by transparent pixels.)

Using the Magic Wand tool

With the Magic Wand tool, you simply click a color in the image and the tool selects all adjacent pixels of the same (or a similar) shade or color. Like the Color Range command (see pages 176–177), the Magic Wand lets you control the range of pixels the tool selects, but unlike Color Range, this tool also lets you add nonsimilar colors to the selection.

To use the Magic Wand tool:

- 1. Click a layer or the Background.
- 2. Choose the Magic Wand tool (W or Shift-W).
- 3. On the Options bar, do all of the following:

 Choose a **Tolerance** value to control the range of colors the tool selects. The higher the value, the wider the range.

Check **Anti-alias** to let the tool add semitransparent pixels along the edges of the color areas it detects. This will produce smoother edge transitions for your image edits.

Check **Contiguous** to limit the selection to areas that are connected to the first pixel you click, or uncheck this option to allow the tool to select similarly colored, noncontiguous (unconnected) areas throughout the image with each click.

To select occurrences of a similar color on all visible layers, check **Sample All Layers**, or uncheck this option to select colors on just the current layer.

- 4. Click a color in the image.
- **5.** Do either of the following (optional):

To $\operatorname{\textbf{add}}$ to the selection, Shift-click any unselected areas. $\pmb{\mathbb{A}}$

To **subtract** areas from the selection, hold down Alt/Option and click them. Or choose the Quick Selection tool, then with the Alt/Option key held down, drag short strokes across the areas to be subtracted.

See also the options in "To expand or add to a selection via a command," on the next page.

6. Optional: If you selected an area of the image that you want to remove and you clicked a layer in step 1, press Backspace/Delete; □ or if you clicked the Background in step 1, choose a Background color, then press Ctrl-Backspace/Cmd-Delete. Deselect (Ctrl-D/Cmd-D).

A To select the sky in this image layer, we clicked on the right side with the Magic Wand tool (Tolerance 38; Contiguous checked), then Shift-clicked more sky areas to add them to the selection (as shown above).

B Some parts of the keys became selected, so we are using the Quick Selection tool with Alt/Option held down to subtract them from the selection.

 ℂ Finally, we pressed Backspace/Delete to get rid of the selected pixels, to isolate the hand and keys (in this document, the Background is hidden).

To select just one color or shade with the Magic Wand tool, choose a Tolerance value of 0 or 1. You can also lower the Tolerance value incrementally between clicks. For instance, you could use a Tolerance of 30-40 for the first click, lower the value to 15-20 and Shift-click, then to add unselected areas along the edges of the selection, lower the value to 5–10 and Shift-click once more.

The Grow command expands a selection only into contiquous areas, whereas the Similar command can add both contiguous and noncontiguous areas to a selection. Both commands select a range of pixels up to the current Tolerance setting of the Magic Wand tool.

To expand or add to a selection via a command:

Create a selection, then choose Select > Grow or Similar; A-B or if the Magic Wand tool is selected, right-click in the image and choose either command from the context menu. You can repeat either command to enlarge the selection further.

To undo the results of the last click made with the Magic Wand tool or the last use of the Grow or Similar command, press Ctrl-Z/Cmd-Z.

Inverting a selection

If one area of a layer is easier to select than another, select the easy part first (such as the sky in a landscape photo), then invert the selection.

To invert a selection:

Do either of the following:

With any tool chosen, press Ctrl-Shift-I/Cmd-Shift-I (Select > Inverse). C-D

With any selection tool chosen, right-click in the document and choose Select Inverse.

TO ANTI-ALIAS OR NOT?

Before using a selection tool that you have chosen, check Anti-alias (if available) on the Options bar to have the edge of the selection fade to transparency, or uncheck this option to produce a crisp, hard-edged selection. The effect of anti-aliasing won't be visible until you copy and paste, move, or edit the selected pixels.

A We clicked the blue sky area with the Magic Wand tool (Tolerance of 35), Shift-clicked once on the clouds...

C This is the original selection.

D And this is the inverse of the same selection.

Using the Color Range command

Using the Color Range dialog, you can select areas of an image based on color or tonal values, such as a sampled color, a range of specific hues, a luminosity range, or skin tones.

To use the Color Range command to create a selection:

- 1. In an RGB document, click a layer. Note: The command samples colors from all the currently visible layers, regardless of which layer is active. Optional: Create a selection to restrict the area in which the command may select colors. A
- 2. Choose Select > Color Range.
- 3. In the Color Range dialog, choose from the Select menu to limit the selection to Sampled Colors (shades or colors you'll click with the Color Range eyedropper); to a specific preset color range (e.g., Reds or Blues); to a luminosity range (Highlights, Midtones, or Shadows); or to Skin Tones.
- 4. If you chose the Select menu option of Sampled Colors, with the **Eyedropper** tool **a** chosen in the dialog, click to sample a color in the preview or in the image.B
- 5. Optional: Check Localized Color Clusters to limit the selection to colors near the one you clicked.
- 6. To add colors or shades to the selection, Shift-click or Shift-drag in the document or preview; or to subtract colors or shades from the selection, hold down Alt/Option and click or drag.
- 7. If you chose the Select menu option of Sampled Colors, you can select a wider or narrower range of similar colors by adjusting the Range value. Similarly, for the Select menu option of Highlights or Shadows, you can use the Range slider to include or exclude adjacent tonal levels from the selection.
 - Or if you chose Midtones as the Select menu option, you can use the black Range slider to include or exclude adjacent tonal levels from lower midtone areas, or use the white Range slider to include or exclude adjacent tonal levels from the upper midtones.*
- 8. For any Select menu option except a specific hue, you can use the Fuzziness slider to expand or narrow the number of partially selected pixels along the edges of the selection.

We created a rough rectangular selection of the water area in this image.

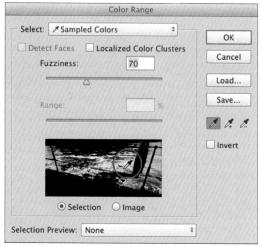

B We opened the Color Range dialog, then with the eyedropper, clicked the water in the preview. (White represents fully selected pixels; gray represents partially selected pixels.)

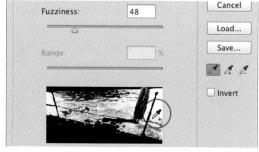

To add to the selection, we Shift-clicked a couple more areas of water, then reduced the Fuzziness value to 48.

A With the Color Range selection still active, we created a Hue/Saturation adjustment layer. The selection converted to white areas in the layer mask.

B Although the ocean area wasn't selected completely, enough of it was selected for the Hue/Saturation adjustment to be successful. Now the ocean looks darker and more blue.

- 9. If you chose Skin Tones in step 3, you can check Detect Faces to improve the accuracy of the selection (A-D, page 178).
- 10. For the document preview, choose an option from the Selection Preview menu: None for no preview, Grayscale to see an enlarged version of the dialog preview, Black Matte to view the selection against a black background, or White Matte (our favorite) to view the selection against a white background.
 - To toggle the Selection and Image previews in the dialog, press Ctrl/Cmd, then release.
- 11. Optional: To save the current dialog settings as a preset, click Save, enter a name, keep the default location and extension, and click Save. The settings file saves to the same location as other presets. \bigstar

12. Click OK.

- 13. Optional: With the selection still active, create an adjustment layer (see Chapter 12). The selection will be converted to white areas in the adjustment layer mask.A-B
- To load a Color Range preset into the dialog, click Load, locate the desired preset, then click Open.
- Color Range settings are sticky, meaning that the last-used settings — including the last color that was sampled with the eyedropper in the dialog — will be in effect the next time you open the dialog. If you want to use the current Foreground color as the sampled color instead, hold down the Spacebar as you open the dialog.

A This is the original image.

The Color Range command produced the selection shown to the left above. With the Lasso tool, we removed some extraneous areas from the selection.

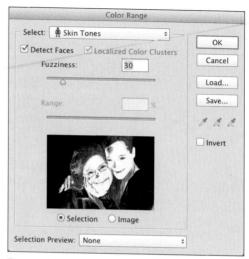

In the Color Range dialog, we chose Select: Skin Tones, checked Detect Faces, then adjusted the Fuzziness value.

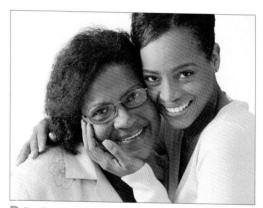

D Finally, we used a Hue/Saturation adjustment layer to correct the hue, saturation, and lightness of the selected skin areas (to learn about Hue/Saturation, see pages 238–239).

Hiding and showing the selection border

You can hide the blinking selection border without having to deselect the selection (say, to preview the results of an edit). If you do hide the border, remember that the selection remains in effect!

To hide or show the selection border:

Press Ctrl-H/Cmd-H or chose View > Extras.

Note: A one-time alert dialog may appear, offering you the option to assign the Ctrl-H/Cmd-H shortcut to the Extras command in Photoshop (our preference) or to the Hide Photoshop command.

If the Ctrl-H/Cmd-H shortcut doesn't hide the selection border, it's because the Selection Edges option is unchecked in the Show Extra Options dialog. To make it available, choose View > Show > Show Extra Options, and in the dialog, check Selection Edges. (We like to keep all the options in that dialog checked so they can all be enabled or disabled quickly via the Ctrl-H/Cmd-H shortcut.)

A We drew an inner selection with the Rectangular Marquee tool on this 300 ppi image, applied a Feather value of 25 px via Refine Edge, then chose Select > Inverse. Next, we used a Levels adjustment to lighten the area within the selection (see pages 230–231).

B Finally, we added four separate editable type layers. The type is easy to read on the lightened background.

Creating a frame-shaped selection

With the Rectangular Marquee or Elliptical Marquee tool, you can create a selection in the shape of a frame, either at the edge of the canvas area or floating within it. Image edits that you apply to the frame-shaped selection (e.g., filters or adjustments) will be visible only within that area.

To create a selection in the shape of a

Method 1 (at the edge of the canvas area)

- 1. Click a layer.
- 2. Choose the Rectangular Marquee tool [1] (M or Shift-M).
- 3. In the document window, drag a border to define the inner edge of the frame selection.
- 4. Optional: To soften the edges of the selection, click Refine Edge on the Options bar. In the dialog, choose On White (W) from the View menu, set the sliders to 0, adjust the Feather value to achieve the desired level of softness, then click OK.
- 5. Press Ctrl-Shift-I/Cmd-Shift-I (or right-click in the document and choose Select Inverse). A-B

Method 2 (within the image)

- 1. Click a layer.
- Choose the Rectangular Marquee or Elliptical Marquee tool (M or Shift-M), then drag to define the outer edge of the frame selection.
- 3. Alt/Option drag inside the first selection to create the inner edge of the "frame." C Before releasing the mouse, you can release Alt/Option then hold down the Spacebar and drag the inner selection. After releasing the mouse, you can drag between the selection borders to reposition the entire "frame."

We are holding down Alt/Option and dragging to subtract one rectangular selection from the other.

Selecting in-focus areas of a photo

The Focus Area command selects the areas of a photo that are most in focus automatically, and lets you modify the selection via sliders and brushes. For the best results, use this command on a photo in which foreground shapes are in sharp focus against a blurry background. You can further improve the selection afterward by using the Refine Edge dialog.

To use the Focus Area command: ★

- 1. Open a photo in which one area is more in focus than other areas.A
- 2. Choose Select > Focus Area. The dialog opens. Check Preview.
- 3. To control how the selection previews in the document, from the View menu, choose Overlay, On Black, On White, or On Layers (these options are described in step 4 on pages 182-183). Pause while the command selects the in-focus areas.
- 4. Under Parameters, do the following:

For the In-Focus Range, keep Auto checked to let Photoshop determine the focus range for the selection; or increase the In-Focus Range value to enlarge the selection area, B or decrease the value to reduce the selection area.

For the Image Noise Level (Advanced area), with Auto checked, Photoshop will try to remove noise (extraneous pixels) it detects from the area around the selection. If the Auto results aren't satisfactory, increase the Image Noise Level slightly.

5. To enlarge or reduce the selection manually, do the following:

Click the Focus Area Add tool (E), then either press X (to view the original image) or V (for the View: Overlay option). Press [or] to set the brush to a small to medium size, then drag over the shape you want to add to the selection (A-B, next page). The tool will try to detect the edges of the shape automatically.

To remove an area from the selection, set the brush size, then hold down Alt/Option and drag over the area to be removed. This is a temporary Focus Area Subtract tool.

6. To output the selection, do either of the following: Choose an option from the Output To: menu. Choose Selection or Layer Mask to output the selection without putting the contents on a new

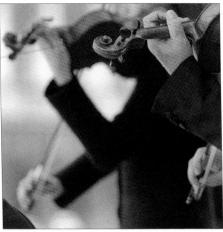

A In the original image, the violinist in the foreground is as prominent as the violinist in the background.

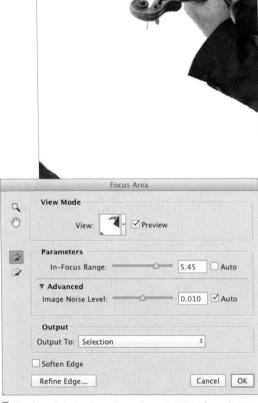

B We chose Select > Focus Area, chose On White from the View menu, then increased the In-Focus Range value to select more of the in-focus area. Most of the violin and arm became selected.

layer (the Layer Mask option adds a mask to the current layer). Or to copy the selection contents to a new layer, choose New Layer (no mask) or New Layer with Layer Mask (the selection will be converted to white areas in a layer mask). Click OK.C-D

A To fine-tune the selection (pun intended), we chose the Focus Area Add tool, then dragged the tool over the neck and pegs of the violin; those areas are now fully selected.

C From the Output To: menu, we chose New Layer with Layer Mask. To accentuate the imagery on the new layer, we lightened it via a Brightness/Contrast adjustment, then clipped the adjustment layer to the new layer. Finally, we added another Brightness/Contrast adjustment to darken the entire Background.

To soften the edge of the selection, check Soften Edge.

Click Refine Edge to open the Refine Edge dialog, then use the dialog to clean up the edges of the selection; see pages 182-183. Refine Edge has the same output options as described in the preceding paragraph.

B Continuing with the Focus Area Add tool, we dragged over the lower hand and bow to select those areas. Next, with the Focus Area Subtract tool, we removed the dark triangle from the lower-left corner of the selection (shown in \mathbb{B} on the preceding page).

In the final image, the foreground figure stands out clearly from the other elements.

Saving and loading selections

Creating a selection can be a laborious process, but fortunately, you can preserve your selection either as an alpha channel (this page) or as a layer mask (see page 190). The channel or mask can be loaded as a selection at any time (see this page and page 194) and can also be edited.

To save a selection to an alpha channel:

- 1. Create a selection.A
- 2. Do either of the following:

On the Channels panel, click the Save Selection as Channel button.

Choose Select > **Save Selection**. The Save Selection dialog opens. Enter a Name, then click OK.

- **3.** An alpha channel listing appears on the Channels panel. Press Ctrl-D/Cmd-D to deselect.
- To reverse the masked and unmasked areas in an alpha channel, click the alpha channel listing on the Channels panel, then press Ctrl-I/Cmd-I.
- To rename an alpha channel, double-click the name, type a new one, then press Enter/Return.
- To delete an alpha channel, right-click the listing and choose Delete Channel.
- When using the File > Save As dialog, you can check Alpha Channels (if available for the current file format) to save alpha channels with your file.

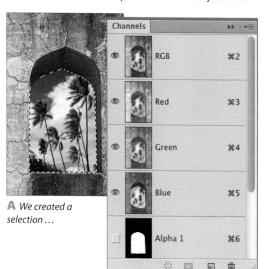

B ... then clicked the Save Selection as Channel button on the Channels panel. The Alpha 1 listing appeared.

To edit an alpha channel:

- 1. On the Channels panel, click an alpha channel.
- 2. Choose the Brush tool (B or Shift-B), set the brush opacity, then paint with white to expand the selection area or with black to remove areas from it (press X to swap the two colors).
- 3. Click the topmost channel on the Channels panel.
- If you prefer to display and edit an alpha channel as a rubylith (red tint) over the image, click the alpha channel, then click the visibility icon for the topmost channel. To restore the normal display, Shift-click the alpha channel.

To load an alpha channel as a selection:

On the Channels panel, do either of the following: Ctrl-click/Cmd-click the alpha channel thumbnail or listing.

Drag the channel listing to the **Load Channel as Selection** button

Refining selection edges

The Refine Edge dialog provides many useful options for refining (e.g., smoothing, contracting) the edges of a selection, as well as options for outputting the selection (e.g., to a new layer or as a layer mask).

To refine the edges of a selection:

- 1. Create a selection and keep the selection tool chosen. Click a layer or the Background. Note: If you're going to output the selection as a layer mask (step 7), you must click a layer.
- Click Refine Edge on the Options bar or press Ctrl-Alt-R/Cmd-Option-R. The dialog opens (A, next page).
- **3.** If the sliders aren't set to 0, reset them all to that value. Zoom in on the selection in the document by pressing Ctrl-+/Cmd-+.
- 4. To control how the selection previews in the document, choose an option from the View menu; or use the assigned letter shortcut, as listed on the menu; or cycle through the options by pressing F. We find these options to be the most useful:

Overlay (V) to view the selection as a Quick Mask (to judge the selection relative to the areas outside it) (**B**, next page).

On Black (B) to view the selection on a black background (useful if you're going to copy the selection to a dark background).

On White (W) to view the selection on a white background (useful if you're going to copy the selection to a light background).

On Layers (L) to view the selection on top of the layer directly below it, if any (to judge how the selection looks on top of that layer).

5. Under Edge Detection, check Smart Radius to allow the Radius to adapt to hard and soft edges that Photoshop detects in the image.

If you want to enlarge the refinement area to include pixels just outside the selection edge, increase the Radius value.

To view just the current refinement area, check Show Radius (J); uncheck it before proceeding.

- Press P to toggle the refinement off, then on.
- 6. Under Adjust Edge, adjust any of these sliders: To smooth out small bumps or jaggedness along the edges, raise the Smooth value slightly.

To feather the edge, increase the Feather value. Note: If you're going to output your selection as a mask, keep this slider at 0 and use the nondestructive Feather slider on the Masks panel instead (see

To produce a crisp selection edge, increase the Contrast value. This option counters the effect of an increased Radius, Smooth, or Feather value.

To contract the selection inward to eliminate background pixels, or to expand it outward to include more, adjust the Shift Edge value.

7. Under Output:

page 192).

If you want to replace a fringe of background pixels along the selection edge with colors from within the selection, check Decontaminate Colors, then adjust the Amount value.

Choose Output To: Selection or Layer Mask to output the refined selection without putting the contents on a new layer. Or to copy the selection contents to a new layer, choose New Layer (no mask) or New Layer with Layer Mask (the selection is converted to white areas in a layer mask). If Decontaminate Colors is checked, only the "New" layer options will be available.

- 8. Optional: Check Remember Settings to have the current settings become the new default values for the dialog (we keep this option off).
- **9.** Click OK. (See also the task on the next four pages.)

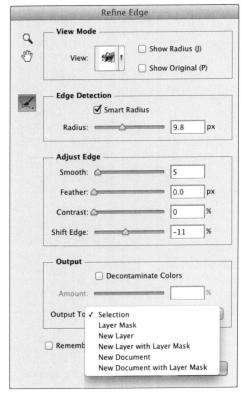

A The Refine Edge dialog provides many options for refining and outputting a selection.

B With Overlay chosen on the View menu in the Refine Edge dialog, the selection displays on a red-tinted Ouick Mask.

C With the On White option chosen on the View menu, the selection displays on a white background.

Using the Refine Radius tool in the Refine Edge dialog, along with the sliders, you can fine-tune the edge of a selection manually. Here we'll show you how to use these controls to refine a selection of hair (the bane of any Photoshopper's existence!), so you will be able to stack just the figure — surrounded by transparent pixels — above a different background.

To improve a selection of hair via the Refine Edge dialog:

- 1. Open an RGB portrait in which the figure has flyaway hair, and duplicate the Background.
- Click the Background, and create a new Solid Color fill layer (see page 211); via the Color Picker, choose a color to appear behind the figure. A Note: You won't see the color in the image until step 5.
- Click the duplicate image layer, then with the Quick Selection tool, loosely select the face and hair. Don't try to select the fine strands.
- **4.** On the Options bar, click **Refine Edge** (Ctrl-Alt-R/Cmd-Option-R). Make sure all the sliders are set to 0 and Decontaminate Colors is unchecked.

A We duplicated the Background in this 300 ppi photo, then created a Solid Color fill layer directly above the Background.

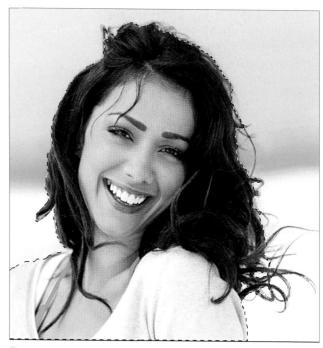

B With the Quick Selection tool, we made a rough selection of the figure, including just the main part of her hair, not the fine outer strands.

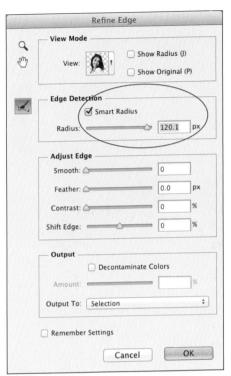

A In the Refine Edge dialog, we checked Smart Radius and increased the Radius value to 120 px.

B In On Layers view, the underlying layer is visible below the unselected areas. Now the selection includes most of her hair, but we will refine it further to add the fine strands.

5. From the View menu, choose On Layers (L). Under Edge Detection, check Smart Radius and set the Radius value to 80-120 px.A-B The higher the Radius value, the wider the area of edge pixels the command analyzes.

To display just the refinement area in the image so you can see how it is affected by the two radius options, check Show Radius or press J.C The Smart Radius feature analyzes the content of the refinement area, narrowing that area where the edges are well defined while keeping it wide where the edges are complex or more finely detailed. Press J again to turn off the Show Radius option.

We pressed J (Show Radius) to view the refinement area, noting where it was wide versus narrow. Afterward, we pressed J to return to On Layers view.

- 6. Choose the Refine Radius tool (E), then press X to view the original image layer. Press or [to set the brush to a medium to large size, then drag over the fine hair strands. Your brush work will display temporarily as green strokes. A-B
- 7. Press X to return to On Layers view.
 To better define the hard edges, if needed, adjust the Radius value, but keep the Contrast, Smooth, and Feather values at 0 so they don't impede the effect of the Refine Radius strokes.
- 8. Check Decontaminate Colors, then raise the Amount value until all colors from the background are removed. If you need to include yet more fine strands in the selection, increase the Shift Edge value slightly.
- **9.** Choose Output To: **New Layer with Layer Mask**, then click OK (**A**-**B**, next page).
- ➤ To make the fine hair strands in dark hair more visible, duplicate the new layer and its layer mask after the last step above (ℂ, next page).

A We clicked the Refine Radius tool, which pressed X to view the original image, then applied strokes over the fine hair strands to include them in the radius. (We didn't apply strokes to the edge of the sweater because the original selection of that area didn't need more refinement.)

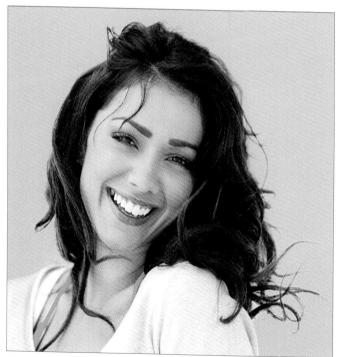

B Because we widened the refinement area, Refine Edge added the fine hair strands to the selection.

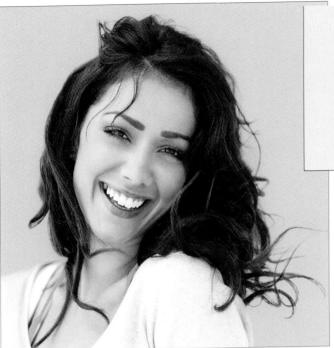

A We checked Decontaminate Colors, set the Amount value to 70%, and increased the Shift Edge value just enough to include more hair strands but none of the original background. From the Output To menu, we chose New Layer with Layer Mask (then clicked OK).

If you find that the Decontaminate Colors option produces unwanted colors along the selection edge, narrow the refinement area in those areas with the Erase Refinements tool.

B A new layer and layer mask appeared on the Layers panel (Photoshop hid the original duplicate layer automatically).

the hair strands look darker, then finally to soften the results, we lowered the Opacity of the newest layer to 70%.

Using Quick Masks

In these steps, you will create a selection, then put your document into Quick Mask mode; the selection displays temporarily as a semitransparent red tint over the image (like a traditional rubylith). You will add or subtract areas from the mask using brush strokes, then put the document back into Standard mode; the mask converts back to a (newly reshaped) selection. You can also use this mode to create a selection from scratch, as described on the next page.

To reshape a selection in Quick Mask mode:

- 1. Select an area of a layer.
- 2. Click the Edit in Quick Mask Mode button on the Tools panel or press Q. A red-tinted mask should cover the unselected areas of the image. B (If the mask is covering the selected area, double-click the same button, click Color Indicates: Masked Areas, click OK, then press Q to reenter Quick Mask mode.)
- 3. Choose the Brush tool (B or Shift-B).
- 4. On the Options bar, click the Brush Preset picker arrowhead, then click a Hard or Soft Round brush (Soft if you want the selection edge to be slightly feathered); choose Mode: Normal; and set both the Opacity and Flow to 100%.
- 5. Zoom in on the mask, size the brush cursor by pressing [or], then do either of the following: To enlarge the masked (protected) area, press D for the default colors (black becomes the Foreground color), then apply brush strokes. To enlarge the unmasked area, press X to swap the Foreground and Background colors (make the Foreground color white), then apply strokes.
 - To create a partial mask, lower the brush opacity before applying strokes. When you edit pixels within the selection, that area will be only partially affected by your edits.
- **6.** To restore the normal document mode, click the **Edit in Standard Mode** button on the Tools panel or press Q. The unmasked areas will turn into a selection.
- 7. Optional: To preserve the selection, store it as an alpha channel (see page 182) or as a layer mask (see page 190). There is no way to save the Quick Mask as a mask or selection while your document is in Quick Mask mode.

We selected an area of a layer.

B When we put the document into Quick Mask mode, Photoshop covered the unselected area with a red mask.

Here, we're unmasking the helmet by applying strokes with the Brush tool.

In these steps, you will paint a mask directly in a document without creating a selection first. As with any Quick Mask, when you restore the document to Standard mode, it is converted to a selection. One practical use for this technique is to select areas for retouching, such as the eyes or teeth areas in a portrait.

To create a selection via a Quick Mask:

- Choose the Brush tool, and choose tool options as described in step 4 on the preceding page.
- 2. Double-click the Edit in Quick Mask Mode button on the Tools panel.
- 3. In the Quick Mask Options dialog, A click Color Indicates: Selected Areas. This will enable the areas that you cover with your red-tinted brush strokes (not the masked areas) to convert to a selection when you exit Quick Mask mode. Click OK.
- Zoom in, size the brush cursor by pressing [or], then using black as the Foreground color, apply brush strokes to create a mask.B
 - You can start by painting with a medium-sized brush, then refine the mask with a smaller one.

If you need to remove any areas from the mask, press X to switch the Foreground color to white.

- 5. Press Q to put the document back into Standard mode. The mask converts to a selection.
- 6. Optional: To feather all the edges of the selection, use the Feather slider in the Refine Edge dialog (see page 183).
- 7. Optional: To store the selection as a mask on the current layer, see the next page. Or to save it as an alpha channel, see page 182.

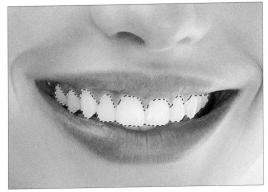

When we restored the document to Standard mode, the mask converted to a selection. (To use a selection like this one to whiten teeth, see page 308.)

A We clicked Selected Areas in the Quick Mask Options dialog, and also changed the mask color from the default of red to blue to have it contrast better with the image.

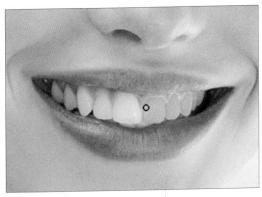

B We're painting a Quick Mask on teeth.

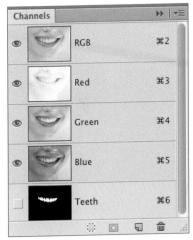

We saved the selection as an alpha channel.

Creating layer masks

A layer mask is an editable (and removable) 8-bit grayscale channel that hides all or some of the pixels. type, or vector shapes on a layer. White areas in a layer mask reveal parts of the layer, black areas hide, and gray areas hide partially. Memorizing this simple phrase will help: White reveals, black conceals.

When a layer mask thumbnail is selected, you can edit the mask or move or copy it to other layers. At any time, you can disable a mask temporarily, apply it to make its effect permanent, or discard it altogether.

A The original image contains a photo of tile on a layer above a photo of an archway on the Background. We selected the archway, then clicked the tile layer.

B To add a black mask to the tile layer, we held down Alt/Option and clicked the Add Layer Mask button on the Layers panel. To blend the tile with the stone wall, we chose Pin Light blending mode and lowered the layer opacity.

To add a layer mask via the Layers panel:

- 1. Optional: Create a selection, which is to become a shape in the mask.
- 2. On the Layers panel, click an image, type, or shape layer, a layer group, or a Smart Object. A
- 3. Do either of the following:

To create a white mask that hides none of the layer or that hides only the areas outside an active selection, at the bottom of the Layers panel, click the **Add Layer Mask** button.

To create a black mask that hides the whole layer or that hides only the areas inside an active selection, Alt-click/Option-click the Add Layer Mask button on the Layers panel. B-C

To create a selection from type, Ctrl-click/ Cmd-click the thumbnail for an editable type layer. You can then hide the type layer by clicking its visibility icon, and use the selection to produce a mask on another layer.

To output a selection as a layer mask via the Refine Edge dialog:

- 1. Create a selection to become a shape in the mask.
- 2. On the Layers panel, click a layer, layer group, or Smart Object.
- 3. Click Refine Edge on the Options bar, and use the dialog to refine the selection edges (see pages 182-183). From the Output To menu, choose Layer Mask, then click OK.

The center of the tile layer is hidden by the arch-shaped mask.

Editing masks

In this task, you'll edit a layer mask by applying strokes in the image with the Brush tool. In the steps on the next two pages, you will edit a mask via the Properties panel. Throughout this book, you will have many opportunities to practice these essential skills.

To reshape an existing layer mask:

- 1. Choose the **Brush** tool **(B** or Shift-B).
- 2. On the Options bar, click a brush on the Brush Preset picker; choose Mode: Normal; and choose an Opacity of 100% to mask or unmask areas fully or a lower Opacity to mask or unmask them partially.
- 3. Do either of the following:
 - To display a mask as a colored overlay on the image, Alt-Shift-click/Option-Shift-click a layer mask thumbnail on the Layers panel. A-B
 - To display a mask in black and white with the image hidden, Alt-click/Option-click a layer mask thumbnail on the Layers panel.
- 4. Size the brush cursor by pressing [or], then do either or both of the following (to change the brush hardness or opacity, see pages 128-129): If the Foreground Color square on the Tools panel isn't white, press D. Apply brush strokes to remove areas of the mask and reveal more of the layer. C Press X (to switch the Foreground color to black), then apply brush strokes to enlarge the mask and hide more of the layer. D-E
- 5. Click the layer (not the mask) thumbnail.
- In lieu of step 3, you can double-click the layer mask thumbnail, then hold down Alt-Shift/Option-Shift or Alt/Option and click the Layer Mask thumbnail on the Properties panel.
- To open a dialog in which you can change the color or opacity that is used to display layer masks in your document, right-click a layer mask thumbnail on the Layers panel and choose Mask Options.

To swap the black and white areas in a layer mask:

Do either of the following:

Click a layer mask thumbnail on the Layers panel, then press Ctrl-I/Cmd-I.

Double-click a layer mask thumbnail on the Layers panel to display the Properties panel, then click the Invert button.

A We're painting out areas of the mask, which we chose to display as a red overlay.

B This is the result.

C Here we're subtracting areas from the mask (painting with white) with just the mask showing in the document.

D We're adding to the mask by painting with black.

E Here we're partially hiding an area of the archway layer by painting on the mask with our brush set to 60% Opacity.

A In this document, a black, hard-edged layer mask is hiding everything on the image layer except the car.

In the Masks pane of the Properties panel, you can use the Density slider to change the overall opacity of a layer or vector mask and/or the Feather slider to adjust the softness of the edge of the mask. These sliders are nondestructive, meaning they don't alter the mask permanently and can be readjusted at any time. (To learn about vector masks, see pages 414-417.)

To adjust the density or feather value of a layer or vector mask:

- 1. Double-click a layer or vector mask thumbnail on the Layers panel \mathbb{A} to show the Properties panel.
- 2. Do either or both of the following: Reduce the **Density** value to lighten the black part of the mask and partially reveal areas of the layer (make the mask more transparent). B Increase the **Feather** value to soften the edge of the mask, for a more gradual transition between

the masked and unmasked areas.

 $oldsymbol{\mathbb{B}}$ To lighten the black part of the mask, we reduced the Density value on the Properties panel.

Next, we increased the Feather value on the Properties panel to soften the edges of the mask. (Note that the layer Opacity is still 100%.) The car is the star of the show, while the faded background plays a supporting role.

To refine the edges of a layer mask:

- 1. Double-click a layer mask thumbnail on the Layers panel to show the Properties panel.
- 2. Click Mask Edge to open the Refine Mask dialog. Note: If you don't see the Mask Edge button, either scroll downward in the panel or enlarge the panel by dragging the gripper bar downward.
- 3. Use the Refine Mask controls to adjust the softness or sharpness of the edge of the mask. For an illustration of this feature, see page 261. The Refine Mask controls work like the controls in the Refine Edge dialog, which is discussed on pages 182-187.
- When we need to feather the edge of a mask, we use the Feather slider on the Properties panel because it's nondestructive, and keep the Feather slider in the Refine Mask dialog at 0 because it's destructive.
- If you create a mask by applying brush strokes or by converting an imprecise selection, some unwanted image pixels may still be visible along the edges. To expand or contract the mask to include or exclude more pixels, in the Refine Mask dialog, try setting the Radius to around 1 or 2, and fiddle with the Shift Edge slider.

If you click Color Range on the Properties panel for a selected mask, you can edit the mask using the same dialog controls as you would use to create a selection via the Select > Color Range command (see pages 176-177).

Working with masks

By default, every layer mask that you create is linked to its layer thumbnail, and when moved, the two travel together as a unit. If you want to move either component separately, you have to unlink them first. Note: This task applies only to layer masks, not to vector masks.

To reposition layer content or a mask independently:

- 1. On the Layers panel, click the **Link** icon ${f @}$ between a layer thumbnail and layer mask thumbnail. The icon disappears.
- 2. Click either the layer thumbnail or the layer mask thumbnail, depending on which component you want to move. A-B
- 3. Choose the **Move** tool (or hold down V to spring-load the tool), then drag in the document window.C
- 4. Click between the layer and layer mask thumbnails to restore the Link icon.

A layer mask is hiding the center of the tile layer and revealing part of the underlying Background.

B We clicked the Link icon to disengage the layer image from the mask, then clicked the layer mask thumbnail.

With the Move tool, we dragged the mask in the document to reveal a different part of the Background.

Note: All the tasks on this page apply to both layer and vector masks.

You can move or copy a layer or vector mask to a different layer (but not to the Background).

To move a mask to a different layer:

Drag a layer or vector mask thumbnail to another layer. The mask disappears from the original layer and appears on the destination layer.

To copy a mask to another layer:

Alt-drag/Option-drag a layer or vector mask thumbnail to another laver.

When you load a layer or vector mask as a selection, it displays in your document as a border of "marching ants."

To load a mask as a selection:

Do either of the following:

On the Layers panel, Ctrl-click/Cmd-click a mask thumbnail.

On the Layers panel, double-click a mask thumbnail, then on the Properties panel, click the Load Selection from Mask button

When you disable a layer or vector mask, a red X appears in the thumbnail on both the Layers and Properties panels, and the entire layer becomes visible

To disable or enable a mask:

Method 1 (Layers panel)

To disable a mask, on the Layers panel, Shiftclick the mask thumbnail A (this doesn't select the thumbnail). To re-enable a layer mask, just click the mask thumbnail; to re-enable a vector mask, Shift-click the thumbnail.

You can also right-click the mask thumbnail and choose Disable Layer Mask or Disable Vector Mask from the context menu (or choose the "Enable" version of either command).

Method 2 (Properties panel)

To disable or re-enable a mask, on the Layers panel, double-click a mask thumbnail, then on the Properties panel, click the Disable/Enable Mask button.

You can discard any masks you don't need. Deleting a layer mask will reduce the file size slightly; deleting a vector mask will have little impact on the file size.

To delete a mask:

- 1. Optional: Copy the file via File > Save As.
- 2. Do one of the following:

On the Layers panel, right-click a mask thumbnail and choose Delete Layer Mask or Delete Vector Mask.

On the Layers panel, click a mask thumbnail, click the **Delete Layer** button, then if an alert dialog appears, click OK (or Alt-click/Option-click the button to bypass the prompt).

On the Layers panel, double-click a mask thumbnail to display the Properties panel, then click the Delete Mask button.

On an image layer (no other kind of layer), you can apply the effect of a layer or vector mask and delete the hidden pixels permanently. The mask thumbnail disappears from the Layers panel.

To apply a mask to its laver:

- 1. Optional: Applying a mask is a permanent change, so you may want to either duplicate its layer or copy the file via File > Save As.
- **2.** Do either of the following:

On the Layers panel, right-click a layer mask thumbnail and choose Apply Layer Mask.

On the Layers panel, double-click a layer or vector mask thumbnail to display the Properties panel, then click the Apply Mask button.

A To disable a layer mask, Shiftclick the mask thumbnail.

Using the History panel, you can selectively restore your document to one of its previous states (in the current work session). The panel provides many more options and much more flexibility than the simple Undo command. In this chapter, you will learn how to set options for the History panel; restore your document to a previous history state; delete, purge, and clear history states; preserve states of the current work session via snapshots; and generate a new document from a state or snapshot.

Choosing History panel options

The History panel keeps a running list of the states, or edits, that you have made to the currently open document, from the "Open" unedited state of the document at the top of the list to the most recent state at the bottom. (This happens even if you don't have the panel open.)

When you click an earlier state, the document is restored to that stage of the editing process. Recent states may become dimmed and unavailable when you do this, depending on whether the panel is in linear or nonlinear mode. A Before using the panel, you need to understand this difference between the two modes.

A With our History panel in linear mode, we clicked an earlier state, which caused subsequent states to become dimmed.

10

IN THIS CHAPTER

Choosing History panel options 195
Changing history states197
Deleting, purging, and clearing history states
Using snapshots199
Creating documents from history states

A BRUSH WITH HISTORY

In Chapter 14, we provide generic instructions on the use of brushes. On pages 301–302 in that chapter, we provide specific instructions for using the History Brush tool, which you can use to restore a history state within brush strokes.

Choosing a mode for the History panel

To choose a mode for the History panel, choose History Options from the panel menu, then in the History Options dialog, check or uncheck Allow Non-Linear History. A We recommend keeping the History panel in linear mode (unchecking Allow Non-Linear History), particularly if you're a newcomer to Photoshop. With the panel in this mode, if you click an earlier state and either resume image editing from or delete that state, all the subsequent (dimmed) states are discarded. Although this mode offers less flexibility, it enables you to restore your document to an earlier state with a simple, clean break.

In nonlinear mode, if you click or delete an earlier state, subsequent states aren't deleted or dimmed. B If you resume image editing while an earlier state is selected, your next edit will show up as the latest state on the panel, and all the states in between will be preserved. That is, the latest state will incorporate the earlier stage of the image plus your newest edit. If you change your mind, you can click any intermediate state whenever you like and resume editing from there. Nonlinear is the more flexible of the two modes, but it can also be confusing.

Choosing other settings for the History panel

The last option in the History Options dialog, Make Layer Visibility Changes Undoable, controls whether the panel creates a "Layer Visibility" state each time you click the visibility icon for a layer on the Layers panel. We keep this option off in order to reserve space on the panel for other states. (For the snapshot options in this dialog, see page 199.)

To specify the number of states that can be listed on the History panel, go to Edit/Photoshop > Preferences (Ctrl-K/Cmd-K) > Performance and, under History & Cache, choose a History States value (the default value is 20). If the maximum number of history states is exceeded during an editing session. the oldest states are removed to make room for new ones. The maximum number of states may also be limited by other factors, including the image size, the kind of edits made to the image, and currently available system memory. Each open document has its own separate list of states.

Beware! Regardless of the current preference setting, when you close a document, all of its history states and snapshots are deleted from the panel.

A In the History Options dialog, uncheck Allow Non-Linear History to put the panel in linear mode, or check it for nonlinear mode.

B With our History panel in nonlinear mode, we clicked an earlier state. All the states remained available, including the recent states below the one we clicked.

Changing history states

Before changing history states, let us remind you of the difference between the two modes for the History panel. If the panel is in linear mode (the Allow Non-Linear History option is off) and you click an earlier state, all the states below the one you click will become dimmed. If you then delete the state you clicked or continue editing the image while that earlier state remains selected, all the dimmed states will be deleted (if you change your mind, you can choose Undo immediately to restore the deleted states).

If the panel is in nonlinear mode and you click an earlier state, then proceed to edit your document, the newest edit will become the latest state, but Photoshop won't delete the prior states.

To change history states:

- 1. Perform some edits on an image.
- Do any of the following:
 On the History panel, foliate a state. A-B
 To Step Forward one state, press Ctrl-Shift-Z/Cmd-Shift-Z.
 - To **Step Backward** one state, press Ctrl-Alt-Z/Cmd-Option-Z.
- When you choose File > Revert, it is listed as a state on the History panel. You can restore the image to a state prior to or after the Revert state.
- Each time you click and change the settings for an existing adjustment layer, the panel lists those edits collectively as one new state (e.g., "Modify Levels Layer" or "Modify Curves Layer").
- You can't restack (change the order of) history states on the panel.

A With our History panel in linear mode, we're clicking a prior state.

B All the states listed below the one we clicked became dimmed.

Deleting, purging, and clearing history states

This task presumes that your History panel is in linear mode (you unchecked the Allow Non-Linear History option). With the panel in this mode, if you delete a state and then resume editing your document, that state and all the subsequent ones will be discarded from the panel.

To delete a history state:

On the History panel, do one of the following: Right-click a state, choose Delete from the context menu, A then click Yes in the alert dialog. That state and all the subsequent ones will be deleted.B

To bypass the alert, drag the state to be deleted to the Delete Current State button.

To delete previous states in reverse order without an alert appearing, click a state, then Alt-click/ Option-click the Delete Current State button as many times as needed.

Note: The Undo command restores only the last deleted state.

When you purge or clear states from the History panel, the most recent state is left as the only state remaining. All snapshots are preserved (see the next page).

To purge or clear the History panel:

To clear all states from your History panel for all of the currently open documents in order to free up memory for Photoshop, choose Edit > Purge > Histories, then click OK if an alert appears. (To prevent the alert from reappearing, check Don't Show Again.) As the alert warns you, this command cannot be undone!

To clear all states from the History panel for just the current document, right-click any state and choose Clear History. This command doesn't free up memory for Photoshop, but it can be undone.

A Right-click a state and choose Delete from the context menu, then click Yes in the alert dialog.

Because our History panel was in linear mode when we deleted a state, Photoshop also deleted all the subsequent states.

Using snapshots

Photoshop deletes states from the History panel if any of the following events occur: the specified maximum number of history states is exceeded, you clear or purge the panel, or you click an earlier state when the panel is in linear mode and then resume editing the document. Snapshots, which are created from a history state, remain on the panel even if any of the abovementioned events occur. When you click a snapshot, the document is restored to the state from which it was created.

Snapshots are represented by thumbnails at the top of the panel, for easy identification. A Note that like states, all snapshots are deleted when you close your document.

On this page, you will choose default settings for snapshots that apply to all Photoshop files. On the next page, you will create snapshots for a specific document.

To choose snapshot options:

- 1. From the History panel menu, choose History Options. The History Options dialog opens.
- 2. Check or uncheck any of the following options, all of which pertain to snapshots:

Automatically Create First Snapshot to have Photoshop create a snapshot each time a file is opened (this option is checked by default and we keep it that way).

Automatically Create New Snapshot When Saving to have Photoshop create a snapshot every time a file is saved. Each snapshot is labeled with the time of day it was created.

Show New Snapshot Dialog by Default to have the New Snapshot dialog appear whenever you click the New Snapshot button, enabling you to enter a name and choose a "From" option (see the next page).

3. Click OK.

Because the Automatically Create First Snapshot option was enabled when we opened this document, Photoshop created a snapshot of the document's opening state (the top snapshot). During the course of editing, we added three more snapshots.

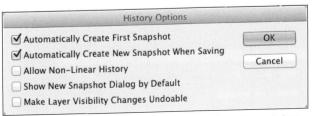

f B The History Options dialog has three snapshot options. We usually keep iust the first two checked.

If the Automatically Create New Snapshot When Saving option is turned off for your History panel, you should get in the habit of creating snapshots periodically as you work and before running any actions on your document. If you follow Method 2 (right), you can choose whether the snapshot is made from all the layers in the document, from all the layers present at a particular state, or from just the current layer.

To create a snapshot of a state:

Method 1 (without choosing options)

- 1. Edit your document so it contains the changes that you want to capture as a snapshot.
- 2. If the Show New Snapshot Dialog by Default option is off in the History Options dialog, click the New Snapshot button on the History panel; or if that option is on, Alt-click/Optionclick the New Snapshot button. A new snapshot thumbnail appears below the last one, in the upper section of the panel.

Method 2 (choosing options)

- 1. Edit your document so it contains the changes that you want to capture as a snapshot.
- 2. On the History panel, 7 right-click the state to be captured as a snapshot and choose New Snapshot from the context menu. A The layer that was being edited at that state becomes selected, and the New Snapshot dialog opens.
- 3. Type a name for the snapshot, then choose an option from the From menu:

Full Document to preserve all the layers that were in the document at the designated state.

Merged Layers to merge all the layers in the document at the designated state into one layer.

Current Layer to create a snapshot of just the layer that was selected at the designated state.

- 4. Click OK.C.
- 5. If you didn't create the snapshot from the latest state, click the state from which you want to resume editing your document.
- To rename a snapshot, double-click the name.

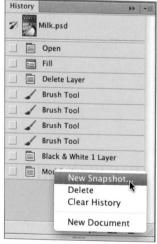

lack A After applying some edits to this image, we right-clicked the latest state and are choosing New Snapshot from the context menu.

f B In the New Snapshot dialog, we entered a name for the snapshot and chose From: Full Document.

C A thumbnail for the new snapshot appeared on the History panel.

Creating snapshots of promising or key document states periodically while editing is a good habit to get into. With their thumbnails, snapshots are easier to identify than states, and unlike states (which Photoshop may delete to make room for new states), snapshots stay on the panel until you close your document. Compare the two different options below, noting the different effect they have on the History panel.

To make a snapshot become the newest state:

After applying some edits to your document and creating one or more snapshots, do either of the following: **A**–**B**

Click a snapshot name or thumbnail. C—D If the History panel is in linear mode, the document will revert to the snapshot stage of editing, and all the states will be dimmed. If you now resume editing, all those dimmed states will be discarded.

Alt-click/Option-click a snapshot name or thumbnail. Earlier states will remain available and the snapshot you clicked will become the most recent state. Use this method if you want to preserve access to prior edits.

To delete a snapshot, drag it to the Delete Current State button or right-click the snapshot name and choose Delete from the context menu.

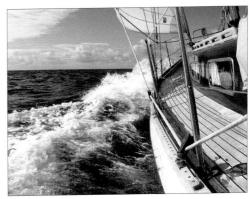

A This is the original image.

B During the course of editing the image (applying some filters), we created a few snapshots of different states.

We clicked a snapshot.

Now the image matches the state of the snapshot.

Creating documents from history states

By using the New Document command, you can spin off versions of your current document (and the current state of the Layers panel) from any state or snapshot.

To create a new document from a history state or snapshot:

- 1. On the History panel, do either of the following:
 Right-click a snapshot or a state and choose New
 Document from the context menu. Click a snapshot or a state, then click the New
 Document from Current State button.
- 2. Save the new document that appears onscreen. B

 The starting state for the document will be listed as "Duplicate State."
- **3.** In the original document, click the history state from which you want to continue editing.

A We right-clicked a snapshot and are choosing New Document from the context menu.

f B A new document appeared, bearing the name of the snapshot from which it was created.

In this chapter, you'll learn ways to choose the colors that are applied by various Photoshop tools and commands. You will also learn how to choose a blending mode for a layer or tool, apply a tint via a Solid Color Fill layer, apply and edit gradients, and create and apply patterns.

Choosing colors in Photoshop The Foreground and Background colors

The current Foreground color is applied by some tools, such as the Brush, Pencil, and Mixer Brush, and by some commands. The current Background color is applied by other procedures, such as when you enlarge the canvas area with the Crop tool (Delete Cropped Pixels option enabled) or cut an area from, or use the Eraser tool on, the Background. One or both of these colors are also used by some of the Photoshop filters.

The Foreground and Background colors are displayed in color squares on the Tools panel **A** and on the Color panel. **B** Note: In this book, Foreground color and Background color are written with an uppercase "F" and "B" to differentiate them from the general foreground and background areas of a picture.

On the following pages, you will learn how to choose Foreground and Background colors via these methods:

- Use the controls in the Color Picker dialog or via an on-image color picker.
- Choose a predefined color from a matching system via the Color Libraries dialog.
- ➤ Use the sliders on the Color panel.
- ➤ Click a solid-color swatch on the **Swatches** panel.
- > Sample a color in an image with the **Eyedropper** tool.

The Default Foreground and Background Colors button (D) makes the Foreground color black and the Background color white.

The Switch Foreground and Background Colors button (X) swaps the two current colors.

A These are the color controls on the Tools panel.

The currently selected square has an extra outer border.

Foreground color square

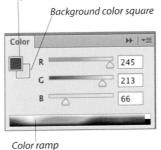

The two color squares also appear on the Color panel.

USING (OLOQ

11

IN THIS CHAPTER

Choosing colors in Photoshop 203
Using the Color Picker204
Choosing colors from a library 205
Using the Color panel
Using the Swatches panel 207
Using the Eyedropper tool 208
Copying colors as hexadecimals 208
Choosing a blending mode209
Creating a Solid Color fill layer 211
Creating a Gradient fill layer
Creating and editing a gradient preset
Using the Gradient tool216
Creating custom and scripted patterns

The color models

Colors in Photoshop can be chosen from four models and a wide assortment of matching systems. When output on a commercial press, your Photoshop image will be printed using different percentages of cyan (C), magenta (M), yellow (Y), and black (K) inks, which together create the impression of smooth, continuous tones. In the printing industry, colors are standardized by number, with each company providing its own system and printed fan guide or chip book (similar to the way you might pick colors of house paint). Spot colors, which are premixed inks based on set formulas (e.g., PANTONE PLUS), are sometimes used in addition to CMYK inks where color accuracy is critical, such as for a company logo. For commercial printing, the only way to get dependable results is by referring to a printed guide. If you pick colors based on whether they look appealing onscreen (even on a well-calibrated display), you may be in for an unpleasant —and potentially costly — surprise when you see them in print.

RGB colors (based on the components of red, green, and blue light in a computer display) are used solely for screen output; for these colors, you don't need to refer to a printed quide. For Web output, some designers also use hexadecimal colors. For the HSB color model, see the sidebar on page 206.

Using the Color Picker

To choose a color via the Color Picker:

1. Do either of the following:

On the Tools panel, click the Foreground or Background color square.

On the Color panel, 🚳 click the Foreground or Background color square if it's already selected (has an extra outer border), or double-click the square if it's not selected.

Note: If the square you click contains a custom color from a matching system (such as PANTONE PLUS), the Color Libraries dialog will open instead of the picker. Click the Picker button to get to the Color Picker dialog.

2. Do one of the following:

Click a color on the vertical color ramp or drag the slider to choose a hue, then click a brightness and saturation value of that hue in the large square. (You can also click or drag in the image to sample a color while the Color Picker dialog is open.)

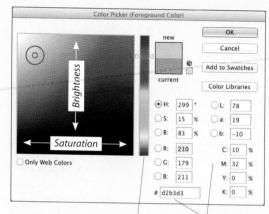

A To pick a color, click a hue on this color ramp or drag the slider, then click a saturation and brightness variation in the large square.

Alternatively, enter a hex # or enter values in a set of fields

USING THE HUD COLOR PICKER

To access Color Picker controls quickly without opening the dialog, choose a tool that uses colors, Alt-Shiftright-click/Cmd-Option-Control-click in the image to display the on-image picker, drag to choose a hue on the hue (spectrum) bar or wheel, then drag to choose a brightness and saturation value in the square. If you want to change the hue without changing the current brightness and saturation values, when the picker displays, release the keys but keep the mouse button down, hold down the Spacebar and drag the pointer to the hue bar or wheel, release the Spacebar, then drag to the desired hue (practice, practice).

Note: For this feature to work, Use Graphics Processor must be checked in Edit/Photoshop > Preferences > Performance. From the HUD Color Picker menu in General Preferences, you can choose a strip or wheel design and size for the HUD Color Picker.

To choose a hexadecimal color (for Web output), enter the desired number in the # field. This field is highlighted by default.

To choose a process color for print output, enter C, M, Y, and K percentages from a printed formula guide for a process color matching system.

For onscreen output, enter R, G, and B values (0 to 255).

- 3. Click OK. The color will appear in the designated color square on the Tools and Color panels. To add the color to the Swatches panel, see page 207.
- To change the interface of the Color Picker, in Edit/Photoshop > Preferences > General, from the Color Picker menu, select either Windows/Apple (the picker for your system) or Adobe (the default Photoshop picker).
- You don't need to restrict yourself to Web-safe colors for Web graphics, because most computers display millions of colors. Ignore the non-Websafe icon if it appears in the Color Picker, and keep Only Web Colors unchecked. For the out-ofgamut icon, a see the sidebar on the next page.

Choosing colors from a library

Before choosing spot colors for print output, ask your commercial print shop which brand of ink they're going to use, then choose colors from a printed guide for that system (each manufacturer makes its own guide). Note: By default, Photoshop color-separates both the process and spot colors in a file into C, M, Y, and K process colors. To output a spot color to a separate plate, you must create a separate channel for it (this is done with type as an example on page 388).

To choose a color from a library:

- 1. Do either of the following:
 - On the Tools panel, click the Foreground or Background color square.
 - On the Color panel, click the Foreground or Background color square if it's already selected (has an extra outer border), or double-click the square if it's not selected.
- 2. If the color square you clicked isn't a custom color, the Color Picker dialog will open. Click Color Libraries to show the Color Libraries dialog.
- 3. From the **Book** menu, choose a matching system. For commercial printing, choose the

- system that your print shop has recommended, and find the desired color in a formula guide.
- 4. Do either of the following:
 - Without clicking anywhere, type the number of the desired color; that swatch will become selected. Click a color on the vertical color ramp (or set the slider) to display a family of hues, then click a swatch on the left side of the dialog.
- 5. Click OK. To add the chosen color to the Swatches panel, see page 207.

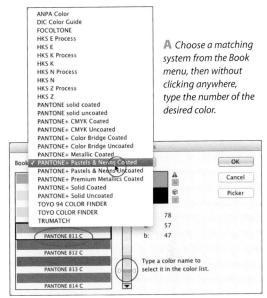

B Another option is to click a color on the vertical color ramp (or move the slider), then click a swatch on the left side.

COLOR LIBRARIES FOR PRINT OUTPUT

- ➤ ANPA colors are used in the newspaper industry.
- ➤ DIC Color Guide and TOYO Color Finder colors are used in Japan.
- ➤ FOCOLTONE is a process color system that was developed to help prevent registration problems. It can be used in North America.
- ► HKS process colors and HKS spot colors (without "Process" in the name) are used primarily in Europe.
- ➤ PANTONE PLUS (+) process and spot colors are widely used in North America.
- ➤ TRUMATCH is a process color system, organized in a different way from PANTONE. It is used worldwide.

Using the Color panel

Another way to select RGB or HSB colors for Web output, or for output to an inkjet printer, is via the Color panel.

To choose an RGB or HSB color using the Color panel:

- Click the Foreground or Background color square on the Color panel, if the desired square isn't already selected.
- From the top portion of the panel menu, choose one of these color models for the sliders: Hue Cube, Brightness Cube, RGB Sliders, or HSB Sliders. (See also the sidebar at right.)
- For any model except a Cube, move any of the sliders; or click or drag in the color ramp; or enter values in the fields.
 - ➤ To enlarge the ramp, drag the bottom of the panel downward. ★

For the Hue Cube model, drag in the hue bar on the right, then drag in the large square to select a brightness and saturation value. D Or for the Brightness Cube model, move the brightness slider and/or drag in the large square to select a hue and saturation value.

- **4.** Optional: To add your new color to the Swatches panel, see the instructions on the next page.
- Alt-click/Option-click the color ramp to choose a color for whichever color square (Foreground or Background) isn't currently selected.
- If Dynamic Color Sliders is checked in Preferences (Ctrl-K/Cmd-K) > General, colors in the bars above the sliders will update instantly as you mix or choose a color.

HSB AND RGB DEMYSTIFIED

- ➤ In the HSB model, the hue (H) is the wavelength of light for which a color is named (such as "red" or "blue"); brightness (B) is the lightness of a color; and saturation (S) is the purity of a color (how much gray it contains versus pure color).
- ▶ In the RGB model, which is used by your computer display, white (the presence of all colors) is produced when all the sliders are at the far right (at 255) on the Color panel, black (the absence of all colors) is produced when all the sliders are at the far left (0), and gray is produced when all the sliders are aligned vertically with one another at any other location.

THE OUT-OF-GAMUT ALERT

An out-of-gamut alert icon an on the Color Picker or Color panel indicates that the current color isn't printable (has no ink equivalent). If you click the icon, Photoshop will substitute the closest printable color, as shown in the swatch next to or below the icon.

Similarly, if the color currently under the pointer is outside the printable gamut, exclamation points will display next to the CMYK color values on the Info panel.

The out-of-gamut range is defined by the current CMYK output profile, which is chosen on the Working Spaces: CMYK menu in Edit > Color Settings. When your image is converted to CMYK mode for commercial printing, all the image colors are brought into the printable gamut automatically. You need to pay attention to the alerts only if you want to convert specific colors manually.

C Click in the color ramp or move any of the sliders.

Hue Cube
Brightness Cube
Grayscale Slider

RGB Sliders

✓ RGB Sliders

HSB Sliders

CMYK Sliders

Lab Sliders

Web Color Sliders

Copy Color as HTML / Copy Color's Hex Code

RGB Spectrum

✓ CMYK Spectrum

Grayscale Ramp

Current Colors

B Choose a model for the sliders.

To learn about these options, see page 208.

Choose a display option for the color ramp (or right-click the ramp and choose from the context menu).

D If you chose the Hue Cube model, drag in the bar to choose a hue, then drag in the large square to choose a brightness and saturation value of that hue.

Using the Swatches panel

Note: For easy access, detach the Swatches panel from the Color panel group by dragging its tab.

To choose a color via the Swatches panel:

- 1. Display the Swatches panel.
- 2. Do either of the following:

To choose a Foreground or Background color for the color square that is currently selected on the Tools and Color panels, click a swatch.

To choose a Foreground or Background color for the color square that isn't selected on the Tools and Color panels, Ctrl-click/Cmd-click a swatch.

Note: In addition to the swatches in the main part of the panel, you can also click any recently used swatch in the top row of the panel.*

To access other libraries of swatches, see page 131 or 133.

LOADING SWATCHES FROM AN HTML, CSS, OR SVG FILE

To load color swatches from an HTML, CSS, or SVG file, use the Load Swatches or Replace Swatches command on the Swatches panel menu. To prevent duplication, Photoshop will load each unique color only once.

 $oldsymbol{\mathbb{A}}$ To add a color to the Swatches panel, we clicked the blank area below the swatches.

B We entered a name for the swatch.

Colors that you add to the Swatches panel will remain there until the swatches are deleted, replaced, or reset, and are available for use in all documents. (To save swatches as a permanent library, see "To save the presets currently on a picker as a library," on page 131.)

To add a color to the Swatches panel:

- Choose a Foreground color via the Color panel or Color Picker, or select a color in the image with the Eyedropper tool (see the next page).
- 2. On the Swatches panel, do one of the following: Click the New Swatch of Foreground Color button.

Click the blank area below the swatches. Right-click any existing swatch and choose New Swatch from the context menu.

- 3. In the Color Swatch Name dialog, enter a name for the swatch, B then click OK. The new swatch will be displayed (or listed) last on the panel.
- To create a new swatch without opening the Color Swatch Name dialog, hold down Alt/Option and click the blank area in the Swatches panel.
- To rename an existing swatch, double-click it, then change the name in the dialog. To learn a swatch name, either use the Tool Tip or list the swatches by name (choose Small List or Large List from the panel menu).
- To restore the default swatches to the Swatches panel, see page 132.
- If you want to use the current swatches on the panel in another Adobe Creative Cloud application, save them via the Save Swatches for Exchange command on the panel menu.

Our new swatch appeared on the panel.

Using the Eyedropper tool

To sample a color from an image using the Eyedropper:

- 1. Choose the Eyedropper tool (or hold down I to spring-load the tool) and click the Foreground or Background color square on the Color panel.
- 2. On the Options bar, do the following:

Choose a Sample Size (see the sidebar below, right). To control the layer(s) from which the tool can sample a color, choose an option from the Sample menu. Notes: If you choose a "Current" option, also click a layer. Choose a "No Adjustments" option to sample color values minus the effect of any adjustment layers.

Optional: Check Show Sampling Ring. Note: To access the sampling ring, Use Graphics Processor must be checked in Edit/Photoshop > Preferences > Performance.

- 3. Do either of the following: Click a color in any open document.A Drag in any document, and release the mouse when the pointer is over the desired color. If you checked Show Sampling Ring, the sampled color will preview at the top of a ring in the image and the former color will display on the bottom.
- Alt-click/Option-click or drag in an image with the Eyedropper tool to choose a Background color when the Foreground color square is selected on the Color panel, or vice versa.

With Show Sampling Ring checked for the Eyedropper tool on the Options bar, we are clicking a color in the image.

Copying colors as hexadecimals

For Web output, you can copy a color as a hexadecimal value from a document in Photoshop and then paste it into an HTML file or Web page layout program.

To copy a color as a hexadecimal value:

- 1. To copy a color to the Clipboard as a hexadecimal value, do either of the following:
 - Choose the Eyedropper tool (I or Shift-I) and choose settings for the tool from the Options bar (see step 2 at left). Right-click a color in the document and choose Copy Color as HTML (HTML color tag) or Copy Color's Hex Code (hex number) from the context menu.
 - Choose a Foreground color via the Color panel, Color Picker, or Swatches panel. From the Color panel menu, choose Copy Color as HTML or Copy Color's Hex Code
- 2. To paste the color into an HTML file, display the HTML file in your HTML-editing application, then choose Edit > Paste (Ctrl-V/Cmd-V).

SAMPLE SIZE FOR THE EYEDROPPER TOOL

- To specify a size for the area from which the Eyedropper tool takes a sample, from the Options bar, choose Sample Size: Point Sample (to sample only the exact pixel you click) or one of the Average options to sample an average value from the area (e.g., from a 5 x 5-pixel square area). The 3 by 3 Average and 5 by 5 Average options are useful for sampling continuous tones, such as skin tones in a portrait photo or the background area in a landscape (we usually use 3 by 3 Average). The 11 by 11 Average through 101 by 101 Average options are better choices for very high-resolution files.
- You can also right-click in the document with the Eyedropper tool and choose a sample size from the context menu.

Choosing a blending mode

The blending mode that you choose for a tool or layer affects how that tool or layer interacts with underlying pixels. To produce a blending mode effect, Photoshop compares colors in one of the following ways: It compares the colors of two layers on a channel-by-channel basis, it compares each color in a layer to a corresponding color in the underlying layer (the base color), or it compares the paint color being applied by a tool to the existing color in the layer.

You can choose from a menu of blending modes A in many locations in Photoshop, such as the Options bar (for most painting and editing tools), the Layers panel, the Layer Style and Fill dialogs, and the Blending Options dialog for a Smart Filter. In order for you to see the results of a blending mode choice for a layer, its contents must overlap some contents of the underlying layer.B-C

 When choosing an Opacity percentage for a tool (via the Options bar), keep in mind that the tool results will also be affected by the opacity of the layer that you edit. For example, strokes applied with the Brush tool at an Opacity setting of 50% on a layer that has an Opacity setting of 50% will appear lighter than the same strokes if applied to a layer that has an Opacity setting of 100%.

✓ Normal Dissolve	The Basic blending modes replace the base colors.
Darken Multiply Color Burn Linear Burn Darker Color	The Darken blending modes darken the base colors.
Lighten Screen Color Dodge Linear Dodge (. Lighter Color	The Lighten blending modes lighten the base colors.
Overlay Soft Light Hard Light Vivid Light Linear Light Pin Light Hard Mix	The Contrast blending modes change the amount of contrast.
Difference Exclusion Subtract Divide	The Comparative blending modes invert the base colors.

A Blending modes are grouped in categories on the menu, based on their function and effect.

The Component blending

component.

modes apply a specific color

B We applied light blue strokes to a blank layer above the image layer. The layer containing the brush strokes has a blending mode of Darker Color.

Hue

Color

Saturation

Luminosity

C This is the same image, except we chose the blending mode of Lighter Color for the layer that contains the brush strokes.

Here you will choose a blending mode for a layer to change how its color values blend with values in the underlying layer. Some blending modes, such as Soft Light, produce subtle changes, whereas others, such as Difference, produce marked color shifts. You can't choose a blending mode for the Background. (To learn about the advanced blending controls in the Layer Style dialog, including an alternative way to access the blending modes, see pages 346–347.)

To choose a blending mode for a layer:

- 1. Click any kind of layer (not the Background), such as a duplicate image layer A or a type, adjustment, fill, shape, or Smart Object layer. You could also select multiple layers or a group.
- From the menu in the upper-left corner of the Layers panel, choose a blending mode. B (No blending occurs in the default mode of Normal.)
- 3. Optional: Adjust the Opacity setting.

B We duplicated the Background, chose Color Dodge mode for the duplicate layer, and lowered the layer Opacity to 57%.

CYCLING THROUGH THE BLENDING MODES

To cycle through the blending modes for the current painting or editing tool, or for the currently selected layer when using a nonediting tool (such as the Move tool or a selection tool), press Shift -+ (plus) or Shift -- (minus).

A This is the original image.

The final image is a combination of the two layers.

Creating a Solid Color fill layer

When we need to add a solid background below type or below an image layer that contains transparent areas, we use a Solid Color fill layer. The advantages to using this method are that we can preview the results, change the color quickly at any time, and edit the fill layer mask. There are other methods of applying a solid color, but although the settings for a Color Overlay layer effect are editable, the effect can't be masked, and if you use Edit > Fill, the only way to change the color is by reapplying the command.

To create a Solid Color fill layer:

- 1. Click the layer above which you want the fill layer to appear. It can be below a type layer, or below an image layer that contains some transparent pixels.
- 2. From the Layers panel menu, choose Panel Options. In the dialog, check Use Default Masks on Fill Layers, then click OK.
- 3. Optional: To make the solid color visible in only part of the layer, create a selection.
- 4. From the New Fill/Adjustment Layer menu . on the Layers panel, choose Solid Color.
- 5. In the Color Picker dialog, choose a color for the tint. Don't sweat over your color choice; you can easily change it later. Click OK.A-B
- To change the color of the fill layer, double-click the layer thumbnail; the Color Picker reopens. C-D You can also change the opacity of the fill layer.
- Whether you created a selection in step 3 or not, you can edit the mask on the fill layer by applying brush strokes (black to reveal, white to conceal).

C We double-clicked the flll layer thumbnail on the Layers panel, then, via the Color Picker, changed the tan color to teal.

A We clicked the Background in this document, then created a Solid Color fill layer (we chose a tan color).

B The color from the fill layer is visible helow the transparent areas in the "BOOKS" layer.

D This is the image after we changed the color in the fill layer.

Creating a Gradient fill layer

A gradient is a soft blend between two or more opaque or semitransparent colors. It can be used to enhance the visible area behind a type or shape layer, or behind an image layer that contains transparent pixels. We will show you how to apply a gradient via a Gradient fill layer and the Gradient tool, and how to create and modify a gradient via the Gradient Editor.

A gradient that you apply via a Gradient fill layer appears in its own layer, complete with an editable mask. Like adjustment layers (and unlike gradients that are applied directly to a layer), Gradient fill layers are editable and don't increase the file size.

To apply a gradient via a fill layer:

- 1. Click a layer on the Layers panel. If you want the gradient fill to display below type or an image layer that contains some transparency, click the layer directly below that image or type layer.
- 2. From the Layers panel menu, choose Panel Options. In the dialog, check Use Default Masks on Fill Layers, then click OK.
- 3. Optional: To make the gradient visible in only part of the layer, create a selection.
- 4. From the New Fill/Adjustment Layer menu 🕗 on the Layers panel, choose Gradient. The Gradient Fill dialog opens.
- 5. Click the Gradient picker arrowhead at the top of the dialog, click a gradient preset on the picker, B then click back in the dialog and keep it open.
 - To load more gradients, open the preset picker menu, 💠 - choose a library name from the assortment at the bottom, then click Append or OK in the alert dialog (see page 131).
- 6. Choose a gradient Style of Linear (a good choice if this is your first try), Radial, Angle, Reflected, or Diamond.
- 7. Do any of the following optional steps: To change the angle of the gradient, move the Angle dial or enter a value.

To control how gradually the gradient colors transition across the layer, choose a Scale percentage via the slider or scrubby slider.

To reposition the gradient, drag in the document window (with the dialog still open). To reset the gradient to its default position at any time, click Reset Alignment.

A The original image consists of an image layer (that contains transparent pixels) above a white Background. We clicked the Background on the Layers panel...

... then chose Gradient from the New Fill/ Adjustment Layer menu. In the Gradient Fill dialog, we clicked the Gradient picker arrowhead, then loaded the Simple library via the picker menu. Here, we are clicking a preset in the picker.

	Gradient Fill	
Gradient:	-	ОК
Style: R	eflected ‡	Cance
Angle:	132.71	•
Scale: 1	15 7 %	
	Reverse 🗹 Dit	her
	Align with layer	
F	Reset Alignment	

 ${f C}$ Finally, we chose the settings shown above, including changing the Angle to align the gradient with the saucepan in the image.

To swap the order of colors in the gradient, check

To minimize banding (stripes) in the gradient on print output, check Dither.

If you created a selection in step 3, check Align with Layer to fit the complete gradient within the selection area, or uncheck this option to have the gradient stretch across the whole layer (in which case only part of the gradient will display within the selection).

- 8. Click OK.A
- 9. If the Gradient fill layer is completely obscuring all the layers below it, do any of the following: Lower the opacity of the fill layer; B restack it below the layers you want to reveal; lower the opacity of some of the color stops within the gradient (see the next page); or click the fill layer mask thumbnail, then apply black strokes in the desired brush opacity to hide areas of the gradient manually.
 - To edit the settings for the Gradient fill layer at any time, double-click the layer thumbnail; the Gradient Fill dialog reopens.
- To apply a gradient by matching its luminosity values to the values in an image layer, see pages 248-249.
- Via the Properties panel, you can adjust the density of the black areas in a mask, or feather its edge.

DESIGNING GRAPHICS FOR COLOR-BLIND VIEWERS

At some point in your career, you may be hired to design graphics, such as signage, that are fully accessible to color-blind viewers. In fact, some countries require graphics in public spaces to comply with Color Universal Design (CUD) guidelines. The View > Proof Setup > Color Blindness - Protanopia-Type and Color Blindness – Deuteranopia-Type commands in Photoshop simulate how your document would look to viewers with common forms of color blindness.

In case you're not familiar with those two terms, for protanopes, the brightness of red, orange, and yellow is dimmed, making it hard for them to differentiate red from black or dark gray. Protanopes also have trouble differentiating violet, lavender, and purple from blue because the reddish components of those colors appear dimmed. Deuteranopes are unable to distinguish between colors in the green-yellow-red part of the spectrum and experience color blindness similar to that of protanopes, but without the problem of dimming.

A This is the image with the Gradient Fill layer.

B As a variation, we created a new, blank layer below the Gradient fill layer and filled it with a Scripted pattern (Stucco 2 in the Texture Fill 2 library, Script: Spiral), and lowered the Opacity of the Gradient fill layer to 77%.

Creating and editing a gradient preset

You can create a variation of any existing gradient preset or create new, custom presets. When you edit a preset, Photoshop forces you to work on a copy of it automatically in order to preserve the original one in the library. We'll show you how to add and change the colors in a gradient, adjust the color transitions, and make parts of the gradient semi- or fully transparent.

To create or edit a gradient preset:

- Open the Swatches and/or Color panels, which you will be using to pick colors for the gradient (you can collapse the panels to icons).
- **2.** To open the Gradient Editor, do either of the following:
 - Choose the **Gradient** tool (G or Shift-G), then click the Gradient thumbnail on the Options bar. Double-click the thumbnail for an existing Gradient fill layer, then click the gradient thumbnail at the top of the Gradient Fill dialog.
- 3. In the Gradient Editor, click a preset swatch from which you want to create a variation (when you begin to edit the gradient, the Name will change to Custom). Keep the Gradient Type as Solid and the Smoothness setting at 100%.
 - If you want to create a gradient that uses the Foreground and Background colors that are in effect when the gradient is applied, click the Foreground to Background preset. (Foreground to Background is the first preset in the default gradient library. If you need to reload that library, choose Reset Gradients from the Gradient picker menu, then click Append or OK.)
- **4.** For any preset except Foreground to Background, click the starting (left) or ending (right) color stop under the gradient bar (**A**, next page), then do either of the following:

Click a color in the gradient bar; *\(\pi\) or outside the Gradient Editor, you can click in the Swatches panel, in the color ramp at the bottom of the Color panel, or in any open document window (the pointer becomes a temporary Eyedropper tool).

Click the Color swatch at the bottom of the Gradient Editor (or you can simply double-click the color stop). Choose a color in the Color Picker, then click OK.

5. For any kind of gradient preset, do any of these optional steps:

To add an **intermediate** color to the gradient, click below the gradient bar to produce a stop, then choose a color for that stop, as described in the preceding step (**B**, next page).

To add an **opacity** stop, click above the gradient bar, then change the Opacity percentage via the scrubby slider (\mathbb{C} , next page). You can also click any existing opacity stop and change its Opacity percentage. In the gradient bar, transparency is represented by a checkerboard pattern.

To change the **location** of a color or opacity stop in the gradient, drag the stop to the left or right.

To control the abruptness of a transition between color or opacity stops, click a stop, then drag a **midpoint diamond** (found on either side of the stop) to the left or right (D, next page). The diamond marks the point at which two adjacent colors or opacity values are evenly mixed.

To **delete** an opacity or color stop, drag it upward or downward off the bar.

- ➤ Use Ctrl-Z/Cmd-Z if you need to undo the last edit (some edits can't be undone).
- **6.** Don't click OK yet! To create a preset of your custom gradient, type a name in the **Name** field, then click **New**.

Note: Your custom presets will be deleted from the picker if you allow them to be replaced by another gradient library or if the Photoshop Preferences file is deleted or damaged. To save the presets on the picker as a permanent library, click Save, enter a name, keep the default location, then click Save again. (See page 131 or 133.)

- 7. Click OK to exit the Gradient Editor, and again, if necessary, to exit the Gradient Fill dialog (E, next page). Your new gradient preset is the last one on the Gradient picker. If you chose and want to use the Gradient tool, see the steps on page 216.
- To delete a gradient preset from the picker, Alt-click/Option-click the preset thumbnail.

A We are opening the Gradient Editor by clicking the Gradient thumbnail on the Options bar.

A In the Gradient Editor dialog, we clicked a preset (in the Simple library), double-clicked one of the original color stops, and changed the Color.

We clicked below the gradient bar to add three more color stops, and chose a color for each one.

We clicked above the bar to add an intermediate opacity stop, and lowered the Opacity setting for that stop. (We also lowered the Opacity of the leftmost opacity stop to 80%.)

D We dragged the right midpoint diamond for the middle opacity stop. (We named our custom gradient, clicked New, then exited both dialogs.)

CREATING A MORE COMPLEX - OR SIMPLER - GRADIENT EFFECT

- For a complex effect, apply gradients that contain some transparency to multiple layers, either via Gradient fill layers (vary the gradient angle or style), or via the Gradient tool (drag in different directions).
- To create a gradient that contains just one color that transitions to transparency, delete the starting or ending stop, * and lower the opacity for that end of the bar.

E We applied our custom gradient via a Gradient fill layer (above an image layer). The dialog settings we chose are shown above. Note that we chose the Reflected style.

Using the Gradient tool

With the Gradient tool, you apply a gradient by dragging in the image. Although you can't edit the results in the same way that you would edit a Gradient fill layer, if you use the tool on a separate layer, at least you will be able to change the layer blending mode or opacity.

To apply a gradient via the Gradient tool:

- 1. Create a new, blank layer to contain the gradient.
- Optional: To confine the gradient to an area of the layer, create a selection.
- 3. Choose the **Gradient** tool (G or Shift-G).
- **4.** On the Options bar, do all of the following: Click the Gradient picker arrowhead, then click a preset on the picker.

Click a Style button: Linear, Radial, Angle, Reflected, or Diamond.

Choose Mode: Normal and Opacity 100%.

5. On the Options bar, check any of the following optional features:

Reverse to swap the order of colors in the gradient. Dither to minimize banding (stripes) in the gradient on print output.

Transparency to enable any transparency that was edited into the gradient, or turn this feature off to apply a fully opaque gradient.

- 6. Drag in the document in any direction. For a Linear or Reflected gradient, try dragging from one side or corner of the image or selection to the other, or for any other gradient style, try dragging from the center of the layer outward. Shift-drag to constrain the angle to a multiple of 45°.A-C
 - ➤ To produce subtle transitions between colors in the gradient, drag a long distance, or for abrupt transitions, drag a short distance. This has the same effect as changing the Scale value in the Gradient Fill dialog.
- Optional: Change the gradient layer mode or opacity.
- To delete the Gradient tool results, click the prior state on the History panel.
- You can use a gradient to create a gradual transition in the mask on an image, editable type, adjustment, fill, Smart Filter, or shape layer. See pages 279–280.

A With the Gradient tool (Diamond style chosen), we dragged diagonally from the middle to the lower right on a new, blank layer.

B This is the Layers panel for the image shown below.

C This is the final image.

Creating custom and scripted patterns

To create and apply a custom pattern:

- 1. Open a document (preferably, a small- or mediumsized one), and click a layer.
- 2. Optional: If you want the pattern tile to be an irregular shape surrounded by transparency, select a nonrectangular area of the layer (See Chapter 9), then press Ctrl-J/Cmd-J to copy the selection to a new layer.
- 3. Hide the layers that you don't want to include in the pattern tile.
- 4. Choose the Rectangular Marquee tool, Then drag to select the area to become the pattern tile.
- 5. Choose Edit > Define Pattern. A In the Pattern Name dialog, type a name, then click OK. Your new pattern is now available on the preset picker in the Edit > Fill dialog, in the Layer Style dialog for the Pattern Overlay effect (see page 397), as a Texture option for the Bevel & Emboss effect (see pages 392-393), and for a pattern fill layer (choose Pattern from the New Fill/Adjustment Layer menu . on the Layers panel).B-C

A We selected an area of an image layer, then used Edit > Define Pattern to create a custom pattern tile.

B From the New Fill/Adjustment Layer menu on the Layers panel, we chose Pattern. When the Pattern Fill dialog opened, we clicked OK.

C The Pattern Fill command repeated the tiles to produce a pattern fill.

Using the Scripted Patterns feature in the Fill dialog, you can choose from an assortment of presets (e.g., Brick Fill, Spiral) that control how pattern tiles are colored and positioned. When you exit that dialog, an additional dialog opens automatically, which lets you customize the pattern. Three novel scripts let you place a pattern along a path, create a patterned frame, or produce a tree (!). You can get some great effects by applying scripted patterns to different layers. For added richness, try choosing different blending modes for the pattern layers.

To fill a layer with a scripted pattern: ★

- 1. Click a layer to contain the pattern. It can be a new, blank laver.
- 2. For just the Picture Frame, Place Along Path, and Tree options (that you will choose in step 4), do one of the following:

For the Picture Frame option, you can let Photoshop apply the frame to the dimensions of the canvas, or if you prefer to define a rectangle for the frame, choose the Rectangular Marquee tool (M or Shift-M), then draw a rectangle.

For the Place Along Path option, draw a path with the Pen tool (see pages 420–422) or the Freeform Pen tool 2 (see page 418), and keep the path selected. (To learn about paths, see pages 418-423).

For the Tree option, choose the Pen tool, then from the Tool Mode menu on the Options bar, choose Path. In your document, click to set a location for the base of the tree, then click again to set an approximate location for the top of the trunk (the tree top is going to extend beyond the end of the path). To finish the path, click another tool.

- 3. Choose Edit > Fill (Shift-Backspace/Shift-Delete). The Fill dialog opens (\mathbb{A} , next page).
- 4. From the Contents: Use menu, choose Pattern. Check Scripted Patterns, then choose an option from the **Script** menu. Keep the Opacity setting at 100%, and uncheck Preserve Transparency to permit transparent areas in the layer to be filled. For any script option except Picture Frame or Tree,

click the Custom Pattern thumbnail, then click a pattern preset (you can load additional pattern

Continued on the following page

- libraries from the lower part of the picker menu). Click OK.
- 5. Another dialog opens automatically, which you will use to customize the pattern. Doptions in the dialog will vary depending on the chosen script. The options are too numerous for us to discuss individually here—we recommend that you just experiment with various settings until you get a result you like (that's how we use the dialog). Note that the Tree script creates only one tree at a time.
 - To produce more variety or naturalism in your pattern, take advantage of dialog options that allow for randomness, such as scale, spacing (either between the tiles or from the path), color, and brightness.
- **6.** Optional: To save the current custom pattern settings for future use, from the preset menu, choose Save Preset. In the Save As dialog, enter a name (keep the default location), then click Save.
- 7. Click OK (A-D, next page, and A-B, page 220).
- To load a saved preset into one of the custom scripted pattern dialogs, use the Load Preset command on the preset menu.
- If you use a custom pattern when applying a script, then discover that after exiting the options

- dialog, the tiles look too large on the layer, undo. Redo steps 3–5 above, using the scale control to reduce the pattern size.
- To hide areas of a pattern on a layer, add a layer mask, then paint with black (see pages 190–193). For a partial mask, lower the brush opacity.

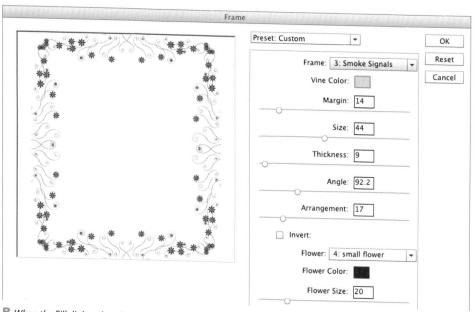

f B When the Fill dialog closed, the Frame dialog opened automatically. We chose the settings shown above.

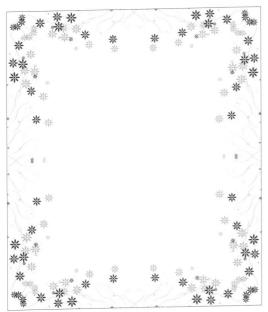

A We duplicated the frame layer, scaled the duplicate layer to make it smaller (see pages 348–349), then lowered its opacity.

B Next, we created a custom shape layer using a leaf preset from the Nature library (see page 406). We applied a gray fill and a stroke of None, hid the other layers, selected the leaf with the Rectangular Marquee tool, then chose Edit > Define Pattern to create a custom pattern. We hid the new shape layer and redisplayed the Background.

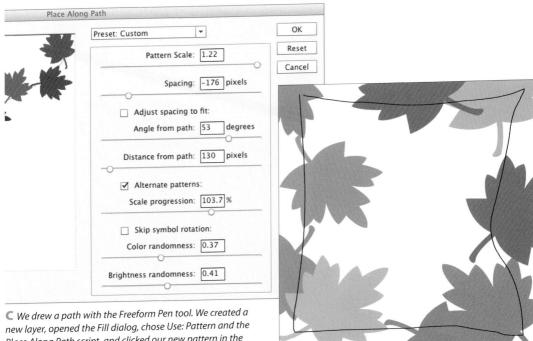

Place Along Path script, and clicked our new pattern in the picker. In the Place Along Path dialog, we chose the settings shown above. We used the Color Randomness and Brightness Randomness options to colorize the gray tiles in the pattern.

This is a view of the layer, showing the leaf pattern that the script placed along our hand-drawn path.

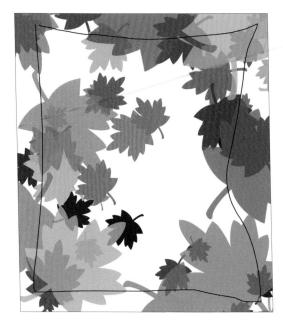

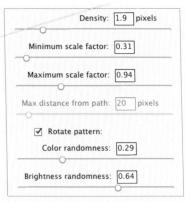

A To add the next element to our design, we created a new layer, opened the Fill dialog, chose Use: Pattern, kept the leaf as the custom pattern, and chose Script: Random Fill. In the Random Fill dialog, we chose the settings shown above. For this pattern, we chose a higher Brightness Randomness value (to produce darker colors) than for the pattern layer shown in D on the preceding page.

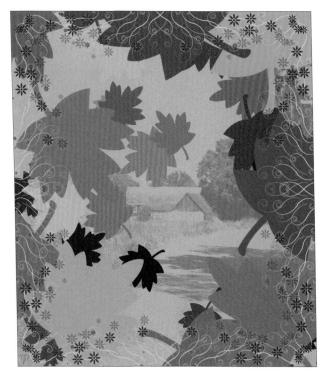

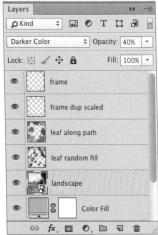

We redisplayed the two frame pattern layers, created a Solid Color fill layer (see page 211), then restacked the fill layer below the pattern layers. We placed a photo of a landscape into our document, and stacked the new image layer above the Solid Color fill layer. Finally, to reduce the image layer to flat color areas, and to let some of the solid color from the underlying fill layer show through, we set the blending mode of the image layer to Darker Color, and lowered the image layer opacity to 40%. The Layers panel for the final image is shown above. When you open a photo into Photoshop, take a few minutes to study it. Is it overexposed (too light) or underexposed (too dark)? Could it use a boost in contrast (brighter highlights, richer shadows)? Are the colors too bright or too dull (over- or undersaturated)? Does it have a color cast? Would you like to transform the photo in some way, say by tinting it with colors from a gradient, or give it a vintage look by converting the colors to grayscale? Enter the digital darkroom!

If you normally capture your photos as raw files or in the JPEG or TIFF format, you can rectify most or all of their tonal and color flaws in Camera Raw. If for some reason you don't use Camera Raw to correct your photos, or if you want to apply further corrections after using Camera Raw, Photoshop offers an impressive array of adjustment commands.

Most of the tonal and color corrections that are available in Photoshop can be applied via adjustment layers, a method that offers the greatest flexibility in editing. At the beginning of this chapter, you will find generic instructions for creating and editing an adjustment layer and its mask. You will also learn how to read the graph on the Histogram panel to monitor changes in the tonal levels of your document as you apply corrections. From page 230 onward, you will find specific instructions for a splendid array of adjustment features. By the end of this chapter, you will have mastered most of the key Photoshop adjustment commands!

Note: To learn the pros and cons of applying corrections via adjustment layers versus the Camera Raw filter, see the sidebar on page 54.

A FEW BASIC RECOMMENDATIONS

- ➤ Before performing any tonal or color adjustments in Photoshop, make sure your display is calibrated properly (see page 6).
- Keep your documents in RGB Color mode for your work in Photoshop, including the adjustments in this chapter (remember, digital photos are captured as RGB).
- ➤ If you need to make final corrections to an image for CMYK output (such as for commercial printing), copy the file, soft-proof the copy onscreen to make sure there are no color problems (see pages 474–475), apply any needed adjustments, then convert the image to CMYK (see page 483).

12

IN THIS CHAPTER

Creating adjustment layers
Editing adjustment layer settings224
Saving adjustment presets
Merging and deleting adjustment
layers
Editing an adjustment layer mask227
Using the Histogram panel
Applying a Levels adjustment230
Applying a Brightness/Contrast adjustment
Applying a Photo Filter adjustment233
Applying an auto correction234
Applying a Color Balance adjustment
Applying a Hue/Saturation adjustment
Applying a Vibrance adjustment 239
Applying a Curves adjustment 242
Applying a Black & White adjustment246
Tinting an image via a Gradient Map adjustment
Applying the Merge to HDR Pro command
Screening back a layer using Levels254

Creating adjustment layers

The effects of a command that you apply via the Image > Adjustments submenu are permanent, whereas the effects of an adjustment layer become permanent only when you merge it downward into the underlying layer or flatten your document. The advantages of using an adjustment layer are that its settings stay editable and you can hide its effect in areas of the image by editing its mask — plus you can restack, hide, or delete it, and drag-copy it between files.

You create an adjustment layer via either the Adjustments or Layers panel, then choose and edit the settings for it via the Properties panel. Each adjustment type has unique options, and each adjustment layer keeps its own settings. Some controls are easy to get the hang of, whereas others take some effort to master but enable you to apply more targeted corrections. For some adjustment types, you can choose from a menu of presets. The Properties panel also has controls for hiding, clipping, and restoring adjustment settings.

To create an adjustment layer:

- On the Layers panel, click an image layer or the Background. The adjustment layer is going to appear above the layer you select.
- 2. Optional: Create a selection, to become the white area in the editable adjustment layer mask, and therefore the only area in which the adjustment effect is visible.
- 3. Do either of the following:

On the **Adjustments** panel, click the button for the desired adjustment type. B

From the **New Fill/Adjustment Layer** menu **O**, on the Layers panel, choose an adjustment type (**A**, next page).

4. Controls for the chosen command appear on the Properties panel. Choose settings to correct your document (B, next page). For a Levels, Curves, Exposure, Hue/Saturation, Black & White, Channel Mixer, or Selective Color adjustment, another option is to choose a preset from the menu at the top of the panel (you can also customize the settings from the preset).

A new adjustment layer with a layer mask appears on the Layers panel (C-D, next page).

The original image lacks contrast.

B On the Adjustments panel, we clicked the Levels button.

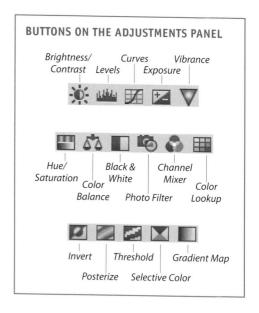

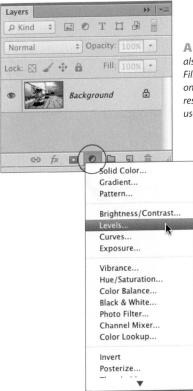

A Adjustment layers can also be created via the New Fill/Adjustment Layer menu on the Layers panel (the results are the same as if you used the Adjustments panel).

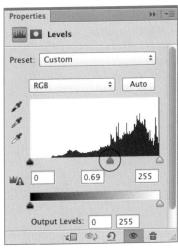

B To darken the midtones, we dragged the top middle slider to the right.

C You can identify each adjustment layer type by its unique icon in the layer thumbnail.

One simple (editable) step corrected the contrast.

A NOTE REGARDING OUR STEPS

For the sake of brevity, in our steps for creating specific adjustments (from page 230 through the end of this chapter), we instruct you to create an adjustment layer by clicking a button on the Adjustments panel. If you prefer to create your adjustment layers via the New Fill/Adjustment Layer menu on the Layers panel, by all means do so. Some folks like clicking buttons and are comfortable switching between the Layers and Adjustments panels; others like to stick with the Layers panel.

Editing adjustment layer settings

Note: For the steps in this section, we recommend showing the Properties panel (it can be in a dock). If your Properties panel is closed, you will need to double-click the adjustment layer to display the Properties panel (instead of just a single click, as in our instructions).

To change the settings for an adjustment layer:

- 1. On the Layers panel, click an adjustment layer. The layer becomes selected and the current settings display on the Properties panel. A
- 2. Edit the settings.
- To undo the last individual Properties panel edit, press Ctrl-Z/Cmd-Z.
- To lessen the overall impact of an adjustment layer, lower its opacity via the Layers panel.

The View Previous State button gives you a temporary view of the image without the current edits you are making to the adjustment layer settings.

To view the image without the newest adjustment layer edits:

- 1. On the Layers panel, click an adjustment layer, then edit the settings on the Properties panel. Keep the layer selected and stay on the panel.
- 2. To toggle your latest edits off (and then on again), press and hold down the View Previous State button or the \ key, then release.

To restore settings to an adjustment layer:

- 1. On the Layers panel, click an adjustment layer.
- 2. After editing any of the settings on the Properties panel, click the Reset to Adjustment Defaults button; the last chosen settings will be restored. To restore the default settings for that adjustment type, click the button again.

To hide the effect of an adjustment layer:

To hide the effect of an adjustment layer, click the visibility icon on the Properties panel or Layers panel (clicking the icon in one location also deactivates it or makes it disappear in the other location). To show the effect, click the icon (or in the icon column) again.

A We used a Curves adjustment to darken the midtones in this photo.

B Later, we double-clicked the Curves layer thumbnail to display the current settings, and tweaked the adjustment by reshaping the curve for the midtones and highlights.

Normally, an adjustment layer affects all the layers below it, but you can clip (restrict) its effect to just the layer directly below it.

To clip an adjustment layer to the layer directly below it:

- 1. On the Layers panel, click an adjustment layer. A-B Make sure it is stacked directly above the layer that you want to clip it to.
- 2. Do either of the following:

On the Properties panel, click the Clip to Layer button.¥□ C-D

On the Layers panel, hold down Alt/Option and click the line between the adjustment layer and the layer below it ($\mathbf{F} \square$ icon).

Note: The adjustment layer listing is now indented and the underlying layer name has an underline. To unclip it at any time, repeat either method in step 2.

A This image contains an image layer, a type layer, and a Background image (the texture).

We clipped the adjustment layer so it is affecting just the Tomatoes layer.

USING THE AUTO-SELECT PARAMETER OPTION

The Auto-Select Parameter option on the Properties panel menu affects adjustment types that have entry fields. When this option is checked and you create an adjustment layer or click an existing adjustment layer on the Layers panel, the first field on the Properties panel becomes highlighted automatically. Although this option lets you enter or change values more quickly and is appreciated by some power Photoshop users, for others it can be an annoyance because it prevents some shortcuts from working (e.g., you won't be able to select a tool via its letter shortcut or delete a layer by pressing Backspace/Delete). We keep it unchecked. Note: Turning the Auto-Select Parameter option off or on in the Properties panel menu does the same for that command on the Adjustments panel menu, and vice versa.

B We applied a Hue/Saturation adjustment to boost the saturation of the Tomatoes layer, but the edit gave the Background texture a pinkish cast.

This is the result of our clipping the adjustment.

Saving adjustment presets

You can save your custom adjustment settings for future use in any document. For instance, say you have a group of photos that were shot under the same lighting conditions, have the same color profile, and require the same corrections. You could save your settings as a preset, then apply it to each file.

To save custom adjustment layer settings as a preset:

- Create and choose settings for an adjustment layer. Presets can be saved only for a Levels, Curves, Exposure, Hue/Saturation, Black & White, Channel Mixer, or Selective Color adjustment.
- 2. From the Properties panel menu, choose Save [adjustment type] Preset. In the Save dialog, enter a name, keep the default location and extension, then click Save. Your user preset is now available on the menu at the top of the Properties panel when the controls for that adjustment type are displaying.
- To delete a user preset, choose that preset, choose Delete Current Preset from the panel menu, then click Yes in the alert dialog.
- ➤ If you create an adjustment that you want to copy to another document and it can't be saved as a preset open the source and target documents, make sure they have the same document color mode, and tile them via the Window > Arrange submenu. Click in the source document, then drag and drop the adjustment layer from the Layers panel into the target document window.

Merging and deleting adjustment layers

When you merge an adjustment layer downward, the adjustments are applied permanently to the underlying image layer. If you change your mind, click the prior state on the History panel.

To merge an adjustment layer:

On the Layers panel, do either of the following:

Click the adjustment layer to be merged downward (or Shift-click multiple adjustment layers and the layer into which you want to merge them), A then press Ctrl-E/Cmd-E.B

Right-click on or near the adjustment layer name and choose **Merge Down** or **Merge Layers** from the context menu.

Note: Adjustment layers can't be merged with one another. If you use the Merge Visible command (see page 165) or the Flatten Image command (see page 166), the effect of any adjustment layers in the file will be applied to the resulting merged layer (and will disappear from the Layers panel).

To delete an adjustment layer:

Do either of the following:

Click the icon for an adjustment layer on the Layers panel, then click the **Delete Layer** button on the same panel or the **Delete Adjustment**Layer button on the Properties panel. If an alert dialog, appears, click Yes. (Click Don't Show Again if you want to prevent the alert from reappearing.)

Click the adjustment layer on the Layers panel, then press Backspace/Delete. (See also the sidebar on the previous page.)

A We clicked the adjustment layer to be merged downward.

B The Merge Down command applied the Levels values from the adjustment layer to the underlying image layer, which in this case was a copy of the Background.

Editing an adjustment layer mask

Photoshop creates a mask for every adjustment layer. If you create a selection before creating an adjustment layer, the selection will appear as the white area in the mask. If you didn't create a selection first, or you want to edit the mask at any time, follow these steps.

To edit the adjustment layer mask:

- 1. Click the mask thumbnail on an adjustment layer.
- 2. Press D to choose the default colors, then press X to switch to black as the Foreground color.
- 3. To hide the adjustment in some areas of the image, do either or both of the following:

Create a selection with any selection tool (e.g., Rectangular Marquee or Lasso); refine it via the Refine Edge dialog, if desired; choose Edit > Fill (Shift-Backspace/Shift-Delete); choose Use: Foreground Color; then click OK. Deselect.

Choose the **Brush** tool (B or Shift-B). On the Options bar, choose a Soft Round brush, Mode: Normal, and an Opacity of 100% (or a lower opacity to apply a partial mask), press [or] to set the brush diameter, then apply strokes in the image. A-C

- 4. Optional: To remove black areas of the mask, press X to swap colors (make the Foreground color white), then apply brush strokes.
- To remove all black areas from the mask, deselect, click the adjustment layer mask, choose Edit > Fill, then choose Use: White in the dialog.
- To confine the effect of an adjustment layer to a small area, start with a fully black mask (click Invert on the Properties panel or apply Edit > Fill, Use: Black), then apply strokes with white.
- To create a gradual mask by applying a gradient, see pages 279-280. To adjust the density or edges of a mask, see pages 192-193.

C Our brush strokes are represented by black areas in the adjustment laver mask thumbnail.

A The bottom area of this photo looks too pink.

B We corrected the color via Curves, clicked the mask thumbnail on the adjustment layer, then applied brush strokes to hide the adjustment in the top part of the image. The adjustment is visible in only the bottom half of the photo.

SHORTCUTS FOR LAYER MASKS

View just the mask in the doc- ument window	Alt/Option click the layer mask thumbnail; repeat to restore the normal view
View the mask in the image as a Quick Mask	Alt-Shift/Option-Shift click the layer mask thumbnail; repeat for normal view
Deactivate or activate the mask	Shift-click the layer mask thumbnail (Layers panel) or click the Disable/Enable button (Properties panel)
Load the unmasked area as a selection	Ctrl/Cmd click the layer mask thumbnail (Layers panel) or click the Load Selection from Mask button (Properties panel)

Using the Histogram panel

The Histogram panel will displays a graph of the distribution of tonal (light and dark) values in the current image. The horizontal axis on the graph represents the grayscale or color levels between 0 and 255, the vertical bars represent the number of pixels at specific color or tonal levels, and the contour of the graph shows the overall tonal range. Before you begin editing your document, study the histogram to evaluate the existing distribution of tonal values. Then as you edit your document, note how the graph updates to reflect changes to the tonal values. The panel remains accessible even while the Properties panel is being used or an adjustment dialog is open.

To choose a view for the Histogram panel:

- 1. From the Histogram panel menu, choose one of the following: Compact View (just the histogram), A Expanded View (the histogram plus a menu providing access to individual channels), B or All Channels View (all the features of Expanded View, plus a separate histogram for each channel). When the panel is in either of the latter two views, you can check Show Statistics on the panel menu to display file data on the panel.
- 2. For Expanded or All Channels view, choose an option from the Channel menu: RGB (all the channels combined), C a specific channel, Luminosity, or Colors. To display the individual channels in color when the panel is in All Channels view, check Show Channels in Color on the panel menu.
- **3.** For Compact View, click a layer or the Background: for Expanded View or All Channels View, from the Source menu, choose Entire Image.

While a large file is being edited, Photoshop maintains the redraw speed of the Histogram panel by reading the data from the histogram cache — not from the actual image. When this is occurring, a Cached Data Warning icon A displays on the panel. Remember to keep updating the panel, as described below (even while editing the settings for an adjustment layer), so it reflects the current tonal values of the image.

To update the Histogram panel:

Do one of the following:

Double-click anywhere on the histogram.

Click the Cached Data Warning icon.

Click the Uncached Refresh button.

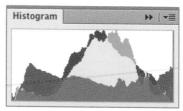

A This Histogram panel is in Compact View.

B Here the panel is in Expanded View. By default, the Channel menu is set to Colors.

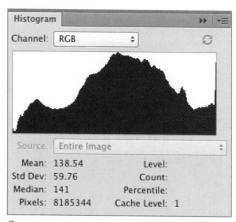

With RGB chosen on the Channel menu, the current tonal values in the image are represented by black areas in the graph.

SETTING THE CACHE

To specify a Cache Levels value for screen redraw in Photoshop (including this panel), see pages 464-465.

Interpreting the histogram

If you want to focus on monitoring tonal values when using the Histogram panel, choose Expanded View from the panel menu, RGB from the Channel menu, and Entire Image from the Source menu.

In the graph, pixels are represented by vertical bars: shadows on the left, midtones in the middle, and highlights on the right. In a dark, low-key image, the tallest peaks will be clustered on the left side of the graph; in a medium-key image in which the lights and darks are relatively balanced, the tallest peaks will be clustered at one or more spots in the middle of the graph; and in a very light, high-key image that contains few or no shadow areas, the tallest peaks will be clustered on the right side of the graph.

If an image has a wide tonal range, the bars will stretch fully from one side of the histogram to the other, and the overall contour of the graph will be relatively solid and smooth. A If an image lacks detail in a tonal range, the graph will contain gaps and spikes, like teeth on a comb.

The following are some typical graph profiles:

- In an average-key but underexposed image that lacks details in the highlights, the bars will rise sharply on the left side of the histogram.
- In an overexposed image that lacks details in the shadows, the tallest peaks will rise sharply on the right side of the histogram.
- In an image in which pixels were clipped (details discarded) in the extreme shadows or highlights, the bars will rise sharply in a very tall cluster at the left or right edge, respectively, of the histogram.
- If an image has lost detail as a result of editing (such as from Photoshop filters or adjustments), the histogram will contain many gaps and spikes. The gaps indicate a loss of specific tonal or color levels, and the spikes indicate that pixels from different levels have been averaged together and been given the same value (the bar will be taller at that level). A few gaps and spikes are an acceptable result of editing, whereas large gaps signify that posterization has occurred and too many continuous tonal values have been discarded. On the other hand, an imperfect histogram doesn't always signify failure; the graph can be thrown off by a simple edit, such as adding a white border to the image. If you like the way the image looks, go with that!

A The tonal ranges in this image are well balanced.

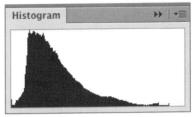

B This image is underexposed.

C This image is overexposed.

Shadow pixels are clipped in this image.

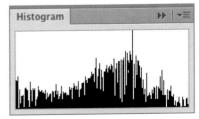

🖺 This image has lost some detail.

Applying a Levels adjustment

You can use either Levels or Curves to apply essential tonal corrections to a photo, both prior to image editing and at any time thereafter. One of the bonus features of Levels is that it displays a histogram of the tonal values of your image. (Levels is also used on pages 234-235 and 254. For Curves, which also has unique correction features, see pages 242-245.)

To correct tonal values using Levels:

- 1. Click an image layer that needs tonal correction.
- 2. On the Adjustments panel, click the Levels button. The Levels controls display on the Properties panel.
- 3. Do either of the following:

To intensify the contrast, brighten the highlights by moving the white input highlights slider to the left and darken the shadows by moving the black input shadows slider to the right. Any pixels located to the left of the black slider will become black; any pixels located to the right of the white slider will become white. (This shifting of tonal values to black or white is called "clipping.")

To control when clipping starts to occur in a temporary high-contrast display called Threshold mode, hold down Alt/Option and drag the highlights slider, then release when only a few areas of color or white display (A, next page); those pixels will be given the lightest tonal value. Next, hold down Alt/Option and drag the shadows slider, then release when only a few areas of color or black appear (B, next page); those pixels will be given the darkest tonal value.

- 4. With the shadows and highlights sliders now in their proper positions, move the middle (midtones) input slider to lighten or darken just the midtones.
- 5. To compare the original and adjusted images, press and hold \setminus , then release ($\mathbb{C}-\mathbb{D}$, next page).
- ► If the "Calculate More Accurate Histogram" alert button appears on the Properties panel as you're applying a Levels adjustment, you can click the button to refresh the histogram in the panel.
- To apply the current Levels settings to other images — such as to a group of photos that were taken under similar lighting conditions and need the same adjustments — save and apply them as a preset (see page 226). There are also some readymade Levels presets.

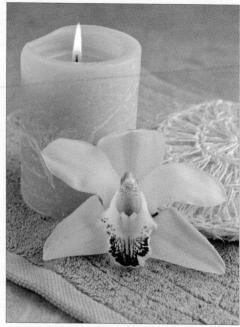

A This image lacks contrast (looks flat and dull).

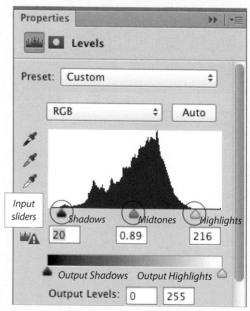

The histogram in this Levels panel doesn't extend all the way to the edges, an indication that the tonal range of the photo is narrow. To expand the range, we moved the shadows and highlights input sliders inward to align with the outer edges of the histogram, and moved the middle slider to the right to darken the midtones.

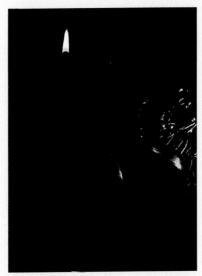

A We held down Alt/Option and dragged the white highlights slider.

B Next, we held down Alt/Option and dragged the black shadows slider.

C Our Levels adjustments improved the contrast (the shadows are darker and the highlights are brighter).

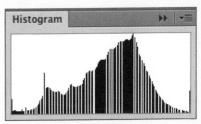

We can tell that the Levels adjustments expanded the tonal range of the image, because now the bars extend all the way from one end of the graph to the other.

Applying a Brightness/Contrast adjustment

The Brightness and Contrast controls are ultra simple to use, but can have a big impact.

To apply Brightness/Contrast adjustments:

- 1. Click a layer or the Background.A
- 2. On the Adjustments panel, click the Brightness/Contrast button. The Brightness/Contrast controls display on the Properties panel.
- 3. Do either of the following:

 Move the Brightness and/or Contrast sliders.

 Click Auto to let Photoshop set the sliders; you can tweak the settings afterward.
- ➤ The Use Legacy option for Brightness/Contrast causes tonal levels to be eliminated from the shadows or highlights (after adjustment, the histogram will show clipped areas on the left or right edge of the graph). Keep this option off to preserve pixel data (in which case, after you move the sliders, the histogram will show only a minor redistribution of tonal values).

A The original image is too light and lacks contrast.

B We reduced the Brightness to darken the image and increased the Contrast to intensify the shadows and highlights (settings shown at left).

Applying a Photo Filter adjustment

To change the color temperature of a scene (make it look warmer or cooler) during a shoot, photographers use colored lens filters. You can simulate the effect of these filters in Photoshop via a Photo Filter adjustment layer, either to neutralize an unwanted color cast or to apply a tint (as a special effect). Choose from among the 20 preset tints that are offered, or choose a custom color.

When you use this feature, we recommend aiming for subtle (sophisticated) or extreme (so it looks deliberate), but not in between. If you go for in between, you will simply give the image an ugly color cast.

To apply a Photo Filter adjustment:

- 1. Click a layer or the Background.
- 2. On the Adjustments panel, click the Photo Filter button. The Photo Filter controls display on the Properties panel.
- 3. Do either of the following:
 - Click Filter, then from the menu, choose a preset warming or cooling filter, or a filter color. The current filter color displays in the swatch.
 - Click the Color swatch, choose a color for the filter via the Color Picker, noting the change in the image, then click OK.
 - For a subtle change, pick a color that is similar to colors in the image. Or for a more striking change, pick a color that is complementary to the predominant colors in the image (one that is on the opposite side of the color wheel — as in red/green, blue/orange, purple/yellow).
- 4. Using the Density slider or scrubby slider, choose an opacity percentage for the tint. Try a modest value between 10% and 25% first. B-C
 - You can also lessen the Photo Filter effect after using the Properties panel by lowering the opacity of the adjustment layer.
- 5. Check Preserve Luminosity to preserve the overall brightness and contrast values of the image. With this option unchecked, the highlights may be softened, but the resulting colorization effect may be too pronounced.
- 6. To compare the original and adjusted images, press and hold \, then release.

A This is the original image.

B For our Photo Filter adjustment layer, we chose Cooling Filter (82) from the Filter menu and a Density value of 20%.

C The Photo Filter adjustment made the image look cooler.

Applying an auto correction

The Auto Color Correction Options dialog offers preset algorithms (formulas) for automatic color and tonal corrections, two of which we cover in this section.

The Find Dark & Light Colors algorithm, used in the task below, analyzes the darkest and lightest colors in an image, then adjusts the shadow and highlight values in each channel based on those colors. Other controls in the dialog will be used to adjust the brightness and color temperature of the midtones.

To apply the Find Dark & Light Colors algorithm:

- 1. Open an RGB image.A
- 2. On the Adjustments panel, click the Levels or Curves button. ✓
- 3. Hold down Alt/Option and click **Auto** on the Properties panel. The Auto Color Correction Options dialog opens. Move it out of the way if it's blocking the image, then click **Find Dark & Light Colors**.
- **4.** Check **Snap Neutral Midtones**. Any colors in the image that are close to neutral will be adjusted

- to match the current values of the Midtones target color.
- 5. To choose a color value for the midtones, click the Midtones color swatch. In the Color Picker, click the H button in the HSB group, then drag the circle in the large square slightly to the right (keep the S value around 10–30). Next, on the vertical Hue bar, click a warm or cool hue. To adjust the brightness of the midtones, drag the circle in the big square slightly upward or downward. B

 Note: Midtones is the only swatch you need to change; Photoshop will adjust the other two swatches automatically based on the printer color profile that is used when you output the file.
- **6.** Click OK to exit the Color Picker, then once again to exit the Auto Color Correction Options dialog (A, next page).
- 7. When the alert dialog appears, offering you the option to save the new target colors as defaults, click No (thank you!) if you would rather choose settings on a case-by-case basis (as we do).

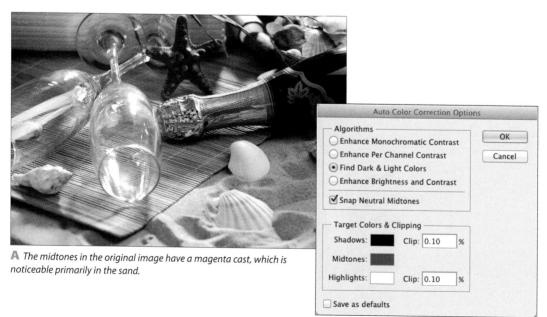

B To neutralize the color cast, in the Auto Color Correction Options dialog, we clicked Find Dark & Light Colors, checked Snap Neutral Midtones, clicked the Midtones swatch, then chose a medium brown via the Color Picker (the new color appeared in the swatch).

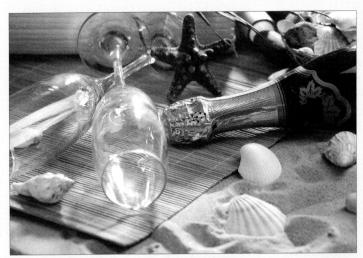

A The adjustments made via the Auto Color Correction Options dialog successfully removed the magenta cast.

BEGIN WITH AN ALGORITHM

When applying a Levels, Curves, or Brightness/Contrast adjustment, you can use one of the auto correction algorithms as a starting point, then tweak the correction further using the sliders or curves.

The Enhance Brightness and Contrast algorithm is a good option for an image that needs substantial tonal correction (e.g., one that is very underexposed). This algorithm uses content-aware technology to evaluate data in the entire image, then via either the sliders or the curve, it corrects the tonal values for the composite RGB channel (instead of for each channel).

To apply the Enhance Brightness and Contrast algorithm:

- 1. Open an RGB image.
- 2. On the Adjustments panel, click the Levels or Curves button. In the dialog, hold down Alt/ Option and click Auto.
- 3. The Auto Color Correction Options dialog opens. Click Enhance Brightness and Contrast, then click OK.C
- 4. Hopefully, the auto algorithm took care of most of the heavy lifting. If further refinement is needed, click the Levels or Curves adjustment layer, and modify the controls on the Properties panel.

B The original image is very underexposed.

The Enhance Brightness and Contrast algorithm did a quick but effective job of brightening the image. Not bad.

Applying a Color Balance adjustment

You can use a Color Balance adjustment layer to apply a warm or cool cast to an image or, conversely, to neutralize an unwanted cast. You choose a tonal range to adjust first (Shadows, Midtones, or Highlights), then move any of the sliders toward a warmer or cooler hue. Note: If you need to restrict color adjustments to an even smaller tonal range, use Curves or Hue/ Saturation.

To apply a Color Balance adjustment:

- 1. Click a layer or the Background.
- 2. On the Adjustments panel, click the Color Balance button 44
- 3. The Color Balance settings display on the Properties panel. From the Tone menu, choose the range you want to adjust: Shadows, Midtones, or Highlights.

Optional: Keep Preserve Luminosity checked to preserve the tonal values of the layer as you make color corrections, or uncheck this option to allow

- the adjustment to change both the luminosity and color values.
- 4. Each slider pairs a cool hue with a warm one. Move a slider toward any color you want to add more of or away from any color you want to reduce **B-C** (and **A-B**, next page). For instance, you could move a slider toward green to reduce magenta, or toward yellow to reduce blue.
 - Try moving two or more sliders toward similar hues. For example, to add a cool cast, you could move the first slider toward Cvan and the third one toward Blue. Or to make an image warmer, move the first slider toward Red and the third one toward Yellow.
- 5. Choose any other range from the Tone menu. then adjust the color sliders for that range. To compare the original and adjusted images, press and hold \, then release.

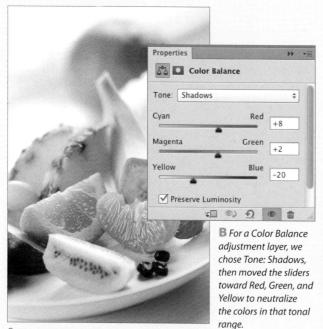

The shadow areas look more neutral than they did before, but further corrections are needed.

A To neutralize the blue cast in the midtones, we chose Tone: Midtones, then moved the sliders toward Red and Yellow. Only the highlight adjustment remains.

B To warm the highlights and neutralize the remaining traces of the blue color cast, we chose Tone: Highlights, then moved the sliders toward Red and Yellow (and very slightly toward Magenta). Now the food and the plate look warmer (and more appetizing!) and the shadows look neutral.

Applying a Hue/Saturation adjustment

Via a Hue/Saturation adjustment, you can apply very targeted hue, saturation, and lightness corrections without having to create a selection. In the example shown below, we use it to correct a color cast and to recolor a garment. This is a very useful command.

To apply a Hue/Saturation adjustment:

- 1. Click a layer.A
- 2. On the Adjustments panel, click the Hue/ Saturation button. The Hue/Saturation settings display on the Properties panel.
- 3. Do any of the following:

To correct all the colors in the image, keep Master as the choice on the second menu; B to adjust a specific color range, choose that color on the

menu. Move the **Hue** slider to adjust the hue(s), C the Saturation slider to adjust the color intensity. or the Lightness slider to lighten or darken. If you adjust the Lightness, you may need to increase the Saturation to revive any colors that were lightened or darkened.

To change a hue, click the Targeted Adjustment tool on the panel, then Ctrl-drag/Cmd-drag horizontally over the color area in the image that you want to adjust. The color range you dragged over is now listed on the menu, and the Hue slider shifts on the panel. Or to change the Saturation of a color range, drag horizontally with the same tool over a color area in the image without holding down Ctrl/Cmd.

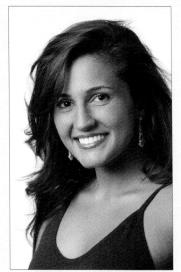

A The original image has a reddish color cast.

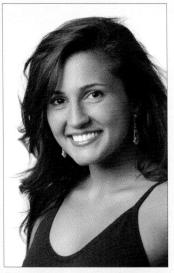

B To fix the overall color cast, we chose Master from the menu, then moved the Hue slider slightly toward the right.

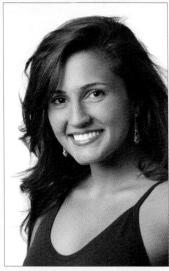

C To recolor her top, we chose Magentas from the menu, then moved the Hue slider to -73 (blue).

SPREADING A HUE/SATURATION RANGE

When a color range (e.g., Yellows or Greens) is chosen on the second menu on the Properties panel for a Hue/Saturation layer, you can spread an adjustment of a color range more gradually into an adjacent one by dragging one of the little squares outward.

For instance, to spread an adjustment of the Greens range into the Yellows range, you would drag the little square to the left, into the yelloworange area. Try it and see how it affects the image. (To change which hue is adjusted, use the Targeted Adjustment tool, as described in step 3 on the preceding page.)

Applying a Vibrance adjustment

Here you will use the Vibrance controls to adjust the saturation of a color layer. On the next two pages, Vibrance is used as a desaturation method.

To guard against oversaturation and clipping, the Vibrance slider boosts the intensity of less saturated colors more than that of highly saturated colors, making this slider particularly useful for adjusting skin tones. The Saturation slider, by comparison, applies the same change to all colors regardless of their original saturation levels.

To adjust the vibrance of skin tones:

- 1. Click a layer or the Background.A
- 2. On the Adjustments panel, click the Vibrance button. The Vibrance settings display on the Properties panel.
- 3. Increase the Vibrance value.
- 4. If necessary, reduce the Saturation value slightly.B

A The color in this portrait is oversaturated.

B For the Vibrance adjustment layer, we set the Vibrance value to +42 and the Saturation value to -15. Now the skin tones look more natural.

In this task, you will use a Vibrance adjustment layer to either strip the color completely from a layer or desaturate a layer partially, and then use the Vibrance slider to adjust the intensity of the remaining color.

To desaturate a layer using a Vibrance adjustment:

- 1. Click a layer or the Background.A
- 2. On the Adjustments panel, ✓ click the Vibrance button. ▼ The Vibrance settings display on the Properties panel.
- 3. Do either of the following:

For a simple, full desaturation, reduce the **Saturation** to its lowest value of -100.

To adjust the color vibrance as you desaturate the layer, reduce the **Saturation** to between -60 and -80, then to control the color intensity in the now desaturated layer, increase or reduce the **Vibrance** value.**B**-**D** Remember, the Vibrance option boosts the intensity of the least saturated colors the most.

ℂ This is the image after we applied the Vibrance adjustment layer settings shown in the preceding figure.

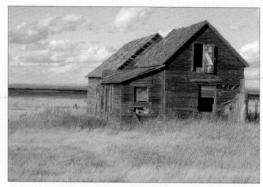

A This is the original image.

B To desaturate the color partially, we lowered the Saturation value on a Vibrance adjustment layer to –60 and set the Vibrance value to –50.

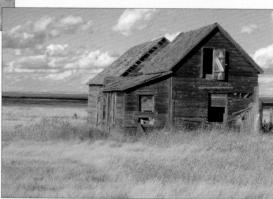

D For this version, we kept the Saturation value of -60 but raised the Vibrance to the maximum value of +100.

To desaturate a color layer using Vibrance, then restore color selectively:

- 1. Click a layer or the Background.A
- 2. On the Adjustments panel, click the Vibrance button. The Vibrance settings display on the Properties panel.
- 3. Reduce the Saturation to the lowest value of -100.
- 4. Choose the Brush tool, and on the Options bar, choose a Soft Round brush, Normal mode, and an Opacity of 50% or less. Choose black as the Foreground color.
- 5. Adjust the brush diameter, make sure the mask thumbnail is still selected on the adjustment layer, then apply strokes where you want to restore the original colors.**B−C** You can change the brush opacity and diameter between strokes. To restore desaturated areas, set the brush Opacity to 100%, and paint with white (press X to swap the colors).

B To strip the color from the image, we created a Vibrance adjustment layer, then lowered the Saturation value to −100. To reveal some color, we applied brush strokes to the adjustment layer mask.

A This is the original image.

The pasta commands most of the attention now, because it is the only area in color.

Applying a Curves adjustment

By using a Curves adjustment layer, you can limit tonal and color adjustments to a narrow range (such as to the highlights, quarter tones, midtones, three-quarter tones, or shadows). The corrections can be applied to the composite image (all the channels) or to individual color channels. In these steps, you will apply tonal corrections first, then apply color corrections.

Note: The information in the steps below pertains to RGB images. For a CMYK image, the controls work in the opposite way.

To apply tonal and color corrections using a Curves adjustment layer:

Part 1: Apply tonal adjustments

- Open an image that needs color and/or tonal adjustments. A
- 2. On the Adjustments panel, click the Curves button.
- 3. On the Properties panel menu, choose Curves Display Options. In the dialog, B keep the Show Amount Of value on the default setting of Light, check all four of the Show options, then click OK.
- **4.** If you need to increase the contrast in the image, do either of the following:

The input sliders set the white and black tonal values in the image. To darken the shadows and brighten the highlights, drag the black shadow input slider and white highlight input slider inward so they align with the ends of the

gray areas in the histogram (A, next page) — or until you see that the contrast in the image is improved. The steeper the curve (which is, for the moment, still a straight line), the stronger the contrast.

To establish the white and black values via a high-contrast display of clipping (called Threshold mode), Alt-drag/Option-drag the black slider until a few areas of color or black appear; do the same for the white slider until a mere smidgen of white appears.

5. For more targeted adjustments, do either of the following:

Drag part of the curve; a (selected) point appears on it. For example, to lighten the midtones, drag the middle of the curve upward, or to darken the midtones, drag the middle of the curve downward.

When a tonal value is lightened, its Output value is increased above its Input value (the original brightness value). When a tonal value is darkened, its Output value is reduced below its Input value.

Click the **Targeted Adjustment** tool in the panel, then move the pointer over an area of the image that contains the tonal level you want to darken or lighten; a small circle appears on the curve. Drag upward to lighten that level

Curves display for each adjusted color channel

A This image is underexposed (too dark) and has a bluish cast.

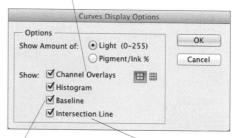

A straight diagonal line that represents no adjustments (for comparison)

Axis guides that appear as you move a point on the curve

B For this task, check all the Show options in the Curves Display Options dialog. (The grid buttons control the size of the grid squares.)

- or downward to darken it. A point corresponding to that level appears on the curve.
- 6. Keep the Curves controls showing on the panel. If the color also needs correcting, see the next page.
- ➣ If the "Calculate More Accurate Histogram" alert button appears on the Properties panel as you're applying a Curves adjustment, click the button to refresh the histogram in the panel.
- To cycle through and select each point on the curve, press the + (plus) key. To nudge a selected point, press an arrow key. To remove a selected point, press Backspace/Delete.
- To enlarge the graph and curve, drag an edge of the Properties panel.

Continued on the following page

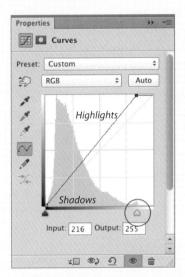

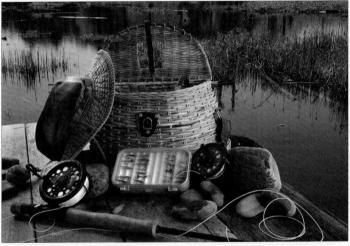

A To lighten the highlights, we created a Curves adjustment layer, then moved the white slider to the left.

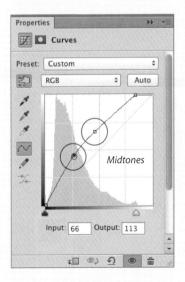

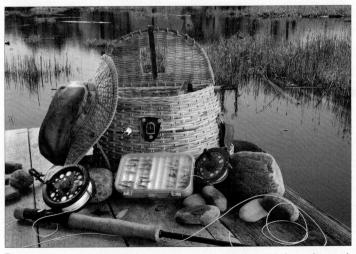

B To lighten the midtones, we clicked the Targeted Adjustment tool, dragged upward slightly on the left side of the basket, then did the same on the right side of the basket (points appeared on the curve). Although our Curves adjustments improved the tonal balance, the colors look a bit washed out. We'll correct that next.

 With the Curves adjustment layer still selected, from the second menu, choose Red to adjust that channel separately, then do any of the following: Add or subtract red in the shadows by dragging the lower part of the curve or the black slider, or in the highlights by dragging the upper part of

the curve or the white slider. A

- Drag the middle of the curve upward to add red to the midtones or downward to subtract red **B** (to a lesser extent, this adjustment will also affect the reds in the shadows and highlights). Often, this midtone adjustment is all that's required.
- Click the Targeted Adjustment tool in the panel, then drag upward in the image to add red to that tonal level or downward to subtract red (the part of the curve that corresponds to that level adjusts accordingly).
- 2. Choose the **Green** channel, then the **Blue** channel, adding or subtracting that color from the image, as in the preceding step. You can switch back and forth between the color

- channels and readjust them if needed (**A–D**, next page).
- 3. Optional: To lessen the overall impact of the Curves adjustment layer, lower the layer opacity. Or to hide the effect from specific areas of the image, click the adjustment layer mask, then with the Brush tool and the Foreground color set to black, apply brush strokes in the image.
- To save your adjustment settings as a preset for future use, see page 226.
- As an alternative to adjusting the curves individually for each color channel, you could, theoretically, correct the overall color by selecting the gray point (middle) eyedropper on the Properties panel for Curves, then click a neutral gray area in the image. However, this method is less reliable than the method described in the task above, because locating a neutral gray is harder than it sounds (in fact, the image may not even contain a neutral gray).

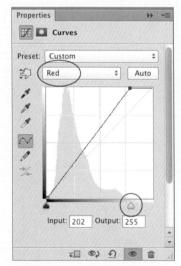

A To add red to the highlights (such as on the basket), with the Red channel selected, we moved the white slider slightly inward (to the left).

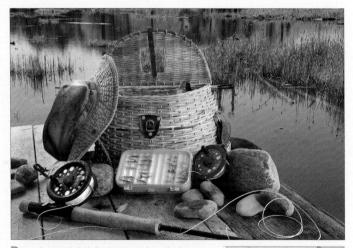

B We dragged slightly downward on the lower part of the curve (where most of the red pixels are clustered on the histogram). This produced a point on the curve (shown at right) and removed some red from the midtones.

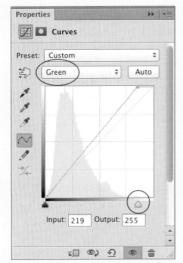

A To add green to (and remove red and blue from) the highlights, with the Green channel selected, we dragged the white slider slightly inward.

B To reduce the amount of green in the midtones, we clicked the Targeted Adjustment tool, then dragged downward slightly in the image, starting from the center of the basket. A point appeared on the curve for the Green channel.

Finally, to add blue to (and remove green from) the highlights, with the Blue channel selected, we dragged the white slider slightly inward.

D To reduce the amount of blue in the midtones, we dragged downward slightly on the lower part of the curve on the panel (where most of blue pixels are clustered); a point appeared on the curve. Although we made only minor adjustments to the curve for each channel, in the final image, you can see that overall, the colors are now better balanced.

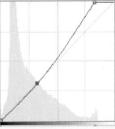

Applying a Black & White adjustment

Our preferred way to strip color from a layer is via a Black & White adjustment. With this awesome command, you can control how the individual R, G, B and C, M, Y color channels are converted to grayscale values. As an added option, you can apply a tint. Note that this feature has no effect on the document color mode.

To convert a layer to grayscale via a Black & White adjustment:

- In an RGB image, click a layer or the Background.
- 2. On the Adjustments panel, click the Black & White button. The Black & White controls appear on the Properties panel.
- 3. Do any of the following:

Click **Auto** to let Photoshop choose the settings (**A**–**B**, next page), or choose a preset from the **Preset** menu. You can also customize the settings, as described below.

Adjust any of the sliders. A lower value produces a darker gray equivalent for a color; a higher value produces a lighter gray equivalent (C-D, next page). For example, you could use the Yellows slider to lighten or darken the skin tones in a portrait or move the Cyans and Blues sliders to adjust the sky in a landscape.

Click the Targeted Adjustment tool in the panel, then drag to the right in an area of the image to lighten that shade, or to the left to darken it. The slider corresponding to the predominant color in that area will shift accordingly.

- **4.** Optional: To apply a tint to the image, check Tint, click the color swatch, choose a color in the Color Picker, then click OK (A, page 248).
- 5. Optional: To restore some of the original color to the whole layer uniformly, lower the opacity of the adjustment layer. To restore color to specific areas, click the adjustment layer mask thumbnail, choose black as the Foreground color, then with the Brush tool, apply strokes to the image (for a more subtle effect, lower the opacity for the tool first).

AUTO-SELECTING THE TARGETED ADJUSTMENT TOOL

To have Photoshop select the Targeted Adjustment tool (or) automatically on the Properties panel when you create a Curves, Hue/Saturation, or Black & White adjustment layer, display the controls for one of those three adjustment types, then choose Auto-Select Targeted Adjustment Tool from the panel menu.

ORCHESTRATING A SCENE

In our environment, as in fine art and photography, colors help to define shapes and spatial relationships and draw our attention to some elements in a scene more than others. When converting an image to grayscale, you will need to reinterpret the composition and orchestrate visual movement using lights and darks instead of color. For example, say there's a bright red shape in the center of the original color layer. When the layer is reduced to grayscale, you could lighten or darken that shape via the Black & White controls, to distinguish it from surrounding grays.

A This image layer is a good candidate for a conversion to grayscale, because it has clearly defined shapes.

A This is the image after we created a Black & White adjustment layer and clicked Auto on the Properties panel.

B These are the slider values that Photoshop chose when we clicked the Auto button.

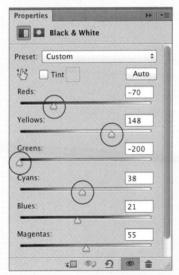

C To darken the cabin on the boat, we reduced the Reds value; to lighten the upper midtones on the boat deck, we increased the Yellows value; to darken the water in the foreground, we reduced the Greens value; and to darken the sky slightly, we reduced the Cyans value.

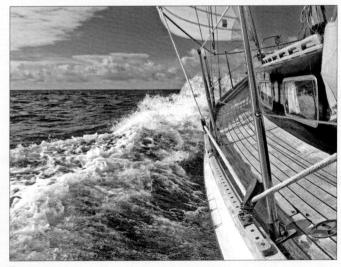

D This final version of the image has better contrast than the Auto version shown above.

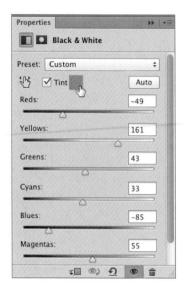

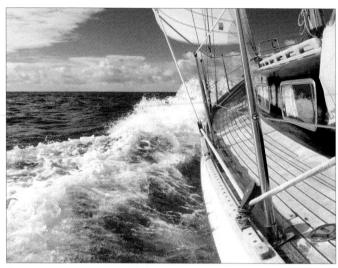

A For this Black & White adjustment, we checked Tint on the Properties panel, clicked the Tint swatch, chose a color in the Color Picker, then used the sliders to intensify the color in some areas, such as on the boat cabin and upper sky. The settings we chose are shown at left.

Tinting an image via a Gradient Map adjustment

A Gradient Map adjustment matches luminosity values of colors in a gradient to luminosity values in an image, replacing one with the other. It produces beautiful effects with little effort (you can look like a Photoshop pro even if you're not one — yet!). This is a fun feature to experiment with.

Note: A recommended prerequisite for this task is familiarity with the Gradient Editor, which is covered on pages 214-215.

To tint an image via a Gradient Map adjustment:

- 1. Click a layer or the Background.B
- 2. On the Adjustments panel, click the Gradient Map button.
- 3. On the Properties panel, click the Gradient picker arrowhead, then via the picker menu, - load a preset library (or two), including the Photographic Toning library. Click a preset on the picker (A, next page). To minimize visible banding on print output, check Dither.
- 4. Optional: Click the Gradient thumbnail to open the Gradient Editor, then edit the gradient (e.g., add or change some color stops, or reposition some stops or midpoint diamonds) (B, next page).

- 5. Optional: Check Reverse to apply the lightest colors in the gradient to the darkest values in the image, and the darkest colors to the lightest values in the image (the opposite of the default behavior). If the gradient contains dark colors, this option may produce a "film negative" effect.
- 6. Optional: Change the blending mode of the Gradient Map layer (C, next page). Try Darken, Soft Light, Pin Light, Hue, or Luminosity.

B This is the original image.

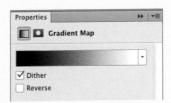

A Via a Gradient Map adjustment, we applied the Sepia 2 gradient (Photographic Toning library); we kept the default settings for the gradient.

C A different Gradient Map adjustment we made to the original image: Light Cyan gradient (Simple library), Reverse checked on the Properties panel, and Pin Light chosen as the blending mode for the adjustment layer.

B In a copy of the original image, we applied a Gradient Map adjustment using the Sepia-Selenium 2 gradient (Photographic Toning library). In the Gradient Editor, we deleted the second color stop, lightened the third color stop, and dragged the third stop slightly to the left.

Applying the Merge to HDR Pro command

To produce an HDR (High Dynamic Range) image, multiple exposures of the same scene are combined into one image. The composite image contains a wider range of tonalities than could be captured in a single shot.

To shoot photos for an HDR composite:

- Use a tripod to ensure that the shots align uniformly, and a cable release to minimize camera shake.
- Use a low ISO setting to minimize noise.
- Capture the photos as raw files.
- ➤ To keep the aperture constant, set the camera to Aperture Priority mode (A mode for a Nikon; AV mode for a Canon).
- ➤ Set the auto bracket feature to capture either three or five shots using different exposures (shutter speeds) automatically. For a Nikon, use the Auto Bracketing Set > AE Only option; for a Canon, use the Exposure Comp/AEB Setting option. For three-shot bracketing, set exposures of two stops underexposed, one normal exposure, and two stops overexposed. For five-shot bracketing, set exposure differences of one and two stops underexposed, one normal exposure, and one and two stops overexposed.

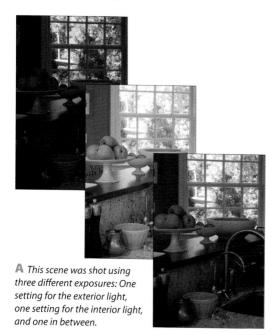

To apply the Merge to HDR Pro command:

- In Bridge, select the three or five bracketed photos you captured for the HDR image, A then choose Tools > Photoshop > Merge to HDR Pro.
- 2. Sit tight while Photoshop merges your photos. When the Merge to HDR Pro dialog opens, choose Mode: 16 Bit or 8 Bit and choose Local Adaptation from the menu as the conversion method (for 32 Bit mode, see the tip on the next page).
- 3. Under Tone and Detail, increase the **Detail** value to boost the image sharpness and contrast, and to provide more tonal variation for the other sliders to work with.
- 4. Under Edge Glow, increase the Strength value to increase edge contrast and create a white edge glow. Increase or reduce the Radius value to adjust the width of the glow (A, next page).

 Optional: To suppress the sharpness of the edges and allow for higher Detail values, check Edge Smoothness.
- 5. Under Tone and Detail, choose a low Gamma value to emphasize the midtones, or a high value to emphasize the highlights and shadows.
 Use the Exposure slider to adjust the overall lighting (B, next page).
- 6. In the Advanced tab, use the Shadow slider to adjust the lightness of the shadow areas. Lower the Highlight value if you need to recover details in the highlights (ℂ, next page). If you plan to refine the HDR image in Camera Raw, as we recommend, use these sliders to apply only minor adjustments.
 - Readjust the Detail value to tweak the sharpness.
- 7. To remove any discrepancies between shots that resulted from the movement of the subject, check Remove Ghosts near the top of the dialog, then click one of the exposure thumbnails at the bottom of the dialog to designate it as the source for aligning the shots (A—B, page 252). The normal (EV.0) or dark (EV-1) exposure thumbnail may work best.
- **8.** To tweak the shadows, midtones, or highlights, click the Curve tab and gently drag the part of the

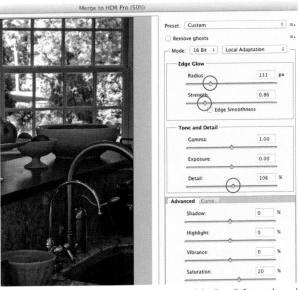

A In the Merge to HDR Pro dialog, we increased the Detail, Strength, and Radius values to heighten the details and edges in the image.

- curve for that tonal range, just as you would for a Curves adjustment (€, next page).
- 9. Click OK. The HDR file will open as a new document in Photoshop. Save the document in the Photoshop PSD format, then follow the steps on page 253 to refine it in Camera Raw.
- ► If you choose 32 Bit as the mode in the Merge to HDR Pro dialog, you can check Complete Toning in Adobe Camera Raw, then click the Tone in ACR button to access — and adjust the document in the Camera Raw dialog. Be aware that 32-bit files are very large and must be converted to 8- or 16-bit for output.

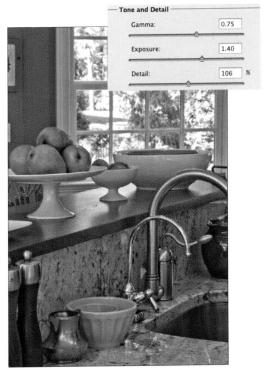

B We lowered the Radius value (to 91) to lessen edge glows, dragged the Gamma slider to the right (to a lower value) to emphasize the midtones, and increased the Exposure value to lighten the overall image.

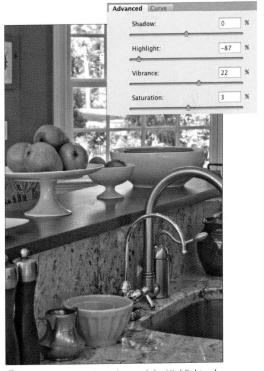

In the Advanced tab, we lowered the Highlight value substantially to recover highlight details, reduced the Saturation value, and increased the Vibrance value to boost the color saturation.

A The leaves outside the window moved when we shot our three exposures, producing what are called "ghosts" — like a double-exposure — in the composite image.

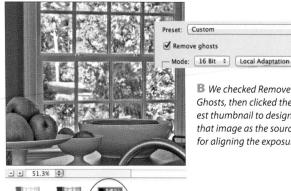

EV +1.00 ■ EV 0.00

B We checked Remove Ghosts, then clicked the darkest thumbnail to designate that image as the source for aligning the exposures.

+

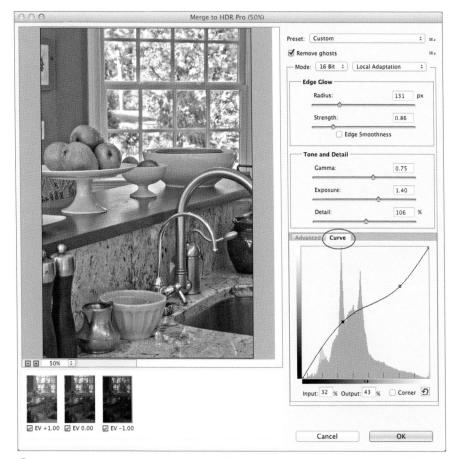

lacksquare Finally, in the Curve tab, we raised the lower middle part of the curve slightly to lighten the shadows and lowered the upper part of the curve slightly to darken the highlights and upper midtones. As you can see in the preview, these HDR Pro settings improved the image considerably.

MAKING AN IMAGE LOOK SURREAL

In the Merge to HDR Pro dialog, choosing high values for the Radius, Strength, and Detail sliders (and checking Edge Smoothness) will produce a stylized, surrealistic image, like the version shown below, whereas lower values will produce a more naturalistic image.

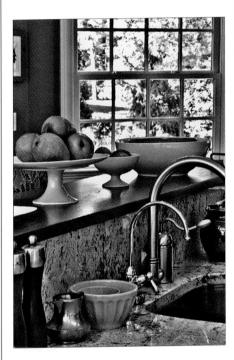

USING THE HDR TONING COMMAND

The Image > Adjustments > HDR Toning command offers the same controls as the Merge to HDR Pro command, except you apply it to a single RGB photo. You could apply HDR Toning to an underexposed photo to correct the color and recover details or, for a very stylized result, choose settings that accentuate the edges and heighten the contrast. Note that HDR Toning will flatten all the layers in your document automatically, so be sure to save a copy of the file first!

After using the Merge to HDR Pro command, we like to tweak the exposure, color, and tonal values in the new composite file afterward by using the Camera Raw Filter.

To process an HDR file in Camera Raw:

- 1. After following the steps on pages 250-252, duplicate the Background, then right-click the duplicate layer and choose Convert to Smart Object.
- 2. Choose Filter > Camera Raw Filter (Ctrl-Shift-A/ Cmd-Shift-A).
- 3. In the Camera Raw dialog, use the Basic or any other tab or sliders to further enhance or improve the image (see Chapter 4).
- 4. Click OK.A

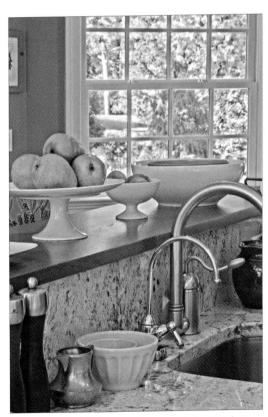

A This is the final HDR image after we applied some adjustments via the Basic tab in the Camera Raw dialog.

Screening back a layer using Levels

When printing dark text or a logo on top of a photo, you need to make sure the picture is light enough for the text or logo to be readable, but not so light that the image content isn't discernible. To achieve both objectives, you can screen back (lighten) an image layer—or a selected area of an image layer—via Levels.

To screen back a layer using Levels:

- 1. Open an image.A
- **2.** Optional: To limit the adjustment to a specific area of the image, create a selection.
- 3. On the Adjustments panel, click the Levels button. Levels controls display on the Properties panel.
- **4.** To reduce contrast in the image, move the output levels shadows (bottom black) slider to the right.
- **5.** To lighten the midtone values in the image, move the input levels midtones (gray) slider to the left.
- **6.** To feather the edge of the mask nondestructively, click the adjustment layer mask thumbnail, then set the Feather value on the Properties panel.
- 7. To compare the original layer and the adjusted version, press and hold \, then release.

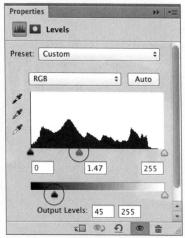

B To lighten the selected image layer, we created a Levels adjustment layer and chose these settings.

A This document contains an editable type layer above an image layer.

■ With the image screened back, the type is more eye-catching and easier to read.

If we had to pick one topic that represents the heart and soul of Photoshop, it would be the art of combining images. In this chapter, you will learn various ways to copy selections and layers within the same document and between documents; create, edit, and replace Smart Objects; combine multiple exposures; and fade the edge of a layer with a layer mask. You will also learn how to use the Clone Stamp tool to clone imagery, the Photomerge and Auto-Align Layers commands to merge multiple images, and Smart Guides and other Photoshop features to precisely position and align layers. You'll be amazed at how easy (and how much fun) it is to create composite images!

Using the Clipboard

One way to transfer a selection of imagery from one layer or document to another is by using the Clipboard commands on the Edit menu. You choose the Cut, Copy, or Copy Merged command first to put the current selection into a temporary storage area in memory, called the Clipboard. Then you choose a paste command, such as Paste or Paste in Place, to paste the Clipboard contents as a new layer in the same document or in another document. If there is an active selection in the target document, another option is to use the Paste Into or Paste Outside command to paste the Clipboard contents inside or outside of the selection.

If you cut (remove) a selection from the Background via the Cut command, the exposed area fills automatically with the current Background color. A If you cut a selection from a layer, the area left behind is replaced with transparent pixels (the same results that you get when you move pixels on a layer). B

The same Clipboard contents can be pasted as many times as needed. Only one selection can be stored on the Clipboard at a time, however, and it is replaced by new contents each time you use the Cut, Copy, or Copy Merged command. If Export Clipboard is checked

Continued on the following page

A This selection was cut from the Background.

B This selection was cut from a layer.

OM BINING IM DCES

IN THIS CHAPTER

Using the Clipboard255
Drag-copying a selection on a layer259
Drag-copying a selection or layer between files with the Move tool260
Drag-copying layers between files via the Layers panel
Creating a layered document from file thumbnails
Creating embedded Smart Objects 264 $$
Editing embedded Smart Objects268
Replacing an embedded or linked Smart Object
Creating linked Smart Objects 272
Working with linked Smart Objects273
Combining multiple "exposures"276
Fading the edge of a layer via a gradient in a layer mask279
Aligning and distributing layers 281 $$
Using the Clone Stamp tool and the Clone Source panel
Using the Photomerge command 284 $$
Using Smart Guides, ruler guides, and the grid286

in Edit/Photoshop > Preferences > General, the Clipboard contents will stay in temporary system memory when you exit/quit Photoshop — but only until you shut down your computer.

To empty the Clipboard at any time in order to reclaim system memory, choose Edit > Purge > Clipboard, then click OK if an alert appears. (To prevent the alert from reappearing, check Don't Show Again.)

When you use a paste command, the contents of the Clipboard appear automatically on a new layer.

To copy and paste a selection:

- 1. Read the sidebar on this page, and change the resolution of a copy of the source file, if needed.
- 2. Click a layer in the source document, then create a selection. Optional: Refine the selection edge via the Refine Edge dialog (see pages 182-183).
- 3. Choose one of the following commands:

Edit > Copy A (Ctrl-C/Cmd-C) to copy pixels from the current layer within the selection area.

Edit > Copy Merged (Ctrl-Shift-C/Cmd-Shift-C) to copy all pixels from all visible layers within the selection area.

Edit > Cut (Ctrl-X/Cmd-X) to cut the selection out of the current layer.

- 4. Click in the same document or in another document.
- 5. Do either of the following:

To have the Clipboard contents land in the center of the document window (or if the dimensions of the copied content are larger than those of the target document, to the top and left edges of the canvas area), choose Edit > Paste (Ctrl-V/Cmd-V).

To have the Clipboard contents land in the same x/y location as in the source layer or document, choose Edit > Paste Special > Paste in Place (Ctrl-Shift-V/Cmd-Shift-V).

- 6. If the source file has a different color profile than the target file, the Paste Profile Mismatch alert dialog will appear. We recommend that you click Convert (Preserve Color Appearance) to preserve the appearance of colors in the source image, then click OK.
- 7. The pasted pixels will appear on a new layer. You can restack the layer, and you can reposition it in the image with the Move tool.

A We created a selection, then pressed Ctrl-C/Cmd-C to copy its contents.

B In another document, we pressed Ctrl-V/Cmd-V to paste the Clipboard contents; they arrived on a new layer.

HEY! MY PICTURE SHRANK!

When you paste or drag and drop a selection between documents, the copied imagery adopts the resolution of the target document. If the resolution of the target file is higher than that of the source one, the copy will look smaller than imagery on other layers; if the resolution of the target file is lower than that of the source document, the copy will look larger. If you want to prevent a size discrepancy when copying imagery between files, before creating the copy, change the resolution of a copy of the source file via Image > Image Size to match that of the target document (resharpen the image, too).

To compare the relative sizes of the source and target documents, use the Window > Arrange submenu to arrange them side by side, and choose the same zoom level for both.

Working with pixels outside the canvas

If the dimensions of the Clipboard contents that you paste are larger than those of the target document, some of the pasted pixels will be hidden from view outside the canvas area (they will save with the document). This will also occur if you use the Crop tool with the Delete Cropped Pixels option off. When you apply an image-editing command (such as a filter), it alters the entire layer, including any pixels outside the canvas area. Here are some ways to work with those pixels:

- To move hidden pixels into view, click the layer, then hold down V (Move tool) and drag in the image.
- To select all the nontransparent pixels on a layer, including any pixels outside the live canvas area (and pixels that may be hidden by a layer mask), Ctrl-click/Cmd-click the layer thumbnail on the Layers panel. Select > All, in comparison, selects only the rectangular boundary of the canvas area.
- To enlarge the canvas area to include all hidden pixels on all layers, choose Image > Reveal All.
- To remove pixels that are outside the canvas area from all layers, choose Select > All, then choose Image > Crop. This can help reduce the file size.
- If a layer contains pixels outside the canvas area and you merge it with the Background (not with another layer), the hidden pixels will be discarded.
- To shrink the contents of the current layer, choose the Move tool, + check Show Transform Controls on the Options bar, Shift-drag a corner handle on the bounding box inward, then press Enter/Return.

ADJUSTING THE SELECTION EDGE

To shrink the edges of a selection, before you move, copy, or drag-copy it, click Refine Edge on the Options bar, then reduce the Shift Edge value. To soften the edges of the selection, use the Feather slider (see the sidebar on page 259). Or even better, if you store a selection as a layer mask, you can use the nondestructive controls on the Properties panel at any time to change the Density and Feather values of the mask (see page 192).

COPYING LAYER SETTINGS, TOO

To copy layer settings (e.g., blending mode, opacity, and layer effects) along with imagery when creating composite documents, instead of using the Clipboard, copy the whole layer, as described on page 260 or 262.

COPYING IMAGERY TO A NEW LAYER

To copy imagery to a new layer within the same document without using the Clipboard, click a layer or the Background, create a selection, then press Ctrl-J/Cmd-J, or right-click in the image and choose Layer via Copy. Or if you want to remove the selected pixels from the original layer and put them on a new layer, press Ctrl-Shift-J/Cmd-Shift-J, or right-click in the image and choose Layer via Cut.

We're dragging a layer from left to right to reveal hidden pixels.

When you use the Paste Into command to paste the contents of the Clipboard into a selection, Photoshop creates a new layer and converts the selection to a layer mask. You can reposition the pasted imagery within the mask, edit the mask to reveal more or less of the imagery that it is hiding, or adjust the mask density or feather value via the Properties panel.

To paste into a selection:

- Select an area of a layer or the Background in a source image from which you want to copy pixels.
- 2. Choose Edit > Copy (Ctrl-C/Cmd-C) to copy pixels from only the currently selected layer, or choose Edit > Copy Merged (Ctrl-Shift-C/Cmd-Shift-C) to copy pixels within the selection area from all visible layers.
- **3.** Click a layer in the same document or in another document.
- **4.** Select the area (or areas) into which you want to paste the Clipboard contents. *B Optional:* Click Refine Edge on the Options bar and use the dialog controls to refine the selection edge.
- **5.** Choose Edit > Paste Special > Paste Into or press Ctrl-Alt-Shift-V/Cmd-Option-Shift-V. ☐ A new layer and layer mask appear.
- 6. Optional: Although the entire contents of the Clipboard were pasted, the layer mask may be hiding some of the imagery. To move the layer contents within the mask, hold down V (Move tool), click the layer thumbnail, then drag in the document. Or to move the layer mask, click the mask thumbnail before dragging. To move the layer and layer mask as a unit, click between the layer and mask thumbnails to produce a Link icon, I then hold down V and drag in the image.
- 7. Optional: To reshape the mask, click the mask thumbnail. With the Brush tool (B or Shift-B), a Soft Round brush, and white chosen as the Foreground color, paint in the document to expose more of the pasted image. To hide more of the pasted image, press X to paint with black.
- When you open the File > New dialog, it lists the dimensions of the smallest rectangle that can surround the current contents of the Clipboard, if any.
- Unlike the Cut and Copy commands, the Edit > Clear command empties a selection area without putting the selection contents onto the Clipboard.

A We used the Rectangular Marquee tool to select an area of this image layer, then chose the Copy command.

B Next, we used the Quick Selection tool to select the sky area in this document.

ℂ Finally, we pasted the Clipboard contents into the selection via the Paste Into command, for a more Baroque sky.

Drag-copying a selection on a layer

In this task, you will drag-copy a selection on a layer within the same document. On the next four pages, you will drag-copy layers and selections between files.

To drag-copy a selection on a layer:

- 1. Select an area of a layer or the Background.
- 2. Do either of the following:

Choose the Move tool (V), then hold down Alt/Option and drag the selection. A The duplicate pixels will remain selected.

Choose a tool other than the Move tool, then hold down Ctrl-Alt/Cmd-Option and drag the selection.

- 3. Deselect (Ctrl-D/Cmd-D).
- Include Shift with either shortcut listed above to constrain the movement to increments of 45°.

A With the Rectangular Marquee tool, we selected the window area in this image, then we held down Ctrl-Alt/ Cmd-Option (and Shift) and dragged the selection to the right ...

B ... to create a copy of the selection.

FEATHERING THE EDGES OF A SELECTION

With a selection active and a selection tool chosen, click Refine Edge on the Options bar (Ctrl-Alt-R/Cmd-Option-R). Choose View: On White (W), increase the Feather value, choose Output To: Selection, then click OK. The feathering will become evident visually when you move, drag-copy, copy and paste, or edit (e.g., apply brush strokes or filters to) the selection.

We created a selection.

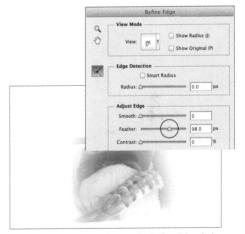

We applied a Feather value via the Refine Edge dialog.

We drag-copied the selection.

Drag-copying a selection or layer between files with the Move tool

When you drag and drop (drag-copy, for short) a selection of pixels from one document to another, presto, a duplicate of those pixels appears on a new layer in the target document. Pixels that land outside the canvas area can be moved into view at any time. An advantage of this method, as opposed to using the Clipboard, is that layer style settings (blending mode, opacity, and effects) in the layer that you drag and drop, along with any masks, are also copied. You can also drag-copy a shape, type, or Smart Object layer.

To drag-copy a selection or layer between documents with the Move tool:

- 1. Open the source and target documents. Change the resolution in a copy of the source file, if needed (see the sidebar on page 256). Suggested contents for the target file are a white or solidcolor Background, a photo of a texture, or a screened-back image.
- 2. Click in the source document, then on the Layers panel, click a layer or the Background. Optional: Select part of the layer or Background.
- 3. Choose the **Move** tool (or hold down V).
- 4. Drag from inside the selection or layer in the source document window to the tab of the target document, A pause until the target document displays, then release the mouse where you want the selection or layer to appear.B
 - To drop the copied selection or layer in the center of the source document, hold down Shift as you release the mouse.
- 5. If the source file has a different color profile than the target file, the Paste Profile Mismatch alert dialog will appear. We recommend that you click Convert (Preserve Color Appearance) to preserve the colors of the source image, then click OK. An alert will also appear if the source and target files have a different bits-per-channel setting. Click Yes to accept the change in image quality (or click No to cancel).
- 6. The duplicate content will appear on a new layer. You can reposition or scale it with the Move tool.
- You can also drag and drop multiple selected layers. To copy a layer group, after step 3, above, check Auto-Select on the Options bar and choose Group on the menu, then continue with steps 4-6.

A Drag a selection from inside a tabbed window to the tab of another document.

B When the target image displays, drag the selection into the image, then release.

The selection appears as a new layer in the target image.

REFINING THE EDGES OF A LAYER AFTER USING DRAG-COPY OR PASTE

We drag-copied a layer containing a photo of a ukulele player from a source file into a beach image. We didn't like the white fringe around the edges of the figure, especially on the skirt (wrong kind of fringe!). To eliminate the fringe, our first step was to choose Layer > Layer Mask > From Transparency. The command converted the transparent areas of the layer into black areas in a layer mask.

On the Properties panel, we clicked Mask Edge to open this dialog, chose View: On Layers, used the settings shown above to mask the fringe, chose Output To: New Layer with Layer Mask, then clicked OK.

The refined mask appeared on a copy of the image layer.

Drag-copying layers between files via the Layers panel

Here you will drag-copy one or more layers from the Layers panel of a source document into a target document. An advantage of this method is that you can control specifically which layers are copied. As with the Move tool method (page 260), any pixels that lie outside the live canvas area are also included.

To drag-copy a layer between files via the Layers panel:

- Open the source and target documents. Change the resolution in a copy of the source file, if needed (see the sidebar on page 256).
- From the Window > Arrange submenu, choose
 2-Up Horizontal or 2-Up Vertical.
- Click in the source document window, then on the Layers panel, click a layer, a layer group, or the Background, or Ctrl-click/Cmd-click multiple layers.
- 4. Drag from the Layers panel of the source document into the target document; hold down Shift while dragging to make the new imagery appear in the center of the target document (A, next page). The new layer (or layers) will be stacked above the previously selected one (B, next page).
- 5. If the source document has a different color profile than the target document, the Paste Profile Mismatch alert dialog will appear. We recommend that you click Convert (Preserve Color Appearance) to preserve the appearance of colors in the source image, then click OK.
 - An alert will also appear if the source and target documents have different bits-per-channel settings. Click Yes to accept the change in image quality (or click No to cancel).
- 6. Either close the source document or right-click the tab for the target document and choose Consolidate All to Here from the context menu.
- 7. Optional: With the Move tool (V), reposition the new layer or layers.
- 8. Optional: To scale a new layer, choose the Move tool and check Show Transform Controls on the Options bar. If you don't see all the handles on the bounding box, press Ctrl-0/Cmd-0 for Fit on Screen view. Shift-drag a corner handle on the bounding box, then press Enter/Return to accept the new size.

SELECTING A LAYER OR GROUP IN THE DOCUMENT WINDOW

To select a layer or group in the document window without using the Layers panel, hold down V (temporary Move tool), check Auto-Select on the Options bar, choose Group or Layer from the menu, then click a pixel area, type, or a shape in the document.

CREATING A NEW DOCUMENT FROM A LAYER

To quickly create a new document from a layer, click the layer, then from the Layers panel menu, choose Duplicate Layer. The Duplicate Layer dialog opens. From the Document menu, choose New, enter a name for the new document in the Name field, then click OK. Save the new file.

A After tiling two documents vertically, we clicked in the document on the left (our source document). In this shot, we're Shift-dragging a layer group from the Layers panel of the source document into our target document window.

B When we released the mouse, a duplicate of the layer group appeared in the center of the target document.

Creating a layered document from file thumbnails

The Load Files into Photoshop Layers command imports multiple files as layers into a new Photoshop document. Photoshop does all the work for you. Easy!

To create a document from file thumbnails:

- 1. In Bridge, select one or more image thumbnails, then choose Tools > Photoshop > Load Files into Photoshop Layers. A Note: The command won't load files that contain embedded Smart Objects. As an alert will inform you, those files will be skipped.
- 2. Stand by while the images are imported as standard image layers (not Smart Objects) into one new Photoshop document.B
- 3. Save the new file. If you want to convert one of the layers to the Background, click it, then choose Layer > New > Background from Layer.

Creating embedded Smart Objects

A Smart Object is pixel or vector art that is either embedded into or linked to a Photoshop file, and is edited differently from a layer. For example, if you create a Smart Object from an Illustrator file, you can edit the object content without altering the original file (Photoshop takes you to Illustrator temporarily). If you apply Photoshop filters to a Smart Object, the filter settings remain available and can be edited at any time. Smart Objects are used in many chapters throughout this book.

To create an embedded Smart Object, you can convert one or more existing layers in a Photoshop document, or open or place an AI (Adobe Illustrator), PDF, PSD, TIFF, or Camera Raw file into Photoshop. On this page through page 267, we describe various methods for creating embedded Smart Objects, then on pages 268-271, we describe how to edit, duplicate, and replace them. To create and work with linked Smart Objects, see pages 272-275.

To convert one or more layers in a Photoshop file to an embedded Smart Object:

- 1. Open a Photoshop document, then select one or more layers on the Layers panel.
- 2. Right-click one of the selected layers and choose Convert to Smart Object from the context menu (A-B, next page).

A In Bridge, we selected six image thumbnails, and are choosing the Load Files into Photoshop Layers command.

B The command imported the selected thumbnails as multiple layers into a new Photoshop document.

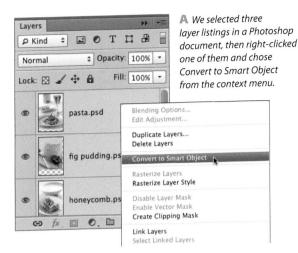

B The command combined the layers into one Smart Object. Note the icon in the corner of the laver thumbnail.

C We used the Open as Smart Object command to open an Adobe Illustrator (AI) file into Photoshop.

To open a file as an embedded Smart Object in a new Photoshop document:

- 1. In Photoshop, choose File > Open as Smart Object. In the dialog, locate and click a PSD, AI, PDF, JPEG, or TIFF file, then click Open.
- 2. For an AI or PDF file, the Open as Smart Object dialog opens. For a multipage or multi-image PDF file, or an AI file that contains multiple artboards, choose a Thumbnail Size of Small, Large, or Fit Page for the preview in the dialog, and click the desired thumbnail. Also choose a Crop To option (if you want to exclude blank areas from outside the artwork, choose Bounding Box). Click OK.
- 3. The file opens as a Smart Object in a new Photoshop document. D Save the new file.

To open a file from Camera Raw into Photoshop as an embedded Smart Object in a new document:

- 1. From Bridge, open a photo into Camera Raw.
- 2. Apply any needed corrections.
- 3. Hold down Shift and click Open Object (Open Image becomes Open Object). Or if the button is labeled Open Object (because Open in Photoshop as Smart Objects is checked in the Workflow Options dialog in Camera Raw), click the button without holding down Shift. See also step 10 on page 58.
- 4. The photo appears as a Smart Object in a new Photoshop document. Save the new file.

The Illustrator file arrived as a Smart Object in a new Photoshop document.

To paste Adobe Illustrator art into a Photoshop document as an embedded **Smart Object:**

- In Adobe Illustrator, go to Edit/Illustrator > Preferences > File Handling & Clipboard, check On Quit: PDF and AICB, click Preserve Appearance and Overprints, then click OK.
- 2. Continuing in Illustrator, open a file, then copy some artwork or type (Ctrl-C/Cmd-C).
- 3. Click in a Photoshop document, then paste (Ctrl-V/ Cmd-V). The Paste dialog opens. A
- 4. Click Paste As: Smart Object, then click OK.
- 5. To accept the new Smart Object, double-click inside it, or click the Commit Transform button 🗸 on the Options bar, or press Enter/Return. (Or to cancel it, press Esc.)

A This little dialog opens if you paste a file into Photoshop.

B In Bridge, we right-clicked an image thumbnail and chose Place > In Photoshop.

You can also drag or place a file into an existing Photoshop document as a Smart Object. The file can be in any format that is supported by Photoshop, such as an AI, JPEG, PDF, PSD, TIFF, or Camera Raw file. Note: For an Illustrator file, put the art that you want to import on its own artboard.

To place or drag a file into a Photoshop document as an embedded Smart Object:

- 1. Open a Photoshop document.
- 2. Go to Edit/Photoshop > Preferences > General, check Resize Image During Place (to let Photoshop scale placed images automatically), and, more important, check Always Create Smart Objects When Placing. * Click OK.
- 3. Click the layer above which you want the Smart Object to appear, then do one of the following: Choose File > Place Embedded. In the dialog, locate the desired file, then click Place. In Bridge, right-click an image thumbnail and choose Place > In Photoshop from the context menu.B

From Bridge or the Desktop, drag a file thumbnail into the Photoshop document window.

- 4. For an Illustrator AI or PDF file, the Open As Smart Object dialog opens. Choose a Thumbnail Size for the preview. If there are multiple thumbnails, click one. And choose a Crop To option (to exclude blank areas outside the artwork, choose Bounding Box). For a raw file or a file that was previously edited in Camera Raw, the Camera Raw dialog opens. Make any adjustments to the photo, if desired.
- 5. Click OK to exit any open dialog. The image will appear within a transform box in the Photoshop document (A, next page).
- 6. Optional: To scale the object proportionally, Shiftdrag a handle on the transform box. To rotate it, position the pointer outside the transform box (two-headed arrow), then drag.
- 7. To accept the new Smart Object, double-click inside it (B, next page) or click the Commit Transform button 🗸 on the Options bar, or press Enter/Return. (Or to cancel it, press Esc.)
- When you place vector art into a Photoshop document as a Smart Object, it stays as vector content (and when output, it is rendered at the resolution of the printer).

A The placed image appeared in our target document. After we double-clicked the transform box ...

B ... the handles and the X disappeared from the object, and the icon for an embedded Smart Object appeared in the layer thumbnail.

SMART OBJECTS SCALE BETTER

We opened a photo from Camera Raw into Photoshop, scaled it down via a transform handle, then accepted it.

Later, we enlarged the Smart Object: The image quality remained high (the details are still crisp) because Photoshop read pixel data from the original file, not from the image layer.

To compare, we opened the same Camera Raw photo as an ordinary pixel layer, shrank the layer, then later enlarged it: The image quality was diminished.

Editing embedded Smart Objects

To apply some kinds of edits to a Smart Object, such as Smart Filters (see pages 360–364), layer effects, transformations (e.g., scaling), and blending mode and opacity changes, you simply click the layer first.

Edits that change pixel data, however, such as those made with a painting, healing, sharpening, or cloning tool, can't be made directly to a Smart Object (try it, and you'll get an alert regarding rasterizing the layer; click Cancel). To make those types of edits, you doubleclick the Smart Object thumbnail; the embedded file opens in a separate (temporary) Photoshop window. After you edit, save, and close that window, your changes appear in the Photoshop file. Round-trip editing is similar for a Smart Object made from an Adobe Illustrator file, except the file opens in Illustrator, and for a Camera Raw file, which opens in Camera Raw.

To edit an embedded Smart Object:

- 1. Double-click a Smart Object thumbnail. If an alert regarding saving your changes appears, click OK.
- 2. If you created the Smart Object from one or more Photoshop layers, the embedded content will open in a separate, temporary document. A-C Edit the document, save it (Ctrl-S/Cmd-S), then close it (Ctrl-W/Cmd-W).

If the Smart Object contains imported content, that content will open in a temporary document in the creator application. For an Adobe Illustrator file, if a PDF Modification Detected alert dialog appears, click "Discard Changes, Preserving Illustrator Editing Capabilities." Edit the document, save it (Ctrl-S/Cmd-S), and close it (Ctrl-W/Cmd-W), then click back in your Photoshop document.

If you created the Smart Object by opening a photo from Camera Raw into Photoshop, it will reopen in Camera Raw. Adjust the settings, then click OK. (To open a photo from Camera Raw into Photoshop as a Smart Object, see pages 265-266 or page 272.)

Note: You have just altered the embedded file. The file from which the original Smart Object was created wasn't altered.

To use the Adobe Camera Raw filter, which gives you access to the Camera Raw features that can be applied from within Photoshop, see page 54.

A We double-clicked a Smart Object thumbnail on our Layers panel.

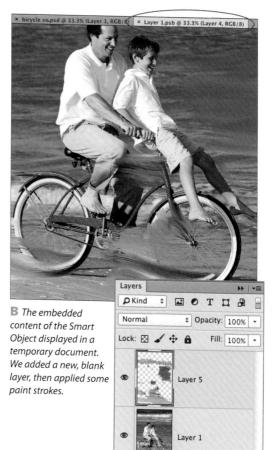

While the temporary document was open, only the layers for the embedded content displayed on the Layers panel.

fx. 0 0. 0 0 0

When you duplicate an embedded Smart Object via the Duplicate layer command, edits that you apply to the content of the Smart Object (e.g., painting, cloning, or healing strokes) will also appear in the duplicate object, and vice versa. Edits that don't change the content of an embedded file, on the other hand (such as transformations and filters), will appear only in the currently selected Smart Object.

To create duplicates of an embedded **Smart Object:**

On the Layers panel, click a Smart Object, A then press Ctrl-J/Cmd-J (Duplicate Layer command). A new Smart Object appears, bearing the same name as the original, with the word "copy" added.

To edit duplicates of an embedded **Smart Object:**

- 1. Click the thumbnail in the original or duplicate Smart Object listing, then apply a transformation (see pages 348-349), B a Smart Filter (see pages 360–364) (A, next page), or a layer effect (see pages 389-391). The edit will appear only in the Smart Object you clicked.
- 2. Double-click the original or duplicate Smart Object thumbnail, then apply a pixel edit, such as some brush strokes, or create an adjustment layer. Save and close the temporary document. Your edit will appear in the original and duplicate Smart Objects (B-C, next page).

COPYING A SMART OBJECT

To create a copy of a Smart Object that isn't linked to the original, right-click the Smart Object listing and choose New Smart Object via Copy. Edits made to either object won't affect the other one. This technique is used in the task on pages 276-277.

A To create an image that showcases some duplicate Smart Objects, our first step was to convert an image layer ("pasta") to a Smart Object. (Note that in this document, the Background is solid white.)

B We duplicated the Smart Object via Ctrl-J/Cmd-J, scaled down and repositioned the duplicate, then copied and repositioned the duplicate twice more. Although our added Smart Objects were created as duplicates, each transformation affected only the currently active layer.

A We clicked the original Smart Object ("pasta"), applied Filter > Blur > Motion Blur as a Smart Filter, and reduced the layer opacity. The filter didn't alter pixels in the embedded file, so the edit didn't appear in the duplicates of the Smart Object.

B Next, we double-clicked the thumbnail for the original Smart Object. The content opened in a temporary document, and the Layers panel listed only the embedded layer. We applied a Levels adjustment, then saved and closed the temporary document; the edit also appeared automatically in all the duplicates.

© Finally, we created a Hue/Saturation adjustment layer for the middle duplicate Smart Object and a Black & White adjustment layer for the layer below it. To restrict each adjustment effect to just the underlying Smart Object, we clicked the Clip to Layer button ▼□ on the Properties panel.

Replacing an embedded or linked Smart Object

The Replace Contents command can be used, when desired, to swap existing embedded Smart Object content with a different file. You must use this command if you edit the original file (from which the Smart Object was created) directly in the creator application — not by double-clicking the Smart Object thumbnail — and you want the file to update in Photoshop. For example, say you place Illustrator art into a Photoshop document as an embedded Smart Object. Later, you open the original file directly into Illustrator, then edit, save, and close it. To update the artwork in Photoshop, you must replace the old file with the newly edited one. Note that any transformations, filters, or layer style settings that were applied to the original Smart Object will appear automatically in the replacement content.

The Replace Contents command can also be used to replace a linked Smart Object file with a different file (a file of a different name). To learn about linked Smart Objects, see pages 272-275.

To replace an embedded or linked Smart Object with a new or edited file: *

- 1. On the Layers panel, right-click a Smart Object listing (not the thumbnail) and choose Replace Contents from the context menu.
 - For a linked Smart Object, you have the option to access the Replace Contents command another way. Click the Smart Object listing on the Layers panel. Next, on the Properties panel, selick the path listing, and from the menu that opens, choose Replace Contents.
- 2. In the dialog that opens, locate either a replacement file or, for an embedded object, it can be the original (newly edited) file, then click Place.
- 3. Respond to any dialogs that open (e.g., the Camera Raw dialog or the Open as Smart Object dialog). The replacement image will appear in the original Smart Object and in any duplicates that were made of that object.A

A After completing the sequence shown on the preceding two pages, we right-clicked one of the Smart Object listings and chose Replace Contents, then chose a new food photo to replace the original one. Although we used the command just once, the new image appeared in the Smart Object that we right-clicked, and in all its duplicates. That's an efficient way to work!

Creating linked Smart Objects

An alternative to creating an embedded Smart Object is to create a Smart Object from an external file that remains separate from — but linked to —your Photoshop file. If an external linked file is edited while the Photoshop files are open, the Smart Object updates automatically in all the documents in which it is being used. Among the advantages to linking Smart Objects are that a single Smart Object can be used in multiple Photoshop documents, the external files remain accessible for editing by multiple designers in a team, and linked Smart Objects produce a smaller Photoshop file size than embedded ones.

To create a linked Smart Object: ★

- 1. Open or create a Photoshop document. Go to Edit/Photoshop > Preferences > General, check Resize Image During Place (to let Photoshop scale placed images automatically), then click OK.
- 2. Do either of the following:
 - Choose File > Place Linked. In the dialog, locate the desired file, then click Place.
 - Go to Adobe Bridge. With Alt/Option held down, drag an image thumbnail from Bridge into your Photoshop document window.
- 3. The image appears in a box with an X through it.A Press Enter/Return to accept the placed art. On the Layers panel, the thumbnail of a linked Smart Object will have this icon: 2, whereas an embedded Smart Object will have this icon: 🗗.
- 4. If the file that you placed contains layer comps, from the Layer Comps menu on the Properties panel, choose a comp to be displayed in the Smart Object: Don't Apply Layer Comp to display the comp that was in effect when the linked file was last saved, or the Last Document State of the linked file, or a specific comp name. B To learn about layer comps, see pages 446-448.
 - Note: The Properties panel lists the dimensions of the Smart Object, its x/y location in the document, and the path to the external file. If you roll over the path listing, the entire path will display in a tool tip.C
- If you transform a linked Smart Object, your edits will affect only the appearance of the content in Photoshop, not the content of the original file.

A Via the Placed Linked command, we placed an image as a linked Smart Object into a Photoshop document.

B Via the Layer Comps menu on the Properties panel, we're choosing a comp to be displayed in the Smart Object.

The Properties panel displays info about the currently selected linked Smart Object. Here we're displaying the full path to the external file.

Working with linked Smart Objects

When editing a linked Smart Object, you can follow the same general rules as when editing an embedded Smart Object. That is, some types of edits (such as Smart Filters, transformations, and changes to layer effect or opacity settings) will alter the appearance of the Smart Object, but not its pixel content. To apply edits that change pixel data (such as painting, healing, cloning, and sharpening), you must edit the contents of the linked file, as described in the task below. In other words, you can't apply pixel edits directly to a linked Smart Object.

To edit the contents of a linked Smart Obiect:★

1. Do one of the following:

On the Layers panel, double-click the thumbnail of a linked Smart Object.

On the Layers panel, right-click next to the name of a linked Smart Object, then choose Edit Contents from the context menu.

On the Layers panel, click the listing for a linked Smart Object, then on the Properties panel, elick Edit Contents.A

- 2. If an alert dialog appears regarding missing or embedded profiles, click OK. Also respond to any alerts that appear regarding nonmatching profiles. If the Smart Object was created in a program other than Photoshop, that program will launch.
- 3. Edit the art as desired.
- 4. Choose File > Save (Ctrl-S/Cmd-S), then close the temporary document. The Smart Object will update automatically in your Photoshop document.

A To edit the contents of our selected Smart Object, we're clicking Edit Contents on the Properties panel.

RASTERIZING A SMART OBJECT

To rasterize a Smart Object (convert it to a standard image layer), right-click it and choose Rasterize Layer. If the Smart Object contained any Smart Filters, they will be applied permanently to the rasterized layer, whereas any layer style settings (blending mode, effects, and opacity) will remain editable. If you want to preserve the original Smart Object, duplicate it (Ctrl-J/Cmd-J) before applying the Rasterize Laver command.

If you link an external file to a Photoshop document as a Smart Object, then edit the external file while the Photoshop document is still open, your edits will display automatically in the linked Smart Object.

If, on the other hand, you close a Photoshop document that contains a linked Smart Object, then subsequently edit the external file, the content of the Smart Object won't update. After reopening the Photoshop document, in order to display the recent edits to the external file, you must update the Smart Object content, as in the steps below.

To update a linked Smart Object that was edited outside of Photoshop: ★

On the Layers panel, look for a linked Smart Object that has an out-of-date link alert in its thumbnail, and do either of the following:

Right-click next to the name of the outdated Smart Object, then choose **Update Modified Content** from the context menu.

Click the listing for the linked Smart Object.

Display the Properties panel. Click the path listing for the outdated link, and from the menu that opens, choose Update Modified Content.

To update the content for all linked Smart Objects in the current document, right-click any linked Smart Object listing and choose Update All Modified Content from the Layers panel menu.

A On the Layers panel, we clicked the listing for a linked Smart Object and are choosing Update Modified Content from the context menu.

If you close a Photoshop document that contains a linked Smart Object, then move or rename the folder in which the external file is located, the link to the external file will be preserved, and it should update automatically when you reopen the Photoshop document. If Photoshop can't find the external file, however, a dialog will open, offering you a chance to locate and relink the missing file. See page 35.

If, while a Photoshop document is open, you move or rename the folder in which an external Smart Object file is located, the link to the external file will be broken, and you will need to follow the steps below to locate and relink the external file. Resolving the link is necessary because the external file must be accessed when the Photoshop document is output to a printer or packaged for export.

Note: A missing link icon may not appear next to a Smart Object listing until you try to edit the Smart Object content.

To relink a missing Smart Object: ★

- 1. On the Layers panel, look for a Smart Object that has a missing link alert in its thumbnail, and do either of the following:
 - Right-click next to the name of the Smart Object, then choose **Resolve Broken Link** from the context menu.
 - Click the listing for the linked Smart Object.
 Display the Properties panel. Click the path listing, then from the menu that opens, choose Resolve Broken Link.
- The Locate Missing File dialog opens. Locate and click the missing file name, then click Place. The alert icon should disappear from the Smart Object listing on the Layers and Properties panels.
- To replace a linked Smart Object with a different external file, see page 271.

GETTING DATA ON MISSING LINKED OBJECTS *

To learn the total number of missing and modified Smart Objects in your current document, from the Status bar menu at the bottom of the document window, choose Smart Objects; Missing and Changed totals will display on the Status bar. Similarly, to display this data on the Info panel, ① choose Panel Options from the Info panel menu, check Smart Objects, then click OK.

If desired, at any time, you can convert a linked Smart Object to an embedded one. The link to the external file will be broken, and a copy of the Smart Object content will be embedded into your Photoshop document. The appearance of the object in the document remains the same. Note that embedding a file will increase the storage size of your document; the new size will be apparent after you use the Save command.

To convert a linked Smart Object to an embedded one: *

Do either of the following:

On the Layers panel, right-click next to the name of a linked Smart Object, then choose Embed Linked from the context menu.

On the Layers panel, click the listing for a linked Smart Object, A then on the Properties panel, click Embed.

Note that the icon within the Smart Object thumbnail has changed.

If you embed a linked Smart Object that contains "nested" imagery from another linked external file, that imagery will also be embedded, and the link between that file and your Photoshop document will also be broken.

The Convert to Linked command does the reverse of the above, which is that it converts an embedded Smart Object to a linked one. This is useful, say, if you want to organize the contents of multiple Smart Objects into one folder so they're more readily accessible for external editing; or if you created a Smart Object from multiple layers, and you want to make those layers available for use in other Photoshop documents; or if you open a legacy Photoshop document and you want to convert some embedded Smart Objects in that document to linked objects.

To convert an embedded Smart Object to a linked one: *

1. Do either of the following:

On the Layers panel, right-click the listing for an embedded Smart Object and choose Convert to Linked.

On the Layers panel, click the listing for a linked Smart Object, then on the Properties panel, click Convert to Linked.

2. The Save dialog opens. Choose a location in which to save the external linked file, then click Save.

A On the Layers panel, the thumbnail of a linked Smart Object has a link icon.

B After we applied the Embed Linked command, the icon in the thumbnail changed to an embedded Smart Object icon.

FILTERING SMART OBJECT LISTINGS ON THE LAYERS PANEL *

From the Filter Type menu on the Layers panel, choose Smart Object, then click one or more of these buttons: Up-to-Date Linked Smart Objects, Out-of-Date Linked Smart Objects, A Missing Linked Smart Objects, or Embedded Smart Objects. (To turn filtering off, click the Layer Filtering On/Off button. To learn more about filtering layer listings, see pages 160-161.

Combining multiple "exposures"

You may have encountered this common dilemma when photographing a subject against a bright sky or in front of a window: If you set the exposure properly for the figure or object in the foreground, the brighter background areas are overexposed. One way to produce an image that captures the "best of both worlds" is to shoot dual exposures — one set for the foreground and one set for the background — and then combine them into one image in Photoshop. If you didn't bracket your photos during the shoot, an alternative method (described here) is to produce two exposure variations of a single raw photo via Camera Raw, then reveal the best areas of the two files in Photoshop by editing a layer mask.

To combine two "exposures" into one photo:

- Open a raw photo into Camera Raw. A (Note: Avoid using a JPEG photo, which is unlikely to contain enough pixel data for this technique to work successfully.)
- Optional: Use sliders in the Basic tab to adjust the exposure properly for the shadows and lower midtones.
- 3. Hold down Shift (Open Image becomes Open Object) and click Open Object. Note: If Open in Photoshop as Smart Objects is checked in the Workflow Options dialog, the button will be labeled Open Object, in which case you should click it without holding down Shift.

A Because the wide range of light conditions in this scene couldn't be captured in one shot, the interior was correctly exposed but the exterior was overexposed.

- 4. The photo opens as a Smart Object in a new Photoshop document. Save the file.
- 5. Right-click near the layer name and choose New Smart Object via Copy from the context menu (don't use Ctrl-J/Cmd-J, the Duplicate Layer command).A
- 6. Double-click the thumbnail on the copy of the Smart Object to open the photo into Camera Raw. Use sliders in the Basic tab to set the proper exposure for the upper midtones and highlights, B then click OK. Because you followed our directive to copy the Smart Object via the New Smart Object via Copy command (it isn't a duplicate of the original one), your newest Camera Raw edits affected just the copy.
- 7. Save the file again. To blend the best areas of the two layers, follow the steps on the next page.

A The New Smart Object via Copy command created a copy of the Smart Object.

We opened the copy of the Smart Object into Camera Raw, used sliders in the Basic tab to recover highlight details (particularly in the exterior areas), then clicked OK to return to our Photoshop file.

To blend two exposure versions via a layer mask:

- 1. Continuing in Photoshop, on the Layers panel, click the upper of the two Smart Objects. If more of the properly exposed areas are on the upper layer, click the Add Layer Mask button ☐ to create a white mask; if more of the properly exposed areas are in the lower layer, Alt-click/Option-click the button to create a black mask. (To compare the two exposures, hide the upper layer, then show it.)
- 2. Choose the Brush tool (B or Shift-B), a Soft Round tip, Normal mode, and Opacity of 80–100%.
- 3. If you created a white mask, make the Foreground color black; if you created a black mask, make the Foreground color white.
- 4. Press [or] to set the brush diameter, then apply strokes to hide areas of the current layer and expose the underlying layer, or to reveal areas of the current layer and hide the underlying layer. A—C If you need to remask any areas, press X and paint with the reverse color.

A We added a black mask to a copy of the Smart Object, then with the Brush tool (100% Opacity) and white as the Foreground color, we applied brush strokes in the window areas to reveal the corrected background and sky on that layer.

B In the original image (shown for comparison), only the interior of the room has the correct exposure.

In the final image, the exposure data from the two Smart Objects is combined. The sky colors are stronger and you can see more details in the landscape.

Fading the edge of a layer via a gradient in a laver mask

Once you have gathered multiple layers into one document (regardless of the method used), you can soften the edges of any layer to make it look as if it's blending into the underlying layers. Here this is done by applying a gradient to a layer mask. This technique works equally well for image, type, and shape layers.

To fade the edge of a layer via a gradient in a layer mask:

- 1. Gather several layers into a target document by following the steps on page 256, 260, 262-263, or 264. Position and scale the lavers with the Move tool as necessary.
- 2. On the Layers panel, click one of the layers, then click the **Add Layer Mask** button. Keep the mask thumbnail selected.
- 3. Choose the **Gradient** tool (G or Shift-G).
- 4. On the Options bar, do the following; Click the Gradient picker arrowhead on the Options bar, then click the "Black, White" gradient. Note: If you don't see this preset, choose Reset Gradients from the picker menu, then click OK in the alert dialog. "Black, White" is the third gradient in the default library.
 - Click the Linear Gradient button. Choose Mode: Normal and an Opacity of 100%.
- 5. In the image, start dragging horizontally or diagonally from where you want the complete fadeout to be located, and stop dragging where you want the layer to be fully visible. Hold down Shift while dragging to constrain the angle to an increment of 45°.
 - The gradient will appear in the layer mask, and the content of that layer will be partially hidden **C** (see also **A**−**B**, next page).
- To redo the mask effect, click the layer mask thumbnail, then with the Gradient tool at 100% Opacity, drag in the document again in a new direction or from a different starting point.

A We dragged layers from other documents onto our target image (a photo of burlap), scaled and repositioned the new layers, and rotated a couple of them.

B We added a mask to the "BLUE" layer, chose the Gradient tool and the "Black, White" preset, then dragged to the left, as shown by the arrow.

C The aradient in the mask is hiding the right side of the "BLUE" layer.

A Next, we added a layer mask to the "WALL" layer, and dragged diagonally with the Gradient tool (note the gradient in each mask).

B This is the final image.

HIDING A SEAM WITH A BRUSH

You can also edit a layer mask with the Brush tool, a basic Photoshop technique that is described fully on page 191.

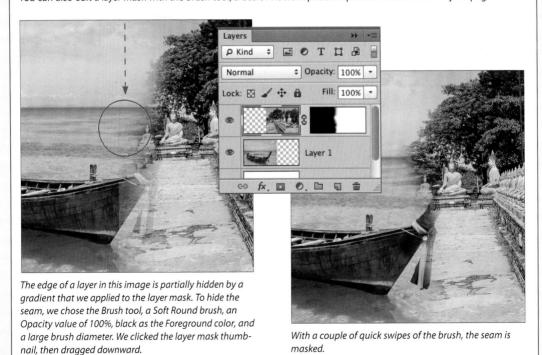

Aligning and distributing layers

Using buttons on the Options bar, you can align the nontransparent content of two or more selected layers by their edges or centers, or equalize the spacing among three or more selected layers. The buttons work for image, type, and shape layers.

To align and/or distribute layers:

- 1. Do either of the following:
 - On the Layers panel, Ctrl-click/Cmd-click two or more layers, then choose the Move tool + (V).
 - Choose the **Move** tool ** (V), then check Auto-Select and choose Layer on the Options bar. In the document window, click a layer, then Shift-click one or more additional layers.
- 2. Do either or both of the following: Click one of the "Align" buttons on the Options bar.B
 - If three or more layers are selected, you can click one of the "Distribute" buttons on the Options bar.C
- Oops! Clicked the wrong button? Choose the Undo command, then try a different button.
- To align layers to the edge of a selection, create a selection before following the steps above.

A We chose the Move tool, then selected four layers.

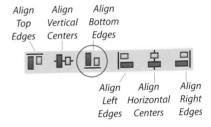

B We clicked the Align Bottom Edges button...

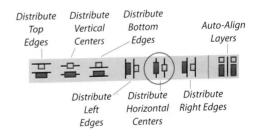

... then clicked the Distribute Horizontal Centers button.

By applying strokes with the Clone Stamp tool, you can clone all or part of an image from one layer to another in the same document or between documents. This tool is useful for creative montaging, commercial retouching, and video editing. Using the Clone Source panel, you can assign and keep track of up to five different source documents (represented by a row of buttons at the top of the panel), as well as transform the source pixels before or as you clone them.

To use the Clone Stamp tool and the Clone Source panel:

- 1. Open one or more RGB documents to be used as source imagery, and create or open a target document.
- Choose the Clone Stamp tool (S or Shift-S).
 On the Options bar, choose a Soft Round brush, a Mode, an Opacity percentage, and a Flow percentage, and check Aligned.
 - Optional: If you have a stylus and tablet, you can activate the Pressure for Opacity button and/or the Pressure for Size button on the Options bar.
 - Optional: If the source file contains any adjustment layers and you want the Clone Stamp tool to ignore their effects when sampling, activate the Ignore Adjustment Layers When Cloning button.
- 3. Show the Clone Source panel. A By default, the first source button is selected. Check Show Overlay and Auto Hide, then set the Opacity to around 35–50% so you'll be able to preview the source image as an overlay (a faint version of the source layer). If you want the overlay to display only within the brush cursor instead of across the whole document, check Clipped.
- 4. In the target document, create a new, blank layer.
- 5. Click the source document tab. From the Sample menu on the Options bar, choose the part of the document from which you want to clone: Current Layer, Current & Below, or All Layers. For either of the first two options, also click a layer.
- **6.** Alt-click/Option-click an area in the image to set the source point. The source file and layer will be assigned to, and will be listed below, the first source button on the Clone Source panel.
- 7. Click the target document tab.

- 8. To position the clone, move the pointer over the image without clicking. Adjust the tool diameter by pressing [or], then start dragging to make the cloned pixels appear (A, next page). The overlay will disappear temporarily (because you checked Auto Hide), then will reappear when you release the mouse. (For other ways to transform the overlay, see the next page.)
- 9. To clone from another open document, click the second source button at the top of the Clone Source panel, then repeat steps 4–8. At any time, you can switch between clone sources by clicking a different button.
 - Beware! The Clone Source panel keeps the links active only while the source documents are open. If you close a source document, its link to the Clone Source panel is broken. We warned ya.
- To use the Clone Stamp tool to retouch imagery within the same document, see pages 318–319.

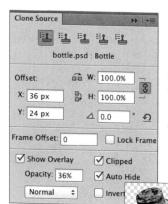

A Using the Clone Source panel, you can switch between multiple sources, transform the clone overlay, and choose display options.

B With the Clone Stamp tool, we held down Alt/ Option and clicked in a source document.

A We're dragging with the Clone Stamp tool on a new, blank layer in our target document to "brush in" part of a bottle image layer from a source document.

Before we began cloning the bottle, we clicked the Flip Horizontal button on the Clone Source panel and changed the Offset values (as shown in the panel at right).

When using the Clone Stamp tool, the position and orientation values of the source overlay stick unless you change them. Between strokes with the tool, you can reposition, scale, flip, or rotate the overlay via the Clone Source panel or via keyboard shortcuts. New settings will apply only to the currently selected clone source.

To reposition, scale, flip, or rotate the clone source overlay:

With the Clone Stamp tool 基 selected and an overlay displaying in your document, do any of the following (on the Clone Source panel, you can use the scrubby sliders):

To reposition the source overlay, uncheck Clipped, then change the Offset X and/or Y values on the panel or Alt-Shift-drag/Option-Shift-drag in the image.

To scale the source overlay, hold down Alt-Shift/ Option-Shift and press (and keep pressing) [or]. Or to scale the overlay via the panel, activate the Maintain Aspect Ratio button I to preserve the aspect ratio of the source imagery, then change the \mathbf{W} or \mathbf{H} value. To preserve the image quality, avoid scaling the source more than 120% or -120%.

To flip the source, click the Flip Horizontal and/ or Flip Vertical 🖥 button. 🛭

To rotate the overlay, change the Rotate value, or hold down Alt-Shift/Option-Shift and press (and keep pressing) < or >.

- To restore the default flip, scale, and rotation values to the current clone source, click the Reset Transform button.
- To show the Clone Source panel when the Clone Stamp tool is selected, you can click the Toggle Clone Source panel button 基 on the Options bar.

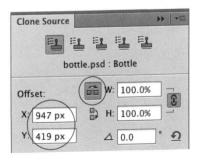

Using the Photomerge command

The Photomerge command combines two or more photos of the same scene into a single panoramic image. To accomplish this, it produces a layer from each photo, then blends the seams using a mask on each layer. It does all the work for you!

To merge photos into one document via the Photomerge command:

- In Bridge, arrange the photos in the correct sequence for the panorama (this will help Photomerge work faster), then select them all. PSD files process more quickly than raw files.
- 2. Choose Tools > Photoshop > Photomerge. The Photomerge dialog opens. A
- Click a Layout option: Auto (Photoshop picks the best layout), Perspective, Cylindrical, Spherical (best for a 360° panorama), Collage (photos are combined by stretching and rotating), or Reposition (no stretching or rotating). Unfortunately, the layout options can't be previewed.
- **4.** Keep **Blend Images Together** checked. Color matching and layer masks will be used to create seamless transitions between the photos.

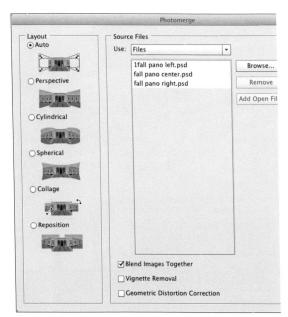

A Choose a Layout and correction options in the Photomerge dialog.

Check either or both of these optional correction features, if they are available for your Layout choice:

Vignette Removal lightens any dark areas that the camera lens produced around the perimeter of the photos.

Geometric Distortion Correction corrects lens distortion, such as pincushioning (pinching), barreling (bulging), or extreme wide angles.

- Click OK, then sit back while Photoshop opens the source files, aligns and blends them into a panorama, and opens a new document onscreen.
- 7. To eliminate any transparent areas that the command produced at the edges of the image, use the Crop tool 4 (A-C, next page).
- **8.** Merge the selected layers, then save the new document.

COMBINING SHOTS VIA AUTO-ALIGN LAYERS

It can be a challenge to get a group of people to smile simultaneously for a portrait, or to have them refrain from blinking. If you take multiple shots of the same scene, you can blend the choice areas of two shots in Photoshop via the Auto-Align Layers command.

Open two RGB photos from the same shoot, then choose a 2-Up option (Window > Arrange submenu). Shift-drag the Background from the Layers panel of one photo into the window of the other. Redisplay just the target document; save your file.

On the Layers panel, Shift-click the two layers, then choose Edit > Auto-Align Layers. In the dialog, click a Projection option: Reposition if you used a tripod, or Auto for other shooting situations. Click OK.

Click the upper layer, Alt-click/Option-click the Add Layer Mask button, and keep the mask thumbnail selected. Choose the Brush tool, a Soft Round tip, Normal mode, and 100% Opacity. Zoom in, then paint strokes with white as the Foreground color to reveal the desirable parts of the top layer. To touch up the mask, decrease the brush diameter and zoom in more. Apply brush strokes along the edges of shapes to reveal more of the top layer, or press X and apply strokes with black to reveal more of the underlying layer.

A We chose these three source photos for our panorama.

B The Auto option in Photomerge used masks to produce this seamless composite image.

C We squared off the image with the Crop tool.

SHOOTING PHOTOS FOR A PANORAMA

To get good results from the Photomerge command, follow these guidelines from Adobe:

- ➤ For better alignment, and to help prevent distortion, use a tripod and shoot all the photos from the exact same spot, in the sequence needed for the panorama.
- ➤ Choose the same focal length (zoom) setting for all the photos.
- Overlap the viewing area from one shot to the next by approximately 40%.
- ➤ Choose the same exposure or aperture setting for all the shots. Provided your basic settings are adequate, Photomerge will be able to even out minor exposure discrepancies.

Using Smart Guides, ruler guides, and the grid

Sometimes a great composite image comes together in a serendipitous way without much forethought or careful alignment. At other times — say, if your Photoshop image must fit perfectly within the confines of a specific Web or print page layout — you need to plan ahead or position objects more precisely. To accomplish this, you can use any of the Photoshop layout features, such as grids, rulers, or guides.

Our favorite alignment feature is Smart Guides. If this feature is on in a multilayer document, and you drag a layer, temporary, magnetic (default color magenta) guide lines will appear where that layer nears the top, middle, or bottom edge of content on another layer. You can also use this feature to align multiple layers, or to create and align a copy of a layer. Note: To use Smart Guides while moving a path, use the Path Selection tool instead of the Move tool.

To use Smart Guides while moving or copying a layer:

- Verify that both View > Extras and View > Show > Smart Guides have a check mark.
- 2. Choose the Move tool (V)
- 3. On the Layers panel, select one or more layers.
- 4. To move the layer(s), drag it near the top, middle, or bottom of content on another layer. A Or to copy the layer(s), press and hold down Alt/Option, then start dragging. The black label shows the distance you have moved the layer. Let the layer snap to a horizontal or vertical guide, or to the intersection of two guides. If you create a copy, a colored label shows the distance between the bounding box of the original layer and the copy. B—C
- ➤ To show the distance (in a label) between the currently active layer and the edges of the canvas, hold down Ctrl/Cmd and position the pointer outside the bounding box. With Ctr/Cmd pressed, roll over an object on another layer; the distance between those layers shows in a colored label.

SHOWING EXTRAS

The View > Extras command (Ctrl-H/Cmd-H) shows or hides whichever features are currently enabled on the View > Show submenu (e.g., the Grid, [ruler] Guides, Smart Guides). These choices affect the current document and any documents that you subsequently open.

As we drag the butterfly layer, we're aligning its upper edge with the vertical center of the bottles layer via a Smart Guide.

B To copy a shape layer, we're dragging it to the right with Alt/Option held down. The magenta label indicates the distance between the original layer and copies; the black label indicates the distance the layer has been moved.

We selected the original and duplicate shape layers, then dragged downward to copy those layers and align the copies.

When you enable the Rulers command in Photoshop, rulers display along the top and left sides of the document window. From the rulers, you can create magnetic, movable horizontal and vertical guides.

To show or hide the rulers:

Choose View > Rulers or press Ctrl-R/Cmd-R. Move the pointer in the image (mouse button up), and you'll notice that its current location is indicated by a dotted marker on each ruler.A

- To change the units for both rulers quickly, rightclick in either ruler and choose a unit from the context menu. Or to get to the Units & Rulers panel in the Preferences dialog quickly, where you can change the units and other settings, double-click either ruler. Changing the unit in one location also changes it in the other.
- To change the ruler origin (so you can measure distances from a specific location in the image), starting from the upper-left corner where the two rulers meet, drag diagonally into the image. To restore the default origin, double-click the upperleft corner.

Guides that you create from the horizontal or vertical ruler can be repositioned or removed at any time. Like Smart Guides, they are magnetic, but unlike Smart Guides, they linger onscreen and save with your document. (To use ruler guides, see the next page.)

To create ruler guides:

Show the rulers, then drag from the horizontal or vertical ruler into the image, releasing the mouse where you want the guide to appear.

If View > Snap is checked as you create a guide, you can snap it to a selection, to the edge of content on the currently selected layer, B-C or to a grid line, if the grid is displayed (see the next page).

- To show the guides if they are hidden, choose View > Show > Guides.
- You can relocate an existing guide with the Move tool (double-arrow pointer), provided guides aren't locked (see the next page). As you move a guide, its current x or y position displays in a readout.
- ► Hold down Alt/Option as you create a guide to swap its orientation from vertical to horizontal, or vice versa.
- To change the color and other attributes of guides, Smart Guides, and the grid, see page 468.

A swe move a layer, the current location of the pointer is indicated by a dotted line on each ruler.

B To create a guide, we are dragging downward into the image from the horizontal ruler.

We snapped the new guide to the top edge of the butterfly layer (which was selected).

When the View > Snap command is on — and depending on which options are checked on the View > Snap To submenu — as you move a selection or layer it will snap to a guide, a grid line, or the edge of content in the document with a little magnetic tug.

To turn on the Snap To feature:

- 1. Choose View > Snap To > Guides, Grid, Layers, Slices, Document Bounds, or All (of the above). Note: For the Snap To > Guides, Grid, or Slices option to be available, that option must have a check mark on the View > Show submenu.
- 2. Make sure View > Snap has a check mark (Ctrl-Shift-;/Cmd-Shift-;). This command enables all the options that are currently checked on the Snap To submenu.
- 3. With the Move tool (V), drag a selection or layer near a ruler guide, a grid line, the edge of layer content, or the edge of the canvas area, and release when you see it "snap" to your target.

To reposition any of your ruler guides (Move tool), you must unlock them first. Conversely, to prevent guides from being moved, lock 'em up.

To lock or unlock all ruler guides:

Choose View > Lock Guides or press Ctrl-Alt-;/ Cmd-Option-;.

If guides are unlocked and you change your document size via the Image Size command, Photoshop will maintain the relative position of the guides in the document.

To create a ruler guide at a specific location:

- 1. Choose View > New Guide.
- 2. In the New Guide dialog, click Orientation: Horizontal or Vertical, enter a Position value relative to the 0 (zero) point on the x or y axis in any measurement unit that is used in Photoshop, then click OK. A guide appears in the document.

To remove one or all ruler guides:

Do either of the following:

To remove one guide, make sure guides aren't locked, hold down V (Move tool), then drag the guide off the edge of the document window. (Don't press Backspace/Delete, which would delete the current layer!)

- To remove all guides from the document, choose View > Clear Guides.
- To get to Edit/Photoshop > Preferences > Guides, Grid & Slices quickly, double-click a ruler guide.

The grid is a nonprinting framework to which you can snap a layer or selection. It can be displayed or hidden as needed for each individual Photoshop document.

To show or hide the document grid:

Choose View > Show > Grid or press Ctrl-'/Cmd-'.A (See also "To turn on the Snap To feature," at left.)

On page 147, you used the Ruler tool to straighten a crooked image. Here you will use it as a measuring device.

To measure the distance and angle between two points:

- 1. Choose the Ruler tool (I or Shift-I).
- 2. Drag in the document window. The angle (A) and length (L) of the ruler line will be listed on the Options bar and the Info panel. Shift-drag to constrain the angle to an increment of 45°.
- 3. Optional: To move the measure line to a new location, drag it with the Ruler tool. To change the angle or length of the line, drag either one of its endpoints.
- 4. To hide the ruler line, choose another tool.
- To redisplay the measure line, hold down I (temporary Ruler tool). To remove the line, click Clear on the Options bar (not Backspace/Delete). A document can contain only one measure line at a time.

A The grid is showing in this document.

In this chapter, you will paint with the Brush tool, customize your brush using a wide assortment of controls, and manage brush presets. You will also create bristle, erodible, and airbrush tips for the Mixer Brush tool, use the Mixer Brush to transform a photo into a painting, and use the History Brush tool to restore areas of an image.

Note: Although we recommend using a stylus and tablet for the instructions in this chapter, it's not a requirement.

Using the Brush tool

Before delving into the complexities of the Brush panel, take a few minutes to familiarize yourself with the Brush tool. To do this, you will choose a brush preset for the tool and choose Options bar settings to control its behavior.

To use the Brush tool:

- 1. Click an image layer or create a new, blank layer. Optional: To confine your brush strokes to a specific area of the layer, create a selection.
- 2. Choose the **Brush** tool (B or Shift-B).
- 3. Choose a Foreground color.
- 4. Right-click in the image to display the Brush Preset picker, then either click a brush in the scrolling window, A or click a recently used brush in the horizontal tray. ★

Continued on the following page

A On the Brush Preset picker, click a brush and, if desired, change any of the brush settings temporarily.

14

IN THIS CHAPTER

Using the Brush tool28
Customizing a brush
Managing brush presets29
Using the Mixer Brush tool 29
Using the Eraser tool
Using the History Brush tool 30

USE YOUR GRAPHICS PROCESSOR

In order to access on-image hardness and opacity controls for brushes (see page 129), and to enhance painting performance (particularly for large brushes), go to Preferences > Performance and make sure Use Graphics Processor is checked (if it's not, check it, click OK, then close and reopen your document).

Optional: Change the brush Size or Hardness setting, drag the arrowhead on the circle to change the brush angle, or drag one of the little circles to change the roundness (see also pages 128–129).

Note: You can also open the Brush Preset picker by clicking the arrowhead or thumbnail on the Options bar.

- **5.** On the Options bar, do the following: Choose a blending **Mode**.
 - Choose an **Opacity** percentage. At 100%, the stroke will completely cover the underlying pixels. Choose a **Flow** percentage for the rate at which

Choose a **Flow** percentage for the rate at which "pigment" is applied (for thick or thin coverage).

- **6.** Optional: If you're using a stylus and tablet, you can activate the Pressure for Opacity button and/or the Pressure for Size button on the Options bar.
- 7. Optional: If you want to edit only nontransparent pixels on the current layer, activate the Lock Transparent Pixels button and on the Layers panel.
- **8.** Draw brush strokes in the image. Feel free to change the Options bar settings between strokes.
- To choose custom settings for the Brush tool beyond the basics that are covered in this task see the next section.
- To draw a straight stroke with a painting tool (e.g., the Brush tool), hold down Shift while dragging.
- To sample a color with a temporary Eyedropper, Alt-click/Option-click in the document.
- Via the Brush Presets panel menu, you can change the panel view.

SHOPPING FOR BRUSH TIPS

When you load a library of brush tips onto the Brush Presets panel (see page 131 or 133), the presets will also appear in the scrolling window on the Brush panel. Not seeing them on the Brush panel? Click Brush Tip Shape at the top of the panel. Below are the basic icons (or examples of them).

Customizing a brush

On pages 128–129, you learned how to set basic size, hardness, and opacity settings for a brush preset. Here you will use a wide array of features on the Brush panel to further customize the characteristics of a brush. Brushes are used with the Brush, Mixer Brush, Eraser, and History Brush tools (all of which are featured in this chapter), as well as with the Pencil, Clone Stamp, Pattern Stamp, Art History Brush, Blur, Sharpen, Smudge, Dodge, and Burn tools.

On the Brush panel, most of the settings for customizing brushes are organized into option sets; a few lone options are simply switched on or off. Many of the options add randomness or variation to a stroke, such as to its shape, texture, or color.

The availability of options varies depending on the currently chosen tool and tip, and some options apply only to a graphics tablet and stylus (when an option set is unavailable, the set name is dimmed). The choices are vast, so we'll just focus on a few of our favorites. With practice, you'll learn which options and settings suit your painting style.

To customize a brush via the Brush panel:

- 1. To see the greatest differences among the settings, choose the **Brush** tool or **Mixer Brush** tool (B or Shift-B). You could also choose one of the tools that we listed in the first paragraph of this section.
- 2. To show the Brush panel, click the panel tab or icon, or click the Toggle Brush Panel button on the Options bar or Brush Presets panel. Click Brush Tip Shape in the top-left corner of the panel, and for this task, click a round or static tip (see the sidebar on this page) (A, next page).
- **3.** As you adjust settings for the tip, keep an eye on the stroke preview at the bottom of the panel:

To change the brush **Size** (diameter), use the slider or scrubby slider.

To restore the original size to a static tip, click the Restore Original Size button.

To change the **Angle** (slant) of an elliptical tip, use the scrubby slider, or drag the arrowhead around the circle, or enter a specific angle. To change the **Roundness** of the tip (make it more oval or more circular), B use the scrubby slider or drag either of the two small dark circles on the ellipse inward or outward.

To change the Hardness of the tip (feather or sharpen its edge), use the scrubby slider.

To control the distance between marks within the stroke, check **Spacing**, then move the slider, D-E or turn this option off to let the speed of your brush stroke control the spacing.

- If you're going to paint with a mouse and you want to produce variations in the stroke via the Jitter and Minimum sliders (found in other sections of this panel), set the Spacing value above 10.
- 4. Next you'll customize the behavior variations for the brush using five of the option sets on the panel. Checking the box for an option set activates the current settings for that set; clicking the set name both activates the current settings and displays the set options.

Continued on the following page

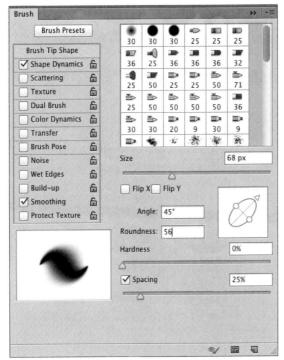

A In the Brush panel, you can select a brush tip, customize it via an assortment of options, and save it as a preset. The preview updates dynamically as you change the settings.

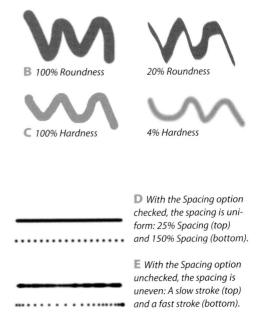

To control the amount of allowable variation in the brush tip shape, click Shape Dynamics, then do any of the following:

Choose Size Jitter, A Angle Jitter, and Roundness Jitter values to establish an allowable amount of random variation for those attributes. For more noticeable variation, increase the Spacing value in the Brush Tip Shape option set.

Check Brush Projection to enable round and static tips to respond to stylus movement, or to Tilt and Rotation settings in the Brush Pose option set. Note that enabling Brush Projection disables the Roundness Jitter option.

If you're using a stylus, from each of the Control menus, choose which stylus feature is to control the variation for that option. Note that variations will occur even when this setting is Off.

Choose Minimum Diameter and Minimum Roundness percentages.

5. To control the placement of pigment in the stroke, click Scattering, then do any of the following:

Check Both Axes to scatter pigment along and perpendicular to the stroke you draw, or uncheck this option to scatter pigment only perpendicular to the stroke. B For a stylus, choose a Control option.

Choose a **Scatter** percentage to control how far the pigment can stray from the stroke. The lower the Scatter percentage, the more solid the stroke.

Choose a Count value to control the number of marks in the stroke (you may need to increase the Spacing value to see any effect).

Choose a Count Jitter percentage to control the amount of variation in the Count.

- 6. For the Brush tool, you can use the Color Dynamics option set to control the variation in hue, saturation, and brightness. Check Apply per Tip to allow jitter settings to display randomly in each tip mark in a stroke, for a multicolor effect.
- 7. To display a texture in the stroke, click **Texture**, then do all of the following:

Click the Pattern picker thumbnail, then click a pattern swatch. (Via the picker menu, you can load the Artist Surfaces or Artists Brushes Canvas library.)

Choose a **Scale** value for the pattern.

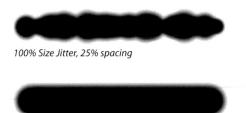

A 0% Size Jitter

0% Scatter, 100% Spacing

500% Scatter, the Both Axes option checked

B 500% Scatter, the Both Axes option unchecked

0% Count Jitter, 100% Spacing

C 100% Count Jitter: The Count varies randomly from 1% to 100% of the Count value.

Choose values for Brightness and Contrast. For a more prominent texture, choose a low Brightness value and a high Contrast value.

Choose a **Depth** value to simulate the depth of a fibrous drawing surface. High values produce more ridges and therefore a more noticeable texture.

8. To control how randomly the overall stroke opacity can vary as you use the tool, and to make the Texture option more pronounced, B click Transfer, then do either or both of the following:

Choose an Opacity Jitter percentage for the amount the opacity can vary. C-D To control the fading, for a stylus, choose a Control option, or for a mouse, choose Off or Fade.

Choose a Flow Jitter percentage to control the rate at which paint is applied. A high Flow Jitter will make the stroke dry and blotchy, but that may be the look you're after. For a stylus, choose a Control option; for a mouse, choose Off or Fade.

- 9. Beware! The custom settings that you have chosen are only temporary. To save them as a preset for future use, click the **New Brush** button **a** at the bottom of the Brush panel. Enter a descriptive name in the Brush Name dialog, check Capture Brush Size in Preset (if desired), then click OK. Your saved preset will appear at the bottom of the Brush Presets panel and the Brush Preset picker.
- **10.** You're ready to paint with your customized brush!
- Click the open a or closed lock icon for an option set to prevent or allow the settings in that set from being edited, regardless of the current preset.

An Erodible Point tip behaves like a soft pencil: The beginning of the stroke is sharp and then it gradually wears down (widening and becoming more blunt) toward the end of the stroke.

To use an Erodible Point tip:

- 1. Choose the Brush tool or Mixer Brush tool.
- 2. On the left side of the Brush panel, click Brush Tip Shape, then click an Erodible Point tip in the scrolling window.
- Activate the Live Tip Brush Preview button (see the sidebar at right).
- 4. Choose a Size value to set the width of the end of the stroke (where the tip is worn down), and

Continued on the following page

A Canvas pattern, 200% Scale, -90 Brightness, 80 Contrast

B The same Texture settings as above with Transfer: 60% Opacity Jitter, 60% Flow Jitter

C 10% Opacity Jitter, 10% Flow Jitter

D 80% Opacity Jitter, 80% Flow Jitter

LISTING THE LIVE TIP BRUSH PREVIEW

To display a schematic of the current brush tip that updates dynamically as you change the settings, activate the Live Tip Brush Preview button on the Brush or Brush Presets panel. For this feature to work, Use Graphics Processor must be checked in Edit/Photoshop > Preferences > Performance. Note: The Live Tip Brush Preview doesn't display for round or static tips.

- To reposition the preview, move the pointer over the top-left corner, then drag the black bar.
- To view the current tip at various angles, keep clicking in the preview.

choose a Softness value to control how quickly the tip erodes. Lower values keep the tip more sharp. A

- 5. From the Shape menu, choose a preset shape.
- 6. Optional: To display some texture in the stroke, click the Texture option set and choose a burlap or canvas texture in the Pattern picker (see step 7 on pages 292-294).
- To change the tilt of a tip when drawing with a mouse, adjust the Tilt Y value in the Brush Pose option set.
- Once you start painting with an Erodible tip (Shape: Point or Round and an increased Softness setting), you can resharpen the tip by clicking Sharpen Tip.

Note: To produce long strokes when using an Erodible Point tip or Airbrush tip with the Mixer Brush tool, choose the Dry, Heavy Load preset from the Useful Mixer Brush Combinations menu on the Options bar. B To learn more about this tool, see pages 296-297.

The Airbrush tips simulate the look of paint that is sprayed from an airbrush device. Via panel options, you can control the degree of graininess and feathering.

To use an Airbrush tip:

- 1. Choose the Brush tool or Mixer Brush tool
- 2. On the left side of the Brush panel, click Brush Tip **Shape**, then click one of the Airbrush tips in the scrolling window.
- 3. Activate the Live Tip Brush Preview button.
- **4.** Change any of the following settings: Choose a Size value to set the size of the stroke.

Choose a Hardness value to control the amount of feathering at the edges of the stroke.

Increase the Granularity value to make the stroke look more speckly, and set a Spatter Size and Spatter Amount to control the size and number of droplets in the stroke.

(See the Note, above, regarding the Mixer Brush.)

If you're going to paint with a mouse, display the Brush Pose option set. To spray a conical stroke from the point where you click, change one or both Tilt values; to widen the stroke, lower the Pressure value. To further elongate a conical shape, in the Brush Tip Shape option set, choose a high Distortion value. (See also the sidebar on page 296.)

A We used the Pencil brush preset (an Erodible Point tip) to create the blue lines in this drawing. A high Softness value was used for the upper stroke; a very low Softness value was used for the lower one.

B We drew the green lines with the Charcoal Pencil preset and the brown strokes with the Triangle Pastel preset.

C We used the Watercolor Spatter Big Drops preset (which has a high Granularity value) to draw the dotted stroke on the left, the Airbrush Soft High Density Grainy preset to draw the blue line in the center, and the Watercolor Wash brush preset to draw the wide blue stroke on the right.

All of the presets used here are in the default library. To identify them by name, choose either of the List views from the Brush Presets panel menu.

Managing brush presets

The Brush Presets panel stores and displays presets, like the Brush Preset picker, plus it offers several additional features. You can use this panel to save and choose brush presets, resize the current preset, save and load brush preset libraries, and access the Preset Manager. A Unlike the Brush Preset picker, the Brush Presets panel can be kept open.

To use the Brush Presets panel:

- 1. Choose a tool that uses brushes, such as the Brush, Mixer Brush, or Pencil.
- 2. To show the Brush Presets panel, click the panel tab or icon (Window > Brush Presets), or click Brush Presets in the upper-left corner of the Brush panel.
- 3. On the panel, do any of the following:

Click a brush to use with the chosen tool: either a recently used preset in the tray at the top of the panel (the last-used brush is shown first), * or a preset in the scrolling window. If the tray is hidden, check Show Recent Brushes on the panel menu.

Change the brush Size (diameter). Note: You can restore the original size to a static tip by clicking the Restore Original Size button.

Activate the Live Tip Brush Preview button (if available) to display a schematic of the brush tip.

To load different presets onto the panel, choose a library name from the panel menu, then click Append or OK (see also page 131). (Via the panel menu, you can also choose a different thumbnail or list option for the panel display.)

To save the current brush and settings as a preset, click the **New Brush** button, add to or change

A Use the Brush Presets panel to select a preset from the current library, change the brush size, load a different library, create a new library, or access Preset Manager.

the name in the Brush Name dialog (use a descriptive name), then click OK.

To save all the presets that are currently on the panel as a library, choose Save Brushes from the panel menu, type a name for the library, keep the default location, then click Save (see also page 131).

To access the Preset Manager dialog, from which you can append, replace, and reset the items that load onto the Brush and Brush Presets panels and the Brush Preset picker upon launch, click the Open Preset Manager button, then see "Using the Preset Manager" on page 133. (This button is also available on the Brush panel.)

To delete the currently selected preset from the panel (but not from its library), click the Delete Brush button, then click OK in the alert dialog.

If you click a preset and then customize its settings via the Brush panel, its listing on the Brush Presets panel will have an orange highlight, indicating that it was modified. If you click a recently used brush in the tray, then modify and use it, a new icon will display in the tray, with "(modified)" in its name. If you modify just the Size value for a preset, the preset must include a size value (a numeral in its panel listing) for it to be designated as "modified."

QUICK ACCESS TO THE BRUSH PANELS

- From the Brush panel, you can open the Brush Presets panel by clicking this button: Brush Presets
- From the Brush Presets panel, you can open the Brush panel by clicking the Toggle Brush panel button:

RESETTING THE PRESETS

To restore the original settings to an individual brush preset (including settings in the option sets, and including the size, if the preset includes a size value), simply click the preset again. To restore the whole library of default presets to the Brush Presets panel, see page 132.

TOOL PRESETS STORE MORE SETTINGS

The brush presets contain only settings from the Brush panel, not settings from the Options bar. When you save settings as a tool preset via the Tool Presets panel or picker (e.g., for the Brush or Mixer Brush tool), on the other hand, it will contain the Brush and Options bar settings and, optionally for some tools, the current Foreground color (see page 134).

Using the Mixer Brush tool

By choosing brush characteristics for the Mixer Brush tool, you can mimic different types of natural bristle brushes, such as oil paint or gouache. You can also control the wetness of the paint, the paint flow, and the degree to which existing colors mix with new strokes. Photoshop "paint" lacks the viscosity of traditional oils, but you can achieve some nice effects with it nevertheless.

To build a bristle brush:

- 1. Choose the Mixer Brush tool (B or Shift-B).
- 2. Display the Brush panel. If you don't see any bristle tips on the panel, click Brush Presets. From the Brush Presets panel menu, choose Reset Brushes. Click OK in the alert dialog, then click the Toggle Brush Panel button To return to the Brush panel.
- 3. Click Brush Tip Shape, then click a bristle tip in the scrolling window. A The shape name is listed on the Shape menu.
- 4. Activate the Live Tip Brush Preview button.
- 5. To pare down the number of options that will affect your brush, either uncheck all the options on the left side of the panel except Smoothing or choose Clear Brush Controls from the panel menu.
- 6. Use the Bristle Qualities sliders to choose these physical characteristics for the tip, while noting the changes in the preview:

Bristles controls the number (density) of bristles. Length controls the length of the bristles.

Thickness controls the width of the bristles (and therefore affects the overall density of the stroke).

Stiffness controls how easily the bristles bend. Choose a low value for smooth, fluid strokes or a high value for scratchy, dry bristle marks.

Angle controls the brush angle if you're using a mouse. Angle variations are most noticeable when a "Flat" shape is chosen for the tip.

- 7. Before using the Mixer Brush tool, choose Options bar settings, as in the steps on the next page.
- You can record the creation of a painting or drawing via an action, and then replay the process again at any time. The artwork will reappear onscreen, stroke by stroke. See Chapter 22.

A When the Mixer Brush tool and a bristle tip are selected, Bristle Qualities options display on the Brush panel.

USING THE BRUSH POSE OPTION SET FOR A MOUSE

When painting with a mouse, click the Brush Pose option set (Brush panel) to access brush handling options, such as the following:

- Use Tilt X or Tilt Y to tilt the entire brush as you apply brush strokes, and thereby mix colors with only part of the tip.
- Use a high Pressure value to bend the brush bristles more, mimicking the way a brush presses into the surface of the paper or canvas, for a darker stroke (akin to decreasing the Stiffness), or lower the Pressure value for a lighter stroke.
- Uncheck the Override boxes, which are for use with a stylus.

Before using the bristle brush that you have just chosen qualities for, you also need to choose settings to control how the brush applies pigment.

To choose paint options for a bristle brush:

- 1. After following the instructions on the preceding page, and with the Mixer Brush tool still selected, on the Options bar, do both of the following:
 - Activate the Load Brush After Each Stroke button 🌌 to have the current Foreground color reload onto the brush after each stroke.
 - Activate the Clean Brush After Each Stroke button X to have a clean Foreground color reload after each stroke, or deactivate this option to allow the last colors in the brush to mix with the current Foreground color.
- 2. To choose a Foreground color, click the Current Brush Load thumbnail on the Options bar, then use the Color Picker; or click a color on the Swatches or Color panel.
- 3. From the Useful Mixer Brush Combinations menu, choose a preset combination of settings. The Dry presets are good for defining object details and edges (because they set the wet value to 0% and thereby disable the Mix option), the Moist presets allow for moderate paint mixing, and the Wet and Very Wet presets work well for blending new strokes with existing ones.

If you prefer to choose custom options (or to refine the settings from a preset), do any of the following:

Choose a Wet value to control the wetness of the existing paint and the extent to which your brush can pick it up in the stroke. A-B

Choose a Load value to control how much paint is supplied to the brush (how quickly the brush runs out of paint), most noticeable with a low Mix value.

Choose a Mix value to control the degree to which new strokes mix or smear with existing strokes (including any white from the Background). C-D

Choose a Flow value to control the rate at which paint is applied (the amount of coverage).

Check Sample All Layers to allow the brush to mix with and pick up paint from all layers. With this option checked, the current Foreground color may not appear in your brush strokes.

 Create a new, blank layer (it can be above an image laver). It's time to paint!

Use this method if you want to wipe a brush clean or reload color to the brush manually, on a one-time basis — that is, override inactivated Load Brush After Each Stroke and Clean Brush After Each Stroke buttons.

To wipe a bristle brush clean:

With the Mixer Brush tool selected, click the Current Brush Load menu on the Options bar, click Clean Brush, then click Load Brush.

A Options bar settings of Wet 10 and Mix 10: The stroke barely blended with the existing color.

B Wet 90 and Mix 10: The stroke blended somewhat with the existing color.

C Wet 10 and Mix 90: The stroke blended and smeared more with the existing color.

D Wet 90 and Mix 90: The stroke blended and smeared almost entirely with the existing color.

PICKING UP COLORS FROM AN IMAGE

Check Sample All Layers for the Mixer Brush tool, then Alt-click/Option-click an area of an image layer. Imagery from the sampled area will appear in the Current Brush Load thumbnail on the Options bar.

In this exercise, you will reinterpret shapes in a photo with the Mixer Brush tool, to produce a digital painting. This is a fun exercise.

To turn a photo into a painting:

- 1. Open a photo A and duplicate the Background.
- 2. Hide the duplicate layer, click the original Background, then use Edit > Fill to fill it with White. To add a texture, use Edit > Fill again, except this time choose Use: Pattern, choose the Canvas pattern (Artist Surfaces library) from the Pattern picker menu, set the Opacity to 75%, uncheck Scripted Patterns, then click OK.
- 3. Click the Background copy, and make it visible again. Create several blank layers, and keep one of them selected.B
- 4. Choose the Mixer Brush tool (B or Shift-B).
- 5. On the Brush Presets panel, click a bristle preset, such as a flat, blunt preset to fill in broad areas or a flat, pointed preset _____ to draw fine lines.
- 6. On the Options bar, do all of the following: From the Useful Mixer Brush Combinations menu, choose a preset to control the character of the paint. The Wet and Very Wet presets are good for painting broad areas, such as backgrounds, and for picking up colors from a photo; the Moist and Dry presets are better for defining details.

Check Sample All Layers to allow the brush to pick up and mix colors from all the underlying layers (strokes will appear only on the selected layer).

If you're using a stylus and tablet, activate the Pressure Controls Size button.

7. To transform your photo into a painting, do either of the following:

To reinterpret the photo with a "clean" brush, deactivate the Load Brush After Each Stroke button 3 on the Options bar and activate the Clean Brush After Each Stroke button X (now the current Load value will have no effect and the Foreground color isn't applied). As you apply brush strokes in the image, start each new stroke over the desired color (A, next page).

To sample a color from the photo, activate the Load Brush After Each Stroke and Clean Brush After Each Stroke buttons on the Options bar, then hold down I (temporary Eyedropper tool) and click in the photo. Click a paint layer, then paint with the sampled color (B-C, next page, and A-B, page 300). Repeat.

- Paint the picture in sections, each one on a separate blank layer. To erase any unwanted strokes, use the Eraser tool (see page 300). To view just your brush work, lower the opacity of the photo layer temporarily.
- As you apply brush strokes, mimic the direction of shapes in the photo. To add variety to your paint, switch bristle tips and change the brush size occasionally between strokes.

 $oldsymbol{\mathbb{A}}$ This is the original photo — a quintessential New England landscape.

This is how the Layers panel looked by the end of step 3 on this page.

A For the Mixer Brush tool, we deactivated the Load Brush After Each Stroke option so we could pick up colors from the photo layer, chose "Wet, Heavy Mix" from the Useful Mixer Brush Combinations menu, then applied brush strokes on a few blank layers.

- **B** We activated Load Brush After Each Stroke, sampled a color in the photo, clicked another blank layer, then painted with a couple of the Moist preset combinations and a couple of the Wet ones.
- To view just your brush strokes in the document (as shown here), lower the opacity of the photo layer. To resume sampling colors, reset the photo layer opacity to 90%-100%.

- Next, we painted the sky with the Round Fan Stiff Thin Bristles and Flat Point Medium Stiff presets, painted the water with the Round Blunt Medium Stiff and Round Point Stiff presets, and painted the siding on the building with the Round Point Stiff preset and the Dry, Heavy Load combination.
- All the presets mentioned above are in the default brush library. To view the preset names, choose Small or Large List from the Brush Presets panel menu.

Continued on the following page

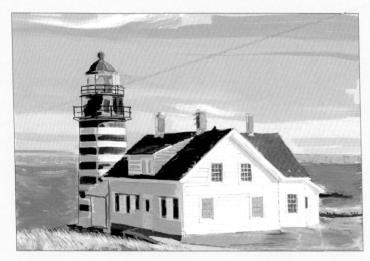

A Finally, we applied brush strokes on the topmost layer using the Round Point Stiff preset, with the Dry combination chosen to prevent the final line work from blending with the other paint layers. Now the image looks like an artist's painting. Note that we didn't slavishly replicate every tiny detail in the photo — that's what artistic license is all about!

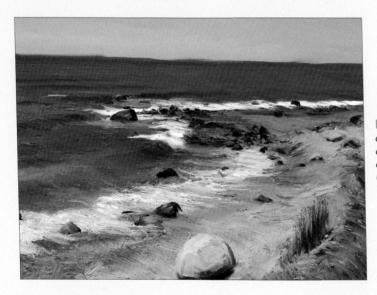

B We transformed this photo in a similar way to the one shown above, using the Mixer Brush tool, a bristle tip, and a few different Useful Combination presets.

Using the Eraser tool

The Eraser tool removes image pixels permanently, so it should be used only to delete areas from a duplicate layer or from a layer that contains, say, just retouching or painting edits that were made via the Sample All Layers option. Don't use it on the original Background!

To use the Eraser tool:

- 1. Choose the Eraser tool (E or Shift-E).
- On the Options bar, do the following: Click a Soft Round brush on the Brush Preset picker.

Choose a Mode (shape) of **Brush**, **Pencil**, or **Block**. For Brush or Pencil mode, choose an **Opacity** percentage; for Brush mode, deactivate the **Airbrush** button and keep the **Flow** setting at 100%.

- 3. Click a layer, make sure the Lock Transparent Pixels button is deactivated, adjust the brush size by pressing [or], then drag to erase pixels.
- Instead of erasing image pixels permanently, an option that we prefer is to hide them via an editable layer mask (see pages 190–191).

Using the History Brush tool

When you apply strokes to a document with the History Brush tool, pixels below the pointer are restored from whichever state or snapshot you have designated as the history source.

Note: Photoshop prevents the use of the History Brush tool if you apply certain kinds of edits after opening your document, such as changing the document color mode or canvas size or cropping. Also, the tool can't be used to recover pixels from a layer that you have deleted, and it works only on 8-bit images.

To use the History Brush tool:

- 1. Click an image layer (or duplicate the Background), and apply some edits, such as a filter or brush strokes (but none of the edits listed in the Note above). A-C
- 2. Choose the **History Brush** tool **3** (Y or Shift-Y).
- 3. On the Options bar, do all of the following: Click the Brush Preset picker arrowhead, then click a brush on the picker.

Continued on the following page

B We duplicated the image layer via Ctrl-J/ Cmd-J, then applied the Gaussian Blur filter to the duplicate layer.

A This is the original image.

We used a Hue/Saturation adjustment layer (Colorize option) to apply a blue-green tint, then merged that layer into the duplicate image layer.

Choose a blending Mode, Opacity percentage, and Flow percentage.

- 4. On the Layers panel, click the layer you edited, and make sure the Lock Transparent Pixels button is deactivated.
- 5. On the History panel, click in the leftmost column for a state, to designate it as the source for the History Brush tool. The history source icon appears in that slot. A Note: If you added a layer during the course of editing (step 1), set the history source to the New Layer or Layer via Copy state.
- 6. Apply strokes to the image. Pixel data from the source state will replace the current data where you apply strokes. B-C
- We recommend using the History Brush immediately after applying edits that you want to remove selectively. This way, it will be easier for you to identify which state you want to use as a source.

A To set the history source icon, we clicked in the leftmost column for the state in which we duplicated the image layer.

B We set the Opacity for the History Brush to 70% and chose the Round Blunt Medium Stiff bristle preset. We applied strokes to selectively restore the original, unedited image in scratchy strokes.

C Finally, with a Soft Round tip and the History Brush Opacity set to 50%, we partially restored some areas of the model's face and neck from the original Background image.

Photoshop provides tools for correcting many kinds of imperfections in a photo, from smoothing pores and wrinkles to removing blemishes, unsightly power lines, and other unwanted elements. Methods are also available for correcting colors, such as whitening teeth, and for replacing colors, such as on a garment in a fashion shot.

In this chapter, you will change colors by using the Replace Color command and the Color Replacement tool; whiten teeth or eyes; correct red-eye; smooth wrinkles with the Healing Brush and Patch tools; remove blemishes with the Spot Healing Brush tool; soften skin and other textures with the Surface Blur and Gaussian Blur filters; replace pixels with the Clone Stamp tool; eliminate unwanted elements from a picture with the Spot Healing Brush tool, Patch tool, and Fill command; and move or extend areas of an image with the Content-Aware Move tool.

The following are some guidelines we recommend following when applying retouching edits:

- ➤ Do the small stuff first. For instance, if you need to heal blemishes or other small imperfections in a facial shot as well as smooth the skin, start with the blemishes. Next, either merge the healing layer into the image layer or select both the healing and image layers, then copy and merge (stamp) them onto a new layer (see page 165). Finally, apply skin smoothing to the newly merged layer.
- ➤ Preserve the original pixels and keep your edits flexible. One way to accomplish this is by duplicating the image layer and editing the duplicate. For some tools, an even better option is to check Sample: All Layers on the Options bar, then apply edits to a new, blank layer. The tool will sample pixels from all the visible layers and send the results to the new layer. You can easily add strokes to, or erase your editing strokes from, that layer at any time.
- Restore some realism. After applying edits to a duplicate or blank layer, you can lower the opacity of that healing or retouching layer slightly to reveal a bit of the original, imperfect (but more natural-looking) photo.

15

IN THIS CHAPTER

Using the Replace Color command304
Using the Color Replacement tool 306
Whitening teeth or eyes
Using the Red Eye tool
Using the Healing Brush tool 310
Using the Spot Healing Brush tool313
Healing areas with the Patch tool 314
Smoothing skin and other surfaces315
Retouching by cloning
Applying a Content-Aware fill321
Using the Content-Aware Move tool322
Removing an image element with the Patch tool

Using the Replace Color command

Using the Replace Color command, not only can you apply hue, saturation, and lightness adjustments, but via selection controls in the dialog, you can limit those edits to specific color areas of the image. This command works best for recoloring discrete areas that are easy to isolate.

To use the Replace Color command:

- 1. Optional: In an RGB document that you're going to send to a commercial printer, choose View > Proof Setup > Working CMYK to view a soft proof of the image in simulated CMYK color.
 - Once you've made a choice from the Proof Setup submenu, you can toggle the proof on and off while the Replace Color dialog is open by pressing Ctrl-Y/Cmd-Y. Regardless of whether the Proof Colors command is on or off, the Color and Result swatches in the Replace Color dialog are going to display in RGB.
- 2. Click a layer (not a Smart Object) or the Background, press Ctrl-J/Cmd-J to duplicate it, and keep the duplicate layer selected.
- 3. Optional: To confine the color selection and replacement to an area of the image, create a selection.A
- 4. Choose Image > Adjustments > Replace Color. The Replace Color dialog opens.
- 5. In the document, click the color to be replaced. The color you click will appear in the Color swatch at the top of the dialog.
- **6.** Do any of the following:

To add more color areas to the selection, click the Eyedropper tool In the dialog, then Shift-click or drag either in the preview or in the document. Increase the Fuzziness value to add similar colors to the selection, or reduce it to narrow the range of selected colors.B

Check Localized Color Clusters to limit the selection to similar, contiguous colors. (We sometimes get similar or better results by lowering the Fuzziness value instead.)

7. If you need to subtract any areas from the selection, with the Eyedropper tool, hold down Alt/ Option and click or drag in the preview or document window (this is a temporary Subtract from Sample Eyedropper tool).

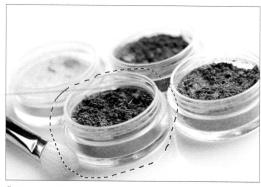

A To recolor the purple eye shadow in this image, our first step was to select that area loosely.

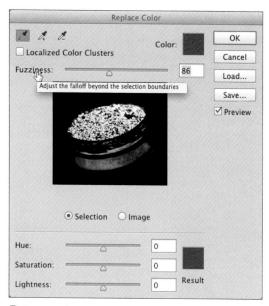

B We opened the Replace Color dialog, then clicked the pot of eye shadow. Areas matching that color displayed as a selection in the preview window. We tried setting the Fuzziness slider to 86.

8. To replace the colors you have selected, do either of the following:

In the Replacement area, choose replacement Hue, Saturation, and Lightness values (you can use the scrubby sliders). A The Result swatch will update as you do this. Note: A Saturation value greater than +25 may produce a nonprintable color.

Click the Result swatch, choose a replacement color in the Color Picker, then click OK. The sliders will shift to reflect the values of the new color.

Note: If you click a different area of the image or add to or subtract from the selection, the Color and Result swatches will change but the Replacement sliders will stay put.

- To toggle the selection and the image in the preview, press and release Ctrl/Cmd (or click Selection or Image below the preview).
- 9. Optional: To save your settings (e.g., to apply to a series of similar photos), click Save, enter a name for the data file, keep the default location, then click Save.

10. Click OK.B

- In a CMYK document, the Replacement sliders don't affect the value of the Black (K) component. That value is established by the CMYK Working Space, which you chose in Edit > Color Settings.
- You can restore the original dialog settings by holding down Alt/Option and clicking Reset (Cancel becomes Reset), but be aware that you will then need to create a new selection from scratch.

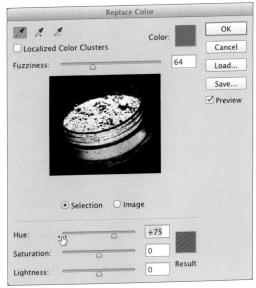

A We settled on a Fuzziness value of 64, Shift-clicked more areas in the eye-shadow pot to add them to the selection, then changed the Hue.

B The eye shadow that was originally purple is now reddish brown.

Using the Color Replacement tool

The Color Replacement tool lets you change color values in areas of an image, but instead of using a dialog, as you do with Replace Color, you apply changes manually with a brush. Unlike the Brush tool, the Color Replacement tool attempts to preserve the original texture (luminosity values) of an area as it replaces colors. This tool, like the Replace Color and Match Color commands, will be of particular interest to advertising and catalog designers.

To use the Color Replacement tool:

- 1. Duplicate the Background in an RGB image to preserve the original pixels, and keep the duplicate layer selected.
- 2. Choose the Color Replacement tool 3 (B or Shift-B).
- 3. As the replacement color, choose a Foreground color via the Color or Swatches panel, or sample a color by Alt/Option clicking in the document.
- 4. If the color you chose isn't on the Swatches panel, add it to the panel by clicking the **New** Swatch of Foreground Color button.
- 5. On the Options bar, choose parameters for the tool:A

On the Brush Preset picker, choose a high Hardness value and a low Spacing value.

To control which color characteristics the tool applies to the image, choose a Mode of Hue, Saturation, Color, or Luminosity. (We've gotten good results with Color mode.)

Click a Sampling button: Continuous 2 to apply the current Foreground color to all pixels the brush touches (we prefer this option because it lets us replace both light and dark colors); or Once to sample the first pixel the brush clicks and apply the Foreground color only to pixels

that match that initial sampled color (because this option confines the sampling to just one color, if you need to replace, say, different shades of a particular color, you would have to sample each one separately); or Background Swatch to replace only colors that match or are similar to the current Background color (for this option, choose a Background color).

From the Limits menu, choose Discontiguous to recolor only the color that is sampled under the pointer; or Contiguous to recolor the sampled color plus adjacent pixels within the current Tolerance value; or Find Edges (our favorite option) to recolor pixels under the pointer plus adjacent pixels, while keeping the color replacement within discrete image shapes.

Choose a Tolerance value (1–100%) for the range of colors to be replaced. A high Tolerance value permits a wide range of colors to be recolored; a low value allows only pixels that closely match the sampled color to be recolored.

Optional: Check Anti-alias for smoother transitions between the original and replacement colors.

If you're using a stylus and tablet, click the Pressure Controls Size of button, and from the Size menu on the Brush Preset picker, choose Pen Pressure or Stylus Wheel.

- 6. Adjust the brush diameter by pressing [or], then drag across the areas to be recolored (A-D, next page). Only pixels that fall within the chosen Sampling, Limits, and Tolerance parameters will be recolored.
- When using the Color Replacement tool, you can change Options bar settings or the brush diameter between strokes.

A We want to change the color of the light green stripes on this woman's sweater to aqua blue.

B With the Color Replacement tool and the settings shown in the figure on the preceding page, we're "painting" over the light green areas on the woman's sweater, to replace it with aqua blue, which is the current Foreground color.

C To recolor both highlights and shadows within a stripe in a small area, we zoomed in, then used the Color Replacement tool with a Tolerance setting of 40%. Here we're replacing colors along the edges of a stripe using a lower Tolerance setting of 15%.

Although the Limits setting for the tool was Find Edges, it recolored some dark stripes, which was not our intention. To repair this error, we Alt/Option clicked to sample the original color in the darker stripe (as shown above). Our next step would be to apply strokes with the newly sampled color.

Whitening teeth or eyes

Another use for a Hue/Saturation adjustment layer (a feature that you learned about in Chapter 12) is to whiten the teeth or the white areas of eyes in a portrait. The first step is to select the problem area(s).

To whiten teeth or eyes in a portrait photo:

- 1. Open a portrait photo, zoom in on the area to be corrected, then do either of the following: Choose the Quick Selection tool. then drag to create a tight selection of the teeth A or of
 - Paint a Quick Mask on the teeth by following the steps on page 189.
- 2. On the Adjustments panel, click the Hue/ Saturation button.

the white areas of both eyes.

- 3. On the Properties panel, for teeth, choose Yellows from the second menu; for the whites of the eyes, choose either Master or Reds. Reduce the Saturation value and increase the Lightness value.B
 - Try not to overdo the whitening, or the teeth or eyes will look unnatural. To view the layer without the correction, click the Layer Visibility button on the Properties panel; click it again to re-enable the correction.
- 4. Also on the Properties panel, click the Masks button, then increase the Feather value to soften the edge of the mask (the transition to the adjusted area). Try a value between 5 and 8 px). C-D You can also lower the Density value of the mask.

Then we adjusted the Feather value for the mask.

A We used the Quick Selection tool to select the teeth in this photo.

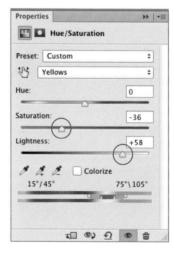

B On the Properties panel for a Hue/ Saturation laver. we lowered the Saturation and increased the Lightness.

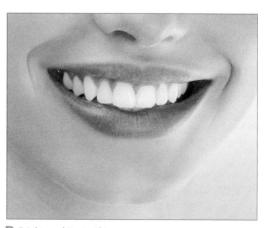

D Brighter, whiter teeth!

Using the Red Eye tool

Red-eye (red in the pupil areas) in a portrait photo results when a person in a relatively dark room looks straight into the camera lens, and light emitted by an electronic flash reflects off his or her retinas. This is less likely to occur if you use a flash bracket and an off-camera flash — and if the subject looks away from the camera. To remove red-eye from a photo that was taken without such preventive measures, you can use the Red Eye tool in Photoshop.

To remove red-eye from a portrait:

- 1. Open a portrait photo, duplicate the Background, and zoom way in on the eye area.
- 2. Choose the **Red Eye** tool **5** (J or Shift-J).
- 3. On the Options bar, do both of the following: Choose a **Pupil Size** for the size of the correction. You can start with the default setting of 50%, and see if you like the results. You don't want the tool to enlarge (dilate) the pupil.
 - Choose a Darken Amount to control how much the tool darkens the pupil in order to remove the red. Try a setting below 30% for light-colored eyes, or above that value for dark-colored eyes.
- 4. Click once on the red area in each pupil. The tool should remove all traces of red, replacing it with black. A-B If not, see the next task.
 - Note: If the tool enlarged the pupil too much, undo the results, lower the Pupil Size value, then click again. Similarly, if the red removal was incomplete or the pupil became too dark, undo the results, then try again with a different Darken Amount value.
- You don't need to drag across the eye with the Red Eye tool; the tool is clever enough to find the pupil area automatically with a simple click.

Some photographers prefer to keep the red-eye feature of their camera off, because it delays the shutter action and they can miss the "magic moment." Also, the subject can mistake the click of the red-eye feature for the shutter, which comes afterward.

If you notice traces of red in the irises of the eyes (the area around the pupils), you can eliminate them.

To remove redness from the irises of the eyes:

- 1. Zoom in on one eye.
- 2. Choose the Color Replacement tool 🛂 (B or Shift-B).
- 3. On the Options bar, choose Mode: Color, Sampling: Once, Limits: Contiguous, and Tolerance: 30%.
- 4. Make the brush tip very small, Alt-click/Optionclick a color in the iris of the eye, then apply short strokes over the remaining traces of red to recolor them with the sampled color.
- 5. Repeat with the other eye.

USING THE RED EYE REMOVAL TOOL IN CAMERA RAW

The Red Eye Removal tool in Camera Raw is similar to the Red Eye tool in Photoshop, except in Camera Raw, you drag before using the sliders. Choose the Red Eye Removal tool, choose a Type option of Red Eye (for humans) or Pet Eye; ** drag across one of the eyes, including some surrounding area; then adjust the sliders. Uncheck Show Overlay (V) to view the results. Repeat for the other eye.

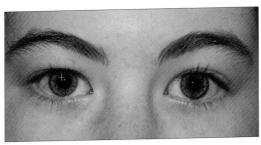

A With the Red Eye tool, we clicked once on each eye.

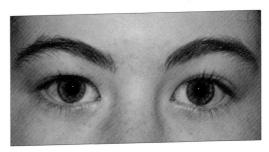

B Click, click, the red-eye is gone.

Unlike the Clone Stamp tool, which merely copies a source color without blending it into the target area (see pages 318–319), the three tools discussed next will sample a texture, apply it to the target area, and blend the texture into the existing color and brightness values. With these tools, it's easy to fix imperfections, such as facial blemishes or paper creases in a vintage photo, and the results are usually seamless.

With the Healing Brush tool, you Alt-click/Option-click to sample from an unblemished or smooth area, then apply strokes in the area to be retouched. A The blemish pixels are replaced with sampled pixels.

With the Patch tool, you select the blemish area first, then drag the selection over an unblemished area for sampling. Here too, the blemish pixels are replaced with the sampled ones.

And with the Spot Healing Brush tool, you simply click a blemish without sampling. Pixels are replaced (almost magically!) based on data gathered from neighboring pixels.

Using the Healing Brush tool

To use the Healing Brush tool:

- 1. Choose the **Healing Brush** tool (J or Shift-J).
- Create a new, blank layer in a portrait photo. (The healing strokes will be applied to this layer.)
- 3. On the Options bar, do all of the following: B
 Via the Brush Preset picker, choose a high
 Hardness value (you can also do this by rightclicking in the image, or by using the interactive
 cursor, as described on page 129). Also, in Edit/
 Photoshop > Preferences > Cursors, click Full
 Size Brush Tip, so you will be able to preview the
 diameter of the brush cursor.

Choose Mode: **Normal** to preserve the grain, texture, and noise of the area surrounding the target; or if you don't need to preserve those characteristics, choose a different mode, such as Lighten (for subtle retouching or to correct wrinkles or creases that are very close together, to prevent them from cloning onto one another).

Click Source: Sampled.

Check **Aligned** to maintain the same distance between the source point and the areas that you drag across, even if you release the mouse between strokes, or uncheck this option to resample from the original source point each time you release the mouse.

From the Sample menu, choose **All Layers**. This setting will permit the tool to sample pixels from all the layers below the pointer (the corrected pixels will appear on the selected, blank layer).

Optional: If the document contains adjustment layers, the effects of which you want the Healing Brush tool to ignore when sampling (so the effect of the adjustments isn't doubled), activate the Ignore Adjustment Layers When Healing button.

If you're using a stylus and tablet, click the **Pressure Controls Size 6** button.

Click the Toggle Clone Source panel button, then check Show Overlay and Clipped on the Clone Source panel so you will be able to preview the cloned pixels within the brush cursor.

A We're going use the Healing Brush tool to soften the wrinkles around the woman's eyes in this photo.

- 4. Press [or] to scale the brush to suit the area to be healed.
- 5. Alt-click/Option-click a smooth or unblemished area to sample it as the source texture. A The sampled area displays within the brush cursor.
- 6. With the new, blank layer still selected, drag a short stroke across the area to be repaired. When you release the mouse, the source texture will be applied to the target area and will be blended into neighboring pixels. It will render in two stages, so be patient. C

A With the Healing Brush tool, we held down Alt/Option and clicked the area to be used as replacement pixels...

The wrinkles around her eyes are softened.

- 7. Optional: To establish a new source point for further repairs, Alt-click/Option-click a different area, then apply more strokes.
- 8. Optional: To soften the results, lower the opacity of the healing layer slightly to blend it with the original layer.D
- Because you applied the healing strokes to a separate layer, you can easily erase any mistakes. Hide the image layers below the healing layer temporarily, then with the Eraser tool, drag across any unwanted strokes.

 $oldsymbol{\mathbb{B}}$...then dragged across the area to be repaired. Note that the brush tip is separate from the sampling pointer.

Our retouching brush strokes are on a separate layer (labeled "healing brush"). To make the portrait look more natural, we lowered the Opacity of that layer to 90%.

REMOVING FACIAL HOT SPOTS

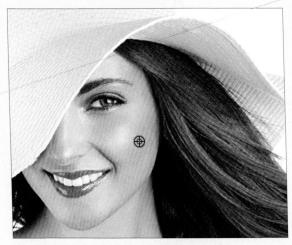

The Healing Brush tool is also handy for removing shiny hot spots, caused by harsh, uneven lighting, from a portrait. You can remove them by doing the following: Choose Mode: Darken on the Options bar for the tool, then Alt-click/Option-click to sample a medium-tone area of skin.

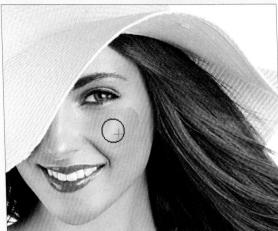

Create a new, blank layer, size the brush, then drag once or twice over a hot spot, letting your stroke(s) follow the natural contours of the face.

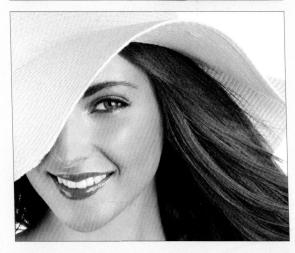

With Darken mode chosen for the tool, it repaired only the lightest area. We repeated this process on the model's forehead and nose. (If you want to soften the results, lower the opacity of the healing layer.)

Using the Spot Healing Brush tool

The Spot Healing Brush tool heals imperfections without your having to sample a source area. With one click or a very short drag, you can zap blemishes or wrinkles, or repair a tear or crease in a vintage or damaged photo.

To use the Spot Healing Brush tool:

- 1. Create a new, blank layer to contain your healing strokes, and keep it selected.
- 2. Choose the Spot Healing Brush tool (J or Shift-J), and zoom the document to 100%.
- 3. In Edit/Photoshop > Preferences > Cursors, under Painting Cursors, click Full Size Brush Tip (so you will be able to preview the diameter of the brush cursor) and check Show Crosshair in Brush Tip (to help you position the cursor).
- 4. On the Options bar, do all of the following: Choose a Mode. To preserve skin tones, try Normal or Lighten mode. (When used in Replace mode, the tool may pick up unwanted facial details in the stroke, such as hair or eyelashes.) To help preserve existing tonal values in the image, such as in skin tones, click Type: Content-Aware (for more about this option, see page 320). Check Sample All Layers to allow the brush to sample pixels from all the layers below the
- 5. Position the pointer above the area to be repaired, press [or] to make the brush just slightly wider than that area, then drag once across it in a short stroke. A-B Repeat to repair other problem areas.

pointer.

- 6. Optional: For a more subtle result, lower the opacity of the healing layer slightly.
- 7. Because you applied Spot Healing strokes to a separate layer, you can show and hide those edits (or erase any unwanted strokes with the Eraser tool) at any time.

A With the Spot Healing Brush tool, we clicked a blemish.

B The blemish disappeared.

RETOUCHING WITH LIQUIFY

To reshape an area of an image (e.g., to slim down a chin or waistline in a portrait), try using the Liquify filter. See pages 352-355.

Healing areas with the Patch tool

The Patch tool is also a good choice for retouching bags or wrinkles below the eyes in a portrait and for repairing rips, stains, or dust marks in a scanned image (such as a vintage photo).

To retouch an area using the Patch tool:

- 1. Press Ctrl-J/Cmd-J to duplicate the Background, and keep the duplicate layer selected.
- 2. Choose the Patch tool (J or Shift-J).
- 3. On the Options bar, click Patch: Normal and Source.
- 4. Drag a selection around the entire area to be repaired. A You can Shift-drag to add to the selection or Alt-drag/Option-drag to subtract from it.
 - If you're retouching an under-eye area, avoid selecting any of the lower eyelid.
- 5. Drag from inside the selection to the area to be sampled. B When you release the mouse, imagery from the sampled area will appear within the original selection, and will be blended with the luminosity and texture of original pixels. Deselect (Ctrl-D/Cmd-D). C
- **6.** Optional: If the results of the Patch repair look too smooth or slick, lower the opacity of the duplicate layer (try 70% or 80%) to reveal some of the original image.
- See also the tip on page 324. (The Patch tool is also used on that page.)

Photoshop blended pixels from the sample area into the original selection area.

A With the Patch tool (Normal setting), we selected the area to be repaired.

B We dragged from the selected area to a nearby area for Photoshop to sample.

We repeated the same steps for the left eye, then lowered the layer Opacity to 70% to soften the effect.

Smoothing skin and other surfaces

Using the Surface Blur filter, you can easily smooth out unwanted textures, such as skin pores in a portrait or grainy paper in a scanned photo or drawing.

To smooth surfaces with the Surface Blur filter:

- 1. Press Ctrl-J/Cmd-J to duplicate the Background in an image that needs some surface smoothing. Right-click the duplicate layer and choose Convert to Smart Object.
- 2. Choose Filter > Blur > Surface Blur. The Surface Blur dialog opens. Check Preview.
- 3. Choose a low Threshold value (try 3-6) to blur only low-contrast areas, such as the cheeks and forehead in a portrait, while preserving the contrast in key details, such as the eyes and mouth.
- 4. Adjust the Radius just to the point that the desired degree of smoothing is reached. To soften skin (e.g., cheeks, forehead), try a value of 6-12.
- 5. Readjust the Threshold to increase or decrease the amount of blurring in the low-contrast areas. Bear in mind that too much smoothing can make a surface look artificial — but then again, this whole task is a lesson in artifice!
- 6. Click OK.B To edit the settings at any time, doubleclick the Surface Blur listing on the Layers panel (under Smart Filters); the filter dialog reopens.
- 7. Optional: To soften the overall filter effect, lower the opacity of the Smart Object.
- 8. Optional: To selectively reveal details from the unaltered layer, click the mask thumbnail for the Smart Filters listing. Choose the Brush tool 🖋 (B or Shift-B). On the Options bar, choose a Soft Round brush and an Opacity of 80–90%. Choose black as the Foreground color and size the brush cursor, then draw strokes on key details, such as the lips, eyes, eyebrows, or hair in a portrait. To reveal the surface blur effect in any areas that you masked unintentionally, paint with white.
- If you want to use the Spot Healing Brush or Healing Brush tool to retouch areas of the Smart Object, check Sample All Layers on the Options bar and work on a new, blank layer. If you want to use the Patch tool, double-click the Smart Object thumbnail to access the embedded image.
- To learn about Smart Filters, see pages 360-364.

A The pores on this woman's skin look too prominent.

B The Surface Blur filter successfully smoothed the skin texture while keeping the facial features crisp (we chose a Radius setting of 9 pixels and a Threshold setting of 6 levels for our 300 ppi file). Compare the cheeks and under-eye areas in this image with those in the preceding one.

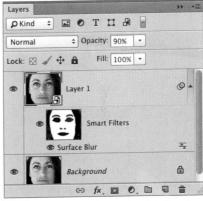

C Finally, we lowered the opacity of the Smart Object and painted with black on the Smart Filters mask to reveal some of the sharp facial details from the underlying layer.

Here we show you how to soften a skin texture with an extra degree of control. You will apply the Gaussian Blur filter twice, in each case using a mask and a layer blending mode to control the visibility of the smoothing effect, first in the light areas, then in the dark areas.

To smooth skin with the Gaussian Blur filter:

- Open an RGB photo of a face. Press Ctrl-Alt-J/ Cmd-Option-J to open the New Layer dialog. Rename the duplicate layer "blur darken," then click OK.
- 2. Choose Filter > Blur > Gaussian Blur. In the dialog, drag the cheek or forehead area into view, then move the Radius slider until the skin starts to look smooth and blurry. Press, then release, on the preview to judge the blur effect. Click OK. Don't be concerned that the facial features now look too blurry.
- 3. Choose Darken as the blending mode for the "blur darken" layer (to smooth only lighter areas), then lower the layer opacity setting until a hint of texture marks reappear in the skin.
- 4. Alt-click/Option-click the Add Layer Mask button ☐ on the Layers panel to add a black mask, and keep the new mask thumbnail selected.
- 5. Choose the Brush tool (B or Shift-B), a Soft Round tip, Normal mode, and 100% Opacity, and press X to make the Foreground color white.

Apply strokes to areas where you want to reveal the smoothing effect, such as on the cheeks, forehead, chin, and nose (A—B, next page).

If you paint over any facial features unintentionally, such as the eyes or eyebrows, press X to make the Foreground color black, and paint over your strokes.

- Press [to reduce the brush diameter to paint over small areas, such as between the eyes and eyebrows or between the nose and lips, then press] to enlarge it again.
- **6.** Press Ctrl-Alt-J/Cmd-Option-J to duplicate the "blur darken" layer. The New Layer dialog opens. Rename the duplicate layer "blur lighten," then click OK.
- 7. Change the blending mode of the "blur lighten" layer to **Lighten** (to smooth only darker areas), then increase or reduce the layer opacity until any dark texture marks on the skin look softer. The skin should now look smoother.
- **8.** To put the top two layers in a group, Shift-click the "blur darken" layer, then press Ctrl-G/Cmd-G (C-D, next page).
- Optional: To restore a bit of "reality" to the portrait, click the group listing, then lower the opacity of the group until the desired amount of skin texture is revealed.

A In the original image, the pores of the woman's skin look too pronounced.

B In the Gaussian Blur dialog, we chose a Radius value of 20.5 pixels.

A We chose Darken as the blending mode for the "blur darken" layer, lowered the layer Opacity to 70%, Alt/Option clicked the layer mask thumbnail, then applied brush strokes to reveal the smoothing effect on the cheeks, forehead, chin, and nose. Because the layer blending mode is Darken, the effect can be seen only in the lighter areas.

B The smoothing effect is visible only where we added white areas to the layer mask, and is hidden by the black areas that are masking the rest of the face.

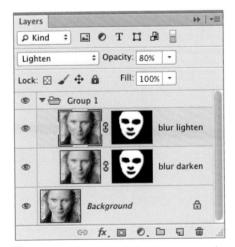

We duplicated the "blur darken" layer, renamed the duplicate "blur lighten," chose Lighten as the blending mode, and changed the layer Opacity to 80%. Finally, we put the two blur layers in a group.

Now the skin on the woman's forehead, cheeks, and nose looks smoother, while the eyes, eyebrows, lips, and hair still look sharp.

Retouching by cloning

The Clone Stamp tool lets you clone pixels either within the same document or between documents. Use it to remove distracting elements from an image, such as the metal pipe shown in our example, or to duplicate an element, such as leaves or a texture.

To retouch a photo by cloning imagery:

- 1. Open an RGB document, and if desired, open a second RGB document from which to clone. If you open two documents, display them both by choosing a tiling option from the Window > Arrange submenu.
- 2. Choose the Clone Stamp tool (S or Shift-S).
- 3. On the Options bar, do the following: A On the Brush Preset picker, choose a Soft Round brush.

Choose Normal as the blending Mode.

Choose an Opacity percentage.

Choose a Flow percentage to control the rate of application.

Check Aligned to maintain the same sampling point even if you release the mouse between strokes (to clone a large area seamlessly); or

uncheck Aligned to resample from the original source point each time you release the mouse (to clone the same area numerous times, separately).

From the Sample menu, choose All Layers to allow the tool to sample pixels from all the visible layers that are directly below the pointer (the new pixels will appear on the blank layer that you create in step 5).

Optional: If the source document contains adjustment layers, the effects of which you want the Clone Stamp tool to ignore when sampling (so the effect of the adjustments isn't doubled), activate the Ignore Adjustment Layers When Cloning button.

Optional: If you have a stylus and tablet, you can activate the Pressure for Opacity button and/or the Pressure for Size button.

4. Click in the source document (it can be the same document or a second one), then Alt-click/Optionclick a point from which to clone. B-C For seamless cloning, pick an area that looks very similar to the area being repaired.

A We chose these settings for the Clone Stamp tool from the Options bar.

B This is the original image. Our objective was to remove the metal pipes from the side of the building and add more leaves to fill in the front of the trellis.

We Alt/Option clicked with the Clone Stamp tool to sample a blank area of the wall.

- 5. Click in the target document (it can be the same document as the source or a different one). Create a new, blank layer, and keep it selected.
- 6. In Edit/Photoshop > Preferences > Cursors, under Painting Cursors, click Full Size Brush Tip (so you will be able to preview the brush diameter).
- 7. Press [or] to scale the brush, then click or drag in very short strokes to make the cloned pixels appear. A-B Imagery from the source point will display within the brush cursor. Note: If the whole layer displays in the overlay as you clone, show the Clone Source panel, then check Clipped.

A We're dragging with the Clone Stamp tool to replace the wire and pipe with pixels from the blank wall.

To prevent noticeable (tacky!) seams from appearing in a cloned texture, either apply short strokes or just click, and sample multiple times.

We're sampling the vine leaves because we want to add more leaves to the front of the trellis.

- 8. Optional: To establish a new source point for further cloning, Alt-click/Option-click a different area in the source document. C-D You can also change settings for the Clone Stamp tool between strokes.
- To create a "double-exposure" effect, with the original pixels partially remaining, lower the Opacity percentage for the Clone Stamp tool.
- To keep track of multiple source documents while using the Clone Stamp tool, use the Clone Source panel (see pages 282-283).

B We're continuing to sample the wall and clone away the pipe.

Compare this new, improved image with the original one, on the preceding page.

USING THE CONTENT-AWARE OPTION OF THE SPOT HEALING BRUSH TOOL

For a quick, easy, and powerful way to remove an "object" from a photo, try using the Spot Healing Brush tool, with its Content-Aware option (Options bar). This tool works better if the object being removed is surrounded by many small, random shapes (such as foliage, water, or clouds in a landscape) A-B than if the surrounding area contains isolated, distinct objects. This tool and option also work well for repairing tears or scratches in a vintage photo.

A To remove the fire hydrant from this image, for the Spot Healing Brush tool, we chose a brush Hardness of 100% (to let Content-Aware healing — not the brush — blend the edges), Normal mode, and Content-Aware. With a medium-sized brush and one continuous stroke, we covered the hydrant and its shadow.

We sat back while the Spot Healing Brush tool analyzed and sampled pixels from neighboring areas to use as replacement pixels for the hydrant... Poof! That was as easy as retouching gets.

ing process of the tool left behind a red tint.

Applying a Content-Aware fill

Sometimes the Content-Aware option of the Fill command does a seamless (or almost seamless) job of removing a distinct shape from a nondistinct background. You can tweak the results with the Clone Stamp, Healing Brush, or Patch tool (or if the Fill results are unsatisfactory, undo and use one of those tools instead).

To replace an image element with a Content-Aware fill:

1. Duplicate the Background in an image (Ctrl-J/ Cmd-J), then hide the Background. Keep the duplicate layer selected.

- 2. Optional: Add a layer mask to the layer, and with the Brush tool and black as the Foreground color, stroke over any areas in the background that you want to prevent Photoshop from sampling as replacement pixels. Click the layer thumbnail.
- 3. Loosely select the element in the image to be removed, then choose Edit > Fill.
- 4. Choose Use: Content-Aware, check Color Adaptation for enhanced color blending, ★ choose Mode: Normal and Opacity: 100%, then click OK.B
- 5. If you created a mask in step 2, deactivate it by Shift-clicking the mask thumbnail.

A Our goal was to eliminate the red shed from this image. To prevent Photoshop from sampling the bushes and rocks on the right side, we hid those areas via a layer mask. Next we selected the shed loosely with the Lasso tool.

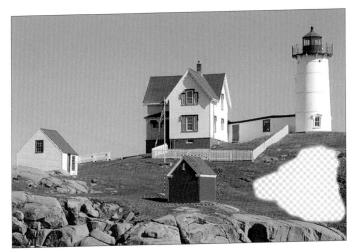

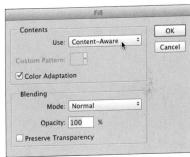

We chose these options in the Fill dialog, then clicked OK.

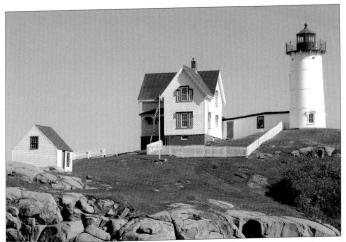

We deactivated the layer mask. The Fill command removed the shed and a small section of the fence, and replaced that area with random grass and stone textures.

NOT SURE WHICH AREAS TO MASK?

Do a practice run through the steps on this page, minus the mask (step 2), and note if there are any unwanted elements that Photoshop included in its calculations. Undo the Fill command, mask any areas that you want the program to ignore, then follow steps 3-4.

Using the Content-Aware Move tool

The Content-Aware Move tool can be used to reposition, or to create an extension of, an element in an image. Photoshop will use Content-Aware calculations either to fill in the exposed areas or to camouflage the seams, blending pixels into the texture and colors of the destination area.

To move or reshape an image element with the Content-Aware Move tool:

- 1. Create a new, blank layer and keep it selected.
- 2. Choose the Content-Aware Move tool X (J or Shift-J). On the Options bar, check Sample All Layers.
- 3. Drag loosely around the element to be moved or extended. A To add areas to the selection, hold down Shift while dragging; to subtract areas, hold down Alt/Option while dragging.
- 4. Do either of the following:

To move the selected area, choose Move from the Mode menu on the Options bar, then drag the selection, preferably to an area that looks like the original setting.B

To extend the object, choose Extend from the Mode menu, then drag the selection in the direction in which you want it to be enlarged.

- 5. The tool will send the selected pixels (and any areas that it filled in) to the new, blank layer. From the **Adaptation** menu and on the Options bar, choose a Structure value (1-5) to control how loosely or strictly the repositioned and replacement pixels blend into the image; the higher the Structure value, the more strict the replacement. Also choose a **Color** value (0-10); the higher the Color value, the more accurate the color matching (♠, next page).★ To apply a setting, press Enter/ Return or click outside the menu. The settings can be changed only while the selection is still active.
- **6.** Deselect (Ctrl-D/Cmd-D). See also **B-D**, next page.
- To hide (then show) the Content-Aware Move selection border, press Ctrl-H/Cmd-H.
- We made the Content-Aware Fill, Content-Aware Move, and Patch features look almost fail-safe by displaying only our successes — but it took some trial and error. Our more dependable results were in images that had fairly simple backgrounds.

A With the Content-Aware Move tool (Mode: Move), we dragged to loosely select the jogger and his shadow, ...

 $f B \ldots$ dragged the selected area to the right, then hid the selection border. Using a Structure value of 1 and a Color value of 0, the jogger is misshapen and has a color halo, and obvious patches are left in the areas that Photoshop filled in (the sand, sea spray, water, and horizon).

A Using a Structure value of 4 and a Color value of 5, the replacement pixels look more seamless. The clouds, mountains, spray, and water look more realistic, and there is no color halo around the jogger.

C We set the tool Mode to Extend, dragged upward to create another tier of pastry, then chose a Structure value of 1 and a Color value of 0. The added crust and filling look slightly distorted.

B With the Content-Aware Move tool, we selected the pastry (more tightly than we selected the dude on the beach, who was on a more complex background).

D Here we chose a Structure value of 4 and a Color value of 4, which blended the new pastry and filling more convincingly, with less distortion. Who doesn't like extra dessert?

Removing an image element with the Patch tool

Another way to replace image content is by using the Patch tool with its Content-Aware option. You draw a selection, then drag it to a source area for Photoshop to analyze as replacement pixels. To vary the results, change the Adaptation setting before you deselect.

To eliminate an image element with the Patch tool:

- 1. Create a new, blank layer, and keep it selected.
- 2. Choose the Patch tool (J or Shift-J).
- 3. On the Options bar, choose Patch: Content-Aware ★ and check Sample All Layers.
- 4. Drag a selection around the area to be removed. A You can Shift-drag to add to the selection or Alt-drag/Option-drag to subtract from it.
- 5. Drag the selection to an area that looks most like the original background behind the object. B When you release the mouse, Photoshop will fill in the exposed area based on those sampled pixels.
- 6. From the Adaptation menu and on the Options bar, choose a Structure value (1–5) to control how loosely or strictly the replacement pixels blend into the image. C−D Also choose a Color value (0 −10); the higher the Color value, the more accurate the color matching. These parameters can be changed only while the selection is still active.
- 7. Deselect (Ctrl-D/Cmd-D).
- To hide the selection border temporarily, press Ctrl-H/Cmd-H (repeat to redisplay it). If you tried different Adaptation settings and still aren't satisfied with the Patch results, press Ctrl-Z/Cmd-Z, then drag the selection to a different sample area.

C At a Structure value and Color value of 1, remnants were left of the original elements (not ruminants, heh-heh...).

A With the Patch tool set to Content-Aware, we selected the elements to be removed.

B Next, we dragged the selection to an area that looked similar to the one around the elements being removed.

D At a Structure value of 2 and a Color value of 7, the replacement pixels make a cleaner, more believable match.

In Photoshop, just as in photography, you can use focusing techniques to enhance a scene, such as a shallow depth of field to differentiate a subject from its background or blurriness to convey a sense of motion. And you can use sharpening methods to counteract the effects of resampling, to remedy blurring from camera shake, or to prepare a file for output.

In this chapter, you'll blur areas of an image using the Field Blur, Iris Blur, Tilt-Shift, Path Blur, and Spin Blur filters (collectively called the Blur Gallery). And you will apply sharpening via the Smart Sharpen, Unsharp Mask, and Shake Reduction filters, and via the Sharpen tool.

Note: For lens corrections, we recommend using the Lens Correction tab in Camera Raw (instead of the Lens Correction filter in Photoshop), either before you open your photo into Photoshop, or by way of Filter > Camera Raw Filter in Photoshop. See pages 80–83.

Applying a filter in the Blur Gallery

The Field Blur, Iris Blur, Tilt-Shift, Path Blur, ★ and Spin Blur ★ filters provide powerful and flexible on-canvas and panel controls for blurring parts of an image.

Note: To apply filters in the Blur Gallery, Use Graphics Processor must be checked in Edit/Photoshop > Preferences > Performance. You will see a more accurate preview while making on-canvas adjustments if your system has a graphics card with 1 GB or more of VRAM or an embedded HD graphics processing unit.

To apply a filter in the Blur Gallery: ★

- Open an image (preferably one that is all or mostly in focus). To keep the filter settings nondestructive and editable, convert a duplicate of an image layer or the Background to a Smart Object.
 - Optional: To mask the filter effect partially, create a selection. The selection area will appear in the Smart Filters mask when you exit the gallery.
- 2. Choose Filter > Blur Gallery > Field Blur to produce multiple blur areas, Iris Blur to blur areas around a focus ellipse, Tilt-Shift to apply blurring in straight bands across portions of the image, or Spin Blur to create an effect of radial motion within a circular area. To apply the Path Blur filter, see pages 330–331.
- 3. A default pin with controls appears in the image, and panels with option settings appear in a dock on the

RETO(USING

16

IN THIS CHAPTER

Applying a filter in the Blur Gallery32
Applying the Smart Sharpen filter 33
Applying the Unsharp Mask filter 33
Applying the Shake Reduction filter33
Using the Sharpen tool

Continued on the following page

right. On the Options bar, make sure Preview is checked (P).

To control the degree of blurring for a Field, Iris, or Tilt-Shift blur, either adjust the **Blur** slider in the dock; or in the image, drag around the blur ring that surrounds the pin (add more black to the ring to reduce the blur, or reduce black to increase the blur).

4. For a Field Blur, add another pin by clicking in the image. Set the Blur value for one pin to 0% (full focus), then click the other pin and give it a higher Blur value (blurring). To use the full potential of this filter, add more pins, some with a Blur value of 0 and some with a Blur value greater than 0 (A-C, next page).

For an Iris Blur, do any of the following: To adjust the shape of the focus ellipse, drag one of the small outer round handles; to scale the ellipse uniformly, drag its edge; to rotate the ellipse, drag outside one of the small handles (double-arrow pointer); to reposition where the blurring begins, drag one of the feather handles (or to move one feather handle separately, drag it while holding down Alt/Option); to change the ellipse to a rounded rectangle, drag the square Roundness knob outward (A-D, page 328).

For a **Tilt-Shift Blur**, do any of the following: To adjust where the blurring begins, drag either or both of the solid focus lines; to adjust the transition between the in-focus and blurred areas, drag either or both of the dashed feather lines; to rotate the focus area, drag a rotation handle slightly to the left or right (A—C, page 329).

For a **Spin Blur**, do any of the following: To reshape the focus ellipse, drag one of the outer round handles; to scale the ellipse uniformly, drag its edge; to adjust the angle, drag around the blur ring or change the Blur Angle value in the panel; to move the blur, drag anywhere inside the ellipse; or to reposition the rotation point (say, to make it look as if subject was shot at an angle), drag the point with Alt/Option held down). See C-D, page 331.

5. You can also do any of the following optional steps:

To add a pin, click in the image.

To **reposition** a pin, drag its center point. You can move a pin outside the canvas area.

To **delete** a pin, click its center point, then press Backspace/Delete.

To **copy** a pin, drag its center point with Alt-Ctrl/ Option-Cmd held down.

To control the amount of focus within the currently selected ellipse for an Iris Blur, or between the two feather lines for a Tilt-Shift blur, adjust the **Focus** setting on the Options bar.

- **6.** To hide the on-canvas controls to judge the blurring effect, press and hold down H (then release).
- 7. Optional: To brighten the blur highlights to the point that they become abstract, colored orbs, for a Field, Iris, or Tilt-Shift Blur, click a pin, check Bokeh in the Blur Effects panel, then adjust the settings (A—C, page 332).
- 8. Optional: To save the blur mask that Photoshop created for the filter to an alpha channel, check Save Mask to Channels on the Options bar (A-D, page 333). To preview the mask, press and hold down M (then release).
- **9.** To accept your blur filter edits, press Enter/Return or click OK on the Options bar. To edit the blur settings or to mask the results, see pages 360–362.
- ➤ To remove all blur pins from an image, click the Remove All Pins button 2 on the Options bar.
- To switch to a different filter in the Blur Tools panel, uncheck the box for the current filter, then expand the category for the desired one.
- To the same Smart Object, you can also apply nonblur filters. We don't recommend applying multiple Blur Gallery filters to an image (except possibly to add a small Field Blur ring to a sharp area), as doing so is likely to blur the whole photo.

USING A SELECTION WITH A BLUR FILTER

- ➤ If you create a selection before applying a Blur Gallery filter to a Smart Object, the selection area will appear as the white area in the editable mask for the Smart Filter. If desired, you can click the mask thumbnail on the Layers panel, then feather the edge of the mask via the Properties panel (Mask options).
- ➤ If you create a selection before displaying the Blur Gallery controls for a standard layer (not a Smart Object), you can control how gradually the blurring bleeds to the edge of the selection via the Selection Bleed slider on the Options bar.

A This is the original image.

THE FIELD BLUR FILTER

Use the Field Blur filter when you need the most flexibility and control in blurring specific areas of an image (such as the hair, arms, and background in the photo on this page), while keeping other, more important, areas in sharp focus. Use as many pins as you like, but be sure to place a few pins with a Blur value of 0% in areas that you want to keep in focus, and place other pins with a Blur value between 5% and 100% in areas that you want to blur (the blurring occurs between the high and low values). A-C You can reposition any pin individually by dragging it in the image. This is one of our favorite features of Photoshop!

B We applied the Field Blur filter using a Blur value of 0% for the pins on the woman's face and hands to keep those areas in focus, and Blur values above 10% for all the other pins.

C This is the result.

THE IRIS BLUR FILTER

The Iris Blur filter applies blurring around a focus ellipse. You can use just a single pin or click in the image to create additional ones. A—D

A This is the original image.

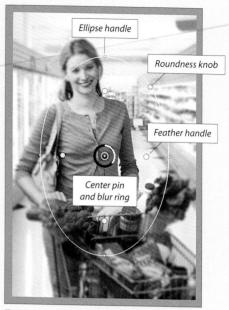

B When we chose the Iris Blur filter, the default on-canvas controls displayed.

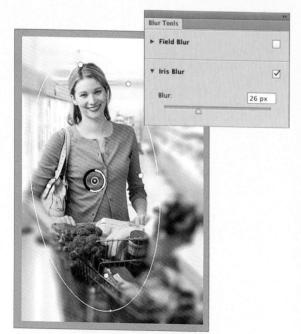

C We moved the ellipse slightly to the left by dragging the pin, elongated the ellipse, rotated it slightly to match the angle of the figure, then held down Alt/Option and dragged just the top feather handle upward to keep the woman's face in full focus.

D In the final image, the figure and part of the shopping cart are in focus, while the background is blurred.

THE TILT-SHIFT FILTER

The Tilt-Shift filter applies blurring in two straight bands across the image, while keeping a band in the center in focus. You can control the width of the blurred area by dragging either or both of the focus lines, adjust the amount of feathering by dragging either or both of the feather lines, or shift the whole widget to a new angle by dragging a rotation handle slightly. A-C You can also choose a negative Distortion value to distort a blurred area along imaginary lines that curve around the pin, or a positive value to distort a blurred area along lines that radiate outward from the pin. Additionally, you can check Symmetric Distortion to apply the distortion in both sides.

A This is the original image.

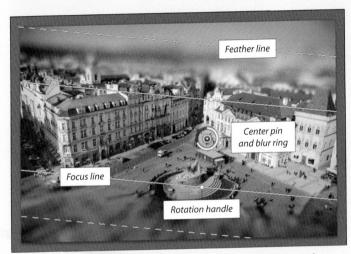

B We chose the Tilt-Shift filter settings shown at right, rotated the pin, and dragged the feather and focus lines.

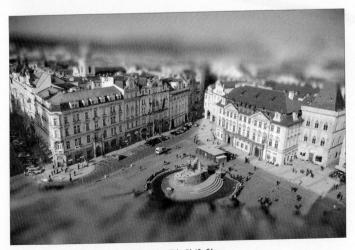

This is the result of our applying the Tilt-Shift filter.

TILT-SHIFT IN PHOTOGRAPHY

When a small- or medium-format camera is outfitted with a special tilt-shift lens, that lens can be tilted slightly toward a landscape so as to capture the whole scene in focus. This tilt feature can also be used with selective focusing to make the foreground and background more blurry than the midground (an intentional change from what is expected), with the result that the landscape looks miniaturized.

The shift feature of a lens sets the image plane so it is parallel to the subject, thereby preventing buildings or other objects that have parallel planes from converging. This feature can also be used to heighten that convergence deliberately.

The Path Blur filter applies a motion blurring effect to a path. You can edit the path to control the shape of the blur, say, to mimic the result of camera movement.

To apply the Path Blur filter: *

- 1. On the Layers panel, click a Smart Object.
- 2. Choose Filter > Blur Gallery > Path Blur, A blue path appears on the image. The arrow on the path indicates the direction of motion.
- 3. After doing any of the following, you can press and hold down H to hide the on-canvas controls:

To change the **length** or **angle** of the path, drag either endpoint.

To produce a curve, drag the center point or a straight segment.A

To add more curve points, drag a segment.

To convert a curve point to a corner point, or to convert a corner point to a curve point, hold down Alt/Option and click it.

To produce another (straight) path, drag in the image. B Or to produce a path that has multiple segments, hold down Alt/Option and click several times, then to end the path, press Enter/Return or Esc, or click the last point you created. To produce multiple curve segments, click without Alt/Option.

To control the speed of the blur, adjust the Speed value in the panel. To control how gradually the blur fades, use the **Taper** slider. These settings affect all Path Blurs in the image (A, next page).

Check Centered Blur for a more uniform. anchored blur; or uncheck this option for a more malleable blur, and to let imagery move more fluidly as you drag paths or blur shapes.

To move a path, hold down Ctrl/Cmd and drag it. You can also move the midpoint along the length of a path (you can't delete the midpoint).

To delete a point or path, click it, then press Backspace/Delete.

To further manipulate a blur shape, click an endpoint, check Edit Blur Shapes in the panel, then drag the white dot at the end of the red guide to rotate just that guide.

To change the blur speed, raise the End Point Speed value on the panel; or with Edit Blur Shapes checked in the panel, drag the end of the red guide to lengthen or shorten it.

To remove the blur from a blue endpoint, hold down Ctrl/Cmd and click the endpoint; or click the endpoint, then set the End Point Speed value in the panel to 0 (zero) (B, next page). The red guide disappears and the endpoint becomes gray.

- 4. Keep High Quality checked to help prevent the blur from looking jagged.
- 5. Follow steps 8-9 on page 326.

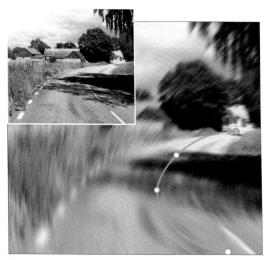

A To create an illusion of fast motion, we repositioned the two endpoints on the blue path for a Path Blur, then dragged to curve the path to match the road. To minimize blurring at the end of the road, we set the right endpoint to an End Point Speed of 0%. (The original image is shown in the inset.)

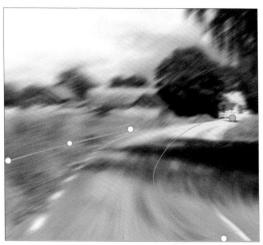

B To straighten the blurring on the left side of the road, we dragged to create a new, straight path.

A We chose these Speed and Taper settings for all of our Path Blur paths.

B To eliminate blurring from the background, we dragged to create another Path Blur, then set the End Point Speed for both endpoints on that path to 0 px.

THE SPIN BLUR FILTER

After choosing the Spin Blur filter, roll over the image to make the on-image controls appear. C-D

We chose the Spin Blur filter, set the Blur Angle to 15°, and enlarged the focus ring by dragging its edge. (The original image is shown in the inset.)

ADDING A STROBE-AND-FLASH EFFECT

To add a strobe effect to a Path or Spin Blur, use these options in the Motion Blur Effects tab:

- Strobe Strength controls how much blur is visible between flash exposures. The higher the strength, the stronger the strobe effect.
- Strobe Flashes controls the number of exposures in the image (positions where a blurred shape is captured).
- Strobe Flash Duration (for a Spin Blur only) controls the amount of rotation that is captured in each strobe flash. The shorter the duration, the more distinct the shapes in the blur.

After exiting the Blur Gallery, we clicked the Smart Filters mask thumbnail, then applied brush strokes to the bike frame and foot to mask the Spin Blur filter effect from those areas.

A This is the original image.

B We created multiple pins for the Field Blur filter, checked Bokeh, increased the Light Bokeh value to brighten the bokeh, increased the Bokeh Color to intensify the color saturation, and moved the Light Range sliders near each other at the right end of the bar to limit the effect to the image highlights.

WHAT IS BOKEH?

The word bokeh (pronounced "BOH-kay") is derived from a Japanese word meaning blur or haze. In photography, the term is used to describe a pattern that is formed by highlights and shadows in blurred areas. Some camera lenses produce more pleasing bokeh than others (good bokeh, bad bokeh).

USING THE BOKEH OPTIONS IN THE **BLUR GALLERY**

To achieve good results from the Bokeh feature in the Blur Gallery, you may need to experiment with various images and settings (it took us a number of tries).

The bokeh will be more pronounced in some areas of an image than in others; you will see this if you drag a pin to a different part of the image. Also, if you change the Blur value for a pin, the size of the bokeh is also affected.

- To control the brightness of the bokeh, adjust the Light Bokeh value. A-C
- To control the amount of color variation in the bokeh, adjust the Bokeh Color value.
- To control the range of brightness values in which the bokeh can appear, drag the Light Range sliders. For smaller bokeh spots, position the sliders near each other at either end of the bar.
- For higher-quality bokeh (but slower rendering), check High Quality on the Options bar.

This is the final image.

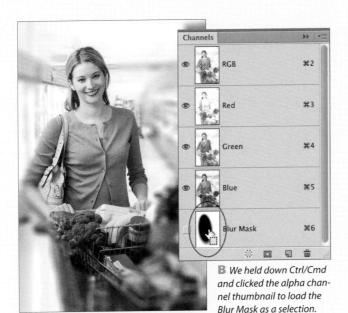

A When we applied the Iris Blur filter to this image, we checked Save Mask to Channel.

USING THE MASK FROM A BLUR GALLERY FILTER

As we stated in step 8 on page 326, while applying a filter in the Blur Gallery, you can save the blur mask to an alpha channel by clicking Save Mask to Channels on the Options bar. After accepting the filter, save your file.

To use the mask in your document, before applying an image edit (such as an adjustment layer, artistic filter, or brush strokes), hold down Ctrl/Cmd and click the alpha channel thumbnail on the Channels panel to load the mask as a selection. It will protect the nonblurred areas of the layer.A-D

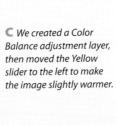

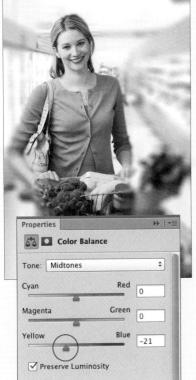

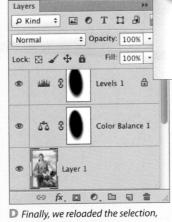

then used a Levels adjustment to lighten the image. The mask on each adjustment layer is hiding the adjustment from the center of the image.

Applying the Smart Sharpen filter

Most digital photos need to be sharpened, and the need increases if you change a file's dimensions or resolution with the Resample Image option checked, convert a file to CMYK Color mode, or apply a transformation command.

To sharpen an image, you can use either the Smart Sharpen filter or the Unsharp Mask filter (the latter, despite its name, has a sharpening effect; see pages 337-338). Be aware that these filters can introduce noise, and therefore should be applied as a final step before output, after all image editing is completed.

High-resolution commercial printing also causes some minor blurring due to dot gain. You can anticipate and compensate for this by sharpening the image again as you prepare it for output. With practice, you will learn how much sharpening is needed.

The Smart Sharpen filter has several unique features that you won't find in the Unsharp Mask dialog (see the sidebar below), but both are powerful commands. We typically use the Smart Sharpen filter for targeted sharpening, as it helps to minimize noise in soft, lowcontrast areas, among other benefits, and use the Unsharp Mask filter for output sharpening. Regardless of which command you use, be sure to sharpen, period!

To apply the Smart Sharpen filter:

- 1. Open a photo that needs sharpening. A To protect the original layer, on the Layers panel, click an image layer or the Background, then press Ctrl-J/ Cmd-J to duplicate it. Right-click the duplicate layer and choose Convert to Smart Object.
- 2. Choose Filter > Sharpen > Smart Sharpen. The Smart Sharpen dialog opens. The dialog is resizable.
 - Set the zoom level for the preview to 100%. To bring a different area of the image into view, either drag in the preview or click in the document. On the menu in the dialog, a make sure Use Legacy is unchecked.
- 3. From the Preset menu, choose **Default**.
- 4. Lower the Reduce Noise slider to around 5% to view the full sharpening effect.
- 5. Choose an Amount value for the strength of the sharpening (for a 300 ppi document, set this value to 250–350%). Increase the Radius value until halo effects display along sharp edges, then reduce it just enough to remove the halos. Don't worry if the image now looks too sharp (\mathbb{A} , next page).
- 6. From the Remove menu, choose an algorithm for the correction: Gaussian Blur is a good

SMART FEATURES OF THE SMART SHARPEN FILTER

- ➤ It lets you sharpen (then fade the sharpening) separately in the shadow and highlight areas of an image.
- ➤ It detects edges, and therefore produces fewer color halos than Unsharp Mask.
- ➤ With its Reduce Noise option, the filter sharpens edges without sharpening noise.
- Smart Sharpen lets you choose from three algorithms (to correct Gaussian blur, lens blur, or motion blur), whereas Unsharp Mask corrects only Gaussian blur.
- Smart Sharpen lets you save and reuse your settings, for greater speed and consistency in your workflow.

A We'll use the Smart Sharpen filter to sharpen specific tonal areas in this blurry portrait (the resolution of this image is 300 ppi).

	☑ Preview		
Preset:	Custom		*
Amount:	<u> </u>	330	%
Radius:	6	2.8	рх
Reduce Noise:	8	5	%
Remove:	Gaussian Blur 💠)	

A The settings we chose in the Smart Sharpen dialog successfully sharpened the key details, such as the eyes and lips, but in the process also oversharpened the skin (now the pores look too pronounced). Note that we chose Remove: Gaussian Blur because we used that filter to soften this photo originally.

all-purpose choice; Lens Blur sharpens details with fewer resulting halos (we prefer this option); Motion Blur is useful for correcting blurring due to slight movement of the camera or subject, but to use this option effectively, you need to enter the correct angle of movement.

- 7. Increase the Reduce Noise value to lessen the amount of noise that is produced by the sharpening. Keep this value between 10% and 20% so image details aren't softened too much.
- 8. Expand the Shadows/Highlights category. To reduce the amount of sharpening in the shadow areas, drag in the preview to display an area of the image that contains both shadows and midtones, then under Shadows, make these adjustments: B Choose a Radius value (between 10 and 25) to control how many neighboring pixels will be compared to each adjusted pixel. The higher the Radius, the larger the area that Photoshop uses for comparison.

Move the Fade Amount slider until you see the desired reduction of oversharpening in the shadows.

Choose a Tonal Width value to control the range of midtones that are affected by the Fade Amount.

	✓ Preview		1
Preset:	Custom		‡
Amount:	0	330	%
Radius:	- 0	2.8	рх
Reduce Noise:		10	%
Remove:	Gaussian Blur 💠 0		• (
	Add The Control of th		
	e de la companya de l		
	A	52]%
▼ Shadows	0	52]%]%

B Under Shadows, we chose a moderate Fade Amount to soften the sharpening and noise in the shadows (such as in the area between the woman's face and hands), and we chose a moderate Tonal Width value to sharpen the shadows fully and the midtones only partially (to keep the midtones looking smooth).

Continued on the following page

The higher the Tonal Width, the wider the range of midtones that are affected, and the more gradually the sharpening fades into the shadows. At a low value (5–20%) only very dark shadow areas will be sharpened.

- 9. To reduce the amount of sharpening in the highlight areas, drag the image in the preview to display an area that contains both highlights and midtones, then under Highlights, A adjust the Radius, Fade Amount, and Tonal Width values (in that order), as you did in the preceding step.
- 10. To compare the unsharpened and sharpened versions of the image, press on the dialog preview, then release. Hopefully, the image details are sufficiently sharp. If the overall image looks too sharp, either reduce the uppermost Radius value slightly or raise the Reduce Noise value slightly.
- 11. Optional: To save the current settings as a preset, choose Save Preset from the Preset menu, enter a name, then click Save. Saved presets are available on the Preset menu for any image.

12. Click OK.B-C

To modify the Smart Sharpen results, double-click the Smart Sharpen listing for the Smart Object.

		personnen	
Amount:	۵	330	%
Radius:	<u> </u>	2.8	рх
Reduce Noise:		10	%
Remove:	Gaussian Blur 💠 🛛 0		
₹ Shadows			
Fade Amount:	△	52	%
Tonal Width:	<u> </u>	50	%
Radius:	6	16	рх
Highlights			
Fade Amount:	<u> </u>	52	%
Tonal Width:	0	58	%
Radius:		20	рх

A Finally, under Highlights, we chose a moderate Fade Amount to soften the sharpening in the highlights, and a higher Tonal Width value to extend the softened sharpening into the midtones (the broad, flat areas, such as the forehead, cheeks, and chin).

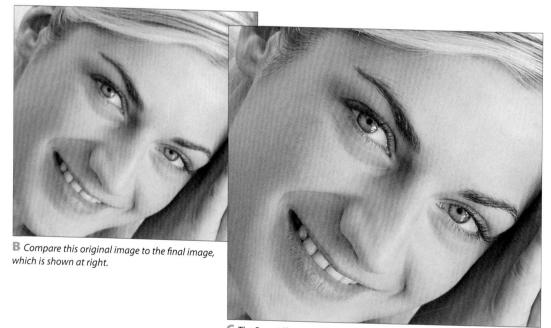

lacksquare The Smart Sharpen filter improved the clarity of the facial features without applying unflattering sharpening to the cheeks and forehead.

Applying the Unsharp Mask filter

In order to do its job of sharpening, the Unsharp Mask filter increases the contrast between adjacent pixels. To control the level of contrast, you will choose settings for three variables: Amount, Radius, and Threshold.

To apply the Unsharp Mask filter:

- 1. Choose a zoom level of 50–100% for your image.
- 2. Duplicate an image layer (Ctrl-J/Cmd-J), A then right-click the duplicate layer and choose Convert to Smart Object.
- 3. With the Smart Object layer selected, choose Filter > Sharpen > Unsharp Mask.
- 4. In the dialog, choose an Amount percentage to control how much the contrast will be increased. For some recommended settings, see the sidebar on this page.
 - Press P to toggle the Preview off, then on, to compare the original and sharpened images. To bring a different area of the image into view, drag in the preview or click in the document.
- 5. The Radius setting controls how many neighboring pixels around high-contrast edges the filter affects. When setting a value, consider the pixel count of the image and its subject matter. The higher the pixel count, the higher the Radius value needed. For a low-contrast image that contains large, simple objects and smooth transitions, try a high Radius of 2; for an intricate, high-contrast image that contains many sharp transitions, try a lower Radius of around 1.

Continued on the following page

SUGGESTED SETTINGS FOR UNSHARP MASK

For an image that is 2000 x 3000 pixels or larger, try using these values:

Soft-edged subjects, such as landscapes	Amount 100–150%, Radius 1–1.5, Threshold 6–10
Portraits	Amount 100–120%, Radius 1–2, Threshold 4–6, or to the point that skin areas begin to look smoother
Buildings, objects, etc., for which contrast is a priority	Amount 150–200% or higher, Radius 1.5–3, Threshold 0–3

A This original 300 ppi image is slightly blurry.

B A high Amount value and a low Radius value for the Unsharp Mask filter barely sharpened the image.

lacksquare A high Radius value of 4.0, on the other hand, produced ugly halos around the numerals on the ruler and on the blue lines of the graph paper.

- Note: The Amount and Radius settings are interdependent, meaning that if you raise the Radius, you'll need to lower the Amount, and vice versa.
- 6. Choose a Threshold value to establish how different in value an area of pixels must be from an adjacent area for it to be affected by the filter. A Start with a Threshold value of 0 (to sharpen the entire image), then increase it gradually. At a Threshold of 5-10, high-contrast areas will be sharpened and areas of lesser contrast will be sharpened much less. When increasing the Threshold, you can also increase the Amount and Radius to sharpen edges.
- A proper Threshold setting will prevent the filter from oversharpening low-contrast areas.
- 7. Click OK. B To adjust the filter settings at any time, double-click the Unsharp Mask listing on the Layers panel.
- If the sharpening produced color halos along the edges of some of the objects, choose Luminosity as the blending mode for the Smart Object. This mode will limit the sharpening to just the luminosity (light and dark) values and remove it from the hue and saturation (color) values.

🗛 At a high Threshold value of 12, the Unsharp Mask filter sharpened only the high-contrast edges. The lower-contrast (light blue) lines on the graph paper remained blurry.

₿ A low Threshold value of 0–1 worked better for this image because it contains a lot of flat surfaces, hard edges, and fine lines.

Applying the Shake Reduction filter

The Shake Reduction filter detects, then resharpens, edges in a photo that were blurred due to slight shaking of the camera. The filter produces better quality results on indoor shots of a static subject taken in good natural lighting with a slow shutter speed and no flash, or on indoor or outdoor photos taken with a long focal length. The photos should contain few bright highlights and minimal noise.

Improvements to the Shake Reduction filter include a new check box that disables or enables Artifact Suppression, as well as controls for adjusting the length or direction of a blur trace path. You can compare and adjust the Smoothing and Suppression settings for any pair of blur trace regions via sliders in a loupe. The dialog preview provides support for retina displays, and the preview on large monitors is also improved.

To apply the Shake Reduction filter:

Part 1 — Choose basic settings

- 1. Do either of the following:
 - For the best results, open a raw photo into Camera Raw; correct for noise; apply minimal exposure adjustments, if necessary; then hold down Shift and click Open Object. A
 - Open an RGB photo into Photoshop. Duplicate the photo layer (Ctrl-J/Cmd-J), then right-click the duplicate layer and choose Convert to Smart Object from the context menu.
- 2. Choose Filter > Sharpen > Shake Reduction. To let the filter evaluate the amount of noise in the image, keep the Source Noise menu set to Auto.
- 3. An area of the photo in which the filter detects blurred edges displays in a loupe (enlarged detail). B If the loupe is docked and you want to float it over the image, click the Undock Detail button [2] (Q) in the Detail area; or if the loupe is floating and you want to dock it in the panel, click its close (X) button. It works the same in both locations.
- 4. You can change the area that the filter evaluates for the correction. If the loupe is floating, drag it to a new location; if the loupe is docked, drag within it. Or choose the Blur Estimation tool (E), then click another area of the image. To optimize the filter results based on the new area, click the **Enhance At Loupe Location** button in the lower-left corner of the loupe. The blur and

- ahosting correction will render first within the loupe, then in the overall preview.
- 5. To try out a few Blur Trace Bounds values, drag the slider to the lower portion of its range, then release to preview the results; next, drag the slider to the middle portion of its range, then release to preview; and finally, do the same for the upper portion of its range (A, next page). Set the slider to the value that produced the best results.
- 6. If you're satisfied with the filter results, click OK. If not, continue with Parts 2 through 7...
- To compare the sharpened and unsharpened versions of the image, press P, then press P again. You can also press and hold on the loupe, then release.

Continued on the following page

A This original photo is blurred due to camera movement.

The Shake Reduction filter chose a location for the loupe.

Part 2 — Reduce edge noise 🖈

- 1. Check Artifact Suppression; the Artifact Suppression slider appears. To eliminate noise artifacts in low- and medium-contrast areas of the image, set the slider to a medium value (30-50%). (If you leave Artifact Suppression off, the image may look sharper, but will also contain more artifacts.)
- 2. The Smoothing option reduces noise in an image, but in so doing also makes the image look less sharp. With artifacts now remedied by Artifact Suppression, we suggest that you reduce the Smoothing value until noise begins to reappear. The lower Smoothing value will make the edges look sharper.
- 3. If you're satisfied with the results, click OK. If not, continue with Part 3, below.

In its standard mode, the Shake Reduction filter analyzes just one region. To enable it to analyze more than one region, follow these steps.

Part 3 — Create multiple blur trace regions

- 1. If the Advanced area isn't expanded, click the arrowhead. Click the Add Suggested Blur Trace button +...: to add a new blur estimation region.B Another thumbnail appears in the side panel.
- 2. If you need to reposition the estimation region, drag the pin in its center. If you need to resize the region, drag any handle.
- 3. To designate the region the filter will use to optimize the sharpening, check the box under one or both thumbnails. If you check both boxes, the filter will optimize the sharpening for each region, then apply a combination of those settings to other areas of the image (A, next page).
 - To remove a blur estimation region, click its thumbnail, then press Backspace/Delete; or right-click the thumbnail or its pin in the preview, and choose Delete Blur Trace from the context menu.

Part 4 — Create and adjust a blur trace path 🖈

1. Zoom to around 200–300% in an area that shows ghosting from camera shake. Choose the Blur Direction tool (R), then drag a very short distance from the ghosted edge to the spot where you want it to be relocated. Another blur trace thumbnail appears in the side panel. Check Preview.

A We tried out low-, mid-, and high-range Blur Trace Bounds values before deciding on a high value of 132 px.

B When we clicked the Add Suggested Blur Trace button, the estimation region created by the filter straddled the edge of the picture frame and produced more ghosting.

To prevent the high-contrast edges of the picture frame from being analyzed, we sized the blur estimation region to fit the oil painting. By manually designating the region to be analyzed, we obtained better results.

- If you want to select (and then adjust) an existing path that you drew with the Blur Direction tool, in the Advanced area, click a blur trace thumbnail (a thumbnail that has a padlock icon), then make sure the box below the thumbnail is checked.
- 2. Under Blur Trace Settings, B move the Blur Trace Length slider to adjust the length of the path (to match the distance that edges in the photo were moved, and therefore blurred, by the camera shake). If needed, also rotate the Blur Trace Direction dial to adjust the angle of the path.
 - Remember, if you want to compare the sharpened and unsharpened versions of the image at any time, press P (then press P again).
- 3. Click OK to apply the filter settings and exit the dialog, or continue with another part of this task.

Part 5 — Compare and adjust blur trace settings in a loupe *

- 1. If you haven't already done so, create two or more blur estimation regions in the preview either by clicking the Add Suggested Blur Trace button, +... or by dragging twice in the preview with the **Blur Estimation** tool \square (E). Adjust the blur trace settings for each region.
- 2. In the Advanced area, hold down Ctrl/Cmd and click two blur trace thumbnails for which you want to compare and adjust settings. The results of the current settings for the selected thumbnails will display side by side in a large loupe.
- 3. Adjust the Smoothing and [Artifact] Suppression sliders in either or both panels of the loupe.

- 4. Optional: To compare and adjust the tracing results while viewing a different part of the image, drag in either panel of the loupe.
- 5. To close the loupe, click the close box (X) in its upper-left corner or press Esc.

Continued on the following page

A To produce a combined sharpening result, we checked both thumbnails in the Advanced area. The white shapes in the thumbnails indicate the shape and direction of a blur that was caused by camera shake.

B Using the controls under Blur Trace Settings, you can customize any user-created blur trace path.

🕻 We held down Ctrl/Cmd and clicked two blur trace thumbnails: The adjustment results for the two regions displayed side by side in a large loupe.

Part 6 — Save your Shake Reduction settings for future use ★

- From the Advanced menu In the Shake
 Reduction dialog, choose Save Workspace to
 save the current estimation regions, blur trace
 thumbnails, and slider settings; or choose Save
 Blur Trace to save just the currently selected blur
 trace thumbnail and its settings. A
- 2. In the Save Workspace or Save Blur Trace dialog, enter a file name (keep the default extension), choose a location, then click Save.
 - To access a saved Shake Reduction workspace or saved blur trace settings at any time, choose Load from the Advanced menu, locate the saved workspace or blur trace file, then click Open.
 - To restore the default settings to the dialog at any time, hold down Alt/Option and click Reset (Cancel becomes Reset).

Part 7 — Exit the Shake Reduction dialog
When you're satisfied with the filter results,
click OK.

Using the Sharpen tool

When used with the Protect Detail option checked on the Options bar, the Sharpen tool enhances details without introducing noticeable artifacts. With this tool, you can sharpen areas selectively without having to use a mask.

To use the Sharpen tool:

- 1. Create a new, blank layer to contain the sharpened pixels, and keep it selected. B
- **2.** Choose the **Sharpen** tool \triangle (it's on the same fly-out menu as the Blur tool).
- 3. On the Options bar, choose a **Strength** value, and check **Sample All Layers** and **Protect Detail**.
- Press [or] to adjust the brush diameter, then drag across the areas that need sharpening.
 For stronger sharpening, drag again in the same area.
- **5.** *Optional:* To reduce the overall effect of the sharpening, lower the opacity of the new layer.

A Via the menu in the Advanced area of the Shake Reduction dialog, you can save and load your custom settings.

The eyes in this photo look too soft.

With the Sharpen tool, we quickly sharpened just the eyes.

Now that you're familiar with many of the basic controls in Photoshop, it's time to learn some fun ways to manipulate the content of

your layers. In this chapter, you will learn how to clip (hide the visibility of) multiple layers using a mask, blend pixels between layers using advanced controls, apply transformation commands to a layer (including normal and Content-Aware scaling), apply the Liquify filter, and apply the Warp command.

Note: For faster previewing of your Liquify, Warp, and transform edits, make sure Use Graphics Processor is checked in Edit/Photoshop > Preferences > Performance before opening your file.

Using clipping masks

When layers are put into a clipping mask, the content of the bottommost layer, called the "base" layer, clips (limits which areas are visible on) the layers above it. The mode and opacity of the base layer are also applied to the clipped layers. Layers in a clipping mask remain fully editable and can be repositioned individually.

To create a clipping mask:

- On the Layers panel, make sure the layers to be clipped are listed consecutively. The base layer can be a type, image, or shape layer or a Smart Object; stack it below the layers to be clipped. A
- 2. Do either of the following:

Click a layer to be clipped, or Shift-click multiple layers to be clipped (not the base layer) (**A**, next page), then press Ctrl-Alt-G/Cmd-Option-G (**B**-**C**, next page).

Continued on the following page

A This document contains five layers (including an editable type layer that is currently hidden behind the image layers).

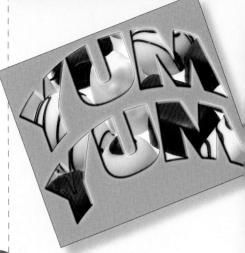

17

IN THIS CHAPTER

Using clipping masks	343
Blending layers	345
Applying transformations	348
Applying Content-Aware scaling	350
Using the Liquify filter	352
Applying the Warp command	356

YUM YUM

To create the image shown above, we used a type layer to clip an image layer (see this page and the next page), warped the type (see page 356), and applied the Emboss, Stroke, and Outer Glow effects (see Chapter 20). We duplicated the type and image layers, moved the duplicate type layer downward, then added a Pattern Fill layer just above the Background.

To clip one layer at a time, Alt-click/Option-click the line between two layers (pointer), or right-click one of the layers to be clipped (not the base layer) and choose Create Clipping Mask.

- 3. Optional: To include more layers in the mask, either restack them between existing layers in the mask or repeat the preceding step.
- 4. Optional: You can reposition one or more selected layers in the clipping mask with the Move tool (V). To link two or more clipped layers so they can be moved more easily as a unit, select their listings, then click the Link Layers button. Click the listing for one of the linked layers, then with the Move tool, drag in the document. D To unlink the layers, select them, then click the Link Layers button.
- To use grouped layers in a clipping mask, all the layers (including the base layer) must be in the group.

When you release a layer from a clipping mask, any and all of the masked layers above it are also released.

To release one or more layers from a clipping mask:

- Do either of the following:
- Alt-click/Option-click the line below the layer to be released.
- Click a layer to be released (not the base layer), then press Ctrl-Alt-G/Cmd-Option-G.

To release an entire clipping mask:

- Alt-click/Option-click the line above the base layer. Click the layer directly above the base layer, then press Ctrl-Alt-G/Cmd-Option-G.
- To merge clipped layers, see pages 164–165.

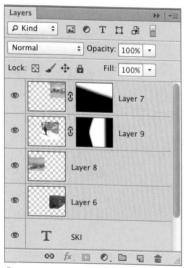

B ... then pressed Ctrl-Alt-G/ Cmd-Option-G to put them in a clipping group. The base layer name has an underline; the clipped layers are indented.

The type (base) layer is clipping the four image layers (it's a "ski mask," ha-ha).

We selected and moved the clipped image layers to the left with the Move tool, while the base layer stayed put.

Blending layers

In these steps, you'll edit a duplicate image layer, then blend the original and duplicate layers via the opacity and blending mode controls on the Layers panel. You can use this method to soften the effect of a filter or other image edits or simply to see how various blending modes or opacity settings affect your document.

To blend a duplicate, edited layer with the original one:

- 1. On the Layers panel, click an image layer, then press Ctrl-J/Cmd-J to duplicate it.
- 2. Apply some creative edits to the duplicate layer, such as some brush strokes or a filter or two from the Filter menu (to learn about the Filter Gallery, see pages 358-359).
 - Note: If you want to apply a filter as an editable Smart Filter (see page 360), right-click the duplicate image layer and choose Convert to Smart Object before going to the Filter menu.
- 3. Keep the duplicate layer or Smart Object selected, then on the Layers panel, do either or both of the following:

Choose a different blending mode. Or if you want to cycle through the blending modes, press Shift -- or Shift-+.

Lower the layer Opacity percentage to make the layer semitransparent.B-C

B We chose Lighten mode for Layer 1 and lowered the layer Opacity to 84%.

A We duplicated the Background in this image, converted the duplicate layer to a Smart Object, then applied the Distort > Ocean Ripple filter (Filter Gallery).

C The final image combines characteristics of the original Background and the filtered Smart Object.

The Advanced Blending options in the Layer Style dialog let you control how a layer blends with underlying layers. Here we focus on the Blend If sliders.

To choose blending options for a layer:

- Double-click next to the name of a layer or layer group on the Layers panel. A—B
- The Layer Style dialog opens (Blending Options should be selected in the upper left). Check Preview.

The first three controls — Blend Mode, Opacity, and Fill Opacity — are the same as on the Layers panel. (The Fill Opacity changes the layer opacity without altering the opacity of any layer effects. To learn about layer effects, see Chapter 20.)

3. Use the **Blend** If sliders to control which pixels in the current layer stay visible and which pixels from the underlying layer show through the current layer:

Move the black **This Layer** slider to the right to drop out shadow areas from the current layer.

A We opened a photo of a surface texture, then created some editable type in a dark color.

B We double-clicked the type layer name to open the Layer Style dialog.

Move the white This Layer slider to the left to drop out highlight areas from the current layer.

Move the black **Underlying Layer** slider to the right to reveal shadow areas from the underlying layer.A

Move the white **Underlying Layer** slider to the left to reveal highlight areas from the underlying layer.

To adjust midtone colors separately from the lightest and darkest colors, Alt-drag/Option-drag a slider (it will divide into two sections), then drag each half of the slider separately.

- 4. Click OK. On the Layers panel, the layer will have this badge. indicating that the Advanced Blending options currently have nondefault settings.
- To display only layers that contain nondefault Advanced Blending settings, choose Attribute from the Filter Type menu on the Layers panel, and Advanced Blending from the second menu.

Blend If: Gray

This Layer:

Underlying Layer: 136 170

A In the Blend If area of the Layer Style dialog, we dragged the black Underlying Layer slider to the right. Dark colors from the texture layer now show through the type layer.

B To enable midtone colors from the underlying texture layer to show through the type layer, we held down Alt/Option and dragged the Underlying Layer slider to divide it, then dragged each section separately. Now the type looks as if it's been worn away by the elements.

255

Applying transformations

You can apply scale, rotate, skew, distort, and perspective transformations to a layer or layer group, among other things (see the sidebar at right). We'll show you how to apply multiple transformations via the Free Transform command and the Move tool — the methods that we find to be most intuitive.

Note: To help preserve the image quality, if you need to apply multiple transformations, do them consecutively and accept the edits only after the last one, so Photoshop resamples the image data just once.

To apply transformations using the Free Transform command or the Move tool:

- On the Layers panel, click a layer, a layer group, or the Background, or Shift-select multiple layers. A Any layers that are linked to the selected one(s) will also be transformed. Or to transform a path, select it via the Paths panel.
 - To transform the Background, you *must* create a selection, and you also should choose a Background color because Photoshop will fill any exposed areas with that color.
- 2. Optional: If you clicked a single image layer, you can create a selection to limit which area is transformed.
- 3. Do either of the following:
 - Press Ctrl-T/Cmd-T (or choose Edit > Free Transform; or for a path, choose Edit > Free Transform Path).

 Choose the **Move** tool (V), check **Show Transform Controls** on the Options bar, then click any handle on the transform box to display transform features on the Options bar.
- 4. For the Free Transform commands, you can select a resampling method from the Interpolation menu on the Options bar, if available (we pick Bicubic Automatic to let Photoshop use the best method).
- 5. A transform box with handles surrounds the selection, path, or opaque part of the layer. Do one or more of the following:

To scale the item horizontally and vertically, drag a corner handle; to scale it just horizontally or vertically, drag a middle handle; to scale it proportionally, Shift-drag a corner handle; or to scale it from the current reference point (marked by a crosshair in the transform box), Alt-drag/Option-drag a handle (add Shift to scale it proportionally from the reference point).

WHAT CAN I TRANSFORM?

- ➤ You can transform an image, type, or shape layer; a path; a layer group; a Smart Object; or a selection of pixels on an image layer or the Background.
- ➤ You can scale, rotate, or skew an editable type layer. To apply a distortion or perspective transformation to type, you must rasterize the layer first (see page 386).
- ➤ To transform a selection border (not its contents), choose Select > Transform Selection, then follow steps 5–6 in the main task on this page and the next.
- ➤ Read about the Snap Vector Tools and Transforms to Pixel Grid preference on page 405.

USING SMART GUIDES

Check View > Extras and View > Show > Smart Guides. As you apply a transformation, you can snap the edge of the transform box to a Smart Guide, which will display as your pointer nears the edge or middle of the contents of another layer.

A This is the original image.

B We selected the car, then copied it to a new layer. Here we're scaling the new layer.

To rotate it, position the pointer outside the transform box (the pointer becomes a curved, twoheaded arrow), then drag. Shift-drag to constrain the rotation to a multiple of 15°.

To skew it, Ctrl-drag/Cmd-drag a middle handle. Include Shift to constrain the movement.

To distort it, Ctrl-drag/Cmd-drag a corner handle.A-B

To apply perspective, Ctrl-Alt-Shift-drag/Cmd-Option-Shift-drag a corner handle vertically or horizontally; an adjacent corner moves symmetrically. C

- To undo the last handle edit, choose Edit > Undo.
- As you perform a transformation, a dynamic readout listing the dimensions or angle of your edits displays next to the pointer.
- 6. To resume normal editing, you must either accept or cancel the transformation:

To accept the edit(s), double-click inside the bounding box, press Enter/Return, or click the Commit Transform button 🗸 on the Options bar. To cancel the edit(s), press Esc or click the Cancel Transform button.

Before dragging a handle to scale or rotate, you can drag the reference point, from which the layer or selection is transformed, to a new location.

MORE TRANSFORM SHORTCUTS

cate the current layer*

METHOD FDIT Hold down Alt/Option Transform a duplicate and choose Edit > Free of a selected layer* Transform (or Edit > Free Transform Path) Choose Edit > Transform Repeat the last trans-

formation (the repeat (or Edit > Transform Path) > Again or press transformation is added to the last one) Ctrl-Shift-T/Cmd-Shift-T Press Control-Alt-Shift-T/ Repeat the last trans-Cmd-Option-Shift-T formation and dupli-

*When the edit is applied to a path, Photoshop adds the transformed duplicate to the same Path listing.

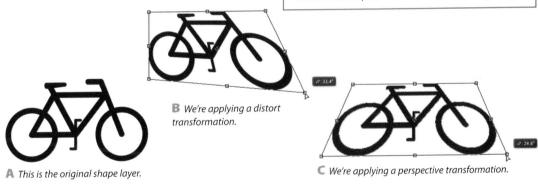

APPLYING TRANSFORMATIONS VIA THE OPTIONS BAR

When you choose the Edit > Free Transform or Free Transform Path command (Ctrl-T/Cmd-T), transform controls become available on the Options bar (you can enter specific values or use the scrubby sliders). If you want to change the reference point from which a transformation occurs, click a square on the reference point locator.

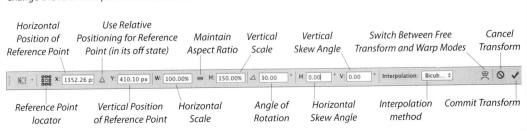

Applying Content-Aware scaling

The standard transform features in Photoshop scale an entire layer uniformly, regardless of the layer content. The Content-Aware Scale command is smarter in that it tries to scale background areas without distorting shapes that have clearly defined borders, such as figures or objects. You can help protect areas from distortion by creating and using an alpha channel.

To apply Content-Aware scaling:

- Duplicate an image layer to be scaled (not a Smart Object), then hide the original layer (A, next page).
- Optional: To minimize distortion in an area of the layer, select that area, then on the Channels panel, click the Save Selection as Channel button.
 Deselect.
- **3.** Choose Edit > Content-Aware Scale (Ctrl-Alt-Shift-C/Cmd-Option-Shift-C).
- 4. On the Options bar, do either of the following:

 If you created an alpha channel (step 2, above),
 select the channel name from the Protect menu.

 If the image contains figures, check the Protect
 Skin Tones button it to help prevent distortion.
 Note that this feature does a better job of recognizing skin than clothing.
- Slowly drag a handle on the bounding box (B, next page), or Shift-drag a corner handle for more proportional scaling.
- **6.** Optional: To permit some normal (non Content-Aware) scaling to occur, set the Amount percentage on the Options bar below 100%. The lower the Amount, the greater the distortion and the less protective the effect of the alpha channel.
- 7. To accept the transformation, press Enter/Return or click the Commit Transform button ✓ on the Options bar (C-D, next page). To cancel the edits, press Esc or click the Cancel Transform button.
- The Content-Aware Scale command can be applied only to a single image layer (not to multiple layers, a Smart Object, or other kinds of layers).
- ➤ To specify the stationary point from which the layer is scaled, click a square on the reference point locator

 (Options bar) before dragging a handle.
- ➤ To scale a layer based on a percentage of its original size, set the W (width) or H (height) percentage on the Options bar. To scale it proportionally, activate the Maintain Aspect Ratio button.

PROTECTING AREAS FROM SCALING

We selected the buildings in this image, then saved the selection as an alpha channel.

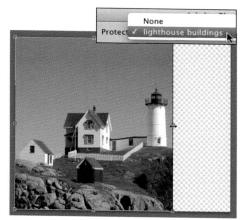

We chose the Content-Aware Scale command, selected the channel name from the Protect menu, then dragged the middle-right handle of the bounding box to the left.

The channel protected the buildings while allowing the rest of the image to be scaled.

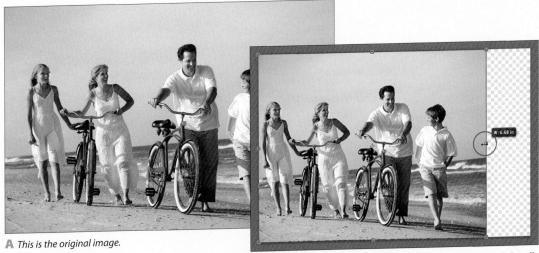

B We chose Edit > Content-Aware, then dragged a side handle to the left.

C The figures scaled less than the surrounding landscape.

D For comparison, we scaled the original image with the Move tool instead of the Content-Aware Scale command. The whole picture looks squashed, including the figures.

Using the Liquify filter

Using the tools in the Liquify dialog, you can reshape any part of an image: Slim a waistline, shrink an oddly shaped area of clothing, twirl part of a landscape — or if you're in the mood, apply bizarre distortion (as in Dr. Spock ears and eyebrows). Note: When using this feature, make sure Use Graphics Processor is checked in Edit/Photoshop > Preferences > Performance before opening your file. Also, in Preferences > General, check Vary Round Brush Hardness Based on HUD Vertical Movement so you will be able to change the brush density interactively (see the tip in step 8; a graphics card with at least 512 MB of memory is required).

To use the distortion tools in Liquify:

- Open an RGB image. A Duplicate the Background, and keep the duplicate layer selected.
 Note: If you want to keep the Liquify results nondestructive and editable, convert the duplicate layer to a Smart Object (Photoshop will save a compressed mesh into the Smart Object). This method increases the file size.
- 2. Optional but recommended: Select the area of the image you want to edit. The rest of the image will be protected from Liquify edits. Other options are to create a layer mask or an alpha channel, to be chosen in the Liquify dialog.
- Choose Filter > Liquify (Ctrl-Shift-X/Cmd-Shift-X). In the dialog, check Advanced Mode. If necessary, zoom in on the area to be reshaped.
- 4. If you want to protect areas of the image from Liquify edits, do either of the following:
 To apply a mask based on an active selection, or on layer transparency, a layer mask, or an alpha

channel in the document, choose that option from the **Replace Selection** (first) menu under **Mask Options**.

To paint a mask manually or to add to an existing mask, choose the **Freeze Mask** tool **(F)**, choose settings under Tool Options (**(A)**, next page), then draw strokes in the preview (**(B)**, next page).

- You can also use any of these masking controls: Hide or show the mask via the Show Mask check box.
 - To remove areas of the mask, choose the **Thaw Mask** tool (D), then draw strokes in the preview (or hold down Alt/Option while using the Freeze Mask tool). (If you need to remove the whole mask, click None under Mask Options.)

 To reverse the masked and unmasked areas, click **Invert All**
- 6. Choose the Forward Warp, ∠ (W) Twirl Clockwise (C), Pucker (S), Bloat (B), or Push Left (O) tool.
- 7. To size the brush cursor so that it covers the entire width of the area to be edited, press [or], or hold down Alt-right-click/Control-Option and drag horizontally in the image. You can also adjust the brush size via the improved Brush Size slider. The larger the brush, the less choppy the distortion.
- 8. Under Tool Options, do all of the following:

 To control the degree to which the distortion is feathered at the edges, set the Brush Density (the lower the density, the greater the feathering).

B We selected the sky area before opening the Liquify dialog.

Note: If you're using a stylus, check Stylus Pressure and lower the Brush Pressure value.

To control the overall strength of the distortion, set the Brush Pressure.

 To adjust the brush pressure interactively, hold down Alt-right-click/Control-Option and drag vertically in the preview.

To control the speed at which tools that are held down in one spot (e.g., Twirl Clockwise, Pucker, Bloat) produce distortion, choose a Brush Rate.

To prevent the edges of the layer from becoming transparent as you drag pixels, check Pin Edges. *

9. Depending on the chosen tool, do the following: With the Twirl Clockwise, Pucker, or Bloat tool, click and hold on an area. If you want to intensify the effect, repeat the click and hold.

Continued on the following page

CANCEL, DEFAULT, OR RESET

- Click Cancel to exit the Liquify dialog without applying any edits to your document.
- ➤ Hold down Ctrl/Cmd and click Default (Cancel becomes Default) to restore the default Photoshop settings to the dialog.
- ➤ Hold down Alt/Option and click Reset (Cancel becomes Reset) to restore the settings that were in place when you opened the dialog.

A Check Advanced Mode to display and access the full array of Liquify options.

B Our selection appeared as the nonmasked area in the Liquify dialog. With the Freeze Mask tool, we Shiftclicked the top edge of the image to add that area to the mask (in a straight line). With the Forward Warp tool, drag in the image preview.A

With the **Push Left** tool, drag downward to push areas to the right, or drag upward to push areas to the left (see the next page).

- If a tool doesn't seem to be having an effect, increase the brush size. To reverse the tool behavior, hold down Alt/Option while clicking or dragging.
- Each tool retains its own settings.
- 10. Optional: To compare the Liquify layer with any underlying layers, check Show Backdrop. From the Use menu, choose All Layers, and choose an Opacity value for the underlying layers.
- 11. Optional: If you applied Liquify to a Smart Object, the current mesh will save with the document. To save the current mesh (Liquify edits) as a preset for use in any image, click Save Mesh, enter a name, choose a location, keep the extension, then click Save. (To load a saved mesh at any time, click Load Mesh).
- 12. Click OK. If you applied the Liquify filter to a Smart Object and you want to edit the results, doubleclick the Liquify listing on the Layers panel. To reload the last-used mesh onto the current document, click Load Last Mesh in the dialog.
- If you applied the Liquify filter to a Smart Object, you can mask any part of the results by editing the filter mask (see page 362).

There are several ways to restore layer pixels to their pre-Liquify state.

To remove Liquify edits:

In the Liquify dialog, do any of the following:

To undo Liquify edits manually, choose the **Reconstruct** tool (R), set the brush size, then press and hold on an area you want to restore.

To apply subtle smoothing to ripples and other irregularities that were produced by multiple small distortion edits, choose the **Smooth** tool (E), then drag in the preview.

To restore all the Liquify edits to a specified amount, under Reconstruct Options, click Reconstruct. The Revert Reconstruction dialog opens. Set the Amount slider to the desired value, then click OK.

To undo all the Liquify edits completely, under Reconstruct Options, click Restore All.

QUICK ACCESS TO THE LIQUIFY TOOLS

Forward Warp	W	Bloat B
Reconstruct	R	Push Left O
Smooth	Е	Freeze Mask F
Twirl Clockwise	C	Thaw Mask D
Pucker	S	Hand H Zoom Z

A We're using the Forward Warp tool to elongate the top cloud.

USING LIQUIFY FOR RETOUCHING

When used with restraint (e.g., low density and pressure settings), Liquify can be useful for retouching. A-F

A The shirt and pants on this fellow are billowing out in an unflattering way.

B With the Push Left tool, we dragged downward along the left side of the shirt a few times (here the Show Backdrop option is on).

Next, we dragged upward with the same tool (smaller brush size) on the right side of the shirt...

...and along the hip area (here the Show Backdrop option is off).

E With the Pucker tool, we clicked and held the mouse down on the billowy shirt to contract it inward.

F This image contains all of our Liquify edits.

Applying the Warp command

To apply warp edits to a layer:

- Click a type, image, or shape layer, or a Smart Object.
- 2. Choose Edit > Transform > Warp.
- 3. Do either or both of the following:

On the Options bar, choose a preset style from the Warp menu. A-B You can also click the Warp Orientation button 🖾 to toggle horizontal and vertical distortion (not available for all presets), or reshape the grid by using the scrubby sliders for Bend: H (horizontal distortion) or V (vertical distortion).

Choose Warp: Custom on the Options bar (not available for editable type), then drag any of the interior squares, square corner points, grid lines, or direction line handles in the grid. Note: If you don't see the grid, turn on View > Extras.

- 4. To accept the warp edits, press Enter/Return or click the Commit Transform button
 on the Options bar **D** (to cancel the edits, click the Cancel Transform button \circ or press Esc).
- To edit the warp settings for a type layer or a Smart Object, repeat steps 1-4, above. If you want to remove the warp, choose None from

- the Warp menu on the Options bar. The warp settings for a standard image layer can't be edited. To remove warp edits from an image layer, you would have to click the state prior to the "Warp" state on the History panel.
- While warp or transform controls are showing in your document, you can click the Switch Between Free Transform and Warp Modes button 🗷 on the Options bar to toggle one mode to the other. In fact, to minimize resampling and preserve the image quality when you need to apply multiple transform and/or warp edits, it's best to choose all your settings (by toggling the modes), then accept them all at once.

USING THE WARP TEXT DIALOG

To open the Warp Text dialog, which has the same controls as the Warp command, except that they apply only to a type layer, choose Type > Warp Text; or if a type tool is selected, you can click the Warp Text button 🗓 on the Options bar.

A In this image, the cups are on a Smart Object layer (separate from the yellow Background).

B We applied the Warp command to the cups layer (Twist preset).

C Finally, we chose the Custom warp option, then dragged a few of the control handles on the grid.

This is the result (it reminds us of the Mad Hatter tea party in Alice in Wonderland).

You may already have used a filter or two in Photoshop (perhaps as a step in an earlier chapter). In this chapter, filters are the star

players. Depending on which filters you apply and which settings you choose, the results can range from a subtle change to a total morph. **A-B** You can make an image look (almost) as if it's hand painted, silkscreened, or sketched; apply distortion; add a pattern, texture, or noise; create a mosaic or a patchwork of tiles — the creative possibilities are infinite. Once you start using the Filter Gallery, you'll see ... time will fly by.

Using this chapter, you will learn techniques for applying filters, including using the Filter Gallery, Smart Filters, and the Smart Filters mask. We also suggest some ways to use filters creatively, to whet your appetite. (To locate tasks in other chapters in which individual filters are used, see "Filter menu" in the index.)

Applying filters

You can apply filters to a whole layer or just to a selection on a layer. Most of the Photoshop filters are applied either via the Filter Gallery or via an individual dialog. A small handful of them, such as Clouds and Blur, are applied in one step simply by choosing the filter name from a submenu on the Filter menu. If you apply a filter to a Smart Object, it becomes an editable, removable Smart Filter (see pages 360–364).

If you try to select a filter and discover that it's not available, the likely cause is that it's incompatible with the current document color mode or bit depth. All the Photoshop filters are available for RGB files, most of the filters are available for Grayscale files, fewer are available for CMYK Color, Lab Color, and 16-bits-per-channel files, still fewer are available for 32-bits-per-channel files, and none are available for Bitmap and Indexed Color files.

IN THIS CHAPTER

Applying filters	35
Creating and editing Smart Filters .	36
Hiding, copying, and deleting Smart Filters	36
Working with the Smart Filters mask	36
More filter techniques	.36

A This is the original image.

B We applied the Charcoal filter.

Most of the Photoshop filters are housed conveniently under one roof in the Filter Gallery dialog. There you can preview dozens of filters and filter settings, show and hide each filter effect that you've previewed, and change the sequence in which Photoshop applies them to your document.

To use the Filter Gallery:

- Open an 8-bit, RGB image. Click an image layer; or for more flexibility, work on a duplicate image layer or a Smart Object (see "To apply a Smart Filter," on page 360).
- **2.** *Optional:* To limit the filter to a specific area of the image, create a selection.
- 3. The Foreground and/or Background colors are used by many filters (see the sidebar on this page), and you must choose those colors now, before opening the Filter Gallery.
- Choose Filter > Filter Gallery. The resizable gallery opens (A, next page).
- 5. To change the zoom level for the preview, hold down Ctrl/Cmd and press – or +. (If the preview is magnified, you can drag it in the window.)
- **6.** Do either of the following: In the middle pane of the dialog, click an arrowhead to expand any of the six filter categories, then click a filter thumbnail.

Choose a filter name from the menu on the right.

- 7. On the right side of the dialog, choose settings for the filter. Note: Some effects and settings take longer to process than others (a progress bar may display below the preview).
- **8.** To edit the list of effects (bottom-right portion of the dialog), do any of these optional steps:

To apply an additional filter effect, click the **New Effect Layer** button, click a filter thumbnail in any category, then choose settings.

To **replace** one filter effect with another, click a filter effect name on the scroll list (don't click the New Effect Layer button), then choose a replacement filter and settings.

To hide (or show) a filter effect, click in the visibility column next to the effect name. To hide or show the previews for all but one filter effect, Alt-click/Option-click a visibility icon.

To remove a filter effect from the list, click it, then click the **Delete Effect Layer** button.

To change the **stacking position** of a filter effect to produce a different result in the image, drag the effect name upward or downward on the list.

- 9. Click OK.
- To remove a non-Smart Filter edit from an image, use the History panel.
- ➤ In Edit/Photoshop > Preferences > Plug-Ins, uncheck Show All Filter Gallery Groups and Names to list, on the submenus on the Filter menu, only filters that are not in the Filter Gallery, or check this option to list all Photoshop filters on the submenus, including those that are in the Filter Gallery (the gallery opens when you choose a filter name).
- The filter effects in the Filter Gallery are sticky, meaning that the last-used settings will redisplay when you open the dialog.

FILTERS THAT USE THE FOREGROUND AND BACKGROUND COLORS

The filters listed below use the current Foreground and/or Background colors. We find that some filters, such as Charcoal, Graphic Pen, and Photocopy (in the Sketch category), look good in the default Photoshop colors of black and white, whereas others look better in color. But don't just take our word for it — experiment and see for yourself.

- ➤ Artistic > Colored Pencil (Background color), Neon Glow (Foreground and Background colors)
- ➤ Distort > Diffuse Glow (Background color)
- ➤ Pixelate > Pointillize (Background color)
- ➤ Render > Clouds, Difference Clouds, Fibers (Foreground and Background colors)
- ➤ Sketch > Bas Relief, Chalk & Charcoal, Charcoal, Conté Crayon, Graphic Pen, Halftone Pattern, Note Paper, Photocopy, Plaster, Reticulation, Stamp, Torn Edges (Foreground and Background colors)
- Stylize > Tiles (Foreground or Background color)
- ➤ Texture > Stained Glass (Foreground color)

REAPPLYING THE LAST FILTER OUICKLY

- ➤ To reapply the last-used filter(s) using the same settings, choose Filter > [last filter name or Filter Gallery] (Ctrl-F/Cmd-F).
- ➤ To reopen either the last-used filter dialog or the Filter Gallery showing the last-used settings, press Ctrl-Alt-F/Cmd-Option-F.

Click this button to hide (or show) the thumbnails and expand (or shrink) the preview area. To preview a filter effect, click a thumbnail or choose a filter name from this menu.

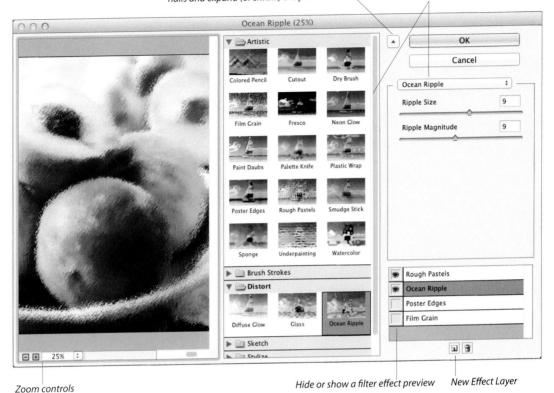

A The Filter Gallery dialog includes a preview area, filter categories (with thumbnails), settings for the currently selected filter effect, and a listing of the currently applied effects.

USING THE PREVIEW IN AN INDIVIDUAL FILTER DIALOG

Some Photoshop filters are applied via an individual dialog (not via the Filter Gallery). Of those individual dialogs, some have a preview window and some do not.

- ➤ For individual filter dialogs that have a preview window, you can click the + button to zoom in or the button to zoom out (we usually do the latter). Most of the individual dialogs also have a Preview check box.
- ➤ In some filter dialogs (such as Blur > Gaussian Blur and Motion Blur), if you click in the document window (square pointer), that area of the image will appear in the preview window. You can drag the image inside the preview window.
- ➤ To compare the image with and without the current filter effect, click and hold on the preview, then release.

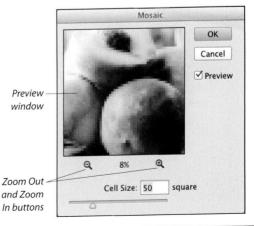

Creating and editing Smart Filters

When you apply a filter to a Smart Object, it becomes what is called a Smart Filter. You can edit or remove a Smart Filter at any time, apply multiple filters to the same Smart Object, hide individual filters while keeping others visible, and move or copy filters from one Smart Object to another. You can also edit the filter mask (which is created automatically), change the stacking order of the filters, and edit the Smart Object itself. To learn about Smart Objects, see pages 264–275.

The file formats that support Photoshop layers such as PSD, PDF, and TIFF — also support Smart Filters. Some third-party (non-Adobe) filters can also be applied as Smart Filters.

To apply a Smart Filter:

- 1. On the Layers panel, do either of the following: Click an existing Smart Object.
 - Click an image layer, then choose Filter > Convert for Smart Filters (or right-click the layer and choose Convert to Smart Object). If an alert appears, click OK.
- **2.** *Optional:* To limit the filter effect, create a selection. (The selection area will appear in the filter mask after you apply a filter in the next step.)
- 3. Apply a filter. A Smart Filters listing, mask thumbnail, and filter listing will appear on the Layers panel.A

The most significant advantage to using Smart Filters is that you can edit the filter settings at any time.

To edit the settings for a Smart Filter:

- 1. Do either of the following:
 - Double-click on or next to the Smart Filter name on the Layers panel.
 - Right-click the Smart Filter name and choose Edit Smart Filter from the context menu.
- 2. If any Smart Filters are listed above the one you're editing, an alert will appear, indicating that those filter effects will be hidden until you exit the Filter Gallery or filter dialog. B Check Don't Show Again to prevent the warning from appearing again (if desired), then click OK. Note: The settings for filters that aren't in the Filter Gallery cannot be edited in this way.
- 3. Make the desired changes in the filter dialog, then click OK.

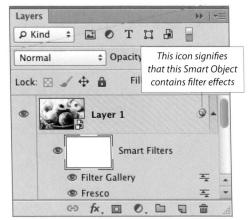

A If you apply a Smart Filter by choosing Filter > Filter Gallery, the filter will be listed as "Filter Gallery," whereas if you apply a Smart Filter by choosing its individual name, it will be listed by its name (see also the second tip on page 358).

B If you edit a Smart Filter and other filters are listed above it on the same layer, this alert dialog will appear.

CHANGING THE COLOR MODE OR BIT DEPTH

When changing the document color mode or bit depth, if the image contains Smart Filters that aren't supported in the new mode or depth, an alert will appear (shown below). If you click Don't Rasterize and then click Don't Flatten or Don't Merge, this symbol 🕰 will display next to the names of filters on the Layers panel that have become inaccessible. If you then convert the file to a mode or depth that does support the filter — and respond to the alerts in the same way — the icon will disappear and the filter settings will be editable again.

Not only can you change the blending mode and opacity of a Smart Object, you can also change the blending mode and opacity setting of each Smart Filter that is applied to that object. Granted, this can be a lot to keep track of. And unfortunately, there is no indicator on the Layers panel to let you know if those settings have been changed from the defaults.

To edit the blending options for a Smart Filter:

- 1. Double-click the **Blending Options** icon 🛬 next to a filter name on the Layers panel, A-B then click OK if an alert dialog appears.
- 2. The Blending Options dialog opens. Check Preview and, if desired, lower the zoom level. Change the blending Mode and/or Opacity (use the latter to fade the filter effect), then click OK.
- For another way to lower the intensity of a filter effect, see page 345.

Hiding, copying, and deleting **Smart Filters**

To hide (or show) Smart Filter effects:

On the Layers panel, do either of the following: Click the visibility icon for the Smart Filters listing to hide all the Smart Filters on that layer.

Click the visibility icon for any individual Smart Filter. This change may take longer to process than clicking the visibility icon for all the filters.

Click where the icon formerly was to redisplay the hidden filter effect(s).

To copy Smart Filters from one Smart Object to another:

- 1. Expand the list of Smart Filters for a Smart Object.
- 2. Alt-drag/Option-drag either the Smart Filters listing or an individual filter listing to another Smart Object.
- You can restack any Smart Filter within a Smart Object list (pause for the edit to process).
- If you drag a filter or the Smart Filters listing from one Smart Object to another without holding down Alt/Option, the filters will be removed from the source layer and added to the target layer. Any preexisting filters on the target layer will be preserved. Pause for the edit to process.

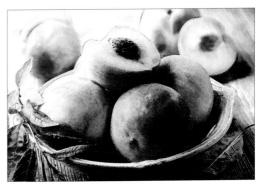

We applied the Fresco and Dry Brush filters to this image.

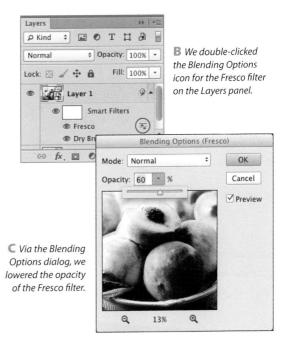

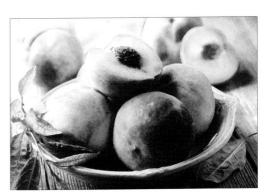

Now more of the Dry Brush filter is showing through.

If you delete a Smart Filter from a Smart Object that contains multiple filters, it may take a moment or two for Photoshop to update the display.

To delete a Smart Filter:

On the Layers panel, do either of the following: Right-click a Smart Filter listing and choose **Delete** Smart Filter.

Drag a Smart Filter listing to the **Delete Layer** button.

Working with the Smart Filters mask

When you apply a filter to a Smart Object, a filter mask appears on the layer automatically. If you create a selection before applying the first filter to a Smart Object, the selection will appear as the white area in the mask. A filter mask can also be edited using the same methods as for a layer mask. A

To edit a filter mask:

- In a Smart Filters listing on the Layers panel, click the filter mask thumbnail.
- 2. Do either of the following:

Click the **Brush** tool, then apply strokes with black to hide the filter effect, or with white to reveal areas you've hidden. For a partial mask, use black and lower the tool opacity (**A**–**E**, next page). To hide the filter effect gradually from one side of the image to the other, click the **Gradient** tool,

➤ To display the filter mask by itself in the document, Alt-click/Option-click the mask; repeat to redisplay the full Smart Object.

then drag across the image (A-C, page 364).

➤ To soften the transition between black and white areas in a filter mask, click the filter mask thumbnail, then on the Properties panel, adjust the Feather value. To control the overall opacity of the mask, use the Density slider.

If for some reason a filter mask is deleted and you want to restore it, do as follows.

To create a filter mask:

- 1. Optional: Create a selection.
- 2. Right-click the Smart Filters listing on the Layers panel and choose Add Filter Mask.

To deactivate a filter mask temporarily:

Shift-click the mask thumbnail (a red X appears over the thumbnail). Repeat to reactivate the mask.

To delete a filter mask:

Do either of the following:

Drag the filter mask thumbnail to the **Delete Layer** button on the Layers panel.

Right-click a Smart Filter listing and choose **Delete** Filter Mask.

A A gradient in the Smart Filters mask is hiding the filter effects fully on the left side of this image, and reveals gradually more of the effects on the right.

SOLVING MEMORY PROBLEMS

If you encounter memory problems when applying filters (Photoshop memory, that is, not your own forgetfulness!), try choosing Edit > Purge > All to free up memory, or exit/quit other open applications. Also bear in mind that the processing time may vary for any given filter slider or option. For instance, a higher setting that produces many small shapes may take longer to process than a setting that produces just a few large shapes.

WORKING WITH SMART FILTERS: AN EXAMPLE

A This is the original image.

Charcoal	• •
Charcoal Thickness	1
Detail	5
Light/Dark Balance	50

B We duplicated the Background, converted the copy to a Smart Object, pressed D to reset the default Foreground and Background colors, then applied Filter Gallery > Sketch > Charcoal (values at left).

We reduced the Opacity of the Smart Object to 62%.

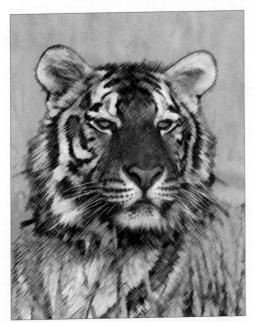

D We clicked the filter mask, then with the Brush tool at 50% Opacity and black as the Foreground color, applied strokes to partially restore the tiger's face to its virgin state.

This is the Layers panel for the image shown at left.

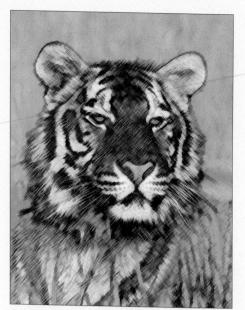

A Next, to wipe the filter mask clean so we could try a different approach, we clicked the filter mask thumbnail, pressed Ctrl-A/Cmd-A to select the whole mask, pressed Backspace/Delete, then pressed Ctrl-D/Cmd-D to deselect.

B With the Gradient tool (100% Opacity, "Black, White" preset, radial type), we dragged from the center of the image outward. The filter effect is at full strength where the mask is white, and it fades to nil where the mask is black.

ℂ The gradient in the filter mask is diminishing the impact of the filter in the center of the image — the tiger's face — right where we want the focal point to be.

USING THE MINIMUM OR MAXIMUM FILTER ON A MASK

If you want to expand or contract the dark area of a mask in a Smart Filters listing, click the mask thumbnail, then try using Filter > Other > Minimum (to expand) or Maximum (to contract).

FILTERS AND AN ADJUSTMENT LAYER

A We duplicated the Background in this image, then converted the duplicate layer to a Smart Object.

More filter techniques

If you apply filters to a Smart Object, you will be able to change the settings easily — and will feel more free to experiment. If you come up with a filter formula that you like, consider recording your steps in an action so you can apply it to other images. Here are a few more suggestions:

- ➤ Filters tend to make an image more abstract, reducing recognizable elements to line work, or to fewer or flatter areas of color. Start with an image that has a strong composition. Look for shapes that contrast in scale and have interesting contours, which will carry more weight once you apply filters.
- Fine-tune the resulting luminosity levels or colors via an adjustment layer above the filtered layer.
- Apply filters separately to a Smart Object one by one (not by creating multiple effects in the Filter Gallery), then via the Blending Options dialog, lower the opacity of the topmost filter

- and/or change its blending mode. You can also apply filters to separate layers, then change the layer opacity or blending mode of any layer (A–E, next page).
- For less predictable and "machine made" results, apply two or more filters that have contrasting or complementary effects. For instance, you could apply one filter that reduces shapes to line work (such as Poster Edges) and another filter that changes the color or applies an overall texture, such as Grain > Texturizer.
- ➤ For a personal touch, apply some paint strokes (A-B, page 367).

B We applied Filter > Filter Gallery > Distort > Diffuse Glow.

D This is the final image.

FILTERS, AN ADJUSTMENT LAYER, AND BLENDING MODES

A We converted a duplicate of the Background to a Smart Object.

B We applied Filter > Other > Minimum (Radius 1), then Filter > Stylize > Find Edges.

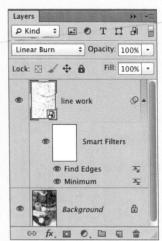

We changed the blending mode of the Smart Object to Linear Burn.

D We created a second duplicate of the Background, moved the duplicate to the top of the Layers panel, changed the blending mode of that layer to Divide, and lowered its Opacity to 50%. Finally, we used a Vibrance adjustment to boost the colors slightly.

E This is the final image.

A TEXTURE FILTER AND PAINT STROKES

A This is the original image.

0.0

B This is the image and the Layers panel after we converted a duplicate image layer to a Smart Object, applied the Texturizer filter (Burlap texture) via the Filter Gallery, and used the Mixer Brush tool (Sample All Layers checked) to apply paint strokes to six new layers. We also applied the Drop Shadow effect to a couple of the paint layers for added depth, and a Levels adjustment to heighten the contrast in the underlying image.

In these steps, you'll turn a photo into a watercolor by applying a series of filters. Try devising some of your own formulas, too!

To turn a photo into a tinted drawing:

- Duplicate an image layer in a high-resolution photo. A
- 2. Choose Filter > Stylize > Find Edges.B
- 3. Choose the Brush tool. On the Options bar, choose a Soft Round brush, Normal mode, and an Opacity below 40%.
- **4.** Click the **Add Layer Mask** button on the Layers panel, and keep the layer mask thumbnail selected.
- Make sure the Foreground color is black, size the brush cursor, then apply strokes to the image to reveal areas of the underlying layer.
- 6. Do any of the following optional steps: Lower the opacity of the duplicate layer. Change the blending mode of the duplicate layer (try Lighter Color, Hard Light, Pin Light, or Luminosity). C—D

Intensify the contrast via a Levels adjustment layer.

B We applied the Find Edges filter to the duplicate layer.

This is the Layers panel for the final image, which is shown at right.

We applied brush strokes to the layer mask to reveal some of the underlying image, and chose Hard Light as the blending mode for the duplicate layer.

We've never heard someone say "A word is worth a thousand pictures" (the reverse of the common adage), but so many artful things can be done with type in Photoshop, the line between pictures and words can be blurred — sometimes even literally! In this chapter, you will learn how to create editable type, then style and format it using a wide assortment of character and paragraph controls. You will also learn special techniques, such as how to transform type, screen it back (as in the image shown at right), rasterize it (convert it to pixels), and make it look like cut paper. Finally, you will learn how to put some type shapes into a spot color channel.

When you use the Horizontal Type tool or Vertical Type tool, editable type appears in your document and a new layer appears on the Layers panel. You can easily change the attributes of editable type, such as the font family, font style, and size; the kerning, tracking, leading, alignment, and baseline shift values; and the color. Moreover, you can transform, warp, or apply layer effects to editable type; change its blending mode; and change its opacity and fill values. To style type, you can use the Character panel A A, the Paragraph panel, the Paragraph Styles panel, the Character Styles panel, and the Options bar.

or words.

10

IN THIS CHAPTER

Creating editable type
Selecting type
Recoloring type
Changing the font family and font style
Using Adobe Typekit
Converting type
Changing the font size
Applying kerning and tracking 377
Adjusting the leading
Shifting type from the baseline 379
Inserting special characters 379
Applying paragraph settings 380
Formatting type with paragraph and character styles
Transforming the bounding box for paragraph type384
Screening back type
Rasterizing a type layer386
Putting type in a spot color channel388

Creating editable type

You can be casual about where you position editable type initially and about which typographic attributes you choose for it, because you can easily edit those attributes or move, transform, or restack the layer.

To create an editable type layer:

- 1. On the Layers panel, click the layer above which you want the type layer to appear.
- 2. Choose the Horizontal Type tool T or Vertical Type tool T (T or Shift-T).
- On the Options bar, A do all of the following:
 Choose a font family, and from the adjacent menu, choose a font style. A sample of each font displays on the menu.

Choose or enter a **font size** (you can use the scrubby slider).

Choose an **anti-aliasing** method for the way in which Photoshop introduces partially transparent pixels along the edges of the characters, to make them look smoother. For print output, choose Sharp (sharpest), Crisp (somewhat sharp), Strong (heavier), or Smooth (smoothest). Or for Web output, choose an anti-aliasing option that allows your system to render the type, so it more closely matches the rendering by your browser. For Safari in the Mac OS, choose Mac LCD or Mac; or for Internet Explorer in Windows, choose Windows LCD or Windows. The LCD options render the type with sub-pixel anti-aliasing (shaded pixels that are added around the characters to make

them look more crisp). Note that in Photoshop, subpixels are grayscale, whereas in Safari and Internet Explorer, they display in RGB color. **B**—**C**

Click an **alignment** button to align point type relative to your original insertion point or to align paragraph type to the left edge, right edge, or center of the bounding box (see also page 380).

Click the **Text Color** swatch, then choose a color via the Color Picker or Swatches panel, or click a color in the document, then click OK.

4. Do either of the following:

To create **point** type (suitable for a small amount of text), click away from any existing text in the document to establish an insertion point, then type the desired text. You can press Enter/Return to create line breaks where necessary, to prevent the type from disappearing off the edge of the canvas. (You can also move the type later with the Move tool.)

To create **paragraph** type (suitable for a larger block of text), drag to define a bounding box for the type to fit into, then type the desired text. Let the words wrap naturally to the edges of the bounding box, pressing Enter/Return only when you need to start a new paragraph. Note: If you prefer to specify dimensions for the bounding box first, Alt/Option click in the document, then enter dimensions in the Paragraph Text Size dialog.

B With antialiasing off, type edges look jagged.

With antialiasing on, type edges look smoother.

- 5. To accept the new text, press Enter on the keypad (not on the main keyboard) or click the Commit button on the right end of the Options bar. (To cancel the type, press Esc or click the Cancel button on the Options bar.) Each time you create new type with the Horizontal or Vertical Type tool, it appears on a new layer. A→B Note: If you prefer not to establish new default Options bar settings for your type tool, click or drag with the tool in the document before choosing settings.
- ➤ Photoshop uses vector outlines for specific font families and styles when you resize editable type, save a file to the PDF format, or output a file to a PostScript printer. Like vector graphics, editable type outputs at the resolution of the printer, not at the resolution of the file.
- You can right-click an editable type listing on the Layers panel and choose an anti-aliasing method

- from the context menu. The new setting will display on the Anti-Aliasing menu on the Character panel.
- ➤ To display East Asian Features or Middle Eastern Features on the Character and Paragraph panels and panel menus, see "Choose Text Engine Options," on page 469.
- To fill a type bounding box with "dummy" text quickly, choose Type > Paste Lorem Ipsum. For overflow text, see page 384.
- ➤ If you place phrases, words, or characters on separate layers, you'll be able to move, align, and apply effects to them individually. To organize multiple type layers, gather them into layer groups. To display only type layers on the Layers panel, choose Kind from the Filter Type menu at the top of the panel, then click the Filter for Type Layers button. T

A After typing "EcoStorage," we pressed Enter/Return so we could type the next word on a second line.

f B Editable type layers have a f T icon in the thumbnail and are given the name of the first word or few words of type in the layer.

REMEMBER TO USE SMART QUOTES!

Typographer's quotation and apostrophe marks are shaped specially to fit around the beginning and end of quotations and abbreviations. To use them in Photoshop (as we highly recommend), go to Preferences > Type and check Use Smart Quotes. Straight (prime) marks should be used solely as abbreviations for foot and inch measurements.

IMPORTING ILLUSTRATOR TYPE AS A SMART OBJECT

For quick round-trip editing, import type from Illustrator into a Photoshop document as a Smart Object (see the methods on pages 265, 266, and 272). To edit a Smart Object, see pages 268 and 273.

Selecting type

Before you can change the character or paragraph attributes or content of type, you have to select a type layer or a specific string of characters or phrases.

Note: To apply some kinds of edits to type, such as filters or brush strokes, you must rasterize it first (see page 386). Note that once type is rasterized, its character or paragraph attributes (such as the font and leading) can't be changed.

To select type for editing or style changes:

Do one of the following:

Click a type layer, choose the Horizontal Type tool T or **Vertical Type** tool T (T or Shift-T), then drag across some characters or words to select them, A or double-, triple-, or quadruple-click, as described in the sidebar on this page.

With any tool selected, double-click the ${f T}$ icon on the Layers panel. All the type on the layer becomes selected. To reduce the selection, drag or doubleor triple-click.

To change the attributes of all the type on a layer via the Character or Paragraph panel, such as the font size, leading, or alignment, simply click the layer (you don't need to select a type tool).

 To delete type characters that you have selected, press Backspace/Delete. Or to delete one character at a time in horizontal type, with a type tool, click to the right of the character to be deleted, then press Backspace/Delete (for vertical type, do the same except click below the character).

To exit type-editing mode:

When you're done editing your type, do one of the following:

Click the Commit button on the Options bar.

Press Enter on the keypad (not on the main keyboard).

Click a different tool.

Click a different layer.

(To cancel your edits before confirming them, either click the Cancel button **O** on the Options bar or press Esc.)

A To select type characters for editing. drag across them with a type tool.

SHOWING THE CHARACTER PANEL

- If the Character panel is open but collapsed to an icon, click the A icon.
- Select the Horizontal Type tool or Vertical Type tool, then click the Toggle Character and Paragraph Panels 🗐 button on the Options bar.
- Choose Type > Panels > Character Panel or Window > Character

SELECTING TYPE CHARACTERS

To select type for copyediting or restyling, choose the Horizontal Type or Vertical Type tool, then do any of the following:

Select consecu- tive characters or words	Drag across them. Or click at the beginning of a series of words, then Shift-click the end.
Select a word	Double-click a word.
Select consecu- tive words	Double-click a word, then drag without releasing the mouse.
Select a line	Triple-click a line.
Select a paragraph	Quadruple-click in the paragraph.
Select all the characters in a type object	Double-click the $\mathbf T$ icon on the Layers panel; or click in the text, then press $Ctrl-A/Cmd-A$.

Recoloring type

To recolor all the type in a type layer:

- 1. On the Layers panel, click a type layer.
- 2. Do either of the following:

Choose the Horizontal Type tool T or Vertical Type tool, T then click the Text Color swatch on the Options bar.

On the Character panel, A click the Color swatch.

- **3.** Choose a color via the Color Picker or Swatches panel, or click a color in the image, then click OK to exit the Color Picker.
- You can also apply a color, gradient, or pattern to a type layer via an editable overlay layer effect (see pages 396–397).

To recolor select characters or words:

- With the Horizontal Type tool T or Vertical Type tool, T select the characters or words to be recolored.
- Do either of the following:
 On the Options bar, click the Text Color swatch.
 On the Character panel, A click the Color swatch.
- 3. Follow step 3 above.B

Changing the font family and font style

To change the font family and font style: Method 1 (choose from the full list) ★

- 1. Select the type to be restyled (use any method on the preceding page).
- On the Character panel A or Options bar, click the Font Family menu arrow to display a scrolling list of available font families and styles.
 - To scroll through the list, leave the mouse button up and press the up or down arrow on the keyboard; fonts will preview in your document.
 - To jump to the next font family, press Shift-up arrow or Shift-down arrow.
- To apply a font and exit the panel, click the font name; or to apply the currently highlighted font, press Enter/Return.
- ➤ If selected type already contains the desired font family and you want to change just the font style, you can use the Font Style area on the Character panel or Options bar.
- ➤ From the Type > Font Preview Size submenu, you can choose a size (e.g., Medium) for the samples of font families that display on the font menus in Photoshop. Note: If your samples preview too slowly, choose a smaller preview size or None.

Continued on the following page

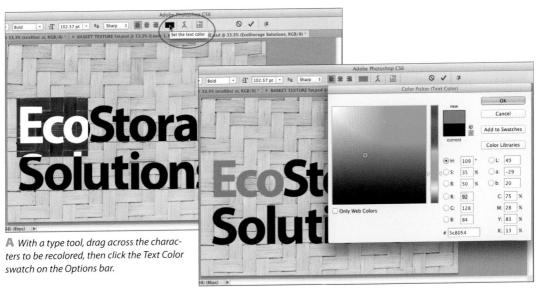

B Choose a replacement color from the Color Picker.

Method 2 (run a search)

- 1. Select the type to be restyled (use any method on page 372).
- 2. On the Character panel or Options bar, click in the Font Family field.
- 3. Do one of the following:

Start typing a font name.

Type a generic category, such as "semibold italic," "black condensed," or "ornaments".

Type an abbreviation for a specific font (e.g., "f g" for Franklin Gothic or "my p" for Myriad Pro). Note the inclusion of spaces.

To display only Typekit fonts on the menu, click the Toggle Typekit Fonts button. **I* (To download fonts from Typekit.com, see the next task. See also the sidebar on this page.)

- 4. Unless you clicked either one of the Typekit buttons, a menu will display, listing the fonts that most closely match your search criteria. To scroll through the list, keep the mouse button up and press the up or down arrow on the keyboard. Fonts will preview in your document.
- 5. To apply a font and exit the panel, click the font name; or to apply the currently highlighted font, press Enter/Return.
- To exit the menu on the Character panel or Options bar during a font search without changing any fonts in your document, press Esc.
- To resolve a case of missing fonts upon opening a document, see page 34.

Using Adobe Typekit

Via the Creative Cloud, you can browse, preview, and download fonts from Typekit.com (an Adobe website), for use in Adobe programs. Before proceeding with this task, see the sidebar on this page.

To download fonts from Typekit.com: ★

- To launch Typekit.com, do either of the following: Choose a type tool. On the font menu on the Character panel or Options bar, click the Typekit button.
 - Deselect all type in your document. Choose Type > Add Fonts from Typekit.
- **2.** Click **Browse Fonts**. To narrow or customize the search for fonts, do any of the following (**A**, next page):

From the Sort By menu, choose Featured or Newest, or for a full alphabetical list, choose Name.

Narrow the search by clicking one or more of the categories on the right side, such as Desktop Use.

- To change the text that is displayed in the thumbnails, in the field under the My Library tab, enter custom text, or from the Edit menu, choose an Alphabets or Pangrams option.
- ➤ To add any font to your list of Favorites, click the heart icon ♥ in the upper-right corner of its thumbnail.
- 3. Click a font you're interested in.
- **4.** To change the way the font previews, click a tab category above the samples. If you want to enter custom text for the preview, click Type Tester.

TURNING ON TYPEKIT

Typekit will search for and sync fonts between the Creative Cloud and Photoshop only if the feature is turned on. You can verify this in either of two ways:

- ➤ Open the Creative Cloud for Desktop app, then click Fonts. If Typekit is off, a Turn Typekit On button displays; click the button.
- ➤ Open the Creative Cloud for Desktop app, ② click the gear icon, ② then click Preferences. In the dialog, click Fonts, then under Settings, Typekit On/Off, make sure the On button is clicked. Close the dialog.

A In the font search field on the Character panel, we entered "b cond," to display only bold condensed fonts on the Font menu.

A On Typekit.com, you can narrow the font search by clicking categories or via the Sort By menu, and you can preview any font via various methods.

- When you find a font you want to use in an Adobe application, click + Use Fonts.
- 6. For desktop use, click the Desktop tab. Make sure all the fonts you want to download have a check mark. (For more info, click Learn More About Desktop Use.) For Web use, click the Web tab. If you haven't already created a kit, click Create a New Kit. (For more info, click Learn More About Web Use.)
- 7. Click Sync Selected Fonts. The selected fonts will be synced to your computer via Creative Cloud, and should now be available in Photoshop and other Adobe applications. Click Close.
- To search for a particular font on Typekit.com, enter the font name in the search field in the upper right, then press Enter/Return.

B Check all the fonts you want to download, then click Sync Selected Fonts.

Converting type

To convert paragraph type to point type:

On the Layers panel, right-click the name of a paragraph type layer and choose **Convert to Point Text**. A line break will be inserted at the end of every line of type except the last one. If the type object contains hidden (overflow) text, an alert dialog may appear, warning you that the hidden text will be deleted if you proceed; click OK.

To convert point type to paragraph type:

On the Layers panel, right-click the name of a point type layer and choose **Convert to Paragraph Text**. If you want to reshape the resulting bounding box, follow the steps on page 384. Be sure to delete any unwanted hyphens that Photoshop may have inserted.

Changing the font size

To assign a specific font (point) size to type, you can use either the Options bar or the Character panel.

To change the font size:

- Choose the Horizontal Type or Vertical Type tool, then click a type layer or select the type characters to be resized.
- 2. Do either of the following:

On the Options bar, use the **Font Size** icon **1** as a scrubby slider (Alt-drag/Option-drag for smaller increments), or enter a value, or choose a preset size from the menu.

On the Character panel, A choose a Font Size.B

To choose a measurement unit for the Character and Paragraph panels, see page 467.

You can also resize type interactively with the Move tool. This is especially useful if your type selection contains different point sizes and you want to preserve those relative differences while resizing.

To scale type with the Move tool:

- 1. On the Layers panel, click a type layer.
- Click the Move tool and check Show
 Transform Controls on the Options bar. A bounding box with handles appears around the type.
- 3. Do either of the following:

To scale both the height and the width of the type, click a corner handle, then drag it. To preserve the

- original proportions of the characters while scaling them (better!), Shift-drag a corner handle.
- To scale just the height or width of the type, drag a middle handle.
- 4. To accept the scale transformation, click the Commit ✓ button on the Options bar or double-click in the text block. (To cancel the edit before accepting it, click the Cancel Transform ⋄ button on the Options bar or press Esc.)
- ➤ To typeset narrow or wide characters, we like to use a condensed or extended font, in which the characters have balanced proportions, instead of the Vertical Scale T or Horizontal Scale Control on the Character panel, which produces distortion.

A To change the font size of selected type via the Options bar, use the scrubby slider, enter a value, or choose a preset size from the menu.

B Another way to change the type size is via the Font Size scrubby slider, field, or menu on the Character panel.

C To scale type proportionally with the Move tool, Shiftdrag a corner handle on the transform box.

Applying kerning and tracking

Kerning changes the spacing between a pair of text characters, whereas tracking changes the spacing between multiple characters.

To apply kerning:

- 1. On the Layers panel, double-click a **T** icon, then click to create an insertion point between two characters.
- 2. Do either of the following:

On the Character panel, choose Metrics from the Kerning menu to apply the kerning value built into the current font, or choose Optical to let Photoshop control the kerning; or use the Kerning icon As as a scrubby slider (for finer increments, hold down Alt/Option); A or enter or choose a positive or negative value.

Press Alt/Option plus the left or right arrow key on the keyboard (to kern in a larger increment, hold down Ctrl-Alt/Cmd-Option while pressing).

To restore the spacing between two characters to the kerning setting of Optical, select both characters, then choose Optical from the Kerning menu.

To apply tracking:

1. Do either of the following:

To apply tracking to a whole layer, click the layer. To apply tracking to part of a layer, double-click a \mathbf{T} icon, then select some characters or words.

2. Do either of the following:

On the Character panel, use the **Tracking** icon as a scrubby slider (hold down Alt/Option for finer increments) or enter or choose a positive or negative value.

If type characters are selected, you can press Alt/ Option and the left or right arrow key (to track in a larger increment, hold down Ctrl-Alt/Cmd-Option).

- To reset the tracking value of selected characters to 0, press Ctrl-Shift-Q/Cmd-Control-Shift-Q.
- If Fractional Widths is checked on the Character panel menu, Photoshop uses fractions of pixels to control the spacing of type (on the entire layer), to optimize its appearance. Keep this option checked unless you're setting small type for Web output.
- ➤ To reset the Character panel and any selected type to the factory-default settings, choose Reset Character from the Character panel menu.

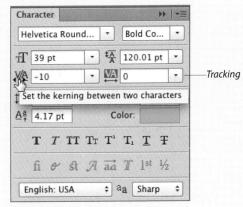

A Kerning and tracking values can be set on the Character panel or via shortcuts (not on the Options bar).

Kern

B Use a negative kerning value to tighten the gap between a pair of characters (here we chose a value of –100).

TRACKING IT OUT

Tracking can make type more or less readable, depending on the tracking value used. Try not to overdo it!

© On occasion, we might spread out a few words, as in the header in this figure, but never a whole paragraph (that's a typesetting no-no!).

Adjusting the leading

The Leading value controls the spacing between each line of paragraph type and the line above it (but not the spacing above the first line in a paragraph). In a block of text that has a uniform font size, uniform leading looks best. Note: To reposition a whole layer, drag it with the Move tool (simple, yet easy to forget!).

To adjust leading in horizontal paragraph type:

- On the Layers panel, do either of the following: Click a type layer.
 - Double-click the \mathbf{T} icon for a type layer, then select the consecutive lines of type for which you want to change the leading value.
- 2. Show the Character panel. A Use the Leading icon as a scrubby slider A—C (Alt-drag/Optiondrag for finer increments), or enter a value in the field, or choose a preset value from the menu. The leading will change from Auto to a numerical value. If you're not sure what value to use, start with a number that's a couple of points larger than the current font size, then readjust it if needed. Note: The character that has the highest leading

value in a line controls the spacing of that line.

- The Auto setting for leading is calculated as a percentage of the current font size, and is set in the Justification dialog (choose Justification from the Paragraph panel menu). For instance, with Auto Leading set to the default percentage of 120%, the leading for 30-point type will be 36 points. To quickly restore the Auto setting to selected type, press Ctrl-Alt-Shift-A/Cmd-Option-Shift-A.
- To adjust the vertical spacing between characters in vertical type, click the type layer, then change the Tracking value (not the leading value) on the Character panel.
- ➤ To change the orientation of type, right-click a type layer name on the Layers panel and choose Horizontal or Vertical. Or double-click a type layer thumbnail, then on the Options bar, click the Toggle Text Orientation button. ♣ After changing the orientation, you may need to move the type or adjust the tracking. To rotate all the vertical type in a layer (or selected vertical type characters) by 90° clockwise, select the type, then uncheck Standard Roman Vertical Alignment on the Character panel menu.

A This 132-pt type has a leading value of 154 pt.

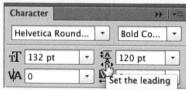

B We're resetting the Leading value on the Character panel.

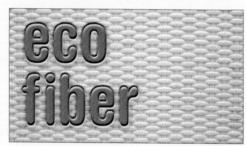

C A leading value of 120 pt brought the bottom line of type closer to the top one.

FADING PART OF A TYPE LAYER

To fade the editable type shown below, we added a layer mask to the type layer, then dragged with the Gradient tool from right to left.

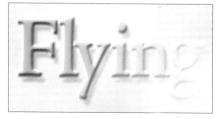

Shifting type from the baseline

Use the Baseline Shift feature to raise or lower type characters from the normal baseline (1 point at a time).

To shift characters from the baseline:

- 1. On the Layers panel, double-click a \mathbf{T} icon, then select the characters or words to be shifted.
- 2. On the Character panel, A use the Baseline Shift icon A as a scrubby slider (Alt-drag/Option-drag for finer increments), or enter a value. A A positive value raises characters upward; a negative value moves them downward. B—D

Inserting special characters

The OpenType buttons on the Character panel substitute alternate glyphs for standard characters, if available in the current OpenType font. For instance, a fraction glyph would be substituted when you type the characters for a fraction, such as ½ for 1/2 or ¾ for 3/4. Among the other possible OpenType options are ligature glyphs for specific letter pairs (such as ff, ffl, and st) and swash and titling characters. The OpenType "Pro" fonts contain the most glyph options.

To insert or specify alternate glyphs for OpenType characters:

1. Do either of the following:

To change all applicable occurrences in existing text, either click a type layer on the Layers panel or highlight characters with a type tool, and if you haven't already done so, choose an OpenType font family and font style.

To specify alternate glyph options for text to be entered in a specific OpenType font, choose a type tool and that font family and style.

2. On the Character panel, A click the desired — and available (not dimmed) — OpenType button(s).

USING THE STYLE BUTTONS

If the current font doesn't contain a particular glyph that you're looking for, you can let Photoshop produce a simulated version of it by clicking the applicable style button on the Character panel.

T T TT Tr T Tr T T

The buttons are Faux Bold, Faux Italic, All Caps, Small Caps, Superscript, Subscript, Underline, and Strikethrough.

A Use the Baseline Shift feature to shift characters or words upward or downward by a few points.

Upanddown

B These characters have a Baseline Shift value of 0.

Upandd⁰wn

C Here the characters have an assortment of different Baseline Shift values, some positive and some negative.

D To emphasize the curve more, we applied Edit > Transform > Warp (Flag preset); see page 356.

E These are the OpenType buttons on the Character panel.

Applying paragraph settings

All the justification, alignment, indentation, and spacing options on the Paragraph panel apply to paragraph type. The first three alignment buttons also apply to point type.

To choose Paragraph panel settings:

- 1. Do either of the following:
 - On the Layers panel, double-click a \mathbf{T} icon, then click in a paragraph or select a series of paragraphs.
 - To apply settings to all the type in a layer, click the layer, but don't select anything.
- 2. To show the Paragraph panel A, choose Type > Panels > Paragraph Panel or Window > Paragraph. Or if a type tool is selected, you can click the Toggle Character and Paragraph Panels button on the Options bar, and then, if necessary, click the Paragraph tab.
- **3.** Via one of the buttons at the top of the panel, apply an alignment option:
 - For paragraph or point type, click a button in the first group Left Align Text, Center Text, and Right Align Text to align the type to the center or an edge of the bounding box that surrounds it.

For paragraph type, click a button in the second group—Justify Last Left, Justify Last Centered, and Justify Last Right—to force all lines but the last one to span the full width of the bounding box.

For paragraph type, click the last button, **Justify All**, to force all lines of type, including the last one, to span the full width of the bounding box.

- 4. If you want to enable automatic hyphenation, check Hyphenate at the bottom of the panel. We especially recommend that you turn on hyphenation for type that is justify-aligned, to help minimize gaps between words.
- 5. You can also change the Indent Left Margin, Indent First Line, or Indent Right Margin values and/or the Add Space Before Paragraph or Add Space After Paragraph values.
- To change the alignment of vertical type, the procedure is the same as described above, except the buttons have different labels.
- To reset all currently selected type and the Paragraph panel to the default paragraph settings, choose Reset Paragraph from the panel menu.
- To open a dialog in which you can specify parameters for hyphenation, choose Hyphenation from the Paragraph panel menu.

PICKING YOUR FAVORITE COMPOSER

The Single-Line Composer and Every-Line Composer algorithms on the Paragraph panel menu control the way in which type wraps within the bounding box. We prefer Every-Line Composer, because it automatically adjusts word breaks at the beginning of a paragraph, when necessary, to improve the line breaks near the end of the paragraph, and gives uneven lines a more aesthetically pleasing contour. Both composers abide by the current Word Spacing and Letter Spacing values in the Justification dialog (which opens from the Paragraph panel menu).

Using paragraph and character styles, you can format and style your type quickly, and ensure that it looks consistent throughout one document or among many related documents. When you edit a type style, all the type in which it is being used updates instantly. Open the Paragraph Style and Character Style panel group from the Type > Panels submenu or the Window menu.

To create a paragraph style:

Method 1 (based on sample text)

- 1. Apply the desired character and paragraph settings to some type, then click in the type with the Horizontal Type tool $\mathbb T$ or Vertical Type tool. $\mathbb T$
- 2. On the Paragraph Styles panel, click the New Paragraph Style button. To rename the style, double-click the style name, enter a descriptive name in the dialog, then click OK.

Method 2 (based on an existing style)

- Choose Select > Deselect Layers, or on the Layers panel, click a non-type layer or the Background.
- 2. On the Paragraph Styles panel, click a style, then choose **Duplicate Style** from the panel menu.
- 3. Double-click the duplicate style. In the Paragraph Style Options dialog, give the style a unique name, change the settings in any of the panels, then click OK.

To apply a paragraph style:

- 1. Click a type layer on the Layers panel; or with the Horizontal Type tool T or Vertical Type tool, T click in a paragraph or drag through some paragraphs.
- 2. On the Paragraph Styles panel, click a style. A Note: If the style doesn't apply correctly, click the Clear Override button 2 on the panel.

To create a character style:

- **1.** Apply the desired character settings to a character or word, and keep the type selected.
- 2. On the Character Styles panel, ♣ click the New Character Style button. Double-click the style, rename it in the dialog, then click OK.
- You can also create a character style by duplicating it (follow the steps in Method 2, at left, except use the Character Styles panel instead).

To apply a character style:

- 1. Select the characters or words to be styled.
- 2. On the Character Styles panel, click a style. B Note: If the style doesn't apply correctly, click the Clear Override button 2 on the panel.

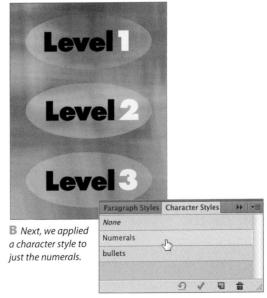

When you edit a style that is currently assigned to type in your file, that type updates instantly.

To edit a type style:

Do one of the following:

Select and restyle a paragraph that contains the style to be edited, so it has the desired new attributes. Click the Redefine Paragraph Style by Merging Override button on the Paragraph Styles panel; or from the panel menu, choose Redefine Style.

Select and restyle one or more characters that contain the style to be edited, so they have the desired new attributes. Click the Redefine Character Style by Merging Override button on the Character Styles panel; or from the panel menu, choose Redefine Style.

Choose Select > Deselect Lavers, then on the Paragraph Styles or Character Styles panel, doubleclick a style name. The Paragraph Style Options or Character Style Options dialog opens. A Change the settings in any of the panels (click a panel name on the left to switch panels), then click OK.B

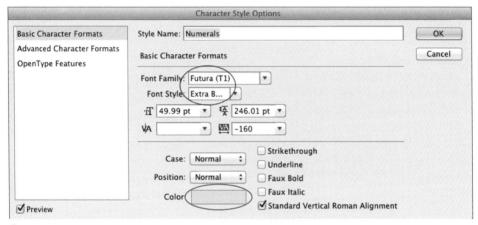

A For our Numerals character style, we changed the font family to Futura, the font style to Extra Bold Oblique, and the Color to an agua blue.

CLEARING OVERRIDES FROM TYPE

Overrides are attributes that are applied to text manually, in addition to any formatting already present in the text from a style. If you click in or select text that contains an override, a plus sign displays next to the style name on the panel.

To clear paragraph and character overrides from selected text — without removing any type style formatting—click the Clear Override button 20 on the Paragraph Styles panel. To clear just character overrides from selected text, click the Clear Override button 20 on the Character Styles panel.

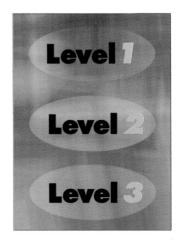

B When we edited the color and font in the character style, the changes appeared instantly in all the styled type in our document.

To load type styles from one document to another:

- 1. Open a Photoshop (.psd) document into which you want to load type styles.
- 2. Do either of the following:

 From the menu on the Paragraph Styles panel stokes Load Paragraph Styles.

 From the menu on the Character Styles panel, choose Load Character Styles.
- **3.** Locate and click a Photoshop (.psd) file that contains the desired styles, then click Open.
- 4. If a name conflict crops up, the Import Paragraph Styles or Import Character Styles dialog will open. Click Replace to allow Photoshop to replace all existing styles bearing matching names with incoming styles, or click Skip to bar Photoshop from replacing existing styles that have matching names. (You can't pick and choose which individual style names Photoshop will replace or skip.) This is a good reason to give your styles unique names!

Paragraph and character styles can be saved as default styles, which will appear automatically in all future Photoshop documents and in any existing documents that you reopen.

To create default type styles:

- Open a Photoshop (.psd) document. Create or load the paragraph and/or character styles that you want to save as defaults, and delete any styles that you don't want to save as defaults. All the styles in the document will be saved as defaults; you won't be able to pick and choose.
- From the menu on the Paragraph Styles panel or the Character Styles panel, choose Save Default Type Styles.
- Each time you choose the Save Default Type Styles command, the new styles replace the existing ones and become the new defaults.

The Load Default Type Styles command loads all the current default paragraph and character styles into a document. You can't load individual styles or specify one kind of style over the other.

To load the current default type styles into a document:

- 1. With a Photoshop (.psd) document open, from the menu on the Paragraph Styles panel or the Character Styles panel, choose Load Default Type Styles. The command will load both paragraph and character styles, regardless of where you choose it.
- 2. If the current document contains styles bearing the same name as any incoming (default) styles, an alert dialog will appear. See step 4, at left.
- The Load Default Type Styles and Save Default Type Styles commands can also be chosen from the Type menu.
- To delete a selected style, deselect the type in your document (choose Select > Deselect Layers), and click the Delete Style button. If an alert dialog appears, click Yes. This can't be undone. To delete multiple styles, Ctrl-click/Cmd-click the style names first.

QUICK-AND-DIRTY WAY TO COPY STYLES BETWEEN DOCUMENTS

For a quick way to copy styles between documents, apply the styles to be copied to some type in a "source" document. Display both the source and target documents via the Window > Arrange submenu, then with the Move tool, drag the type layer containing the desired styles from the Layers panel of the source document into the window of the target document. You can keep or delete the copied type (the incoming styles will remain on the Paragraph Styles and Character Styles panels).

A If any incoming paragraph styles have the same names as styles in the existing document, the Import Paragraph Styles dialog will appear.

Transforming the bounding box for paragraph type

If you change the shape of the bounding box that surrounds paragraph type (e.g., make the box narrower or wider), the type will reflow to fit the new dimensions without the characters becoming distorted. Enlarging the bounding box is a necessity if you want to reveal overflow type (indicated by a tiny plus sign in the lower-right corner handle). Instructions are also given here for rotating the bounding box.

To transform paragraph type via its bounding box:

- 1. On the Layers panel, double-click the $oldsymbol{\mathbb{T}}$ icon for a paragraph type layer, then click anywhere in the text. A dashed bounding box with handles surrounds the type.
- 2. Do either or both of the following:

To reshape the bounding box, drag a control handle. A To preserve the proportions of the bounding box while scaling it, start dragging a corner handle, then hold down Shift and continue to drag (release the mouse, then release Shift). The type will reflow into the new shape.

To rotate the bounding box, position the pointer just outside one of the corners (it will become a curved, double-arrow pointer), then drag in a circular direction.

- 3. To accept the transformation, press Enter on the keypad or click the Commit button
 on the Options bar. (To cancel the edits, press Esc or click the Cancel button **O** on the Options bar.)
- To align or distribute multiple layers, including type layers, see page 281.
- To move a type object while a type tool is selected, drag the object with Ctrl/Cmd held down (temporary Move tool). Note: If you press V to access the Move tool instead, make sure your type cursor isn't inserted in type, or you will either replace selected type with that letter or insert the letter into your text.

We're dragging a control handle to transform the bounding box that surrounds a type object.

B When we widened the bounding box, the type reflowed into the new shape.

TRANSFORMING TYPE

- You can apply any transform command, such as Free Transform, to paragraph or point type (see pages 348-349). Both the bounding box and the characters within it will be affected by the transformation.
- You can move, scale, rotate, or skew editable or rasterized type; you can apply a distortion or perspective transformation command only to rasterized type.
- If you want to transform characters individually, create each one on a separate layer.

WAYS TO EMBELLISH TYPE

- ➤ Apply layer effects or styles to an editable or rasterized type layer (see the next chapter).
- ➤ "Fill" editable type with imagery by using it as the base layer in a clipping mask (see pages 343-344).

Screening back type

In these steps, you'll use a Levels adjustment layer to screen back type. A lightened version of the image will be visible only within the type shapes. This is a very "Photoshoppy" way to combine type with imagery.

To screen back type:

- Create a document that contains a medium to dark image layer and an editable type layer (the type color doesn't matter), preferably in a large font size and a bold or black font style.
- On the Layers panel, Ctrl-click/Cmd-click the T icon to load the type as a selection. Hide the type layer, then click the underlying image layer or Background.
- On the Adjustments panel, click the Levels button. The Levels controls display on the Properties panel, and the selection disappears from view.
- 4. Move the middle input slider to the left to lighten the midtones in the type (you can also move the highlights slider). Move the output shadows slider to the right to reduce the contrast in the type. B − C
- For added depth, apply layer effects to the adjustment layer. Try Inner Shadow, Bevel & Emboss, or Drop Shadow. See the next chapter.
- To reposition the type in the image, click the adjustment layer, then Ctrl/Cmd drag in the document.
- ➤ To screen back the imagery instead of the type, after following the steps above, click the adjustment layer mask thumbnail, then on the Properties panel, click Invert (or press Ctrl-I/Cmd-I).

B The mask on the Levels adjustment layer is hiding the adjustment everywhere but within the type shapes.

A The original document contains an image layer and an editable type layer.

C In this screened-back version, the Levels adjustment is visible only within the type shapes.

Rasterizing a type layer

If you want to edit type by applying a filter or the Transform > Distort or Perspective command, or draw strokes on it directly with a tool such as the Brush, you have to convert it to pixels first via the Rasterize Type command. Although you can't change the typographic attributes of rasterized type, there are countless creative things you can do with it.

To rasterize type into pixels:

- 1. Optional: To preserve the editable type layer, duplicate it (Ctrl-J/Cmd-J), then hide the original. Keep the duplicate layer selected.
- Right-click the editable type layer name and choose Rasterize Type (or choose Type > Rasterize Type Layer). In the layer thumbnail, you will see the type shapes surrounded by transparent pixels.

CREATING A CUT PAPER EFFECT

In this example, we'll "attack" the type characters with knives (well, actually, a lasso tool)!

- Create an editable type layer, duplicate it, then right-click the duplicate layer and choose Rasterize Type. Hide the editable type layer.
- 2. To select a portion of a type "character," drag with the Lasso tool ♀ (L or Shift-L) or click with the Polygonal Lasso tool. ♀ ▲
- 3. Choose the Move tool or hold down Ctrl/Cmd, then drag the selection in the document window or press any of the arrow keys.
- **4.** Repeat steps 2–3 for other "characters" to create an aesthetically pleasing design (A–C, next page).

A We created editable type in an extra bold font, duplicated and hid the type layer, and rasterized the duplicate. With the Polygonal Lasso tool, we created a straight-edged selection of the stem on the letter P.

A With the Lasso tool, we created an irregular-shaped selection of the top of the letter A.

B We moved the selection.

C This is the final "cut paper" image after we moved more straight-edged and irregular selections of the rasterized type layer.

PUTTING SECTIONS OF RASTERIZED TYPE ONTO SEPARATE LAYERS

With the Magic Wand tool (Tolerance 0, Contiguous checked), we clicked each piece of "cut paper" separately, then used the Layer > New > Layer via Cut command (Ctrl-Shift-J/Cmd-Shift-J) to put it on a new layer. Note: If you follow these steps, remember to reselect the original rasterized layer each time before clicking with the Magic Wand.

With the sections on different layers, we were able to apply the Color Overlay and Drop Shadow layer effects to each separate layer, and also to move the layers individually. Fun!

These are some of the Layers panel listings for the image shown at left.

Putting type in a spot color channel To put type in a spot color channel:

- 1. Make sure your document has a suitable resolution for commercial printing (typically, 300 ppi).
- 2. Show both the Layers and Channels panels. If you haven't already done so, create some editable type. then choose the Move tool.
- 3. Display the Channels panel, then from the panel menu, choose New Spot Channel.
- 4. In the New Spot Channel dialog, click the Color swatch, and if necessary, click Color Libraries to get to the Color Libraries dialog.
- 5. From the Book menu, choose a spot color matching system, such as one of the PANTONE PLUS + systems (not Color Bridge); click the desired color or type a number that you have gotten from a printed swatch guide; then click OK to return to the New Spot Channel dialog. Optionally, change the Solidity (density) value just for the onscreen preview to simulate the transparency of the ink (this doesn't affect output). Click OK.
- **6.** On the Layers panel, Ctrl-click/Cmd-click the **T** icon to select the type shapes, A then hide the type layer.
- 7. On the Channels panel, make sure the new spot color channel is still selected, then choose Edit > Fill (Shift-Backspace/Shift-Delete). In the dialog, choose Use: Black, Mode: Normal, and an Opacity value that matches the tint (density) value of the spot color ink to be used on press. Click OK. The selection will fill with the spot color.
- 8. Deselect (Ctrl-D/Cmd-D). On the Channels panel, the type shapes should display in only the spot channel thumbnail. B Click the RGB channel.
- 9. To preserve the spot color channel, save the file in the Photoshop or Photoshop PDF format.
- To reposition the type shapes, click the spot channel listing on the Channels panel, then drag in the document with the Move tool. When you're done, click the RGB channel listing.
- You can't edit the type characters in a spot color channel, since technically they're just areas of color, not type. If you don't like the results, you will need to redo it from scratch. Fill the channel with White. 100% Opacity, redisplay and edit the original type layer, then repeat steps 6-8, above.

A The type is converted to a selection.

B With the type shapes in a spot color channel, a commercial printer will be able to print them from a separate plate.

As a Photoshop user, you're in the business of creating illusions. With layer effects, you can accomplish this in a few easy steps. The Photoshop effects that you can apply to a layer, either alone or in combination, include Bevel, Emboss, Stroke, Inner Shadow, Inner Glow, Satin, Color Overlay, Gradient Overlay, Pattern Overlay, Outer Glow, and Drop Shadow. Once applied, layer effects can be edited, hidden, or removed at any time. And best of all, when you modify type or pixels on a layer, any effects on that layer will update automatically (they should be called "Smart Effects"!). Once you develop a combination of effects that you like, you can save it collectively (along with other Layers panel settings) as a style to the Styles panel, for easy access and use in any document.

In this chapter, you will learn the generic steps for applying, copying, moving, and removing layer effects; change the layer fill percentage; learn specific steps for applying some individual effects; create, save, and apply layer styles; and finally, perform a couple of fun exercises that involve type and layer styles.

Layer effect essentials

Layer effects can be applied to any type, image, Smart Object, or shape layer (or group thereof), but not to the Background. They are applied and edited via the Layer Style dialog and are listed on the Layers panel below the layer they belong to. Layer effects appear either on or along the edges of layer pixels or vector shapes (including type), and will update instantly if you add, modify, or delete areas (or type characters) from the layer. You can edit the settings for a layer effect at any time, and turn the visibility of an effect on or off.

Before exploring any of the individual effects, familiarize yourself with these generic steps.

To apply layer effects (generic steps):

1. Do any of the following:

Double-click to the right of or below a layer or layer group name; or for an image layer (not a type or shape layer or a Smart Object), you can double-click the layer thumbnail instead.

Click a layer or layer group, then choose an effect from the **Add Layer Style** menu fx from the bottom of the Layers panel.

The Layer Style dialog opens (A, next page). Check Preview.

Continued on the following page

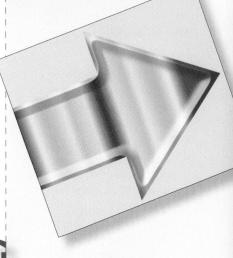

20

IN THIS CHAPTER

Layer effect essentials
Applying a bevel or emboss effect392
Applying a shadow effect 394
Applying the Stroke effect
Applying the Gradient and Pattern Overlay effects
Copying, moving, and removing layer effects
Changing the layer fill percentage 399
Applying layer styles
Creating layer styles
Applying multiple layer effects 402

STYLES USED FOR THE ARROW

The arrow, above, was styled with the Bevel effect (under Bevel & Emboss, Style: Inner Bevel) and the Gradient Overlay effect.

- **2.** Click an effect name on the left side of the dialog, then choose settings on the right side.
- **3.** Optional: Click other effect names to apply additional effects to the same layer or group.
- 4. Click OK.
- 5. Edit the layer (e.g., transform or move a shape, edit the type in a type layer, add pixels to an image layer). Watch as the "smart" effect(s) update instantly.
 - On the Layers panel, any layer that contains effects will have this icon: A. Click the arrowhead next to the icon to collapse or expand that list of effects (A, next page).
- **6.** To change the settings for an effect, or to add more effects to a layer, double-click the layer or

- the Effects listing or double-click an individual effect name (nested below the layer name).
- To hide or show one layer effect, expand the
 effects list for the layer, then click the visibility
 icon for the effect.
 - To hide or show all the effects on a layer, click the visibility icon for the Effects listing.
- Some effects have an Angle setting (e.g., Inner Shadow, Satin, and Drop Shadow). If you change the Angle for an individual effect while Use Global Light is checked, the angle will update on any other effects in which the Global Light option is being used. Use this feature to keep the lighting uniform among multiple effects.

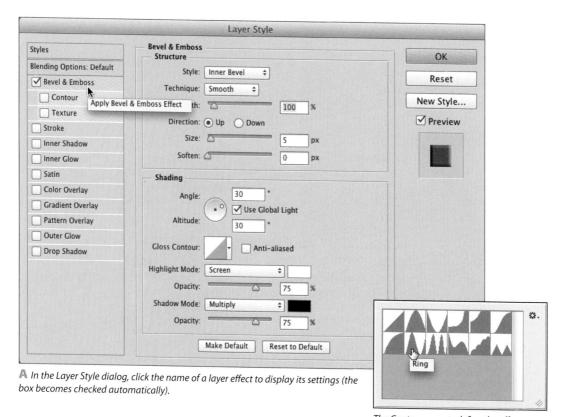

The Contour presets define the effect profile. Gray areas in the thumbnail represent opaque pixels; white areas represent transparency. To close the preset picker, either double-click a contour or click anywhere outside the picker.

Choosing imagery for layer effects

- We usually apply layer effects that work inward or outward from edges — Bevel, Emboss, Stroke, Inner Shadow, Inner Glow, Outer Glow, and Drop Shadow — to a type or shape layer, or to an image layer that contains some transparent areas. B To produce a layer that contains transparency, click an existing image layer, create a selection, then press Ctrl-J/Cmd-J (for the Layer via Copy command).
- The Satin, Color Overlay, Gradient Overlay, and Pattern Overlay effects look fine on any kind of layer, whether the layer contains transparency or not.
- ➤ When applying effects that spread outward (e.g., Outer Glow, Drop Shadow) to type, allow some breathing room between the characters. You can use the Tracking and/or Kerning controls on the Character panel to adjust the horizontal spacing (see page 377).

Layers

DEFAULT LAYER STYLE SETTINGS

- To establish new default settings for a specific layer effect, choose the desired settings in the Layer Style dialog, then click Make Default.
- To apply the settings to a layer effect that you established by clicking Make Default (or to restore the factory default settings, if you didn't establish your own default settings), click Reset to Default.
- ➤ To restore all settings (in all panels) that were in place when you opened the Layer Style dialog, Alt-click/Option-click Reset (Cancel becomes Reset).
- To restore the factory default settings to all layer effects, you have to reset all the Photoshop settings files (do this only if it's a necessity): Hold down Ctrl-Alt-Shift/Cmd-Option-Shift as you relaunch Photoshop, and click Yes in the alert.

Outer Glow... ✓ Drop Shadow... A Click the arrowhead to expand or collapse a list of layer effects.

The "fx" icon signifies that this layer contains layer effects.

dialog, choose an effect from the Add Layer Style menu (or double-click the layer). In the dialog, effects that are currently applied to the layer will have a check mark.

The Layers panel for this document is shown at left. Note that the image layer contains transparent areas.

Applying a bevel or emboss effect

The Bevel and Emboss effects create an illusion of volume by adding a highlight and shading. The results can range from a chiseled bevel to a pillowy emboss that looks as if it's been stamped onto porous paper. For variety, experiment with the Contour options.

To apply the Bevel or Emboss effect:

- 1. On the Layers panel, double-click near a layer A or group name to open the Layer Style dialog.
- 2. Click Bevel & Emboss.
- 3. Under Structure, choose a Size for the depth of the bevel or emboss effect.
- 4. Choose other Structure settings:

Choose a Style option: Outer Bevel, Inner Bevel, Emboss, Pillow Emboss, or Stroke Emboss C−D (and A-B, next page). (Note: Before applying the Stroke Emboss style, we recommend applying the Stroke effect, at an increased Size setting.)

From the Technique menu, choose Smooth, Chisel Hard, or Chisel Soft

Choose a **Depth** for the intensity of the highlight and the shadow.

Click the **Up** or **Down** button to swap the positions of the highlight and shadow (try this on the Pillow Emboss style).

Raise the Soften value if you want to blur the effect. The softening is most noticeable when a Chisel option is chosen as the Technique.

Steps 5-7 are optional.

5. Under Shading, do any of the following:

Choose an Angle and an Altitude (height) to change the location of the light source, and therefore the position of the highlight and shadow. Check Use Global Light to apply the same Angle and Altitude settings to all effects in which the Global Light option is being used, for uniform lighting, or uncheck it to apply a unique setting for just this effect. Note: If you change the Angle or Altitude for an effect while Use Global Light is checked, all other effects that are using the Global Light option will adopt those values.

Click the Gloss Contour arrowhead, then choose a profile in the Contour Preset picker.

For a reverse bevel, try the Rolling Slope – Descending contour.

The original image contains two layers.

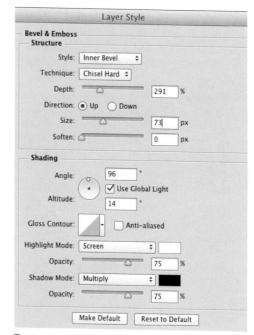

f B We chose these Layer Style options to produce figure f C.

Ammong	1	

The Inner Bevel effect is applied (and also the Drop Shadow effect).

Here we applied the Outer Bevel effect (plus a Drop Shadow).

Choose a Highlight Mode and Opacity for the highlight and a Shadow Mode and Opacity for the shadow.

To change the highlight or shadow color, click the corresponding color swatch, then choose a color via the Color Picker (or, while the picker is open, click a color in the Swatches panel or the document). Click OK.

6. If you want to add a Contour to the edges of the bevel or emboss, do the following:

On the left side of the dialog, under Bevel & Emboss, click Contour. Click the Contour arrowhead, then click a contour preset in the picker. This option can alter the appearance of the effect dramatically.

Check Anti-aliased to soften the transition between the dark and light areas in the contour.

For the Style option of Outer Bevel or Inner Bevel, adjust the Range (the position of the bevel on the chosen contour) to minimize or maximize the prominence of the bevel.

7. If you want to add a texture to the effect, click Texture on the left side of the dialog, click a pattern in the picker, then do any of the following: C Adjust the Scale of the pattern.

Change the **Depth** to increase or reduce the contrast between the highlights and shadows in the pattern.

Check Invert to swap the highlights and shadows. This has the same effect as changing the Depth percentage from negative to positive, and vice versa.

Check Link with Layer to link the texture and layer so they will move as a unit when dragged in the document.

Drag in the document to reposition the texture within the effect; click Snap to Origin if you want to realign the pattern to its default location.

- 8. Click OK.
- For another use of the Emboss effect, see page 404.

SAVE YOUR SETTINGS!

If you produce a layer effect or combination of effects and Layers panel settings that you want to preserve for future use, save that collection of settings as a style on the Styles panel, then save the styles on the panel as a library (see page 401).

A We imported these original Illustrator objects into Photoshop as a Smart Object.

We applied the Pillow Emboss effect (Technique: Smooth).

We added the Texture option of the Emboss effect.

Applying a shadow effect

You can create an inner shadow or drop shadow with just a few clicks of the mouse.

To apply the Inner Shadow or Drop Shadow effect:

- On the Layers panel, double-click near a layer or group name to open the Layer Style dialog.
- 2. Click Inner Shadow or Drop Shadow.B-D
- Choose an overall Size for the shadow (in pixels).Choose a Distance value (in pixels) by which you want the shadow to be offset from the edge of the layer shapes.
 - You can reposition a drop shadow by dragging in the document while the dialog is open, but be aware that this will also reposition any other effects that are using the Global Light option.

Choose a **Choke** percentage for an Inner Shadow or a **Spread** percentage for a Drop Shadow to control where the shadow begins to fade.

4. Do any of the following (optional):

Choose a **Blend Mode** from the menu. (For a drop shadow, we usually keep this on the default setting of Multiply.)

To choose a different shadow **color**, click the color swatch, choose a color via the Color Picker or click a color in the document with the eyedropper (the color previews in the document), then click OK.

Choose an **Opacity** percentage for the transparency level of the shadow. For a drop shadow, we usually lower the Opacity below the default value of 75%.

Choose an **Angle** for the position of the shadow relative to the original layer shapes, and decide whether to check **Use Global Light**.

In the Quality area, click the **Contour** arrowhead and choose a preset in the picker for the edge profile of the shadow (we're usually content with the shape of the default Contour).

Check **Anti-aliased** to soften the edges between the shadow and the layer imagery.

Adjust the **Noise** level. The addition of noise (speckling) can help prevent banding on print output, but a very low value is best.

For the Drop Shadow effect, if the layer (not the effect) has a Fill value below 100% or has a

A This original image consists of an image layer (hammer and nail and transparent pixels) above a solid-color Background.

B We applied the Drop Shadow effect to the image layer.

C This image consists of an image layer (popsicle and transparent pixels) above a solid white Background.

We applied the Inner Shadow effect to the popsicle layer. Slurp.

- blending mode other than Normal, check Layer Knocks Out Drop Shadow to prevent the shadow from showing through the layer pixels.
- 5. Click OK. If you want to reshape the shadow, follow the steps below.

Depending on the time of day and the angle of the sun or other light source, cast shadows tend to be either short or elongated. You can reshape a drop shadow via the Distort command to mimic this natural effect.

To transform a Drop Shadow effect:

- 1. Apply the Drop Shadow effect to a layer (see the preceding instructions) and no other effects. Keep the layer selected.
- 2. To transfer the shadow effect to its own layer, rightclick the Effects listing on the Layers panel, then choose Create Laver from the context menu. If an alert dialog appears, click OK.
- 3. Click the new Drop Shadow layer.
- 4. Choose Edit > Transform > Distort, drag the handles of the transform box to slant the shape, or for a symmetrical perspective distortion, hold down Ctrl-Alt-Shift/Cmd-Option-Shift while dragging a corner handle. Press Enter/Return. Note: If you don't see all the handles, press Ctrl-0/Cmd-0 (zero) to fit the image in the document window.
- To link the image and shadow layers so they will move and transform as a unit, Shift-click them, then click the Link Layers button 🗭 at the bottom of the panel.
- To limit any painting or fill edits that you apply to the Drop Shadow layer to just the existing pixels on that layer, activate the Lock Transparent Pixels button on the Layers panel first.

A Starting with the image shown in figure B on the preceding page, we applied the Create Layer command to transfer the drop shadow to its own layer and then, as shown above, we applied a Distort transformation.

This is the final image, the Layers panel for which is shown at left. Note: We lowered the Fill setting for the Drop Shadow to 68%.

Applying the Stroke effect

The Stroke effect works particularly well on type.

To apply the Stroke effect:

- 1. Double-click near a layer or group name on the Layers panel to open the Layer Style dialog.
- 2. Click Stroke.
- 3. Do any of the following:

Choose a Size (width) for the stroke.

From the Position menu, choose a location for the stroke relative to the layer content: Outside, Inside, or Center.

For the Fill Type, choose Color, Gradient (see steps 3-5 below), or Pattern (see steps 3-4 on the next page) and choose settings for the options that become available.

You can also change the Blend Mode and Opacity percentage.

4. Click OK.A

Applying the Gradient and **Pattern Overlay effects**

You can apply the Gradient Overlay and Pattern Overlay effects to an image, shape, or type layer. On an image layer, the overlays work effectively whether the layer contains transparency or not. (Color Overlay, not covered here, works the same way.)

To apply the Gradient Overlay effect:

- 1. Double-click near a layer or group name on the Layers panel to open the Layer Style dialog. B
- 2. Click Gradient Overlay. C-D
- 3. Click the Gradient arrowhead, then click a gradient on the picker. (To load gradients from another library, choose a library name from the lower part of the picker menu; see page 131.) You could also click the gradient thumbnail and edit the gradient.
- 4. From the Style menu, choose Linear, Radial, Angle, Reflected, or Diamond.
- 5. Do any of the following (optional):

Change the Blend Mode.

Check **Dither** to help prevent noticeable color bands in the gradient on print output.

Adjust the Opacity of the overlay.

Check Reverse to swap the position of the colors in the gradient.

We applied the Stroke effect to a type layer, with Gradient selected as the Fill Type.

B We began by applying a Bevel effect (Inner Bevel style) to some type.

	Layer Styl	e
Gradient Ove Gradient	erlay	
Blend Mode:	Normal	Dither
Opacity:		100 %
Gradient:		Reverse
Style:	Reflected	Align with Layer
Angle:	23	Reset Alignment
Scale:		77 %
	Make Default	Reset to Default

In the Layer Style dialog, we added the Gradient Overlay layer effect, choosing these settings.

This is the Gradient Overlay effect (added to the Bevel effect).

Change the Angle of the gradient.

Choose a Scale percentage to control how gradually the gradient colors transition across the layer.

Drag in the document to reposition the gradient within the layer shapes. To reset the gradient to its default position at any time, click Reset Alignment.*

- 6. Check Align with Layer to fit the gradient within just the nontransparent pixels, type, or shape on the layer, or uncheck this option to center the gradient on the full layer.
- 7. Click OK.
- If you apply two overlay effects to the same layer (e.g., Gradient Overlay and Pattern Overlay), lower the opacity of the one that's listed first in the dialog; otherwise the bottom one won't be visible.

Patterns that you apply via the Pattern Overlay effect can range from those that have an obvious repeat, such as polka dots or stripes, to overall textures resembling "real" surfaces, such as gritty sandpaper, handmade paper, woven fabric, or variegated stone.

To apply the Pattern Overlay effect:

- 1. Double-click near a layer or group name on the Layers panel to open the Layer Style dialog.
- 2. Click Pattern Overlay.
- 3. Click the Pattern arrowhead, then click a pattern preset in the picker. To load patterns from another library, choose a library name from the lower part of the picker menu (see page 131). To create a custom pattern, see page 217.
- 4. Do any of the following (optional): Change the Blend Mode.

Adjust the Opacity of the overlay.

Drag in the document to reposition the pattern; click Snap to Origin to realign the pattern with the upper-left corner of the document.

Choose a Scale percentage for the pattern size.

Check Link with Layer to link the pattern to the layer so they'll move as a unit if you drag the layer.

5. Click OK.A

A To produce these metallic letters, we created a pattern from a photograph of rusted metal, then applied it as a Pattern Overlay layer effect. (We also applied the Drop Shadow and Emboss effects.)

SCALING LAYER EFFECTS

To scale just the effects on a layer without scaling other layer content, right-click the Effects listing and choose Scale Effects from the context menu, then specify the desired Scale percentage in the dialog.

APPLYING THE SATIN EFFECT

To make the surfaces of objects, type, or brush strokes look reflective or metallic, use the Satin effect.

- ➤ If the Satin effect doesn't look noticeable, try increasing the Distance and/or Size values.
- ➤ Before adding the Satin effect to type, or to intensify its effect, give the type a medium or light color and apply a strong Inner Glow or Bevel effect.

To the type shown in figure B on the preceding page (which has an Inner Bevel), we added the Satin effect.

Copying, moving, and removing layer effects

If you like how an individual effect looks on one layer or group, you can copy or move it to another layer or group; no existing effects are deleted from the target layer. However, if an existing effect has the same name as an incoming effect, the new settings will override the existing ones. If you move *all* the effects from one layer to another, the incoming effects will replace any and all existing effects on the target layer, and will be removed from the source layer.

To copy an individual effect from one layer to another:

Alt-drag/Option-drag an individual effect name from one layer or group to another. The original effect stays where it is, and a copy of the effect appears in the target layer or group.

If you move a layer into a group to which layer effects are applied, those effects will be applied to the newly added layer.

To move an effect to another layer:

Drag an individual effect name from one layer to another. The effect is removed from the source layer and appears in the target layer.

To move all the effects from one layer to another:

Drag the Effects listing from one layer or group to another. All effects on the target layer will be replaced with the effects from the source layer.

Clicking to remove the visibility icon for a layer effect or unchecking the box for an effect in the Layer Style dialog doesn't remove the effect—it merely hides it from view. If you want to permanently delete one or all effects from a layer, do as follows.

To remove layer effects:

Do either of the following:

Drag a single effect name to the Delete Layer button at the bottom of the Layers panel.

To remove all the effects from a layer, drag the Effects listing over the Delete Layer button.

If you turn off an effect via the check box in the Layer Style dialog and then check it to turn it back on again, the last-used options for that effect will be reapplied.

LAYER EFFECTS ARE LIVE

Layer effects reshape automatically when you edit the object(s) they're applied to, as illustrated below.

We applied the Emboss, Gradient Overlay, Outer Glow, and Drop Shadow effects to the type layer, and the Inner Glow and Drop Shadow effects to the image layer.

When we shrank the image layer and added a type character, the effects updated automatically.

Changing the layer fill percentage

The Fill feature on the Layers panel affects the opacity of a layer, excluding any layer effects (as shown below), whereas the Opacity feature controls the opacity of a layer, including any layer effects (see page 158).

To change the layer fill percentage:

- 1. Click any kind of layer (not the Background) or select multiple layers.A
- 2. On the Layers panel, set the Fill percentage (you can use the scrubby slider). B The lower the Fill value, the more content from the underlying layer(s) is revealed.

To change the layer fill percentage via the Layer Style dialog, click Blending Options on the left side, then adjust the Fill Opacity setting.

A This image contains three image layers and an editable type layer. The Drop Shadow effect is applied to all the layers.

B When we lowered the Fill percentage of the type layer to 60%, the layer opacity changed but the Drop Shadow effect remained at full opacity. When we lowered the Opacity of the basil and bay leaf image layers to 70%, the drop shadows on those layers also became lighter.

Applying layer styles

You can conveniently store multiple layer settings collectively as a style on the Styles panel. The style will include layer effects (e.g., Drop Shadow, Outer Glow) and/or blending options (blending mode and laver opacity and fill settings). Once stored, styles can be quickly applied to a type, image, or shape layer. To acquaint yourself with this panel, apply one of the predefined styles to a type layer or to a layer that contains some transparency.

To apply a style to a laver:

- 1. Show the Styles panel. A You can load additional style libraries onto the panel via the panel menu.
- 2. Do either of the following:
 - Click a layer (not the Background) on the Layers panel, then click a style on the Styles panel. A-D Double-click a layer to open the Layer Style dialog, click Styles at the top left, click a style thumbnail, then click OK.
- Normally, when you apply a style, it replaces any and all existing effects on the current layer. If you want to add the effects from a style to the existing effects on a layer, hold down Shift as you click the desired style. Note: Whether or not you hold down Shift, if two effects have the same name, the settings in the incoming style will replace the old.

To remove styling from a layer:

Click a (hidden or visible) layer that contains layer style edits, then click the Clear Style button On the Styles panel (or right-click the layer listing and choose Clear Layer Style from the context menu). All layer effects are removed, the layer Opacity is reset to 100%, and the blending mode is reset to Normal

A Click a layer, then click a style thumbnail on the Styles panel.

B Web Styles library > Blue Paper Clip

Abstract Styles library > Rose Impressions

KS Styles library > Lightning

E Styles can also be applied to a layer via the Layer Style dialog. Click Styles at the topleft side of the dialog, then click a thumbnail.

Creating layer styles

In addition to using the layer style presets, you can create and save custom layer styles. You can use an applied preset as a starting point or begin from scratch with your own settings. An option is provided via a dialog for the style to include the layer effects and/or the blending option settings that are applied to the currently selected layer.

To save a style to the Styles panel:

- 1. To any layer, apply the effects settings and/or blending option settings that you want to save collectively as a style.
- 2. Do either of the following:

On the Layers panel, click the layer that contains the desired settings, A then on the Styles panel, click either the blank area or the New Style button. B

On the Layers panel, double-click the layer that contains the desired settings, then on the right side of the Layer Style dialog, click New Style.

- 3. In the New Style dialog, enter a name for the new style, check whether you want to Include Layer Effects and/or Include Layer Blending Options (e.g., layer blending mode, opacity, and fill opacity settings) in the style, then click OK. If the Layer Style dialog is open, click OK to exit. The new style appears as the last listing or thumbnail on the Styles panel, and can be used in any document. C-D
- 4. Your custom styles will be deleted from the Styles panel if you allow them to be replaced by another library or if the Adobe Photoshop CC 2014 Prefs.psp file is deleted or damaged. To save the styles on the panel as a permanent library, choose Save Styles from the Styles panel menu, enter a name, keep the default location, then click Save again. (See also page 131 or 133.)
- To copy a style between layers, right-click the layer that contains the desired effects and settings and choose Copy Layer Style. Click the target layer, then right-click it and choose Paste Layer Style. The incoming style will replace any existing style settings on the target layer.
- You can't edit an existing style on the Styles panel, but you can apply a style, edit the settings, and save the new settings as a new custom style.

A On the Layers panel, we clicked a layer that contains the effects and/or other settings to be saved as a style.

B On the Styles panel, we clicked the New Style button.

C Our new custom style appeared at the bottom of the panel.

We applied the new style to a shape layer in another document.

Applying multiple layer effects

With the exception of Drop Shadow and Overlay, layer effects tend to produce a more convincing visual illusion when applied in combination, as in the example shown here A-B (and A-C, next page) and on page 404. After applying a series of effects, remember to preserve your settings as a layer style — and in a custom library!

MAKING TYPE LOOK LIKE RUSTED METAL

A We created editable type (Bauhaus 93 Regular font, 223 pt.) above a photo of rusted metal.

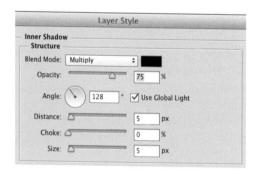

L	ayer Style		
Outer Glow Structure			
Blend Mode: Screen	‡		
Opacity:	75	ж	
Noise:	0	%	
• • • •]	
Elements			
Technique: Softer \$			
Spread:	5	%	
Size:	6	рх	

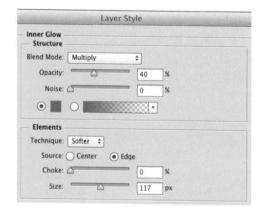

	La	yer Style				
Drop Shadow Structure						
Blend Mode:	Multiply	\$				
Opacity:						
Opacity.		7	5	%		
Angle:	128		Use Glo		ht	
	128		Use Glo		ht	
Angle: (128	<u>a</u>	Use Glo	bal Lig	ht	

B We applied the Inner Shadow, Inner Glow, Outer Glow, and Drop Shadow effects, using the settings shown above.

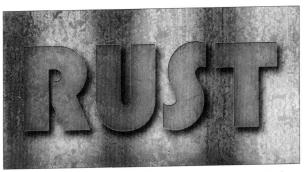

A To reveal some of the underlying layer within the type, we lowered the Fill percentage of the type layer.

B To further "corrode" the edges of the letters, we Ctrl/Cmd clicked the type layer thumbnail to create a selection from the characters, clicked the Add Layer Mask button, then applied Filter > Filter Gallery > Brush Strokes > Spatter. The filter roughed up the edges of the mask. This is the Layers panel for the final image, which is shown below.

RASTERIZING LAYER STYLES AND **EFFECTS**

- To rasterize all the layer style settings on the current layer, including layer effect, blending mode, opacity, and fill settings, click a layer that contains layer styles (or select multiple layers), then choose Layer > Rasterize > Layer Style. Beware! If you apply this command to a type or shape layer, or to a Smart Object, the layer content will also be rasterized.
- ➤ To flatten all the layer effects in a document — on all layers — choose File > Scripts > Flatten All Layer Effects. Like the Rasterize > Layer Style command, this script will rasterize all type, shape, and Smart Object layers that contain effects.

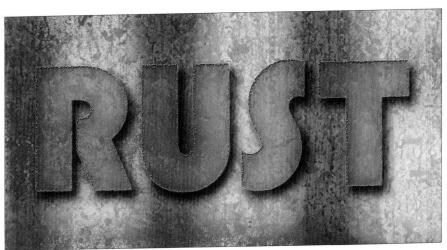

C The Spatter filter added just the finishing touch we were after. (You can try the Distort > Glass filter instead of Spatter.)

EMBOSSING LEATHER

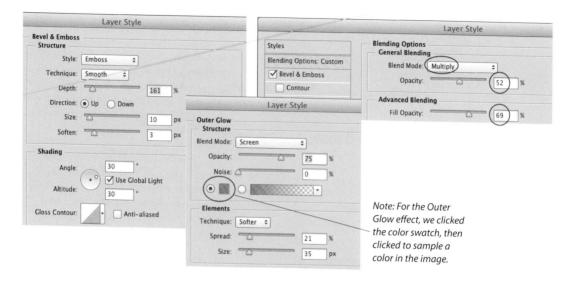

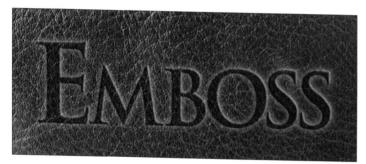

To create these embossed letters, we opened a photo of leather and created some type (Trajan Pro font, Bold, 112 pt.). We chose the Move tool, clicked the Color swatch on the Character panel, chose a color for the type by clicking in the image (eyedropper pointer), then exited the Color Picker. In the Layer Style dialog, we chose the Emboss and Outer Glow settings shown above, and in the Blending Options option set of the same dialog, chose the layer settings of Multiply mode, Opacity 52%, and Fill Opacity 69%.

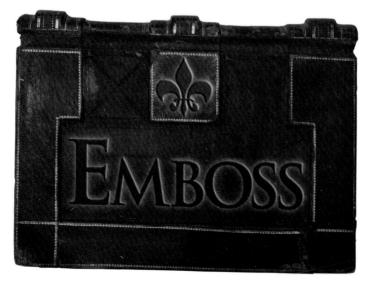

We saved the settings shown above as a layer style, then applied it to a type layer above a Background photo of a leathercovered book. We changed the color of the Outer Glow effect by sampling a light area in the image, and also lowered the layer Fill Opacity value to 10%.

The shape and path tools in Photoshop produce vector objects, which have crisp and precise edges, like objects in a vector drawing program. You can use these tools to add a precisely drawn element to a photo (such as a filled rectangle or ellipse), to produce a precisely-shaped selection, or to create a sharp-edged mask that hides areas of a layer. Unlike pixel layers, vector objects are resolution independent, meaning they print at the resolution of the output device (not at the resolution of the file) and keep their original crispness when transformed or exported.

Before you create a vector object, you must decide whether it will be stored as a colored shape on its own layer on the Layers panel (with a built-in Shape Path that is listed on the Paths panel when the shape layer is selected), or as a path on the Paths panel (a wireframe object not associated with any layer, from which you can produce a vector mask, a selection, or a filled pixel area). You can create a vector object by using one of the shape or pen tools or by converting an existing selection. An existing vector object can be reshaped via the usual transform controls or, as we show you on page 424, by manipulating its segments or anchor points.

Aligning vector objects for Web output

- ➤ To minimize anti-aliasing along horizontal and vertical edges of objects for sharper rendering onscreen, before you create, transform, or edit any vector objects, go to Edit/Photoshop > Preferences > General and verify that Snap Vector Tools and Transforms to Pixel Grid is checked. Photoshop will snap the bounding box of a shape, or anchor points that are created with the Pen tool, to the pixel grid. (To view the grid, choose View > Show > Pixel Grid and zoom in to 600% or greater.)
- ➤ To have Photoshop minimize or remove anti-aliasing from the edges of a selected shape that was created with the "Snap Vector Tools" preference off, check Align Edges on the Options bar. Horizontal and vertical edges of the shape that touch the edges of its bounding box will be aligned to the pixel grid. Note: This feature may offset the stroke on an object from its path.

21

IN THIS CHAPTER

Creating shape layers with a shape tool
Changing the attributes of a shape layer
Selecting shape layer paths
Isolating a shape layer
Working with multiple shapes413
Creating vector masks
Working with vector masks
Drawing with the Freeform Pen tool418
Saving, displaying, selecting, and repositioning paths418
Drawing with the Pen tool
More ways to create paths and shapes
Reshaping vector objects
Working with paths

Creating shape layers with a shape tool

The easiest way to create a shape layer is by using one of the ready-made presets, as in the steps here. Later in this chapter, you'll learn how to draw custom shapes.

Note: If you want to use a shape tool to produce a path instead of a shape, follow steps 1–3 in the task on page 415.

To create a vector shape:

- 1. On the Layers panel, click the layer (not a shape layer) above which you want a new shape layer to appear.
- 2. On the Tools panel, choose one of the shape tools (U or Shift-U). A
- From the Tool Mode menu, choose Shape.

 You can choose fill and stroke settings from the Options bar now, or change the shape properties after finishing this task (see the next two pages).

 Open the tool options menu. If it lists an Unconstrained option, make sure it's selected. If you're using the Custom Shape tool, click a shape on the Custom Shape picker (or right-click in the image and choose from the preset picker on the context menu).
- 4. To produce the shape, do either of the following:

 Drag in the document. To constrain the proportions of the shape, hold down Shift while dragging. C-D

 Click in the document. A dialog opens. Enter values and choose settings, then click OK.
 - A new vector shape layer appears on the Layers panel. All the Layers panel settings are available for it (e.g., blending mode, opacity, layer effects).
- To load more libraries onto the Custom Shape picker, see page 131 or 133.
- To reposition a shape layer, see page 157.
- ➤ To draw a straight, solid line, we use the Pen tool:
 One click to start the line, a second click to finish it, then Ctrl-click/Cmd-click to deselect it.
 We prefer this method to using the Line (shape) tool, which produces a very thin, hollow rectangle.

A We chose the Custom Shape tool on the Tools panel.

B On the Options bar, we chose the Shape option from the Tool Mode menu and a preset from the Custom Shape picker.

Next, we Shift-dragged to produce this shape.

D The last-used fill and stroke attributes appeared in the shape layer. (To reveal the underlying wood texture within it, we chose Color Burn as the layer blending mode.)

Changing the attributes of a shape layer

You can change many attributes of a shape layer. For example, you can change the interior (fill) color or the edge (stroke) color, or for either component, you can apply a color of None. You can change the details of a stroke, such as the width, style (solid, dotted, or dashed), alignment, cap style, and corner style. And you can change unique properties for specific kinds of shapes, such as the radius of one or more corners of a Rounded Rectangle.

To change the properties of a shape layer:

1. To access the properties controls, do as follows: If you just created a new Rectangle, Rounded Rectangle, or Ellipse shape layer, and if Show on Shape Creation is checked on the Properties panel menu, that panel will open automatically.

On the Layers panel, click one or more existing Rectangle, Rounded Rectangle, or Ellipse shape layers. Choose the **Path Selection** tool (A or Shift-A), click the shape(s) in the document, show the Properties panel, then click the Live Shape Properties button.

For other kinds of shapes, click one or more layers, then use the Options bar.

2. To recolor the shape(s), click the Fill Color or Stroke Color swatch to open the picker, then do any of the following (when you're done using a picker, click outside it to close it):

Click the **No Color** button \square to apply a fill or stroke color of None.

Click the Solid Color button, then click a color swatch; A or click the Color Picker button, choose a color, then click OK. Colors that you try out are added as temporary swatches below Recently Used Colors.

Click the **Gradient** button to display a gradient editor, then click a gradient swatch. B To add another color stop, click below the bar. To recolor a stop, double-click the stop to open the Color Picker, choose a color, then click OK. To use the other controls on the picker (e.g., add opacity stops, change the gradient style or angle), see pages 214–215.

Click the Pattern button, click a pattern swatch, and adjust the Scale percentage, if desired.

To load other libraries onto the Solid Color, Gradient, or Pattern preset picker, see page 131.

Continued on the following page

A We clicked the Fill Color swatch to open the picker, clicked the Solid Color button, clicked a few colors, then clicked our favorite swatch under Recently Used Colors.

B We clicked the Gradient button, then clicked a gradient swatch.

We clicked the Pattern button, then clicked a pattern swatch (we also applied a color to the object's stroke).

3. To change the stroke details of a Rectangle, Rounded Rectangle, or Ellipse, you can use the Properties panel or Options bar; for other kinds of shapes, you must use the Options bar or the Stroke Options picker on the Options bar:

Change the Stroke Width value.

Click the **Stroke Options** picker, then click a stroke preset in the scrolling window.**B**

From the **Align** menu, choose an option for the position of the stroke on the path.

From the **Caps** menu, choose an option for the shape of the stroke at the endpoints — if the path is open — or for the shape of dots or dashes.

From the **Corners** menu (Stroke Options picker) or **Join** menu (Properties panel), choose an option to make angles in the path (if any) mitered, round, or beveled.

- To create and save a custom dashed or dotted stroke, see Photoshop Help.
- Optional: To save customized stroke details as a preset, choose Save Stroke from the picker menu.
- 5. To change other properties of the shape, do any of the following, if available:

To resize the shape, change the **W** and/or **H** values. To move the shape to an exact location, change the **X** and/or **Y** values.

To adjust the **radius** of any individual corner in a Rectangle or Rounded Rectangle, make sure the Link icon is deactivated, and use a corner icon as a scrubby slider or enter a value in the field. Or to adjust the value of all four corners simultaneously, activate the Link icon, then change any one value (A-C, next page).

A This is the original shape layer.

B We chose a dotted preset from the Stroke Options picker on the Properties panel.

 ℂ We changed the Align setting to Outside. The screen capture at right shows the selected path.

A This document contains a Rectangle shape layer above an image layer. (The blending mode of the shape layer is set to Multiply, and the Opacity of the layer is 50%.)

B Via the Properties panel, we changed the stroke width and color and chose a different radius value for two of the corners.

C The results of our Properties panel edits are shown here.

To copy properties from one shape layer to another:

Do one of the following:

To copy a fill or stroke color, gradient, or pattern between shapes, click a shape layer, and choose the Path Selection tool (A or Shift-A). From the menu on the Fill Color or Stroke Color picker on the Options bar or Properties panel, choose Copy [Fill or Stroke]. Click another shape layer, then choose Paste [Fill or Stroke] from the same menu.

To copy stroke details (not colors) between shapes, click a shape layer. From the menu on the Stroke Options picker on the Options bar or Properties panel, choose Copy Stroke Details. Click another shape layer, then choose Paste Stroke Details from the same menu. Note: If the new details don't appear, make sure the target shape has a Stroke color (not a setting of None).

To copy all the stroke and fill settings from one shape to another, including the colors and stroke details, right-click a shape layer and choose **Copy Shape Attributes** from the context menu. Click another shape layer, then choose **Paste Shape Attributes** from the context menu.

Only one set of fill and stroke settings (e.g., one fill color, stroke color, and stroke option preset) can be applied to a given shape layer. You can't apply unique settings to a subshape within a multishape layer.

To load a shape layer as a selection:

Hold down Ctrl/Cmd and click the shape layer thumbnail on the Layers panel.

To convert a shape layer to a standard pixel layer, right-click the shape layer and choose Rasterize Layer from the context menu. If you want to restrict future image edits to the newly rasterized shape areas, activate the Lock Transparent Pixels button and on the Layers panel.

CREATING BUTTONS FOR A WEB PAGE

To create buttons for a Web page, draw some vector shapes, then apply a layer style to them via the Styles panel (see page 400). To align and redistribute the shape layers, see page 281.

Selecting shape layer paths

To select whole shape layer paths:

- 1. Choose the Path Selection tool (A or Shift-A).
- 2. Do either of the following:

From the Select menu on the Options bar, choose All Layers to allow the tool to select any shapes that you drag across, regardless of which listings are selected on the Layers panel.A

On the Layers panel, hold down Ctrl/Cmd and click all the layers that you want to potentially include in a selection. From the Select menu on the Options bar, choose Active Layers.

3. Drag across the shapes that you want to select. Note that if you drag across part of a shape, the entire shape will become selected. B-E (and A-D, next page).

Anchor points on the shape paths became selected and visible ...

A We chose the Path Selection tool, then chose All Layers from the Select menu on the Options bar.

B Although only one layer happens to be selected on our Layers panel ...

C ... when we dragged across an area in our document, we were able to select shapes from multiple layers.

🖺 ... and the respective layer listings for the three shapes we dragged across became selected

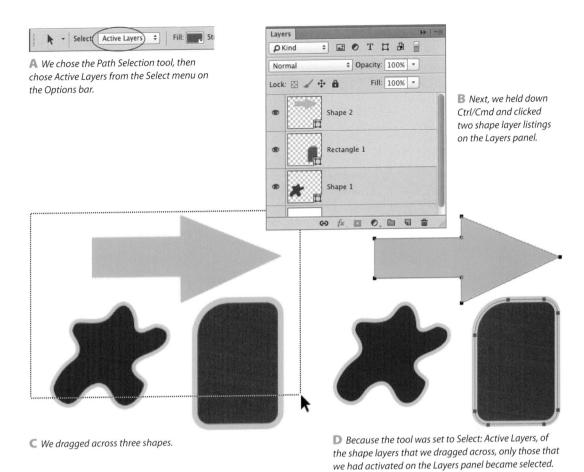

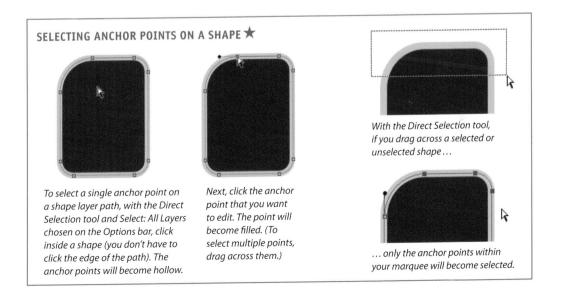

Isolating a shape layer

When you isolate a shape layer, editing is temporarily limited to just that shape, and no other layers can be edited (note that the entire document remains visible).

To isolate a shape layer: * Method 1

- 1. Choose the Path Selection or Direct Selection tool (A or Shift-A selects whichever of the two tools was used last).
- 2. On the Option bar, choose Select: All Layers.
- 3. In the document, double-click a shape. A

Method 2

- 1. Choose the Path Selection or Direct Selection tool.
- 2. On the Option bar, choose Select: Active Layers.
- 3. On the Layers panel, click the listing for the shape layer that you want to edit.B

To de-isolate a shape layer and redisplay all layer listings on the Layers panel:

- 1. On the Options bar, make sure Select: All Layers is chosen
- 2. Choose the Path Selection or Direct Selection tool.
- 3. Double-click on or outside the isolated shape.
- To filter layer listings on the Layers panel of a specific category, such as all shape or type layers, see pages 160-161.
- To clear all filtering from the Layers panel (even if the Layer Filtering On/Off button is activated), choose the Move, Path Selection, Direct Selection tool, or a pen tool, then right-click in the document and uncheck Isolate Layers on the context menu. *You can also clear filtering by unchecking Select > Isolate Layers.

A If you isolate a shape layer by doubleclicking it in the document, that layer (temporarily) becomes the solo listing on the Layers panel.

B If you isolate a shape by choosing Select: Active Layers, then click its layer listing, all the layer listings will remain visible on the panel.

Working with multiple shapes

To reposition or copy a shape:

- 1. On the Layers panel, click a shape layer.
- 2. Choose the Path Selection tool (A or Shift-A).
- 3. Drag a shape to a new location; or to copy the shape, hold down Alt/Option before and while dragging (the copy will appear in the same layer).
- To delete one shape in a multishape layer, with the Path Selection tool, click the shape you want to discard, then press Backspace/Delete.

To combine multiple shape layers into one layer:

- 1. On the Layers panel, select two or more shape layers. A The layers don't have to be consecutive.
- 2. Choose the Path Selection tool (A or Shift-A).
- 3. Right-click in the document and choose Unite Shapes. B Or to unite only the intersection of two overlapping shapes, choose Unite Shapes at Overlap. C—D All the shapes will adopt the fill and stroke settings of the uppermost of the selected layers; the other selected layers will be discarded. (For a different result, you could choose Subtract Front Shape or Subtract Shapes at Overlap.)

To align shapes within the same layer:

- 1. Choose the Path Selection tool (A or Shift-A).
- **2.** In the document, Shift-click two or more shapes that reside on the same layer.
- **3.** From the **Path Alignment** menu and on the Options bar, choose one or more options (e.g., Top Edges).
- To align multiple shape layers, see page 281.

To unite, subtract, intersect, or exclude shapes within the same layer:

- On the Layers panel, click a layer that contains multiple shapes.
- 2. Choose the Path Selection tool (A or Shift-A).
- **3.** To see the effect of the button you will click in the next step, make sure that at least some area of two or more shapes overlap one another.
- 4. If you selected Rectangle, Rounded Rectangle, or Ellipse shapes, on the Properties panel, amake sure the Live Shape Properties are displaying; for other kinds of shapes, use the Path Operations menu on the Options bar. Click the Combine, Subtract, Intersect, or Exclude button.

A This document contains three shape layers.

B The Unite Shapes command combined all the shapes into one.

• We started with these two shape layers.

We chose the Unite Shapes at Overlap command.

ADDING A SHAPE TO A LAYER USING PATH OPERATIONS

To control how shapes interact as you add a shape to an existing layer, before drawing the shape with a shape tool, click a shape layer, choose an option from the Path Operations menu on the Options bar (the current Path Operations choice displays as the icon for the menu). Or to add a shape to an existing layer without having to use the Path Operations menu, drag with Shift held down; to subtract from an existing shape, drag with Alt/Option held down.

Creating vector masks

Like a pixel mask, the function of a vector mask is to hide areas of a layer. We'll show you how to create a vector mask from a shape layer or path, from a new path that you draw, and from a type layer.

To create a vector mask from a shape layer:

- 1. Arrange a shape layer so it overlaps the content of the layer to be masked (if needed, restack it via the Layers panel and/or reposition it). A
- 2. Hold down Ctrl-Alt/Cmd-Option and drag the shape layer listing over an image, type, adjustment layer, or layer group listing (not the Background). Release when a rectangular border appears around the target laver.
- 3. Hide the shape layer. В−С

A We created a shape layer with the Custom Shape tool (Flower 1 preset, Shapes library).

B We dragged from the shape layer to the image layer; the shape appeared within a new vector mask. Finally, we hid the shape layer.

To create a vector mask from an existing path:

- adjustment layer or layer group to which you want to add a vector mask (not the Background).
- 2. On the Paths panel, The click a path listing.
- 3. Choose the Path Selection tool (A or Shift-A), then position the path over the layer content to be masked.
- 4. Right-click inside the document and choose Create Vector Mask from the context menu (A-B, next page).

The mask is hiding parts of the image layer.

A We created a path with the Custom Shape tool (Talk 4 preset, Talk Bubbles library), clicked an image layer, selected the path, then chose the Create Vector Mask command.

To create a vector mask by drawing a path:

- 1. Choose a shape tool (U or Shift-U), the Pen tool, or the Freeform Pen tool (P or Shift-P).
- 2. From the Tool Mode menu on the Options bar, choose Path. If you're using the Custom Shape tool, also click a shape on the Custom Shape picker.
- 3. If you chose a shape tool, drag in the document, or Shift-drag to constrain the proportions of the object. ☐ (If you want to reposition the path while it's being drawn, also hold down the Spacebar.)

 Optional: After drawing a path with the Rectangle, Rounded Rectangle, or Ellipse tool, you can change some of its properties via the Properties panel. ★

 If you chose the Pen or Freeform Pen tool, draw a path. To learn how to use the Pen tool, see pages 420–422, or for the Freeform Pen tool, see page 418.
- 4. On the Layers panel, click the image, type, adjustment layer, or layer group to which you want to add a vector mask (not the Background).
- 5. On the Options bar, click the Mask button.

■ We dragged to produce a path with the Custom Shape tool (Diamond Card preset, Shapes library).

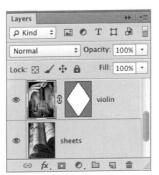

D We clicked the violin layer, then clicked the Mask button on the Options bar, which converted the path to a vector mask on the current image layer. The mask is hiding parts of the violin layer.

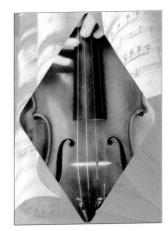

To create a vector mask from type:

- Create an editable type layer. A
- 2. Right-click the type layer listing and choose Create Work Path. Hide the type layer.
- 3. On the Layers panel, click an image layer or adjustment layer or a layer group, then Ctrl-click/ the layer has a layer mask, you can click the button without holding down Ctrl/Cmd.)

MORE ESSENTIAL VECTOR MASK TOPICS

- To move or copy a vector mask to another layer, see page 194.
- ➤ To disable or delete a vector mask, see page 194.
- ➤ To lower the density of a vector mask, or to feather its edges, see page 192.
- To reshape a vector mask, click the mask thumbnail on the Layers panel, then either use Edit > Free Transform Path (see pages 348–349) or manipulate the points or direction lines on its path (see page 424).

A This is an editable type layer.

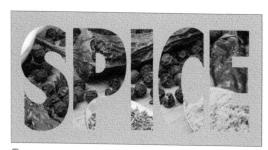

B We created a work path from the type layer, then used the path to create a vector mask on an image layer.

Working with vector masks

By moving a vector mask separately from the layer content, you can hide a different area of the layer.

To reposition a vector mask:

- 2. Choose the Path Selection tool (A or Shift-A).
- **3.** If the mask contains multiple subpaths (such as type shapes), Shift-click the ones you want to reposition.
- 4. Drag in the document.A-B
- ➤ To move the layer content instead of the mask, on the Layers panel, click the Link icon the layer and vector mask thumbnails (the icon disappears). Click the layer thumbnail, drag in the document with the Move tool, then click between the thumbnails to restore the Link icon.

You can switch the hide and reveal functions of a vector mask.

To switch the function of a vector mask:

- 1. Choose the Path Selection tool (A or Shift-A).
- 2. On the Layers panel, click a vector mask thumbnail.

 □
- If the path segments and anchor points aren't selected, click the path or drag a marquee around it.
- **4.** From the Path Operations menu on the Options bar, choose **Subtract Front Shape**, or press (minus key).
- ➤ To restore the default reveal and hide functions to a vector mask, choose Combine Shapes from the Path Operations menu on the Options bar, or press + (plus key).

If a layer contains both a layer (pixel) mask and a vector mask, the layer mask thumbnail will be adjacent to the layer thumbnail (on the left), followed by the vector mask thumbnail (on the right).

To convert a vector mask to a layer mask:

- **1.** *Optional:* To preserve a copy of the vector mask, on the Layers panel, duplicate its whole layer.
- 2. Right-click the vector mask thumbnail and choose Rasterize Vector Mask from the context menu.

B ... to reveal a different part of the image within the mask shape.

We selected the leaf-shaped vector mask...

... then switched the function of the mask by pressing – (minus key).

Drawing with the Freeform Pen tool

The simplest way to draw a custom object is with the Freeform Pen tool. It produces bumpier and less precise curves than the Pen tool, but if you're new to vector drawing, it's a good tool to start with. If you have a stylus and tablet, use them.

To use the Freeform Pen tool:

- 1. Choose the Freeform Pen tool (P or Shift-P).
- From the Tool Mode menu on the Options bar, choose Path or Shape.
- 3. If you're going to draw a path, display the Paths panel, 1 then click the New Path button.
- 4. Drag to draw a shape or path, then release the mouse. If you want to close the shape, drag the pointer over the starting point (a little circle displays in the pointer); otherwise, just release. A—C Note: When you use the Freeform Pen tool, Photoshop creates the anchor points needed for the path. The higher the Curve Fit value you chose for the tool (options menu on the Options bar), the smoother the path and the fewer anchor points are created, but the less precisely the path follows the movement of your mouse.

Saving, displaying, selecting, and repositioning paths

Note: The features discussed in this section apply only to path listings on the Paths panel (not to shape layers or their respective mask listings on the Paths panel).

If you draw a path without clicking the New Path button (or an existing path listing) on the Paths panel first, the path will be listed on the panel as a temporary Work Path. If you deselect the Work Path listing and then proceed to draw another path, the current Work Path will be replaced by a new Work Path. Due to the fleeting nature of the Work Path listing, we recommend always clicking the New Path button before drawing a path (we'll remind you to do this in our instructions). If you forget to create a new path listing before you start to draw, don't worry — you can still save the current Work Path as a permanent path, as described in the first task on the next page.

Note: If you click a Work Path or other listing on the Paths panel and then draw a new path, the new path will appear as a subpath within the same listing. To learn about combining paths, see page 425.

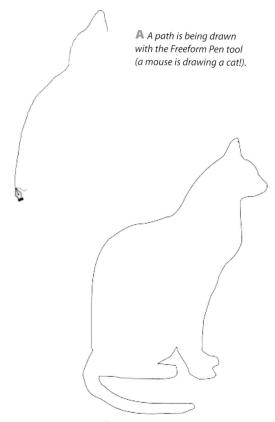

B The path is completed.

The new path displays in the thumbnail on the Paths panel.

DRAWING STRAIGHT SIDES WHILE USING THE FREEFORM PEN TOOL

Start dragging with the Freeform Pen tool, keep the mouse button down, hold down Alt/Option and click to create points (straight sides), press the mouse button, release Alt/Option, then continue drawing.

To save a Work Path as a permanent path:

On the Paths panel, and do either of the following: Double-click the **Work Path** listing. The Save Path dialog opens. Change the name, if desired, then click OK.

To save the path under a default name, drag the Work Path listing to the **New Path** button.

- To rename a saved path, double-click the existing name, type a new name, then press Enter/Return.
- If you want to name a permanent path as you create it, Alt/Option click the New Path button, enter a name in the New Path dialog, then click OK.

To display one or more paths:

- On the Paths panel, a click a path listing. The path displays in the document window (or multiple paths display, if the listing contains subpaths). A-B
- **2.** Optional: Hold down Ctrl/Cmd and click one or more additional path listings.

To hide one or more paths:

Do either of the following:

To hide all currently displayed paths, either hold down the A key and press Esc, or on the Paths panel, click the blank area below all the listings. To hide just one of several visible paths, hold down Ctrl/Cmd and click a path listing on the Paths panel.

To open a dialog in which you can change the size of the thumbnails on the Paths panel, choose Panel Options from the panel menu.

When you select a path, its anchor points become visible and accessible, ready for editing.

To select one or more paths:

- 1. Show one or more paths, as described in "To display one or more paths," above.
- 2. Choose the Path Selection tool (A or Shift-A).
- 3. Do either of the following:

Click the edge of a path. If desired, Shift-click additional paths or subpaths.

Drag a marquee across multiple paths. (Note that if you use this method, any shape layers that you drag across will also become selected.)

When you deselect a path, its anchor points become hidden, but its listing on the Paths panel stays selected.

To deselect one or more paths:

Do either of the following:

To deselect all paths, choose a path selection or pen tool, then hold down Ctrl/Cmd and click a blank area of the artboard.

To deselect one path in a multiple selection, choose the **Path Selection** tool, then Shift-click one of the selected paths.

To reposition one or more paths:

- 1. Follow steps 1–3 in "To select one or more paths," on this page.
- 2. Drag the edge of one of the paths.

Drawing with the Pen tool

With the Pen tool, you can create shapes or paths. Shapes are listed on the Layers panel (and when a shape layer is selected, its path is also listed on the Paths panel); paths are listed only on the Paths panel. Depending on how you use the Pen, you can draw straight sides, smooth curves, nonsmooth curves — or a combination thereof (see the sidebar on page 423).

To draw a straight-sided path or shape with the Pen tool:

- 1. Choose the **Pen** tool (P or Shift-P).
- 2. On the Options bar, do the following:
 From the Tool Mode menu, choose Path or Shape.
 On the tool options menu, ... check Rubber Band.
- 3. If you chose the Path option, on the Paths panel, click the New Path button. If you chose the Shape option, choose Select > Deselect Layers, then choose fill and stroke attributes via the Options bar. These attributes can easily be changed later.
- 4. Click to create the first anchor point, then click to create a second one; a straight segment will connect them automatically. A The last-created point will be solid (selected), then will become deselected (hollow) when you create the next point.
- Click to create additional anchor points. To constrain a straight segment to an increment of 45°, hold down Shift while clicking.
- 6. To complete the object, do one of the following: To close the object and keep it selected, position the pointer over the starting point (a tiny circle appears next to the pointer), C then click.
 - To keep the object open and deselect it, Ctrl-click/ Cmd-click anywhere on the artboard.
 - To keep the object open and selected, press A or Shift-A for the Path Selection tool.
- **7.** Optional: To change the fill color, stroke color, or stroke details of a shape, see pages 407–408.
- To draw paths that are aligned to the pixel grid, for better Web output, see page 407.
- ➤ To help you align the points that you produce while drawing a path (as shown in A-C), on the View menu, check Show > Guides, Rulers, Snap, and Snap To > Guides. Drag guides into the document from the rulers. See also pages 287–288.

A We created a few ruler guides in our document, then with the Pen tool, we clicked to create two points. Photoshop connected them with a straight segment. Here we're about to click to produce another segment; the segment previews because the Rubber Band option is on.

B We clicked to create more points.

The tool is positioned over the starting point (note the circle next to the pointer). When we click that point, Photoshop will close and complete the shape.

To draw a curved path or shape with the Pen tool:

- 1. Choose the **Pen** tool (P or Shift-P).
- On the Options bar, do the following:
 From the Tool Mode menu, choose Path or Shape.
 On the tool options menu, a check Rubber Band.
- 3. If you chose the Path option, on the Paths panel, click the New Path button. If you chose the Shape option, choose a nonshape layer, then choose fill and stroke attributes via the Options bar (see page 407).
- 4. Drag (don't click) to create the first anchor point. The direction you drag will determine the angle of the direction handles that appear on the point; the distance you drag will control the length of the handles. The handles, in turn, control the shape of the curve. Release the mouse.
- 5. Position the mouse where you want the first curve to change direction, then drag to define the next curve. A curved segment will connect the two anchor points, and the next pair of direction handles will appear. A
- **6.** Drag to create more anchor points with direction handles.**B**−**ℂ**
- 7. To complete the object, do one of the following:

 To close the object and keep it selected, position the pointer over the starting point (a little circle appears next to the pointer), then drag to produce the last pair of direction handles.

To keep the object open and deselect it, Ctrl-click/ Cmd-click anywhere on the artboard.

To keep the object open and selected, press A or Shift-A for the Path Selection tool.

- **8.** Optional: To change the fill color, stroke color, or stroke details of a shape, see pages 407–408.
- For smoother curves, draw the minimum number of points needed to define the object. Remember, you can always reshape the curves later by adjusting the length and angle of the handles (see page 424).

A To draw a curved shape with the Pen tool, we dragged to create the first anchor point, moved the mouse, then dragged to create the second point (note the direction handles). Photoshop connected the two points with a curved segment.

B We dragged to create a third point. (Note: The stroke on this path has the Align setting of Center; see page 408.)

■ We dragged to create the final point and third curve (we'll end this shape as an open object).

The anchor point on a nonsmooth curve can have either just one direction handle or two handles that can be rotated in different directions. In contrast, the pair of handles on a smooth curve always remain in a straight line.

To draw a nonsmooth curve:

- Continue to draw nonsmooth curves, or click to create straight sides, or drag to create smooth curves.

A After dragging to produce a smooth curve, we're holding down Alt/Option and positioning the Pen tool over the last point.

B We're dragging the end of one of the direction handles. Now the handles are in a "V" shape.

We released, then repositioned the mouse, and will proceed to create more points.

D For all of the paths in this image, from the menus on the Stroke Options picker, we chose the settings of Align: Center, Caps: Round, and Corners: Round (see page 408).

More ways to create paths and shapes

You can create a path from a selection, such as an area of an image layer that you have selected with the Quick Selection tool. (If you prefer to create a path directly with a shape or pen tool, follow steps 1–3 in the task on page 415 instead of doing the task below.)

To produce a path from a selection or an existing shape layer:

- Do either of the following:
 Create a selection with any selection tool (e.g.,
 Quick Selection or a lasso tool).
 Hold down Cmd/Ctrl and click a shape layer
 thumbnail.
- 2. Display the Paths panel. The panel contains a Work Path and you don't want it to be discarded, double-click it to save it as a permanent path.
- 3. Click the Make Work Path from Selection button,

 then double-click the resulting Work Path to save it as a permanent path.

You can paste a path from Illustrator into a Photoshop document, and have it appear as either a path or a shape layer.

To create a path or shape from Illustrator artwork:

- In an Illustrator document, select one or more vector objects, then copy the artwork via Edit > Copy.
- 2. Open a Photoshop document. If you're going to create a path, make sure no paths are selected on the Paths panel and no layers are selected on the Layers panel.
- 3. Choose Edit > Paste.
- **4.** In the Paste dialog, do either of the following: Click Paste As: **Path**, then click OK. A Work Path will appear on the Paths panel; double-click it to save it as a permanent path.

Click Paste As: **Shape Layer.** The shape(s) will be given the current fill color and a stroke color of None.

To produce a shape from a path:

- 1. On the Paths panel, 7. click a path listing.
- 2. Choose the Pen tool (P or Shift-P).
- 3. On the Options bar, make sure **Path** is chosen on the Tool Mode menu, then click the **Shape** button.

You can save any shape or path to the Custom Shape picker, for use in any document.

To save a vector object as a custom shape:

- Do either of the following:
 On the Layers panel, click a shape layer; also choose the Path Selection tool (A or Shift-A).
 On the Paths panel, click a path listing.
- 2. Choose Edit > Define Custom Shape.
- 3. In the Shape Name dialog, enter a name, then click OK. The new shape appears as the last thumbnail on the Custom Shape picker. The picker displays on the Options bar when you use the Custom Shape tool (see page 406).

Note: To save all the shapes currently on the Custom Shape picker as a permanent library, so they're not replaced if you load a new library, see page 131.

COMBINING YOUR PEN SKILLS IN ONE OBJECT

Once you become acquainted with the Pen tool, practice drawing an object that contains different kinds of segments. A few suggestions are shown below. Click to create a straight side (the point will have no direction handles), drag to create a smooth curve (the point will have a pair of direction handles that stay in a straight line; see page 421), or follow step 1 on the preceding page to create a nonsmooth curve (the point will have just one direction handle or a pair of handles that can be moved in different directions).

Reshaping vector objects

There are several ways to reshape a vector object: You can convert a corner to a smooth curve, or vice versa; rotate one handle independently of the other; drag an anchor point or segment; or add or delete points.

To convert points on a vector object:

- 1. Do either of the following: On the Paths panel, 🔼 click a path listing. On the Layers panel, click a shape layer listing or a vector mask thumbnail.
- 2. Choose the Direct Selection tool (A or Shift-A).
- 3. Click the edge of a path, then click a point on the path; or click inside a shape.
- 4. To use a temporary Convert Point tool, hold down Ctrl-Alt/Cmd-Option and do any of the following: To convert a corner point to a smooth point (add direction handles), drag away from the point. A-B To convert a smooth point to a corner point (remove both direction handles), click the point. To rotate one direction handle on a point independently of the other handle, drag the handle.
- In step 4 above, you can choose the Convert Point tool N directly from the Pen tool menu; or if you're using the Pen tool, hold down Alt/Option.

To reshape a segment on a vector object:

- 1. Choose the **Direct Selection** tool (A or Shift-A).
- 2. Do either of the following:

On the Layers panel, click a shape layer listing, then in the document, click inside the shape. Click a path listing on the Paths panel or a vector mask thumbnail on the Layers panel, then click the edge of the path in the document.

3. Do any of the following:

Drag an anchor point.

Drag a segment. (If you want to prevent adjacent segments from reshaping, check Constrain Path Dragging on the Options bar.)

Click a point on a curve segment, then drag the end of a direction handle toward or away from the anchor point, or rotate it around the point.

If you click a selected anchor point on a path, all other selected anchor points become deselected automatically.*

To add or delete anchor points from a vector object:

- 1. Follow step 1 in the first task on this page.
- 2. Choose the **Pen** tool (P or Shift-P)
- 3. Choose Path from the Tool Mode menu on the Options bar, then check Auto Add/Delete.
- 4. Hold down Ctrl/Cmd (for a temporary Path Selection tool) and click the path in the document.
- 5. Do any of the following:

To add a point, click a segment (note the plus sign in the tool pointer). E-F Optional: If you want

A We're using the Convert Point tool to convert a corner...

B ... to a curve.

We rotated one of the new handles independently.

We're dragging a direction handle on a smooth curve.

E We're adding point to a segment.

F With Ctrl/Cmd held down, we're dragging the new point downward.

to remove both direction handles from the new point (convert it to a corner point), hold down Alt/ Option and click the point; or to rotate one handle separately, drag it with Alt/Option held down.

To delete a point, click it (note the minus sign in the tool pointer).

To add a segment to an open path, click to select the endpoint, reposition the mouse, then click or drag to create one or more points.

Working with paths

To copy a path listing:

On the Paths panel, 77 Alt-drag/Option-drag a path listing upward or downward.

To restack a path listing on the Paths panel (not a Work Path or Shape Path), drag it upward or downward; release when the double line appears in the desired position.

To transform one or more paths:

- 1. On the Paths panel, select one or more path listings.
- 2. Do either of the following:

 $\label{eq:choose Edit} Choose \ Edit > \textbf{Free Transform Path} \ (Ctrl-T/Cmd-T).$ Choose an option from the Edit > Transform Path submenu (if you choose a rotate or flip option, skip the next step).

3. A transform box displays around the paths. Follow steps 5-6 on pages 348-349.

To delete one or more saved paths:

- 1. On the Paths panel, click the listing for the path to be deleted, or Ctrl/Cmd click multiple listings.
- 2. Click the Delete Path button, then click Yes in the alert dialog (or to bypass the alert, hold down Alt/Option as you click the button).

FILE FORMATS THAT PRESERVE PATHS

To keep paths editable in your Photoshop document, save it in the Photoshop (PSD), Large Document Format (PSB), JPEG, JPEG 2000, Photoshop PDF, or TIFF format. Avoid the Photoshop EPS and Photoshop DCS formats, which will rasterize the paths (and remove their listings from the Paths panel) when you reopen the file in Photoshop.

Subpaths within a path listing can be edited individually or as a bloc.

To combine multiple paths into one listing: Method 1 (Clipboard)

- 1. On the Paths panel, select one or more path listings, then press Ctrl-C/Cmd-C to copy them.
- 2. Click the listing in which you want the copied paths to appear, then press Ctrl-V/Cmd-V.B

Method 2 (loading a path as a selection)

- 1. On the Paths panel, Ctrl-click/Cmd-click to select two or more path listings.
- 2. Click the Load Path as Selection button at the bottom of the panel, then click the Make Work Path from Selection button.
- 3. A new Work Path appears on the panel. Doubleclick it to save it as a permanent path.

Method 3 (drawing)

- 1. On the Paths panel, click a path listing.
- 2. With the Pen, or Freeform Pen, or a shape tool, draw a path.
- To add a Shape Path as a subpath, click the shape layer on the Layers panel, then follow one of the methods above.

A On the Paths panel, we clicked our "LOGO1" listing, then used the Copy command.

B We clicked the "LOGO 2" listing, then used the Paste command. Now two subpaths display in the same thumbnail. When you recolor a path, the color appears as an area of pixels on the current image layer.

To apply a fill and/or stroke color to one or more paths:

- 1. On the Layers panel, click an image layer or create a new blank layer.
- 2. Choose a Foreground color.
- 3. If you're going to apply a brush to the path stroke (next step), choose a tool that uses brushes, then right-click in the image and choose from the preset picker on the context menu.
- 4. On the Paths panel, This select one or more path listings, then click the Fill Path with Foreground Color or Stroke Path with Brush button.A-B
- 5. Deselect the path listing(s).
- Instead of applying a fill or stroke color, after clicking a path listing in step 4, apply a style via the Styles panel.
- You can also apply a stroke to a path using any painting or editing tool. Choose a tool and Options bar settings, then Alt-click/Option-click the Stroke Path button on the Paths panel. From the tools menu in the dialog, choose the tool for which you just chose settings, then click OK.

To load a path as a selection:

On the Paths panel, do either of the following: Hold down Ctrl/Cmd and click a path thumbnail. Click a path listing, then click the Load Path as Selection button.

A We created a blank layer on the Layers panel. Next, on the Paths panel, we clicked a path listing, then clicked the Fill Path with Foreground Color button.

The area defined by the path filled with pixels.

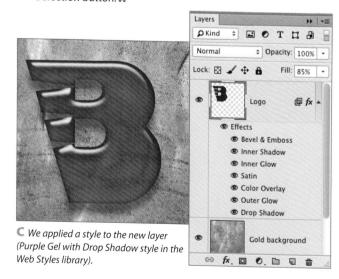

We loaded a path as a selection.

To automate repetitive (and boring) editing tasks, you can record a sequence of commands in an action and, at any time, replay the action on one image or on a batch of images. Actions can be used to execute anything from a simple edit, such as converting files to a different format or color mode, to a complex sequence of commands, such as applying a series of adjustments or filters, or a sequence of preflight steps to prepare your files for output. With actions, you can boost your productivity, relieve your life of (some) drudgery, and standardize your editing steps. You can use any of the ready-made actions that are included with Photoshop, or create your own custom actions for various tasks. In this chapter, you'll learn how to record, play, and edit custom actions, and how to save and load action sets (collections of actions).

Recording an action

Using the Actions panel, you can record, store, edit, play, delete, save, and load actions. The panel has two modes: List (edit) A and Button (A, page 429). When the panel is in List mode, you can expand or collapse the list of commands in an action; toggle a dialog control on or off; add, exclude, delete, rerecord, or change the order of commands; or save actions and action sets to an actions file. To put the panel into List mode, uncheck Button Mode on the panel menu.

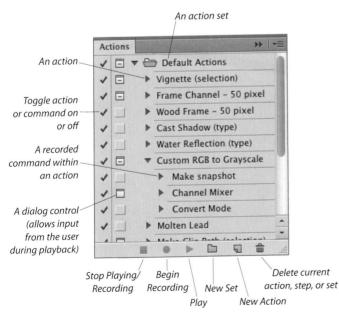

A This Actions panel is in List mode.

ACTIONS ACTIONS

22

IN THIS CHAPTER

Recording an action
Playing an action
Editing an action
Deleting commands and actions 438
Saving and loading action sets 438

Each command that is recorded in an action is nested below the action name on the Actions panel. Actions, in turn, are stored in sets. Note: To include edits in an action that aren't directly recordable, see pages 433–434.

To record an action:

- The action you're about to record has to be stored in a set. To create a set, click the New Set button at the bottom of the Actions panel, type a descriptive Name, then click OK.
- Open a document or create a new one. We recommend copying the document using File > Save As.
- 3. Click the **New Action** button at the bottom of the Actions panel.
- 4. In the New Action dialog, enter a Name for the action, and from the Set menu, choose a set (either the one you created in step 1 or a different one).
- 5. Optional: Choose a shortcut for the action from the Function Key menu, and check Shift and/ or Command to prevent conflicts with the function keys that are assigned to system commands. Choose a color to display behind the action name when the panel is in Button mode.
- 6. Click Record.
- 7. We recommend as a first edit that you create a snapshot of the current state of the document on the History panel. Next, execute the commands that you want to record, as you would normally apply them to any image. Any time you enter values in a dialog and click OK, your settings will be recorded (unless you click Cancel).
- **8.** When you're done recording edits for the action, click the **Stop Playing/Recording** button.
- The new action listing appears on the panel. Note: To save your action sets to a file (recommended), see page 438.
- If you create layers or alpha channels while recording an action, assign them descriptive, nongeneric names to prevent the wrong layer or channel from being edited when the action is played.
- ➤ When recording the Save As command in an action, don't change the file name. To preserve the original file, either choose a different folder location or add a modal control to the action to make it pause at the Save As command to allow for user input (see page 435).
- To open the Action Options dialog for an action (e.g., to change the shortcut), double-click its listing.

RULER UNITS MATTER IN ACTIONS

The current ruler units affect how Photoshop records tool edits that are made in a specific x/y location in the image (e.g., by the Brush tool or by a selection or shape tool). An action that is recorded when the ruler units are actual (e.g., inches or picas) will play correctly only on a file that has the same dimensions as the file in which it was recorded. An action that is recorded when the default unit is Percent will work correctly on a file of any dimensions, because the tool edits will be positioned and scaled relative to each document. To establish the units setting, go to Edit/ Photoshop > Preferences > Units & Rulers, and from the Units: Rulers menu, choose an actual unit or Percent.

RECORDING BRUSH STROKES

To record the strokes for painting tools (e.g., Brush, Pencil, Mixer Brush), set the desired ruler units (see "Ruler Units Matter In Actions," above), and check Allow Tool Recording on the Actions panel menu. While recording an action, select the desired tool. If you're using the Brush tool, choose a Foreground color and Brush panel settings. Apply strokes in the image. You can change colors and settings between strokes. Note that if a desired setting is already chosen, you will need to choose a different one, then the desired one.

For the Brush or Mixer Brush tool, before you begin recording, you need to create a tool preset (via the Tool Presets panel) that contains the desired color and Options bar settings. Choose your preset while recording the action. For added variety, you can create multiple tool presets, then switch among them while recording.

	New Action	
Name:	Rough black frame	Record
Set:	Frames ‡	Cancel
Function Key:	None ‡ Shift Command	
Color:	₩ Violet ‡	

A Use the New Action dialog to assign a name and set to your action, as well as an optional shortcut and/or color, then begin recording.

Playing an action

An action can be triggered in various ways: via the Play button on the Actions panel; via a keyboard shortcut that was assigned to it; by dragging a file or folder full of files onto a droplet icon that was made from the action; or by using the Batch feature. We'll begin with the Play button and shortcuts.

To play a whole action on one image:

- 1. Open an image and create or click an image layer.
- 2. Optional: If the action to be played doesn't include creation of a snapshot as an initial step, use the History panel to create one now, to preserve the option to restore the image to its pre-action state.
- 3. Do one of the following:

If the Actions panel is in List mode, click an action name, then click the Play button.

If the panel is in **Button** mode, click the button for the action to be played.

Execute the keyboard shortcut, if one has been assigned to the desired action.

To load more action set libraries onto the panel, see page 438.

Vignette (selection)	Frame Channel - 50 p	
Wood Frame - 50 pixel	Cast Shadow (type) Custom RGB to Graysc Make Clip Path (select	
Water Reflection (type)		
Molten Lead		
Sepia Toning (layer)	Quadrant Colors	
Save as Photoshop PDF	Gradient Map	
Mixer Brush Cloning P	Water Reflection F7	
Gradient Map	brush shape	

A When the Actions panel is in Button mode, each action is listed as a colored button. Assigned shortcuts, if any, are also listed.

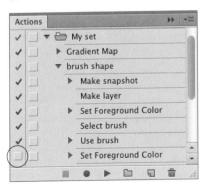

To exclude a command from playback:

- 1. Put the Actions panel in List mode (actions can't be edited in Button mode).
- 2. Expand the list for the action to be edited.
- 3. Click in the leftmost column for the command that you want to exclude from playback, to remove the check mark. B The check mark for the main action listing turns red. (To reinclude the command, click in the same column again.)

Note: If you click the check mark for an action, as an alert may inform you, Photoshop will uncheck or recheck all the commands in the action.

To play a partial action:

- 1. Put the Actions panel in List mode.
- 2. If necessary, click the arrowhead next to an action name to expand its list of commands.
- 3. Do either of the following:

To play the action from a command onward, click the command name, then click the Play button.

To play just one command in an action, click the command name, then Ctrl-click/Cmd-click the Play button (or simply Ctrl-double-click/Cmd-doubleclick the command).

CHOOSING PLAYBACK OPTIONS

Put the Actions panel in List mode, choose Playback Options from the panel menu, then click one of these options in the dialog:

- Accelerated: The fastest playback option.
- Step by Step: The list for the action expands on the panel, and the name of each command or edit becomes highlighted as it's executed. Slower than Accelerated.
- ➤ Pause for [] seconds: This option works like Step by Step, except that a pause for the duration you designate occurs after each step.

To exclude a color change in our "brush shape" action from playback temporarily, we unchecked that step.

The ability to play an action on multiple files is a great timesaver. This can be done quickly by dragging a folder of files onto a droplet (see "To create a droplet for an action," on page 432). Or if you need to choose a destination, a file-naming scheme, and other options for the files to be processed by the action, use the Batch command instead, as described on this page.

To play an action on a batch of images:

- In Bridge, put all the files to be processed into one folder and display the folder contents (or to limit which images are processed, select those thumbnails), then choose Tools > Photoshop > Batch.
- The Batch dialog opens (A, next page). Under Play, choose an action set from the Set menu and an action from the Action menu.
- 3. For the Source, choose Bridge.
- **4.** Optional: If the action contains an Open command, check Override Action "Open" Commands to have the batch command ignore the specific file name that was chosen when the Open step was recorded.
- 5. Check Suppress File Open Options Dialogs and/ or Suppress Color Profile Warnings to prevent those dialogs or alerts from appearing onscreen (and pausing the playback) as source files are opened.
- 6. Optional: By default, Photoshop will stop the Batch process if it encounters an error. To have it play the whole action and keep track of error messages in a text file instead, from the Errors menu, choose Log Errors to File, then click Save As. In the Save dialog, type a name for the text file (keep the extension), choose a location for it, then click Save. If errors are encountered, after the batch processing is finished, you will be alerted via a prompt that errors were logged into the designated error log file.
- 7. From the **Destination** menu, choose one of the following options:

None to keep all the files open after processing.

Save and Close to have the files save after processing and then close.

Folder to have the files save to a new folder and to make the File Naming options for naming the resulting files accessible (the naming options prevent the new files from replacing the original ones). Click Browse/Choose, choose a destination folder, then click OK/Choose.

Optional: If you check the Override Action "Save As" Commands option, the Batch command will ignore any Save As command that was recorded into the action and execute the Destination option that you have chosen instead.

8. If you chose Folder as the Destination, under File Naming, you can do the following:

Type text to be included in the name in one or more fields on the left, or choose a file-naming option from one or more menus on the right. Look at the Example to verify your naming convention choice.

If you chose a naming option that uses sequential (serial) numbers, enter a one- to four-digit starting number in the **Starting Serial** # field.

Check any or all of the file-name **Compatibility** options for the platforms in which you need the files to be compatible.

- 9. Click OK to start the batch processing.
- You can also play an action on a batch of images via File > Scripts > Image Processor in Photoshop or Tools > Photoshop > Image Processor in Bridge. In the dialog, check Run Action, then choose an action set and an action from the menus.
- When you play an action on an image, provided the last step in the action doesn't close the document, the action steps are listed as states on the History panel.
- To stop the batch command while it's processing, press Esc, then click Stop in the alert dialog.

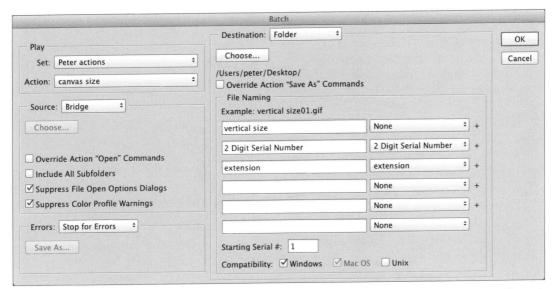

A In the Batch dialog, choose an Action to be played, choose Bridge as the source, specify a Destination for the processed files, and choose optional File Naming settings.

PUTTING IDEAS INTO ACTIONS

Can't think of a good use for actions? Observe your typical Photoshop edits over the course of a week or two. Are there repetitive commands or tasks that you execute frequently? Did you devise a great image-editing effect that requires many time-consuming steps?

Here are a few suggestions:

- ➤ Record the use of the Crop tool set to a specific size and resolution.
- ➤ Use the Image Size dialog to size a document to a specific resolution or dimensions.
- ➤ Create a new document from the currently selected layer (Duplicate Layer command, choose New in the dialog).

- ➤ Record the steps needed to prepare a file for commercial printing: Flatten the file, convert the document color mode to CMYK Color, apply sharpening, and save a copy of the file.
- ➤ Create a few adjustment layers that you typically use for tonal or color correction. (The adjustment settings can be changed after the action is played.)
- ➤ Copy a layer, convert the copy to a Smart Object, then apply one or more of your favorite filters.
- ➤ Record an action that applies a vignette (see page 439). Add an Insert Stop command (see page 433) to let the user redraw or reposition the selection for the vignette.

An action can be turned into its own little mini-app, called a droplet, that sits on the Desktop or in a folder, waiting to be triggered. If you drag a file or a folder full of files onto a droplet icon, Photoshop will launch (if it's not yet running), and the action that the droplet represents will be played on those files. Droplets can be shared among Photoshop users.

To create a droplet for an action:

- 1. Choose File > Automate > Create Droplet. The Create Droplet dialog opens.
- 2. Click Choose. The Save dialog opens. Enter a name in the Save As field (keep the extension), choose a convenient location for the droplet, then click Save to return to the Create Droplet dialog.
- Choose an action set from the Set menu, then an Action to be saved as a droplet.
- **4.** Check any **Play** options to be included in the droplet, and choose **Destination** and **Errors** options for the processed files (see steps 4–8 on page 430).
- Click OK. The droplet will appear in the designated location.
- **6.** To use the droplet, drag a file or a folder full of files onto it in Explorer/Finder. Photoshop will launch, if it's not already running, and the action will play on the files.

MAKING A DROPLET PLATFORM-COMPATIBLE

- ➤ To make a droplet that was created in Windows usable in Macintosh, drag it onto the Macintosh Photoshop application icon.
- ➤ To create a droplet in Macintosh for use in Windows, save it with an ".exe" extension.

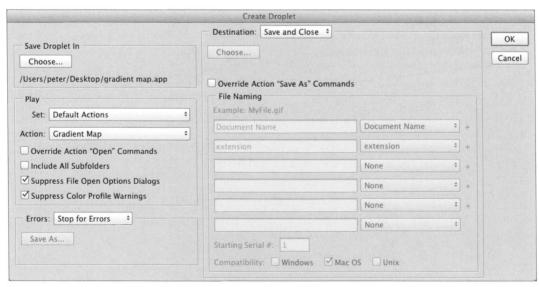

B Use the Create Droplet dialog to choose a location and other options for your action droplet.

Editing an action

If you want to experiment with an action or add to it without messing around with the original, duplicate it, then edit the duplicate.

To duplicate an action:

Do either of the following:

Click an action, then choose **Duplicate** from the Actions panel menu.

Drag an action over the **New Action** button on the Actions panel.

To rename an action, double-click the name.

When you insert a Stop in an action, the playback will pause at that point so the user can perform a manual or nonrecordable edit (e.g., choose a source point for a cloning tool or create a selection at a specific size and location). You can also include an instructional message for the user, which will appear in an alert dialog when the pause occurs, such as a directive to use a tool in a specific way or to choose specific panel settings. After completing the manual edit, the user resumes the playback by clicking the Play button.

To insert a Stop in an action:

- 1. Do either of the following:
 - While recording an action, pause at the point at which you want the Stop to appear.
 - To add a Stop to an existing action, on the Actions panel, click the command name after which you want it to appear.
- 2. Choose Insert Stop from the Actions panel menu.
- 3. In the Record Stop dialog, type an instructional or alert message. A We recommend also spelling out in the message that after clicking Stop and performing the desired edit, the user should click the Play button to continue the playback.
- 4. Optional: Check Allow Continue to include a Continue button in the alert dialog (in addition to a Stop button). If the user opts not to perform the requested manual edits, he or she can click Continue to resume the playback (instead of having to click Stop, then click the Play button on the panel). Don't check Allow Continue if the requested manual edit is essential to the user's

- execution of the remaining steps in the action (e.g., the creation and positioning of a selection).
- 5. Click OK. The Stop listing will appear below the command you paused after or clicked in step 1.B-€ If you expand the Stop listing, you will see your instructional message.
- 6. If you're creating a new action, record the remaining edits that you want it to contain, then hit the Stop Playing/Recording button.

A In the Record Stop dialog, we typed an instructional message for the user. We also checked Allow Continue to add a Continue button to the alert dialog, which will appear when the action is played.

B The Stop command appeared as a step within the action.

When we played the action on an image, our instructional message and a Continue button appeared in this alert.

Perhaps you neglected to include a particular menu command when you initially recorded an action. The Insert Menu Item command gives you a second chance. Also, some menu commands (e.g., on the View or Window menu) can't be included when an action is initially recorded. Using this feature, you can insert those commands afterward.

To insert a menu item into an action:

- Expand the listing for an existing action, then click the command after which you want the new menu command to be inserted.
- From the Actions panel menu, choose Insert Menu Item. The Insert Menu Item dialog opens.
- 3. From the Photoshop menu bar, choose the command to be added to the action. The command name appears in the Insert Menu Item dialog. A
- 4. Click OK.B
- 5. If the menu command that you inserted requires user input in a dialog, you will need to add a modal control to the action for that command. See the first task on the next page.

If you forgot to include a particular command or editing step in an action, or you want to improve an action by adding a command, here's your second opportunity.

To add a command or edit to an action:

- On the Actions panel, expand the listing for the action to which you want to add an edit, then click the command name after which you want the new edit to appear.
- 2. Click the Begin Recording button.
- 3. Execute the desired command(s). Note: You can't add a command that's available only under certain conditions (e.g., the Feather command, which requires an active selection) unless those conditions are present and the creation of those conditions is also recorded as steps in the action.
 - To record an action that produces different results depending on whether a specified condition is detected in the document, see pages 436–438.
- 4. Click the Stop Playing/Recording button.
- To expand or collapse all the steps that are nested within an action, Alt-click/Option-click the arrowhead next to the action name.

A When we chose the Fill command from the Edit menu, the command name appeared automatically in the Insert Menu Item dialog.

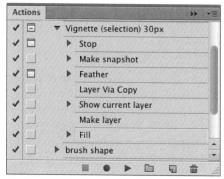

B The menu item that we inserted appeared as a listing within the action on the Actions panel.

DUPLICATING COMMANDS WITHIN OR BETWEEN ACTIONS

- ➤ To copy a command from one action to another, expand the listings for both actions, then hold down Alt/Option and drag the command to be copied from one list to the other (if you don't hold down Alt/Option, you'll move the command out of the original action). Note: Use caution when copying a Save command, as it may contain information that pertains only to the original action.
- ➤ To duplicate a command within an action, hold down Alt/Option and drag it upward or downward to the desired stacking position.

You can enable a pause, called a modal control, for any step in an action that enables user input, such as a dialog in which the user chooses custom settings or an edit that requires Enter/Return to be pressed (such as a transform command).

To add a modal control to a command in an action:

- 1. Put the Actions panel in List mode, and expand the list for an action.
- 2. For any individual listing within the action, click in the second column; the **Dialog** icon appears.A

When the action is played, it will pause when it encounters the command that has that modal control, and the dialog or on-canvas controls will appear onscreen. In the case of a dialog, the user can enter new values, or accept the original recorded settings just by clicking OK, or click Cancel. When the user exits the dialog or commits to the edit, the playback continues automatically.

To toggle a modal control off, click the Dialog icon.

To enable or disable all modal controls for an action:

Click in the Dialog column for an action name. Depending on their current state, all the modal controls in the action will be turned on or off. If an alert prompt appears, click OK.

Note: A short horizontal line in the Dialog icon for an action listing indicates that the modal controls in the action are in a mixed state (some off and some on). To reset the modal controls to their original state, click the Dialog icon; if an alert prompt appears, click OK.

To re-record an action using different dialog settings:

- 1. Click the name of the action that contains the settings to be edited.
- 2. From the Actions panel menu, choose Record Again.
- 3. The action will play back, stopping at each command that uses a dialog. Enter new settings where needed, then click OK. Each time you close a dialog, the re-recording continues.
- 4. The action will stop automatically after the last command. If you want to halt the re-recording midstream, click Cancel in a dialog.

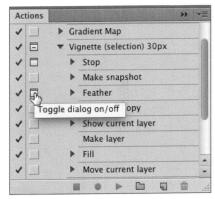

A Via the Dialog icon, you give the user an opportunity to enter custom settings in a dialog when it opens during playback.

When you insert a conditional step into an action, it will test for a specified condition in the documents in which it is played, then will play one of two other additional specified actions (or none) based on whether or not that condition is detected.

To add a conditional step to an action:

- 1. Create two actions that accomplish an editing task in different ways: one that performs specific edits when a specific condition is found A and another that performs alternative edits (or no other edits) when that condition is not found. B Save both actions in the same set.
- 2. To create a third action that is designed to test for the specific condition, click the New Action button on the Actions panel. In the New Action dialog, enter a Name, and from the Set menu. choose the same set as in step 1. Click **Record**.
- 3. Optional: On the History panel, create a snapshot of the current state of the document.
- 4. From the Actions panel menu, choose Insert Conditional. The Conditional Action dialog opens. From the If Current menu, choose the condition for which you want documents to be tested.
- 5. Choose from the other two menus in the dialog, (the menus will list only actions in the current set): From the Then Play Action menu, choose the action to be played when the specified condition

Layer is Layer Group

Layer Has Pixel Mask Layer Has Vector Mask Layer Has Effects

Layer Is Locked

Laver Is Visible

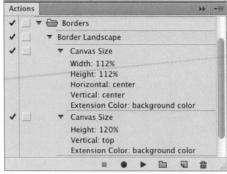

A In the sequence of steps shown on these two pages, we created an action that adds a white border with extra white space on the bottom if played on a horizontal image, or adds extra white space on the right if played on a vertical image. To begin, we created an action called "Border Landscape," used Image > Canvas Size to add a uniform white border around the image, then used the command once more to add extra canvas area to the bottom of the image.

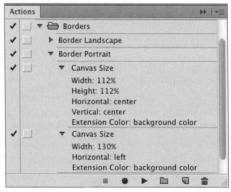

B We created a second action called "Border Portrait" in which we used Canvas Size first to add a uniform white border, then a second time to add extra canvas area to the right side of the image.

Next, we created a third action called "Add Border." To enable this action to detect the orientation of documents on which it is played, we chose the Insert Conditional command. then from the If Current menu in the Conditional Action dialog (shown at left), we chose Document Is Landscape.

is detected in documents on which it is played (see step 1 on the preceding page).

From the Else Play Action menu, choose the alternative action to be performed when the specified condition is not found, A or to prevent any alternative action from being played, choose None.

- 6. Optional: Perform any additional editing steps to be played by the original action after the conditional action step is completed.
- 7. Click the Stop Playing/Recording button.

- 8. To test the three actions that you created in this task, open an image that contains the condition you chose in step 4 and another image that doesn't contain that condition.
- 9. On the Actions panel, click the action that tests for the specified condition, then click the Play button. C-D Click in the second document, then play the action again.
- 10. When you're ready to play the action containing the conditional step on multiple files, use the Batch command (see pages 430-431).

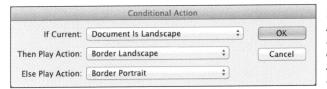

A From the Then Play Action menu, we chose our Border Landscape action, and from the Else Play Action menu, we chose our Border Portrait action.

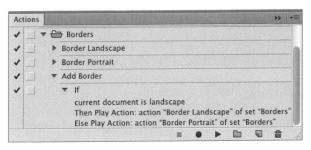

B Our last step was to click the Stop Playing/Recording button on the Actions panel. The "Add Border" action now contains the conditional "If" command.

When we played our Add Border action on this photo, because the conditional step in the action detected the "Document is Landscape" condition, it played the Border Landscape action. Now there's room for some type ...

D In this photo, the same action detected that the Document is Landscape condition was not present, so it played the alternative action that we specified for this scenario, which was Border Portrait.

To change the settings for a command in an action:

- On the Actions panel, expand the listing for an action, then double-click a command that uses a dialog for which you want to change the settings.
- 2. Enter new settings.
- 3. Click OK.

This may seem obvious, but remember that if you change the order of edits in an action, the new sequence may produce different results than the original.

To change the order of edits in an action:

- 1. On the Actions panel, expand the list for an action, if it's not already expanded.
- **2.** Drag a command upward or downward on the list.

Deleting commands and actions

You can delete a whole action, or just delete individual commands from an action.

To delete an action or delete a command from an action:

- If you created (or edited) any custom action sets that you want to preserve for future use, follow the steps in "To save an action set to a file," at right.
- On the Actions panel, click the individual command or action to be deleted, then, if desired, Ctrl-click/Cmd-click to highlight additional commands or actions.
- 3. Click the **Delete** button, then click OK (or to bypass the prompt, Alt-click/Option-click the Delete button).

Saving and loading action sets

Be sure to save any custom or edited action sets that you want to preserve for future use. Saved action sets can be shared among Photoshop users.

To save an action set to a file:

- On the Actions panel, click the action set to be saved.
- 2. Choose Save Actions from the panel menu.
- In the Save dialog, type a name for the action set file, keep the extension and default location, then click Save. Each file is regarded as one set, regardless of how many actions it contains.
- **4.** When you relaunch Photoshop, your newly saved set will appear on the Actions panel menu. Note: If you edit any actions in the set, you will need to resave the set by following the steps above.

Photoshop includes many useful actions beyond those in the default set. To load them on the panel, or to load any user-created set, follow the instructions below.

To load a set onto the Actions panel:

- 1. On the Actions panel, click the set name that you want the loaded set to appear below.
- 2. From the Actions panel menu, choose a predefined action set (Commands, Frames, Image Effects, LAB–Black & White Technique, Production, Stars Trails, Text Effects, Textures, or Video Actions), or a user-saved set.

To reload the default action set:

From the Actions panel menu, choose **Reset Actions**. In the alert dialog, click Append to add the default set to the existing sets on the panel, or click OK to replace the existing sets with the default one.

In this chapter, you'll learn various ways to showcase your images for clients. You will spotlight your subject matter as a vignette; add an artistic border; create a PDF presentation of multiple images; create and present layer comps (layer variations within a single document); and create and edit a video.

Creating a vignette

We'll show you several ways to create a vignette (lighten or darken the outer part of an image).

To create a white-bordered vignette:

- 1. Duplicate the Background in an image (Ctrl-J/Cmd-J).
- Click the Background, then press Shift-Backspace/ Shift-Delete. In the Fill dialog, choose Use: White, Mode: Normal, and Opacity: 100%, then click OK.
- Click the image layer. Choose the Elliptical Marquee tool (M or Shift-M). To select the area of the image you want to keep visible, drag with Alt/Option held down (to draw the selection from the center).
- On the Layers panel, click the Add Layer Mask button.
- 5. On the Properties panel, adjust the Feather value to soften the edge of the mask. A
- **6.** Optional: To reposition the mask to reveal a different part of the image, on the Layers panel, click between the layer and mask thumbnails (the link icon disappears), click the mask thumbnail, then hold down V (temporary Move tool) and drag in the document. Click between the thumbnails to restore the link.

An oval, feathered mask gives this garden photo a vintage look.

23

IN THIS CHAPTER

Creating a vignette
Adding an artistic border
Creating a PDF presentation of images
Creating and using layer comps 446
Creating a PDF presentation of layer comps
Importing video clips into Photoshop .449
Adding video tracks to a timeline450
Changing the length, order, or speed of a clip
Playing or reviewing a video
Splitting a clip
Adding transitions to video clips 452
Adding still images to a video 453
Adding title clips to a video
Applying adjustment layers and filters to a video
Keyframing
Adding audio clips
Rendering clips into a movie 456

Another way to create a vignette is by manipulating light and dark values. Here you will use the layer mask on a Brightness/Contrast adjustment layer to control where a bright area is located in an image. The effect is like shining a spotlight.

To create a vignette via a tonal adjustment and mask:

- 1. Choose the Elliptical Marquee tool (M or Shift-M), then drag with Alt/Option held down to select the area of the image you want to feature (Alt/Option draws the selection from the center).
- 2. Optional: To transform the selection (e.g., rotate it), choose Select > Transform Selection, and follow steps 5–6 on pages 348–349.
- 3. On the Adjustments panel, click the Brightness/Contrast button. Press Ctrl-I/Cmd-I to invert the adjustment layer mask, then on the Properties panel, lower the Brightness value to darken the unmasked areas.
- 4. To soften the edge of the mask, click the Masks icon on the Properties panel, then increase the Feather value.
- 5. To reposition the mask to spotlight a different part of the image, on the Layers panel, click between the layer and mask thumbnails (the link icon disappears), click the mask thumbnail, then hold down V (temporary Move tool) and drag in the document. Click to restore the link. C-D
- For other ways to create a vignette, choose Filter > Camera Raw Filter, then use either the Radial Filter tool (see pages 88–89) or the Post Crop Vignetting controls in the Effects tab (see page 85).

A We created an elliptical selection, then rotated it via the Select > Transform Selection command.

B Next, we applied a Brightness/Contrast adjustment, inverted the mask, then softened the edge of the mask via the Feather slider.

• We clicked between the adjustment layer and mask thumbnails to remove the Link icon, then with the Move tool, we dragged the layer mask slightly to the left.

Now the mask is positioned better on the bottle.

A third way to create a vignette is by using the Vignette controls in the Lens Correction filter dialog. With this method, you can't control where the vignette is positioned, but it's quick and easy, and if you apply it to a Smart Object, you can edit the settings at any time.

To create a vignette via the Lens Correction filter:

- 1. Duplicate the Background in an RGB image.
- 2. Right-click the duplicate layer and choose Convert to Smart Object.
- 3. Choose Filter > Lens Correction (Ctrl-Shift-R/Cmd-Shift-R). At the bottom of the dialog, check Preview and uncheck Show Grid.
- 4. Click the Custom tab, then under Vignette, do the following: B
 - Choose a negative Amount to darken the outer part of the layer.
 - Adjust the Midpoint value to control where the darkening effect begins in the image (you may need to readjust the Amount value afterward).
- 5. Click OK. To edit the Lens Corrections settings at any time, double-click the Lens Correction listing on the Layers panel.

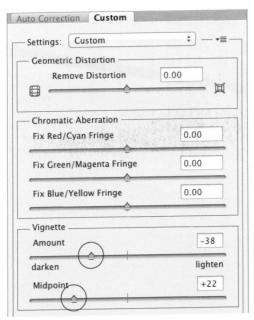

B We chose these values in the Custom tab of the Lens Correction dialog.

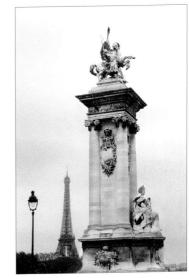

A This is the original image.

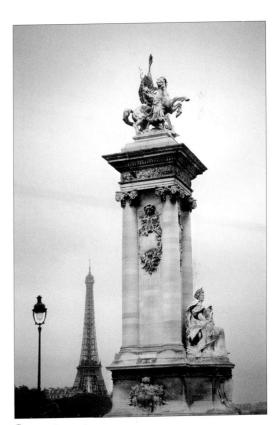

C This is the result.

Adding an artistic border

Using controls in the Refine Edge dialog, it's super easy to add an artistic border to an image.

To add an artistic border to an image:

- 1. Click the Background on the Layers panel.
- 2. Choose the Rectangular Marquee tool (M or Shift-M), then draw a selection within the image where you want the inner part of the border to begin. A You can reposition the selection border with the same tool.
- 3. On the Options bar, click Refine Edge.
- 4. In the dialog, choose View: On White (W), then adjust the Radius, Smooth, Contrast, and Shift Edge values to create rough edges that you like. B
- **5.** From the Output To menu, choose **New Layer with** Layer Mask, then click OK. ℂ
- **6.** Click the Background, make it visible, then press Shift-Backspace/Shift-Delete. In the Fill dialog, choose Use: White, Mode: Normal, and Opacity: 100%, then click OK.
- The actions in the Frames library apply various kinds of frames. Apply to a one-layer document.

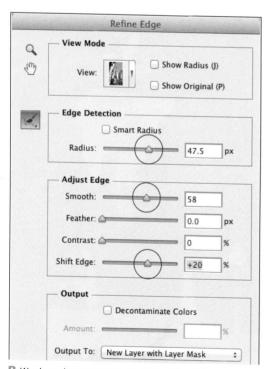

B We chose these settings in the Refine Edge dialog.

A We created a rectangular selection.

C So easy!

USING ARTISTIC BORDERS IN A MONTAGE

To create this Paris montage, we created a border in each image separately in its own file, using the technique described on the preceding page. We dragged each image layer into a larger document, which contains a photo of burlap as the Background image. To complete the composition, we scaled and repositioned the layers, then rotated two of them.

Creating a PDF presentation of images

An easy way to package and send files to a client or friend is via a PDF presentation, in which images play sequentially onscreen. To view the presentation in Adobe Reader or one of the Adobe Acrobat programs, all the viewer has to do is double-click the PDF file icon.

To create a PDF presentation of images:

- 1. In Bridge, put all the image files for the presentation in the same folder.
- 2. In Photoshop, choose File > Automate > PDF Presentation. The PDF Presentation dialog opens.
- 3. Click Browse, navigate to the folder you set up in step 1, Ctrl-click/Cmd-click some or all of the file names, then click Open.
- 4. Optional: Drag a file name up or down on the list to change the order in which the files display in the presentation. (To remove a file from the list, click the file name, then click Remove.)
- 5. Under Output Options, do the following: Click Save As: Multi-Page Document to place each source image as a page in the PDF file, or click Presentation to create both a multipage PDF document and a slideshow.

Choose Background: White, Gray, or Black for the color to be displayed behind the images.

Under Include, check the categories of text that you want to appear below each image (to be

RESPECT THE WORK OF YOUR FELLOW ARTISTS

It's easy and tempting for any of us to help ourselves to imagery that we see on the Web, and to repurpose it for our own needs. But consider that for every photo you view and enjoy, a fellow artist took the trouble to shoot it, edit it, put their personal stamp on it, and optimize it. They have the rights to it, and we don't. Just as we urge you to take steps to protect your own work (however difficult the law is to enforce), if you don't have rights to artwork or it's not in the public domain, don't download it or use it. (Okay ... end of lecture.)

PROTECT YOUR OWN WORK, TOO

For a more thorough method of protecting your images from copyright infringement, explore the services and features offered by the Digimarc company (digimarc.com). When you install their plug-in on your system, it becomes accessible in Photoshop (Filter > Digimarc submenu). The imperceptible watermark that it embeds into a document can survive substantial image editing (e.g., copying, scaling, cropping, and compression).

Also, when you enroll in one of their subscription packages, Digimarc lets you manage and monitor the use of your images on the Internet. If you subscribe to the Basic Edition or Professional Edition and someone downloads your image, that user is notified of your ownership and contact information. The Professional Edition also includes the Digimarc Search Service, which lets you track authorized and unauthorized use of your images.

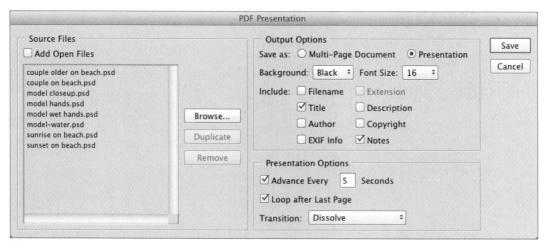

🖺 In the PDF Presentation dialog, we clicked Presentation to have Photoshop produce both a multipage PDF document and a slideshow from the images in the selected folder.

- taken from the metadata in the file), and choose a Font Size for the text.
- 6. If you clicked the Presentation option, you can choose these options:

To have frames advance automatically, check Advance Every, then enter the duration (in Seconds) that you want each frame to display.

To have the slideshow loop continuously, check Loop After Last Page (after the last frame displays, the show replays from the first frame).

Optional: To display a transition effect between frames, choose a Transition option (e.g., Dissolve or Wipe Right).

7. Click Save. In the Save dialog, enter a file name, choose a location, then click Save.

A The Presentation option produced this fullscreen slideshow (we chose the Transition option of Glitter Down).

8. The Save Adobe PDF dialog opens. Check View PDF After Saving to have Adobe Reader or an Acrobat program launch automatically when you exit the dialog. Click Save PDF.

Depending on which Save As option you clicked in step 5, Photoshop will take a few moments to produce just a multipage document, or a multipage document plus a presentation (slideshow). If you chose the latter option, an alert pertaining to fullscreen mode may appear; click Yes. The slideshow will play onscreen. A To end the show at any time, press Esc. For both Save As options, the new multipage document will open onscreen in Adobe Reader or in one of the Acrobat programs.

CREATING A CONTACT SHEET

A contact sheet is an arrangement of image thumbnails on one page. It's a useful format for cataloging

images, such as the photos that you back up onto DVDs or need to present to clients. To create a contact sheet, in Bridge, click a folder to display its contents or Ctrl-click/Cmd-click multiple image thumbnails, then choose Tools > Photoshop > Contact Sheet II. In the

Contact Sheet II dialog, under Source Images, choose Use: Bridge, then choose other settings.

B Both the Multi-Page Document and Presentation options produce a multipage document. This document is being displayed in Adobe Reader.

Creating and using layer comps

A layer comp, short for "composition," is a record of a state of the layers in a document. Categories of settings that can be saved in a comp include layer visibility, position, and styles. Using layer comps, you can quickly display different design variations within one file, say, as a way to compare them, or as a way to present them to colleagues or clients. Layer comps are saved to, and displayed via, the Layer Comps panel.

To create a layer comp:

- Create design variations within your document using multiple image, type, shape, fill, or adjustment layers, or Smart Objects. The layers can have the usual characteristics, such as masks, Smart Filters, blending modes, and effects.
- 2. To create a comp, for each layer in the document, do any of the following: Choose a visibility setting, a position (location), and layer style settings (blending mode, Opacity setting, etc.).
- 3. Show the Layer Comps panel, A then click the New Layer Comp button at the bottom of the panel. The New Layer Comp dialog opens. ■
- Enter a Name, then check the categories of layer settings that you want saved in the comp: Visibility, Position, and/or Appearance (Layer Style).
- 5. Optional: Enter text in the Comment field, such as an explanatory note, to appear only on the panel.
- **6.** Click OK. To create more comps from different design variations, repeat steps 2–6 (e.g., hide or show different layers, move the content of a layer, or change the layer style settings).
- ➤ To change which categories of layer settings are stored (and therefore displayed) in a comp, or to add or edit the Comment data, double-click to the right of the comp name; the Layer Comp Options dialog opens. To enable or disable a category for a comp without opening the dialog, click the Layer Comp Visibility, Layer Comp Position, or Layer Comp Appearance button within the comp listing.

To display a layer comp:

Do either of the following:

On the Layer Comps panel, click a blank square in the left column. The Layer Comp icon I moves to that slot.

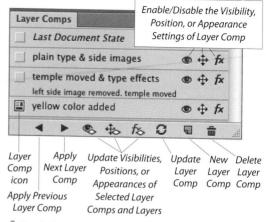

A Use the Layer Comps panel to create, store, show, edit, update, and delete layer comps.

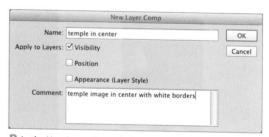

B In the New Layer Comp dialog, we typed a Name, checked Visibility to save just that layer characteristic in the comp, and entered a comment for the viewer to read on the panel.

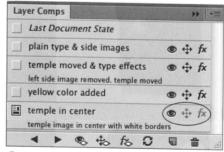

C Our new comp appeared on the panel. Note that only its Visibility button is enabled.

CREATING A LAYER COMP FROM A DUPLICATE

If you don't want to create a new layer comp from scratch, you can start from a duplicate instead. Right-click a layer comp name and choose Duplicate Layer Comp. To edit and update the duplicate, see the second task on the next page.

To cycle through the comps on the panel, click the Apply Next Selected Layer Comp button For Apply Previous Selected Layer Comp <a> button.A

Let's say that after creating some layer comps in a document, you edit your document further, then display a comp. If you want to restore the document to its state before you displayed the comp, do the following.

To restore the last document state:

On the Layer Comps panel, do either of the following:

Click in the left column next to the Last Document State listing.

Right-click a layer comp and choose Restore Last Document State.

You can update one or more layer comps to include edits that you have made to layers in your document.

To apply layer edits to one or more layer comps: ★

- On the Layer Comps panel, make sure the layer comp to be edited has the Layer Comp icon (click in the leftmost column).
- 2. Change the visibility setting, position, or layer style settings of one or more layers. You can also edit exisiting layers, or add and edit new layers.
- 3. Do either of the following:

To update just the layer comp you edited, click that comp listing. Optionally, if you want to prevent Photoshop from updating any category of settings for a layer comp, deactivate its Layer Comp Visibility, ■ Layer Comp Position, + or Layer Comp Appearance is button. Finally, click the Update Layer Comp button at the bottom of the panel, or right-click the layer comp and choose Update Layer Comp from the context menu.

To sync (apply) your edits to multiple layer comps, select all the layers you edited. Next, hold down Ctrl/Cmd and click the comps to which you want to sync your edits. Finally, click one or more of these buttons at the bottom of the panel: Update Visibilities of Selected Layer Comps and Layers, Supdate Positions of Selected Layer Comps and Layers, to or Update Appearances of Selected Layer Comps and Layers. Alternatively, to access the update commands via a context menu, right-click one of the selected layer comps.

A The variations shown above are layer comps (document variations) within a single image.

- ➤ If you add new layers to a document and you want to apply that addition to the currently selected layer comp, click the Update Layer Comp button. ✓ Or to sync the addition of layers to multiple comps, select the new layers on the Layers panel; next, on the Layer Comps panel, select multiple comps, then click the Update Visibilities of Selected Layer Comps and Layers button.
- When you place an image that contains layer comps into a Photoshop document as a Smart Object, you can specify which comp will display in the document. See step 4 on page 272.
- To rename a comp, double-click its name.

If you change the layer count in an image (e.g., delete or merge layers or convert a layer to a Smart Object), and the image contains layer comps, an alert icon, and indicating that the "Layer Comp Cannot Be Fully Restored," will appear next to the names of any comps that are missing data. Follow either option below to remove the alert icon(s) and sync the comp(s) with the layers' current status. Deleted layers won't be retrieved.

To clear an alert icon from a layer comp:

Do either of the following:

Click a layer comp that has an alert icon, then click the icon. If an alert dialog appears, click **Clear**. Right-click the alert icon and choose **Clear Layer Comp Warning** (or to clear all the alert icons, choose Clear All Layer Comp Warnings instead).

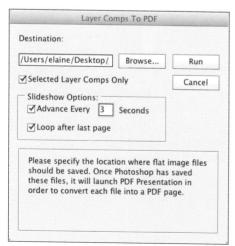

A In the Layer Comps to PDF dialog, choose a destination folder and options for the PDF slideshow.

When you delete a layer comp, no layers are deleted, and the appearance of the document is preserved.

To delete a layer comp:

- 1. On the Layer Comps panel, ☐ click the listing for the layer comp to be deleted.
- Click the Delete Layer Comp button on the panel, or right-click the comp listing and choose Delete Layer Comp from the context menu.

Creating a PDF presentation of layer comps

Via the Layer Comps to PDF script, you can produce a PDF presentation of the layer comps in your document, which any viewer can watch as a slideshow in an Acrobat program, such as Adobe Reader.

To create a PDF presentation of layer comps:

- 1. Open a Photoshop file that contains layer comps.
 - To create the PDF presentation from select layer comps in your document (instead of all of them), Ctrl-click/Cmd-click those listings.
- 2. Choose File > Scripts > Layer Comps to PDF. The Layer Comps to PDF dialog opens.
- Click Browse. In the Save As dialog, enter a file name and choose a location for the PDF file, then click Save.
- If you selected some layer comps in step 1, check
 Selected Layer Comps Only.
- **5.** Under Slideshow Options, check **Advance Every** [] **Seconds** to let the comps advance automatically, and enter a time value.
 - Optional: Check Loop After Last Page to allow the slideshow to replay continuously (after the last frame displays, the show will replay from the first frame).
- 6. Click Run. Pause while the script produces a PDF file from your document. When it's done processing, an alert dialog will appear, indicating that the script was successful. Click OK.
- 7. In Bridge or your Desktop, locate and double-click the PDF file. One of the Acrobat programs will launch, such as Adobe Reader, Acrobat XI Standard, or Acrobat XI Pro. If an alert pertaining to Acrobat appears, click Yes.
- **8.** The PDF file will open onscreen, then the slideshow will play. (To halt the show, press Esc.)

Importing video clips into Photoshop

Using the Timeline panel in Photoshop, A you can edit video that is shot with a digital camera or other input device. Although the controls in Photoshop won't replace stand-alone video applications, they do provide basic editing features. As an added bonus, many of the Photoshop features that you have learned to apply to still photos can also be applied to video, such as filters and adjustments. The first step is to set up your Photoshop workspace for video editing.

To set up the Photoshop workspace for video editing:

- 1. Choose Window > Workspace > Motion. By default, the Timeline panel is docked at the bottom of the Application frame. You can leave it there or drag it out of the frame.
- 2. On the Timeline panel menu, check Enable Timeline Shortcut Keys.
- 3. From the Timeline panel menu, choose Panel Options. In the Animation Panel Options dialog, click Timeline Units: Timecode, then click OK.
- To reopen the Timeline panel if it's not showing, choose Window > Timeline.
- To enlarge the Timeline panel if it's docked, drag the top of the panel (the dark line) upward. If the panel isn't docked, drag a side, bottom, or corner.

LEARNING THE VIDEO LINGO

- ➤ The work area in which you edit a video project in Photoshop is called the timeline.
- Each video file that you open into Photoshop is called a video clip. Each video clip displays as a blue bar on the Timeline panel.
- ► Each horizontal row (labeled Video Group) on the timeline is called a track. A track can contain one or more video clips and/or title clips (type). Audio clips are on separate tracks, and display as green bars.
- ➤ Each split-second image within a video clip is called a frame. The first frame of each clip is shown in a thumbnail on the Timeline panel.
- ➤ The Playhead (blue marker atop the red vertical line) designates the frame at which a video will begin to play.
- ➤ Effects that are used to blend the end of one clip to the beginning of the next are called transitions.
- The markers that designate where changes in a frame sequence begin and end are called keyframes.
- The process by which all the clips in the timeline are combined into a movie is called rendering.

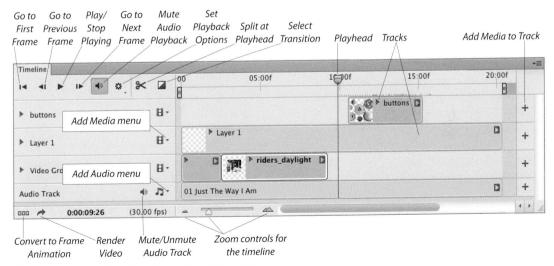

A The Timeline panel is used for video editing in Photoshop.

Photoshop can import standard and high-definition video files in many popular formats. When you edit a video, your edits are stored in a Photoshop document; the original video file isn't altered. As a last step before playing your final video, you will need to render it (see page 456).

To import a video file into a new Photoshop document:

- 1. Close all open Photoshop documents, then do either of the following:
 - From Bridge, drag a video file thumbnail into the Application frame in Photoshop.
 - On the Timeline panel in Photoshop, the choose Add Media from the Add Media menu to or, at the right end of the timeline, click the Add Media to Track button. In the Add Clips dialog, select one or more clip files, then click Open.
- 2. If an alert regarding the pixel aspect ratio appears, click OK. On the View menu, uncheck View > Pixel Aspect Ratio Correction. A new document appears in Photoshop. The video clip appears on the Layers panel within a Video Group listing, A and on the Timeline panel as a blue bar. B The first frame of the clip displays as a thumbnail within the bar.
- 3. Optional: Add more clips via the Add Media menu (not via dragging). They will appear from left to right on the timeline in the sequence in which you import them.
 - Note: Once you have imported a video into a Photoshop file, don't move the original video file, or the link to that file will be broken.
- **4.** Save your file in the Photoshop format—and remember to save it periodically while editing it.
- As your video becomes more complex, you will need to drag the scroll bar horizontally on the panel in order to view the clips.

Adding video tracks to a timeline

By default, clips that you add to a timeline appear within the currently selected Video Group (track), and are also listed on the Layers panel. The first clip in a track corresponds to the bottommost layer on the Layers panel, and plays back first. If you want clips to play simultaneously, such as a title clip on top of video footage, you need to put them on separate tracks.

To add a track to the timeline:

- 1. From the Add Media menu 🖽 on the Timeline panel, choose New Video Group. A new Video Group appears on both the Timeline and Layers panels.
- 2. Drag a video clip from another track (Video Group) into the new track, or import it via the Add Media menu 🖽 or the Add Media to Track button. +

FREE VIDEO FILES

You can download video clips of national parks and historic sites from nps.gov/pub_aff/video/index.html. The clips are in the public domain.

A The three clips that we added to a Video Group are listed on the Layers panel.

B This Timeline panel is showing the same Video Group as on the Layers panel. The three layers display as clips in one track.

Changing the length, order, or speed of a clip

One of the first edits you should make to a video is to trim off any excess footage.

To trim a clip by dragging:

Position the pointer over either end of a clip (the Trim cursor appears Φ), then drag inward to shorten the clip. A

As you trim the clip, the frame at which the clip will begin or end displays temporarily in what is called a trim window. The current Start or End position of the Trim cursor on the timeline is also listed in the window, as well as the Duration (length) of the clip.

Trimmed frames aren't deleted. To retrieve trimmed frames at any time, drag the start or end of the clip outward.

To specify the length or speed of a clip via a panel:

- 1. To display the temporary Video panel, right-click a clip or click the arrowhead at the end of the clip.B
- 2. Do either or both of the following:

To adjust the length of the clip, click the Duration arrowhead, then adjust the slider; or enter a value in the field.

To adjust the speed at which the clip plays, click the Speed arrowhead, then adjust the slider; or enter a value in the field. Any audio in the clip will be muted, as the change in speed will cause audio distortion. A high Speed value will shorten the Duration.

A swe dragged the end of a clip to shorten it, the frame at which the clip would end displayed temporarily in a trim window.

To change the order of clips in a track:

Do either of the following:

On the Timeline panel, drag a clip to the left or right, either between two other clips or to the beginning or end of its track, and release when the vertical black bar or rectangle displays.

On the Layers panel, drag a clip layer upward or downward. The clip that is listed at the bottom of a Video Group plays first.

To delete a clip or track:

Do either of the following:

On the Timeline panel, click a Video Group listing or a clip (colored bar), then press Backspace/ Delete.

On the Layers panel, expand a Video Group listing, click a clip layer, then press Backspace/Delete.

Playing or reviewing a video

Any time you edit a timeline, you can preview the results by doing either of the following:

To play your video at normal playback speed, press the Play button on the Timeline panel. Had enough? To stop the playback, press the button again (same button, different icon).

If you want to review just a section of your video (a process called scrubbing), simply drag the Playhead along that section of the timeline.

- From the Set Playback Options menu, you can choose a resolution for the playback quality.
- To mute the audio in all video clips, click the Mute Audio Playback button at the top of the Timeline panel. To mute the audio in just one video clip, right-click the clip, click the Audio icon, In then check Mute Audio on the temporary panel.

B We right-clicked a clip to display this Video panel, then chose new Duration and Speed settings.

Splitting a clip

When you split a clip into sections, an insertion point is created between them, into which you can add other clips. Optionally, you can move or delete any of the sections that result from the split.

To split a clip:

- 1. On the Timeline panel, click a clip.
- 2. Drag the Playhead (the blue marker at the top of the red line) over the frame at which you want to split the clip.
- 3. Click the Split at Playhead button.
- **4.** Optional: To split the clip further, repeat steps 2–3.

You can click any section that results from a split, then drag it to a new location within the same track or into another track, or press Backspace/ Delete to remove it. Any resulting gap in the track will close automatically.

When you split a clip, although each new section looks shorter (and plays for less time), it still contains all the original video footage. If you decide you want to include more frames in one of the clips, position the pointer over either end of it (the Trim cursor appears), then drag to lengthen it.

Adding transitions to video clips

Although video editors sometimes use a "jump cut" (abrupt transition) between scenes to convey a sense of action and energy, a smoother transition, such as a fade, creates a more gentle segue between clips, and can be used to convey the passage of time.

To add a transition to a clip:

- On the Timeline panel, click the Transition button, then drag a transition from the temporary panel to the start or end of any clip (A, next page), or between two clips to have the transition apply to the end of the first clip and the beginning of the second one.
- 2. To change the transition style, right-click the transition ramp in the lower-left or lower-right corner of the clip and choose a different option from the menu on the temporary Transition panel.

To adjust the duration of a transition:

Do either of the following:

Position the cursor over the transition ramp on the clip, then drag inward to shorten the effect or back outward to lengthen it (you'll see the Trim cursor) (B, next page).

Right-click the transition ramp on the clip to display a temporary **Transition** panel, then change the **Duration** value via the slider or field.

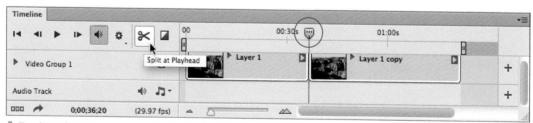

A To split a selected clip, we moved the Playhead to the desired position, then clicked the Split at Playhead button.

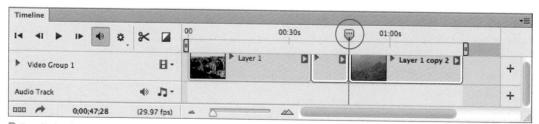

B To split the clip once more, we moved the blue Playhead further along the timeline. Because we split the clip, we now have the option to delete any unwanted sections or move a section to a different track.

Adding still images to a video

You can also add still images to a timeline, then have them "come to life," making them pan, zoom, or rotate. You can play a still image on top of a video track, or import a series of still image clips into one track to be played in succession, like a slideshow.

To add a still image to a video:

- 1. Save a copy of a photo, then use the Image Size dialog to change its resolution to 72 ppi.
- 2. On the Timeline panel, click a Video Group, then from the Add Media menu, E choose Add Media.
- 3. The Add Clips dialog opens. Click a still image, then click Open. The still image will appear as a new purple bar on the timeline.
- 4. Optional: Drag the Playhead over the image clip, then press Ctrl-T/Cmd-T (if you don't see all the transform handles, press Ctrl-0/Ctrl-0). Shift-drag a corner handle to scale the image to the desired size, then double-click in the transform box.
- 5. Optional: Each still image is assigned a default play interval of 5 seconds. You can adjust that interval by dragging its edge.
- For the most flexibility in trimming and positioning a still image clip, create a new track (see page 450), then drag the clip to that track.

To apply a motion effect to a still image:

To open a temporary Motion panel, right-click a still image clip or click its arrowhead. Choose an option from the first menu, C then choose other applicable settings, such as the angle for a pan or the origin for a zoom.

Drag To Apply Fade Cross Fade Fade With Black Fade With White Fade With Color 1 s

A We clicked the Transition button on the Timeline panel to open this temporary panel. Our next step will be to drag an option from the panel to a clip on our timeline.

B We're dragging a transition ramp to change its duration.

Adding title clips to a video

The addition of titles to a video adds a professional touch, and sometimes essential information. Just make sure your titles are concise, carefully kerned, and easy to read. Avoid using serif fonts, which can become fuzzy on a low-resolution monitor, and the color red, which can smear or bleed onscreen.

To add a title clip to a video:

- 1. On the Timeline panel, position the Playhead where you want the title to appear.
- 2. With the Horizontal Type tool, create an editable type layer. The type layer will appear within the currently selected Video Group on the Layers panel and as a purple clip on the Timeline panel.

To have a title clip play on top of a video clip:

- 1. Do either of the following:
 - Create a new track above all the other tracks (see page 450), then drag the title clip into that group. On the Layers panel, drag the type layer to the top of the layer stack.
- 2. Optional: To extend the duration that the title clip plays, drag its right edge. (The maximum duration is the current length of the timeline.)

You can apply a motion effect to a title clip to make it less static, just as you can to a still image.

To apply motion to a title clip:

Follow the second task at left. If you want the title to fill the entire screen when the video plays, check Resize to Fill Canvas on the Motion panel.

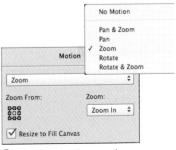

We're choosing Zoom as the motion option from the top menu on the Motion panel.

Applying adjustment layers and filters to a video

You can apply any Photoshop adjustment command to a clip or track, or to the whole timeline. By default, each adjustment layer is clipped to, and only affects, the clip directly below it. If desired, you can expand the adjustment to affect all the clips in the Video Group or to all the tracks on the timeline. The adjustment layer settings can be edited at any time.

To apply an adjustment layer to one clip:

- On the Layers panel or the Timeline panel, click the clip to be adjusted, then on the Timeline panel, drag the Playhead over that clip.
- Create an adjustment layer (via the Adjustments or Layers panel) and choose settings in the Properties panel. Try applying a Color Lookup adjustment, which adds Hollywood movielike effects

To apply an adjustment layer to all the clips in a Video Group:

- 1. On the Layers panel or Timeline panel, click a Video Group.
- 2. Create an adjustment layer.
- 3. To unclip the adjustment layer, on the Layers panel, Alt-click/Option-click the line between the clip layer and the adjustment layer. If the adjustment layer isn't at the top of its Video Group, drag it upward to that stacking position.

 Note: The adjustment clip won't display as a clip

Note: The adjustment clip won't display as a clip on the timeline (unless you follow the steps in the next task).

To apply an adjustment layer to all the tracks in a timeline:

- On the Layers panel, do the following:
 Click the topmost Video Group.
 - If you haven't already done so, create an adjustment layer.
 - Drag the adjustment layer above (and outside of) its original Video Group. A
- 2. On the Timeline panel, the adjustment clip will appear in a new track. To adjust its duration, drag its right edge to the right.
- When an adjustment layer is in its own track, you can apply keyframing edits (such as opacity changes) to make the effect appear gradually over time (see the next page).

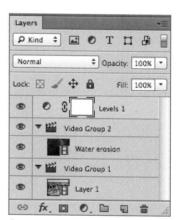

A On the Layers panel, we dragged an adjustment layer out of a Video Group.

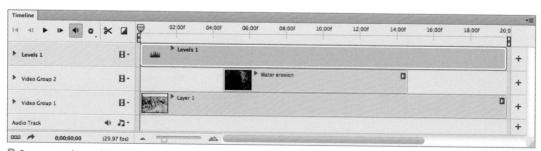

Because we dragged the Levels adjustment layer clip to its own track, the adjustment will apply to all the tracks below it on the timeline. We also lengthened the adjustment clip to have it apply to the entire duration of the video.

You can apply any Photoshop filter to a clip. By default, the filter will affect only the frame where the Playhead is located. To have a filter affect an entire clip, you must convert the clip to a Smart Object before you apply it.

To apply a filter to a clip:

- 1. On the Timeline panel, click a clip.
- 2. Choose Filter > Convert for Smart Filters (click OK if an alert dialog appears). The clip color changes to purple. Apply one or more filters (Filter menu). A Smart Filters listing appears on the Layers panel. To edit the filter at any time, double-click the listing.
- You can apply a filter in the Blur Gallery to a clip (Filter > Blur > Field Blur, Iris Blur, or Tilt-Shift Blur). For a "miniaturized" effect, try Blur > Tilt-Shift.
- To apply a filter to just a section of a clip, split the clip, click a section, then follow step 2 above.
- To make a filter effect fade in and out over time, on the Layers panel, duplicate the clip layer. Add a new track (see page 450), drag the duplicate clip into the new track, and position it directly above the original one. Apply the filter to the duplicate, then follow the steps in the last task on this page.

Keyframing

By using keyframe markers, you can apply an edit to a video that plays over a specified span, such as a transformation (e.g., scale change), opacity change, or layer style change (blending mode or layer effect).

To create a picture-in-a-picture:

1. Make sure your timeline contains at least two video clips that are on separate tracks. Drag the upper clip to the right (so the video begins with the lower clip).

- 2. Click the clip on the upper track, then to enable it to be transformed, if it's not already a Smart Object, right-click its layer on the Layers panel and choose Convert to Smart Object.
- 3. Move the Playhead to the right, to the location in the clip where you want the clip to begin to scale.
- 4. Expand that Video Group listing, then click the Enable Keyframe Animation button of for Transform. A yellow diamond-shaped marker appears on the timeline.
- 5. Move the Playhead to the point in the clip where you want the scaling to end.
- 6. Press Ctrl-T/Cmd-T for the Transform command. Shift-drag a corner handle in the document window to shrink the clip proportionally, drag the scaled clip to the desired location, then press Enter/Return to accept the transformation. A second keyframe marker appears on the timeline.
- 7. As you play the video, the still image will shrink and move between the keyframes.A
- If you need to change the Speed setting for the clip, double-click its Smart Object thumbnail on the Layers panel.

To create a manual fade:

- 1. On the timeline, click a clip (not one in the bottommost Video Group), then position the Playhead several seconds inward from the end of the clip.
- 2. Expand the Video Group and click the Enable Keyframe button of for Opacity.
- 3. Move the Playhead to the end of the clip.
- 4. On the Layers panel, lower the Opacity value to 0%. A second keyframe marker appears on the timeline.

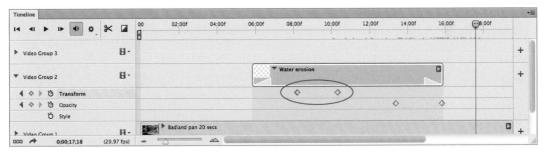

A We added keyframes to a video clip to designate where we wanted Transform and Opacity changes to occur. The section between each pair of diamonds within the row marks the area of transition.

Adding audio clips

By default, one audio track (for narration or music) is included in each timeline. You can add more audio clips or tracks as needed, plus you can fade, mute, or adjust the volume for any existing audio clip.

To adjust the settings of an audio clip:

- To display the temporary Audio panel, right-click a video clip, then click the Audio icon A; or right-click an audio clip. B
- Adjust the Volume, Fade In, and Fade Out sliders (or if you want to mute the clip, check Mute Audio).
- ► If the audio doesn't play as you play the video, click the Enable Audio Playback button.

To add an audio clip or track to a timeline:

- 1. Optional: To add an audio clip to a new track, from the Add Audio menu on an audio track, choose New Audio Track.
- From the Add Audio menu on an audio track, choose Add Audio; or click the Add Audio to
 Track button at the right end of the timeline.
- **3.** The Add Audio Clips dialog opens. Locate an audio file, then click Open.

A To access the audio settings for a video clip, we clicked the Audio icon.

B We right-clicked an audio clip to display these Audio panel settings.

REOPENING A VIDEO FILE

If you close, then reopen, a video file and Photoshop can't locate one or more of the media files that are used in the video, an alert dialog will appear. For each file name that is listed in the dialog, click Choose, then locate the missing file.

Rendering clips into a movie

Rendering is the essential final step of combining edited clips into a playable movie file.

To render a timeline into a final video:

- 1. Save your file. On the Timeline panel, click the Render Video button.
- **2.** The Render Video dialog opens. C Do all of the following:

Enter a **Name** for your video file (keep the default extension).

Click **Select Folder**, choose a location for the file, then click OK/Choose.

Choose a **Format** and **Size** for the video. (The Preset menu for the H.264 format offers presets for many popular tablets, devices, and video services.) Leave the other menus alone.

Under Range, click **All Frames** (or click Start Frame and enter a specific range of frames).

Click **Render**. The rendering process may take a while, depending on the speed of your computer and the length of the video.

To enable your Photoshop video to be played on a home DVD player, use Windows Live Movie or Apple iMovie to convert it to the proprietary file format for DVD players.

Render Video	
Location Name: badlands proj2 pl.mp4 Select Folder Users:peter:Desktop: Create New Subfolder:	Render
Adobe Media Encoder ‡	
Format: H.264 ÷	
Preset: High Quality	•
Size: Document Size \$ 720 x 480	
Frame Rate: Document Frame Rate ‡ 29.97 fps	
	•
Aspect: Square (1.0)	i
Range ● All Frames Start Frame: 0 End Frame: 1023 Work Area: 0 to 1023	
Render Options	
Alpha Channel: None ‡	
3D Quality: Interactive ‡	

The Render Video dialog provides a lot of output options.

Preferences are settings that you specify for various Photoshop application features, such as the gray shades for the Photoshop interface and measurement units for the rulers. Most preference changes take effect immediately (and are saved to the Photoshop Preferences file) when you exit/quit Photoshop, but a handful of preference changes don't take effect until you relaunch Photoshop or Bridge; we note such exceptions.

Opening the Preferences dialogs

To open the Preferences dialog for **Photoshop**, press Ctrl-K/Cmd-K, or choose Edit/Photoshop > Preferences > General or another option from the submenu. In the dialog, click one of the 13 panel names on the left side, A or click Prev or Next, or press a shortcut between Ctrl-1/Cmd-1 and Ctrl-0/Cmd-0 (zero).

To open the Preferences dialog for **Bridge**, in Bridge, press Ctrl-K/Cmd-K or choose Edit/Adobe Bridge CC > Preferences.

General	Guides	
Interface Sync Settings	Color: Cyan	‡
File Handling Performance	Style: Lines	•
Cursors	Smart Guides	
Transparency & Gamut Units & Rulers	Color: Magenta	÷
Guides, Grid & Slices		
Plug-Ins Type	Grid	
3D	Color: Custom	
Experimental Features	Style: Lines Contact Contact	

A The Preferences dialog in Photoshop contains 13 panels.

RESETTING ALL THE PREFERENCES

- ➤ To reset all the Photoshop preferences to their default settings, hold down Ctrl-Alt-Shift/Cmd-Option-Shift as you launch the program. If the User Account Control dialog appears in Windows, respond to it while continuing to hold down Ctrl-Alt-Shift. In Windows/Mac OS, when the alert dialog appears, release the modifier keys, then click Yes to delete (and reset) the Adobe Photoshop Settings file.
- ➤ To reset the Bridge preferences, hold down Ctrl/Option as you launch Bridge. When the Reset Settings dialog appears, check Reset Preferences, then click OK.

24

IN THIS CHAPTER

Opening the Preferences dialogs 457
General Preferences
Interface Preferences
Sync Settings Preferences
File Handling Preferences
Performance Preferences
Cursors Preferences
Transparency & Gamut Preferences 466
Units & Rulers Preferences
Guides, Grid & Slices Preferences 468
Plug-ins Preferences
Type Preferences
Experimental Features Preferences469
Preferences for Adobe Bridge 470

SYNCING PREFERENCES VIA THE CREATIVE CLOUD

To sync your Photoshop preferences between two computers via the Creative Cloud, see pages 497–498.

General Preferences (A, next page)

For the default **Color Picker**, choose either Adobe (the default setting) or your system color picker.

For the onscreen **HUD** (Heads-Up Display) **Color Picker**, choose a strip or wheel style and size. See page 204.

Choose a default Image Interpolation option for Photoshop edits that involve resampling or transforming, such as a use of the Crop tool: Nearest Neighbor (Preserve Hard Edges), the fastest and the best for hard-edged graphics but the least precise; Bilinear, for medium quality; Bicubic (Best for Smooth Gradients), higher quality but slower; Bicubic Smoother (Best for Enlargement); Bicubic Sharper (Best for Reduction); or the default setting of Bicubic Automatic (Photoshop determines the best method).

Options

Check **Auto-Update Open Documents** to have open Photoshop documents that you edit in other applications update automatically when you return to Photoshop, such as when you assign metadata to a file in Bridge.

Check **Dynamic Color Sliders** to have the colors above the sliders on the Color panel update as you move the sliders.

With Use Shift Key for Tool Switch checked, in order to access tools from a fly-out menu, you must press Shift plus the assigned letter (e.g., press Shift-B to cycle through the Brush, Pencil, Color Replacement, and Mixer Brush tools). If you uncheck this option (as we do), you can cycle through related tools simply by pressing their assigned letter. To learn the tool shortcuts, see pages 112–114 or use Tool Tips.

Check **Animated Zoom** for smooth, continuous zooming as you click and hold with the Zoom tool to zoom in, or hold down Alt/Option and click and hold to zoom out. Note: To use this feature, Use Graphics Processor must be checked in the Performance panel of this dialog; see pages 464–465.

If your mouse has a scroll wheel and you check **Zoom with Scroll Wheel**, you can change the zoom level by scrolling the wheel horizontally or vertically.

Check **Enable Flick Panning** to enable a magnified image to quickly float across the screen when you drag it with the Hand tool a short distance, then release the mouse (Use Graphics Processor must be

checked in the Performance panel of this dialog; see page 464–465).

Check **Beep When Done** to have a beep sound when a command is done processing. This can be handy for commands that take a while to process (so you can take a break).

Check **Export Clipboard** to retain the current Clipboard contents on the system Clipboard when you switch between Photoshop and other programs.

Check **Resize Image During Place** to have images or graphics scale to fit the current canvas area automatically when they are imported via the File > Place Embedded or File > Place Linked command.

Check Always Create Smart Objects When Placing *\pi to have raster images that you bring into Photoshop via the Place Embedded command arrive automatically as Smart Objects (see page 266).

With Zoom Resizes Windows checked, a floating document window will resize when you change the zoom level via the Ctrl/Cmd- + (plus) or Ctrl/Cmd- - (minus) shortcut or the Zoom tool. You can also control this behavior for the Zoom tool via the Resize Windows to Fit check box on the Options bar. Note: With this option checked, as you change the zoom level, the document is also positioned over — but not docked into — the document window area of the Application frame.

Check **Zoom Clicked Point to Center** to have Photoshop center the image at the location you click when zooming.

With Vary Round Brush Hardness Based on HUD Vertical Movement checked, you can hold down Alt-right-click/Control-Option and drag vertically to change the brush hardness; with this option unchecked, the shortcut changes the brush opacity instead. This option affects the Brush, Pencil, Color Replacement, Clone Stamp, History Brush, Sharpen, and other tools (see page 129). HUD stands for "Heads Up Display," and it refers to the ability of the user to choose settings via on-canvas controls. Note: To display the hardness or opacity value as a tint within the cursor, check Use Graphics Processor in the Performance panel of this dialog.

Check **Snap Vector Tools and Transforms to Pixel Grid** to have future vector paths that you create, and

existing shapes that you transform, snap to the pixel grid for sharper rendering in onscreen output (see page 405).

History Log

Check **History Log** to have Photoshop generate a log of your editing activity from each work session. The log can be useful if you need to preserve an exact record of your editing steps or need to tally your billable hours for clients.

For Save Log Items To, choose where the log is to be saved: to the Metadata of a file, to a separate Text File, or to Both of the above. For either of the latter two options, choose a location for the text file in the dialog that opens automatically, then click Save.

From the Edit Log Items menu, choose what data is to be saved in the log: Sessions Only to log just the date and time when you launch or exit/quit Photoshop and which files were opened; Concise to log Sessions information plus a list of edits (states on the History panel); or Detailed to include all of the above data plus any actions used and the options and parameters used in each editing step.

Reset Warning Dialogs

Click Reset All Warning Dialogs to reactivate all alert dialogs in which you have clicked Don't Show Again.

			Preferences	
General	Color Picker:	Adobe	*	
Interface Sync Settings	HUD Color Picker: Hue Strip (Sm)	
File Handling Performance	Image Interpolation:	Bicubic Automa	tic	\$.
Cursors	Options			
Transparency & Gamut	Auto-Update Op	en Documents	Export Clipboard	
Units & Rulers	 ✓ Dynamic Color Sliders Use Shift Key for Tool Switch ✓ Animated Zoom Zoom with Scroll Wheel ✓ Enable Flick Panning ✓ Beep When Done 		Resize Image During Place	
Guides, Grid & Slices Plug-Ins			Always Create Smart Objects whe	n Placing
Type			✓ Zoom Resizes Windows	
3D			Zoom Clicked Point to Center	
Experimental Features			✓ Vary Round Brush Hardness base	d on HUD vertical movement
			✓ Snap Vector Tools and Transform	s to Pixel Grid
	✓ History Log			
	Save Log Items To:		Choose	
		O Text File	Choose	
		O Both	_	
	Edit Log Items:	Sessions Only	•	
			Reset All Warning I	Dialogs

Interface Preferences (A, next page)

Appearance

Click a Color Theme for the Photoshop interface, including the background and text color in the panels, Options bar, and Application frame, and the blank background behind the canvas area.

Via the Color menus next to Standard Screen Mode. Full Screen with Menus, and Full Screen, choose a shade or color for the area around the canvas for each screen mode: Default (the shade associated with the current Color Theme); Black or a Gray option; or Select Custom Color. For the latter option, choose a color from the Color Picker; thereafter, that color will appear if you choose the Custom option. For the Border around the canvas area, choose Line, Drop Shadow, or None. Note: For the Line and Drop Shadow options, you must also check Use Graphics Processor in Performance preferences. For the screen modes, see page 104.

Options

If Auto-Collapse Iconic Panels is checked and you open a collapsed panel, then click anywhere outside it, the panel will collapse back to an icon. With this option unchecked, the panel will remain expanded. See page 106.

Check **Auto-Show Hidden Panels** to allow panel docks that you have hidden to redisplay temporarily. In Standard Screen mode, you can hide the docks by pressing Tab or Shift-Tab, then redisplay them temporarily at any time by letting the pointer pause on the dark gray vertical bar at the right edge of the Application frame (or the left edge of the frame, for the Tools panel). Move the pointer away from the docks, and they will disappear again. In either of the Full Screen modes, let the pointer pause at the edge of your display to make the dark bar appear, followed by the docks.

Check **Open Documents as Tabs** to have documents dock automatically as tabs when opened instead of as floating windows (we recommend checking this option). Note: In the Mac OS, if you check this option but hide the Application frame, images will dock as tabs within one document window automatically.

Check Enable Floating Document Window Docking to allow a floating document window to be docked as a tab when you drag its title bar just below the Options bar in the Application frame or next to an existing document tab in a floating window. (We recommend keeping this option checked.)

Check Show Channels in Color to display RGB or CMYK channels in color thumbnails on the Channels panel and in the document window when clicked individually. Uncheck this option (as we do) to display the channels in grayscale, which is useful for judging luminosity values.

Check **Show Menu Colors** to activate the display of background colors that have been assigned to menu commands via Edit > Menus and to workspaces in which they were saved (e.g., the "What's New" workspace).

If Show Tool Tips is checked and the pointer is currently hovering over a Photoshop feature (mouse button up), a label pertaining to that feature appears briefly onscreen. This is a good way to identify panel and dialog options, as well as tools and tool shortcuts.

Mac OS users: Check Enable Gestures if you have a laptop with a multi-touch trackpad (or are using a Magic Mouse or Magic Trackpad with any Macintosh computer) and you want to enable the capability of the trackpad to zoom, rotate, or flick images. Uncheck this option if you find that the gestures are causing unwanted highlighting or pointer movements.

Check **Enable Text Drop Shadows** to display a very subtle drop shadow behind text labels in panels.

If you're using Photoshop on a laptop, check Enable Narrow Options Bar for a compact Options bar.

Click Restore Default Workspaces to restore, to the Workspace menu, any predefined Adobe workspaces that were deleted via the Window > Workspaces > Delete Workspace dialog.

From the **Show Transformation Values** menu, choose a location (e.g., Top Left or Bottom Right) for the label that appears and updates dynamically as you transform objects, indicating the current rotation, scaling, or other values. Choose Never from the menu if you prefer to turn this feature off.

Text

As noted in the dialog, to implement these Text options, you must relaunch Photoshop.

If you are using a multilingual version of Photoshop, from the **UI Language** menu, choose a language for the interface.

From the **UI Font Size** menu, choose Tiny, * Small, Medium, or Large as the font size for features in the Photoshop user interface (panels, Options bar, etc.).

				Prefer	ences	
General Interface Sync Settings	Appearance Color Theme:					
File Handling Performance Cursors	Standard Screen Mode: Full Screen with Menus: Full Screen:	Color		Border		
		Default	÷	None		
ransparency & Gamut		Default	•	None	•	
Units & Rulers Guides, Grid & Slices Plug-ins Type 30 Experimental Features		Black	\$	None	•	
	✓ Auto-Collapse Iconic I ✓ Auto-Show Hidden Pa ✓ Open Documents as T ✓ Enable Floating Docur	✓ Show Menu Colors ✓ Show Tool Tips ✓ Enable Gestures ✓ Enable Text Drop Shadows Enable Narrow Options Bar Restore Default Workspaces ze: Small ‡				

A Interface Preferences

Sync Settings Preferences B ★

You can sync Photoshop settings between two computers in which the same Creative Cloud membership ID is being used. Via the Sync Settings panel in Preferences (or via commands on the Edit/ Photoshop > [your Adobe ID] submenu), you upload the current Photoshop settings on one computer to the Creative Cloud server, then download the settings from the Creative Cloud to your second computer. See also pages 495-496.

Creative Cloud

The Signed In As info is your current Creative Cloud membership ID. Also listed are the date and time of the Last Upload and Last Download.

Advanced Settings

From the What to Sync menu, choose Everything (to check all the boxes); or choose Custom, then check the kinds of settings that you want to upload or download (Preferences, Workspaces, and presets for Photoshop panels and pickers).

Next, click Upload to upload the specified Photoshop settings from your computer to the Creative Cloud, or click **Download** to download the current settings in the Cloud to your computer.

Log

The Log lists settings that were uploaded and downloaded, and the times they were uploaded or downloaded. The log clears when you exit/quit Photoshop.

	Preferences	
General Interface Sync Settings File Handling Performance Cursors Transparency & Gamut Units & Rulers Guides, Grid & Slices Plug-Ins Type 3D Experimental Features	Creative Cloud Signed in as: Last upload: 5/3/14 at 6:21 PM Last download: -	Upload Download
	Advanced Settings What To Sync Custom * ✓ Preferences ✓ Brushes ✓ Gradients ✓ Patterns ✓ Workspaces ✓ Swatches ✓ Custom Shapes ✓ Contours ✓ Actions ✓ Styles ✓ Tool Presets	

B Sync Settings Preferences

File Handling Preferences (A, next page)

File Saving Options

Choose Image Previews: Never Save to save files without a thumbnail preview for the Desktop, or Always Save (our preference) to have an updated preview save with files each time they're saved, or Ask When Saving to decide which previews to include via Image Previews check boxes when saving files via the Save or Save As dialog. See pages 18–20.

In the Mac OS, check **Icon** to have the thumbnails of files display as their icons on the Desktop and in the File > Open dialog. Check **Windows Thumbnail** to have the thumbnail for a file display when the file is selected in File > Open.

In the Mac OS, choose **Append File Extension**: Always (our preference) to have Photoshop include a three-letter abbreviation of the file format (e.g., .tif, .psd) automatically when you save a file via the Save As command; or Ask When Saving to be given the option to decide in each case whether to include the extension via File Extension check boxes in the Save As dialog. Extensions are helpful when converting files for Windows, and are necessary when saving files for the Web. Keep Use Lower Case checked to have file extensions appear in lowercase characters instead of in uppercase.

In Windows, choose **File Extension**: Use Lower Case or Use Upper Case.

Check **Save As to Original Folder** (as we do) to have the location in the Save As dialog always default to the existing location of the current file.

Check **Save in Background** to permit image editing to occur while Photoshop is saving a file.

Check **Automatically Save Recovery Information Every**, and choose a time interval from the menu, to let Photoshop save a temporary copy of the current document to your hard disk. If Photoshop exits/quits unexpectedly, the temp file will open by default upon relaunch.

File Compatibility

Click Camera Raw Preferences to open that dialog.

Check **Prefer Adobe Camera Raw for Supported Raw Files** to have raw files that you open via File > Open open into Camera Raw, as opposed to other conversion software. We keep this option checked.

Files that are 32-bit (e.g., the files that are produced by the Merge to HDR Pro command from multiple exposures), must be converted to 8- or 16- bit for export or printing. With Use Adobe Camera Raw to Convert Documents from 32 bit to 16/8 bit checked, 32-bit files will open into Camera Raw automatically when you convert them to a lower bit depth via the Image > Mode > 16 Bits/Channel or 8 Bits/Channel command, so you can apply color and tonal adjustments.

Ignore EXIF Profile Tag enables Photoshop to read a camera's EXIF metadata color space data when opening files. This option is necessary only for files from early digital cameras, so we keep it unchecked.

Check **Ignore Rotation Metadata** to have Photoshop ignore any rotation settings that are applied to image thumbnails in Bridge.

Check Ask Before Saving Layered TIFF Files to have an "Including layers will increase file size" alert dialog appear when saving a layered file in the TIFF format. You can use this alert as a reminder to uncheck the Layers option in the Save As dialog.

Check **Disable Compression of PSD and PSB Files** to prevent Photoshop from compressing files when saving them in the PSD or PSB format. When this option is checked, documents save more quickly but have a larger file size.

To save your files so they can be opened in applications that don't support layers, check Maximize PSD and PSB File Compatibility. Photoshop will save a composite preview with your layered files, along with a rasterized copy of any vector art. Although this option produces larger files (and the save process takes longer), it's necessary for compatibility. Choose Ask to have Photoshop offer this as an option via an alert dialog when files are saved, or choose Always to have Photoshop produce compatible files automatically without an alert appearing. See pages 18–20.

Note: Upon saving a layered file, if Ask is the current Maximize PSD and PSB File Compatibility preference and you check Maximize Compatibility and Don't Show Again in the Photoshop Format Options dialog, Photoshop will switch the preference setting to Always. If you uncheck Maximize Compatibility but do check Don't Show Again in the alert, the preference setting will switch to Never.

Adobe Drive

For information on Adobe Drive, search for "adobe drive" at Adobe.com.

File list

In the Recent File List Contains [] files field, enter the maximum number of files (up to 100) that can be listed at a time on the File > Open Recent submenu in Photoshop.

Performance Preferences (A, next page)

Note: To implement changes made in this panel (except for Use Graphics Processor) you must relaunch Photoshop. For Use Graphics Processor, you must close and then reopen any open documents.

Memory Usage

The Let Photoshop Use field and slider control the maximum percentage of your computer's RAM that can be used by Photoshop. We recommend keeping this value on the default setting.

Scratch Disks

Check which hard drives Photoshop may use as Scratch Disks when available RAM is insufficient for processing or storing image data. To change the sequence of drives that have a check mark, click a drive, then click the up or down arrow.

- ► Hold down Ctrl-Alt/Cmd-Option while launching Photoshop to open the Scratch Disk Preferences dialog.
- From the Info panel menu in Photoshop, choose Panel Options, then check Efficiency under Status Information. When Photoshop is using the scratch disk, the Efficiency readout value on the panel is below 100%.

History & Cache

Low-resolution versions of the current file are saved in cache buffers to help the image and histograms redraw more quickly onscreen. To optimize the cache levels and tile size for Photoshop, click a generic document type (not your body type!): Tall and Thin (for smaller documents that contain many layers), Default (best for general use), or Big and Flat (best for larger documents that contain few layers).

Enter the maximum number of History States the History panel can list at a time. When this number is reached, older states are deleted.

Choose a higher Cache Levels value for large files that contain few layers and a lower Cache Levels value for smaller files that contain many layers.

The Cache Tile Size value controls how much data Photoshop processes at a given time. If you need faster processing of large images, you can choose a higher value.

Graphics Processor Settings

The **Detected Graphics Processor** area lists the graphics card that is currently installed in your system.

Check **Use Graphics Processor** if your system has OpenGL capability and you want to use the OpenGL features of Photoshop, such as Animated Zoom, Scrubby Zoom, Flick Panning, Pixel Grid, HUD Color Picker, the Sampling Ring for the Eyedropper tool, a tint in the brush cursor for hardness and/or opacity, the Live Tip Brush Preview, the Rotate View tool, and better performance when using some commands or filters, such as the Blur Gallery. (For a complete list, rest your pointer in the Graphics Processor Settings option, and look in the Description area.)

Description

In the **Description** window at the bottom of the dialog, you can read about whichever feature your pointer is currently hovering over.

A Performance Preferences

Cursors Preferences A

Painting Cursors

For the Painting Cursors (the Art History Brush, Background Eraser, Blur, Brush, Burn, Clone Stamp, Color Replacement, Dodge, Eraser, Healing Brush, History Brush, Mixer Brush, Pattern Stamp, Pencil, Quick Selection, Sharpen, Smudge, Sponge, and Spot Healing Brush tools), click the preferred cursor to be displayed onscreen: Standard for the tool icon; Precise for a crosshair; Normal Brush Tip for a circle that is half the size of the current brush; or Full Size Brush Tip for a circle that is the full size of the current brush. For either of the latter two options, you can also check Show Crosshair in Brush Tip to have a crosshair appear in the center of the circle and/or Show Only Crosshair While Painting to have only a crosshair display when the mouse is dragged, for faster performance when using large brushes.

Other Cursors

For the **Other Cursors** (all those not listed in the preceding paragraph, such as the Eyedropper and Crop tools), click **Standard** to have the tool icon display onscreen as you use the tool, or click **Precise** to display a crosshair instead.

Press Caps Lock to turn a Standard cursor into a Precise cursor (crosshair) or, if Precise is the current Painting Cursors setting, to turn any Painting cursor into a Full Size Brush Tip (circle).

Brush Preview

Click the **Color** swatch and choose a color via the Color Picker to represent the current brush hardness or opacity as a tint in the brush cursor as you Alt-right-click/Control-Option drag vertically (Use Graphics Processor must be checked in the Performance panel).

Transparency & Gamut Preferences B

Transparency Settings

Choose a **Grid Size** for the checkerboard that Photoshop uses to represent layer transparency on the Layers panel and in the document window.

For the transparency checkerboard, choose one of the **Grid Colors** options from the menu, or click each color swatch and choose a color via the Color Picker.

Gamut Warning

To change the color that Photoshop uses to mark out-of-gamut colors when the View > Gamut Warning feature is on, click the **Color** swatch. You can also change the **Opacity** of the Gamut Warning color.

Transparency & Gamut Preferences

Units & Rulers Preferences A

To get directly to the Units & Rulers panel of the Preferences dialog, double-click either ruler in the document window.

Units

From the Rulers menu, choose a unit of measure to display on the horizontal and vertical rulers; in dialogs, such as Image > Canvas Size; and on panels, such as the Info panel. To learn about the rulers in Photoshop, see pages 287-289.

 To change the ruler units without opening the Preferences dialog, right-click either one of the rulers in the document window and choose a unit from the context menu. When changed this way, via the Info Panel Options dialog, or via the Preferences dialog, the units change in all locations.

From the Type menu, choose Pixels, Points, or Millimeters as the unit of measure for the Character panel and Paragraph panels, and for the Font Size field on the Options bar when a type tool is selected.

Column Size

If you need to fit your Photoshop images into a specific column width in a page layout program, enter values in the Width and Gutter fields here. Thereafter, when you open the New, Image Size, or Canvas Size dialog and then choose Columns from the units menu next to the Width field, Photoshop will use your Width and Gutter preference values to calculate the Width.

New Document Preset Resolutions

Enter a Print Resolution value in either one of the available units to display as the Resolution setting when you choose one of the three print presets (such as U.S. Paper) in the New dialog; the default value is 300 ppi. For the Screen Resolution, enter a value to display as the Resolution when you choose the Web, Mobile & Devices, or Film & Video preset (the default value is 72 ppi). See pages 15-16.

Point/Pica Size

Click PostScript (the default, and recommended, setting) to have Photoshop use the standard PostScript value as the points-to-inch ratio.

Guides, Grid & Slices Preferences A

Note: Changes made in this dialog will preview immediately in your document.

Guides

For ruler guides, choose a Color from the menu (or click the swatch and use the Color Picker), and choose a Style, See pages 287-288.

Smart Guides

For Smart Guides, temporary lines that display as you move a layer or selection, choose a Color from the menu (or click the swatch and use the Color Picker). See page 286.

Grid

For the nonprinting grid, choose a Color and a Style. (To show or hide the grid in your document, press Ctrl-'/Cmd-'.)

To display grid lines onscreen at specific intervals, choose a unit from the menu, then enter a Gridline Every value. If you choose Percent from the menu and enter a value, grid lines will appear at those percentage intervals of the document width, starting from the left edge of the canvas. To control the spacing between the thinner grid lines that fall within the main grid lines, enter a Subdivisions value.

Slices

Choose a Line Color for the slice boundaries. Check Show Slice Numbers to have Photoshop display a slice number in the upper-left corner of each slice. (To learn about the slice tools, see Photoshop Help.)

Plug-ins Preferences (A, next page)

Note: To implement changes made in this panel, you must relaunch Photoshop.

Generator *

With Enable Generator checked, you can generate GIF, JPEG, PNG, or SVG image assets from Photoshop layers for output to the Web or mobile devices. See pages 489-494

Check Enable Remote Connections to let Photoshop set up a wireless connection with companion apps (e.g., Adobe Nav, Color Lava, and Eazel) that run on tablets and iPads. To learn more about this feature, see "Companion Apps" in Photoshop Help.

Filters & Extension Panels

Check Show All Filter Gallery Groups and Names to list all Photoshop filters in the submenus on the Filter menu, including those that are accessible in the Filter Gallery. With this option off, the submenus list only the filters that are not in the Filter Gallery, and the menu is more streamlined.

Panels from Adobe and third-party suppliers are accessed in Photoshop via Windows > Extensions. Check Allow Extensions to Connect to the Internet here to enable those extension panels to connect to the Internet in order to access updated content.

Check Load Extension Panels to have the extension panels that are currently residing in the Plug-ins folder (within the Photoshop application folder) load automatically when you launch Photoshop.

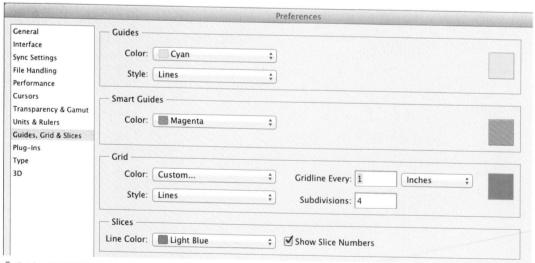

	Preferences		
General Interface Sync Settings	Generator ✓ Enable Generator □ Enable Remote Connections		
File Handling Performance	Service Name: Photoshop Server Hostname: elaines-imac-2.local		
Cursors	Password: •••• IPv4 Address: 10.0.1.5		
Transparency & Gamut Units & Rulers Guides, Grid & Slices	Password must be six characters or longer. Filters & Extension Panels		
Plug~ins	Show all Filter Gallery groups and names		
Type	✓ Allow Extensions to Connect to the Internet		
3D Experimental Features	✓ Load Extension Panels (i) Changes will take effect the next time you start Photoshop.		

A Plug-ins Preferences

Type Preferences B

Type Options

Be sure to check Use Smart Quotes to have Photoshop insert typographically correct (curly) apostrophes and quotation marks automatically as you input type, instead of the incorrect (straight) foot and inch marks.

Check Enable Missing Glyph Protection to permit Photoshop to substitute Roman characters for missing glyphs, such as Japanese or Chinese characters.

Check Show Font Names in English to have non-Roman font names display in English on the Font menus (e.g., "Adobe Ming Std" instead of in the equivalent Chinese characters).

Choose Text Engine Options

To display special language features on the Character and Paragraph panels and panel menus, click East Asian or Middle Eastern and South Asian here, then on the Type > Language Options submenu in Photoshop, check East Asian Features or Middle Eastern Features. (One of those two options will be listed in addition to the standard setting, which is Default Features.)

Note: A change in the Text Engine Options setting won't affect existing documents, but will apply to new documents without your having to relaunch Photoshop.

	Preferences	
General	─ Type Options ✓ Use Smart Quotes	
Interface Sync Settings	■ Use Smart Quotes ■ Enable Missing Glyph Protection	
File Handling	✓ Show Font Names in English	
Performance Cursors	Choose Text Engine Options	
Transparency & Gamut	East Asian	
Jnits & Rulers	Middle Eastern and South Asian	
Guides, Grid & Slices Plug-Ins	(1) Changes will take effect the next time you create a new Document.	
Type		

Type Preferences

Experimental Features Preferences *

Experimental Features

Here you can enable features that Adobe is currently working on (that are not officially part of Photoshop), that you want to experiment with. Click Learn More to get info about the current features in Adobe Help.

Preferences for Adobe Bridge

General Preferences A

Appearance

Click a Color Theme for the Bridge interface.

Choose a gray value as the overall **User Interface Brightness**, which appears in the side panes.

Choose a gray value for the **Image Backdrop**, the area behind the Content and Preview panels. This value also displays as the background behind images when displayed in Full Preview View or in Slideshow or Review mode.

Choose an **Accent Color** for the highlight border around selected folders, thumbnails, and stacks, and for text that is selected in the panels.

Behavior

Check When a Camera Is Connected, Launch Adobe Photo Downloader to make the Downloader the default system utility for acquiring photos (this option is for Mac OS users only).

Check **Double-Click Edits Camera Raw Settings** in **Bridge** to have raw files open into Camera Raw, hosted by Bridge, when double-clicked. See page 52.

If Ctrl-Click/Cmd-Click Opens the Loupe When Previewing or Reviewing is checked, you have to hold down Ctrl/Cmd while clicking an image preview to make the loupe display. With this option unchecked, you can make the loupe appear simply by clicking the preview (see page 31).

For Number of Recent Items to Display, enter the maximum number of files (0–30) that can be listed at a time on the Open Recent File menu and on the Reveal Recent File or Go to Recent Folder menu on the Path bar

Favorite Items

Check the items and system-generated folders you want Bridge to list in the **Favorites** panel.

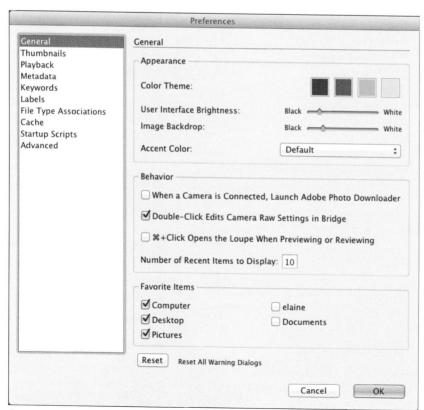

Thumbnails Preferences A

Performance and File Handling

Note: To implement a change to the Performance and File Handling setting, you must purge the folder cache by choosing Tools > Cache > Purge Cache for Folder [folder name].

For Do Not Process Files Larger Than, enter the maximum file size for which you will permit Bridge to display a thumbnail (the default value is 1000 MB). Bear in mind that large files preview slowly.

Details

For Additional Lines of Thumbnail Metadata, check Show for each line of metadata that you want Bridge to display, and choose the category of file information you want listed next to or below the image thumbnails in the Content panel (see page 37).

Check Show Tooltips to allow Tool Tips to display in Bridge, such as when you rest the pointer on an image thumbnail.

Playback Preferences

Stacks

Choose a Stack Playback Frame Rate to control the speed at which a stack of thumbnails plays back via the Play button.

Audio and Video

Choose options to control whether audio and video files will play automatically when previewed and/ or loop automatically when viewed in the Preview panel.

Metadata Preferences

Check the categories of metadata you want Bridge to display in the Metadata panel.

Check Hide Empty Fields to hide any fields on the Metadata panel that are empty.

Check Show Metadata Placard to display camera data in a separate section at the top of the Metadata panel (see page 29).

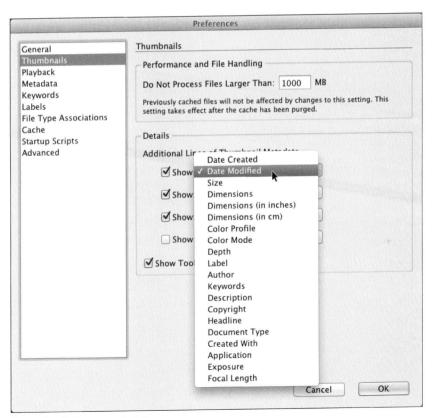

A Thumbnails Preferences, in Bridge

Keywords Preferences

Check **Automatically Apply Parent Keywords** to have the parent keyword also apply automatically when a subkeyword box is checked in the Keywords panel. If this option is on and you want to apply just a subkeyword, Shift-click the check box in the Keywords panel. See pages 38–39.

For Write Hierarchical Keywords, click an Output Delimiter character to be used to separate keywords in files that are exported from Bridge; and for Read Hierarchical Keywords, click an Input Delimiter character to be used to separate keywords in files that are imported into Bridge.

Labels Preferences

Check whether to **Require the Control/Command Key** [to be pressed in the shortcut] **to Apply Labels and Ratings** to selected file thumbnails (see page 40). You can also change the label names here, but not the colors.

File Type Associations Preferences

These settings tell Bridge the applications into which it may open files of different types. Don't monkey around with these settings unless you know what you're doing!

Cache Preferences

Options

Check **Keep 100% Previews in Cache** to save large JPEG previews of image thumbnails to disk for faster previewing when using the loupe and when previewing images in Slideshow mode at 100% or in Full Screen Preview view. We keep this option unchecked, because it uses a lot of disk space.

Check **Automatically Export Caches to Folders When Possible** to have Bridge export all cache files (in which metadata and thumbnail information is stored) to the same folders in which the images are located or to which they are copied. See page 48.

Location

If you need to specify a different location for the Bridge cache, click **Choose**, choose a folder, click

Open, then relaunch Bridge. We recommend leaving this setting alone.

Manage

If you have a very large hard disk, you can use the **Cache Size** slider to increase the maximum number of items that Bridge can store in its cache.

Click **Compact Cache** to allow previously cached items that are no longer available to be removed from the cache, for improved performance.

Click **Purge Cache** to purge all cached thumbnails and previews from the central database, in order to free up space on your hard disk or as a remedy if Bridge is having trouble displaying your image thumbnails. Do this only when absolutely necessary.

Startup Scripts Preferences

All **Startup Scripts** that are checked in this dialog will be activated at startup. We recommend keeping all of them checked, unless you have a specific reason to uncheck any. Changes to these settings take effect when you relaunch Bridge.

Advanced Preferences

Miscellaneous

If (and only if) you encounter display problems in Bridge, check **Use Software Rendering**, then relaunch Bridge. This option turns off hardware acceleration for the Preview panel and Slideshow mode.

Check **Generate Monitor-Size Previews** to have Bridge generate previews based on the resolution of your display. In a dual-monitor setup, the previews are sized according to the resolution of the larger of the two monitors.

Check **Start Bridge at Login** if you want Bridge to launch automatically upon startup.

International

To implement a change in Language that you choose for the Bridge interface and/or for the Keyboard, you must exit/quit and relaunch Bridge.

When you're done editing your Photoshop image, you can output it to a desktop inkjet printer, prepare it for commercial printing, export it to another application (such as Adobe InDesign), or generate assets from any of its individual layers for display on the Web and mobile devices.

In the first task in this chapter, you will view your document as a simulation of three different kinds of output: an inkjet print, a commercial press print, and display on the Web. This simulation, called a soft proof, will give you useful feedback so you can apply some final tweaks and adjustments to your document.

Once your document is finalized, you will learn how to output it from Photoshop to an inkjet device, and how to convert it to CMYK Color mode for commercial printing. We offer guidelines for exporting files to Adobe InDesign and Adobe Illustrator, give instructions for saving files in the versatile TIFF and PDF formats, and finally, show you how to generate image assets from Photoshop layers for output to the Web and mobile devices.

Important note: If you're planning to output your document to a desktop inkjet printer, keep it in RGB Color mode. Although desktop printers print using six or more process ink colors, their drivers are designed to receive RGB data, and they perform the conversion to printer ink colors internally. One less thing for you to worry about!

TI & FAPULA

IN THIS CHAPTER

Proofing document colors offscreen474
Outputting a file to an inkjet printer
Preparing a file for commercial printing
Getting Photoshop files into Adobe InDesign and Illustrator484
Saving a file in the PDF format 486
Saving a file in the TIFF format487
Saving multiple files in the JPEG, PSD, or TIFF format
Generating image assets from Photoshop layers
Using the Package command 494

Proofing document colors onscreen

In this phase of color management, you'll create a custom proof setting for your specific inkjet printer and paper, and use it to view a soft proof (onscreen simulation) of the document as if it were output to print. Although this proof won't be perfectly accurate, it will give you a rough idea of how your colors will look, without costing you a cent.

To proof a document as an inkjet print onscreen:

- Open an RGB image. From the View > Proof Setup submenu, choose Custom. The Customize Proof Condition dialog opens. In the following steps, you will choose proofing settings for your specific output device.
- Check Preview, then from the Device to Simulate menu, choose the correct color profile for your inkjet printer and paper—the profile that you either downloaded from the manufacturer's website or installed with your printer driver file (see page 11).
- Uncheck Preserve RGB Numbers, if available, to allow Photoshop to simulate how the colors will look when converted to the output profile.
- 4. Choose a Rendering Intent to control how colors will change as the image is shifted to the output profile (see the sidebar on the next page). We recommend choosing either Perceptual or Relative Colorimetric. To compare these options, choose them one by one and look at your document onscreen or even better, output a test print for each one and compare the results.

- Check **Black Point Compensation** to allow adjustments to be made for differences in the black point among different color spaces. With this option chosen, the full dynamic range of the image color space is mapped to the full dynamic range of the color space of your output device. With this option off, black areas in the image may display or print as grays. For an inkjet proof, we recommend checking this option.
- 5. Optional: For Display Options (On-Screen), check Simulate Paper Color to preview the white of the printing paper, as defined in the chosen printer profile, or if you're going to print the file on uncoated paper, check Simulate Black Ink to preview the full range of black values that the printer profile can produce.
- 6. To save your custom proof setup, click Save, enter a name, keep the .psf extension, keep the default location (the Proofing folder), then click Save.
- 7. Your newly saved proof setup appears on the Custom Proof Condition menu. Click OK. The setup is now also available on the View > Proof Setup submenu for use at any time, and View > Proof Colors is checked automatically so you can study the soft proof onscreen. (While Proof Colors is checked, the color profile that is currently chosen on the Proof Setup submenu is also listed in the document tab.) Remember, the Proof Setup options control only how Photoshop simulates colors onscreen. Colors in the file won't actually be converted to the chosen profile until you physically output the document to an inkjet printer or convert it to a different color mode (such as from RGB to CMYK).

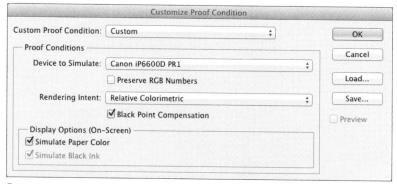

A To generate a soft proof of our document, from the Device to Simulate menu in the Customize Proof Condition dialog, we chose the profile for our Canon Pixma inkjet printer.

CHOOSING A RENDERING INTENT

- ➤ Perceptual changes colors in a way that seems natural to the human eye, while attempting to preserve the appearance of the overall image. It's a good choice for continuous-tone images.
- ➤ Saturation changes colors with the intent of preserving vivid colors. It is a good choice for charts and graphics, which typically contain a limited number of colors, but it can compromise the color fidelity of continuous-tone images.
- ➤ Absolute Colorimetric maintains the color accuracy only of colors that fall within the destination color gamut (i.e., the color range of your printer), but in so doing it sacrifices the accuracy of colors that are outside that gamut.
- ➤ Relative Colorimetric, the default intent for all the Adobe predefined settings in the Color Settings dialog, compares the white, or highlight, of your document's color space to the white of the destination color space (the white of the paper, in the case of print output), shifting colors where needed. This is the best rendering intent choice for documents in which most of the colors fall within the color range of the destination gamut, because it preserves most of the original colors.

Note: Consult the manual for your inkjet printer before choosing a rendering intent (e.g., for some models, Perceptual may be recommended over Relative Colorimetric).

DO THE RESEARCH

- ➤ When preparing files for commercial printing, ask your output service provider which settings and formats you should select in Photoshop.
- ➤ For more specialized technical information that is beyond the scope of this chapter, refer to the documentation for your specific printer model, and to Photoshop Help.
- ➤ Regardless of the output medium, you can learn from trial and error. Output a file, study the print, make adjustments to the file, then output it again. The experts become so by learning from both their successes and their failures.

In this task, you will choose a Proof Setup preset, then turn on the soft-proof feature so you can preview onscreen how the colors in your file will look if printed using CMYK inks or viewed online on a Windows or older Macintosh display.

To proof colors onscreen for commercial printing or online output:

- From the View > Proof Setup submenu, choose the preset for the output display type that you want Photoshop to simulate:
 - Working CMYK to simulate colors for the type of commercial press that is currently selected on the CMYK menu under Working Spaces in the Edit > Color Settings dialog in Photoshop.
 - If your file will be sent to a commercial print shop, ask them for a .csf or .icc profile. After you install the profile, it will be available on, and should be chosen from, the Settings menu in the Color Settings dialog (see page 11). If you're not given a profile, ask your print shop to suggest which predefined CMYK profile you should choose instead (see page 8).

Legacy Macintosh RGB (Gamma 1.8) to simulate colors for online output using the legacy Mac gamma setting of 1.8 as the proofing space, or Internet Standard RGB (sRGB) to simulate online output using the more common Windows gamma of 2.2.

Monitor RGB to simulate colors using the current display profile that is assigned to your monitor.

- View > Proof Colors will be checked automatically, so you can examine your document for any color changes.
 - When you're ready to turn off soft proofing, uncheck it on the menu or press Ctrl-Y/Cmd-Y.

Outputting a file to an inkjet printer

In this section, you'll learn how to output your file to an inkjet printer so the results match, as closely as possible, the document you have been editing and viewing onscreen. We have divided the steps for using this dialog into three parts: Choose settings for your printer driver, choose settings for printing (including color management), and finally, verify that color management has been turned off for the printer and print the file from Windows or the Mac OS.

Phase 1

In this phase, you will tell Photoshop what type of printer you're going to use via the Print Settings dialog, then use the print dialog for your operating system to specify the paper size, paper type, and other options for your printer.

To choose settings for your printer driver:

 Open the RGB file to be printed, then choose File > Print (Ctrl-P/Cmd-P). The Photoshop Print Settings dialog opens. (You can enlarge the dialog to increase the preview size.)

- From the Printer menu, choose your target inkjet device.
- Click Print Settings to open the [Printer Name]
 Properties/Print dialog for your operating system.
- **4.** The menu names will vary depending on the chosen printer model and your operating system, so we refer to them here generically:

In Windows, in the Main (or other) tab, choose the best-quality option for photo printing. For the paper options, choose the source for your paper, the specific type of paper to be used, and the paper size (A, next page).

In the Mac OS, if necessary, click Show Details to display the full dialog. The inkjet printer you chose in step 2 will be listed on the Printer menu. Choose the desired paper size for the print (for a borderless print, pick a size that includes the word "borderless"). From the fourth menu, choose the category (e.g., Quality & Media or Print Settings) that lets you choose media type and print quality

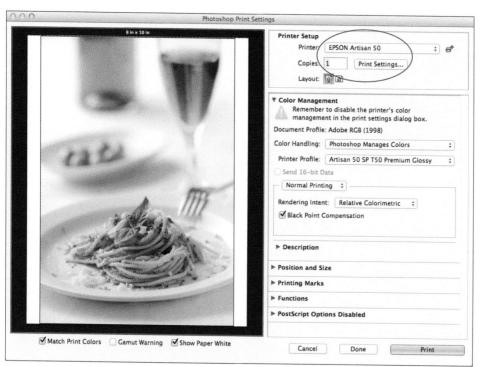

A In the Photoshop Print Settings dialog, choose your inkjet device from the Printer menu, then click Print Settings.

settings). From the media or paper type menu, choose the type of paper you will be using, **B** and from another menu, choose a print quality option.

- In Windows and the Mac OS, the printer and paper type should match the printer profile you have downloaded and installed (see page 11).
- 5. Click OK/Save to close the print dialog for your operating system and return to the Photoshop Print Settings dialog. Keep the latter dialog open and follow the steps on the next page to choose print settings for Photoshop.
- ➤ The gray background in the preview matches the current background in the Photoshop document window. If you want to change that shade, right-click the gray area in the preview and choose a shade from the context menu.

A This is the Print Settings > [Print Name] Properties dialog for an Epson printer in Windows 8. We chose a Quality Option and Paper Options.

Phase 2

After choosing print settings as described on the preceding two pages, the next step is to choose color management, position, scale, and other output options in Photoshop Print Settings dialog.

To choose Photoshop print settings:

- In the Photoshop Print Settings dialog (A, next page), click the portrait or landscape Layout button.
- Expand the Color Management category. The current document profile is listed at the top.
 From the Color Handling menu, choose Photoshop Manages Colors to let Photoshop handle the color conversion, for optimal color management (see the sidebar on the next page).
- 3. From the Printer Profile menu, choose the custom printer/ink/paper profile that you down-loaded from the printer or paper manufacturer's website and installed in your system (see page 11). This is the last phase of the color management workflow that you began in Chapter 1. Note: All installed profiles for the currently selected printer are listed on the top part of the menu.
- **4.** If the chosen device has the capacity to output a 16-bit file (and your document is 16-bit), you can check **Send 16-Bit Data** to produce a print with finer details and smoother color gradations.
- 5. From the next menu, choose Normal Printing. From the Rendering Intent menu, choose the same intent that you used when you created the soft-proof setting for your inkjet printer, which most likely was either Perceptual or Relative Colorimetric (see the sidebar on page 475).
 - You can run one test print for the Perceptual intent and one for the Relative Colorimetric intent, and see which one yields better results.
- **6.** Check **Black Point Compensation**. This option maps the full color range of the document profile to the full range of the printer profile, to preserve shadow details and the darkest blacks.
- 7. Expand the Position and Size category.

 Under Position, check Center to print the image in the center of the paper. Or to reposition the image on the paper, uncheck Center and choose new Top and Left values (note the change in the preview) or drag the image in the preview.

- 8. Optional: To scale the print output slightly, under Scaled Print Size, do either of the following: Check Scale to Fit Media to fit the image automatically on the paper size you chose in step 4 on pages 476–477.
 - percentage or enter specific **Height** and **Width** values (you can change the unit via the Units menu). These three values are interdependent; changing one causes the other two to change. Note: Use these features to scale the print by only a small amount (i.e., a fraction of an inch or 5–10 percentage points). If a greater scale change is needed, cancel out of the dialog, use Image > Image Size to scale the image (see pages 137–139), then resharpen it.

Uncheck Scale to Fit Media, then change the Scale

- 9. Uncheck Print Selected Area to reset the margins to the chosen paper size, or check it to adjust the margins for the current printout. If you check this option, drag a margin control to adjust the top, bottom, left, or right margin for the printout; or Alt/Option-drag a margin control to move the top and bottom, or left and right, margins in unison; or Ctrl/Cmd-drag a margin control to move all four margins simultaneously.
- 10. Below the preview, do the following:

Check **Match Print Colors** to display a colormanaged soft proof of the image in the preview, based on the current printing device and printer profile settings.

Uncheck **Gamut Warning**. Monitoring out-ofgamut colors (shown as gray in the preview) is beneficial only when printing to a commercial CMYK printer.

Check **Show Paper White** to have Photoshop simulate the paper color in any white areas in the preview, based on the current printer profile.

- 11. Next, you need to verify that color management has been turned off for your output device. For Windows, see page 481; for the Mac OS, see page 482. To print from the same device in the future, you can just click **Print** here and skip that last task.
- If you want to save all of your settings for the current file and close the dialog without printing the file, click Done in the Photoshop Print Settings dialog, then save your file.

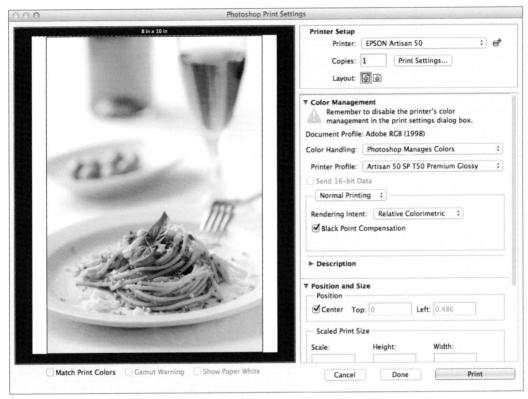

A Choose settings in the various expandable categories in the Photoshop Print Settings dialog.

BENEFITS TO LETTING PHOTOSHOP MANAGE YOUR DOCUMENT COLORS

Via the Color Handling menu of the Photoshop Print Settings dialog, you can opt to have Photoshop or your printing device manage the document colors. What's the difference?

- ➤ If you choose Photoshop Manages Colors (the option we recommend), you will be able to select a profile that matches the paper type you selected in the Print Settings dialog. Choose either the printer and paper profile that you downloaded from your paper or print manufacturer's website or a profile that was installed for your printing device. Photoshop will adjust your document colors to fit that profile, then send the data to the printer. Using the profile preserves your color-managed workflow and allows Photoshop to produce the best possible color.
- ➤ If you choose Printer Manages Colors, the printer driver will handle the color conversion instead of Photoshop. This may limit the print quality, for two reasons. First, the printer won't be aware of your custom paper choice and custom printer profile. And second, the color conversion will be subject to the printer's ability to convert colors rather than the color management settings you have established. If you're still not convinced that it's a good idea to avoid this setting, at least resist the temptation to adjust the amount of individual ink colors used by the printer (in the Print Settings dialog), which would override the printer settings.

CHOOSING OUTPUT OPTIONS

Options for commercial printing on a PostScript printer are found in the Printing Marks and PostScript Options categories in the Photoshop Print Settings dialog. Some of the Printing Marks options are listed (and illustrated) below; for other options, see Photoshop Help.

In the Printing Marks category, check any of these options:

- ➤ Corner Crop Marks and Center Crop Marks print short little lines that a print shop uses as guide lines when trimming the final print.
- Registration Marks prints marks that a print shop uses to align color separations.
- Description prints user data below the image. Click Edit in this category to enter or edit a description (you can also enter data in the Description field of the Description tab in the File > File Info dialog).
- ➤ Labels prints the file name on each page (outside the image area).

These three options in the PostScript Options category pertain only to PostScript printing:

- Calibration Bars prints a grayscale and/or color calibration strip outside the image area.
- ► Include Vector Data prints vector objects (such as type, shapes, or imported vector art) at the printer resolution, not at the document resolution. This option is checked automatically (and should be kept checked) if the file contains type or vector art.
- Keep Interpolation unchecked.

To specify a bleed width for your document:

Click Bleed in the Functions category, then specify a distance (0-3 inches). Crop marks will be placed within the image area at that specified distance from the outer edge of the image.

OUTPUTTING A QUASI HARD PROOF

To output a simulation of output (a quasi "hard" proof) to a desktop printer, expand the Color Management category in the Photoshop Print Settings dialog and choose Hard Proofing from the menu. From the Proof Setup menu, choose the soft-proof setup that you created by following the steps on page 475. Check Simulate Paper Color to preview the white of the paper as defined in the chosen printer profile, or uncheck this option and check Simulate Black Ink to preview the full range of black values as defined by the printer profile.

Phase 3

The final step before outputting a file to an inkjet printer is to verify that color management is turned off for that device, to enable Photoshop to manage the color conversion from RGB color to actual inks. (Remember, you chose Photoshop Manages Colors in step 2 on page 478.) Note: Mac OS users, your instructions are on the next page.

Color management options in the Photoshop Print Settings dialog vary depending on the printer driver for the chosen output device, and also differ for each operating system. In the following steps, we describe how to verify that color management is turned off for an Epson device. If your output device is a different brand, or you see different options in the dialog, do some research on how to access print quality and color management settings for your printer, and use these steps just as general auidelines.

Windows: To verify that color management is turned off for your printer, then print the file:

- 1. In the Photoshop Print Settings dialog, click Print Settings to get to the [Printer Name] Properties dialog for your Windows system.
- 2. Click the Advanced tab. A These options include controls for color management.
- 3. In the Color Management area, click ICM, if it's not already selected, to switch control of color management from the Epson driver to the color management system that's built into Windows.
- 4. Below the ICM button, make sure Off (No Color Adjustment) is checked.
- 5. Click OK to close the Properties dialog and return to the Photoshop Print Settings dialog.
- 6. Click Print. Phew! You made it.

A In the Print Settings > Properties dialog for an Epson printer in Windows, we clicked the Advanced tab to display these Color Management options.

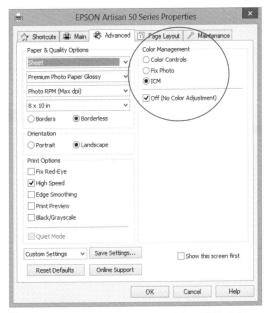

B We verified that ICM was selected, and that Off (No Color Adjustment) was checked.

In the Photoshop Print Settings dialog (step 2 on page 478), you were instructed to choose the Color Handling option of Photoshop Manages Colors. This option gives Photoshop control over color management (lets Photoshop manage the color conversion from RGB color to actual inks in your printer), and turns off the color management settings for a Mac OS printer driver automatically (dialog options for the driver are dimmed). Once you have verified that color management is turned off for your particular device, for future output, after choosing the desired settings in the Photoshop Print Settings dialog, you can skip the task below and simply click Print. If you discover, upon following the steps below, that color management is on for your printer driver, be sure to turn it off (see step 3).

Color management options in the Photoshop Print Settings dialog vary depending on the printer driver for the chosen output device, and also differ for each operating system. In the following steps, we describe how to verify that color management is turned off for an Epson device. If your output device is a different brand, or you see different options in the dialog, do some research on how to access print quality and color management settings for your printer, and use these steps just as general guidelines.

Mac OS: To verify that color management is turned off for your printer, then print the file:

- In the Photoshop Print Settings dialog, click Print Settings to open the Print dialog for your Mac operating system.
- From the fourth menu, choose Color Management. A
- 3. Verify that Off (No Color Adjustment) is selected. B Note that with color management turned off for the printer, depending on the printer model, the color controls and the Advanced Settings sliders either won't display at all or will be dimmed.
- **4.** Click **Save** to return to the Photoshop Print Settings dialog.
- 5. Click Print. Congratulations!

A In the Print dialog (which we accessed by clicking Print Settings in the Photoshop Print Settings dialog) for an Epson printer in the Mac OS, we chose Color Management from the fourth menu.

B We verified that Off (No Color Adjustment) was selected.

A WORKFLOW FOR COMMERCIAL, FOUR-COLOR PRINTING

The steps needed to prepare a file for commercial printing are too complex to be covered fully in this QuickStart Guide, but we offer this summary:

- 1. Make sure your display is properly calibrated, and that you have established all the necessary color settings (see Chapter 1).
- 2. Ask your commercial print shop what type of press and lines-per-inch setting will be used to print your document and what settings they recommend you choose in Photoshop, such as the resolution, file format, and color mode. Save the file according to their specs.
- 3. Ask your commercial printer to supply you with a printer profile for their press, ink, and paper, then load it into the Color Settings dialog (see page 11).
- 4. Use the printer profile to create a custom proof condition, and view a soft (onscreen) proof of the image for that specific press (see page 475).
- 5. Save a copy of the file in the requested format.
- 6. Convert your RGB files to CMYK, using the printer profile from your print shop.
- 7. Make any final tonal adjustments (e.g., to the midtones or contrast) and any final color adjustments.
- 8. Sharpen the image (see pages 334-338).
- 9. Have your print shop output a CMYK color proof for you to analyze. If it looks good, the document is good to go. If not, tweak it based on the problems you noted in the proof, then print and analyze another proof.

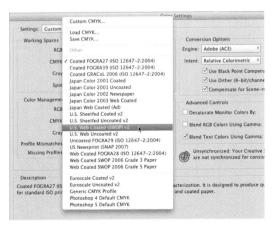

A In the Color Settings dialog, from the CMYK menu in the Workspace Spaces area, choose the correct CMYK profile.

Preparing a file for commercial printing

Computer monitors display additive colors by projecting red, green, and blue (RGB) light, whereas commercial presses print subtractive colors using CMYK (cyan, magenta, vellow, and black) and/or spot color (mixed) inks. Obtaining high-quality CMYK color reproduction from a commercial press is an art that takes experience and know-how.

When preparing a file to be sent to a print shop for output to a commercial press, you need to establish the correct CMYK working space in Photoshop. Ask your print shop to give you the necessary color settings file, then be sure to save it in the correct folder (see page 11) so it's available in the Color Settings dialog for the CMYK conversion.

To convert your file from RGB to CMYK Color mode:

- 1. Use the File > Save As dialog to save a flattened copy of your file (uncheck the Layers option).
- 2. Choose Edit > Color Settings (Ctrl-Shift-K/ Cmd-Shift-K).
- 3. To specify which profile will be used to control the conversion of your image to CMYK Color mode, do one of the following:

From the **Settings** menu, choose the .csf profile that you received from your commercial printer and installed in your system.

Click Load, locate the .csf profile that you received from your commercial printer and copied to your hard drive, then click Open.

In the Working Spaces area, from the CMYK menu, choose either the .icc prepress profile that you received from your print shop, or the predefined profile your print shop says is the closest match to their press and paper.A

- 4. Click OK.
- Choose Image > Mode > CMYK Color. If an alert appears, click OK.
- 6. Save the file.

Getting Photoshop files into Adobe InDesign and Illustrator

Photoshop to Adobe InDesign

Files in the Photoshop PSD and Photoshop PDF formats can be imported directly into Adobe InDesign using the File > Place command.

InDesign can color-separate RGB and CMYK files, it can read embedded ICC color profiles, and it works with Bridge, for file and color management. Photoshop layers (and layer comps) are preserved, and you can turn their visibility on or off in InDesign; alpha channels, layer masks, and transparency are also preserved. If you want to import just an area of a Photoshop image into InDesign, see our easy steps on the next page.

Photoshop to Adobe Illustrator

Photoshop and Illustrator files are compatible in many, but not all, respects. Here are some ways to get Photoshop content into Illustrator (note that a 16-bit file will be imported as an 8-bit file):

Method 1

Arrange your Photoshop and Illustrator windows so they're both visible. With the Move tool, drag and drop a selection or layer or layer group from the Photoshop document window into the Illustrator document. In Windows, the imagery will appear on the Layers panel as an image layer; in the Mac OS, it will appear as an image layer within a layer group. Nondefault opacity settings are reset to 100% (but are preserved visually), nondefault blending modes are ignored, the effects of any layer or vector masks are applied, and transparent areas are filled with white. Type and vector shapes are rasterized.

Method 2

Select all or part of an image layer in Photoshop, copy it, then paste it into Illustrator. The effects of any layer or vector masks, nondefault blending modes, and opacity settings are ignored.

Method 3

In Illustrator, use File > Place to import either a whole Photoshop image or one layer comp. If you place a Photoshop image with the Link option checked, the image will appear on the Layers panel on a single image layer, and any masks will be applied. If you embed the Photoshop image as you place it (uncheck the Link option), then Shift-click in the document with the loaded graphics pointer, you will be given the option via the

Photoshop Import Options dialog to Convert Layers to Objects (Make Text Editable Where Possible) or Flatten Layers to a Single Image (Preserves Text Appearance).

If you click Convert Layers to Objects, each Photoshop layer will appear on a separate nested layer within a group. Opacity values are preserved, whereas only the blending modes that have matching names on the Transparency panel in Illustrator will remain editable in Illustrator. Both transparency and modes are listed as editable appearances. Layer masks become opacity masks. Layer effects are applied to the layer, and their visual appearance is preserved.

If you click Flatten Layers to a Single Image, the effect of all opacity settings, blending modes, and layer masks will be preserved visually, but won't be editable in Illustrator.

Check Import Hidden Layers if you want Illustrator to include any hidden image layers from the Photoshop file.

Method 4

In Illustrator, use File > Open to open a Photoshop image as a new Illustrator document. See also the information regarding the Link, Convert Layers, and Flatten Layers options in Method 3, above.

Notes

- If a Photoshop file contains visible adjustment layers, or a layer that contains layer effects, those layers won't arrive as individual layers when opened or placed into Illustrator. Before importing the file, hide or merge down any adjustment layers, and reset the blending mode to Normal.
- Any shape layers that contain layer effects will be rasterized.
- A layer mask in the Photoshop document won't convert to an opacity mask in Illustrator if the layer containing the mask also contains layer effects.
- Via the Effect menu in Illustrator, Photoshop (raster) effects and Illustrator (vector) effects can be applied to an imported Photoshop image.
- When you open or place a TIFF, EPS, or PSD file into Illustrator, it adopts the color mode of the Illustrator file automatically.

To place just a portion of a Photoshop PSD image into InDesign or Illustrator, you need to isolate that area onto a separate layer or by using a layer mask, then save a copy of the file.

To isolate part of an image layer in Photoshop:

- 1. Do either of the following: Select an area of a layer, then create a layer mask. Select the area to be isolated, and put it on its own layer by pressing Ctrl-J/Cmd-J.B
- 2. Using File > Save As, save a copy of the file in the Photoshop format. In the dialog, check As a Copy and keep Layers checked.
- 3. Follow the steps on this page for InDesign or Illustrator.

To place a Photoshop layer into InDesign:

1. In InDesign, open or create a document, then choose File > Place. In the Place dialog, click the

A In Photoshop, we hid part of an image layer via a layer mask.

In Illustrator, we used the Place command to import the Photoshop file, then clicked the visibility icon on the Layers panel to hide the Background.

- Photoshop file, uncheck Show Import Options, then click Open. Drag with the loaded graphics pointer.
- 2. Choose Object > Object Layer Options.
- 3. In the dialog, check Preview, show the layer that contains transparency or a mask, hide all other layers (click their visibility icons), then click OK.

To open or place Photoshop layers into Illustrator:

- 1. In Illustrator, do either of the following: Use File > Open to open the Photoshop file. Open a file, then use File > Place to import the Photoshop file (Link option unchecked). In the document, Shift-click with the loaded graphics pointer.
- 2. The Photoshop Import Options dialog opens. Click Convert Layers to Objects, then click OK. The Open command converts each Photoshop layer to a separate layer in Illustrator, whereas the Place command nests the layers within a group. C-D

B Alternatively, we could have copied a selected area to a new layer.

D This is how the imported Photoshop file looks in Illustrator (you have to take our word for it!).

Saving a file in the PDF format

PDF (Portable Document Format) files can be opened in many Windows and Macintosh applications and in all of the Acrobat programs (Adobe Reader, Acrobat Standard, and Acrobat Pro). This format saves 8-bit and 16-bit files (but not 32-bit files) in any color mode except Multichannel.

If you want to preserve image, font, layer, and vector data in the PDF file, and have it include just one image, you should check Preserve Photoshop Editing Capabilities in the Save Adobe PDF dialog. (If you need to save multiple images in one PDF file, see "Creating a PDF presentation of images" on pages 444–445.)

If you want Photoshop to produce a generic PDF file, similar to a PDF that is produced by a drawing or page layout application, uncheck the Preserve Photoshop Editing Capabilities option. The image will be flattened and rasterized, so your ability to re-edit it in Photoshop will be very limited.

To save a file in the PDF format:

- 1. Choose File > Save As, enter a file name or keep the current name in the File Name/Save As field, choose a location for the file, choose Save As Type/ Format: Photoshop PDF, then click Save. If an alert dialog appears, click OK.
- 2. From the Adobe PDF Preset menu in the Save Adobe PDF dialog, A choose a preset that's best suited to your target output medium.
 - Note: The High Quality Print and Press Quality presets produce a large Photoshop PDF file, compress the file using JPEG compression and an Image

Quality setting of Maximum, embed all fonts automatically, and preserve transparency. The Preserve Photoshop Editing Capabilities option is checked. For commercial printing, ask your shop for advice regarding these settings.

High Quality Print (the default preset) creates PDF files that are suitable for desktop printers and color proofing devices. The color conversion is handled by the printer driver. The file won't be PDF/X-compliant (see the PDF/X presets below).

Press Quality is designed for high-quality prepress output. Colors are converted to CMYK.

Note: Preserve Photoshop Editing Capabilities isn't available for the PDF/X presets and is unchecked for the Smallest File Size preset, so these presets produce generic PDF files:

PDF/X-1a:2001, PDF/X-3:2002, and PDF/X-4: 2008 create PDF files that will be checked for compliance with specific printing standards, to help prevent printing errors.

Smallest File Size uses high levels of JPEG compression to produce very compact PDF files for output to the Web and mobile devices. All colors are converted to sRGB.

- 3. Click Save PDF, then click Yes if an alert dialog appears.
- To learn more about the PDF format, see Photoshop Help.

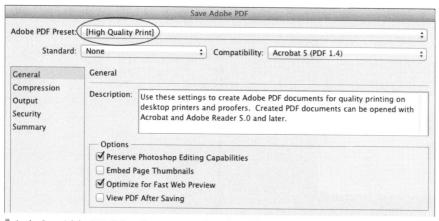

 $oldsymbol{\mathbb{A}}$ In the Save Adobe PDF dialog, choose a preset from the Adobe PDF Preset menu.

Saving a file in the TIFF format

TIFF files are versatile in that they can be imported into most applications and are usable in many color management scenarios. If your target application can't read a Photoshop PSD or Photoshop PDF file, this is the next-best option. Both InDesign and QuarkXPress can color-separate a CMYK color TIFF.

Note: Although Photoshop files as large as 4 GB can be saved in the TIFF format, most other applications can't read a TIFF file that is larger than 2 GB.

To save a file in the TIFF format:

- 1. If you have arranged for your document to be printed on a four-color press and your commercial printer requests that you convert it to CMYK Color mode, choose Image > Mode > CMYK Color (see page 483).
- 2. Choose File > Save As, enter a name or keep the current one, choose Save as Type/Format: TIFF, and choose a location for the file.
- 3. In the Save area:

Check As a Copy to keep the existing file open onscreen and save a copy of it to disk.

Uncheck Lavers to flatten the file (or check this option if you must preserve layers). Note that few other image or layout programs can work with layered TIFFs, and those that don't are going to either flatten the layers without your choice or ignore the layer data.

If you need to save Alpha Channels, Notes, or **Spot Colors** in the file, check any of those options.

4. Check ICC Profile/Embed Color Profile to include the embedded color profile (if any) with the file. For more about color management, see Chapter 1.

- Click Save. The TIFF Options dialog opens. A
- 6. If the file is going to be color-separated (e.g., from InDesign), under Image Compression, click None (output service providers prefer to receive uncompressed files). If you need to reduce the storage size of the file, click LZW or ZIP; these methods are non-lossy, meaning that they don't discard image data. Note that some programs can't read a ZIP-compressed TIFF, so that's something to investigate. Avoid the JPEG compression option, which causes data loss.

Optional: Check Save Image Pyramid to save multiple resolutions of the image in one file, for faster previewing at different zoom levels. Photoshop doesn't offer options for opening image pyramids, whereas Adobe InDesign does.

Under Pixel Order, keep the default setting of Interleaved (RGBRGB).

Under Byte Order, click IBM PC or Macintosh, for the platform on which the file will be used.

If the bottommost layer in the file is a layer (not a Background), and has an opacity setting below 100% and/or contains some transparent pixels, you can preserve that transparency by checking Save Transparency. If an alert dialog appears, click Yes.

If the file contains layers, under Layer Compression, click a compression method.

7. Click OK.

A This is the TIFF Options dialog in the Mac OS.

Saving multiple files in the JPEG, PSD, or TIFF format

If you want to save copies of multiple files in a different format (or formats), you can get the job done quickly via the Image Processor command. And while you're at it, if needed, you can also run an action.

To save multiple files in the JPEG, PSD, or TIFF format:

- In Bridge, open a folder that contains multiple PSD or JPEG files or raw photos. (If desired, you can Ctrl-click/Cmd-click to select specific thumbnails.) Choose Tools > Photoshop > Image Processor. The Image Processor dialog opens. A
- 2. Optional: If you selected a series of raw photos, check Open First Image to Apply Settings to have the Camera Raw dialog open for the first selected raw photo, giving you the opportunity to choose settings. Check this option only if you're certain all the other raw photos you have selected need the same adjustments.
- **3.** To choose a location for the new files, do either of the following:

Click Save in Same Location.

Click the button next to Select Folder, click **Select Folder**, navigate to the desired folder, then click Open.

4. Click the desired **File Type** (or types) and applicable settings, as needed.

Optional: Check Run Action, then choose an

action set and action to be played on all the files.

5. Under Preferences, do the following:

- Optional: Enter Copyright Info (such as your name), to be added to the files' metadata.

 Check Include ICC Profile to include each file's color profile so its display and output can be color-managed.
- 6. Click Run. If a file opens into Camera Raw, choose settings, then click Open Image (your settings will be applied to that file and to the processed copies of all the raw files). After Photoshop finishes opening, processing, and closing the new files, they will appear in one or more new folders (labeled with the chosen file format), in the location you designated.

Via the Save button in the Image Processor dialog, you can save the current settings as a preset. To apply a preset to other images, use the Load button.

CREATING A COMPRESSED ZIP FILE

To reduce the storage size of a file without discarding any of its data, you can create a compressed version of it using the ZIP compression command that's built into your system.

- ➤ To create a ZIP file in Windows, right-click a file and choose Send To > Compressed (Zipped) Folder from the context menu. A compressed version of the file will appear in a new folder within the current folder.
- ➤ To create a ZIP file in the Mac OS, right-click a file name in the Finder and choose Compress [file name] from the context menu.

A Using the Image Processor command, you can quickly save multiple files in the JPEG. PSD, or TIFF format.

Generating image assets from Photoshop layers

Choosing a file format for output to the Web and mobile devices

Using the Generator plug-in, you can produce an image asset in the GIF, JPEG, PNG, or SVG* file format from a Photoshop layer, for output to the Web or mobile devices.

By entering a quality setting for a JPEG or PNG asset, you can control to what degree it is compressed, and thereby control its resulting quality. The ultimate goal is to compress a file to the point that it downloads quickly, while keeping its quality as high as possible.

The pixel dimensions of an asset affect how large it looks when displayed in a Web browser or on a mobile device. The Photoshop file from which you create asset files should have a resolution of 72 ppi (we'll remind you about this later).

Before learning how to produce image assets via Generator (pages 490–494), see the following comparison of file formats.

GIF

- GIF preserves flat colors and sharp edges of a layer (such as a type or shape layer) better than JPEG, although not as well as SVG.
- ➤ GIF is an 8-bit format, meaning that it can save no more than 256 colors in a file. This color restriction makes it a good choice for a layer that contains a limited number of solid colors.
- ➤ GIF preserves existing transparency in an image or gradient layer, but note that because the resulting asset will have an 8-bit depth, it won't have smooth transitions between opaque and transparent areas.

JPEG

➤ The JPEG format preserves the full 24-bit color depth — and therefore the color fidelity — of photos, gradients, and other continuous-tone image layers, which contain countless colors and tonal values.

- The JPEG format can shrink an image significantly. The lower the quality setting you specify, the more compression is applied, and the greater is the resulting data loss; the higher the quality setting, the less the asset is compressed, but the larger will be its resulting file size.
- ➤ The JPEG format doesn't preserve transparency.

PNG

- PNG doesn't cause data loss (it's "lossless").
- The PNG format supports bit-depth values of 8, 24, and 32. If you generate an asset from a continuous-tone layer and assign it an 8-bit depth, no more than 256 colors will be preserved, whereas if you assign the asset a bit depth of 24 or 32, the original color fidelity will be preserved (this is similar to the JPEG format).
- The PNG format preserves existing transparency in an image by using an alpha channel. A PNG asset that you assign an 8-bit depth will have non-smooth transitions between opaque and transparent areas. A PNG asset that you assign a 24- or 32-bit depth will have smooth transitions between those areas, making this file format a good choice for a layer that contains a transparent background.

SVG

- Unlike the three bitmap formats described above. SVG is vector based, making it the best choice for generating assets from shape and type layers (vector-based layers).
- SVG files are not only compact, but also resolution independent, meaning that they output at the resolution of the current output medium whether that medium is the Web, a mobile device, or a printing device.

^{*}In case you're wondering, GIF stands for Graphics Interchange Format, JPEG stands for Joint Photographic Experts Group (the group that created the format), PNG stands for Portable Network Graphics, and SVG stands for Scalable Vector Graphics.

The Generator plug-in for Photoshop enables you to quickly produce a JPEG, PNG, GIF, or SVG asset file from the content of a specific layer or layer group in a Photoshop PSD document.

This method for creating asset files from individual layers is faster than copying layer content to separate files. You can import the asset files into another program manually, for output to the Web or mobile devices.

Another benefit of using Generator is a more efficient editing workflow between Photoshop and Adobe Edge Reflow, a Creative Cloud application that produces scalable, HTML-based layouts for the Web and mobile devices. After using Generator to connect a Photoshop file to an Edge Reflow file, you can then import a whole folder of generated asset files into Edge Reflow in one step. And because the imported asset files remain linked to their Photoshop layers, any subsequent edits to those layers will appear automatically and immediately in the Edge Reflow document. In the future, you can expect other Web layout applications to be upgraded to allow for a similar linkage.

Note: In this section, you will learn how to generate assets. To learn how to manage assets between Edge Reflow and Photoshop, search for "Edge Reflow Photoshop plugin tutorial" in Photoshop Help.

To use the Generator plug-in, it must be enabled. Once enabled, the plug-in will load automatically whenever you launch Photoshop.

To enable the Generator plug-in: ★

- 1. Choose Edit/Photoshop > Preferences > Plug-ins.
- 2. Check Enable Generator, then click OK.

To generate image assets from Photoshop layers: ★

- Open or create a copy of a Photoshop PSD file that contains multiple layers, and that has a resolution of 72 ppi (see the second task on page 139). Make sure the name of each layer and layer group is descriptive (not the default names Layer 1, Layer 2, etc.), and that it doesn't include spaces, a: (colon), or an * (asterisk).
- 2. Save the file.
- **3.** Choose File > Generate > **Image Assets** to activate the command (it should now have a check mark).
- 4. On the Layers panel, double-click the name of a layer or layer group to activate the field. At the end of the name, type the .jpg, .png, or .gif file format extension (or for a vector or a type layer that doesn't contain any applied layer effects, use the .svg extension), then press Enter/Return or click outside the field. Repeat for each layer or layer group that you want to export as an asset (A, next page).

A While creating a Web page design (shown at left), we put related elements into layer groups, and assigned a descriptive name to each group.

- If you add a format extension to a layer group, a single, flattened file will be generated from the content of all the nested layers in the group. B Similarly, if you add a format extension to the base layer name of a clipping mask, a flattened file will be generated from the content of the base layer and all the nested (masked) layers.
- 5. Optional: By default, Generator will put all the asset files in a new folder. If you want an asset to appear in a subfolder within that new folder, in front of the file name and format extension within the layer listing, type a subfolder name, followed by a slash (e.g., special-assets/shape1.png).
- 6. Optional: By default, Generator produces JPEG assets with a quality setting of 90%, and PNG assets with a bit depth of 32. If you want to change either of these parameters, on the Layers panel, double-click the name of a layer that has a .jpg or .png extension, click at the end of the name, then do either the following: C

For a .jpg layer, type a number (1-10) or a percentage (1-100%), then press Enter/Return. For instance, you could change .jpg to .jpg6 or .jpg70%.

Continued on the following page

B Here one of the layer groups is expanded to demonstrate that although assets were generated from the Photoshop layer groups, the layers remain accessible for potential future editing.

A We added the .png file extension to each layer group name. Generator produced a single, flattened file from each group. (We also added .png to the solo, non-grouped layer.)

To each layer and layer group to which we added a .jpg or .png extension, we also added a quality setting value.

For a .png layer, type a bit-depth value of 8, 24, or 32, then press Enter/Return. For instance, you could change .png to .png24.

You can change the quality or bit depth of an existing JPEG or PNG asset file at any time via the method described above.

Note: You can't add a quality parameter to a .gif layer.

- 7. The asset files will appear in a new folder, named "[Photoshop file name] – assets," within the same folder as the Photoshop PSD document from which they were generated. If you typed a subfolder name in any layer names, those asset files will appear in a subfolder, bearing that name, within the above-mentioned "- assets" folder.
- 8. At any time, if you edit the contents of a layer or layer group from which an asset was produced, the linked asset file will update instantly with your edits (that is, provided the Image Assets command is enabled; see the sidebar on this page) (A-D, next page). Be sure to edit the layer or layer group in your Photoshop document, though — don't change the name or location of the asset files or edit them directly.
- If you generate a GIF, JPEG, or PNG asset from a layer or layer group that contains editable type or a shape, those features will be rasterized and flattened automatically in the generated asset (but not in your Photoshop file), whereas in an SVG asset, type and shapes are preserved as vector objects. If a layer contains any transparency or layer styles, those elements will be flattened and applied to the asset.
- The entire contents of a layer will be included in an asset file, including any pixels that extend beyond the canvas area. If you want to exclude pixel areas from an asset file, add a layer mask to the Photoshop layer before or after adding the file extension.
- To generate assets from the content of an individual layer or layer group in multiple file formats, type the layer name in the name field multiple times, each time adding a different extension and a comma. For example, if we were to enter the layer name "buttons.png, buttons.jpg", the plug-in would generate two separate asset files (one .png, one .jpg).

ENABLING THE IMAGE ASSETS COMMAND

The File > Generate > Image Assets command will remain enabled for the current Photoshop PSD document even after you close and reopen it, provided you don't uncheck the command on the menu. While the command is off, document edits won't be applied to existing linked asset file(s), and new assets won't be generated if you add file extensions to layers. If you reenable Image Assets, asset files will be updated automatically with any layer edits that were made — or layer extensions that were added — while the option was disabled. Smart feature!

A This Web page design contains two plain, solid-color buttons, each of which is a separate shape layer. To create an asset file from each shape, we added the .png file extension to their layer listings.

B The asset files display as thumbnails in the Content panel in Bridge.

■ To give the buttons a 3D appearance, we applied styles (from the) Glass Buttons library) to each button shape layer.

D Our layer edits appeared automatically in the linked asset files. We were able to quickly monitor those edits by looking at the asset thumbnails in Bridge.

You can scale a generated image asset by adding a size parameter to the Photoshop layer name.

To scale a generated image asset: ★

- On the Layers panel, double-click a layer name that contains the .jpg, .gif, or .png extension, then click to the left of the first character.
- 2. Do either of the following:

Enter width and height values for the asset, followed by a space (e.g., "300 x 200 toy.png"). If you don't specify a measurement unit, the value will be calculated in pixels; or if you want to specify a unit, enter the abbreviation of in, px, cm, or mm after the value

Enter a **percentage** value for scaling, followed by a space.

You must type a space between the size parameter and the layer name, but when specifying dimensions, you don't have to type a space before or after the "x".

(Continuing with our example, by adding "300 x 200" to our "toy.png" layer name, we sized the PNG asset file to 300 pixels wide by 200 pixels high. If we were to rename the layer "55% toy.jpg," the JPEG asset file would be scaled to 55% of the original layer content.)

To generate two assets of different sizes from one layer or layer group, enter two names for the layer, each with a different scale value, separated by a comma and a space. For instance, to generate one asset at 100% scale (for a nonretina computer display) and a second asset at 200% scale (for a retina display), we typed "100% toy.png, 200% toy2.png". Note that because both assets have the same file extension (.png), in order to generate two separate files, we had to enter two different file names ("toy" and "toy2").

Using the Package command

The Package command gathers a copy of every linked Smart Object file that is being used in your document, and puts the copies in a destination folder of your choice.

To gather copies of linked Smart Objects: ★

- Choose File > Package. The Choose Package Destination dialog opens.
- 2. Choose a location for the package folder or create a new folder, then click Choose. A copy of the Photoshop file will appear in a new folder (labeled with the Photoshop file name) inside the folder you designated. Within this new folder you will also find a subfolder labeled "Links," containing a copy of all the files that you linked to the Photoshop document, as well as copies of any files that were linked into those linked files.

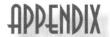

Syncing Photoshop settings via the Creative Cloud

Via the Adobe Creative Cloud, you can sync Photoshop presets and application preferences between two computers (e.g., a desktop computer and a laptop); manage your files (e.g., post them publicly); and acquire program updates immediately when they are released.

Adobe permits each user to activate his or her licensed copy of Photoshop on two computers. For a more consistent workflow, you can sync your Photoshop presets, workspaces, preferences, and other settings between two computers. To do this, you will upload your Photoshop preferences and panel settings from one of your computers to the Cloud, then sync your settings from the Cloud to your other computer. The computers don't have to be connected to each other, but you must be signed in to your Cloud account. In these tasks, we'll refer to the two machines as the first and second computer, but you can sync from either computer to the Cloud.

To upload settings from your first computer to the Creative Cloud: ★

- Choose settings in the Preferences dialog and/or in any Photoshop panels or pickers. For example, you could add swatches to the Swatches panel or gradients to the Gradient picker, define custom shapes, create brushes or actions, or load Adobe default or user-created libraries onto any panels. You can also create and save custom workspaces.
- 2. To verify that you are currently signed in to your Creative Cloud account, click the Edit/Photoshop menu; your account name should be listed.

- 3. To choose or change which categories of settings are synced, choose Edit/Photoshop > Preferences > Sync Settings. A From the What To Sync menu, choose Everything or Custom. If you chose Custom, check boxes for the categories of settings that you want to sync (Workspaces is a new option). Click Upload.
- 4. While the settings are being uploaded, a progress bar displays in the dialog. A list of the settings, and their individual time of upload, will appear in the Log window (the latest one is at the top of the list). Only user-created, non-default settings and libraries that are currently on the pickers and panels will be uploaded. Any existing presets and workspaces in the Cloud that have the same names as those that are being uploaded will be overwritten with the settings from your current computer. Note: When you exit/quit Photoshop, the Log window will be cleared.
- 5. Click OK.
- To upload Photoshop settings from your computer to the Cloud at any time using the current What To Sync settings (bypassing the Preferences dialog), choose Edit/Photoshop > [your Adobe ID] > Upload Settings.
- To stop an upload (or download) while it's in progress, click Stop.

Continued on the following page

- Workspace settings that you create on one operating system can't be downloaded to a computer that has a different operating system.
- If you need to deactivate the Sync Settings feature, from the What To Sync menu in the Sync Settings panel of the Preferences dialog, choose Nothing (all categories will be unchecked).

Once you have uploaded your settings from your first computer to the Cloud, you can sync (download) those settings to your second computer at any time.

Note: If any of your panels or pickers contain unsaved presets that you want to preserve, save them as a library before following the steps below (see page 131); otherwise, when you follow those steps, your unsaved presets will be overwritten with settings from the Cloud. If you have made edits to any user-created preset library, save it under a new name. Also, if you have reconfigured any default or user-created workspace, save it under a new name (see page 108).

To download settings from the Creative Cloud to your second computer: ★

- On your second computer, launch Photoshop, and verify that you're signed in to your Creative Cloud account.
- Choose Edit/Photoshop > Preferences > Sync Settings. From the What To Sync menu, choose Everything or Custom. If you chose Custom, check the boxes for the categories of settings that you want to download.
- 3. Click Download. While the settings are being downloaded, a list of those settings, and their individual time of download, will appear in the Log window. Any existing presets and workspaces on your current computer that have the same names as those that are being downloaded will be replaced by the settings in the Cloud.
- 4. Click OK.
- To download Photoshop settings from the Cloud to your current computer at any time using the current What To Sync settings (bypassing the Preferences dialog), choose Edit/Photoshop > [your Adobe ID] > Download Settings.

Managing files via the Creative Cloud

One of the benefits of having a Creative Cloud subscription is that you are allotted space on your page to store your files (as of this writing, up to 20 GB). Once they're stored in the Cloud, you can access them from any computer, post them publicly, or transmit them via email. You can get to your Creative Cloud page directly from Photoshop.

To upload files to the Creative Cloud: *

- 1. Launch the Creative Cloud app.
- 2. Click Files, then click View on Web.
- 3. Your personal Creative Cloud page displays in your browser. Do either of the following: From the Actions menu, choose Upload. In the dialog, locate and click a file name (or Ctrl/Cmd click multiple file names), then click Choose. Move the Creative Cloud window slightly to the side, then drag a file thumbnail (or multiple selected thumbnails) from Bridge into the Creative Cloud window.
- 4. A progress bar will display at the top of your Cloud page while the files are uploading. When the uploading is finished, a thumbnail of the chosen file(s) will display on your page.

A You can post, send, move, rename, or archive any individual file from your Creative Cloud page via commands on the menu in the lower-right corner of the file thumbnail.

To share, rename, move, or archive files via the Creative Cloud: *

- 1. Follow steps 1-2 in the preceding task.
- 2. From the View menu at the top of your Creative Cloud page, choose Mosaic or List.
- 3. From the menu in the lower-right corner of any file thumbnail, choose one of these options: A

To share the file via Behance, choose Post Publicly (if available for the current file format). To learn more about Behance, see the sidebar on this page.

To email the file, choose Send Link, Click Create Public Link to unlock the file: check Allow File Download, if desired; enter the email address of the recipient; then click Send Link.

To put the file into a folder on your Creative Cloud page, choose Move, click a folder name in the dialog, then click Move [number of] Items. (If you need to create a new folder first, from the Actions menu above the image thumbnails, choose Create Folder, enter a name, then click Create Folder.)

To rename the file, choose Rename, enter the desired name, then click Rename.

To archive the file (remove it from your main page and move it to an Archive page, for potential future deletion from the Cloud), click Archive, then click Archive again. To display all your archived files, click Archive in the menu bar. Check the box next to the files that you want to restore or delete, click Permanently Delete or Restore (at the top of the list), then click the button of the same name. To return to your personal page, click Creative Cloud Files.

MORE CREATIVE CLOUD RESOURCES

- To display a dialog that provides links to Creative Cloud Apps, Assets, and Community, click your name on the menu bar.
- To display a panel that indicates how much of your current Creative Cloud Storage is occupied, and also contains links for you to Manage your Desktop Sync Settings and access Creative Cloud Help, click the gear icon above the image thumbnails. To learn more about Behance, click Find Answers to Common Questions Here, then click a Behance topic under Tutorials for Creative Cloud or Community.

To manage an individual file via other commands on the Creative Cloud: *

- 1. On your Creative Cloud page, click a file thumbnail.
- 2. The file displays in an enlarged view, and information about the file displays under Details on the right.A
- 3. Do any of the following:

To change the visibility of layers in the file, click the Layers button above the image, then click the visibility icon for the layer(s) you want to show or hide. (If the file doesn't contain layers, that icon won't display.) If you want to restore all layers to the visibility settings that were saved in the file, click Reset Layers.

Via the Share menu, you can access the Post Publicly and Send Link commands. And via the Actions menu, you can access the Download, Rename, Archive, and Replace commands.

To load swatches of colors that are found in the current image into Adobe Kuler (kuler.adobe.com), an Adobe website that is used for browsing and creating color themes, click the swatches bar under Made With. The swatches will display on the Create page at Adobe Kuler. To learn about Kuler, search for "Kuler" in Photoshop Help.

To manage comments about the file, click Activity. To add a comment, click in the field, type your remarks, then click Add Comment. To delete a comment, roll over the comment and click the X. then click Delete Comment.

4. To return to viewing your personal page of thumbnails, click either Files on the menu bar, or click the back arrow to the left of the file name.

To sign out of your Creative Cloud page: *

Click your name on the menu bar, then in the dialog click Sign Out.

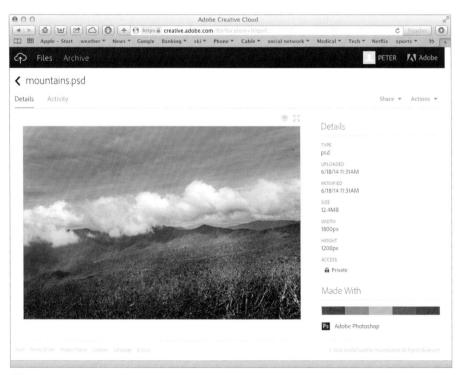

🖺 On our personal Creative Cloud page, we clicked a file thumbnail to enlarge its display size and to view its file details.

Unless noted otherwise, the listings in this index pertain to Photoshop.

Auto Mask option, 77

correction, editing, 77

Duplicate option, 75

edits, removing, 78

local edits with, 74-76

adjustment layer presets

Black & White, 246-248

Brightness/Contrast, 232

Mask option, 74, 75, 76, 77, 78

Mask Overlay Color swatch, 77

applying to video clips or tracks, 454

defined, 55

using, 74-78

choosing, 222

deleting, 226

adjustment lavers

saving, 226

A Action Options dialog, 428 actions command insertion, 434 command modal controls, 435 command settings, changing, 438 conditional steps, adding, 436-437 defined, 116, 427 deleting, 438 droplets for, 432 duplicating, 433 edit insertion, 434 edit order, 438 editing, 433-438 excluding command from playback, 429 menu item insertion, 434 modal controls, 435 partial, playing, 429 playback options, 429 playing on batch of images, 430-431 playing on one image, 429 recording, 427-428 renaming, 433 rerecording, 435 ruler units in, 428 sets, 438 Stops, inserting, 433 testing, 437 use suggestions, 431 Actions panel Button mode, 429 Dialog icon, 435 illustrated, 116, 427 Insert Conditional command, 436 Insert Menu Item command, 434 Insert Stop command, 433 List mode, 427, 429 loading set onto, 438 New Action button, 428, 433, 436 Play button, 429 Playback Options command, 429 Record Again command, 435 Reset Actions option, 438 Save Actions command, 438 uses, 427 Add Anchor tool, 115

Add Clips dialog, 453

accessing, 73-78

Adjustment Brush tool (Camera Raw)

clipping, 225 Color Balance, 236-237 creating, 126, 222-223 Curves, 235, 242-245 defined, 124 deleting, 226 editing, 126 effects, hiding, 224 filters and, 365, 366 Gradient Map, 248-249 Hue/Saturation, 238 identifying, 223 layer effects application to, 385 Levels, 230-231, 254 mask, editing, 227 merging, 164, 226 new edits, viewing images without, 224 options on Properties panel, 126 Photo Filter, 233 presets, 226 settings, editing, 224 settings, restoring, 224 Vibrance, 239-241 Adjustments panel Auto-Select Parameter option, 225 Black & White button, 246 Brightness/Contrast button, 232, 440 buttons, 117, 222 Color Balance button, 236 Curves button, 235, 242 Gradient Map button, 248 Hue/Saturation button, 238, 308

illustrated, 117 Levels button, 230, 235, 254, 385 Photo Filter button, 233 Reset to Adjustment Defaults button, 224 Vibrance button, 239, 240, 241 View Previous State button, 224 Adobe Bridge. See Bridge Adobe Creative Cloud. See Creative Cloud Adobe Illustrator, See Illustrator, Adobe Adobe InDesign, See InDesign, Adobe Adobe RGB color space, 5, 8 Advanced dialog (Photo Downloader), Advanced preferences (Bridge), 472 Airbrush tips, 294 alert dialogs, resetting, 459 alerts missing color profile, 35 missing fonts, 34 missing linked Smart Object, 35 aligning layers, with Auto-Align Layers command, 284 layers, with one another, 281 point type, 370 shapes in same layer, 413 with Smart Guides, 157 type, 380 vector objects, 405 alpha channels deleting, 182 editing, 182 layers while recording actions, 428 loading as selection, 182 saving selections as, 182, 188 anchor points selecting on paths, 424 selecting on shapes, 411 ANPA colors, 205 anti-aliasing selection tools and, 175 type tools and, 370 **Application frame** defined, 97 docking document windows into, 99

illustrated, 97, 98

Mac OS, 98

minimizing, 98

redocking floating panels into, 107	photoshop channels and, 2	image previews in, 29-32
resizing, 98	Bitmap mode, 4	keywords, 38-39
Art History tool, 115	Black & White adjustment layer	Keywords panel, 26, 38–39
artistic borders, 442–443	grayscale conversion via, 246–248	launching, 23
asset files	Targeted Adjustment tool, 246	loupe
bit depth, 491–492	tints, 246, 248	moving, 32
creating, 490–493	blemishes, removing	preference settings for, 470
default location, 491	Spot Healing Brush tool, 313	using, 31
generating from layers or layer	Spot Removal tool (Camera Raw),	metadata display, 37
groups, 492	90–91	Metadata panel, 26, 39
quality settings, 491–492	blending layers	Metadata placard, 29
thumbnail display, 493	Blending Options, 346–347	navigation controls, 29
See also image assets	modified with original one, 344	Open Recent File menu, 33
Assign Profile dialog, 12	opacity, 345	opening files from, 33–35
audio clips, 456	blending modes	Options for Thumbnail Quality and
Auto Color Correction Options dialog,	brush, 290	Preview Generation menu, 30
234–235	categories, 209	panes and panels, configuring, 36
Auto Resolution dialog, 138	choosing, 209–210	Photo Downloader, 24–25
Auto-Align Layers dialog, 284	cycling through, 210	Preview panel, 26
nato Angri Edyers dialog, 204	fill layer, 211–213	Refine menu, 32
В	filters and, 366	resetting, 38
Background	list of, 209	Reveal Recent File or Go to Recent
converting into layer, 152	Blending Options	Folder menu, 33
converting layer to, 152	for Layers, 346–347	Review mode, 32, 40
customizing, 104	for Smart Filters, 361	saving, 38
deleting selection from, 170	**************************************	thumbnails, 29, 30, 36, 40–43, 47
duplicating, 298	Blur Gallery	uses, 23
filling selection on, 170	applying filters in, 325–333	View Content buttons, 37
moving upward on list, 154	blurring adjustment, 326	window customization, 36–37
new document, choosing for, 15	Bokeh feature, 332	window features, 26–27
Background color	defined, 325	window illustration, 27
choosing, 203, 204, 207	Field Blur filter, 325, 326, 327	workspaces
filters that use, 358	filter masks, 333	changing, 28
Background Eraser tool, 115	filter pins, 326	choosing, 28
baseline shift, 379	Iris Blur filter, 325, 326, 328	default, 26
Basic blending modes, 209	Path Blur filter, 330–331	deleting, 38
Basic tab (Camera Raw)	selections with filters, 326	predefined, restoring, 38
Clipping Warning buttons, 64	Spin Blur filter, 325, 326, 331	resetting, 38
color saturation adjustments, 67	Tilt-Shift filter, 325, 326, 329	saving, 38
contrast adjustments, 64–66	Blur tool, 115	Brightness/Contrast adjustments, 232
defined, 61, 63	bokeh options in Blur Gallery, 332	bristle brushes, 296–297
edge contrast adjustments, 67	Bridge	
exposure adjustments, 64–66, 276,	cache, exporting, 48	Brush panel
277	collections, 46–47	Airbrush tips, 294
histogram tonal edits, 64	Collections panel, 26, 46-47	Angle option, 290
using, 63–67	Content panel, 26, 29, 30, 37	Brush Pose option, 296
white balance adjustments, 63	custom, 38	Brush Projection option, 292
Batch dialog, 430–431	deleting, 38	Brush Tip Shape option, 290, 293, 294
Batch Rename dialog, 44	Favorites panel, 26, 29, 46	Color Dynamics option, 292
Bevel effect, 392–393	file searches, 45	Create New Brush button, 293
bit depth	Filter Items by Rating menu, 41	customizing brushes via, 290–293
changing, 360	Filter panel, 26	displaying, 117
changing, 500	Folders panel 26, 29	Erodible Point tips, 293–294

Folders panel, 26, 29

Generator default, 491–492

Hardness option, 291	editing graduated or radial filter	settings, removing, 93
illustrated, 117, 291	mask with, 86–87	settings, save location, 94
Live Brush Tip Preview button, 293	flow rate, 290	settings, saving as preset, 92
New Brush button, 130	hardness, 128, 129	settings, synchronizing, 94
quick access to, 295	opacity, 129, 290	Settings menu, 62, 92
Roundness option, 291	roundness, 128	shadow clipping, 66
Scattering options, 292	saving, 295	sharpening, 50, 70
Shape Dynamics option, 292	settings, choosing, 128	Snapshots, 61, 92
Size option, 290	size, changing, 129, 290	Split Toning tab, 61, 79
Spacing option, 291	tips, 290-294	Spot Removal tool, 55, 90–91
Texture option, 292–293	Burn tool, 115	Straighten tool, 55, 57
Transfer option, 293	C	Targeted Adjustment tool, 68–69, 73
uses, 117	cache (Bridge), 48	toggling between default settings, 62
Brush Preset picker, 289, 306–307		tonal redistribution, 50
brush presets	Cache preferences (Bridge), 472	Tone Curve tab, 61, 68–69
deleting, 295	calibration, display, 6	tools, 55
identifying types of, 128	Camera Calibration tab (Camera	updating, 51
loading, 295	Raw), 61	white balance, 62
managing, 295	Camera Raw	White Balance tool, 55
modified indication, 295	Adjustment Brush tool, 55, 74–78	workflow options, 58–60
names, viewing, 299	advantages to using, 49	zoom methods, 55
3.	Before/After Views menu, 61	Camera Raw Filter, 54
resetting, 295	Basic tab, 61, 63–67	
saving, 131, 295	Camera Calibration tab, 61	cameras
settings, 295	Crop tool, 55, 56	Adobe RGB color space, 5
tools that use, 128	default settings, restoring, 61	capturing tonal values (Camera Raw), 50
Brush Presets panel	Detail tab, 61, 70–71	
illustrated, 118	dialog illustration, 53	downloading photos from, 24–25
Live Brush Tip Preview button, 293,	editing layers in, 54	canvas
295	Effects tab, 61, 84-85	area, enlarging with Crop tool, 146
Open Preset Manager button, 133, 295	filters, 54	pixels outside of, 257
	Gamut Warning button, 59	size, changing, 140
quick access to, 295	Graduated Filter tool, 55, 86-87	view, rotating, 103
saving brushes from, 131	HDR file processing in, 253	Canvas Size dialog, 140
brush strokes, recording, 428	host selection for, 52	channels
Brush tool	HSL/Grayscale tab, 61, 72-73	alpha, 182, 188, 428
Airbrush tip, 294	Lens Corrections tab, 61, 80-83	core, 2
choosing settings for, 128–129	luminance, reducing, 70	Curves adjustment layer, 244
creating selections with, 189	noise reduction, 50	defined, 2
defined, 114	opening files from, as embedded	document color mode and, 3
editing layer masks with, 280	Smart Objects, 265	spot color, 388
Erodible tip, 293–294	opening layers in, 54	Channels panel
in hiding filter effect, 362	opening photos into, 53	displaying, 2
Options bar, 188, 191, 227, 290	presets, applying, 92	illustrated, 118
painting with, 289–294	presets, saving, 92	Load Channel as Selection button,
reshaping layer masks with, 191, 280	Presets tab, 61	182
reshaping selections with, 188	previews, 50, 55, 61	New Spot Channel command, 388
in turning photos into drawings, 368	Radial Filter tool, 88–89	Photoshop color modes and, 2–4
brushes	reasons for using, 49–51	Save Selection as Channel button, 182
blending mode, 290	Red Eye Removal tool, 55	Character panel
bristle, 296–297	scrubby-sliders, 61	Baseline Shift controls, 379
customizing, 130, 290-294	settings, applying to multiple	Color swatch, 373

photos, 93

displaying, 119

diameter, 129, 278, 306

East Asian Feaures, 371, 469	CMYK Color mode	CMYK Color, 3, 4, 221
Font Family menu, 373	channels, 3	conversions, 3
Font Size menu, 376	conversion, 483	Grayscale, 4
Font Style menu, 373	defined, 3, 4	Indexed Color, 4
illustrated, 119, 369	output, final corrections in, 221	Lab Color, 4
Kerning menu, 377	soft-proofing, 475	RGB Color, 3, 4, 221, 473
Leading controls, 378	working space, 483	selecting, 15
Middle Eastern Features, 371, 469	CMYK color model	Smart Filters and, 360
OpenType buttons, 379	in color selection, 204	color noise reduction (Camera Raw),
resetting, 377	defined, 2	70–71
showing, 372	collections (Bridge)	Color panel
South Asian features, 469	adding to Favorites panel, 46	choosing colors with, 203
Toggle Typekit Fonts button, 374	contents, displaying, 46	illustrated, 120
Tracking controls, 377	creating and using, 46–47	out-of-gamut alert, 206
Character Style Options dialog, 382	deleting, 46	Color Picker
Character Styles panel	naming, 46	choosing colors with, 203
illustrated, 119	relinking missing file to, 47	HUD, 190
Load Character Styles command, 383	from search results, 45	opening, 120
Load Default Type Styles command,	Smart, creating and editing, 46	out-of-gamut alert, 206
383	standard, adding/removing	replacement color, 373
New Character Style button, 381	thumbnails, 47	color profiles
Redefine Character Style by Merging	standard, creating, 47	assigning, 35
Override button, 382	types of, 46	changing, 12
Save Default Type Styles command,	Collections panel (Bridge)	converting, 12
383	in creating and using collections,	defined, 5
Choose Package Destination dialog,	46–47	mismatch, 10
494	defined, 26	missing, 10, 35
Clipboard	Color Balance adjustments, 236–237	removing, 12
New dialog and, 16	color corrections	selecting, 15
with Paste command, 256	auto, 234–235	for soft proof, 474–475
with Paste Into command, 258	Color Balance adjustment, 236–237	Color Range command, 176–178
purging, 256	Curves adjustment, 242–245	•
using, 255–258	display calibration and, 221	Color Replacement tool
clipping	Hue/Saturation adjustments, 238	defined, 114
adjustments, 225	Photo Filter adjustments, 233	in red-eye removal, 309
high-contrast display of, 242	Vibrance adjustment, 239–241	using, 306–307
layers, 343–344	color depth (Camera Raw), 58	Color Sampler tool, 114
clipping masks	Color Libraries dialog, 203, 205	Color Sampler tool (Camera Raw), 55
creating, 343–344	<u> </u>	color settings
grouped layers in, 344	color management	choosing, 7, 8
releasing, 344	benefits of using, 5	installing, 11
releasing layers from, 344	Color Handling menu, 478, 479 color modes and, 3–4	saving, 11
using, 343–344		synchronizing, 9
Clone Source panel	display calibration, 6	Color Settings dialog
clone source overlay transformations,	introduction to, 5–6	accessing, 7, 8, 10, 11
283	Output options, 480	in color policy customization, 10
illustrated, 120	Photoshop, benefits of, 479	color space selection in, 8
using, 282	policies, customizing, 10	Missing Profiles option, 10
Clone Stamp tool	settings, 478	Profile Mismatches option, 10
defined, 114	turning off for printer, 481–482	saving color settings in, 11
using, 318–319	color modes, document	Settings menu, 8, 483
cloning, retouching by, 318–319	Bitmap, 4	Working Spaces settings, 8, 483
	changing 360	C-1C-11 (D:1 \)

changing, 360

Color Settings dialog (Bridge), 9

color spaces	search results, 45	text styles, between documents, 383
Adobe RGB, 5, 8	thumbnail display, 30	vector masks, 416
assigning via Workflow Options	Content-Aware fill, 321	Count tool, 114
dialog, 96	Content-Aware Move tool	Creative Cloud
choosing, 7-8	defined, 114	application adherence to ICC
defined, 5	moving/reshaping with, 322-323	profiles, 5
setting, 5	Content-Aware scaling, 350–351	downloading settings from, 496
color-blind viewer design, 213	context menus	individual file management, 498
color(s)	Layers panel, 155	launching, 497
Background, 203, 204	using, 112	missing fonts and, 34
basic methods for choosing, 203-204	continuous tones, 2	preferences, 461
blending modes, 209-210	contrast	sharing, renaming, moving, or
as building blocks, 2	auto adjustment, 235	archiving files via, 497
choosing, 203-204	Brightness/Contrast adjustment, 232	signing out of, 498
choosing from color libraries, 205	Curves adjustment, 242–243	storage amount, checking, 497
choosing from Swatches panel, 207	Levels adjustment, 230–231	syncing fonts and, 374
choosing with Color Picker, 203,	contrast adjustments (Camera Raw)	syncing Photoshop settings via,
204–205	adjustments, 64–66	495–496
continuous tones, 2	edge, 67	syncing preferences via, 457
copying as hexadecimals, 208	Contrast blending modes, 209	syncing presets with, 130
depth (Camera Raw), 60	Convert Point tool, 115	uploading files to, 497
desaturating, 240, 241	Convert to Profile dialog, 12	uploading settings from first
fill layers, 211	converting	computer to, 495–496
Foreground, 203, 204	Background to layer, 152	crop box
layer, assigning, 160, 161	color profiles, 12	choosing options for, 142
layer mask, 191	layer to Background, 152	cropping to, 144
process, 205	layer to grayscale, 246–248	guide lines within, 142
proofing, 474–475	layers to Smart Objects, 264	repositioning images within, 142
rendering intents, 475, 478	RGB files to CMYK files, 483	resizing, 141, 144
replacing, 304–305	shape layers to pixel layers, 409	restoring, 141
restoring, selectively, 241	type, paragraph to point/point to	selection in defining, 145
sampling, 203, 208	paragraph, 376	Crop tool
spot, 204, 205	vector masks to layer masks, 417	Camera Raw, 55, 56
type, 373	copying	crop box reset, 142
commands (action)	action commands, 434	cropping image, 141
adding, 434	colors as hexadecimals, 208	cropping multiple images, 144–146
adding modal controls to, 435	imagery to new layer, 257	cropping to aspect ratio, 144
deleting, 438	layer effects, 398	cropping to crop box, 144
duplicating within/between	layer masks, 194	cropping to size and resolution, 144
actions, 434	layer settings, 257	defined, 114
settings, changing, 438	layer styles, 401	enlarging canvas area, 146
commercial printing	layers, 165	overlay options, 142
file preparation for, 475, 483	layers, Smart Guides and, 286	preview options, 142
workflow for, 483	pasting, 256	recording use of, 431
Comparative blending modes, 209	path listing, 425	saving settings as preset, 145
Component blending modes, 209	selection borders, 171	shield options, 142
Conditional Action dialog, 436–437	selections, 256	sticky settings, 145
contact sheets, 445	shapes, 413	straightening images with, 147
Content panel (Bridge)	Smart Filters, 361	cropping
defined, 26	Smart Objects, 269	to aspect ratio, 144
in image display, 29	stroke and fill attributes on	to crop box, 144
metadata display in, 37	shapes, 409	manually, 141

nondestructive, 142	document windows	embedded Smart Objects, 269
photos (Camera Raw), 56	displaying one image in two, 100	layer comps, 446
to specific size and resolution, 144	docking, 99	layers and layer groups, 151
trim areas, 146	floating, 99	See also copying
.csf files, 11	multiple, rotating among, 102	E
Cursors preferences, 113, 313, 466	multiple, scrolling/zooming in, 103	Edge Reflow, 490
Curves adjustment layer	repositioning images in, 102	Edit menu
applying, 242–245	resizing, 100	Assign Profile command, 12
color correction with, 244	right-clicking in, 112	Auto-Align Layers command, 284
in darkening midtones, 224	selecting layers or layer groups in,	Clear command, 258
options, 242–243	153, 262	Color Settings command, 7, 8, 10,
Targeted Adjustment tool, 242, 244	Status bar, 21	305, 475, 483
tonal adjustments with, 242–243	tiling, 100	Content-Aware Scale command,
See also adjustment layers	documents	350, 351
Curves Display Options dialog, 242	blank, creating, 15–16	Convert to Profile command, 12
Custom Shape tool	closing, 22	Copy command, 256, 258
creating shape layers with, 406	creating from history states, 202	Copy Merged command, 256, 258
defined, 115	creating from layers, 262	Cut command, 170, 256
Customize Proof Condition dialog, 474	creating from thumbnails, 264	Define Custom Shape command,
D	dimensions, 21, 135–139	130, 423
Darken blending mode, 209, 316–317	dragging files into, as Smart Objects,	Define Pattern command, 130, 217
Delete Anchor tool, 115	266–267	Fill command, 131, 211, 217, 227, 321
Delete Workspace dialog, 109	flattened, 166	Free Transform command, 348, 349
desaturation, 240–241	information, getting quickly, 21	Free Transform Path command, 348,
Detail tab (Camera Raw)	open, displaying specs of, 16	425
defined, 61	opening as tabs, 99	Menus command, 108
using, 70–71	pixel scale ratio, 21	New command, 258
DIC Color Guide, 205	presets, creating, 16	Paste command, 256, 423
Diffuse Glow filter, 365	profiles, 21	Paste Special command, 256, 258
	resolution, 135–139	Presets command, 132, 133
Digimarc, 444	reverting to last version, 18	Purge command, 198, 256
dimensions	saving, 18–20	Transform Path submenu, 425
document, 135–139	size, 21	Transform submenu
selection, 168	state, restoring, 447	Distort command, 386, 395
Web output, 13, 16	Status bar, 21	Flip commands, 148
Direct Selection tool, 115, 412, 424	type styles, loading, 383	Perspective command, 386
displays, calibrating, 6, 221	Dodge tool, 115	Rotate commands, 148
distortion	downloading photos (Bridge), 24–25	Warp command, 356, 379
geometric, 80–83	drag-copying	Edit menu (Bridge)
layer, 348–349	layers, 262–263	Color Settings command, 9
Liquify filter, 352–354	selections, 259–261	Develop Settings command, 93
Warp, 356	drawings, changing photos into, 368	Find command, 45, 46
See also transformations	Drop Shadow layer effect	Edit Smart Collection dialog, 46
distributing layers, 281	in adding depth, 367	editable type layers
DNG files, 95	applying, 394–395	creating, 370–371
docks, panel	in rusted metal type, 382	defined, 124
collapsing, 106	transforming, 395	fading, 378
creating, 107	droplets for actions, 432	filling, 384
floating, 107	Duplicate Layer dialog, 262	merging, 164
hidden, displaying, 105	duplicating	preserving, 386
reconfiguring, 106–107	actions, 433	See also type

actions, 433 Background, 298

Effects tab (Camera Raw)	F	opening as embedded Smart Object,
defined, 61	Favorites panel (Bridge), 26, 29, 46	265
grain texture application, 84	Field Blur filter	opening from Camera Raw as
vignette application, 85	blurring control, 326	embedded Smart Object, 265
Ellipse tool, 115	defined, 325	placing into Photoshop as Smart
Elliptical Marquee tool	mask, using, 333	Objects, 266–267
in creating selections, 168	pins, 326, 327, 332	preparing for commercial printing,
in creating vignettes, 439, 440	using, 327	483
defined, 114	file formats	resampling, 135
in deselection, 170	Photoshop feature preservation, 18	resolution, 13–14
fixed ratio/dimensions selection, 168	in saving files, 18–20, 486–489	saving in PDF format, 486
in frame-shaped selections, 179	for Web and mobile devices, 489	16-bit, 17
Options bar, 168, 439, 440	File Handling preferences, 20, 462-463	32-bit, 17, 21
Embedded Profile Mismatch alert	Adobe Drive, 463	versions, saving, 20
dialog, 35	File Compatibility, 462	video, 450
embedded Smart Objects	File List, 463	ZIP, 488
converting layers in Photoshop files	File Saving Options, 462	files (Bridge)
to, 264	illustrated, 463	assigning keywords to, 38–39
converting to linked, 274	File menu	batch-renaming, 44
creating, 264–267	Automate submenu, 432	cache, 48
duplicates, creating, 269	Browse in Bridge command, 9	copying, 43
duplicates, editing, 269–270	Close command, 22	deleting, 43
20 0 0 00000	Fig. 50.000. Control of the Control	managing, 38-39, 43-44
editing, 268	Exit command, 22	moving, 43
opening files as, 265	Generate submenu, 490, 492	opening, 33–35
opening files from Camera Raw	New Command, 15, 16	quick search, 45
as, 265	New Dialog command, 150	renaming, 43
pasting Adobe Illustrator art as, 266	Open as Smart Object command, 265	reopening, 33
placing/dragging files as, 266–267	Open command, 33, 484	searching for, 45
replacing, 271	Open Recent command, 33	files (Camera Raw)
See also Smart Objects	Package command, 494	advantages to using, 49-51
Emboss layer effect, 392–393	Place command, 484, 485	JPEG files versus, 49, 51
Eraser tool	Place Embedded command, 266	opening into Photoshop, 94
defined, 115	Place Linked command, 272	previewing, 50
using, 300	Print command, 476	saving, 94
Erodible Point tips, 293–294	Revert command, 18, 197	TIFF files versus, 49, 51
Essential workspace (Bridge), 28	Save As command, 12, 18, 20, 139,	workflow options for, 58–59
Every-Line Composer, 380	166, 483, 485	Fill dialog, 217–218, 220, 321
Experimental Features preferences,	Save command, 18	fill layers
469	Scripts submenu, 399	blending mode, 211–213
Export/Import Presets dialog, 132	File menu (Bridge)	color, changing, 211
exporting	New Window command, 28	defined, 124
Bridge cache, 48	Open Recent command, 33	Gradient, 212–213
color swatches, 207	File Type Associations preferences	
preset libraries, 132	(Bridge), 472	opacity, 211–213
exposure correction (Camera Raw)	files	Pattern, 213
adjustments, 64–66	asset, 490-493	with scripted patterns, 217–220
Basic tab, 276, 277	dragging into documents as Smart	Solid Color, 184, 211
exposures, combining, 276–278	Objects, 266-267	Filmstrip workspace (Bridge), 28
Eyedropper tool	8-bit, 17	Filter Gallery
defined, 114	getting into Illustrator, 484-485	accessing, 358, 360
1:	getting into InDesign, 484, 485	dialog illustration, 359

getting into InDesign, 484, 485

managing via Creative Cloud, 497–498

previews, hiding/showing, 358

using, 358-359

sampling colors with, 208

eyes, whitening, 308

memory problems and, 362

filter masks	Minimum, 364, 366	Freeform Pen tool
creating, 362	Path Blur, 330-331, 333	defined, 115
deactivating, 362	preferences, 468	in drawing paths, 415
deleting, 362	preview feature, 359	using, 418
editing, 362	reapplying, 358	Full screen mode, 104
gradient, 364	Shake Reduction, 339–342	G
wiping clean, 364	Smart Sharpen, 334–336	gamma, calibration, 6
Filter menu	Spatter, 403	Gaussian Blur filter, 316–317
Blur Gallery submenu	Spin blur, 325, 326, 331, 333	
Field Blur command, 325	Surface Blur, 315	General preferences, 458–459
Iris Blur command, 325	techniques for using, 365-367	Always Create Smart Objects When Placing, 266, 458
Path Blur command, 330	Texturizer, 367	Animated Zoom, 101
Spin blur command, 325	Tilt-Shift, 325, 326, 329, 333	Export Clipboard, 255–256, 458
Tilt-Shift command, 325	unavailable, 357	History Log, 459
Blur submenu	Unsharp Mask, 337-338	HUD Color Picker, 458
Gaussian Blur command, 316	uses, 357	illustrated, 459
Surface Blur command, 315	video clip application to, 455	Image interpolation, 458
Brush Strokes submenu, 403	Find dialog (Bridge), 45	Options, 458
Camera Raw Filter command, 54	Find Edges filter, 366	Resize Image During Place, 266, 272,
Convert for Smart Filters	flattening	458
command, 360	layer effects, 399	Snap Vector Tools and Transforms to
Filter Gallery command, 358, 360	layers, 166	Pixel Grid option, 405, 458–459
Lens Correction command, 441	flipping	Vary Round Brush Hardness Based on
Liquify command, 352	clone source overlay, 283	HUD Vertical Movement, 129, 458
Other submenu, 364	layers, 148	General preferences (Bridge), 470
Sharpen submenu	FOCOLTONE colors, 205	Generator
Shake Reduction command, 339	Focus Area Add tool, 180, 181	asset files location, 491
Smart Sharpen command, 334	Focus Area dialog, 180–181	benefits of using, 490
Unsharp Mask command, 337	Focus Area Subtract tool, 181	bit depth, 491–492
Stylize submenu, 366, 368	folders (Bridge)	defined, 490
Filter panel (Bridge)	adding to Favorites panel, 29	enabling, 490
defined, 26	copying, 43	image asset generation, 490–493
in thumbnail display, 41	creating, 43	preferences, 468
filters	current, exporting Bridge cache	quality setting, 491–492
adjustment layers and, 365, 366	for, 48	geometric distortion, correcting
applying, 357–359	deleting, 43	(Camera Raw), 80–83
applying as Smart Filter, 360	displaying contents of, 29	GIF format, for Web and mobile device
applying via Filter Gallery, 358-359	moving, 43	output, 489
blending modes and, 366	navigating to, 29	Golden Ratio, 142
Diffuse Glow, 365	purging cache files from, 48	Golden Spiral, 143
effects, replacing, 358	Folders panel (Bridge), 26, 29	Gradient Editor dialog
effects, stacking position, 358	fonts	illustrated, 215
Field Blur, 325, 326, 327, 332, 333	family, changing, 373–374	opening, 214, 248
Find Edges, 366	missing fonts alert, 34	in tinting images, 248–249
Foreground/Background colors, 358	size, changing, 376	Gradient Fill dialog, 131, 212, 215
Gaussian Blur, 316-317	style, changing, 373–374	Gradient fill layers
Iris Blur, 325, 326, 328, 333	Typekit, 34, 374–375	applying gradients via, 215
last used, reopening, 358	vector outlines, 371	creating, 212–213
Lens Correction, 441	Foreground color	settings, editing, 213
Liquify, 313, 352-355	choosing, 203, 204, 207	Gradient Map adjustments, 248–249
Maximum, 364	filters that use, 358	Gradient Overlay layer effect, 396–397
		Gradient Overlay layer effect, 390-39/

Frame dialog, 218

Cura di anti ta al	wrinkles, softening, 310, 311	1
Gradient tool	100 LB1	Illustrator, Adobe
applying gradients via, 216	highlights Color Balance adjustment, 237	art, pasting into Photoshop, 266
defined, 115	with Levels adjustment, 230	art, path/shape creation from, 423
editing layer mask via, 279–280	lightening, 243	opening/placing Photoshop Layer
filter effect, 362, 364		into, 485
Gradient thumbnails, 214	Histogram panel	Photoshop to, 484
Options bar, 279 gradients	illustrated, 121 using, 228–229	image assets
	History Brush tool	file formats, 489
applying via fill layer, 212–213		generating, 490–493
applying via Gradient Overlay effect, 396–397	defined, 115	scaling, 494
applying via Gradient tool, 216	History panel with, 121	See also asset files
creating, 130	using, 301–302	lmage menu
defined, 212	History Options dialog, 196, 199	Adjustments submenu
effects, complex, 215	History panel	command effects, 222
filter mask, 364	defined, 195	HDR Toning command, 253
layer mask, 279–280	Delete Current State button, 198	Replace Color command, 304
	History Brush tool with, 121	Canvas Size command, 140
loading, 212	illustrated, 121	Image Rotation commands, 103, 148
presets, 214–215 repositioning, 397	linear mode, 195, 196, 197	Image Size command, 256
resetting to default position, 397	New Document from Current State button, 202	Mode submenu, 3
		Trim command, 146
saving, 131	New Snapshot option, 200	Image Processor dialog, 488
scaling, 397	nonlinear mode, 196, 197	Image Size dialog
Graduated Filter tool (Camera Raw), 55, 86–87	number of states, 196	Auto Resolution option, 138
100	options, 195–196	downsampling for print size, 139
grayscale	history states	downsampling for Web output, 139
converting layer to 246	changing, 197	image resolution, changing for print
converting layer to, 246–248	clearing, 198	output, 136
Grayscale mode, 4	deleting, 121, 198	image upscaling for print output, 137
grid	document creation from, 202	settings, restoring, 136
preferences, 468	number of, 196	images
showing/hiding, 288	purging, 198	colors as building block of, 2
Guides, Grid & Slices preferences,	restacking, 197	cropping, 141–143
286, 468	snapshots, 199–201	downsampling, 139
Н	HKS colors, 205	flipping, 148
hair selection, 184–187	Horizontal Type Mask tool, 115	HDR, 250–253
Hand tool	Horizontal Type tool	for layer effects, 391
Camera Raw, 55	in changing font size, 376	maximum size, 13
defined, 116	creating type with, 370–371	moving, in document window, 102
in repositioning images, 102	defined, 115	multichannel, 4
temporary, 102	recoloring type with, 373	multiple, cropping, 144–146
HDR (High Dynamic Range) images	selecting type with, 372	PDF presentation of, 444–445
Merge to HDR Pro command,	HSB model, 206	playing actions on, 429, 430–431
250–252	HSL/Grayscale tab (Camera Raw), 61,	previews (Bridge), 29–32
processing in Camera Raw, 253	72–73	print resolution, 13
producing, 250–253	HUD color picker, 204	repositioning, in document window,
shooting photos for composite, 250	Hue/Saturation adjustments	102
HDR Toning command, 253	applying, 238	reshaping areas in, 313
Healing Brush tool	for increasing saturation, 225	resizing (Camera Raw), 60, 82
defined, 114	range, setting, 239	resolution, 136, 137
hot spot removal, 312	Targeted Adjustment tool, 238	rotating 148

using, 310-312

rotating, 148

rotating (Camera Raw), 82	saving raw files as (Camera Raw),	copying, 398
scaling (Camera Raw), 82	95–96	default settings, 391
straightening, 147	for Web and mobile device output, 489	Drop Shadow, 382, 394–395
tinting, 248–249		Emboss, 392–393
trimming areas around, 146	K	essentials, 389–391
upscaling for print output, 137	kerning type, 377	flattening, 399
Web resolution, 13	keyframes , 449, 455	Gradient Overlay, 396–397
Import Options dialog, 485	Keyword preferences (Bridge), 472	hiding/showing, 390
importing	keywords (Bridge), 38–39	imagery selection, 391
preset libraries, 132	Keywords panel (Bridge)	Inner Glow, 382
type as Smart Object, 371	assigning keywords to files via, 39	Inner Shadow, 382, 394
video files, 450	creating keywords/subkeywords	live aspect of, 398
InDesign, Adobe	in, 38	moving, 398
Photoshop to, 484	defined, 26	multiple, applying, 402–403
placing Photoshop layer into, 485	L	Outer Glow, 382, 404
Indexed Color mode, 4	Lab Color mode, 4	Pattern Overlay, 397 Pillow Emboss, 393
Info panel, 122	labels, thumbnail (Bridge), 40	
inkjet printing	Labels preferences (Bridge), 472	rasterizing, 403
outputting files for, 476–482	Lasso tool	removing, 398 Satin, 397
printer driver settings, 476–477	defined, 114	
proofing documents for, 474	in deselection, 170	scaling, 397 settings, changing, 390
RGB Color mode for, 473	in free-form selections, 169	settings, changing, 390
Inner Glow layer effect, 382	launching	Stroke, 396
Inner Shadow layer effect, 382, 394	Bridge, 23	types of, 389
Insert Menu Item dialog, 434	Photoshop, 1	
Interface preferences, 99, 104, 112,	Layer Comp Options dialog, 446	layer groups
460–461	layer comps	asset generation, 492 in clipping mask, 344
illustrated, 461	alert icons, clearing, 448	creating, 154–155
Options, 460	applying layer edits to, 447–448	deleting, 156
inverting	creating, 123, 446	dragging up/down, 154
layer masks, 191	defined, 123	duplicating, 151
selections, 175	deleting, 448	hiding/showing, 316
Iris Blur filter	displaying, 446–447	locking, 159
blurring control, 326	duplicating, 446	moving layers out of, 155
defined, 325	PDF presentation of, 448	opacity, changing, 158
mask, using, 333	syncing edits to, 447–448	renaming, 152
using, 328	updating, 447	selecting, 153, 262
isolating layers, 162	Layer Comps Options dialog, 123	ungrouping, 156
isolation mode, exiting, 163	Layer Comps panel	layer masks
J	Delete Layer Comp button, 448	adding via Layers panel, 190
JPEG files	illustrated, 123	adjustment, editing, 227
Generator quality setting, 491–492	Last Document State listing, 447	applying, 194
importing into Photoshop as	New Layer Comp button, 446	black versus white areas in, 278
embedded Smart Objects,	Restore Last Document State	blending exposures via, 278
265–266	command, 447	color, changing, 191
opening, 33	Update Layer Comp button, 447	converting vector masks to, 417
opening into Camera Raw, 52–53	Layer Comps to PDF dialog, 448	copying, 194
previously edited, opening (Camera	layer effects	creating, 190
Raw), 52	applying, 389-390, 391	defined, 190
raw files versus (Camera Raw), 49, 51	applying to adjustment layer, 385	deleting, 194
saving, 20, 488	Bevel, 392-393	density adjustment 192

density adjustment, 192

disabling, 194	desaturating, 240, 241	Add Layer Style menu, 389
edges, refining, 193	distributing, 281	Add Vector Mask button, 416
editing, 191–193	document creation from, 262	Advanced Blending badge, 347
editing on adjustment layers, 227	drag-copying, between files (Layers	Apply Layer Mask option, 194
editing with Brush tool, 280	panel), 262–263	Background, 149, 151, 152
enabling, 194	drag-copying between files (Move	blending modes, 210
feather adjustment, 192	tool), 260-261	Blending Options, 361
gradients in, 279–280	dragging from inside, 260	context menus, 155
loading, 194	duplicating, 151	Convert to Smart Object command,
moving, 194	edges, fading via gradient in layer	264
outputting selections as, 190	mask, 279–280	Create Fill/Adjustment Layer menu,
repositioning, 193, 439	editable type, 124, 370–371	211, 212, 222
reshaping, 191	editing in Camera Raw, 54	Delete Layer button, 226, 398
shortcuts for, 227	file formats that support, 360	Delete Layer Mask option, 194
working with, 193–194	file size and, 166	Delete Vector Mask option, 194
Layer Style dialog	fill, 124, 211–213	display options, 159
Angle setting, 390	Fill percentage, 399	drag-copying layers with, 262-263
Bevel and Emboss, 392–393	filtering, 160–161	Duplicate Layer command, 165
Blending Options, 346–347	flattening, 166	Fill setting, 399
Contour presets, 390	flipping, 148	Filter Type menu, 160, 163
Drop Shadow, 394–395	hiding, 149, 156	Flatten Image command, 166
Gradient Overlay, 396–397	image, 124	illustrated, 124
illustrated, 390	image asset generation from,	isolation mode, exiting, 163
Inner Shadow, 394	489–494	Layer Filtering On/Off button, 160,
for layer styles, 400	isolating, 162–163	163
opening, 346, 389, 391	locking, 159	layer mask creation with, 190
Pattern Overlay, 397	merging, 164	listings, filtering, 160-161
Stroke, 396	moving out of groups, 155	Lock Transparent Pixels button, 158,
layer styles	multiple, selecting, 153	290, 302
applying, 400	naming, 151	Merge Down command, 226
copying, 401	nontransparent areas, selecting, 167	Merge Layers command, 226
creating, 130, 401	nudging one pixel at a time, 157	Merge Visible command, 165
defined, 127	opacity, changing, 158	New Group button, 155
with Layer Styles dialog, 400	opening in Camera Raw, 54	New Group from Layers command,
rasterizing, 403	pixel selection conversion into, 151	154
removing, 400	releasing from isolation, 162	New Layer button, 150, 151
saving, 401	renaming, 150, 152	options, 159
scaling, 138	repositioning, 157	selecting layers via, 153
layers	restacking, 154	thumbnail options, 159
aligning, with one another, 281	rotating, 148	uses, 124
aligning, with Smart Guides, 157	scaling, 262	Video Group listing, 455
asset generation, 492	screening back, 254	leading, 378
blank, adding, 150	selecting, 153, 167	Lens Correction filter, 441
blending modes, 210, 345–347	selecting, in document window, 262	Lens Corrections tab (Camera Raw)
blending options, 346	shape, 124, 405–423	defined, 80
clipping masks, 343–344	straightening, 147	edits, applying to multiple photos, 83
	visible, merging, 165	Manual settings, 81–83
color-coding, 159	warping, 356	for multiple photos, 83
content, repositioning, 193 converting to Smart Object, 264	See also adjustment layers	preset corrections, 81
,	Layers panel	Profile settings, 80
copying and merging, 165	Add Layer Mask button, 278, 279,	using, 80–83
creating, 150–152	284 315 368 439	

284, 315, 368, 439

deleting, 156

Magnetic Lasso tool, 114

Levels adjustment layer	masks	bristle brush creation, 296
illustrated effects, 230	with Adjustment Brush tool (Camera	bristle brush paint options, 297
mask, 385	Raw), 74–78	cleaning bristle brushes, 297
screening back layers with, 254	Blur Gallery filter, 333	defined, 114
settings, applying, 230	clipping, 343–344	Erodible tip, 294
tonal values correction with, 230-231	creating, 190	photos into paintings, 298-300
See also adjustment layers	density, 192	using, 296–298
Light Table workspace (Bridge), 28	edges, softening, 440	mobile devices, file format selection,
Lighten blending mode, 209, 316-317	editing, 191–193	489
Line tool, 115	feathering, 192	Monitor Color preset, 8
linked Smart Objects	layers, 190–194	Motion panel, 453
alert, missing, 35	options on Properties panel, 126,	Motion workspace, 449
converting to embedded, 274	192–193	Move tool
creating, 272	partial, 188	in adding isolated layers, 163
editing contents of, 273	refining edges of, 193	drag-copying with, 259, 260-261
gathering copies of, 494	storing selections as, 189	in layer selection, 153
Layer Comps menu, 272	vignette creation via, 440	in moving selection contents, 171
missing, getting data on, 274	zooming in on, 188	Options bar, 257, 262, 281
relinking, 274	See also filter masks; layer masks;	in repositioning layer mask, 193
replacing, 271	Quick Masks; vector masks	in repositioning layers, 157
updating, 274	Maximum filter, 364	scaling type with, 376
working with, 273-275	Merge to HDR Pro dialog	transformations with, 348-349
See also Smart Objects	Advanced tab, 250, 251	moving
Liquify filter	Curves tab, 252	with Content-Aware Move tool, 322
applying to Smart Objects, 354	in making images look surreal, 253	layer effects, 398
distortion tools, 352-354	opening, 250	layer masks, 194
edits, removing, 354	Tones and Detail, 250, 251	layers, Smart Guides and, 286
protecting image areas from, 352	using, 250–252	selection borders or contents, 171
quick access to tools, 354	merging	vector masks, 416
Reconstruct Options, 354	adjustment layers, 226	N
for retouching, 313, 355	layers, 164	
Tool Options, 352–353	visible layers, 165	Navigator panel functions, 125
locking	metadata (Bridge), 37	illustrated, 125
layers or layer groups, 159	Metadata panel (Bridge)	in repositioning, 102
transparent pixels, 158	assigning keywords to files via, 39	in zooming, 102
loupe (Bridge), 31, 32, 341, 470	defined, 26	New (document) dialog, 15–16
luminance (Camera Raw), 70-71	Metadata placard (Bridge), 29	-
M	Metadata preferences (Bridge), 471	New Actions dialog, 428
Mac OS	midtones	New Crop Preset dialog, 145
Application frame, 98	adjusting separately, 347	New Document Preset dialog, 16
droplet usability in, 432	auto correction of, 234–235	New Layer Comp dialog, 446
exiting Photoshop in, 22	Color Balance adjustment, 237	New Layer dialog, 152
launching Bridge in, 23	color value selection, 234	New Preset dialog (Camera Raw), 92
launching photoshop in, 1	darkening, 223, 224	New Snapshot dialog, 200
Save As dialog box, 19	with Levels adjustment, 230	New Spot Channel dialog, 388
ZIP file creation, 488	lightening, 243, 254	New Style dialog, 401
Magic Eraser tool, 115	reducing blue and green in, 245	New Tool Preset dialog, 134
Magic Wand tool	Minimum filter, 364, 366	New Workspace dialog, 38, 108
defined, 114	Missing Fonts dialog, 34	noise reduction (Camera Raw), 50
using, 174–175	Missing Profile alert dialog, 35	North America Newspaper preset, 8
using, 1/4-1/5	Mixer Brush tool	North America Web/Internet preset, 8

Airbrush tip, 294

North American General Purpose 2	Ruler tool, 288	panels
preset, 8	Sharpen tool, 342	closing, 106
North American Prepress 2 preset, 7,	Spot Healing Brush tool, 313	configuring, 105–107
8, 9, 10	Toggle Brush Panel button, 107	deleting presets from, 130
Note tool, 114	Tool Preset picker, 113	hidden docks, displaying, 105
	values, canceling, 110	hiding, 105, 106
0	Vertical Type tool, 370, 373, 376	icons, 112
opacity	Warp command, 356	maximizing/minimizing, 106
blending layers, 345	Workspace menu, 104, 108, 109, 110	moving, 107
brush, 290	orientation, type, 378	opening, 105
changing, layer or layer group, 158	Outer Glow layer effect, 382, 404	preset management via, 130–132
duplicate layer, 368	out-of-gamut alert, 206	redocking into Application frame, 107
fill layer, 211–213	P	restoring default presets to, 132
fill percentage, 399	•	showing, 105, 106
overlay, 396, 397	Paint Bucket tool, 115	widening or narrowing, 107
shadow, 394	paintings	panels (Bridge)
Smart Object, 363	Texturizer filter and, 367	Collections, 26
stops, 214	turning photos into, 298–300	configuring manually, 36
tool, 209	panel	Content, 26, 29, 37, 45
Open as Smart Object dialog, 265	Actions, 116, 427–438	displaying/hiding, 36
OpenGL, enabling, 97	Adjustments, 117, 221–226	Favorites, 26, 29
OpenType characters, 379	Brush, 117, 290–294	Filter, 26, 41
optimized files, 488	Brush Presets, 118, 295	Folders, 26, 29
Options bar	Channels, 2–4, 118	Keywords, 26, 38-39
accessing, 110	Character, 119, 369, 371, 377–379	Metadata, 26
Brush tool, 188, 191, 227, 290	Character Styles, 119, 380, 383	Preview, 26, 29
Character panel, 373	Clone Source, 120, 282–283	panoramas, 284-285
Clone Source tool, 282	Color, 120, 206	PANTONE PLUS (+) colors, 205
Clone Stamp tool, 318–319	Histogram, 121, 228–229	Paragraph panel
Color Replacement tool, 306, 309	History, 121, 195–202	alignment buttons, 380
Content-Aware Move tool, 322	Info, 122	controls, 380
Content-Aware Scale command, 350	Layer Comps, 123, 446–448	East Asian Features, 371, 469
Crop tool, 141, 142, 146	Layers, 124, 149–166, 262–264, 278–279, 284	functions, 125
Elliptical Marquee tool, 168, 439, 440	Motion, 453	illustrated, 125
Eraser tool, 300	Navigator, 102, 125	justification buttons, 380
Eyedropper tool, 208	Paragraph, 125, 371, 380	Middle Eastern Features, 371, 469
features, changing, 110	Paragraph Styles, 125, 380, 383	South Asian features, 469
Free Transform command, 349	Paths, 125, 418–419, 423–426	Paragraph Styles panel
Freeform Pen tool, 415, 418	Properties, 126, 191, 194, 222–226	Clear Overrides button, 381
Gradient tool, 279	Styles, 127, 400–401	functions, 125
Healing Brush tool, 310	Swatches, 127, 207	illustrated, 125
History Brush tool, 301–302	Timeline, 127, 449	Load Default Type Styles command,
Horizontal Type tool, 370, 373, 376	Tool Presets, 127	383
Magic Wand tool, 174	Tools, 113–116, 188	Load Paragraph Styles command, 383
Mixer Brush tool, 110, 296, 297, 298	Transition, 452	New Paragraph Style button, 381
Move tool, 153, 257, 262, 281	panel groups	Redefine Paragraph Style by Merging
numerical values, changing, 123	closing, 106	Override button, 382
Patch tool, 314, 324	floating, 107	Save Default Type Styles command,
Path Selection tool, 407, 412	maximizing/minimizing, 106	383
Pen tool, 217, 415, 420, 421, 423, 424 Quick Selection tool, 172	moving, 107	paragraph type
Quick Selection tool, 172	1104119, 107	converting to point type, 376

reconfiguring, 106–107

creating, 370

Rectangular Marquee tool, 168

Red Eye tool, 309

transforming, 384 Make Work Path from Selection shooting for HDR composite, 250 Paste Camera Raw Settings dialog, 93 button, 423, 425 shooting for panorama, 284 Paste dialog, 266 path listings, restacking, 425 turning into paintings, 298-300 Stroke Path with Brush button, 426 pasting turning into tinted drawing, 368 working with, 418-419 files as Smart Objects, 266 photos (Camera Raw) Illustrator art into Photoshop, 266 Pattern Fill dialog, 217 archiving as DNG files, 95 refining selections after, 261 Pattern fill layers, 213 cropping, 56 into selections, 258 Pattern Overlay layer effect, 397 cycling through, 94 selections, 256 Pattern picker, 292 embedded Smart Object, editing, Patch tool Pattern Stamp tool, 114 defined, 114 patterns grayscale, color tint application, 79 removing image elements with, 324 custom, 217, 218 lens correction synchronization, 83 retouching with, 314 hiding areas of, 218 opening into Camera Raw, 52 Path Blur filter opening into photoshop, 95 illustrated, 218 applying, 330-331 repositioning, 397 preferences, setting, 52 blurring elimination, 331 saving, 218 resolution, 58, 60 rotating, 82 mask, using, 333 scaling, 397 strobe effect, 331 scripted, 217-220 scaling, 82 Path Selection tool **PDF** format sharpening, 58, 70 in Photoshop feature preservation, 19 straightening, 57 in aligning shapes, 413 defined, 115 stretching, 82 presentation of images, 444-445 Options bar, 407, 412 presentation of layer comps, 448 updating, 52 in uniting shapes, 413 vignette application to, 85 saving files in, 486 workflow settings for, 60 with vector masks, 414, 417 selecting, 18 paths PDF Presentation dialog, 444-445 Photoshop exiting/quitting, 22 applying fill/stroke colors to, 426 Pen tool combining, 425 getting to quickly (Bridge), 33 in adding/deleting points, 424 copying, 425 launching, 1 combining skills, 423 Photoshop Import Options dialog, 485 creating from Illustrator, 423 defined, 115 creating from shape layer, 423 in drawing curved paths/shapes, 421 pickers creating vector masks from, 414 deleting presets from, 130 in drawing nonsmooth curves, 422 curved, drawing, 421 loading presets onto, 131, 133 in drawing paths, 415 deleting, 425 in drawing straight-sided paths/ preset management via, 130-132 hiding/displaying, 419 shapes, 420 restoring default presets to, 132 loading as selection, 426 Pencil tool, 114 saving presets on, 131 nonsmooth curve, drawing, 422 Performance preferences, 464-465 See also specific pickers preserving, choosing file formats Graphics Processor Settings, 464 Pillow Emboss layer effect, 393 for, 425 History & Cache, 196 pixels producing shapes from, 423 illustrated, 465 adding to canvas, 140 repositioning, 419 Memory Usage, 464 erasing, 300 selecting/deselecting, 419 Scratch Disks, 464 maximum image size in, 13 storing and accessing, 125 Use Graphics Processor, 97, 103, 289 outside canvas, 257 straight-sided, drawing, 420 perspective pasted, 256 temporary (Work Paths), 418, 419 problems, correcting, 144 rasterizing type into, 386-387 transforming, 425 transformation, 349 selection, turning into layer, 151 working with, 425-426 Perspective Crop tool, 114, 144 shadow, in histogram, 229 Paths panel transparent, locking, 158 Photo Downloader (Bridge), 24-25 Delete Path button, 425 Photo Filter adjustments, 233 Place Along Path dialog, 219 Fill Path with Foreground button, 426 Place dialog, 271, 484 Photomerge dialog, 284-285 illustrated, 125

photos

downloading (Bridge), 24-25

sampling colors from, 298

Load Path as Selection button, 425,

426

Playback preferences (Bridge), 471

Plug-ins preferences, 468-469, 490

ProPhoto RGB color space, 8

PNG format	Preset Manager	Printing Marks options, 480
Generator quality setting, 491–492	illustrated, 133	settings, 478-480
for Web and mobile device output,	loading presets with, 133	print output
489	opening, 133, 295	commercial, 475, 483
point type	saving presets with, 133	downsampling photos for, 139
aligning, 370	presets	file resolution, 14, 16, 136
converting to paragraph type, 376	adjustment layer, 226	quasi hard proof, 480
creating, 370	brush, 128, 295	scaling, 478
Polygon tool, 115	Color Range, 177	soft proofing for, 474-475
Polygonal Lasso tool	color settings, 7	upscaling images for, 137
defined, 114	creating, 16	printers
in straight-sided selections, 169	creation of, 130	color management, turning off and,
pop-up sliders, 123	default, restoring, 132	481–482
PostScript printing options, 480	deleting, 16, 130, 133	driver settings, 476–477
preferences, 457–472	document, 16	profiles, acquiring, 11
Cursors, 113, 313, 466	exporting, 132	rendering intents and, 475
Experimental Features, 469	gradient, 214	process colors, 205
File Handling, 20, 52, 462–463	importing, 132	profiles
General, 101, 129, 255–256, 272, 405,	loading, 133	color, 5, 12
458–459	naming, 16	document, 21
Guides, Grid & Slices, 286, 468	renaming, 133	printer, 11
Interface, 99, 104, 112, 460–461	saving, 16, 133	proofing colors
opening, 457	tools, 134	for commercial printing, 475
Performance, 97, 103, 196, 289,	unsaved, storage, 130	for inkjet output, 474
464–465	presets (Camera Raw)	for Web output, 475
Plug-ins, 468-469, 490	applying, 92	Properties panel
resetting, 457	saving settings as, 92	adjustment layer options, 126
Sync Settings, 461, 495–496	Presets tab (Camera Raw), 61	Apply Mask button, 194
syncing via Creative Cloud, 457	Preview panel (Bridge)	Auto-Select Parameter option, 225
Transparency & Gamut, 158, 466	defined, 26	Black & White controls, 246, 247, 248
Type, 371, 469	image display in, 29	Brightness/Contrast controls, 232
Units & Rulers, 16, 467	Preview workspace (Bridge), 28	Clip to Layer button, 225
preferences (Bridge), 470–472	previews (Bridge)	Color Balance settings, 236, 237
Advanced, 472	comparing, 30	Curves Display Options, 242
Cache, 48, 472	full-screen, 30	Delete Adjustment Layer button, 226
Camera Raw, 52	quality options, 30	Delete Mask button, 194
File Type Associations, 472	in Review mode, 32	Gradient Map controls, 248, 249
General, 52, 470	thumbnail, 29	Hue/Saturation controls, 238, 308
Keywords, 472	previews (Camera Raw)	illustrated, 126
Labels, 472	histogram clipping warnings, 64	Invert button, 191
Metadata, 471	positions, swapping, 61	Levels controls, 230, 254
opening, 457	raw photos, 50	Linked Smart Object controls, 272,
Playback, 471	Threshold, 66	273
resetting, 457	zooming in, 55	Live Shape Properties button, 407
Startup Scripts, 472	previews (filter), 358, 359	Load Selection from Mask button, 194
Thumbnails, 37, 471	Print dialog	Mask Edge option, 193
preferences (Camera Raw), 52	accessing, 476	mask options, 126
preset libraries	Color Management settings, 478,	Photo Filter controls, 233
exporting, 132	481, 482	settings, 222–226
importing, 132	illustrated, 479	Vibrance controls, 239, 240
loading, 131	PostScript Options category, 480	Properties/Print dialog, 476, 477

printer driver settings, 476-477

saving presets as, 131

PSB files	Palifer Para de la la	
in Photoshop feature preservation, 19	Red Eye Removal tool (Camera Raw),	guidelines, 303
selecting, 18	55, 309	Healing Brush tool, 310–312
working with, 20	Red Eye tool	Liquify filter, 313, 355
PSD format	defined, 114	Patch tool, 314, 324
	using, 309	Red Eye tool, 309
in Photoshop feature preservation, 19	Refine Edge dialog	Replace Color command, 304–305
saving files in, 488	accessing, 182	skin smoothing, 315
saving raw files in (Camera Raw), 95–96	in artistic border creation, 442	Spot Healing Brush tool, 313
selecting, 18	Decontaminate Colors option, 186,	Surface Blur filter, 315
_	187	teeth whitening, 308
Q	illustrated, 183	Revert Construction dialog, 354
Quick Mask Options dialog, 189	layer mask creation with, 190	reverting, to last saved document
Quick Masks	Output To menu, 442	version, 18
creating selections via, 189	Refine Radius tool, 186	Review mode (Bridge)
in reshaping selections, 188	refining hair selection with, 184–187	previewing images in, 32
in whitening teeth or eyes, 308	refining selection edges with, 182–183	rating thumbnails in, 40
Quick Selection tool	Smart Radius option, 184	RGB Color mode
defined, 114	Refine Mask dialog, 193	channels, 3
using, 172–173	Refine menu (Bridge), 32	defined, 3, 4
R	refocusing. See Blur Gallery	for inkjet printing, 473
Radial Filter tool (Camera Raw)	- /	for Photoshop work, 221
darkening photo areas with, 88-89	Render Video dialog, 456	RGB color model
defined, 88	rendering intents, 475, 478	choosing, 206
mask, editing with a brush, 86	Replace Color dialog, 304–305	in color selection, 204
RAM , 21	Replace Contents command, 271	defined, 2, 206
rasterizing	resampling files, 135	Rotate View tool, 103, 116
layer effects, 403	reshaping	rotating
layer styles, 403	bounding box, 384	bounding box, 384
Smart Objects, 271	with Content-Aware Move tool, 322	clone source overlay, 283
type, 386–387	images, 313	images (Camera Raw), 82
ratings, thumbnail (Bridge), 40	layer masks, 191	items, 349
raw files (Camera Raw)	with Liquify filter, 352–355	layers, 148
advantages to using, 49–51	selections, 188	Rounded Rectangle tool, 115
copy, opening, 95	shadows, 395	ruler guides
JPEG files versus, 49, 51	with Warp command, 356	attributes, changing, 287
opening into Camera Raw, 52, 53	resolution	creating, at specific location, 288
opening into photoshop, 95	auto, 138	creating by dragging, 287
previewing, 50	calculating, 13–14	locking/unlocking, 288
saving, 95	default values, setting, 16	relocating, 287
TIFF files versus, 49, 51	document, 135–139	removing, 288
See also Camera Raw	image, 135–136	showing, 287
Record Stop dialog, 433	methods of setting, 14	Ruler tool
Rectangle tool, 115	photos (Camera Raw), 58, 60	defined, 114
Rectangular Marquee tool	print output, 14, 16, 136	in measuring distance or angle
in creating selections, 168	selecting, 15	with, 288
defined, 114	Web output, 13, 16	straightening layers with, 147
in deselection, 170	retina displays, zoom and, 101	rulers
in fixed ratio/dimensions selection,	retouching	origin, changing, 287
168	by cloning imagery, 318–319	showing and hiding, 287
in frame-shaped selections, 179	Color Replacement tool, 306–307	units, changing, 287
	eye whitening, 308	units, in actions, 428

Gaussian Blur filter, 316-317

attributes, changing, 407-409

S	Screen mode menu, 104, 105	Lasso tool, 169
Satin layer effect, 397	screening back type, 385	layer-based, 153
saturation adjustments	scripted patterns, 217–220	loading, 182
Basic tab (Camera Raw), 67	scrolling, in multiple document	loading layer masks as, 194
Color Replacement tool, 306-307	windows, 103	loading paths as, 426
Hue/Saturation, 225	scrubby sliders, 123	loading shape layers as, 409
vibrance, 239–241	searching for files (Bridge), 45	nontransparent areas of layer, 167
in whitening teeth, 308	Select menu	pasting into, 258
Save Adobe PDF dialog, 445, 486	Active Layers command, 410	Polygonal Lasso tool, 169
Save As dialog, 18, 19, 20, 483	All command, 167	Quick Selection tool, 172–173
Save As Web dialog, 139	Color Range command, 176	Rectangular Marquee tool, 168, 179
Save dialog, 131	Deselect command, 170	reselecting, 170
Save Options dialog, 95-96	Deselect Layers command, 382	reshaping, 188
Save Settings dialog (Camera Raw), 92	Focus Area command, 180–181	saving, 182
saving	Grow command, 175	shape layer path, 410–411
action sets, 438	Inverse command, 175	shrinking, 172
adjustment presets, 226	Isolate Layers command, 162	storing as masks, 189
Brush Presets panel brushes, 131	Reselect command, 170	straight-sided, 169
brushes, 295	Similar command, 175	transforming, 348–349
Camera Raw settings as preset, 92	Transform Selection command, 348	type, 372
color settings, 11	selection edges	vector tool, 169
custom workspaces, 108–109	adjusting, 257	Settings menu (Camera Raw)
document presets, 16	feathering, 259	restoring settings via, 62
documents, 18–20	refining, 183-187	saving settings as presets with, 92
files (Camera Raw), 94	selections	shadows
files, in JPEG format, 488	adding to via command, 175	auto correction, 234–235
files, in PDF format, 486	in adjustment layers, 222	Brightness/Contrast adjustment, 23
files, in PSD format, 488	anchor points on shapes, 411	clipping, removing (Camera Raw), 6
files, in TIFF format, 487, 488	border, moving, 171	Color Balance adjustment, 236
flattened documents, 166	border, showing/hiding, 178, 324	Curves adjustment, 242–243
layer effect settings, 393	canvas area of a layer, 167	drop (layer effect), 394–395
layer styles, 401	of colors, 176-178	HDR images, 250–253
multiple files, 488	contents, moving, 171	Levels adjustment, 230
patterns, 218	creating paths from, 423	pixels in histogram, 229
presets, 133	creating via Quick Mask, 189	softening, 335
previously saved documents, 18	creating with Color Range command,	tinting (Camera Raw), 79
workspaces (Bridge), 38	176–178	Shake Reduction filter
scaling	in defining crop boxes, 145	applying, 339–342
based on percentages, 350	deleting, 170	blur trace path, creating/adjusting,
clone source overlay, 283	deselecting, 170	340–341
Content-Aware, 350–351	drag-copying, between files (Move	blur trace regions, creating, 340
gradients, 397	tool), 260–261	defined, 339
image assets, 494	drag-copying, on same layer, 259	edge noise, reducing, 340
images (Camera Raw), 82	Elliptical Marquee tool, 168, 179	settings, saving, 342
items, 348	enlarging, 172	settings, selecting, 339
layer effects, 397	expanding, 175	settings comparison/adjustment in
layers, 262	filling, 170	a loupe, 341
patterns, 397	in-focus areas, 180–181	shape layers adding shapes to, 413
print output, 478	frame-shaped, 179	3 .
Smart Objects, 266, 267	free-form, 169	aligning shapes within, 413
styles, 138	hair, 184–187	anchor points selection, 411

inverting, 175

type, 376

deleting, 362

combining into one layer, 413 creating from presets, 219 creating paths from, 423 creating vector masks from, 414 creating with shape tools, 406 defined, 124 de-isolating, 412	editing, 360 example use, 363–364 hiding/showing effects, 361 mask, 362 restacking, 361 Smart Guides aligning layer content with, 157	Snap To feature, 288 snapshots creation of, 199 deleting, 201 document creation from, 202 of history state, 200 naming, 200
excluding shapes in, 413 intersecting shapes in, 413 isolating, 412 loading as selection, 409	in moving or copying layers, 286 transformations with, 348 Smart Objects applying filters to, 360–367	as newest history state, 201 options, 199 using, 199–201 Snapshots tab (Camera Raw), 61, 92
merging, 164 paths, selecting, 410–411 properties, changing, 407–408 properties, copying, 409 subtracting shapes in, 413	converting, 274 copies, converting into layer, 271 copying, 269 defined, 264 duplicating, 269	soft proofs commercial printing, 475 defined, 473 inkjet, 474 Solid Color fill layers, 184, 211
uniting shapes in, 413 warp settings, 356 See also vector objects Shape Name dialog, 423	embedded converting layers in Photoshop files to, 264 converting to linked, 274	Spatter filter, 403 Spin blur filter blurring control, 326 defined, 325
Sharpen tool defined, 115 using, 342 sharpening	creating, 264–267 duplicates, creating, 269 duplicates, editing, 269–270 editing, 268–270	mask, using, 333 strobe effect, 331 using, 331 Split Toning tab (Camera Raw), 61, 79
Camera Raw, 50 photos (Camera Raw), 58, 70 Shake Reduction filter, 339–342 Sharpen tool, 115, 342	opening files as, 265 opening files from Camera Raw as, 265 pasting Adobe Illustrator	splitting video clips, 452 Sponge tool, 115 spot colors
Smart Sharpen filter, 334–336 Unsharp Mask filter, 337–338 shortcuts layer mask, 227	art as, 266 placing/dragging files as, 266–267 replacing, 271 importing type as, 371	channel, putting type in, 388 choosing, 205 for color accuracy, 204 defined, 204
tool setting changes, 129 transform, 349 undo, 111 zoom, 101	in lieu of merge or flatten, 164 linked converting to embedded, 274 creating, 272	separation into process colors, 205 Spot Healing Brush tool Content-Aware option, 313, 320 defined, 114
Single Column Marquee tool, 114, 168 Single Row Marquee tool, 114, 168 Single-Line Composer, 380	editing contents of, 273 missing, alert for, 35 missing, getting data on, 274 relinking, 274	using, 313 Spot Removal tool (Camera Raw), 55, 90–91 spring-loading tools, 113
16-bit files, 17 skewing items, 349 skin smoothing with Gaussian Blur filter, 316–317 with Surface Blur filter, 315	replacing, 271 updating, 274 working with, 273–275 merging, 164	sRGB IEC61966-2.1 color space, 8 standard collections (Bridge), 46, 47 Standard screen mode, 104 Startup Scripts preferences (Bridge),
Slice Select tool, 114 Slice tool, 114 Smart collections (Bridge), 46 Smart Filters	Missing and Changed list, 21 opacity, 363 rasterizing, 271 replacing, 271	472 Status bar, 21 Straighten tool (Camera Raw), 55, 57 straightening
applying, 360 blending options, editing, 361 copying, 361	thumbnails, 269, 270, 271 Smart Quotes, 371 Smart Sharpen filter, 334–336 Smudge tool, 115	images, 147 layers, 147 photos (Camera Raw), 57 strobe-and-flash effect, 331

Audio panel access, 456

3D Material Drop tool, 115

Blur, 115

Brush, 114, 129, 289-294

Burn, 115 Ruler, 114, 147, 288 tracking type, 377 Clone Stamp, 114, 318-319 selecting, 113 tracks, video Color Replacement, 114, 308 Sharpen, 115, 342 adding to timeline, 450 Color Sampler, 114 shortcuts for changing settings, 129 applying adjustment layer to, 454 Content-Aware Move, 114, 322-323 Single Column Marquee, 114, 168 audio, 456 Convert Point, 115 Single Row Marquee, 114, 168 deleting, 451 Count, 114 Slice, 114 See also video Crop, 114, 141-142, 144-146 Slice Select, 114 transformations Custom Shape, 115, 406 Smudge, 115 applying, 348-349 Delete Anchor, 115 Sponge, 115 Drop Shadow layer effect, 395 Direct Selection, 115, 424 Spot Healing Brush, 114, 313 with Free Transform command. Dodge, 115 spring-loading, 113 348-349 Ellipse, 115 Targeted Adjustment, 238, 242, 244, with Move tool, 348-349 Elliptical Marquee, 114, 168, 439 paragraph type, 384 Elliptical Marquee tool, 179 3D Material Drop, 115 path, 425 Eraser, 115, 300 3D Material Eyedropper, 114 selection border, 171 Eyedropper, 114, 208 Vertical Type, 115, 370 shortcuts, 349 Freeform Pen, 115, 418 Vertical Type Mask, 115 with Smart Guides, 348 Zoom, 101, 103, 116 Gradient, 115, 214, 279 type, 376, 384 Hand, 102, 116 tools (Camera Raw) via Options bar, 349 Healing Brush, 114, 310-312 Adjustment Brush tool, 55, 73–78 Transition panel, 452 hidden, selecting, 113 Crop tool, 55, 56 transitions, video hints, 113 Graduated Filter tool, 55, 86-87 adding, 452 History Brush, 115, 121, 301-302 Radial Filter tool, 88-89 defined, 449 Red Eye Removal tool, 55 Horizontal Type, 115, 370 duration, adjusting, 452 Spot Removal tool, 55, 90-91 Horizontal Type Mask, 115 See also video Lasso, 114, 169 Straighten tool, 55, 57 Transparency & Gamut preferences, Line, 115 Targeted Adjustment tool, 68-69, 73 158, 466 Magic Eraser, 115 types of, 55 Trim command, 146 White Balance tool, 55 Magic Wand, 114, 174-175 TRUMATCH color system, 205 Magnetic Lasso, 114 Tools menu (Bridge) type Mixer Brush, 110, 114, 296-298 Batch Rename command, 44 aligning, 370, 380 Move, 153, 171, 193, 257, 259, Cache command, 48 anti-aliasing, 371 260-261, 262, 348-349 Photoshop submenu attributes, changing, 372 Note, 114 Batch command, 429 baseline shift, 379 opacity, 209 Contact Sheet II command, 445 converting, point/paragraph, 376 Option bar settings, 113 Image Processor command, 488 deleting, 372 Paint Bucket, 115 Load Files into Photoshop editable, 369, 370 Patch, 114, 314, 324 Layers command, 264 editing, 372 Path Selection, 115, 407, 413, 417 Merge to HDR Pro command, 250 editing mode, exiting, 372 Pattern Stamp, 114 Photomerge command, 284 embossed leather, 404 Pen, 115, 420-422 Process Collections command, 284 fading, 378 Pencil, 114 Tools panel font family/style, changing, 373 Perspective Crop, 114 Change Screen Mode option, 116 font size, changing, 376 Polygon, 115 cycling through tools on, 113 formatting, 381-383 Polygonal Lasso, 114, 169 Edit in Quick Mask Mode option, 116, hyphenation, 380 188, 189 Quick Selection, 114, 172-173 importing as Smart Object, 371 Edit in Standard Mode button, 188 Rectangle, 115 justifying, 380 illustrated, 114-116 Rectangular Marquee, 114, 168, 442 kerning, 377 Rectangular Marquee tool, 179 Screen Mode menu, 104, 105 leading, 378 Red Eye, 114, 309 using, 113 orientation, 378 Rotate View, 103, 116 See also tools paragraph, 370, 376, 384 TOYO Color Finder, 205 Rounded Rectangle, 115 paragraph settings, 380

recoloring, 373 working with, 415–417 wector objects repositioning, on image, 385 scaling, 376 scaling, 372 creating, 406 anchor points, adding/deleting, 424–425 special characters, 379 in spot color channel, 388 points, converting, 424 reshaping, 424–425 reshaping, 424–425 special characters, 379 in spot color channel, 388 points, converting, 424 reshaping, 424–425 special characters, 379 in spot color channel, 388 points, converting, 424 reshaping, 424–425 spempting, 376, 384 saving as custom shape, 423 segments, reshaping, 424 reshaping, 424 and 50 per shaping, 424 reshaping, 424 reshaping, 424 reshaping, 424 reshaping, 424 reshaping, 425 spempting, 381 default, creating and loading, 383 reating type with, 370 defined, 115 recoloring type with, 370 recoloring type with, 370 recoloring type with, 372 formatting type with, 381–383 selecting type with, 372 fonts, downloading, 374–375 audic clips, 456 fonts, downloading, 374–375 audic clips, 456 fonts, downloading, 374–375 fonts, previewing, 374 filter applying, 337–335 suggested settings, 337 variables, 337 tracks, 449, 450 stitransitions, 449 workspace setup for editing, 449 deleting, 451 rendering 456 speed secting, 4	point, 370, 376	repositioning, 417	trimming by dragging, 451
recoloring, 373 repositioning, on image, 385 scaling, 376 screening back layers with, 385 scaling, 372 special characters, 379 in spot color channel, 388 tracking, 377 reshaping, 424–425 saving as custom shape, 423 saving as custom shape, 424 saving setting, 356 Vertical Type tool in changing font size, 376 creating 381 default, creating and loading, 383 editing, 382 default, creating and loading, 383 editing, 382 default, creating and loading, 383 editing, 382 deformatting type with, 381–383 loading between documents, 383 overrides, clearing, 382 Typekit fonts, downloading, 374–375 fonts, previewing, 374 missing font substitution, 34 turning on, 374-375 keyframe, 449 missing font substitution, 34 turning on, 374-375 keyframe, 449 missing font substitution, 34 turning on, 374-375 playing, 451 rendering, 265 playing, 451 rendering clips, 456 reviewing, 451 terminology, 449 turning on, 374 vector mask suggested settings, 337 variables, 337		-	
repositioning, on Image, 385 scaling, 376 scaling, 376 screening back layers with, 385 selecting, 372 in spot color channel, 388 points, converting, 424 reshaping, 424-425 reshaping, 424 reshaping, 424-425 reshaping, 424 reshaping, 425 reshaping, 428 reshaping, 429 reshaping, 42	•		
scaling, 376 screening back layers with, 385 screeting, 372 special characters, 379 in spot color channel, 388 tracking, 377 transforming, 376, 384 warp settings, 356 suppreferences, 371, 469 type styles type styles specially converting, 424 creating from type, 438 defined, 405 special characters, 379 in spot color channel, 388 warp settings, 356 suppreferences, 371, 469 type styles type styles type styles specially converting, 424 tracking, 377 transforming, 376, 384 warp settings, 356 suppring, 381 default, creating and loading, 383 default, creating and loading, 383 default, creating and loading, 383 editing, 382 formatting type with, 381–383 loading between documents, 383 overrides, clearing, 382 diding, 382 Typekit fonts, downloading, 374–375 fonts, previewing, 374 missing font substitution, 34 turning on, 374 using, 374–375 Typekit fonts, downloading, 374–375 fonts, previewing, 374 missing font substitution, 34 turning on, 374 using, 374–375 Typekit fonts, Rownloading, 374–375 fonts, previewing, 374 missing font substitution, 34 turning on, 374 using, 374–375 Typekit fonts, Rownloading, 374–375 fonts, previewing, 374 missing font substitution, 34 turning on, 374 using, 374–375 Typekit fonts, Rownloading, 374–375 fonts, previewing, 374 missing font substitution, 34 turning on, 374 using, 374–375 Typekit fonts, downloading, 374–375 flies, importing, 450 filter application to, 455 files, importing, 450 filter application to, 455 playing, 451 terminology, 449 turning on, 374 using, 374–375 type title clips, 456 reviewing, 451 terminology, 449 turning on, 374 using, 374–375 type title clips, 456 reviewing, 451 terminology, 449 turning on, 374 using, 374–375 type title clips, 456 reviewing, 451 terminology, 449 turning on, 374 using, 374–375 type title clips, 456 reviewing, 451 terminology, 449 turning on, 374 using, 374–375 type title clips, 456 reviewing, 451 terminology, 449 turning on, 374 using, 374–375 forth, previewing, 374 missing font substitution, 34 turning on, 374 turning on, 374 turning on, 374 tur		•	
screening back layers with, 385 selecting, 372 special characters, 379 in spot color channel, 388 tracking, 377 transforming, 376, 384 warp settings, 356 Vertical Type with, 372 segments, reshaping, 424 tracking, 387 transforming, 376, 384 say segments, reshaping, 424 tracking, 387 transforming, 376, 384 say segments, reshaping, 424 type styles applying, 381 creating, 381 creating, 381 default, creating and loading, 383 editing, 382 formatting type with, 381–383 coverrides, clearing, 382 formatting type with, 381–383 coverrides, clearing, 382 formatting type with, 381–383 overrides, clearing, 382 Typekit fonts, downloading, 374–375 fonts, fownloading, 374–375 fonts, previewing, 374 turning on,			
selecting, 372 special characters, 379 special characters, 379 special characters, 379 special characters, 379 spoints, converting, 424 reshaping, 424–425 saving as custom shape, 423 sapplying, 381 copying between documents, 383 certaing, 382 Typekit command, 287 special may be specification, 34 turning on, 374 missing font substitution, 34 turning on, 374 mosh specification, 450 turning on, 374 mosh specification, 387 turning on, 374 mosh specification, 387 turning on, 374 converting to layer masks, 417 copying, 416 converting to layer masks, 417 copying, 416 creating by drawing path, 415 creating from shape layer, 414 creating from shape layer, 414 creating from shape layer, 414 creating from type, 416 deleting, 194 density adjustment, 192 function, switching, 417 movin Alfa specification, 416 deleting, 417 movin Alfa specification, 418 playing deleting, 416 deleting, 416 deleting, 417 movin Alfa specification, 418 playing deleting, 416 deleting, 417 movin Alfa specification, 418 playing deleting, 416 deleting, 417 movin Alfa specification, 419 playing deleting, 416 deleting, 417 movin Alfa specification, 417 movin Alfa specification, 417 movin Alfa specification, 417 movin Alfa specification, 418 playing deleting, 416 defined, 419 deleting, 416 defined, 419 deleting, 416 defined, 419 deleting, 416 deleting			
special characters, 379 in spot color channel, 388 tracking, 377 transforming, 376, 384 warp settings, 356 Type preferences, 371, 469 Vertical Type tool applying, 381 copying between documents, 383 creating, 382 formatting type with, 373 selecting type with, 372 selecting type with, 372 selecting type with, 372 selecting type with, 373 selecting type with, 372 selecting type with, 373 selecting type with, 372 selecting type with, 372 selecting type with, 372 selecting type with, 372 selecting type with, 373 selecting type with, 372 selecting type with, 372 selecting type with, 372 selecting type with, 373 selecting type with, 372 selecting type with, 372 selecting type with, 373 selecting type with, 372 wignetts Wibrance adjustment, 292 fine, importing, 450 files, importing, 450 file ordinal proving and in a da			
in spot color channel, 388 tracking, 377 transforming, 376, 384 saving as custom shape, 423 segments, reshaping, 424 Vertical Type Mask tool, 115 Vertical Type tool in changing font size, 376 creating, 381 creating, 381 default, creating and loading, 383 creating, 381 default, creating dolading, 383 recting, 382 formatting type with, 381–383 loading between documents, 383 overrides, clearing, 382 Typekit fonts, downloading, 374–375 fonts, previewing, 374 missing font substitution, 34 turning on, 374 missing font substitution, 34 turning on, 374-375 Typekit.com, 374–375 Typekit.com	•		
tracking, 377 reshaping, 424–425 saving as custom shape, 423 288 warp settings, 356 segments, reshaping, 424 Snap Command, 287, 288 Type preferences, 371, 469 Vertical Type Mask tool, 115 Snap To submenu, 143, 171, 288 vignettes applying, 381 changing font size, 376 creating, 381 defined, 115 creating from existing path, 415 creating from shape layer, 416 creating by alignstment, 137 shape, 424 Snap Command, 287, 288 Type preferences, 371, 469 Vertical Type Mask tool, 115 Snap To submenu, 143, 171, 288 vignettes signet creating, 381 creating type with, 370–371 defined, 115 creating from existing path, 415 creating from shape layer, 416 deleting, 194 center of the protocol or specification, 451 deleting, 194 center of the protocol or specification, 451 deleting, 194 density adjustment, 192 function, switching, 417 moving, 416 creating from type, 416 deleting, 147 moving, 416 treating from type, 416 deleting, 147 moving, 416 treating from type, 416 deleting, 147 moving, 416 treating from type, 416 deleting, 417 moving, 416 treating from type, 416 deleting, 147 moving, 416 treating from type, 416 deleting, 417 moving, 417 moving, 418 treating, 429 function, 50 microcol and fine protocol and fine	ALL CONTRACTOR CONTRAC		
transforming, 376, 384 warp settings, 356 segments, reshaping, 424 Type perferences, 371, 469 type perferences, 371, 469 type styles applying, 381 default, creating and loading, 383 editing, 382 formatting type with, 381–383 loading between documents, 383 overrides, clearing, 382 formatting type with, 381–383 loading between documents, 383 overrides, clearing, 382 formatting type with, 381–383 loading between documents, 383 overrides, clearing, 382 formatting type with, 381–383 loading between documents, 383 overrides, clearing, 382 formatting type with, 373 adding still images to, 453 adjustment layer application to, 453 fonts, downloading, 374–375 fonts, previewing, 374 missing font substitution, 34 turning on, 374 using, 374–375 Typekit Ounsharp Mask filter applying, 337–338 suggested settings, 337 variables, 349 vector masks applying to its layer, 194 converting to layer masks, 417 copying, 416 creating from shape layer, 414 density adjustment, 192 disabling or deleting, 416 deleting, 194 density adjustment, 192 function, switching, 417 moving, 416 deleting, 194 density adjustment, 192 function, switching, 417 moving, 416 deleting, 194 feather adjustment, 192 function, switching, 417 moving, 416 speed setting, 452 function, switching, 417 moving, 416 speed setting, 452 function, switching, 417 moving, 416 deleting, 417 moving, 418 default, creating from type with, 370 selecting type with, 370 selecting type with, 372 selecting type with, 372 selecting type with, 373 selecting type with, 373 defenet, 449 vice of the vice adjustment, 440 recating from type adding stall images to, 453 adjustment layer application to, 453 setting (Camera Raw), 63 ware reading with effects tab, 85 song r			
warp settings, 356 Type preferences, 37, 469 Type styles	20 20 20 20 20 C	, 5	
type preferences, 371, 469 type styles yes tyles applying, 381 copying between documents, 383 creating, 381 default, creating and loading, 383 editing, 382 formatting type with, 381–383 loading between documents, 383 overrides, clearing, 382 formatting type with, 381–383 loading between documents, 383 overrides, clearing, 382 formatting type with, 381–383 loading between documents, 383 overrides, clearing, 382 formatting type with, 381–383 loading between documents, 383 overrides, clearing, 382 formatting type with, 381–383 loading between documents, 383 overrides, clearing, 382 formatting type with, 372 tybekit fonts, downloading, 374–375 fonts, previewing, 374 missing font substitution, 34 turning on, 374 using, 374–375 fypekit.com,			
type styles applying, 381 in changing forn size, 376 creating via Lens Correction filter, 441 copying between documents, 383 creating, 381 default, creating and loading, 383 recoloring type with, 370–371 defined, 115 recoloring type with, 373 white-bordered, creating, 439 via tonal adjustment, 440 recording actions that apply, 431 white-bordered, creating, 439 viagnetts (Camera Raw) applying with 581–83 correcting in Profile tab, 80 correcting in Manual tab, 81–83 correcting in Profile tab, 80 warp family adjustment, 440 files importing, 450 filter application to, 455 frames, 449 missing font substitution, 34 turning on, 374 frames, 449 filter application to, 455 frames, 449 manual fade, 455 picture-in-a-picture, 455 picture-in-a-picture, 455 picture-in-a-picture, 455 picture-in-a-picture, 455 picture-in-a-picture, 455 picture-in-a-picture, 455 receivening, 451 terminology, 449 timeline, 449, 450 title clips, 453 suggested settings, 337 variables, 337 tracks, 449, 450 title clips, 453 transitions, 449 workspace setup for editing, 449 workspace setup for editing, 449 converting to layer masks, 417 copying, 416 deleting, 194 density adjustment, 192 defined, 449 deleting, 416 deleting, 194 density adjustment, 192 finedting, 416 feather adjustment, 192 fineding, 416 feather adjustment, 192 fineding applying adjustment layer to, 454 applying adjustment layer to, 454 applying adjustment layer to, 454 applying filters to, 455 defined, 449 feather, 449 for the deleting, 416 feather adjustment, 192 filter, 452 f	, 3		
applying, 381 copying between documents, 383 creating, 381 default, creating and loading, 383 editing, 382 formatting type with, 381–383 loading between documents, 383 overrides, clearing, 382 Typekit fonts, downloading, 374–375 fonts, previewing, 374 missing font substitution, 34 turning on, 374 using, 374–375 Typekitcom, 374–375 U Undo shortcuts, 111 Units & Rulers preferences, 16, 467 Unsharp Mask filter applying, 337–338 suggested settings, 337 variables, 337 Vector masks applying to its layer, 194 converting to layer masks, 417 copying, 416 creating by drawing path, 415 creating from existing path, 415 creating from existing path, 415 creating from type, 416 deleting, 194 density adjustment, 192 dinastity adjustment, 192 function, switching, 417 movine, 416 in changing font size, 376 creating type with, 370–371 defined, 115 defined, 115 reacting type with, 373 selecting type with, 372 viblants, 372 viblants, 382 recoloring type with, 373 selecting type with, 372 viblants, 372 viblants, 383 recoloring type with, 373 selecting type with, 372 viblants, 372 viblants, 383 verrides, clearing, 382 vigentes (Camera Raw) applying with Effects tab, 85 correcting in Profile tab, 80 Warp command, 356 Warp Text (ialog, 354 watermarks, 444 Web output aligning vector objects for, 405 buttons for, 409 downsampling images for, 139 file format selection for, 489 resolution and dimensions for, 13, 16 white balance adjustments, applying (Camera Raw), 55 white point, calibration, 6 Window menu Arrange submenu, 99, 100, 102, 256, 262 Brush Presets command, 295 Channels command, 2 Character command, 372 Options command, 110, 113, 128 Workspace submenu, 104, 449 workspace set setting, 451 rendering, 452 speld setting, 453 speld setting, 452 speld setting, 453 speld setting, 454 speld setting, 454 speld setting, 455 speed setting, 452 speld setting, 455 speed setting, 452 speld setting, 452 speld setting, 452 speld setting, 452 speld s			
creating shetween documents, 383 creating type with, 370–371 defined, 115 recoloring type with, 373 selecting type with, 372 formatting type with, 381–383 loading between documents, 383 overrides, clearing, 382 Typekit fonts, downloading, 374–375 fonts, previewing, 374 missing font substitution, 34 turning on, 374 using, 374–375 Typekit.com, 374 tusing, 374–375 terminology, 449 timeline, 449, 450 title clips, 453 tracks, 449, 450, 451 transitions, 449 video clips adding transitions to, 452 applying adding transitions to, 452 applying adding transitions to, 452 applying adding transitions to, 452 Typekit.com, 374			
creating, 381 default, creating and loading, 383 recoloring type with, 373 seletting, 382 formatting type with, 381–383 loading between documents, 383 overrides, clearing, 382 Typekit fonts, downloading, 374–375 fonts, previewing, 374 missing font substitution, 34 turning on, 374 using, 374–375 Typekitcom, 374 Usuring on, 37			_
default, creating and loading, 383 editing, 382 selecting type with, 373 selecting, 439 vignettes (Camera Raw) applying with Effects tab, 85 correcting in Manual tab, 81–83 overrides, clearing, 382 Typekit fonts, downloading, 374–375 fonts, previewing, 374 missing font substitution, 34 turning on, 374 using, 374–375 Typekit.com, 374–375 Typekit, sing of the substitution, 34 turning on, 374 using, 374–375 Typekit, sing of the substitution, 34 turning on, 374 using, 374–375 Typekit, sing of the substitution, 34 turning on, 374 using, 374–375 Typekit, sing of the substitution, 34 turning on, 374 using, 374–375 Typekit, sing of the substitution, 34 turning on, 374 using, 373–375 Typekit, sing of the substitution, 34 turning on, 374 using, 373–375 Typekit, sing of the substitution, 34 turning on, 374 turning on, 374 using, 373–375 Typekit, sing of the substitution, 34 turning on, 374 turning on			
editing, 382 selecting type with, 372 vignettes (Camera Raw) applying with Effects tab, 85 correcting in Manual tab, 81–83 correcting in Profile tab, 80 Wrap Correcting in Profile tab, 80 Wrap Correcting in Profile tab, 80 Warp Correcting in Manual tab, 81–83 correcting in Profile tab, 80 Warp Correcting in Manual t			-
formatting type with, 381–383 loading between documents, 383 video overrides, clearing, 382 Typekit fonts, downloading, 374–375 fonts, previewing, 374 missing font substitution, 34 turning on, 374 using, 374–375 Typekit.com, 374–375 I U Undo shortcuts, 111 Units & Rulers preferences, 16, 467 Unsharp Mask filter applying, 337–338 suggested settings, 337 variables, 337 variables, 337 Vector masks applying to layer masks, 417 copying, 416 creating from shape layer, 414 creating from existing path, 415 creating from shape layer, 414 creating from shape layer, 416 deleting, 194 density adjustment, 192 function, switching, 417 movine, 416 feather adjustment, 192 function, switching, 416 feather adjustment, 192 function, switching, 417 movine, 416 feather adjustment, 192 function, switching, 417 maying, 416 formatinages to, 453 adding still images to, 453 adding still images to, 453 adding still images to, 453 dading still images to, 453 adiustment layer application to, 453 watermarks, 444 Web output aligning vector objects for, 405 buttons for, 409 downsampling images for, 139 file format selection for, 489 resolution and dimensions for, 13, 16 white balance adjustment, 94 watermarks, 444 Web output aligning vector objects for, 405 buttons for, 409 downsampling images for, 139 file format selection for, 489 resolution and dimensions for, 13, 16 white balance adjustment, 94 watermarks, 444 Web output aligning vector objects for, 405 buttons for, 499 downsampling images for, 139 file format selection for, 489 resolution and dimensions for, 13, 16 white balance adjustment, 94 downsampling images for, 139 file format selection for, 489 resolution and dimensi			_
loading between documents, 383 overrides, clearing, 382 adding still images to, 453 correcting in Manual tab, 81–83 correcting in Profile tab, 80 Typekit adjustment layer application to, 453 adding still images to, 453 Warp Text dialog, 354 Warp Text dialog, 354 watermarks, 444 Warp Text dialog, 354 watermarks, 444 Web output aligning vector objects for, 405 buttons for, 409 downsampling images for, 139 file format selection for, 489 resolution and dimensions for, 13, 16 white balance adjustments, applying to its layer, 194 converting to layer masks, 417 copying, 416 creating from existing path, 415 creating from existing path, 414 creating from shape layer, 414 creating from shape layer, 414 density adjustment, 192 disabling or deleting, 416 feather adjustment, 192 disabling or deleting, 416 feather adjustment, 192 function, switching, 417 movine 146 wideo clips adding still images to, 453 adding still images to, 453 adjustment layer application to, 453 adjustment layer application to, 453 warding transition to, 455 watermarks, 444 Web output aligning vector objects for, 405 buttons for, 409 downsampling images for, 139 file format selection for, 489 resolution and dimensions for, 13, 16 white balance adjustment, 449 white balance adjustment, 449 white point, calibration, 6 Window menu Arrange submenu, 99, 100, 102, 256, 262 262 Chanacter command, 20 Character command, 20 Character command, 20 Character command, 21 Character command, 172 Options command, 110, 113, 128 Workspace submenu, 104, 449 Windows droplet usability in, 432 exiting Photoshop in, 22 launching Bridge in, 23 launching photoshop in, 1			
Typekit adjustment layer application to, 453 fonts, downloading, 374–375 fonts, previewing, 374 missing font substitution, 34 turning on, 374 using, 374–375 fypekit.com, 374–375 fypekit.com, 374–375 Typekit.com, 374–375 U Undo shortcuts, 111 Units & Rulers preferences, 16, 467 Unsharp Mask filter applying, 337–338 suggested settings, 337 variables, 337 Vector masks applying to its layer, 194 converting to layer masks, 417 copying, 416 creating from existing path, 415 creating from existing path, 414 creating from shape layer, 414 creating from type, 416 deleting, 194 density adjustment, 192 disabling or deleting, 416 feather adjustment, 192 disabling or deleting, 416 feather adjustment, 192 function, switching, 415 speed setting, 452 function, switching, 415 speed setting, 452 function, switching, 415 moving 416 Warp command, 356 Warp Text dialog, 354 watermake, 444 Web output aligning vector objects for, 405 buttons for, 409 downsampling images for, 139 file format selection for, 489 resolution and dimensions for, 13, 16 white balance adjustment, 494 tyeb output aligning vector objects for, 405 buttons for, 409 downsampling images for, 139 file format selection for, 489 resolution and dimensions for, 13, 16 white balance adjustments, 494 web output aligning vector objects for, 405 buttons for, 409 downsampling images for, 139 file format selection for, 489 resolution and dimensions for, 13, 16 white balance adjustments, 494 whethoutput aligning vector objects for, 405 buttons for, 409 downsampling images for, 139 file format selection for, 489 resolution and dimensions for, 13, 16 white balance adjustments, 494 web output aligning vector objects for, 405 buttons for, 409 downsampling images for, 139 file format selection for, 489 resolution and dimensions for, 13, 16 white balance adjustments, 494 who have tideleting, 449 white balance adjustments, 494 white balance adjustments, 494 where tideleting, 494 deleting, 495 character command, 205 Character command, 205 Character command, 110, 113, 128 Workspace s		•	
Fypekit fonts, downloading, 374–375 fonts, previewing, 374 missing font substitution, 34 turning on, 374 using, 374–375 forms, 449 missing font substitution, 34 filter application to, 455 fights, importing, 450 manual fade, 455 picture-in-a-picture, 455 picture-in-a-picture, 455 picture-in-a-picture, 455 picture-in-a-picture, 455 pundo shortcuts, 111 playing, 451 rendering clips, 456 reviewing, 451 remedring clips, 456 reviewing, 451 remedring clips, 456 reviewing, 451 title clips, 453 suggested settings, 337 variables, 337 title clips, 453 suggested settings, 337 variables, 337 title clips, 453 suggested settings, 349 vorkspace setup for editing, 449 cector masks applying to its layer, 194 converting to layer masks, 417 copying, 416 creating from existing path, 414 creating from existing path, 414 creating from existing path, 414 creating from shape layer, 414 creating from shape layer, 414 creating from type, 416 deleting, 194 density adjustment, 192 disabling or deleting, 416 feather adjustment, 192 disabling or deleting, 416 feather adjustment, 192 disabling or deleting, 416 feather adjustment, 192 function, switching, 417 movine 416 Warp Command, 356 Warp Command, 356 Warp Text dialog, 354 watermarks, 444 Web output aligning vector objects for, 405 buttons for, 409 downsampling images for, 139 file format selection for, 489 resolution and dimensions for, 13, 16 white balance adjustments, applying (Camera Raw), 63 setting (Camera Raw), 62 White Balance tool (Camera Raw), 55 white point, calibration, 6 Window menu Arrange submenu, 99, 100, 102, 256, 262 Brush Presets command, 20 Character command, 20 Character command, 372 Options command, 110, 113, 128 Windows droplet usability in, 432 exiting Photoshop in, 22 launching Photoshop in, 1			
fonts, downloading, 374–375 fonts, previewing, 374 missing font substitution, 34 turning on, 374 using, 374–375 keyframes, 449 using, 374–375 keyframes, 449 manual fade, 455 Typekit.com, 374–375 manual fade, 455 picture-in-a-picture, 455 playing, 451 rendering clips, 456 reviewing, 451 Unsharp Mask filter applying, 337–338 suggested settings, 337 variables, 337 variables, 337 vector masks applying to its layer, 194 converting to layer masks, 417 creating from existing path, 415 creating from existing path, 415 creating from shape layer, 414 creating from shape layer, 414 creating from type, 416 deleting, 194 density adjustment, 192 disabling or deleting, 416 feather adjustment, 192 function, switching, 417 moving 416 forts application to, 455 files, importing, 450 Warp Text dialog, 354 watermarks, 444 Web output aligning vector objects for, 405 buttons for, 409 downsampling images for, 139 file format selection for, 489 resolution and dimensions for, 13, 16 white balance adjustments, applying (Camera Raw), 62 White Balance tool (Camera Raw), 62 White Balance tool (Camera Raw), 55 white point, calibration, 6 Window menu Arrange submenu, 99, 100, 102, 256, 262 Brush Presets command, 295 Channels command, 2 Character command, 372 Options command, 110, 113, 128 Workspace submenu, 104, 449 Windows droplet usability in, 432 exiting Photoshop in, 22 launching Photoshop in, 1			-
fonts, previewing, 374 missing font substitution, 34 turning on, 374 using, 374–375 Typekit.com, 374–375 U undo shortcuts, 111 Units & Rulers preferences, 16, 467 Unsharp Mask filter applying, 337–338 suggested settings, 337 variables, 337 V vector masks applying to its layer, 194 converting to layer masks, 417 copying, 416 creating by drawing path, 415 creating from existing path, 414 creating from existing path, 414 creating from shape layer, 414 creating from type, 416 deleting, 194 density adjustment, 192 disabling or deleting, 416 files, importing, 450 filet application to, 455 manual fade, 455 buttons for, 409 downsampling images for, 139 file format selection for, 489 resolution and dimensions for, 13, 16 white balance adjustments, applying (Camera Raw), 63 setting (Camera Raw), 62 White Balance tool (Camera Raw), 55 white point, calibration, 6 Window menu Arrange submenu, 99, 100, 102, 256, 262 Brush Presets command, 295 Channels command, 295 Channels command, 372 Options command, 110, 113, 128 Workspace submenu, 104, 449 Windows droplet usability in, 432 exiting Photoshop in, 22 launching Priods in, 23 launching Priods on in, 1			W
missing font substitution, 34 turning on, 374 using, 374—375 Typekit.com, 374—375 Meyframes, 449 keyframes, 449 keyframes, 449 keyframes, 449 manual fade, 455 picture-in-a-picture, 455 playing, 451 Units & Rulers preferences, 16, 467 Unsharp Mask filter applying, 337—338 suggested settings, 337 variables, 337 variables, 337 vector masks applying to its layer, 194 converting to layer masks, 417 copying, 416 creating from shape layer, 414 creating from shape layer, 414 creating from type, 416 deleting, 194 density adjustment, 192 disabling or deleting, 416 feather adjustment, 192 function, switching, 417 moving, 416 ffarms, 449 ffarmes, 449 ffarmes, 449 ffarmes, 449 ffarmes, 449 plotting idea, 455 plotture, 456 plotture, 456 plotture, 456 plotture, 456 plotture, 456 plotture,		and the second s	Warp command, 356
turning on, 374 using, 374–375 Typekit.com, 374–375 Web output aligning vector objects for, 405 buttons for, 409 downsampling images for, 139 file format selection for, 489 resolution and dimensions for, 13, 16 white balance applying, 337–338 terminology, 449 timeline, 449, 450 transitions, 449 converting to layer masks, 417 copying, 416 creating from existing path, 415 creating from type, 416 deleting, 194 density adjustment, 192 disabling or deleting, 416 efeather adjustment, 192 disabling or deleting, 417 moving, 416 feather adjustment, 192 function, switching, 417 moving, 416 feather adjustment, 192 funct		100 100 100	Warp Text dialog, 354
using, 374–375 Typekit.com, 374–375 Meyframes, 449 manual fade, 455 picture-in-a-picture, 455 buttons for, 409 downsampling images for, 139 file format selection for, 489 resolution and dimensions for, 13, 16 White balance applying, 337–338 suggested settings, 337 variables, 337 title clips, 453 tracks, 449, 450, 451 transitions, 449 vector masks applying to its layer, 194 converting to layer masks, 417 copying, 416 creating from existing path, 414 creating from existing path, 414 creating from type, 416 deleting, 194 density adjustment, 192 disabling or deleting, 416 feather adjustment, 192 function, switching, 417 moving, 416 manual fade, 455 buttons for, 409 downsampling images for, 139 file format selection for, 489 resolution and dimensions for, 13, 16 white balance adjustments, applying (Camera Raw), 63 setting (Camera Raw), 62 White Balance tool (Camera Raw), 55 white point, calibration, 6 Window menu Arrange submenu, 99, 100, 102, 256, 262 Brush Presets command, 295 Channels command, 2 Character command, 372 Options command, 110, 113, 128 Workspace submenu, 104, 449 Windows deleting, 194 density adjustment, 192 disabling or deleting, 416 feather adjustment, 192 function, switching, 417 moving, 416 speed setting, changing, 455 speed specification, 451 splitting, 452 function, switching, 417 moving, 416	-		watermarks, 444
Typekit.com, 374–375 U undo shortcuts, 111 Units & Rulers preferences, 16, 467 Unsharp Mask filter applying, 337–338 suggested settings, 337 variables, 337 Vector masks applying to lits layer, 194 converting to layer masks, 417 copying, 416 creating from existing path, 415 creating from type, 416 deleting, 194 density adjustment, 192 disabling or deleting, 416 feather adjustment, 192 disabling or deleting, 417 even defined, 417 even defined, 455 picture-in-a-picture, 455 picture-in-a-picture, 455 playing, 451 rendering clips, 456 reviewing, 451 rendering, 456 speed setting, changing, 455 feather adjustment, 192 function, switching, 417 moving, 416 undo shortcuts, 111 playing, 451 rendering clips, 456 resolution and dimensions for, 13, 16 white balance adjustments, applying (Camera Raw), 63 setting (Camera Raw), 62 White Balance tool (Camera Raw), 55 White point, calibration, 6 Window menu Arrange submenu, 99, 100, 102, 256, 262 Brush Presets command, 295 Channels command, 2 Character command, 372 Options command, 110, 113, 128 Workspace submenu, 104, 449 Workspace submenu, 104, 449 Workspace submenu, 104, 449 density adjustment, 192 disabling or deleting, 416 speed setting, changing, 455 feather adjustment, 192 speed specification, 451 splitting, 452 launching Bridge in, 23 launching photoshop in, 1	- 11 march 11 march 12 march 1		Web output
undo shortcuts, 111 Units & Rulers preferences, 16, 467 Unsharp Mask filter applying, 337–338 suggested settings, 337 variables, 337 variables, 337 vector masks applying to its layer, 194 converting to layer masks, 417 copying, 416 creating from existing path, 415 creating from type, 416 deleting, 194 density adjustment, 192 disabling or deleting, 416 feather adjustment, 192 function, switching, 417 goving 416 playing, 451 rendering clips, 456 reviewing, 451 rendering clips, 456 reviewing, 451 transitions, 449 white balance adjustments, applying (Camera Raw), 63 setting (Camera Raw), 63 setting (Camera Raw), 63 setting (Camera Raw), 63 setting (Camera Raw), 55 white point, calibration, 6 Window menu Arrange submenu, 99, 100, 102, 256, 262 Brush Presets command, 295 Channels command, 2 Character command, 372 Character command, 372 Options command, 110, 113, 128 Workspace submenu, 104, 449 Windows droplet usability in, 432 exiting Photoshop in, 22 launching Bridge in, 23 launching photoshop in, 1	-	500 as vas	aligning vector objects for, 405
undo shortcuts, 111 Units & Rulers preferences, 16, 467 Unsharp Mask filter applying, 337–338 suggested settings, 337 variables, 337 variables, 337 vector masks applying to its layer, 194 converting to layer masks, 417 copying, 416 creating by drawing path, 415 creating from existing path, 414 creating from shape layer, 414 creating from type, 416 deleting, 194 density adjustment, 192 disabling or deleting, 416 feather adjustment, 192 function, switching, 417 moving 416 file format selection for, 489 resolution and dimensions for, 13, 16 white balance adjustments, applying (Camera Raw), 63 setting (Camera Raw), 62 White Balance tool (Camera Raw), 55 white point, calibration, 6 Window menu Arrange submenu, 99, 100, 102, 256, 262 Brush Presets command, 295 Channels command, 295 Channels command, 2 Character command, 372 Options command, 110, 113, 128 Workspace submenu, 104, 449 Windows droplet usability in, 432 exiting Photoshop in, 22 launching Bridge in, 23 launching photoshop in, 1	50 - Control C		buttons for, 409
Units & Rulers preferences, 16, 467 Unsharp Mask filter applying, 337–338 suggested settings, 337 variables, 337 variables, 337 vector masks applying to its layer, 194 converting to layer masks, 417 copying, 416 creating from existing path, 415 creating from shape layer, 414 creating from type, 416 deleting, 194 density adjustment, 192 disabling or deleting, 416 feather adjustment, 192 function, switching, 417 moving 416 Units & Rulers preferences, 16, 467 reviewing, 456 reviewing, 456 reviewing, 456 reviewing, 451 the lips, 456 reviewing, 451 the lips, 450 time format selection for, 469 resolution and dimensions for, 13, 16 white balance adjustments, applying (Camera Raw), 63 setting (Camera Raw), 63 workspace setup for editing, 449 white Balance tool (Camera Raw), 55 white point, calibration, 6 Window menu Arrange submenu, 99, 100, 102, 256, 262 Brush Presets command, 295 Channels command, 2 Character command, 2 Character command, 372 Options command, 110, 113, 128 Workspace submenu, 104, 449 Windows droplet usability in, 432 exiting Photoshop in, 22 launching Bridge in, 23 launching photoshop in, 1	U		downsampling images for, 139
Unsharp Mask filter applying, 337–338 suggested settings, 337 variables, 337 vertor masks applying to its layer, 194 converting to layer masks, 417 copying, 416 creating by drawing path, 415 creating from existing path, 414 creating from shape layer, 414 creating from type, 416 deleting, 194 density adjustment, 192 disabling or deleting, 416 feather adjustment, 192 function, switching, 417 moving, 416 feather adjustment, 417 feather adjustment, 417 moving, 416 feather adjustment, 417 feather adjustment, 416 feather adjustment, 416 feather adjustment, 417 feather adjustment, 417 feather adjustment, 416 feather adjustment, 417 feather adjustment, 416 feat	undo shortcuts, 111		file format selection for, 489
unsharp Mask Rifer applying, 337–338 suggested settings, 337 variables, 337 variables, 337 vector masks applying to its layer, 194 converting to layer masks, 417 copying, 416 creating by drawing path, 415 creating from existing path, 414 creating from shape layer, 414 creating from type, 416 deleting, 194 density adjustment, 192 disabling or deleting, 416 feather adjustment, 192 function, switching, 417 moving 416 suggested settings, 337 timeline, 449, 450 timeline, 449 timeline, 449, 450 timeline, 449 timeline, 449, 450 timeline, 469 timeline, 449 timeline, 449 timeline, 469 timeline, 449 timeline, 469 timeline, 4	Units & Rulers preferences, 16, 467	• .	resolution and dimensions for, 13, 16
suggested settings, 337 variables, 337 variables, 337 vector masks applying to its layer, 194 converting to layer masks, 417 copying, 416 creating by drawing path, 415 creating from existing path, 414 creating from type, 416 deleting, 194 density adjustment, 192 disabling or deleting, 416 feather adjustment, 192 function, switching, 417 moving 416 suggested settings, 337 title clips, 453 title clips, 453 setting (Camera Raw), 62 White Balance tool (Camera Raw), 55 white point, calibration, 6 Window menu Arrange submenu, 99, 100, 102, 256, 262 Brush Presets command, 295 Channels command, 2 Character command, 295 Channels command, 2 Character command, 372 Options command, 110, 113, 128 Workspace submenu, 104, 449 Windows droplet usability in, 432 exiting Photoshop in, 22 launching Bridge in, 23 launching photoshop in, 1	Unsharp Mask filter	1 1 1 1 1 1 1 1 1 1 1 1 1 1 1 1 1 1 1	white balance
title clips, 453 variables, 337 variables, 337 tracks, 449, 450, 451 transitions, 449 vector masks applying to its layer, 194 converting to layer masks, 417 copying, 416 creating by drawing path, 415 creating from existing path, 414 creating from shape layer, 414 creating from type, 416 deleting, 194 density adjustment, 192 disabling or deleting, 416 feather adjustment, 192 function, switching, 417 moving 416 vitle clips, 453 setting (Camera Raw), 62 White Balance tool (Camera Raw), 55 white point, calibration, 6 Window menu Arrange submenu, 99, 100, 102, 256, 262 Brush Presets command, 295 Channels command, 2 Character command, 295 Channels command, 2 Character command, 372 Options command, 110, 113, 128 Workspace submenu, 104, 449 Windows droplet usability in, 432 exiting Photoshop in, 22 launching Bridge in, 23 launching photoshop in, 1	applying, 337–338		adjustments, applying (Camera
vector masks applying to its layer, 194 converting to layer masks, 417 copying, 416 creating by drawing path, 415 creating from existing path, 414 creating from type, 416 deleting, 194 density adjustment, 192 disabling or deleting, 416 feather adjustment, 192 function, switching, 417 moving 416 tracks, 449, 450, 451 transitions, 449 workspace setup for editing, 449 white Balance tool (Camera Raw), 55 white point, calibration, 6 Window menu Arrange submenu, 99, 100, 102, 256, 262 Brush Presets command, 295 Channels command, 2 Character command, 372 Character command, 372 Options command, 110, 113, 128 Workspace submenu, 104, 449 Windows droplet usability in, 432 exiting Photoshop in, 22 launching Bridge in, 23 launching photoshop in, 1	suggested settings, 337		
vector masks applying to its layer, 194 converting to layer masks, 417 copying, 416 creating by drawing path, 415 creating from existing path, 414 creating from type, 416 deleting, 194 density adjustment, 192 disabling or deleting, 416 feather adjustment, 192 function, switching, 417 video clips adding transitions to, 452 applying adjustment layer to, 454 applying filters to, 455 defined, 449 defined, 449 defined, 449 defined, 451 creating from type, 416 deleting, 194 density adjustment, 192 function, switching, 417 moving, 416 video clips adding transitions, 449 window menu Arrange submenu, 99, 100, 102, 256, 262 Brush Presets command, 295 Channels command, 2 Character command, 372 Options command, 110, 113, 128 Workspace submenu, 104, 449 Windows droplet usability in, 432 exiting Photoshop in, 22 launching Bridge in, 23 launching photoshop in, 1	variables, 337		setting (Camera Raw), 62
vector masks applying to its layer, 194 converting to layer masks, 417 copying, 416 creating by drawing path, 415 creating from existing path, 414 creating from type, 416 deleting, 194 density adjustment, 192 disabling or deleting, 416 feather adjustment, 192 function, switching, 417 moving, 416 applying adjustment layer to, 454 applying adjustment layer to, 454 applying adjustment layer to, 454 applying filters to, 455 channels command, 295 Channels command, 2 Character command, 372 Options command, 110, 113, 128 Workspace submenu, 104, 449 Windows droplet usability in, 432 exiting Photoshop in, 22 launching Bridge in, 23 launching photoshop in, 1	V		White Balance tool (Camera Raw), 55
applying to its layer, 194 converting to layer masks, 417 copying, 416 creating by drawing path, 415 creating from existing path, 414 creating from shape layer, 414 creating from type, 416 deleting, 194 density adjustment, 192 disabling or deleting, 416 feather adjustment, 192 function, switching, 417 moving, 416 video clips adding transitions to, 452 applying adjustment layer to, 454 applying filters to, 455 channels command, 295 Channels command, 2 Character command, 372 Options command, 110, 113, 128 Workspace submenu, 104, 449 Windows droplet usability in, 432 exiting Photoshop in, 22 launching Bridge in, 23 launching photoshop in, 1	vector masks		white point, calibration, 6
converting to layer masks, 417 copying, 416 creating by drawing path, 415 creating from existing path, 414 creating from type, 416 deleting, 194 density adjustment, 192 disabling or deleting, 416 feather adjustment, 192 function, switching, 417 moving, 416 cropying, 416 creating transitions to, 452 applying adjustment layer to, 454 applying filters to, 455 Channels command, 29 Character command, 29 Character command, 29 Character command, 29 Character command, 20 Character command, 29 Character command, 20 Character comm			
copying, 416 creating by drawing path, 415 creating from existing path, 414 creating from shape layer, 414 creating from type, 416 deleting, 194 density adjustment, 192 disabling or deleting, 416 feather adjustment, 192 function, switching, 417 moving, 416 creating thinstitol, 752 applying adjustment layer to, 454 applying adjustment layer to, 454 applying adjustment layer to, 455 channels command, 29 Character command, 372 Options command, 110, 113, 128 Workspace submenu, 104, 449 Windows droplet usability in, 432 exiting Photoshop in, 22 launching Bridge in, 23 launching photoshop in, 1		N	
creating by drawing path, 415 creating from existing path, 414 creating from shape layer, 414 creating from type, 416 deleting, 194 density adjustment, 192 disabling or deleting, 416 feather adjustment, 192 function, switching, 417 moving, 416 speed setting, 452 speed specification, 451 defined, 449 defined, 449 defined, 449 defined, 449 defined, 449 defined, 449 defined, 451 deleting, 451 deleting, 451 workspace submenu, 104, 449 Windows droplet usability in, 432 exiting Photoshop in, 22 launching Bridge in, 23 launching photoshop in, 1	- 1	_	262
creating from existing path, 414 creating from shape layer, 414 creating from type, 416 deleting, 194 density adjustment, 192 disabling or deleting, 416 feather adjustment, 192 function, switching, 417 moving, 416 spends spends setting, 459 deleting, 450 creating from type, 416 deleting, 451 deleting, 451 deleting, 451 deleting, 451 deleting, 451 vortespace submenu, 104, 449 windows droplet usability in, 432 exiting Photoshop in, 22 launching Bridge in, 23 launching photoshop in, 1			Brush Presets command, 295
creating from shape layer, 414 deleting, 451 Options command, 372 creating from type, 416 length specification, 451 Workspace submenu, 104, 449 deleting, 194 order, changing, 451 Windows disabling or deleting, 416 speed setting, changing, 455 exiting Photoshop in, 22 function, switching, 417 splitting, 452 launching Bridge in, 23 moving, 416 speed specification, 451 launching photoshop in, 1			
creating from type, 416 deleting, 194 density adjustment, 192 disabling or deleting, 416 feather adjustment, 192 function, switching, 417 moving, 416 speed specification, 451 length specification, 451 workspace submenu, 104, 449 Windows droplet usability in, 432 exiting Photoshop in, 22 launching Bridge in, 23 launching photoshop in, 1	3.		Character command, 372
deleting, 194 order, changing, 451 Windows density adjustment, 192 rendering, 456 droplet usability in, 432 disabling or deleting, 416 speed setting, changing, 455 exiting Photoshop in, 22 feather adjustment, 192 speed specification, 451 launching Bridge in, 23 moving, 416 speed specification, 452 launching photoshop in, 1		5	
density adjustment, 192 rendering, 456 droplet usability in, 432 speed setting, changing, 455 exiting Photoshop in, 22 function, switching, 417 splitting, 452 launching Bridge in, 23 launching photoshop in, 1			Workspace submenu, 104, 449
disabling or deleting, 416 speed setting, 455 exiting Photoshop in, 22 speed specification, 451 launching Bridge in, 23 splitting, 452 launching photoshop in, 1	•	, 5 5	
feather adjustment, 192 speed specification, 451 launching Bridge in, 23 splitting, 452 launching photoshop in, 1	20. TO 10. TO 10		
function, switching, 417 splitting, 452 launching Bridge in, 23 moving, 416 splitting, 452 launching photoshop in, 1	5		
moving 416 launching photoshop in, 1	ESSENCE OF SECURIOR AND SECURIOR SECURI		
Save As dialog box, 19			
		uue, 455	Save As dialog box, 19

ZIP file creation, 488

Work Paths, 418, 419

Workflow Options dialog (Camera Raw)

Depth menu, 58

Intent options, 58

Open in Photoshop as Smart Objects option, 58

Preset menu, 58

presets, 58–59, 60

working spaces

Resize to Fit menu, 60

Space menu, 58, 59

corking spaces CMYK, 483 current, assigning, 12 settings, 8

settings, choosing, 58-59, 95

Simulate Paper & Ink option, 58

Workspace menu (Options bar), 104, 108, 109, 110

workspaces choosing, 104 deleting, 109
non-user-defined, resetting, 109
resetting, 109
saving, 108–109
setting up for video editing, 449
workspaces (Bridge)
changing, 28
choosing, 28

changing, 28
choosing, 28
custom, 38
default, 26
deleting, 38
Essentials, 28
Filmstrip, 28
Light Table, 28
order, changing, 28
predefined, restoring, 38
Preview, 28

Preview, 28 resetting, 38 saving, 38

wrinkle removal, 310, 311, 314

Z

ZIP files, 488

zoom

level, changing, 101–103
level, changing via Navigator panel, 102
level, changing with Zoom tool, 101
level, matching in multiple documents, 102
in multiple document windows, 103
retina displays and, 101

Zoom tool

shortcuts, 101

defined, 116 Scrubby Zoom, 101 Zoom All Windows option, 103 zoom level changes with, 101

Photography credits

Shutterstock.com

Photographs on the following pages are © ShutterStock.com: 1, 22, 40, 45, 56, 57, 63, 68, 74, 77, 81, 84, 85, 88, 90, 97, 100, 103, 104, 135, 136, 137, 140, 141, 142, 143, 148, 150, 151, 160, 167, 168, 169, 170, 171, 172, 174, 175, 176, 178, 179, 180, 183, 184, 188, 189, 195, 200, 201, 204, 208, 209, 211, 212, 222, 227, 230, 232, 233, 234, 236, 238, 239, 240, 241, 242, 248, 256, 258, 259, 263, 267, 268, 269, 276, 280, 282, 298, 301, 304, 310, 312, 313, 314, 315, 316, 318, 321, 322, 323, 324, 327, 328, 329, 330, 334, 337, 342, 343, 351, 352, 355, 356, 361, 365, 366, 367, 391, 394, 398, 404, 406, 414, 415, 417, 420, 437, 441, 442, 443, 445, 457

Gettyimages.com

Pages 14, 307, 348, 357, 384

Other photographs

Page 25 Rob Knight © Rob Knight Photography
All other photographs © Elaine Weinmann and Peter Lourekas